SENTINEL

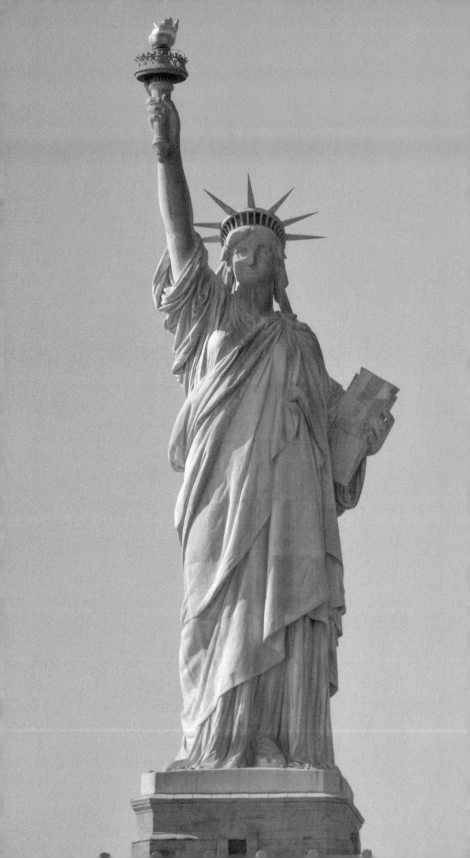

SENTINEL

The Unlikely Origins of
the Statue of Liberty

FRANCESCA LIDIA VIANO

Harvard University Press

CAMBRIDGE, MASSACHUSETTS · LONDON, ENGLAND

2018

An earlier version of this volume was originally published in Italian as *La statua della libertà. Una storia globale* by Editori Laterza, © 2010 Gius. Laterza & Figli SPA.

First printing

LIBRARY OF CONGRESS CATALOGING-IN-PUBLICATION DATA
Names: Viano, Francesca Lidia, 1973– author.
Title: Sentinel : the unlikely origins of the Statue of Liberty / Francesca Lidia Viano.
Description: Cambridge, Massachusetts : Harvard University Press, 2018. |
Includes bibliographical references and index.
Identifiers: LCCN 2018009508 | ISBN 9780674975606 (alk. paper)
Subjects: LCSH: Statue of Liberty (New York, N.Y.)—History. | Statue of Liberty
National Monument (N.Y. and N.J.)—History. | Bartholdi, Frédéric Auguste,
1834–1904. | Laboulaye, Édouard, 1811–1883.
Classification: LCC F128.64.L6 V528 2018 | DDC 974.7/1—dc23
LC record available at https://lccn.loc.gov/2018009508

To Erik August,
"*Nate, meae vires, mea magna potentia*"
—Virgil

The experience of the old is not a motor: it is only a lamppost, warning against dangers; the light that illuminates the long path ahead is you, the youth who are holding its torch; it is you who are to illumine the future and its obscurities.

AUGUSTE BARTHOLDI, July 30, 1898

Contents

Color plates follow page 356

SENTINEL

Prologue

THE GREEK INVADERS were tired and demoralized after long years of war with the Trojans when they decided to tempt the fates with their guile. "On a framework of ribbing with interlocked sections of pitch pine," Virgil sang, the Greeks crafted a horse that was as "high as a mountain." Inside its flanks, "unseeing, unseen, they secretly sealed up" an entire army of soldiers. Others were sent to the nearby island of Tenedos with the order to hide "on its desolate coastline," while the Greeks left a young soldier behind to lure the Trojans into believing that they had returned to Mycene for good. The colossal horse, the young decoy explained, had been made to placate Athena's anger after Greek marauders had desecrated her temple, the Palladium. "Do not trust the horse," the Trojan priest Laocoön warned. "I am afraid of Greeks, not least when they bear gifts." But terrible serpents emerged from the water to devour him and his two sons alive. Persuaded by the ominous sign, the Trojans dragged the colossus into their city. Everyone joined in the work: "setting rollers under the creature's feet, to facilitate sliding, and hawsers of hemp, to get traction, over the neck," until "this monstrous fulfillment of doom" was safe "in our citadel's sanctum." The Greek soldiers hiding inside the bowels of the wooden horse waited until nightfall before emerging into the very heart of the defenseless city. The gift, the "Trojan horse," marked Troy's downfall, and by morning the impregnable city lay vanquished and burning, its cunning conquerors forever written into the annals of history.[1]

Though the present volume traces a more recent history, with, so far at least, a rather different ending, Virgil's rendition of the Homeric epics is not without resonance. For what follows is the story of how a colossus—of copper and iron, not wood—embodying mystic visions of French national grandeur and entrusted with guarding France's renewed imperial expansion across the world, was given to the people of America, without most Americans realizing its meaning and purpose. The Statue of Liberty remains a deeply occult symbol, not merely in terms of the largely ignored esoteric traditions that informed its genesis, but also with regard to the many mysteries that still surround its history, and, like the Trojan Horse, its hidden payload.

Weighing in at more than two hundred tons and standing some ninety-three meters tall, the so-called Statue of Liberty, technically named *Liberty Enlightening the World* (in French, *La Liberté éclairant le monde*), was given to the city of New York in July 1884, just a few months after it was completed in Paris. Its architect was Frédéric-Auguste Bartholdi, a painter and sculptor who had grown up with a single mother and an older brother in Alsace, a beautiful and exotic corner of France on the border with Germany. Bartholdi's adviser and mentor for the project was Édouard Lefebvre de Laboulaye, an heir to a Norman family of French merchants and royal bureaucrats. Laboulaye, however, developed a precocious taste for intellectual pursuits that found expression in a fruitful career as writer and politician. As a writer, he composed works ranging from treatises of political philosophy to mysticism and popular fables; as a politician, he railed against socialism and communism in the name of individual rights and the sacredness of property.

"Why did they build this enormous hulk of a horse?" the noble Trojan King Priam asked the Greek prisoner. "Who designed it? What's the idea? Some rite of religion? Some engine of warfare?"[2] The Greek prisoner answered only with lies. When asked similar questions by the *North American Review* in 1885, Bartholdi, too, replied craftily. A year before the colossus stood completed in

New York Harbor, he told his American readers that the idea of building the Statue of Liberty had been all Laboulaye's. (Dead for two years, Laboulaye could neither confirm nor deny the artist's account.) It was on an unspecified night of 1865, he explained, that Laboulaye invited him and some other friends to Glatigny, near Versailles, and reminded them of the sacrifices made by the French to help Americans win their independence from the British. Such a friendship, Laboulaye then concluded, demanded "a monument . . . built in America as a memorial to their independence . . . by united effort, . . . a common work of both nations."[3] Bartholdi remembered having been impressed by the idea, but he was too busy to pursue it at the time. Indeed, when Laboulaye summoned him to his mansion, Bartholdi was an accomplished sculptor living on rich commissions from government bureaucrats and friends of the emperor Napoléon III. Everything changed after the summer of 1870, when the Franco-Prussian War led to the French emperor's fall, humiliated the country, and cost France Alsace and Lorraine, which went to Germany as part of onerous war reparations.

As a member of the national guard, Bartholdi spent those years side by side with French troops, soldiers whom he saw suffer and die. The shock of these events would leave a mark on all his future monuments, the Statue of Liberty included. Bartholdi escaped the fate of his fellow soldiers because he was assigned to the Italian revolutionary hero Giuseppe Garibaldi's corps of volunteers in the Vosges Mountains, where he struggled with hunger and cold in his effort to secure weapons, munitions, horses, and blankets for the army. For a while, the red-jacketed "Garibaldini" were Bartholdi's only family; he dressed like them, sketched them, followed them, and cried with them when the war was lost. But he also trekked across shell-torn landscapes, hiding in ruined hotels and waiting in deserted stations and busy ports. It was allegedly in the coastal cities of Brest and Bordeaux that Bartholdi discovered that most of the arms directed to France came from America. And it was this discovery, he later recounted, that prompted him to return to

Laboulaye at the end of the war and embark on the project to design a memorial to American independence.

Most historians have trusted Bartholdi's narrative as reliable, even if it clearly omitted some pertinent facts.[4] His story does not, for example, explain why Bartholdi had been invited to Glatigny by Laboulaye in the first place, nor does it tell of their relations during the five years following the party. Yet we know from alternative sources that they had kept seeing each other until the outbreak of the Franco-Prussian War. Why did Bartholdi keep this secret? For the moment, a definitive answer to these and numerous other questions is compromised by a lack of documents: in particular, a crucial block of Bartholdi's letters was removed from his archive long ago, and most of Laboulaye's personal correspondence remains inaccessible in private hands. Yet signs of Bartholdi's and Laboulaye's collaboration—and what it tells us about the origins and deeper meaning of the Statue of Liberty—are scattered throughout their lives, which have rarely been studied in parallel.

This book aims to do just that, as it follows Bartholdi's and Laboulaye's stories between their places of origin, Alsace and Normandy, to Paris and beyond—to Cairo, "dark" Africa, and the Arabian Peninsula; to Venice, Florence, and Naples; back to the desert of the Bedouins; and on to New York, the Midwest, and California—all against a rich backdrop spanning the realms of international shipping and high finance, the mines of Norway and Latin America, and the arts of Japan, Land of the Rising Sun. Tracing and mapping these global entanglements can be difficult, particularly because Bartholdi and Laboulaye never journeyed together, and always used different means, both physical and symbolic, to reach their destinations. Bartholdi was a compulsive traveler; partly to escape an overly possessive mother, partly to find alternatives to the white inexpressiveness of classical art, he sailed along the Nile, sketched Egyptian tombs, and photographed local men and women, who were both curious and impatient in front of his camera. Next he pushed himself to the ancient lands of the Queen of Sheba and

visited the ruins of Pompeii, saw the black ashes of the Vesuvius, descended the Roman catacombs, and admired Michelangelo's statue for the tomb of Julius II, a horned Moses with an angry face.

There are no doubts that Bartholdi was an "orientalist" in the sense in which Edward W. Said defined the term, namely one who encountered and studied "the Orient" within the context of Europe's colonial exploitation of the East.[5] Paris itself, at the time of Bartholdi's youth, was a deeply orientalist city, and Bartholdi's mentors and colleagues, including the celebrated Jean-Léon Gérôme, were orientalist artists who had grown tired of the eighteenth-century passion for classical examples of liberty and virtue. By the time Bartholdi was studying art in Paris, the colossal papier-mâché statues of Minerva and Hercules that had been exposed during the Revolutionary festivals had long since melted away. As a painter, Bartholdi was advised to find inspiration instead in the histories of sacrifice, death, and resurrection that orientalists believed they had found at the center of Eastern religions, such as the "mysteries" of Isis, Cybele, or Dionysus, all of which required terrible travails and sacrifices in exchange for their revelation.

The nineteenth-century writer Victor Hugo was wise enough to recognize that the Orient had become "a sort of general preoccupation" for everybody in Europe, and he found it particularly liberating for artists, because it expanded the kinds of stories and images available to them. Artists, Hugo said, were now "free" to "believe in God or in more gods, in Pluto or Satan"; they could craft the most innovative images without having to justify themselves.[6] But the orientalists' freedom was not anarchy. Hugo explained this with crystalline clarity when he argued that the fusion of opposites—life and death, pain and happiness—characterizing oriental narratives only betrayed the inner workings of nature. For nature too blended the "grotesque" and the "sublime, good with evil, shadow and light."[7] Thus the Statue of Liberty can be understood as a gigantic exercise in grotesque art: as a colossus, the statue is indeed a sort of monster, shining like the Luciferian morning star against a tar-black night.

Indeed, the statue has been perceived as a symbol of disgrace since it was first advertised in America, in 1876, when cartoonists portrayed her against a backdrop of apocalyptic destruction or infernal darkness. But the statue's monstrosity, I will argue, ultimately serves the purpose of highlighting its divinity, which heralds regeneration, revelation, emancipation, and divine justice.

Hugo could hardly have imagined, when visiting the Statue of Liberty in Paris just a few years before his death, frail and hunched, that what he saw as a devilish colossus would transcend its complex origins to become a symbol of Western liberty, a sentinel or guardian that still gazes upon travelers both proudly and menacingly from their green cards, at airports, and in immigration offices across the United States. How did the people of America come to recognize their most cherished value—freedom—in this ambivalent icon of colonial domination? How could they brandish her image as the custodian of America's inner values and their symbol of engagement in so many military campaigns, which have often been inspired by a desire to fight evil, when only one of the statue's two faces is benign?

In this book, I chart the story of what, at first glance, may appear to be a simple case of iconological misunderstanding, but that actually tells us something deeper about the unpredictable ways in which images are built, read, and reread. Soon enough, Hugo had foreseen, the "Orient" would be "called to play a role in the West."[8]

Laboulaye believed he knew just the way in which it would happen. He was a Freemason, and with his white hair worn long over his shoulders, he walked the streets of Paris dressed like a Quaker or a Benjamin Franklin. Contrary to Franklin or Bartholdi, however, Laboulaye never traveled widely, at least not physically. But he imagined voyaging, with the entire city of Paris in tow, to America on a mystical journey; he invented the story of a noble Bedouin finding sacred truth in the scattered leaves of Eve's clover, which he discovered with the help of the Koran and a wise Jew. Long before Bartholdi would combine God and Satan, Isis and Christ

in his colossus, Laboulaye had shown that the Old and New Testaments shared a core of philosophical truth with the Koran, and that venerable Eastern mysteries had anticipated Christ's passion and resurrection. For Laboulaye, America was the chosen land in which the oriental knowledge of Hermes and Orpheus had fused with Western civilization once and for all; the place where ancient ideals of social order, religious tolerance, and universal solidarity finally would be realized in laws and everyday life.

Indeed, in Laboulaye's eyes, crossing the border to the New World was like being initiated into a new sphere of existence; it meant abandoning the old European ways in favor of timeless wisdom. The Statue of Liberty is there to signal, but also to stand guard over, this transformation. Like an oriental divinity, the statue speaks of a world of mysteries to be revealed (the starry crown around her head, the torch and the sacerdotal bands falling on her shoulders) and of sacrifices to be made (her mausoleum-like pedestal, the frown on her face, the darkness surrounding her at night). As a signpost of esoteric knowledge, it is a beautiful goddess of ancient rites: it could be Isis, the goddess of nature and motherhood, who resurrected Osiris and guided sailors safely home with her light; it could be Demeter, forever looking for her daughter Proserpina in the Underworld. As we will see later, the statue also has a masculine identity, one reminding us of Orpheus, who first introduced plebeians to music and instituted order on Samothrace—a "shining lighthouse that will light up islands and seas from afar"—before being devoured by his pupils; Bacchus (also known as Liber), who liberated men and women from temporal constraints through the gift of wine; or Hermes, the messenger of the gods and the god of borders himself.[9]

Knowing this, it may not be surprising to learn that the Statue of Liberty's original destination was not America, but rather another promised land: the Middle East. In 1867, Bartholdi had just finished modeling a *maquette* for a colossal lighthouse that he intended for Suez, where French businessmen and engineers were relying on

local workers to complete the construction of a canal connecting the Red Sea to the Mediterranean. With its right arm lifted up to raise a lantern, the *Égypte apportant la lumière a l'Asie* (Egypt bringing light to Asia) looked strikingly similar to the Statue of Liberty, but Bartholdi denied any coincidence by saying that all he had done was "a little sketch which has remained in its place [in Egypt]."[10] In truth, Bartholdi not only took the said sketch with him back to France; he used it to make a series of similar oriental models no longer bearing the name *Égypte*. Seeing one next to the other is like watching a stop-motion movie of the making of the Statue of Liberty: first the lantern becomes a torch, then the head is lit up, and next a symbol of emancipation, a broken vase, appears in the statue's hand.

Too easily convinced by Bartholdi's account, scholars have often neglected the possible influence of the statue's Egyptian past on its meaning and role in America.[11] Each in their own way, Robert Belot, Daniel Bermond, and Regis Hueber (former curator of the Bartholdi Museum in Colmar, Alsace) have been among the few to suggest that Laboulaye might have been involved already in the earliest, Egyptian-looking maquettes of the Statue of Liberty.[12] In this book, I look deeper into that possibility and, in the light of all available documentation, chart Laboulaye's and Bartholdi's collaboration through the various stages of the statue's development. My conclusion is that, from the very beginning, Laboulaye and Bartholdi wanted to make the originally Egyptian statue equally suitable for the Eastern and Western hemispheres. But this raises interesting questions. What were their motives? What ideas were initially embodied in the statue? How did they articulate their plan? And crucially, what was the relationship between their mystical and aesthetic orientalism, on the one hand, and their geopolitical vision (if they had one) of East-West integration on the other?

Facing southeast, the statue looks back across the Atlantic, perhaps toward Europe—her motherland—but also toward a world of potential colonies in Africa, which European powers still were

disputing at the time. In 1876, Laboulaye made quite clear that
his involvement in the construction of the statue had political
motivations, too. He was firmly convinced that France's loss of its
American colonies to Britain after the Seven Years' War (1756–1763)
had left a deep mark on the French economy. But he was also sure
that France could make up for its loss by expanding a financial
empire across the ocean, in the territories that it had once colo-
nized. Laboulaye's rancor against Britain and his project of financial
revenge perfectly resonated with the rhetoric of death and life,
pain and resurrection embodied by the statue's mystical personal-
ity. French revanchism, however, also influenced the making of
the statue in more concrete ways. The banks, magnates of iron
and copper, mines and casters that contributed to the construction
of the statue were equally involved in the project of challenging
Britain's position of leadership in international markets. It was not
coincidental, for example, that the donor of the statue's copper
would be implicated in a global plot to corner the British market
of copper soon after the statue's inauguration.

But the Statue of Liberty's vengeful face is not only directed at
the British. It was meant to threaten Americans themselves, who
were aiming to expand their control over areas of Central and South
America that France considered its own. Of course France could
not send armies or bureaucrats to accomplish its ambitious plan to
secure these territories. But the statue was there to remind Ameri-
cans of their French past. Similarly, the Panama Canal, which was
being excavated by Ferdinand de Lesseps at the time of the statue's
inauguration, was proof of France's continuing presence in Central
America. Indeed, Lesseps is a key figure in this story: father of the
canal and stepfather to the statue, he would try to translate Labou-
laye's abstract plans of financial colonization into actual policy.

Finally, as the Cuban poet and revolutionary José Martí once
suggested, the statue is an expression of Bartholdi's outrage against
the Germans, who had invaded his country and treated him like
an alien. What is never mentioned, however, is that the French

colossus itself, like the Trojan horse, was secretly armed. But what was her weapon, and against whom was it ultimately aimed? And further, how can a military statue championing national self-determination also be an icon of renewed French imperialism? The tension between liberalism and empire is one of the most venerable in the history of political philosophy, and remains difficult to reconcile even today. But it is also important to underline that the Statue of Liberty resulted from the collaboration between two very different men, and the combination of two projects and sets of scientific, philosophical, religious, and artistic ideas, which not always coincided.

One way of making sense of these conflicts would have been to compare the statue's iconography and symbols with those of visually similar works of art. I have preferred to follow a different path. Rather than chasing morphological analogies or looking for archetypes, I have sought to trace verifiable biographical connections—to describe the distinct human lives, contexts, and experiences out of which the Statue of Liberty originated. Rather than deciphering Bartholdi's colossus in the light of some language considered typical of art, I have tried to reconstruct how Bartholdi developed his own language through his personal experiences, intellectual discoveries, life changes, and emotions. A consequence of this approach of studying the statue's complex origins and construction from the perspectives of people from distinctive backgrounds and with diverse interests is that we see the unpredictability of icons and iconic encounters across time and space. That is, the story of the Statue of Liberty suggests that reducing these layered meanings to a systematic science—encapsulating these images' significance in a precise language, whether political, visionary, or religious—may be impossible. Indeed, over the course of the story, as Bartholdi and Laboulaye weave their web across the Mediterranean and then the Atlantic, the statue will emerge through a series of "theatrical stages" that may seem unconnected yet in the end all contribute to the iconic result. In one stage, the statue will develop from the

Liberty icons of the French Revolution and the gigantic paintings of Romantic artists; in another it will be a mythical goddess resuscitating from her own ashes; in yet another, it will be a copper jewel representing France's commercial ambition in America, a temple working as a colossal battery, or a ship crossing the horizon of New York Harbor.

The art historian Albert Boime famously claimed that the Statue of Liberty is "hollow" and thus everything you want her to be, indeed that her very success depends on her semantic flexibility.[13] This, I would argue, is another historiographical extreme equally worth resisting. The different contexts out of which the statue took shape imbued it with quite specific meanings at the outset, and some of these were purposefully ambiguous for reasons that soon will be clear. Born in the East and later used to symbolize the West, made by the French to portray and simultaneously warn America—not to mention threaten Britain and Germany—and ultimately used by Americans to glorify and justify their world hegemony, the Statue of Liberty is a global icon, not an empty one. Further, her global nature stems not only from the various imperialistic aims involved in its construction, but also from the fact that the statue was originally designed to symbolize the universal truth as mystical unity of resistance and empire, death and rebirth, sacrifice and revelation, masculinity and femininity, past and future.

The last two oppositions are particularly relevant when it comes to answering two apparently marginal questions: what is the statue's gender and what is her age? Scholars still argue about the statue's sexuality—with some being more prone to emphasize her gentle, maternal character, and others her masculinity and sternness— rather than acknowledging that the statue's universal nature allows for both answers. But little has been said about the statue's age. Is it young or old? Laboulaye loved to recall a story that Lafayette told to his French audiences late in his life. Lafayette still remembered having seen, at some point during the Revolution, a procession of children carrying torches to greet Washington, who approached

them with a smile and these words on his lips: "The future is dark; I am not sure that we will make it; if we don't, these children will avenge us."[14]

An avenging youth ready to strike against the older generation, the statue is also incredibly old; it is a man or a woman holding aloft "the warning lamppost of dangers."[15] Old and young, man and woman, the Statue of Liberty may have been a by-product of material and ideological exchanges between rival countries during the long nineteenth century, but the story of its creation also offers a unique opportunity to explore some of the hidden, even occult, dynamics of our symbolic communication.

SEA-BOUND COMET

On October 25, 1886, a French delegation arrived in New York for the inauguration of a colossal monument. The tallest in the world, it was taller than the column in Paris's Place Vendôme, and more than twice as tall as the enormous statue of Charles Borromeo in Arona, Italy (pedestals included).[1] Compared to the statue's height of 305 feet and weight of more than two hundred tons, Ludwig Michael von Schwanthaler's gigantic *Statue of Bavaria*—an enormous eighty-seven-ton woman with a sword at her right side and an oak wreath in her raised left hand, inaugurated in Munich in 1850—now seemed "a shadow of herself."[2] The New York statue had no trace of the aggressive femininity of the German Valkyries. With a stern, almost severe face staring straight into space and her arm outstretched to lift a burning torch, she rather recalled a Teutonic warrior raising his sword to the heavens. It was no accident that, upon arriving in New York Harbor, Karl Rossmann, the young and unlucky character in Franz Kafka's *Amerika*, mistook the Statue of Liberty's torch for a sword, as if a copy of the warlike *Arminius* of Detmold—triumphant in his military cloak with blade aloft—had been moved to America to greet him.[3] Like *Arminius*, our statue too is armed. We will see later what kind of weapon she is carrying. But the military fort on which she was placed and the cannons surrounding her were menacing enough. Not to mention her skin, which was made of the same copper sheets normally used to make bullets, guns, and cannons. Yet few at the time noticed the statue's martial attire; if anything, observers complained that a simple tunic draped

around shoulders and hips was not well suited for the weather in New York, where "nude figures suggest great discomfort."[4] Yet the physical attributes glimpsed, or evoked, beneath the dress were those of a teenager or an androgynous being. The massive statue's name was *Liberty Enlightening the World*, and she was a gift from the French, who first had named her *Liberté éclairant le monde*.

For days, foul weather had threatened the monument's inauguration, and when the day came on October 28, New Yorkers awoke under a leaden sky. It was a bad start, commented the acerbic *Times* of London, and it was hard to disagree. A rain-drenched celebration meant no fireworks and more policemen; those who had rented balconies weeks in advance to watch the celebratory parade would not be able to use them; and those who had taken the day off work would now have to stand, soaking, in the downpour. No one could have deplored the bad weather as much as the man in charge of the parade, General Charles Pomeroy Stone, who had supervised the construction of the statue and its pedestal at Bedloe's since April 1883. Before then, he had seen almost everything in his life. A graduate of West Point (who had early on acquired the still rare habit of smoking cigarettes), he had served under General Winfield Scott in the Mexican War between 1846 and 1848, then tried a banking career in San Francisco. Next, he became director of a scientific research expedition to Sonora, Mexico, which was prematurely interrupted after the Mexican authorities realized that Stone had never received governmental authorization to operate in the country. When the Civil War broke out, Stone joined the Union army. He opposed the election of Lincoln, whom he thought would divide the country over the question of slavery, yet unraveled a conspiracy against him in 1861. This heroic action resulted in Stone's promotion to colonel of the army and brigadier general of volunteers, but his good fortune would not last long. Accused (probably unjustly) of causing the defeat of Ball's Bluff in 1861 and of surrendering slaves to their Virginia owners, Stone spent six months in solitary detention at Fort Lafayette in Brooklyn without formal charges. After his

sudden release, he served briefly in Louisiana before his army was defeated and he was expelled by the Confederates. It was the spring of 1864, and Stone set sail for North Africa, where he served first in Egypt as the head of the Egyptian army—surrounded by a beautiful library of his own creation—during the years of Bartholdi's dealings there, and then in Sudan, fighting for the pasha and distributing American Remington guns among his soldiers.[5]

Quite ingloriously, Stone flew from Africa under the fire of British bombs in 1882, but mysteries and suspicions followed him back to America. And they were still surrounding him on that morning of October 28, when he was stoically conducting the civilian and military parade through the city streets in the pouring rain. At ten o'clock in the morning, "handsome and erect" in his uniform, he entered Fifty-Seventh Street ready to lead the parade.[6] He had brought only a small group with him, but, moving along Fifth Avenue, the parade gradually grew to a long, snaking column with more than two miles of regular troops, shining in a golden halo of swords and medals, followed by many bands, the *New York Times* noted, "somber and sad and thin, looking as though they had been packed away in a damp trunk some time about the centennial, with no camphor, and had just emerged, somewhat moldy and careworn and a little moth-eaten, but amazingly enthusiastic and discordant."[7]

Following these groups were the "sons of France"—mainly French societies and their Franco-American counterparts (like la Prévoyance of Boston or l'Amitie of New York)—then "the Judges and Governors, the Mayors, the veterans of wars," the famous police forces of Philadelphia and Brooklyn. Next in line, preceded by the "carriage of the Father who gave us liberty," George Washington, were the higher ranks of the masonic groups of the Knights of Pythias and the august Knights Templar. Their march was so swift that it looked like the passing of a "comet" that burned its way past and swept seaward, "dissolving like a dream."[8]

As the parade proceeded down Fifth Avenue, the side streets were filled with motley groups: French, Italian, and various immigrant

"societies" waited to join the flag-waving procession, while ordinary people everywhere were looking for comfortable places from which to watch the show. Some had set up small stands at crossroads, offering to sell seats for a dollar; others had set themselves atop piles of stone slabs left on the sidewalks by masons who were working between Thirteenth and Twentieth Streets.[9]

Neighborhoods like these were strongholds of the contemporary "leisure class," as a famous sociologist soon would describe it.[10] But this was an exceptional day, so the poorer sorts, who were normally crammed in the Lower East Side, temporarily encroached on the private spaces and doorways of Fifth Avenue, which were polished to a shine every morning by servants. Bands of youths were standing outside the Francis I–style chateau with which railroad magnate William K. Vanderbilt had sought to appease his beautiful wife's social ambitions; some were clambering up the walls that connected John Jacob Astor's villa with his brother William's, while others climbed the scaffolding of a building under renovation just below Thirty-Third Street. With the exception of tobacco magnate Pierre Lorillard, none of the New York elites exposed themselves to public scrutiny or saluted Stone and his following. Barricaded in their houses, the great barons of New York left it to their liveried servants to celebrate the procession.

A certain level of tension is implicit in such public ceremonies. Historians and anthropologists have often claimed that, in more or less pronounced ways, all ceremonies are forms of transgression. Ancient Rome would be opened up to the triumphant troops of a victorious emperor, who staged a kind of "peaceful invasion" of the city in ritual violation of its status as a largely demilitarized zone, with soldiers allowed to flirt with mutiny by directing ribald songs at their general.[11] The advantage of such a "reversal," one is further told, is not only that the lawful crossing of social boundaries during festivals secures good conduct in normal times (thus functioning as a "safety valve"), but also that the "reversals" inspired by collective celebrations represent the risks that communities must run in order

to construct a collective memory and form a "body politic."[12] In other words, "carnivalesque revolts" are the price paid by a community to reinforce its unity or even rejuvenate its political structures. But the community of those welcoming the French statue in New York was a composite one, made up of Americans and French alike. So, one may ask, why should the people of New York have run the risk of social unrest, why should they have brought troops into the city and let immigrants and the poor from the Bronx march near the lustrous doors of the houses on Fifth Avenue, for the mere inauguration of a foreign monument? What made this monument, in particular, so important in their eyes? What part of their collective memory did they hope to reconstruct with this ceremony?

This book seeks to answer these questions and others. For now, however, one should note that there were plenty of reasons why Stone and the parade marched by the houses in the richest part of town. One of the most pressing was that the statue's principal sponsors for the past years had been wealthy French and American families. But immigrants, feminists, and the poor too had made their offers to the statue, and they deeply cared for the colossal lady. Some of them joined the celebration not just out of curiosity, but also because they felt "a kind of proprietary interest in the celebration," as if they believed they were "part of the show." Why? Did they think that the statue was a symbol of their own struggles for rights, for equality, and for dignity? The statue is, indeed, an enigmatic monument, one that can simultaneously speak to the rich and the poor, the established and the marginal, men and women.[13] But what does it whisper to them?

Before we proceed any further in revealing the statue's many enigmas, it is worth pausing to appreciate the extent to which they were engrained in the contemporary scene. The 1880s were troubled years for Americans. For the first time in their history, the threat of social revolution had become real. Only five months before the statue's inauguration, a strike for the eight-hour movement had degenerated into civilian slaughter, triggered by the explosion of a bomb in Haymarket Square. The subsequent conviction of eight anarchists,

five of whom were German immigrants, cemented in the public opinion the idea that the real cause of public disorder lay in immigration. Discrimination on the basis of gender and ethnicity was the order of the day, but recent prejudice against foreign workers had merged with other, more venerable bigotries. Although slavery was formally abolished by the Thirteenth Amendment in 1865, African Americans were still marginalized in public places and at work, bloody wars had forced the last indigenous peoples onto reservations, and the Supreme Court had authorized Congress to impose racial barriers to immigration and expel foreigners who had not been naturalized. Women had won constitutional civil rights but had yet to be given the vote in most states, and had no protection within the family, where they still suffered violence and discrimination.[14]

The specter of rebellion still loomed large over the festooned streets of New York on the day of the inauguration. In addition to ethnic minorities, the *New York Times* reported, there were also feminist, anarchist, and socialist associations out and about. The Bulgarians present at the celebration had recently read in the newspapers that two Russian ships had approached the port of Varna to begin the occupation of the city, but even if many of them would soon return to Bulgaria "to fight . . . for their freedom," they found time to watch the parade, their "bosoms" swelling with pride "when they thought of the day when they too might have a Liberty!" Not far from them, "a dozen Russians" enjoyed the show, no longer fearing "the wrath of Alexander" or feeling any hatred for the Bulgarians, while nearby a group of Irishmen "cheered for Parnell and Erin in their breasts while their tongues shouted for American freedom." As for the socialists and anarchists, they had come simply to register their joy at living in a country where they "could stand up as men, say what they pleased . . . without putting their necks in danger."[15]

Although decidedly saccharine, the *New York Tribune*'s account of the bond many immigrants felt with the statue was spot-on. The memoirs of the Russian expatriate Emma Goldman, who had arrived in America as a political exile in late December 1885, before the

statue's inauguration in New York Harbor, capture this idyll at the moment of its birth. "Ah, there she was, the symbol of hope, of freedom, of opportunity!" Goldman exclaimed upon first seeing the statue. "She held her torch high to light the way to the free country, the asylum for the oppressed of all lands."[16] It was somewhat ironic that a statue that had been sponsored by wealthy New Yorkers ended up arousing so much affection among expatriates like Goldman. As Robert Harbison points out, the Statue of Liberty is not necessarily a benign figure. With her arm raising a torch aloft, she could easily be interpreted threateningly as saying, "Go back!" or, more flippantly, "We can't see here. Bring light."[17] But marginal people probably liked the statue because it, too, was an exile. And marginal women in particular liked that it had a feminine appearance with a powerful, if masculine, look and an imposing posture.

Plausibly, there was a third reason why marginalized peoples were attracted to the monument: the statue did not include any of the iconic American patriotic symbols, like the flag or the bald eagle. Not even the tables she pressed against her breast were American laws of order and present justice. Instead, engraved on their first page was "JULY IV MDCCLXXVI," or "July 4, 1776." That is, Lady Liberty, as many would come to call her, held a copy of the American Declaration of Independence, a radical statement of individual and national liberty composed by American colonials on the eve of their separation from Britain. For Jefferson, the Declaration was "an instrument, pregnant with our own and the fate of the world," for it would give "a signal of arousing men to burst the chains, under which monkish ignorance and superstition had persuaded them to bind themselves, and to assume the blessings and security of self-government."[18] Jefferson did not expect the Declaration to also legitimize internal wars against "domestic oppressors."[19] But this was inevitable, as the social reformer Frederick Douglass had noted in 1852, for the Declaration asserted radical principles of freedom and equality not yet recognized by American laws; the Declaration was, therefore, "the very ring-bolt in the chain of your yet undeveloped destiny"—a weapon of social

justice, as long as the marginal and the oppressed remembered to "stand by those principles, be true to them on all occasions, in all places, against all foes, and at whatever cost."[20]

Associating the Statue of Liberty with the Declaration was thus one way of arming the colossus, like the Greeks had armed their horse. The Declaration championed radical ideas of liberty that both were not yet assimilated by the American political and legal system, and were embraced (and on the way to being embraced) globally by oppressed people seeking independence from colonial powers and autocratic governments. Perhaps the *New York Tribune* was right to note at the time that, to some expatriates, the Statue of Liberty truly did appear as a beacon of the freedom they had sought in distant lands like Ireland, Russia, and Bulgaria. To others, however, the erection of a colossus championing the Declaration was an expression of pure hypocrisy on the part of the American government. This second group of dissatisfied people may not have hidden in the statue's iron bowels, but their goals, like those of the Greek soldiers ready to capture Troy, were far from friendly to the status quo. As soon as they heard of plans to erect the French statue in America, suffragists thought it would be the perfect moment to denounce "the cruelty of woman's present position." Why? Because the statue was "proposed to represent Freedom as a majestic female form in a State where not one woman is free." Years later, they would go to the inaugural celebrations armed with a copy of the *Declaration of Rights and Sentiments*, an 1848 reformulation of the Declaration of Independence that affirmed the equality of men and women. They would proclaim openly that the statue should be read not as the symbol of "what the nation has already attained, but as the ideal toward which all the righteous women and men of the Nation do constantly strive."[21]

Women protesters were not the only ones using the statue to attack the government. The *New York Sun*, for example, ran an article of protest, signed by the Chinese exile Saum Song Bo, that denounced New Yorkers for having asked the Chinese for donations toward the construction of the statue when they knew full

well that Chinese immigrants did not enjoy the same rights as other American citizens. "The Statue represents Liberty holding a torch which lights the passage of those of all nations who come into this country." But, Saum Song Bo asked rhetorically, "are the Chinese allowed to come?" The answer was obviously "no." Accordingly, Saum Song Bo urged his compatriots neither to contribute, nor to "bow down" to the false idol and "graven image" of Liberty.[22]

As Henry James wrote in his travel-writing anthology *The American Scene*, there was an evident "margin" between what Americans had accomplished and what they could—and hopefully *would*—accomplish in the future. In James's eyes, this margin was the very essence of the United States, a "vaster lake of the materially possible" that "flares" when caught by the "torch" of the human mind, revealing the "central flotilla" of what already had been accomplished. Just like James's "torch," vividly enlightening the potentialities of the "American scene," the statue was plausibly meant to shed light on "the vision of a possible greater good" than what the present "given case" offered.[23] Of course, James's vision belonged to the realms of poetry. But the statue, too, embodied poetical meanings, and the real question is whether this idea of potential accomplishment (of liberty, universal rights, equality, and so forth) was consciously embedded in the statue not for aspirational, but for antagonistic or even hostile, purposes.

There is no need to postulate any malevolence in the French gift. If the Greeks had been at war with the Trojans for a decade before destroying them with their equestrian trick, France and the United States had been friends (although intermittently) for centuries, ever since the French had started trading with American colonists in defiance of British mercantile prohibitions.[24] The Declaration that the statue held in its hand was a pledge of independence that was ultimately meant to help Americans reassure other countries regarding their relationship with Britain and establish America's role in the international order on a new, legal basis.[25] The Declaration's geopolitical ends were realized, for the formal

statement of independence from Britain gave speed to the French decision to send weapons, money, and men across the ocean and, two years later, to sign a treaty with the rebellious colonies. The Statue of Liberty, Bartholdi himself explained in the *North American Review*, was meant to celebrate this very alliance against the British Empire.[26] And yet, it was only a partial truth, one of the many that Bartholdi would tell his French and American audiences. Indeed, the statue was not a mere memorial of Franco-American friendship. It also represented an idea of what specific groups in France thought America represented, for them and the world in general. And it was this alien interpretation of America that, if used with hostile intent, could prove dangerous.

After making its way down Fifth Avenue, Stone's parade turned left to reach Madison Square, marching past the U.S. president, the highest federal and municipal authorities, and French dignitaries alike. A wooden stand had been erected on one side of the square. "Do not look for anything resembling something one could find in Europe on a similar occasion," advised one member of the French delegation, "everything in the States is made simply, cheaply, summarily." The workers had nailed down some boards to form a dozen steps, without covering them with "a tissue or the least decoration," and without even preparing a seat for the president. Finally, around ten o'clock, the "Lafayette guards" fetched the French guests from the luxurious Hoffmann Hotel, on Madison Square, opposite the stand. Behind them stood the statue's sculptor, Frédéric-Auguste Bartholdi, elegant in his dark suit, looking small and frail in comparison with the host of military men in full dress uniform, including General Péllisier; Admiral Jaures, "superb in his navy uniform, embroidered in gold, his breast heavy with shiny medals"; Colonel Bureau de Pusy; Lieutenant Villegente; and "captain Halphen, . . . with his panache of tricolor feathers on his képi."[27] The impression they gave was one of war heroes triumphantly returning from some patriotic expedition, ready to be celebrated with a great military feast. As we will see, this military spirit reflected some of the statue's innermost meanings.

The square was "teeming with people and all black" when, around eleven o'clock, the Democratic president, Grover Cleveland, made his solemn entrance. French commentators described him as "a bit fat," but "with a placid and serene figure." His round face and "moustache drooping down the sides of his mouth" stood in stark contrast to the scene's military pomposity.[28] This might have disappointed some of the French, but their mood lifted when they saw the various army corps lining up, each with its own banner. The president "wore a bored but resigned look" while "regarding with a stone stare his surroundings and showing apparently little interest in the proceedings about to begin." Yet all around, excitement reigned, and when the Seventh Regiment struck its first notes, the crowd was seized by an uncontrollable euphoria. In an instant, the measured beats of "La Marseillaise" flooded the streets, intermingling with the more fluid rhythm of "Yankee Doodle" and eliciting cries of joy from the public, who waved handkerchiefs and threw their hats in the air, warmly greeting soldiers and civilians on the march. Ladies, forgetful of hairstyles and hats, put their umbrellas aside and stood on the tips of their toes to get a better view. Even the French ladies, more restrained by habit, threw all composure to the wind at the sight of the Philadelphia police: "Ah, ce sont de beaux gens," they cried; "c'est magnifique!"[29]

After the military show on Madison Square, the procession made its way again down Fifth Avenue. It continued straight on to Park Row and then made a complicated turn, during which it was difficult not to break ranks, to stop at the great arch outside the offices of the *New York World*, the newspaper owned by the Hungarian Joseph Pulitzer (who had played a crucial role in raising the money for the statue's pedestal). Finally it returned to Broadway and crossed to the Battery. The rain had become heavier and had soaked the uniforms, the flags hanging from balconies, and the colorful festoons. It all made for a rather depressing sight, with banners and elegant decorations everywhere ruined by water. Wet tricolors and starred ribbons crowned a dripping papier-mâché statue of liberty at the entrance of the Vienna Café, while the

famous tailors Rogers, Peet & Company complained about all
the work they had wasted to combine the now-soaked French and
American flags above their sign and to hang an enormous banner
across their entire facade, bearing the words "Liberté, Egalité, Fra-
ternité," the French national motto. The banner was attached on
one side to a colored portrait of Cleveland and on the other to one
of the French president, Jules Grévy.

At Everett House, on Fourth Avenue, soaking wet red, white,
and blue ribbons framed a life-size portrait of Lafayette, the young
French general who had helped the Americans win independence
from Great Britain during the Revolutionary War. Lafayette's story
was on everybody's lips on that day of celebration. As a young aristo-
crat with a far-from-aristocratic demeanor and features (his face too
white, his hair too red), Lafayette, enflamed by the idea of joining
the Continental Army in America, had been drawn to the New
World by a mixture of ambition and personal difficulties in fitting
in at the French court.[30] He had sailed from Bordeaux in April 1777
on board a small ship, the *Victoire*, leaving behind his pregnant wife
and a fuming father. In Philadelphia, Lafayette's story became even
more of an adventure. A Freemason himself, of the French lodge of
the Candeur, he was brought to the military lodge of the American
Union and there, among occult signs in darkened rooms, befriended
Washington, to the point where the two became "deux frères bien
unis."[31] The statue, as we shall see, bore evident signs of Masonic kin-
ship with the American Union Lodge. But few noticed them among
the more obvious clues to the statue's meaning. All eyes were focused
on the portraits of Lafayette and Washington, for example, which
were to be seen everywhere at the statue's unveiling, sometimes
accompanied by those of the comte de Rochambeau, who had sailed
to America in 1780 to become lieutenant general under Washington,
and comte de Grasse, the naval hero of the Battle of the Chesapeake.
Nobody seemed to remember that, behind these famous figures, lay
the tireless work of anonymous American and French agents and
spies on both sides of the Atlantic; even more importantly, nobody

seemed to wonder how, or why, a transoceanic network of Freemasons originally orchestrated Lafayette's encounter with Washington. Some additional investigation would have revealed that American and French businessmen and Freemasons (those of the Candeur, the Contrat Social, and the Société Olympique lodges) had collaborated for years before Lafayette's voyage to train soldiers and send saltpeter, brass cannons, and textiles from Nantes and Bordeaux to the American colonies. The statue's metallic skin evoked the foundries of Douai, Toulouse, and Strasbourg, which similarly had worked overtime to provide Americans with guns and cannons.[32] But on the day of its unveiling the Statue of Liberty, along with its war-torn past, was still wrapped in fog, and nobody paid particular attention to its Masonic symbolism or to its armor.

Having marched along Broadway, the procession reached the esplanade at Battery Park, where a throng of people had been waiting for hours. From the early morning, small crowds had formed here and there of those who had not found room in Madison Square or along the streets of Broadway—spectators anxious to find a spot from which to watch the fireworks and lightshows scheduled for four o'clock, or families waiting to board a ferry bound for Bedloe's Island or Governor's Island to see the ceremony up close. Boats of all sizes bobbed around the docks, half shrouded in the mist. The clock had just struck one when all of a sudden the crack of cannon fire pierced the wall of fog; a second of absolute silence followed before the shot was echoed by a volley of another twenty or more shots. It was the salute, the *feu de joie* coming from the USS *Gedney* to signal the beginning of the naval parade on the Hudson, the second part of the celebration. The mist, however, was so thick that the *Gedney* was unable to lead the parade and had to fall back at least twice before something resembling a procession had formed behind it; many boats did not see the *Gedney*, while others had already sailed ahead to Bedloe's Island, where they awaited its arrival like sea ghosts suspended in a great void.

The people assembled at Battery Park mistook the shots for a preview of the fireworks display announced for the afternoon and

immediately poured onto the docks to see the statue light up. Others, attracted by the electric light that glowed dimly through the mist on the dome of the Washington Building, turned toward the Battery thinking that the time had come for the main show. Fireworks represented the high point of all public celebrations at the time, when authorities and police would stand aside and allow people to flood the streets to enjoy popular attractions like street acrobats and feast on sweets. But nothing of the kind happened that day, as both the fireworks display and the lighting of the statue were cancelled due to the inclement weather.

Those who persisted in waiting for the show at the Battery were dispersed by the police, who in their eagerness to clear the area and not leave a job half done, turned their truncheons against even the workers of the respectable Unexcelled Fireworks Company, who in their forced idleness were standing by watching the human spectacle unfold.[33] Beaten and deprived of the most colorful part of the celebration, ordinary people forlornly watched the boats and steamers sail toward the statue, where the final part of the celebration—from which they were excluded—was to be held. The feminists would have had to remain ashore like everyone else, had it not been for their ever-present spirit of initiative; although the municipal authorities had refused them a boat, they managed to rent one and embark two hundred friends of their association, only twenty-five of whom were men, for the trip to the statue.

Around two o'clock, the fog lifted for about an hour and let the Statue of Liberty emerge in all its magnificence. All of its massive body was now visible, along with its raised hand holding the torch, but not its eyes, which were covered by a French flag hanging from her crown. At Bedloe's Island, workers had been busy since seven in the morning when the steamer *Firenze* had left ashore "a large party of ladies and gentlemen," among them David H. King Jr., the local contractor who had overseen construction of the statue and its pedestal. While daring Mrs. Clarence Carey, a belle of New York high society, "climbed to the outside of the torch on the statue"—

the "first lady to accomplish this laborious feat"—her father and friends sat on the platform built against the seaward side of Liberty's pedestal and patiently waited for the other guests to arrive.[34]

The speakers' stand was protected by a canopy draped with American and French flags. Underneath the canopy, behind the speakers, an enormous shield hung over the stage, bearing the red, white, and blue of the French flag on its right and the American stars and stripes on its left. In full view between the two were the fasces and axe, symbol of unity among the states, but also of the imperial authority of Ancient Rome, while the word "liberty" and an olive branch, a Greek symbol of peace, lay across a shield. These symbols unequivocally marked the end of the "carnivalesque" part of the celebration, in which the poor were allowed to venture near the homes of the rich to affirm their sense of "ownership" over the statue, and women to protest against men's privileges. With authority and social concord reasserted, it was time for French and American diplomats to dispel the idea that the statue was a symbol of improvement and replace it with the rival conviction that it was a symbol of order and legality, of the establishment, so to speak.

The Twenty-Second Regiment band, conducted by Maestro Gilmore, entertained the audience by playing French and American national songs as the speakers kept everyone waiting. At a certain point, a gunshot signaled the beginning of the ceremony and the band fell silent. Reverend Storrs, pastor of the Congregational Church of the Pilgrims in Brooklyn, took the stand first, the fasces and olive branch looming large behind him, to invoke a solemn prayer for the statue. "We pray," he intoned, while the flags were whipped up by the wind and the sea roared at a distance,

> that Thou who enablest man to mold the metal and make lightning his servants, wilt accept the dedication of this monument to Thee; and that here it may continue, undisturbed of tempest, its munition of rocks not shaken by earthquake, while waters encircle it, and the light of the morning returns

to greet it . . . We pray that the Liberty which it represents
may continue to enlighten with beneficent instruction, and
to bless with majestic and wide benediction, the nations
which have part in this work of renown; that it may stand a
symbol of perpetual concord between [them].[35]

Standing at the foot of the statue, like a Lilliputian straight
out of Gulliver's *Travels*, the reverend seemed to be asking God's
pardon for the hubris that had led man to create such a wonder, by
"mold[ing] the metal" and making fire his servant. Storrs must have
known that the statue's main metal, copper, traditionally was used to
make weapons, and that these very weapons had been the founda-
tion of the Franco-American friendship that was being celebrated.
Otherwise, why address the statue's "munition of rocks," as if the
copper, still enclosed inside red rocks, was stored in the statue like
in an armory?

But the reverend approached the matter from a more mytho-
logical angle. Indeed, since ancient times, fire had always evoked a
kind of knowledge that was alternate, or even a rival, to the divine.
In *Works and Days* and *Theogony*, Hesiod relates how the titan Pro-
metheus incurred the perpetual wrath of the gods by stealing their
fire (hidden in the hollow stalk of a giant fennel) and making a gift
of it to men.[36] For Hesiod, Prometheus was a symbol of humanity's
foolish curiosity, responsible for its fall and wretchedness. But by
the late nineteenth century there was a long tradition of thought
that had rehabilitated Prometheus, one that told how, together with
fire, he had also given humans knowledge and wisdom.[37]

By the end of the nineteenth century, America was crossed
by railways, lit up more and more by electricity, and studded
with steel-producing iron mills. Here the Promethean flame was
blazing once more—this time with electric light—as a symbol of
technological progress and of a knowledge that was entirely human,
made up of mathematical formulas and technical wisdom.[38] The
Promethean radiance of the statue's torch was too evident to be

hidden, even when it remained unlit. Yet, skilled preacher that he was, Storrs covered the statue's pagan appearance with a Christian cloak and, voilà, transformed a symbol of divine rage and military might into a token of "concord." Such an interpretation may have been far-fetched, but the olive branches painted behind Reverend Storrs made it all a bit more plausible. Unfortunately for him though, the day would not go down in history for the harmony that reigned there.

After the reverend came a Frenchman who had become familiar of late to American audiences, but not because of the statue. Elegant in appearance, with bright white hair, a thick moustache, and almond-shaped eyes, Ferdinand de Lesseps was France's most famous businessman. He was eighty-one, but looked at least twenty years younger; his beautiful wife, little more than thirty years of age, had borne him nine children. The littlest, Ferdinande—affectionately called Tototte—accompanied him on all his trips and was with him even then, as she looked proudly up at her father. De Lesseps was descended from a French-Spanish family of wealthy merchants on his mother's side and a dynasty of diplomats and explorers on his father's.[39] He too became a diplomat, but he was fascinated more by the prospect of exotic journeys than by the technicalities of negotiation.[40] His missions brought him to Lisbon as attaché to the French Consulate, to Tunis as *élève vice-consul*, then to Algier, Alexandria, and Cairo, where he conquered the confidence of the then-pasha Muhammed Ali and the absolute trust of his son Said. We will return to de Lesseps's rides through the desert and his projects to dig a canal connecting the Mediterranean to the Red Sea.[41] For now, it suffices to note that he was in Italy when, at the height of the first Italian War of Independence of 1849, he tried to save the republican rebels from the pro-papal maneuvers of the French government, and almost got himself killed by an anonymous assassin. De Lesseps's mission was meant not to sever relations between Italy and France, though, but to guarantee that "French intervention might secure genuine and real guarantees of liberty for the Roman States."[42] The plan was cancelled

by Napoléon, and de Lesseps found himself forced to change profession. Luckily for him, life changed for everyone during the Second Empire, when Napoléon III used his power in the service of a new class of financiers, committed to channeling household savings into major industrial investments around the world. Realizing that his business acumen was even sharper than his diplomatic talent, de Lesseps (who also happened to be the cousin of Napoléon's wife, Eugénie de Montijo) turned his efforts to financing one of the riskiest ventures of the century through the power of the media. In 1857 he created a joint stock company to finance the digging of the Suez Canal and managed to sell all the shares before the project was even completed. Just over twenty years later, he would attempt to repeat the scheme in Panama.[43]

De Lesseps had this very Panama affair in mind while addressing the audience in front of the statue. Indeed, the excavation of a canal to connect the Atlantic and the Pacific oceans was one of those enterprises that made people like Reverend Storrs shudder, and which had led the sixteenth-century Jesuit theologian Josephus Acosta to exclaim that "no human power [would have been] able to beat and break down those strong and impenetrable mountains" dividing the two seas.[44] Ever a propagandist, de Lesseps silenced the detractors who held that a sea-level canal was impossible and circulated falsely optimistic projections of future earnings, raising a considerable amount of funding for the coffers of the Compagnie universelle du canal interocéanique de Panama. Some magazines and newspapers had insinuated that de Lesseps agreed to join in the celebrations in New York only because he was already on his way to Panama. Indeed, the ties between the statue and the isthmus ran deep, and the same international bankers and businessmen involved in the financing of the statue were also involved in the making of the Panama Canal. But the two projects were at different stages: except for its electrical apparatus, the statue was now finished, while work on the canal had languished for several years. Although small investors still believed in the enterprise and money kept flowing in

from Europe and South America, the reality was that the company's directors and workers were dying of yellow fever by the day, while the mountains seemed to resist every effort of human industry to break them down, just as Acosta had foreseen. With his flair for publicity, there can be no doubt that de Lesseps had calculated the media impact of his appearance at a ceremony intended to celebrate the friendship between America and France. His taking part as the lead French speaker at an event in which American businessmen brushed shoulders with French diplomats and entrepreneurs was a real publicity stunt, doubtlessly intended to boost the spirits of the company's French investors and restore the value of their shares to earlier levels.

"Clad in evening dress, and pulling off his overcoat and baring his gray hair to the fine penetrating rain," de Lesseps "stepped to the front of the stand." He was greeted by a roar of applause when he proclaimed that the American constitution "is not the product of the soil, and . . . does not grow out of the English spirit," but could, rather, "be regarded as an exotic plant, born in the atmosphere of France."[45] This was an approximate quotation of a passage by the English journalist William Hepworth Dixon, who, famous for disliking France even more than he did America, had traced the defects of the American Constitution back to harmful French influences and criticized it for failing to recognize the principle that "all men are free and equal." As someone naturally inclined to mystification (and desperately willing to avoid any reference to the Declaration's rebellious message), de Lesseps craftily disguised Dixon's criticism of American and French illiberalism as a benevolent (or at least neutral) comment on their constitutional kinship, and added his own praise: "in landing beneath its rays," he said, "people will know that they have reached a land where individual initiative is developed in all its power."[46]

As he spoke these words, de Lesseps knew full well how tenaciously the Americans protected their economy from external threats and how much trouble they had given him in Panama. For his part,

he had just sacked a North American supplier of mining explosives and given the contract to the French Société centrale de dynamite. But he smiled and reassured his audience that no "sad memories" darkened "the relations" between the two countries. The sole cause of "rivalry was progress"; "we accept your inventions, as you accept ours, without jealousy." "Go ahead" was the motto that summed up the American spirit of enterprise and ambition, he concluded, and the French had taken it quite literally—first by building the statue, which, as Reverend Storrs himself had said, was a technological and architectonic wonder, and then by going on to build the Panama Canal. Above it, de Lesseps promised, perhaps a bit too optimistically, "the flag of the United States, with its thirty-eight stars, will float beside the banner of the Independent States of South America, and will form in the New World, for the benefit of mankind, the prolific and pacific alliance of the Franco-Latin and Anglo-Saxon races."[47]

After the heavy garb of sainthood that Reverend Storrs had cast on the statue, de Lesseps's words seemed to confer on it a more mundane appearance, no matter how ambiguously he referred to the Constitution and American laws generally. So the job of reintroducing some historical or legal perspectives into the day's rhetoric fell on the shoulders of Senator William Maxwell Evarts, a man born into a family that revered the memory of the Declaration of Independence. Evarts's mother was the daughter of one of the most illustrious signers of the Constitution, Roger Sherman, while his father was an old-fashioned Puritan who could trace his ancestry in Connecticut back to Scottish immigrants who first arrived in 1635.[48] Known for his shabby attire and the way he wore his hat, always a bit too low on his forehead, Evarts had studied at Yale and Harvard Law School before opening one of New York's most prestigious law firms, whose clients included the managers of Union Pacific and other corporations traded on Wall Street. But he was also a politician. In 1855, Evarts joined the newly founded Republican Party and put his forensic talent in the service of the abolitionist cause. During the Civil War, he was sent to the U.S.

consulate in Liverpool to work with spies and secret agents who were smuggling arms to America and diverting those destined to the Confederates. Eventually, Evarts would prove himself capable of standing up to the blatantly pro-Confederate British government and convinced an international court in Geneva to fine it $15.5 million.

More inclined to compromise when it came to domestic politics, Evart looked with trepidation on the rise of a radical fringe in his party that wished to centralize the political and military control of the defeated South in Washington. This is why, though he condemned Southern efforts to restore slavery in their states, Evarts disagreed with the radicals' decision to impeach President Johnson and defended him with the longest speech of the trial. With one foot on Wall Street and one in the Republican Party, Evarts liked to define himself as an "independent," but when the Republican Rutherford B. Hayes became president in 1877 and appointed him secretary of state, Evarts accepted willingly and helped Hayes pursue his plans for America's commercial expansion in South America and Asia. In so doing, Evarts would inevitably clash with de Lesseps. In March of 1880, six years before the unveiling of the Statue of Liberty and in one of his last duties as secretary of state, Evarts sent to the president a report stating that "the United States cannot consent to the surrender of this control [of the Panama Canal] to any European power." It was on the basis of that message (and the acknowledgment that "an interoceanic canal . . . will be . . . virtually a part of the coast line of the United States") that the president urgently requested that a canal under American control be built.[49]

The technical difficulties encountered by de Lesseps and his company in digging the canal led Evarts to soften his tone over time. In his speech for the inauguration of the statue, Evarts refrained from mentioning the old Franco-American conflict; he also glossed over the freedom of enterprise one could enjoy in America, to which de Lesseps had previously referred, perhaps to avoid justifying to Americans the presence of foreign companies on American soil. Rather, he

insisted on the political affinities between the two countries. Liberty, in his view, was the great principle shared by the two "populous, powerful, and free republics, knit together in their pride and joy at their own established freedom."[50] It was not clear what, precisely, Evarts meant by "liberty," but he traced it back to the American War of Independence, when the French monarchy had sent troops, ships, and money, at a historically enormous financial cost to itself, to support the English colonists in America in their war against the motherland. The wind was too noisy (people in the audience were already crying "Louder, louder") and the time too short for Evarts to find the time to evoke the memorable chapters of the French adventure in America: the young aristocrat Lafayette's march to Philadelphia to meet Washington and offer his service; Count d'Estaing's 1778 landing at Delaware Caps at the head of a powerful fleet, which, however, failed to arrive in time to face Admiral Howe; the arrival of reinforcements in the form of an army of five thousand French soldiers, under Lieutenant Jean-Baptiste Donatien de Vimeur de Rochambeau, who landed at Newport on July 10, 1780; and, finally, the Franco-American victory at Yorktown in 1781. Yet these were the events that Evarts had in mind when he said that "in the conflict which agitated and divided the people of the United States," the French showed not only "solicitous interest" and "enthusiasm," but also "their historic and momentous friendship in securing American independence."[51]

Evarts kept quiet on the topic of the commercial and diplomatic interests implicated in the military collaboration between the French and the Americans. He also did not mention that France and the United States had waged an informal naval war after the signature of the 1795 Jay Treaty between the United States and Britain, when the French had accused their former allies of violating their past agreements to favor the British. Indeed, military solidarity does not necessarily translate into political affinity or, for that matter, economic agreements. Nothing reflects this tension like the Franco-American collaboration during the War of Independence. At that time, France was still under the monarchy of

Louis XVI, whose decision to back the colonists was aimed more than anything else at inflicting a decisive blow to British trade in the Western Hemisphere. As for the American colonies, though they declared themselves "free" in 1776, they formally became a republic only after 1787. The Statue of Liberty would portray this ambiguity in subtle ways. Evarts may have pretended not to see it, or his thoughts may simply have been lost to the howling wind, which blew away so much of his rhetorical talent that day. However insistently the crowd extolled him to speak louder, Evarts's words remained almost inaudible. Exhausted, he rushed to conclude his speech with a dedication to the president, while, high above in the statue's head, three men waited for the signal to drop the French flag still blindfolding her. Evarts had barely enough time to pronounce the words, "Today, in the name of the citizens of the United States . . . I declare, in your presence and in the presence of these distinguished and honorable guests from France, and of this august assemblage," before a "young man" standing by the stage waved a white handkerchief to signal the end of the speech. A rope was pulled and the "banner folded itself like a curtain drawn aside and disappeared through the crown adorning the brow of the Goddess." Guns on the shore, along with the warships gathered around the island, shot thunderous blanks. With the wind, the smoke, and the smell of gunpowder, the whole scene gained an undeniably bellicose flair. Bells above deck rang out in unison, producing a tremendous sound.[52]

From the volleys of gunfire to the smoke from the steamships, everything was designed to re-evoke the American military victory in the Revolutionary War. Newspapers would, in effect, concede that the "prototype" of the statue was "born from the smoke of battle":

[. . .] from the guns on the ramparts on shore bright flashes of flame . . . rent the gray blue of the atmosphere with scarlet tongues. Great columns of smoke rose from the war vessels

and floating upward made a halo half circling the island and completing with the mist the obscurity in which was hid the immense flotilla that thickened the waters of the bay.[53]

"The whistles blew, the guns boomed, the bands played, the drums rolled, and the throngs on the island and on the river shouted one thundering paean of acclamations."[54] It was "the music of hell," some Frenchmen lamented, "invented by Satan"; it was the "eternal chant of those musicians who have peeled our ears."[55]

In this apocalyptic atmosphere, as the roar of the cannons continued to resound and the bridge of their ship lay shrouded in smoke, the suffragists reached Bedloe's Island. Amid the general confusion they gathered on deck to declare loudly that "in erecting a statue of Liberty embodied as a woman in a land where no woman has political liberty, men have shown a delightful inconsistency which excites the wonder and admiration of the opposite sex."[56] In this moment of great jubilation, when Americans were glorifying their past and their triumph over despotism, these women claimed the statue as a symbol of their own crusade, transforming an icon of the struggle for national independence into a symbol of the struggle for human rights. More pointedly, born on the field of battle, the statue seemed to call for war even in a time of peace—a war between business interests over the control of Panama, a war of women against men, a war, for civil and political equality, of exiles and immigrants against Americans who wished to close their borders.

THE FRIENDLY FACE of the next speaker provided some light relief against this ominous backdrop of past and future battles. Known as "Uncle Jumbo" to his nephews and the "Big One" to his political allies, President Grover Cleveland had begun his career as mayor of Buffalo, New York. When elected to the presidency, he knew almost nothing of foreign policy. Apparently unconcerned that in twenty-one years of almost uninterrupted government, the

Republicans, among them Evarts who introduced him on stage, had laid the groundwork for expanding America's presence in Asia and South America, Cleveland sought a return to Monroe's pacifism and policy of disengagement. With this goal in sight, he fought with all his strength against tariffs on foreign imports and in favor of the free trade of goods and services. With respect to the Panama Canal, Cleveland did not share Evarts's nationalist alarmism and even held that the canal should be neutral and open to all nations. (His approach would change shortly after he entered the White House when, in March 1885, uprisings took place in Colombia and the rebels were able to seize a number of American ships. To restore order, Cleveland—the champion of free trade, disengagement, and world peace—ordered the landing of more than 1,200 men on the coasts of the isthmus, in what was the largest naval operation since the Mexican War of 1846.)[57]

The U.S. intervention did not close the harbors of Panama or even impose American control over the canal's construction, but it sufficed to alarm the French. They knew that Cleveland's real sympathies lay with Great Britain and not with France—with British ancestry on his father's side, Cleveland was clearly partial toward the old country. They knew, too, that Cleveland had vetoed the New York State legislature's financing of the Statue of Liberty in 1884, when the statue's friends had had run out of funds to complete the monument.[58] Perhaps it was for this reason that, although his speech was introduced by gunfire and public remembrances of the Franco-American war against Britain, Cleveland did not speak of the statue as a symbol of the national liberty won in that war, nor did he quote the Declaration of Independence. What he did say was that the light of the statue's torch "illuminates the way to man's enfranchisement," and to the home of Liberty.

Although statements like these may appear to refer covertly back to the second paragraph of the Declaration of Independence ("that all men are created equal, that they are endowed by their Creator with certain unalienable Rights"), they should not be taken here

to imply any recognition on Cleveland's part of the universal rights claimed by marginalized minorities. Cleveland was an old-fashioned conservative who, despite his words about the universality of human rights, had little time for strikes or the protests of suffragettes. In his view, a good wife was "a woman who loves her husband and her country with no desire to run either."[59] He protected American Indians as he would a species of animal threatened with extinction, and thought that the Chinese, practically banished from the United States by the 1882 Exclusion Act, were impossible to assimilate and integrate into American society. He would do his best to make sure his own prophecies came true, by signing in 1888 the umpteenth law prohibiting Chinese people from entering the United States.[60]

Cleveland's views were common at the time, particularly the idea that every nation had the right to determine its own racial composition so as to "preserve itself."[61] It is not surprising, therefore, that in presenting the statue to the public Cleveland described her as a goddess "keeping watch and ward before the gates of America." The statue was a guardian, a sentinel-goddess at whose altar "willing votaries" would keep the fire burning so its light could "gleam as a beacon to our sister peoples of the East and . . . penetrate the darkness of man's oppression, until Liberty shall, in truth, enlighten the world."[62]

Cleveland did the only sensible thing that was needed to convert the Statue of Liberty into a conservative icon, by connecting her with the preservation of America's borders and identity. Crossing geographical borders has always been considered a ritual act, one from which the ancient Egyptians, Assyrians, and Babylonians used to expect great spiritual changes.[63] As a result, they placed "guardians," often monumental, at the entry points of their lands, before which foreigners were supposed to perform certain sacrifices before being let in.[64] The statue too, as will be clear, was meant to represent the spiritual initiation to liberty that one had (and still has) to expect in crossing the American border. But Cleveland put the accent on selection rather than initiation; on guardianship rather than revelation.

Each in their own way, Storrs and Evarts had anticipated this development. The afternoon's last speaker, Chauncey Depew, reinforced it spectacularly. President of the New York Central & Hudson River Railroad Company, Depew was said to be the most elegant and eloquent man in New York, probably even "the best most known private citizen in America."[65] Like Evarts, Depew was largely against opening up domestic markets to foreign competition; for him, as for Evarts, true liberty was freedom of contract within America's borders. It was a liberty they had won in the Civil War, fighting alongside blacks and abolitionists against pro-slavery Southerners. At the foot of the statue, Depew brandished his abolitionist credentials, stating that "the development of Liberty was impossible while she was shackled to the slave." Other times, when it came to other (non-human) forms of property, he would invoke the Fourteenth Amendment (which in part stated that no state should "deprive any person of life, liberty, or property, without due process of law") to defend owners from state intervention.[66] And yet, like many Americans of his age, Depew was mostly convinced that, despite the sacredness of property, the government had a fundamental right to "reallocate property rights" in the name of "economic development."[67]

This reality was widely shared among the statue's friends, who might have wondered why a statue sponsored and financed by private groups in France and America was located on federal ground, above a military fort. But Depew avoided the topic. Instead, he entertained the audience with romantic images of American belles dancing with French troops and chivalrous friendships between stylish Frenchmen and rugged American soldiers fresh from the farm. But his tone changed sharply as he moved on to current affairs. The "problems of labor and capital, of social regeneration and moral growth, of property and poverty," he said firmly, "will work themselves out under the benign influences of enlightened law-making and law-abiding liberty." There was no need for strikes and protests, no need for "anarchists and bombs," according to Depew, because the American system already had

what it needed to solve the major issues of the moment. The statue
was not a catalyst for future hopes, and certainly not an embodi-
ment of America's conscience and the ideals of the Declaration
of Independence. It was, rather, a "teacher" of civilization: "It will
teach . . . the poor and the persecuted" that "there is room and
brotherhood for all who will support our institutions and aid in
our development, but that those who come to disturb our peace
and dethrone our laws are aliens and enemies forever."[68]

It is quite clear that, despite their eagerness to recount old anec-
dotes of Franco-American friendship, the speakers of the afternoon
had championed a purely American interpretation of the statue
as a sentinel or "teacher" of borders. Still, it was striking that their
argument was based only on the statue's location at the entrance
of New York Harbor, for neither Cleveland nor Depew had been
able to find a single national symbol in Bartholdi's colossus, except
for the politically loaded Declaration, which they avoided like the
plague. The inauguration, however, was not yet over, and other,
more occult interpretations would soon be made. That evening,
the most notable speakers would reconvene for a private gathering
in one of New York's most fashionable restaurants, Delmonico's,
where a last, crucial reading of the statue would be offered, this
time connecting it to a biblical interpretation of America's origins.

ONE OF THE HOTTEST TOPICS raging through New York's high
society at the time concerned the intrinsic merits of European cui-
sine. Some swore by a good roast beef, a rack of lamb, and pud-
ding; others put their faith in Italian or French gastronomy. Both
factions happily dined together at Delmonico's, a restaurant first
opened seventy years earlier by a former Swiss schooner captain
who specialized in the wine trade, Giovanni Del-Monico, and his
brother, the pastry-maker Pietro.

"Delmonico & Brother" (the hyphen in the name was left off
the sign) was established in 1827, at 23 William Street, as a small

shop filled with the intense aroma of Cuban cigars and the pungent vapors of wine and spirits. Its only furniture consisted of six pinewood tables scattered throughout the room and a pinewood counter covered in white napkins, on which fresh-baked French desserts were displayed. But that was in the beginning. Later the Delmonico brothers opened a restaurant at 25 William Street and bought a farm on Long Island, where—a first in the history of the American restaurant business—they grew their own produce, in particular vegetables that were hard to find in New York's markets. It was at Delmonico's that Americans first learned to eat tomatoes instead of watering them as decorative plants, and to blend Italian, French, Russian, and German cuisines. Delighted with the menu, written entirely in French, Louis Napoléon, the future emperor then in exile in America, spent entire evenings there in the company of the great actor James Wallack. In the blink of an eye, Delmonico's expanded into the richest neighborhoods of New York. Bankers and shipping magnates converged on the "Citadel," the venue opened in 1837 on South William Street, a three-story building adorned with marble pillars pilfered from the excavations at Pompeii; politicians, lawyers, and merchants gravitated around the Chambers Street venue (founded in 1856); stockbrokers were the fond patrons of the five-story brownstone at 22 Broad Street (1865); while high society preferred the luxurious Restaurant-Café opened on Union Square at East Fourteenth Street (the first restaurant in New York to admit women, as long as they were chaperoned).[69]

Ten years before the statue's inauguration, in 1876, another Delmonico's opened its doors, this time on Twenty-Sixth Street. The first floor of this five-story mansion housed the restaurant's main dining room, which was lushly decorated with mirrors and chandeliers whose light reflected off a fountain in the center of the hall; the second floor had a red and gold ballroom, and the third had rooms for exquisite private banquets. After the noonday ceremony had ended, it was there that the speakers all headed to sample the

menu of the most famous chef of the day, Charles Ranhofer. Hailing from Alsace, like the statue's architect, Ranhofer was a corpulent yet agile man, with a stern look to his face even under his colossal white chef's hat, who would soon gather his best recipes in the still-famous cookbook *The Epicurean*.[70]

It was said that when Ranhofer prepared oysters, their hearts would still be beating when they reached the table. Presented on a bed of thinly chopped ice, two or three per plate, with a quarter of a lemon on the side, the oysters were served with very thin crackers lightly spread with butter and smothered in a hot vinegar and onion cream.[71] Given Chef Ranhofer's traditional feasts, it is likely that raw oysters were served at the dinner that evening, alongside other types of oysters that he usually prepared only for his non-French guests: curried oysters, fried oysters à la Horly, unshucked oysters, and oyster soup. Oysters were always followed by soups, usually one clear and one thick. We know that dishes reserved for grand occasions then came out: hors d'oeuvres, among them timbales created in honor of de Lesseps, followed by fish and entrées. A magnificent series of sorbets then wowed the guests and refreshed the palate before an English roast beef made its solemn entrance in tribute to Great Britain—because without "the roast beef of old England," explained the *New York Tribune*, "French liberty and American patriotism cannot exist."[72] After that came the hot desserts.

Two hundred and ten places were laid out on five long tables, with four arranged around the sides of the room and a longer one, reserved for the most important guests, located in the center and decorated with a series of food sculptures. What these pieces of edible art represented for the occasion we do not know, but one day earlier, at a gala organized by the Union League Club in New York, the chef and sculptor Camovito had displayed a sugar sculpture of Lafayette and Washington, alongside the French frigate *Minerva* and the flagship *Tennessee* in cane sugar, the column of the Bastille in nougat, and a "gigantic decorated salmon, supposedly to be swimming in the Seine, which was shown in real water filled with

fish, alive and frisky." Not far away, among real flowers of every kind and fragrance, stood a sugared copy of the State of Liberty, overlooking the Seine, the Bastille, and the ocean.[73]

The gourmet magic of the food would vanish around eleven o'clock in the evening, "when the blue smoke [began] to curl ceilingward," a sign that the sorbets had been consumed. It was then that the lawyer Frédéric Coudert stood up to speak on behalf of the American government.[74] Coudert was an international lawyer of French family origin, the son of one of Napoléon's former officials who had plotted against the Bourbons along with Lafayette (without ever sharing the latter's republicanism), was saved by the famous *salonnière* Madame Récamier, and had escaped with her help to the United States.[75] Together with his younger brothers, Frédéric specialized in international cases, especially those involving French and Spanish nationals who resided in America, and often acted as a proxy for the French government itself. International law was still a little-known discipline in America, although disputes with England during the Civil War had given it a great boost. But Coudert had made a true profession of it, selecting employees who possessed both knowledge of the law and great skill with languages.

As a consultant to the Italian, Spanish, and French governments, Coudert did not like to associate himself too closely with American authorities, but the cosmopolitan and idealistic profile of a Democrat like Cleveland—free trade and universal peace—suited him perfectly. Coudert had worked for Cleveland many times in the past, although his Catholicism, and his feminism, had raised suspicion in the administration. Indeed, Coudert was among the few who thought that if women "are fit to be stenographers, typewriters, and law clerks, that is, to serve men, they must be permitted to rise in the scale and to make men serve them."[76] True enough, he was careful not to betray his heterodoxy in front of the men or the very few women invited to Delmonico's that evening, ladies of high society who tended to share the point of view of their husbands and fathers—a point of view that, on that evening especially, excluded

them from the five tables of honor and confined them, packaged like bonbons, to the galleries, together with the orchestra. But those who knew Coudert well detected the feminism underlying his apparently innocent joke about the statue's femininity: she "enjoys all the rights of a citizen — or, rather, a female citizen," but "owing to her sex, . . . she can hardly vote without provoking criticism unworthy of her dignity."[77]

If Coudert's feminism could do little to counter the evening's supercilious and male-chauvinist atmosphere, his Catholicism added to it a touch of Christian moralism. "The statue," he said, is the expression of a universal doctrine that had no comparisons since the time of the "lesson of divine fraternity" first formulated by Jesus in the Sermon on the Mount. The sermon that Jesus gave to the peoples of Galilee, Jerusalem, and Judea was, in reality, a rather menacing and even revolutionary one. From the mountain-top Jesus had promised to destroy the existing order: "Blessed are the poor in spirit," he began, "for theirs is the kingdom of heaven; blessed are they that mourn, for they shall be comforted." After having promised them justice after death, Jesus compared the Jews to "the light of the world":

> You are the light of the world. A city on a hill cannot be hidden. Neither do people light a lamp and put it under a bowl. Instead they put it on its stand, and it gives light to everyone in the house. In the same way, let your light shine before men, that they may see your good deeds and praise your Father in heaven.[78]

The Sermon on the Mount was a kind of coded message for those present, because everyone knew that behind Coudert's words hid a crucial reference to America's national history. In one of his earliest speeches to the Massachusetts colonist, John Winthrop had quoted Jesus's sermon to invite the colonists to create "a city on a hill." In going back to the sermon and alluding to Winthrop's speech,

Coudert linked the statue with the very source of the historical providentialism that had inspired the formal speeches throughout the day. Moreover, Jesus's sermon and that of Winthrop shared a very pronounced apocalyptic element, the promise of a more just order, one anticipated on Earth first by the Jews and then by the Americans.

A substantial part of American providentialism was fueled by a certain kind of visionary English literature, especially Joseph Meade's *Clavis Apocalyptica* (1627), in which America was presented as the chosen seat of the final battle between Satan and Christ—not England, as many of his countrymen had believed until then.[79] Even if many of these texts, founded on the Book of Revelation more than the Old Testament, had lost their appeal after the outbreak of the American Revolution, apocalyptic visions continued to be featured in American literature. Such images of divine punishment are surely what explained Storrs's worried expression while giving his talk at the foot of the statue.

The same was very likely true for Coudert, who may have alluded to the Sermon on the Mount in the glare and gunfire of the statue's inauguration. Its torch, in this reading, was that which Winthrop wanted to ignite in America, an exemplary light of purity and conscience. If so, Coudert abstained from saying it explicitly, content with claiming that the statue incarnated "all that [was] more striking in moral and religious instruction," global in reach because it was "a poem that everybody [could] understand without being a poet, . . . written in the universal language."[80] What Coudert seemed to ignore, however, was that the statue also kept much of the apocalyptic and violent meaning of Jesus's original speech. It was an icon of violent change and revolution: that which had liberated Americans from British control, but also that of the oppressed against their oppressors everywhere in the world.

FIGURE 2.1. Atelier Nadar, *Édouard René de Laboulaye*, n.d., albumen print, 8.5 × 5.8 cm, Bibliothèque Nationale de France, Départment Estampes et Photographie, FT 4-NA-235(2).

THE WINTER PARTY

B EFORE SETTING SAIL for the New World, Bartholdi had pre-
pared the Americans for the reception of his colossus. In a special
issue of the *North American Review*, he had told the story of how
the statue was conceived of and constructed. It began like this:
one evening in 1865, Édouard René Lefebvre de Laboulaye, his
"most . . . illustrious friend," invited him to his estate at Glatigny,
near Versailles, to meet a circle of colleagues and political allies.[1]
Bartholdi did not tell his readers that Napoléon III was then ruling
France with a strong arm, nor that he himself, a young painter of
thirty-one, short and slim, with thick hair and a shy but determined
look, had many friends in the establishment. Anyway, none of those
friends were sitting at Laboulaye's table that evening in 1865. For
Laboulaye, then in his fifties, with "thin brown hair combed straight
over his head," a clean-shaven face, and a "black riding coat but-
toned up to his neck" that gave him a "vaguely clerical look," was
no friend of the Napoleonic empire (Figure 2.1).[2] Nor were his
colleagues, who, sitting in his salon, were waiting for Bartholdi to
come. All men in their sixties or seventies, they were liberals who
had taken part in the Orléanist monarchy and who had looked at
the republic of 1848 with ambivalence. But what brought them
together, or so it seemed, was a pressing interest for the United States,
which emerged clearly once Laboulaye and his guests moved to
the *fumoir* after dinner. There, they started discussing the latest news
from across the Atlantic and, incidentally, the possibility of building
a Franco-American statue.

Laboulaye's *fumoir* was, therefore, the place where everything began, at least according to Bartholdi, who—as we will see later—had his own reasons for choosing this particular starting point. For all we know, the Glatigny meeting might have never taken place as Bartholdi describes it. Yet his story has the merit of introducing us to the artist's environment at a time of his life that (in one way or another) was crucial in the making of the Statue of Liberty. Which is why, before we hasten to tell the rest of the story, it is important to follow Bartholdi beyond the doors of Laboulaye's mansion and consider the backgrounds of the people who used to gather there, and to whom he was introduced at some point during the 1860s.

Each in their own way, all of Laboulaye's friends had played crucial roles in the American Civil War, which had ended almost a year before Laboulaye gave his party. The one who had contributed the most was probably Agénor de Gasparin. With a pair of fancy spectacles and a graying beard that contrasted sharply with his black moustache, Gasparin made rare appearances in Parisian salons. The former minister of instruction under the Orléanist monarchy, he had left France for Switzerland after the birth of the Republic. There he had spent his days studying and practicing spiritism, magnetic communication with the dead, and moving tables, but also fighting slavery in the French colonies of the New World and in the United States. Slavery had been a topic of importance for only a few enlightened men and women in France before the early 1840s, when French ships were still loading slaves in Sierra Leone, Gambia, Bissau, and Cameroun to sell them on the Brazilian coast, in Cuba, the United States, and the islands of São Tomé, Príncipe, and Cap-Vert. It was a prosperous business that continued despite the formal interdiction of slave trade from French ports.[3] Gasparin was among the few French abolitionists to raise his voice against slavery at a time when the interests of the planters of Guadalupe and Martinique, and those of their French suppliers of butter, wine, and grains, forced many into silence.

But Gasparin was an enemy of slavery, not of colonies: he believed that a gradual emancipation of slaves would increase rather than diminish the productivity of the sugar plantations in the French West Indies. Further, he thought that the slow introduction of slaves into a system of free work and bank savings would gradually instill in them "the habits of the worker and the costumes of a free man [or woman]."[4]

When the Civil War broke out in America, Gasparin suddenly found a more attentive audience for his ideas in France, and he seized the occasion to chastise the slave system of the American South while warning the French against its expansionism in America and abroad.[5] In Britain and France alike, the general sympathy was for the slave states, which provided both countries with cotton and, in turn, bought manufactured goods and illegal slaves from them. But Gasparin made his French readers notice that the division of the United States into two independent nations would have increased the possibility for European powers other than France (especially Britain) to impose a protectorate on the Southern states and use it to counteract the French presence in the West Indies. Aiding the North, Gasparin concluded, was not merely a moral but also a geopolitical necessity, because France required a strong and united North America to resist British expansion in the Atlantic.[6]

Soon enough, we will see this very idea take shape in the statue. For the moment, however, Bartholdi was trying to follow these discussions as best he could, without probably understanding where they were heading. In any case, he was intrigued as he listened to Laboulaye endorse Gasparin's arguments. Indeed, no one believed in Gasparin more than Laboulaye. If possible, Laboulaye had been even more concerned than him by the threats posed by the Confederacy, which he had feared would build an empire based on slavery and elevate the latter "to the rank of federal institution." Inside the Union, Laboulaye had told his readers, federal agents walked "on free territories to seize the unlucky fugitives and throw them back

into servitude"; on the international scene, the Confederates would clash with "France's rising relations" in Africa, Cuba, and Mexico. If the French cared for their transoceanic empire—and Laboulaye cared no less than Gasparin—the last thing they should do was side with the South and its imperial plans. They should rather support the North and annihilate the "cancer"—slavery—"that has been gnawing at it for the last thirty years."[7]

During the Civil War, Laboulaye, Gasparin, and their few abolitionist friends had worked side by side with American secret agents to spread their message in newspapers or through public speeches. Though we cannot know for sure, none of their arguments seem to have reached Bartholdi, who at the time was busy making a name for himself in imperial circles. But at the dinner of Glatigny in 1865, or whenever Laboulaye first decided to introduce him to his friends, Bartholdi found himself quite at ease with the venerable activists who were interested in the destinies of French colonial investors as much as in those of colonial slaves. It was a curious combination of ideas, and Laboulaye's friends supported them from different angles and social perspectives. At Glatigny, for example, Bartholdi remembered having seen Oscar Lafayette, the grandson of the American "hero," a former deputy in the Orléanist monarchy and the Constituent Assembly of 1849, but also the notorious Freemason Henri Martin, a Catholic abolitionist and republican historian who was affiliated with the Masonic lodge of the Grand Orient de France and had written a voluminous French history before joining ranks with Laboulaye on the American question.[8] Another guest was Charles de Rémusat, who had even served as the inspiration for Honoré de Balzac's inimitable character of Henri de Marsay: the king of French popinjays, a man who was "famous for the passions he inspired," with a "soft, effeminate beauty, but corrected by a fixed, calm, wild and rigid gaze, like that of a tiger." Rémusat's effeminate beauty had earned him the admiration of Pauline, Lafayette's granddaughter, and a marriage into the famous clan of Franco-American heroes. This certainly

explained his interest in the American cause and his presence at Glatigny, along with the fact that he was one of the founding members of the Society of Christian Morals, an association famously "committed to hasten the effectual abolition of slave trade" in the name not only of "laws" and "conscience," but also of France's colonial interests.[9]

The sacredness of the French colonies was inviolable for Laboulaye and his friends, but so was that of banks, which they considered the most effective vehicles for spreading civilization in the colonies and finally replacing slavery with salaried work. This way of thinking had its most famous representative in a last guest Bartholdi remembered meeting at Laboulaye's house: Louis Wolowski. The son of a celebrated Polish jurist, Louis and his brothers were sent to Paris for their education so that they would become familiar with French language and culture. Louis later returned to Warsaw to study law, but the Russian repression of the 1830 revolution forced him to go back to France for good. In Paris, Louis Wolowski completed his legal studies then founded a journal, the *Revue de législation et de jurisprudence,* to which Laboulaye often contributed. Wolowski, however, also had remarkable business acumen, and was very much the architect behind the spread of mortgage banks in France. His most famous creation was the Crédit foncier, which was established by the government and individual investors with the purpose of providing low-interest, long-term credit to farmers; investing "the small savings of the poor in real estate securities"; and making "real estate securities negotiable on the stock market." Things did not work out the way Wolowski had hoped. As the Crédit foncier gradually shifted its investment focus from farming to real estate, he decided to create another bank for lending to farmers, the Crédit agricole.

The Crédit agricole would not meet Wolowski's expectations either, because the bank's terms were costly and, as a contemporary source put it, the peasants did not seem to utilize its funds.[10] So Wolowski and his associates channeled their capital

into international speculation, especially in Egypt. It is possible
that, during the party at Glatigny, Laboulaye and his guests came
to talk about the role played by Egypt during the American Civil
War, when American cotton had disappeared from European
markets and Wolowski's banks had earned spectacular returns by
speculating in Egypt's textile industry. Or maybe someone men-
tioned the fact that the Egyptian khedive had offered 47,000 (French
or Belgian) guns to the American Unionists.[11] Even if he knew
about it, Bartholdi may not have thought it relevant for understand-
ing the origins of the future Statue of Liberty. Yet the victory of the
North and the end of the Civil War meant that French business
interests were poised to leave Egyptian textile securities behind to
focus instead on American financial markets (particularly mort-
gage bonds). The first securities had begun flowing from New
York to France two years earlier, and it is very possible that some
of them already were in the hands of Wolowski and other friends
of Laboulaye's.[12]

Whatever the case, Bartholdi was introduced to a group of lib-
eral aristocrats, bankers, and politicians who were taking advantage
of the end of the American Civil War to launch their ideas of
colonial expansion and liberal emancipation in France. But how
could Bartholdi help their cause? It all became clear after dinner,
when Laboulaye invited his guests to follow him into the drawing
room and raised the question of international relations. The dis-
cussion revolved around whether nations could feel gratitude the
same way people did, or if their relations were purely based on
"material interest." Laboulaye disagreed fervently with those who
denied the possibility of such deeper sentiments between countries,
and argued that France's collaboration with the United States was
based on "a genuine flow of sympathy," which was caused by "the
remembrance of a community of thoughts and struggles, sustained
with common aspirations." For Bartholdi's benefit, Laboulaye went
back to the time when the French helped the Americans win the
Revolutionary War, when they sailed across the ocean to join the

Continental Army and "spilled their blood for the principles that they hoped to see in France and in the world."[13]

"No one in the United States speaks of the Treaty of Versailles," Laboulaye recalled as a proof of his thesis. "Many Americans are ignorant even of the date of that treaty," but "everyone recalls the name and the deeds of the French soldiers." So, he concluded, "if a monument were to be built in America as a memorial to their independence, I should think it very natural if it were built by united effort, if it were a common work of both nations."[14]

Neither Laboulaye nor any of his friends proposed that Bartholdi should build such a monument that evening, and the artist simply recalled that "this conversation interested" him "so deeply that it remained fixed" in his "memory."[15] In any case, he was too busy at the time to undertake such a vast project. Other things were on his mind, things curiously connected with both Wolowski's affairs in Egypt and with Egypt's rivalry with the American suppliers of European cotton. Laboulaye, too, had a full plate, as he struggled against slavery and worked toward the expansion of France's credit in America. The idea of a Statue of Liberty may have been born at Glatigny in 1865, or under similar circumstances during the 1860s. What matters is that it was elaborated by a group of people trying to change French politics by drawing together financiers, colonizers, and liberal intellectuals. Some, as will be clear, would even conceptualize the statue as an icon of this very party, rather than of the United States. Indeed, the strategic re-evocation of the War of Independence and Lafayette's journey to the American colonies would be exploited by Laboulaye and his friends as rhetorical narratives with which to magnify France's historical bid for power in the world, particularly in its rivalry with Britain.

CHAPTER 3

THE *FONDEUR*

Accorsing to Bartholdi's testimony, Laboulaye was the statue's original "arteficer," the one who gave him the three key ingredients he needed to create the colossus: the idea (Franco-American friendship), the project (a monument to be built by both French and Americans), and its supporters (French financiers and intellectuals interested in the New World). So who was this Édouard Laboulaye? And why did Bartholdi feel the need to credit him with such a prestigious role in the creation of the statue?

The story of Laboulaye's life before his dinner at Glatigny is still mostly a mystery, but what little we know reveals that his admiration for America might have had genealogical foundations. His family, the Lefebvres, hailed from Normandy, a land of seamen, sailors, and merchants who as far back as the sixteenth century, if not earlier, had traveled far across the ocean to fish and trade in the New World. Huguenots from Dieppe had founded a "compagnie d'aventuriers" in 1629 to conquer Quebec for Charles I of England and exploit the Saint Lawrence Valley.[1] Three years later, the region was back in French hands, but the Normans had never lost their dominance in Franco-American trade, with ships packed with merchants, merchandise, and immigrants regularly setting sail from Le Havre.

The Lefebvres too were merchants, at least since the sixteenth century, but little is known about their business until the birth of René, in 1679.[2] Born in Mortagne-au-Perche, an unconquerable Norman village situated on a hilltop and defended by moats—a

village whose onetime lord Geoffrey II joined forces with William the Conqueror to invade England in 1066—he married the daughter of a Parisian merchant, Marie-Anne Baroux, and later moved to Paris to become a merchant himself. It was the first step toward the family's promotion to the capital's leading class of "grand negociants," or international merchants.[3]

According to the celebrated eighteenth-century political philosopher Montesquieu, merchants could never truly prosper in a monarchy.[4] But the Lefebvres appear to have navigated that divide quite well, because in the early eighteenth century René had bought an impressive amount of land near Marcouville and had become the "seigneur de Marcouville, de la Tour Pinte, de Lucarzière, de la Courpinte et de Laboulaye." As *premier avocat* in Parliament and a member of the Académie royale des sciences of La Rochelle, René prepared his son François-Benoit's further ascent. While continuing to practice commerce, indeed, François rose to the position of France's "president treasurer" at the office of Montauban during the reign of Louis XV. But he was skilled enough to reinforce this new prestige with a mercantile alliance by marrying into the Charlier family, known as providers of sumptuous gold, silver, and silk for Louis XIV's court at Versailles.[5]

This would prove to be just the beginning of an incredible ascent, which eventually would be crowned by the achievements of Édouard's grandfather, Jean-Baptiste René Lefebvre, a lawyer appointed to Parliament, Louis XVI's own *notaire,* and a member of the Masonic lodge Saint Charles des Frères Unis. It was thanks to Jean-Baptiste that the Lefebvres, after decorating the king's palaces in Versailles, finally managed to enter the king's closest circle of advisers.[6]

But Jean-Baptiste was also a loving grandfather who entertained Édouard with stories from the time of Louis XVI and instilled in him nostalgia for the monarchy and a passion for the eighteenth century. This passion led Édouard to study law in Paris, but he soon regretted this choice, disappointed by his professors' lack of

imagination and dry interpretation of the subject. The only excep-
tion was Victor Cousin, a professor of philosophy, who introduced
Édouard to the works of Descartes and Hegel, and convinced him
that only a powerful and secular state could guarantee individual
liberties.[7]

When Édouard was not studying law or discussing philosophy,
he was busy casting typographic characters in his own foundry
alongside his brother Charles, a graduate from the École polytech-
nique and the École de guerre de Metz who had left the army to
serve his apprenticeship with the caster and printer Firmin Didot.
At Didot's, Charles had learned a secret method for casting printing
type, even cursive typefaces: increasing the proportion of copper in
the compound.[8] Adding extra copper to the tin alloy was crucial,
one would read in Charles's *Dictionnaire des arts et manufactures*,
because copper not only reduced "the effects of crystallization" and
made the types harder, but also gave "them a bit of tenacity, which
is copper's principal quality."[9]

It was no accident that copper, the metal covering the Statue
of Liberty's iron body, had entered the life of the Laboulayes more
than forty years before the statue was constructed—and the link
between Charles's laboratory and the Statue of Liberty was Édouard
himself. We don't know exactly when Édouard bought his foundry,
but Charles must have joined him after receiving his printer's license
in 1831. It was a momentous but challenging time to enter the
printing industry, because rising levels of literacy and the growth
of urban populations had increased popular demand for newspa-
pers. Competition among founders and printers alike was fierce,
as they vied to invent new methods of casting and printing that
could meet rising demand while also supporting higher prices.
Armed with Didot's harder and more resistant alloy, Charles and
Édouard found a competitive edge in the industry and would make
much headway.[10]

True enough, Édouard was more of a philosopher and thinker
than his brother, but he worked hard at the machines, which stained

his hands and smock. Perhaps it was the prospect of being a printer-philosopher like the great Benjamin Franklin that appealed to him, particularly because Charles Laboulaye's mentor was a descendant of François Ambroise Didot, who had taught the art of "engrav-ing and founding type" to Benjamin Franklin's grandson while the Franklins lived in Paris in 1790.[11] Édouard was fond of Franklin to the point of wearing round-collared shirts and double-breasted jackets with thick cloth-covered buttons, like those worn by his hero in the eccentric portraits in which he posed as an old Quaker or a rustic Republican.[12] But Édouard might have also become a caster for the simple reason that working with metals—sewing gold and silver into the king's curtains, as Laboulayes' grandfathers had done, or casting copper into type—was part of the family tradition.

What interests us here is that, by 1837, the Laboulayes and the caster Lion were advertising type made of "a special alloy that lengthened the life of the type without increasing its price," an alloy obtained by adding a certain percentage of antimony to Didot's old formula.[13] Édouard helped his brothers and colleagues, but "after the foundry" was "closed for the day," he "retired to a library to read, to take notes, or to seek the company of people more edu-cated than himself."[14] His earlier interest in philosophy, combined with his conversations with Cousin, drew most of his attention to politics and, in particular, to the political status of religion. For a long time, Édouard shared Cousin's idea that because all of the world's religions, from Hinduism to Christianity, had a com-mon nucleus of truth (one that philosophy was in a better posi-tion to explain than priests or Brahmins), the state should deny the clergy the right to teach specific religions in schools. In awe of Cousin's principle, Laboulaye became a supporter of a strong state, particularly in matters of education, despite the new theories recently proposed by Tocqueville on the basis of his experiences in the United States. There, Tocqueville had ventured, there was no need for a strong, all-powerful state to keep religion within the private domain. The only requirement was a constitution promot-

ing individual enterprise and association, for—as Tocqueville put it—"the spirit of religion and the spirit of liberty" were "intimately intertwined" in America.[15]

It would have been difficult to find a better candidate than Édouard to voice Cousin's theories against the heterodoxy of Tocqueville and other Catholic liberals at the time. But then two things happened that would change the course of Édouard's life and gradually undermine his faith in Cousin's certainties. The first was the death of his wife, Virginie Augustine Paradis, in the summer of 1841. A year later, Édouard was still grieving her passing, dedicating himself to a study of the history of women since ancient Rome that he eventually would present to the Académie des sciences morales et politiques.[16] The ensuing book—a historical study of the role of women in society—was dedicated to his wife's memory, but addressed to all women alike, those "tender souls" whom Laboulaye called upon to agitate for the right to administer part of their dowries, to earn higher wages at work, and to have access to education.

It is tempting to conjecture that Laboulaye, the godfather of the female yet eminently masculine Statue of Liberty, was also a speaker for women's rights, and indeed, he believed that true knowledge was simultaneously masculine and feminine. But it is a long way from this conviction to the idea that women ought to have political rights and a career outside of the house. Enfranchisement, according to Laboulaye, was essentially needed to improve women's conditions inside the home, as holders of part of the family estate and as competent educators of children, not as a springboard for demanding votes and the right to political action. Édouard mocked the idea that women could aspire to political power and, like the sixteenth-century jurist Jean Bodin or Montesquieu, he held that "the inconveniences of the rule of women [would be] visible even to less perspicacious eyes." As for the question of suffrage, it was Édouard's view that women were wholly devoid of "the firm will that comes from conviction of spirit."[17]

Édouard would stick to his ideas regarding the "gentle sex" for years to come, but grieved for Virginie for barely two or three. In 1843 or 1844, still handsome with his dark eyes and full, shapely mouth, Édouard married one of the richest heiresses in all of Paris, Valérie Michelin Tronçon de Coudray, daughter of a counselor at the Court of Audit and granddaughter of Marie Antoinette's lawyer. Her dowry put the couple near the top 13 percent of Paris's wealthiest households.[18] This was the second time in only a few years that Laboulaye's life changed direction. Judging from the principles he had enumerated in his own *Recherches sur la condition civile et politique des femmes*, he must have allowed his wife to control at least a part of her dowry. The rest, however, was all Édouard's, and though we do not know if he invested any of his wife's money in the printing press he ran with his brother Charles, their business had great things in store.

CHAPTER 4

AN AMERICAN ASTRAY

At some point between 1837 and 1839, the Laboulaye brothers began working with the founder Hippolyte Biesta, the ambitious son of a small clockmaker whose Fonderie générale des caracterès français et étrangers (General foundry of French and foreign characters) had gathered other French entrepreneurs into the largest casting establishment ever created in Europe. Charles Laboulaye's discovery of a new copper alloy already had important implications for the manufacture of coins (Charles suggested the possibility of using it to make new French centimes) and for the art of binding and gilding. But since their collaboration with Biesta and other casters, the Laboulayes were in the position to buy a new kind of mold, called "American," that enabled them to cast some "20,000 letters per day at least" and cut labor costs by 75 percent. In 1842 (only a year before Édouard's second marriage), the Laboulayes moved their equipment into Biesta's laboratory on 22 rue Madame and initiated an impressive corporate merger with a share capital of 1,200,000 francs, divided into 240 shares of 5,000 francs each.[1]

The operation should come as no surprise, for Édouard had the prospect of becoming one of Paris's richer men after his marriage, and Biesta was a friend and business associate of a new circle of bankers, who in turn were active in corporate investments across the country.[2] True enough, Biesta may be thought to have had only a minor and indirect role in the annals of the Statue of Liberty, but the financial and philosophical ideas with which he familiarized Laboulaye were destined to shape its meaning in a profound manner. It is

therefore worth pausing to examine Biesta's ideological background as a means of shedding light on some of the most remote and least known origins of the iconic New York monument.

Biesta's mentors were the Péreire brothers, Sephardic Jews who had grown up in the Bordeaux ghetto and spent their youth working as accountants in the local maritime enterprises before moving to Paris and starting up in banking under the protection of the Rothschilds.[3] In those same years, Paris was a cradle of bold new economic ideas, many of which charmed the Péreires and their publisher friends like Biesta. Among these ideas, however, few left greater marks on Laboulaye's circle than those of the eccentric philosopher Claude Henri de Rouvroy de Saint-Simon, a Frenchman who had fought with the Continentals in North America, where he had found inspiration for his own utopia.

Historians have often suspected that the Statue of Liberty somehow was indebted to Saint-Simon, but the precise nature of this connection has remained shrouded in mystery.[4] As we will see, publishing and editing were arguably the channels through which Saint-Simonianism first came to influence the Laboulayes—most directly through Biesta—and then the Statue of Liberty.

Appropriately, this story begins in America, where Saint-Simon, who was born into a conspicuous family of bureaucrat-aristocrats and had been the pupil of the *philosophe* d'Alambert, had sailed to help the colonials win their independence from Britain. Saint-Simon had taken an active part in battles—most notably Yorktown, in 1781—until he was taken prisoner and brought to Jamaica, where he was forced to stay until 1783.[5] Despite all this, he had the time to embark on his own sociological inquiry. The U.S. Constitution had not been framed yet, but Saint-Simon already saw that the founders had granted individual liberties "to all citizens alike and even to foreigners." This, however, was not America's most striking characteristic, according to Saint-Simon, who was rather impressed by the effect that individual freedom and the abolition of privileges had on the growth of national wealth. Indeed, he suggested, free-

dom and equality reduced governmental intervention in the country's economic life, spread public recourse to credit more evenly, and encouraged productive work among all social classes. But this occurred only if productivity was channeled toward the creation of public infrastructures in the form of canals, railroads, bridges, and roads, for these alone were able to connect consumers and producers within and between countries. The role of the state was limited, but crucial: "government will no longer drive men; they will simply make sure that useful works be not disturbed."[6]

Having identified the main goals a nation needed to pursue in order to realize freedom and prosperity for all, Saint-Simon was ready to export the formula to the poor and illiberal countries of the world. He started in Mexico, a country he visited after the end of his captivity in 1783. It did not take long for Saint-Simon to realize the possibility of using public subscriptions (such as those he had seen in action in the North during the war) to cut a canal through the Isthmus of Panama and join the Pacific and Atlantic oceans—the most ambitious global infrastructure project to that date. Four years later, in 1787, he similarly looked at the possibility of building a canal linking Madrid to the Atlantic in Spain. Like his Panama scheme, this project, too, would go nowhere. But Saint-Simon was a persuasive man and, after his return to Paris, he put his charm to good use by convincing a rising generation of new French entrepreneurs that infrastructure truly was the key to national and colonial growth. Its potential, however, could only be unlocked by a new and improved financial system in which capital was not accumulated in the hands of idle rentiers and usurers, or concentrated among a small number of administrators of the Banque de France, but left free to circulate through a number of competing banks at low interest rates.[7]

Saint-Simon himself had become a wealthy man after speculating in the public sale of the church's feudal proprieties in 1789. With these funds, he opened his own business, and eventually emerged as one of the boldest and most charismatic entrepreneurs

in all of France, one whom it became fashionable to quote and discuss. Eventually, however, the dashing Saint-Simon grew tired of this life, while his success encouraged him to rebrand himself as a philosopher and visionary. In his famous 1803 *Lettre d'un habitant de Genève à ses contemporains*, Saint-Simon planned nothing less than the construction of an entirely new order, one ruled by scientists and devoted to the cult of Isaac Newton. But this was only the beginning. As he came to think less about the theoretical foundations of his social plan and more about its implementation, Saint-Simon found it necessary to trust producers and industrialists with the executive power in his scheme, and artists and thinkers with the role of clerics of a new civic religion of creativity and imagination.[8]

By the time Saint-Simon met the Péreire brothers, in 1824, he was an old man believing that businessmen should be tasked with planning the country's economic development through a public works program of bridges, roads, canals, railways, and dams, assisted by intellectuals who would interpret the course of history and artists who would imagine possible new futures. By this time, Saint-Simon's mysticism had grown to the point of becoming a veritable religion for its initiates, a "New Christianity." Like other businessmen, the Péreire brothers were inspired not only by the central role assigned to them in Saint-Simon's grand plan of associating finance and social engineering, but also by the idea of using an easily accessible system of credit to counteract aristocratic privileges.[9] This second project fell on even more fertile ground among entrepreneurs like Biesta and the Laboulayes, for publishers had always been troubled by slow financial returns, subsequent cash-flow problems, and the need for cheaper and longer-term credit.[10]

The situation of publishers was particularly fraught in France, where credit traditionally was afforded to affluent individuals of conspicuous means at the exclusion of small and medium enterprises, and always on a short-term basis. These impediments became even more serious in the late 1840s, when the rise of investments in infra-

structure, coupled with a series of poor harvests, marked the onset of an economic crisis that, in 1848, the enemies of the Orléans government used to accelerate the fall of the regime. While the old bankers behind the Banque de France were struggling with the crisis and subsequent revolution (the famous Rothschilds included), Laboulaye's printer friends began sketching the blueprint of an alternative financial system based on collaboration between private and public banks and aimed at building a sort of "capitalism without capitalists," as the historian Nicolas Stoskopf has called it.[11]

As for Laboulaye, the revolution "destroyed" all of his "projects" and "shattered all [of his] ideas." No matter how much he disliked the privileges of the Orléanist republic and looked forward to a more democratic settlement in politics and finance, he rejected the republican alternative for fear that the state might fall in the hands of "socialists" who knew nothing about "executive and legislative power." As a corollary of his rejection of socialism and communism, Laboulaye also dismissed the need for a strong "STATE, this impious Saturn to whom the socialists sacrifice human nature."[12]

But whatever Laboulaye's caveats regarding the state, he was not afraid of a strong executive, having learned from Cousin to appreciate the importance of administrative centralization. What concerned him most was rather the legislative assembly's presumption that it was the ultimate interpreter of the people's will and, therefore, the only source of national laws. So while his printer friends were planning a way to resurrect the republic's credit by combining private competition and state investments, Laboulaye looked toward America. With the notable exception of the Saint-Simonians, Tocqueville, and a few others, deep interest in the United States was not widespread in France at the time, and, as Laboulaye later would confess to his friend the New York agent John Bigelow, he had often felt like "an American astray in old Europe."[13] Not unlike Saint-Simon, Laboulaye was struck by America's wealth; and, like Tocqueville, he was intrigued by the way in which the American Constitution combined respect for individual liberties with a

strong central administration. But he was, in this context, alone in thinking that the central government of the United States almost could be considered a monarchy, or, as he put it, "a republic that was too monarchic for our modern Sparta."[14]

By July, Laboulaye had gathered materials enough to write his "first political pamphlet," the *Considérations sur la constitution.* Taking a close look at such an obscure pamphlet might seem like an unnecessary detour given our purposes. But not if, like the international lawyer Coudert did at the inauguration dinner of 1886, you consider the Statue of Liberty as a "doctrine" or a "poem" in metal form.[15] Indeed, given Laboulaye's later involvement with the making of the statue, his *Considérations* (as well as his later works on American economics and politics) provide a crucial and underappreciated context for understanding the doctrinal content of the iconic colossus.

Laboulaye addressed his pamphlet to General Cavaignac, "the chief of the executive power," in the hope that he might convince his colleagues to model the new French republican constitution after the American one, at least in two crucial ways: first, by including a "declaration of rights" enunciated not as "absolute maxims," but as "legal rules, which the ordinary legislator is required to respect, and the judge to apply"; and second, by ensuring the "maintenance of the legislative power inside its limits," which the United States had accomplished by subjecting its legislative assemblies to the written word of the Constitution and by leaving a wide range of "independent action" to the executive.[16]

The marvelous result of this system, Laboulaye explained, was that the United States had been able to build simultaneously a strong executive and a legislative respectful of individual rights, a sort of chimera from the point of view of European socialists and liberals alike. What was their secret? Laboulaye did not give a definitive answer to the question, but offered some suggestions. One was that Americans had grounded their civil rights on a broad conception of the individual, seen not only as a rational being, but also as a

social agent (that is, an owner or member of a family, a religious sect, a community).[17] Laboulaye started then to elaborate an idea that would emerge more clearly from his university courses on the history of the law, namely that any legal system devoted to realizing "the general happiness of all members of the association" (like the Declaration of Independence) through "the balanced, regular, pacific development of all forces of human nature" (rational, social, and spiritual) was an instrument of liberty.[18]

Still years before the construction of the Statue of Liberty, it is evident that Laboulaye imbued the American Declaration of Independence with a special meaning, one that he wished could transcend the French division between state centralizers and champions of individual rights. But would Laboulaye stick to this interpretation in the years to come? If so, it is doubtful that any of the people present at the statue's unveiling forty years later, in faraway 1886, immediately would have grasped his philosophical reading of the Declaration of Independence embraced by Bartholdi's colossus. Indeed, many of the misunderstandings that would arise that day resulted from the statue's long and tumultuous germination. At this earlier stage, however, Laboulaye also had another, less philosophical way to explain America's greatness — one that, eventually, also would contribute to the statue's complex meaning. Laboulaye's theory was namely that, by bringing "treaties of commerce, customs, taxes, loans, finances, all those things from which national prosperity depends" under a unified and stable authority, the federal government had contributed to economic growth more than almost anything else in American history.[19] He must have found this idea directly in the Federalist writings from the 1780s, where centralization often was justified as a tool for increasing international trust and therefore financial stability and economic development in the young United States.[20] Alternatively, Laboulaye might have relied on the ever-popular publications of the Saint-Simonians, such as Michel Chevalier's 1836 *Lettres sur l'Amérique du Nord,* a popular book that had praised the American system for its unexpected combination of military

strength and economic liberalism. Would it be possible—Chevalier wondered—to transform the American army into "a huge industrial school"?[21] Laboulaye was not interested in this project; he was more fascinated by the consequences of the American system on social laws and behavior. His personal impression was that, given the social (or communal) nature of American liberty (as interpreted in the Declaration) and the increased wealth produced by such liberty and applicable to the care of the poor, assistance would never transform itself into "society's charitable obligation" or, for that matter, ever "ruin the rich."[22]

Laboulaye was being overly optimistic regarding America's structural penchant for social harmony. Yet it is not hard to see why he might have felt drawn to emphasizing the composite nature of American liberty. Indeed, his and his brother's Saint-Simonian friends all believed that the government could help promote the general economy and face the crisis of 1848 not by appropriating private wealth, but by investing state capital in individual initiatives. This project became particularly popular when the provisional government was formed, in 1849, and the Laboulayes' publisher colleagues—Louis Hachette, Louis Gosselin, Antoine Laurent Pagnerre, and Biesta—were called on to guide the process of financial reconstruction. Their solution was to establish a national system of banks, the Comptoirs d'escompte, that invested private and public savings (in the form of state and municipal obligations) in infrastructure projects, while financially backing large and medium-sized businesses and entrepreneurs through long-term loans.

It was a challenging project. To pursue it, Biesta left the Fonderie to Charles Laboulaye, who in turn became a prominent advocate for the creation of "a credit institution for booksellers" and was appointed administrator of the Sous-Comptoirs de garantie for the publishing industry (an agency created at the advice of the Péreires to set up a system of intermediaries through which publishers could deposit merchandise as security on loans, with the principal reimbursed by the Banque de France).[23]

In contrast to Biesta, the Laboulayes did not abandon the printing business, but plausibly took advantage of their friendly relations with the financial establishment. These friendships became more and more important after Louis-Napoléon Bonaparte, the nephew of the former emperor and one of the most active enemies of the Orléans monarchy, returned to France after years abroad to build his own political movement. Louis-Napoléon — a cretin according to the statesman and historian Adolphe Thiers, but wily enough to exploit his uncle's name and keep his distance from the repression of the June uprisings — ran for office and easily won the election of December 10, 1848. Even if he had not taken part in the popular revolution (or maybe precisely because of his non-involvement), Napoléon won with five million votes, which was more than the candidates of the Left and Right had received. And yet, because he did not have an ideological allegiance and his program was a contradictory mixture of populism and conservatism framed inside a patriotic scheme, the Right and Left found the new government quite fitting to their agendas.[24] The new class of bankers led by the Péreires and Biesta, for example, managed to impress on him the necessity of deregulating credit and authorizing the creation of joint stock companies throughout France. In February 1852, Napoléon III subsequently promulgated a law that authorized the creation of mortgages throughout the country, legalized joint stock companies, and deregulated the market for loans. Backed by the new regime, the Péreire brothers were now in a position to build a real business empire. Their first move would be to establish the famous Crédit mobilier, an investment bank with a share capital of 60 million francs, divided into shares of just five hundred francs each, designed to channel people's savings into massive infrastructure investments like the railroad sector.[25]

Thanks to his friendship with Napoléon III, Biesta kept his position at the Comptoir and developed important connections with the Crédit mobilier, but he would never abandon his dream of establishing an "eminently democratic" capitalist system, one

promoting "the principle of the association with the State, the com-
mune, and the citizens."[26] At the same time, however, he started
looking outward, aiming to extend his network beyond France, par-
ticularly to the Middle East and Asia. After 1860, the Comptoir
would open branches in Bombay, Hong Kong, and Saigon (now
Ho Chi Minh City).[27] But though it would succeed in becoming
colonial, the Comptoir was never democratic; small entrepreneurs
could not even afford to open an account there. For all his talk of
spreading "credit to the people," Napoléon III supported the Péreire
brothers' projects only when they were aimed at large and medium-
sized enterprises. He turned his back on those designed for small
businessmen, that is, those based on the establishment of credit
cooperatives (sociétés de crédit mutuel).[28]

LABOULAYE fleshed out most of his theories on America while
animated by a sort of magical excitement, which—if you look
carefully—left its mark in his statue. It is often said, but never dem-
onstrated, that Laboulaye was a Freemason. The late Walter D.
Gray, who worked on Laboulaye's personal papers under the per-
mission of his heirs, once told me of having learned that, upon
Édouard's death, Masonic papers had been found on his writing
desk and immediately destroyed. This family memory is, by itself,
not enough to prove Laboulaye's Masonic affiliation, but it rein-
forces the widespread suspicions regarding his closeness to Masonic
circles, particularly if combined with evidence of his interest in
mystical traditions, and the Masonic affiliation of his grandfather.[29]

Laboulaye's mysticism, still hidden in the Considérations,
became evident in the spring of 1848, when he was appointed to
teach legal history at the Collège de France. Not surprisingly, one
of his first courses was about the Constitution of the United States,
but he decided to introduce his students to the topic not through
the likes of John Locke or the writings of the Founding Fathers, but
through the ideas of mystics and theosophists, as if America had a

mystical, almost miraculous aspect to it that escaped the rigid categories of European philosophy. In this, Laboulaye was hardly alone, for even if the American system remained relatively obscure to most people in the world, it was common to treat it as a sort of "miracle." The French were particularly fond of this approach, having experienced what has been called "an orgasm of vicarious self-fulfillment" in the New World ever since the onset of the American Revolution.[30]

Take, for example, the Saint-Simonian Michel Chevalier, who had returned from his American journey in 1834. "Study the population of our [European] countrysides, probe the brains of our peasants," he observed, and one would find nothing but "a shapeless mass of biblical parables and old legends of a crass superstition." But "do the same thing with the American farmer and, in his head, the great traditions of the Bible are joined harmoniously together with the precepts of the new science put forth by Bacon and Descartes, with the principles of moral and religious independence proclaimed by Luther, and with the most modern ideas of political independence. He is an initiate."[31]

It is still premature to claim that, with her torch raised high in the dark sky, the Statue of Liberty symbolizes an initiator of such mysteries waiting to impart her knowledge on immigrants and exiles passing through the gates of the New World. Laboulaye might well have taken the idea from Chevalier directly, but would undoubtedly have encountered similar notions elsewhere as well, including in Tocqueville, who famously saw the curves traced by God's finger point to America. Indeed, Laboulaye's most immediate source might have been American historian and statesman George Bancroft's history of the American colonies, which he used to prepare his courses at the Collège. For Bancroft had described the growth of American colonies as the culmination of a dialogical and religious initiation that had begun in the Protestant communities of Europe but only come to fruition in the New World, where the light of God's intuitive wisdom had entered "into the houses of the common people."[32] In each and all of these cases, the leading metaphor

of American exceptionalism was "light," as Coudert would suggest at Delmonico's on the night of the statue's inauguration. It was the light of God. Fittingly, "God and Liberty" was the epigraph of Laboulaye's 1855–1866 *Histoire des États-Unis*.

Two further mystical sources of Laboulaye's thought are worth highlighting here, sources that rarely, if ever, are mentioned in histories of the Statue of Liberty, but that counted dramatically in its making. One was Pierre-Simon Ballanche, a theosophist from Lyon who was credited with helping Madame de Récamier to release Coudert's father from prison.[33] Laboulaye never met Ballanche, but he knew his writings by heart, for they provided him with nothing less than a spiritual history of humanity, in which America's moral experiment could be framed in ways that suited Laboulaye's approach quite well. Ballanche's story began with the mythical Orpheus, the lyricist who enchanted the world with his music and poetry. According to Ballanche, Orpheus was a patrician born in the barbarian regions of ancient Thrace, where he initiated the plebs, or commoners, to the mysteries of Bacchus, or Liber, the god of wine who liberated men and women from temporal and material constraints through intoxication. But Orpheus's most important work for civilization happened only after he married the patrician Eurydice, for true knowledge, as Ballanche claimed, was masculine and feminine at the same time. After their marriage, Orpheus and Eurydice moved to Samothrace, a "shining lighthouse that will light up islands and seas from afar," where they gave barbarians laws to distinguish between the just and the unjust, to ensure the right to property and marriage, to establish burial rites, and to regulate marriages and births.[34]

The key fact here, Laboulaye explained to his students, was that Orpheus's laws of property had little to do with man's rational exploitation of the land, as a long tradition focused on Locke had argued. Rather, they resulted from man being one and the same with property, for—as Laboulaye quoted Ballanche—"man made the earth; the soil is him."[35] Ballanche had used the language of

Orphic initiations, but Laboulaye explained to his students that the quotation meant something relatively simple: because "property was a divine institution" and each man needed it to become fully realized according to God's designs, it should be equally distributed among the largest number of people in order to make a nation "happy and satisfied."[36] Ballanche had called this law the "law of solidarity" or "law of Gospel" and had explained that, as a consequence of their corrupt natures, men could no longer aim to enjoy it in society. But he was talking about Europe, not America. The United States was a completely different matter, because Americans (despite their acceptance of slavery) had acknowledged the importance of spreading knowledge, property, and solidarity among the people at large. As a result, Ballanche had once argued, America had "put itself under the protection of the God of liberty, the God of the Christians," by leaving individuals free to associate and pursue their religion.[37]

Laboulaye probably had Ballanche in mind when, in his seventh lesson on American history, he told his students that the first colonists had sailed to Massachusetts "to bring there the torch of Gospel, to pray there God in liberty." It is easy to imagine Laboulaye here starting to imagine the future Statue of Liberty, with a masculine face and a feminine body, an iconic fusion of Orpheus and Eurydice with the torch of Christian liberty raised to redeem humanity from its original sin. True enough, America was no Samothrace, but, like the mythical Greek island, it—and a symbolic statue—could well be imagined as a "shining lighthouse" that would "light up islands and seas from afar."[38]

However evident the Samothracian origins of the Statue of Liberty may seem, Laboulaye had in effect only applied the first, tentative brushstrokes to the virtual canvas of his future project, and many more would follow before Bartholdi even entered the scene. For after dealing with Ballanche, Laboulaye introduced his students to his second source, the German Freemason and philosopher Karl Christian Friedrich Krause.[39] A friend of Cousin who believed

in unconscious communication with other "spheres of life," in magnetism, and in the magical character of dreams, Krause was a Neoplatonist who maintained that God was "present" in his own creation and that it reflected his light like mirrors reflect the rays of the sun. But these reflections, he explained, could be misleading, for they gave the illusion of two "hemispheres"—*Natura*, or nature, and the *Liberum*, "the set of distinct rational beings"— coming together to form a "complete organism." Krause thought he recognized the highest example of metaphysical integration between the *Natura* and *Liberum* in the American Constitution, which he saw as a *Gemeindeverfassung*—or "municipality constitution"—that defended men in their private possessions by virtue of a strong government while simultaneously giving them the freedom to associate, encouraging solidarity and "sociability."[40]

Laboulaye was seduced by Krause's vision. It was, he told his students, "a system of universal harmony," one in which it was impossible to reduce "all explanations to a unique principle"; instead "the various existences"—of "man as individual" and as a "member of society"—were ordered according to a system of "coordination" or "unoppressive hierarchy." The students had better use this theorem as their "point of departure for [their] studies," Laboulaye lectured peremptorily. The implication was radical: his students had to forget the old idea that societies were born from social contracts and justice based on human agency, and accept the alternative point of view that justice was "grounded on human nature, a nature that was free, reasonable, and sociable as part of the universal order established by God."[41]

If not for his students, the idea certainly became the starting point for Laboulaye himself, and the scheme offers a new framework for considering central aspects of the Statue of Liberty, including her judge's toga and the book of laws (recorded in the Declaration, and also, metaphorically, God's laws) that she carries. But there were other aspects of Krause's thought that, though Laboulaye did not discuss them in class, seem to have inspired his later design to

build a French statue in America. In particular, Krause thought that the occult mysteries of the world would one day cease to be a hermetic tradition and instead be revealed, apocalyptically, to all of humanity. Krause foresaw a future in which mystical wisdom would leave the secret lodges of the elected to educate and enlighten the whole world; a future in which Masonic symbols and art (especially sculpture and music) would appear in public squares and allow everyone to behold the symmetry and unity of being, and thus God himself, in whose idea humankind would be recognized as a unified whole. It was, in many ways, a continuation of what Ballanche identified as Orpheus's and Eurydice's civilizing mission, but this time the revelation included music, statues, and specific forms of architecture, which would create a more agreeable and conducive space for human sociality. Krause declared in a visionary passage with which Laboulaye was certainly familiar: "I see in spirit the most beautiful churches and freest squares in the capitals of this land . . . transformed into mankind's sacred places. Just as the sacred places of heretics were turned into Christian pilgrimage sites."[42]

The Statue of Liberty would eventually be conceptualized precisely as such a monument: a colossal statue with Masonic symbols (the flame, the book, and the star on her head), half man and half woman, or at least androgynous, that would reveal its truth not just to members of the secret lodges but also to the masses, as a sort of monumental incarnation of Orpheus and Eurydice. What kind of truth would be revealed, one may ask? Perhaps that already discovered by the Founding Fathers of the American Republic, who had known how to create a government strong enough to defend individual rights and social commitments, liberty and order, property and charity. Bartholdi's participation in the building of the statue, however, would add ever new layers of meaning to the monument, layers that would interact in unpredictable ways with Laboulaye's original vision.

CHAPTER 5

THE SIN OF COLOR

The first-century Greek biographer Plutarch wrote his *Parallel Lives* under the conviction that history is moved by certain patterns that reappear across time and space in various people of influence. The main characters of our history, Laboulaye and Bartholdi, not only shared similar plans and interests, but also lived in the same era and came from equally influential families. While the Laboulayes had moved from Normandy to Paris centuries earlier to join the ranks of the nobility, however, Bartholdi's family came to the French province from foreign regions.

Frédéric-Auguste (or simply Auguste, as his family called him) Bartholdi was born in Colmar, Alsace, to a Protestant family of foreign origin. Auguste's brother, Charles, who valued genealogy and heraldry, traced the family's origins to the Italian city of Como at the time when it was under the sway of the Sforzas of Milan. He claimed that the Bartholdis were an old "patrician" family stemming from the "armiger" of Como Giovanni Bartoldi (spelled without the "h"), whose son, the squire Anselmus, moved to Germany.[1] Charles did not explain why Anselmus left Como, though one can surmise that his endorsement of Luther's Reformation and subsequent need to escape papal persecution may have been influential factors. Indeed, one is told, Anselmus moved to Frankfurt, a sanctuary of exiled protestants at the time, where he became lord of the cities of Mühlenskin and Abensberg and member of the family association of Frankfurt am Main, the Adelige Ganerbschaft des Hauses Alten Limpurg. Because the city's rulers usually

accorded the title of "lord" to long-distance traders, it is possible that Anselmus (like the first Laboulayes) was an international *negociant*.[2] Charles did not say; instead, his research revealed that, by 1543, Anselmus had germanized his surname by adding an "h" to it, and exhibited a coat of arms portraying a hand and a helmet surmounted by a little man (*Männlin*) dressed all in red and sporting a long, white beard. Both hands and the color red would come to play important roles in Bartholdi's art.

Sometime during the sixteenth century, the Bartholdis were believed to have split in two. One branch, the descendants of Horatius Bartholdi, noble *Freiherr* of Parthenfeld, settled in Vienna and abandoned the Protestant community to become Catholic, substituting their red coat of arms with a blue one surmounted by three helmets crowned by golden diadems. Intriguingly, one of these diadems had a raised arm holding an arrow on top. Charles Bartholdi may have forced the historical evidence to prove his family's aristocratic origins (although Horatius Bartholdi is indeed listed as "Freiherr von Parthenfeld" in the *Life of Leopold the Great* of 1713), but his genealogy left a deep mark on Auguste, who would use it to personalize his art in ways that rarely have been acknowledged by historians.

The story of the other branch of the Bartholdi family—which remained true to the Reformation—is easier to track. Charles rightly traced it back to the theologian Veit Bartholdi, who was born around 1578 near Dusseldorf, moved first to Weissenburg and then Jena, and later settled in Aberzhausen, in Bayern. Almost a century and a half later, one of his descendants, Jean-Georges, himself a pastor, moved to Wissembourg, in Alsace. He died there in 1733, by which time most of Alsace had passed into the hands of the French. One of Bartholdi's children, Gilles-François, became a pharmacist and, after marrying his second wife, Ursula Sonntag, moved to Colmar around 1751 to succeed his father-in-law in the Protestant synod and take over his pharmacy, Le Soleil, on the rue des Marchands. The pharmacy's

sign — possibly hung from an iron bracket above the door — bore a gilt copper or bronze sun (for Sonntag, the name of the original owner, meaning "sun day") that is still preserved today in the Bartholdi house in Colmar and of which countless reproductions are spread across the city.[3]

Too far away to be subject to complete Parisian control, Alsace was located at the crossroads of major trade routes to the north and east, where the écu d'or, the French gold coin, mingled with the Spanish pistole and the Rhenish guilder. It was a waypoint for traders, but also for heretics, atheists, freethinkers, and simple journeymen. Voltaire took refuge in Colmar after quarreling with his friend, the king of Prussia, and spent two years there before returning to France. Arriving in 1753 with a heavy heart, Voltaire was rather unimpressed by Colmar, which he dismissed as the "capital of the Hottentots," where the diocese was run by "German Jesuits, who are as despotic with the savages living along the Rhine as they are in Paraguay."[4] Plagued by all the world's ills, whether real or imaginary, he survived his time in Colmar by "plundering" the local pharmacies (including, therefore, that of our Bartholdi) of "rhubarb and pills" and writing *Annals of the Empire*, which he would print on the presses of the local publisher Schoepflin.[5]

Voltaire brought to Colmar the winds of reform that had already swept through Paris, where the diffusion of books and newspapers had spread to a wider public an interest in issues once confined to scholars. Following the example of the cultural associations and literary salons of the capital, the Protestant poet Conrad-Théophile Pfeffel founded the Société littéraire or Lesegesellschaft in Colmar, where Gilles Bartholdi and other members would read and discuss (in two languages) the greatest works of eighteenth-century French and Scottish philosophy and all the volumes of the *Encyclopédie*, as well as grapple with a wide variety of scientific, medical, educational, and artistic topics, including "eclipses," "the effects of women's imagination on fetuses," "seizures," the teaching of art, and so on.[6]

Some of the books on show in the Bartholdi House today, neatly ordered on shelves protected by glass doors, are those that Gilles bought at Pfeffel's encouragement. The house, at number 30 rue des Marchands, is a solid fifteen-century mansion located on a narrow street in the center of Colmar, where carriages were taken down a dim portico and parked in a wide courtyard covered in gray tiles. It was the house of Colmar's old *Stettmeister* ("master of the city") Étienne Meyer, a Lutheran and austere place where Auguste's grandfather, Jean-Charles, one of Gilles's sons, came to live after marrying the stettmeister's daughter, Catherine-Dorothée. It was from that dark yet elegant abode that Jean-Charles, the city's doctor, and his wife witnessed the beginning of the French Revolution. Many rich families escaped from the city, but the Bartholdis stayed in town, where the men of Colmar evoked the storming of the Bastille by carrying a replica of the building surrounded by colored flames in procession, and girls dressed like Vestal virgins marched toward the Champ de Mars with agricultural symbols in their hands (rakes, sickles, ears of wheat).[7] In the middle of this commotion, in 1791, Jean and Catherine celebrated the birth of their only son, Jean-Charles junior (the father of our sculptor), only one year before Prussia joined with Austria in its war against France.

Alsace was among the first to suffer the consequences of that war. After crossing the Alsatian border, in 1792, the Prussian Army burned villages and displaced between 40,000 and 50,000 Alsatians. In Colmar as in Paris, the emergency government launched summary executions, prohibited religious cults, and outlawed monastic orders. Jean-Charles was still a toddler when the citizens of Colmar placed a giant Phrygian cap on the Cathedral of Saint Martin, whose interiors they had emptied out to set up a "Temple of Reason." They erected tribunes and daises, probably in the nave, and placed in the choir a wooden structure topped with a dome, which they then covered in green carpets and pines to simulate a "Mountain of Reason." On solemn occasions, they lit a large fire in a bowl placed on top of this mountain, while women stood on its slopes singing

hymns to freedom. Finally, on top of the Mountain of Reason, not far from the fire, was the Throne of Reason, personified by one of the city's young belles, "the one whose features were most reminiscent of the Minerva of Phidias."[8]

Jean-Charles probably had no memory of those days, but he might have heard tales of them from elders, tales to share with his wife and sons years later, in the comfort of the dining room of the rue des Marchands family home. It is tempting to picture the family gathered around the fireplace intent on listening to stories of gigantic Liberties erected in Colmar between 1793 and 1795; big, armed statues, carried on carts, celebrated by torchlight like divinities at night. And Alsatian Liberties, it has to be said, were even more aggressive in posture than those in Paris, for Alsace was caught between the Rhine and the blood-soaked government of the Revolution. The Minerva making a show of her beauty on the Mountain of Reason is just one example. Another is a gigantic Liberty that Jean-Jacques Karpff painted in his *Scène de la Révolution:* a seated statue erected in Champ de Mars, at Colmar, during the Revolution, leaning, left arm bent, upon two great tablets containing the laws—those of the Constitution of 1795 (Year III), the canvas seems to read—while her right arm is outstretched, pointing a drawn sword at the audience.

Whether or not Jean-Charles talked about this colossal and aggressive statue of Liberty to his family, and whether or not Karpff's painting was a reliable depiction of actual events, the fact that it was hanging from the walls of the Colmar Museum when Auguste Bartholdi was a young art student is telling enough. Karpff was Colmar's most famous artist, a disciple of the revolutionary painter and festival designer Jacques-Louis David and a local festival designer himself.[9] There is no way this painting could have escaped the attention of the young Auguste, who was a frequent visitor of the museum along with his mother, Charlotte Beysser. And she, if possible, was even fonder of revolutionary memories than her husband.

With long raven hair, combed straight around her thin, long face, Charlotte had a slightly masculine appearance. Her black eyes, sunken and surrounded by blue shadows, were penetrating yet melancholic, but her most beautiful feature was her nose, flat and straight like those of Greek statues, and revealing a marked strength of character.[10] Charlotte's parents were descended from hoteliers and coopers, and belonged to the Protestant community of nearby Ribeauvillé; they had instilled in their daughter a deep religious devotion combined with a sophisticated literary culture. The French novelist Stendhal doubtlessly had girls like her in mind when he explained that there were "scarcely any women living in the province who do not read five or six volumes a month," and that many of them would read even "fifteen or twenty."[11] While the Bartholdi family's liberal beliefs had been shaped by the essays of philosophers like Voltaire, Condorcet, Montesquieu, and Hume, and occasionally bent to the demands of imperial or monarchical governments, the Beyssers were enthusiastic supporters first of the Jacobin Republic and later of the Napoleonic empire—so much so that Charlotte's great-uncle, the general Jean-Michel Beysser, was said to have helped put down the anti-revolutionary uprising in the Vendée in his own way, sporting a pair of trousers made of human skin torn off the *brigands* of Chatelineau and a cap made of severed ears. As for Charlotte's father, Simon, he was a committed Bonapartist who remained mayor of Ribeauvillé until Napoléon's fall and would return to office only during the so-called Hundred Days between Napoléon's return from exile on Elba on March 20 and the restoration of King Louis XVIII on July 8, 1815.[12]

Born too late to support the Revolution, Charlotte had nevertheless absorbed its spiritual echoes through Christian and sentimental interpretations of Rousseau, shaped by the pietistic culture of Alsace. Her family's old library of works by Voltaire, Diderot, and Rousseau was expanded by Charlotte with the romantic novels of Madame de Stäel (which she annotated and from which she copied and recopied entire passages) and the pathos-laden poems of Pierre-

Jean de Béranger. Especially through Madame de Stäel, Charlotte became acquainted with an exceptionally aristocratic form of liberalism that was already deeply permeated by the religious fashions of the time. Reading her novel *Delphine*, Charlotte had learned to appreciate individuality through its emotional repercussions and endorsed Stäel's call to society to "treat the superiority of spirit and the soul with more respect."[13]

AUGUSTE BARTHOLDI, the sculptor of the Statue of Liberty, was born into this atmosphere of emotional tenderness and religious sentimentalism on August 2, 1834. Tragically, his father was taken from his family by a rapid and incurable disease (caused "by a misapplied new medicine") only two years after Auguste's birth.[14] He spent his childhood in the family home on the rue des Marchands, where his mother entertained the ghosts of the past and a brother, older by two years, showed early signs of a brooding character. "The sound of the wind, storm gusts, summer evenings, winter chills," Charlotte wrote, "these opposite pictures produce similar impressions, and give rise in the soul to a sweet melancholy, true human feeling . . . the only situation of the heart, which leaves to meditation all its action, all its strength."[15] To combat her sadness, Charlotte explained, perhaps paraphrasing or quoting Madame de Stäel, she would admire "beautiful nature, which is never as surprising as when it is reborn in all its splendor and gives us . . . an incredible mirage of resurrection."[16]

But Charlotte was not completely alone, for the Bartholdis still had a rich relative in Paris. Jacques-Frédéric Bartholdi, one of the sons of the pharmacist Gilles, had left Colmar in the late 1780s to become a banker in Paris and marry into the business elite. Soon enough, the rise of Napoléon had made his dreams come true, for Napoléon, who had spent time as a young officer in the artillery company stationed in Strasbourg, had a special fondness for Alsace. But Alsace figured in Napoléon's

schemes for other reasons as well. Because French Protestants had always been excluded from power, Napoléon had planned to win their support across the country, and in Alsace in particular, by selecting them to participate in a "new" aristocracy that would be loyal to the emperor, able to speak German (the language of the enemies), and independent from the old balances of power. As a result of this policy, Lutherans of Alsatian origin had filled the ranks of Napoléon's senior staff officers and generals, while Protestant tailors, carpenters, and jewelers were distracted from the rigor of their original creed to delight in the renewed extravagance of court life and high society under Napoléon. As tariffs disappeared from the right bank of the Rhine (reconquered by the French in 1806) and new ones were raised against British goods all along the borders of the continent, Alsatian craftsmen had introduced a new style in furniture (square and heavy, in briar or solid mahogany, and enlivened with inlays, imperial emblems, or graceful swirls) and Alsatian weavers had indulged their wildest fantasies, designing vivacious fabrics for the new fashion in women's dresses, very simple in line, but featuring generous necklines and waistlines high enough to emphasize even the smallest bust.[17]

The Parisian branch of the Bartholdi family had enjoyed the consequences of Napoléon's policies like few others. By 1797, Auguste's great-uncle (Jacques-Frédéric) had become a wealthy banker and was ready to open his own bank with his father-in-law, Jean-Michel Sohenée, to invest in the haberdashery trade from India, and to finance dying operations in Munster and sales in Colmar. Later, with the establishment of the Banque de France in 1800 to centralize control over the country's finances and Soehnée's appointment to it as a *censeur*, Jacques-Frédéric had begun his climb to the upper echelons of finance: he became judge of the Commercial Court in 1810, then general councilor of the Seine, general administrator of Paris's Caisse d'épargne (savings bank) in 1815, and president of the Cie royale d'assurances générales (Royal general insurance company), all of which would

culminate in his being named chevalier of the Legion of Honor in 1837.[18]

Jacques-Frédéric and Soehnée were ardent acolytes of Saint-Simon, particularly in regard to his visionary ideas on finance and banking, and might have introduced the young Jean-Charles, Frédéric-Auguste's father, to the doctrine. Indeed, Jean-Charles had spent periods of his youth with his Parisian uncle to learn a bit of accounting and urban manners. He had grown fond of his Parisian relatives, who had welcomed him as a son.[19] Jean-Charles had never entirely fit in with their ambitious milieu, but this did not diminish Jacques-Frédéric's affection for him. So much so that, when Jean-Charles died, Jacques-Frédéric took responsibility for his widow, Charlotte, and her two children. Charlotte was no less eager to receive advice than Jacques-Frédéric was to give it. In her letters to Jacques-Frédéric, she sought to involve him in her personal life and asked for counsel on how best to educate her children in a way that suited their distinctive characters. For her two sons were extremely different. The elder son, Charles, had suffered much from his father's death, but, as Charlotte wrote to Jacques, he was no different, psychologically or intellectually, from other children his age. Auguste, by contrast, puzzled her. Sure enough, he was "strong and robust" with a "dark complexion, eyes and hair," like his mother's, and he was also a "very good boy," even "affectionate," but he had "faculties usually associated with an older age." Such a precocious child needed special treatment, Charlotte thought, because it was clear to her that Auguste bore the seeds of a "steady and resolute character," which, at his young age, manifested itself as "stubbornness."[20]

Years later, when Charlotte and Auguste would quarrel over the advisability of Auguste's journey to America and over the building of the Statue of Liberty, Charlotte may well have marveled at the foresight she had shown in those letters. But Charlotte was stubborn too. She taught Charles to play the cello and Auguste the violin, taking them to concerts and playing trios, however reluctant they

might have been. Music was not Charles's and Auguste's forte, but they both liked drawing and they both (Charles more than Auguste) excelled in it when they started art classes at school.[21] So Charlotte sent them to the studio of the Alsatian painter Martin Rossbach, a follower of Karpff, the artist who had drawn Colmar's Statue of Liberty, the Minerva with the drawn sword. Karpff's painting of Minerva had been an artistic manifesto of sorts: a joyful cherub, peeking from behind the armed Liberty, shows a stele on which the words "Miscendo utile dulci" (mixing the useful with the pleasant) are written. It is as though the cherub is supposed to cheekily divert the attention of a reverent public from the self-importance of Liberty and her constitution to the laws of drawing, which consisted in applying classical design to useful ends.

It is worth pausing on this image. Art, in Colmar, was traditionally about making useful things appear beautiful or, in other words, decorating industrial items. Indeed, classical drawing had found an immediate, industrial application in Alsace. From well before the French Revolution and long into the nineteenth century, demand had been strong for decorators and industrial designers in Colmar and other Alsatian cities, especially in the textiles industry. Exporters from Mulhouse (such as members of the Dollfus and Koechlin families) were particularly keen employers of well-trained designers. Because Jacques-Frédéric knew these textiles businessmen well, he may have been the one who first directed the Bartholdis to Rossbach's drawing school. Whatever the case, one can only imagine what their training looked like during the long afternoons they spent at their teacher's studio. As a neoclassical painter, Rossbach thought his mission was that of protecting his students for as long as possible from the medieval "horrors" that were still present in Colmar. In his own times, Karpff had done his best to hide in the city's attics these religious, colorful, and sometimes grotesque paintings, which included Virgin Marys with narrow shoulders and outstretched, elongated fingers, and Christs with horribly mutilated bodies, because they offended the classical taste of Karpff

and his colleagues. In their place, Karpff had ordered a collection
of plaster copies of classical sculptures from the Louvre, includ-
ing representations of Castor and Pollux, the Apollo of Belvedere,
and the Gladiator. One can still see the reflections of these early,
foundational exercises in the Statue of Liberty's classical dress and
demeanor, not to mention in her status as a "useful" building with
a statuary appearance; in that sense, she is a colossal, quintessen-
tial envoy of Alsatian decorative art abroad. The immediate link
between the lady in New York Harbor and Karpff's and Rossbach's
industrial teaching can be found in the Bartholdi brothers' child-
hood art lessons in Colmar. At the time, Rossbach insisted on
the importance of associating art with industrial purposes, and
linking the study of statues with that of commercial objects, such
as "antique furniture, vases and constructions, which are always
elegant and noble."[22]

But the Statue of Liberty is also a colossus, a gigantic monument
challenging the canons of classical harmony with its enormous
proportions. Perspectival exaggerations were a trademark of much
medieval and Renaissance art, from which Bartholdi had been
spared for part of his youth. Only part, though, for Rossbach's influ-
ence on his art would only be dominant until Jacques-Frédéric
insisted the family move to Paris in order for the children to have
a better education. For Charlotte, it was a difficult choice, but,
as she wrote in her diary, "the education and development of my
children come before anything else"; indeed "there is no sacrifice
I am not prepared to make for them."[23]

In 1843, Charlotte let out part of the house on the rue des
Marchands, leaving a wing for herself and her children. But the
Bartholdis also had a house near the river Lauch, with a wonder-
ful garden and a view of the three towers of the ruined castle of
Eguisheim ominously emerging from the Vosges forest. In the
family's possession since time immemorial and still inhabited—
according to legend—by the spirits of the ancestors portrayed
in large frames along the walls, the house kept silent memory of

all the afternoons in which Gilles Bartholdi had invited poets and intellectuals of the city to debate medical and philosophical questions on the river, or welcomed them inside, beyond the bas-relief of the family sun overlooking the entrance.[24] This was the world that, in 1843, the Bartholdis left behind for the City of Lights.

THE ROAD TO HELL

Charlotte settled with her children in a small apartment on the rue d'Enfer, in Paris. The name of the road — "road to Hell" — evoked nightmarish images of houses inhabited by devils or of some special entrance to the underworld, and rumor had it that the road indeed had a mysterious history. It was said that the rue d'Enfer (now split into rue Denfert-Rochereau and rue Henri-Barbusse) was built not far from a place originally named Vauvert or Vallis Virdis, which Louis IX had promised to the Chartusian monks if they agreed to cast out the devil ("le diable de Vauvert") haunting the place. More likely, the road's name was a later deformation of the original Latin name, *via inferior* (the lower street), or referred to an iron door ("en fer") in the wall of Philip II Augustus, which once surrounded the city.[1]

Still, there was something disquieting about the place. Located at the outskirts of Paris, not far from the city's catacombs (a maze of underground ossuaries that even then attracted thrill-seekers from other parts of the city), rue d'Enfer was a poor area where few children ventured to play. The absence of green spaces there was acknowledged in earlier times, for Victor Hugo recounts, in *Les Misérables*, that "the owners of the houses on rue Madame and rue d'Enfer had a key of the Luxembourg garden, which their renters could use when the [park's] gates were closed." Later, however, "this tolerance was abolished," and the place remained a gray and dilapidated area with few attractions beyond the mortuary.[2]

It was in this once cursed Parisian quarter that Charlotte started a new life. She bought a green notebook with plain white pages, where she listed all her expenses and sometimes recorded her thoughts about life in Paris. She also enrolled her sons in school, at the Lycée Louis le Grand. The Bartholdi boys did not enjoy school much, however, and their professors were soon disappointed. Not even Auguste, whom Charlotte thought was precocious and talented, met his teachers' expectations: he was "weak and little accustomed to work"; his "memory needed some training."[3] Charlotte grew apprehensive—even more so after Jacques-Frédéric died in 1844, in the wake of which she was left with no support except that of his relatives. Still, Charlotte did not really need Jacques-Frédéric to remind her that her children's talents did not lay in writing or rote memorization, but drawing. Her next step, therefore, was to find them a new art teacher in Paris.

The city of Paris itself was, in its own eccentric way, a school of art—and judging from Charlotte's complaints about their frequent absences, the two young Bartholdis must have discovered it quickly. Raised in calm rural environments that hewed to the white and unexpressive rigor of classical art, they suddenly found themselves in an urban jubilation of color, shapes, and forms of expression: the City of Lights itself. When they wandered along the quai du Louvre, then skirted the Tuileries Palace and its gardens, they reached the place de la Concorde, where revolutionaries had erected their guillotine and which the Orléans architects had turned into a copy of Rome's Piazza Navona. At the center of the square, where the bleeding head of Louis XVI once had fallen prosaically into a casket, stood a monument celebrating Napoléon's Egyptian campaigns, an obelisk given to the French by Muhammad Ali, viceroy of Egypt, on which hieroglyphics celebrated the feats of Ramses II. Egyptian art was certainly not part of the canon that the Bartholdis had been trained to emulate and respect, but seeing the obelisk between two colossal fountains decorated with colorful statues (which their former teacher Rossbach undoubtedly would have deemed "vulgar") was even more of a surprise. To the north and south of the obelisk,

two huge three-tier fountains by the German-born architect Jacques Ignace Hittorff displayed a variety of statues representing fantastic creatures all painted in gold and bronze: in the southern fountain, powerful gods of the Atlantic and the Mediterranean stood on the prows of ships, surrounded by mythical figures adorned with corals, shells, pearls, and fish; in the northern one, the gods of the Rhine and the Rhône were edged by tritons and Nereids.

It was a tribute to France's commerce and empire, one that Auguste Bartholdi would soon learn to emulate. Eventually, he would even develop a taste for colorful materials, for metals and stones like those used by Hittorff. But Paris had other forms of unconventional art on display as well. West of the obelisk, for example, Hittorff had designed the broad avenue linking the place de la Concorde to the Arc de Triomphe, the monument commissioned by Napoléon after his victory at Austerlitz and left incomplete until the engineer Éricart de Tury finally directed its completion between 1833 and 1836. Four years later, Napoléon's remains, returned from Saint Helena and secured inside a porphyry sarcophagus carried on a gilded carriage by four groups of richly barded horses, passed under the arch on their way to Les Invalides. The arch displayed none of Hittorff's bright colors; the sculptures decorating its walls rather reflected the austere pallor of neoclassical sculpture. But the sculptures themselves were unusual: they featured threatening expressions of sorrow, rage, and fear on their faces, which were so finely rendered that it was as if their sculptors had been able to turn their chisels into brushes to create them. But there was a second, crucial detail: the colossal statues were part of giant, almost theatrical scenes that were attached to the arch's walls in chronological order so as to narrate a history of France stretching from 1792 to 1815.

On the side facing Paris, a shouting figure with a face contorted in anger and her sword drawn (like the Revolutionary Liberty painted by Karpff but with greater verve) pointed to the places where French volunteers of 1792 had fought abroad, while a leader encouraged his soldiers to fight in the foreground; in a second scene, a triumphant Napoléon is crowned by a half-naked allegory of

Victory, while History writes his deeds and a surrendering city bends to his will. On the other side of the arch, facing Neuilly, a glowering angel with a curious grin represents France's resistance against its European enemies in 1814: a flame on his head, the angel urges a young and naked warrior to fight against the enemy and protect his mother (who is holding a dying child in her arms) and old wounded father gripping his legs, while in the background a knight falls from his horse (Figure 6.1). The last work portrays a scene related to the following year, 1815: a somber and threatening Athena, with helmet, breastplate, and spear gives her consensus to "Union and Order," the consequences of which are illustrated by figures below: a man working at his field, a soldier putting his sword back into its sheath, a woman nurturing and educating her children, and a peasant yoking a rampant bull.[4]

For the Bartholdi boys, it all must have been like leafing through a monumental book of sculpted illustrations: on an artistic scale they had never before witnessed, it told them about the enthusiasm of the first volunteers, the pride of Napoléon's victories, the pain of resistance, and the rebirth of peace. In that desolate corner of Paris, still barely lit, Auguste might have felt assailed by the terrifying image of the female warrior guiding the volunteers to the revolutionary front or by the devilish spirit, his head aflame, instigating the people to fight, and ultimately to sacrifice. Who exactly was that uncanny figure? In many ways it was reminiscent of another winged statue, less frightening and all painted in a striking gold, which stood in precarious balance on top of the July Column of place de la Bastille. The column, 154 feet high, was built where Napoléon had started the construction of an enormous elephant-shaped fountain celebrating his Eastern campaigns. The fountain had never been finished, and the enormous stucco elephant had been left to rot in the rain, its decomposing entrails providing, as Victor Hugo remembered in Les Misérables, shelter to the city's destitute. It was Louis-Philippe's job, after a popular revolution had brought him to power in 1830, to erect a monument to liberty in the

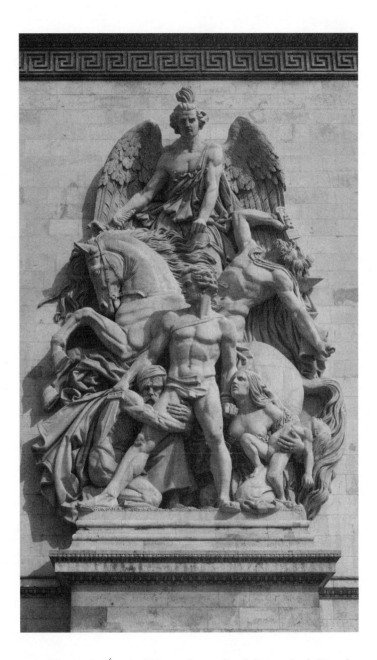

FIGURE 6.1. Antoine Étex, *La Résistance de 1792*, 1833–1836, stone, Arc de Triomphe, western façade.

same place in which the storming of the Bastille had taken place. And a powerful monument it was, one celebrating not so much the revolutions of both 1789 and 1830, but their victims.

The July Column was, indeed, a sepulcher, and the angel crowning it, the *Génie de la Liberté*, a graceful but masculine figure resembling the Greek messenger of the gods, Hermes, whom Renaissance philosophers and Freemasons identified with the guardian of God's wisdom and the alter-ego of the Egyptian god Thoth.[5] Winged and naked with the star of wisdom on his forehead, this Hermes of liberty balanced on a globe without his usual symbol, the winged staff or caduceus; instead, he raised a torch with his right hand and held broken chains in his left.

One could easily find parallels between the *Génie* and the Statue of Liberty, though this requires anticipating some facts about the statue's origins. The first parallel has to do with their symbols, as the Statue of Liberty too lifts a torch of liberty with her right hand and has pieces of broken chains laying near her feet. The second similarity is to be found in the ambiguity of the monuments' gender: the *Génie* is a naked male with feminine grace and facial features, while the statue represents a female body with masculine qualities. The third and probably most telling parallel is that both monuments celebrate liberty through their victims: the *Génie* was a symbolic tomb for the victims of 1789, and the statue commemorated the French and American soldiers who had fought together against the British during the War of American Independence. Later chapters will show how Bartholdi and Laboulaye designed their monument with the belief that liberty was a mystery to be learned and appreciated through initiation, sacrifice, even death. Laboulaye's own fascination with mysticism dates at least from the first lectures he gave on America at the College de France in 1849. But what about Auguste?

BY THE TIME the Bartholdis arrived in Paris, mysticism was everywhere, and its most immediate source lay in the study of "oriental"

esoteric religions. "The Oriental colors," Hugo would note, "have come as by themselves to impregnate all his [the poet's] *rêveries* and his thoughts have found themselves [to be] . . . Jewish, Turkish, Greek, Persian, Arabic, Spanish too, because Spain is still Orient."[6] Auguste's ancestors had been early enthusiasts of orientalist literature in pre-Revolutionary Alsace, and were among the few there to possess a copy of Barthélemy d'Herbelot's 1697 *Bibliothèque orientale*, which Edward Said once defined "the standard reference work" on orientalism until the early nineteenth century.[7] Even if Auguste had not read the book in his youth, he could not have ignored the signs of oriental influences on the art that had welcomed him to Paris. Some signs, of course, were easier to recognize than others, like the obelisk standing in the middle of place de la Concorde. Other monuments, however, revealed their oriental influences only to discerning and inquisitive eyes.

It has been argued that the most evident aspect of European orientalism was its "excessiveness," a characteristic deriving from the "Western" belief that everything in the East was somehow beyond measure: sentiments, libido, colors, and so forth. A typical example of oriental excess was to be found in ancient dramas and their terrible stories, such as that of Pentheus, king of Thebes, being killed by his mother Agave and her bacchant friends. Other stories of cruel deaths and sacrifice were promulgated through the so-called oriental "mysteries," secret cults and religions of which very little was known except that they seemed to require rituals and sacrifices to attain specific privileges from the divinities, perhaps even immortality.[8] Take, for example, the story of the phoenix, the mythical bird with wings of gold and scarlet that comes from the East and is consumed by an internal fire only to be reborn from its own ashes; or the history of Demeter (the Greek goddess of harvest and fertility), who is deprived of her daughter Persephone by the god of the underworld. Distraught, Demeter speeds off "like a bird over land and water" holding "burning torches" until the sight of the withered and barren earth moves Zeus to intervene, forcing the god of the underworld to return Persephone to her mother and to keep her

only one third of each year, thus giving rise to the seasons.[9] Even gloomier is the story of Dionysus (or Bacchus), the god of wine; born from fire, and for this reason called "flamboyant," Dionysius was sometimes said to be the son of Jupiter and the virgin Semele, who perished in the union with her fiery mate. Dionysus too would disappear mysteriously during a celebration in his honor, the Agrionia, probably killed by his devotees (the maenads) in a rapture of mystic possession and destined to survive in the underworld as a "nocturnal god" or a "nocturnal sun."[10]

Glimpses of oriental excess could be seen in some of the most eccentric monuments on display in Paris at the time of Auguste's arrival: for instance, the menace and rage so powerfully expressed on the faces of the figures sculpted on the Arc de Triomphe, or the suffering of the victims of the French revolutions to which the gloomy Hermes on the July Column alludes. Auguste may well have noticed these signs of excess, although it remains debatable whether by then he was able to recognize their "orientalism" or understand the deeper reasons for their success among French sculptors and intellectuals. Soon enough, however, he too would succumb, like so many of his contemporaries, to the pull of orientalism.

Oriental culture was attractive because it was believed to be predictable. The eighteenth-century philosopher Constantin François de Volney had once claimed that oriental myths were allegories of nature, because they followed a pattern of death and rebirth that was based on the cycles of the sun and the earth.[11] Mere decades later, in a famous work of 1809, the German philologist Georg Friedrich Creuzer argued that oriental mythologies drew on the cycles of the seasons to help people understand God's liberating presence in the world, or the immortality of the soul: Demeter is the earth liberated by the sun, which gives fruits in spring and summer; Dionysus, the god of heat and humidity, is born under the sign of Taurus, when the rain fecundates the earth, but lives in the night of the underworld, or winter. The previously mentioned phoenix, finally, is an allegory of renewal

and the cyclical nature of time, but also of the sun itself and its liberating power.[12]

The second factor that contributed to the spread of orientalism was its symbolism. As early as ancient times, people associated the mysteries of death and resurrection with certain political parables of captivity and emancipation. Creuzer tells us, for example, that statues of Dionysus were all red and often named *Liber* ("free" in Latin), another name for the divinity.[13] Interestingly, for our perspective, the Statue of Liberty, too, would be red (the red of unoxidized copper) when first conceptualized and constructed. And at night, she too would be a "nocturnal goddess" raising her torch like those used in the rites of Dionysus. Creuzer further cites the example of the Italic cult of the children of Demeter, Koros and Kore, who were known by the names Libero and Libera, and relates how, during the festivities in honor of Saturn (the god of production and agriculture often confused with Cronos) between December 17 and 23, Romans observed the custom of freeing their slaves, a practice that Creuzer also found in the cult of "Hercules the liberator" worshipped at Thasos.[14]

By the time Auguste arrived in Paris, Laboulaye had already shown a weak spot for such mystic readings of political history. This, indeed, was the reason of his appreciation for Ballanche and Krause, both of whom had used ancient, mystical tales to interpret the course of history. In due time, Bartholdi too would become familiar with these mysteries, to which so many Parisian monuments already alluded. Indeed, the Arc de Triomphe and the July Column both exposed in public the mystical theories of sacrifice, purification, and resurrection about which Laboulaye lectured to his students. The story of the French people portrayed on the walls of the Arc de Triomphe, from their death in the European wars of 1789 to their resurrection in a post-Napoleonic world, was indeed an allegory of the larger story of humanity, from its early sins through sacrifice to its future resurrection. In his own way, Ballanche, who was one of Laboulaye's main sources, had attempted a similar

experiment in his book on Orpheus, where he had portrayed the French people as a sort of nation-Messiah, carrying the burden of human sin on their shoulders and paving the way for universal renewal through their sacrifices in wars and revolutions. As for the July Column, though no stories of death and resurrections were engraved on its surface, the whole monument alluded to the military sacrifices that the French had made during the Revolution of 1789 and later, in 1830. But the monument also reflected some of Krause's prophecies regarding the future disclosure of Masonic secrets to the masses. Indeed, the naked Hermes was portrayed as the "torch bearer" for at least two reasons: one is that Hermes was also the god of borders and his torch embodied the ultimate boundary, that between life and death, light and obscurity. Second, the "torch bearer" was a canonical figure in Masonic rituals, one impersonating the sun of revelation during initiations.[15]

Missing from the Arc de Triomphe or the July Column was an apocalyptic glorification of America as the site of humanity's renewal. But other artists, in other parts of the world, had already portrayed American exceptionalism with the same mystical language traditionally used by European authors to represent their own country's deaths and rebirths. One of the most successful attempts at this was realized by the Irish painter and decorator James Barry two decades earlier, after the Americans had signed their Declaration of Independence: in the foreground, the body of a dead woman (an allegory of British liberty) lies wrapped in a classical tunic on top of a sarcophagus (Figure 6.2). Around her are ruins and a gathering of famous men (including John Locke, Oliver Cromwell, and John Milton), some crying, others pointing into the distance where, beyond a river, in a landscape reminiscent of the painter Poussin's fantastic backgrounds, but lacking their depth, stands a circular temple, on whose dome a phoenix sits perched.[16] Rising up from the burning bird is a personification of Liberty, her right arm stretched up, holding a bell aloft; this was European Liberty which, having died amid the flames of the American Revolution,

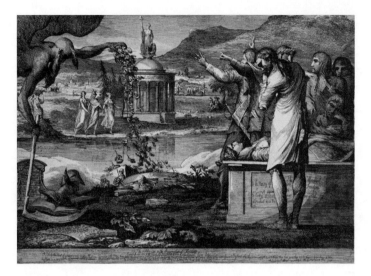

FIGURE 6.2. James Barry (1741–1806), *The Phoenix or the Resurrection of Freedom,* 1776–1808, etching, line engraving and aquatint on paper, 43.3 × 61.3 cm, from *A Series of Etchings by James Barry, Esq. from his Original and Justly Celebrated Paintings, in the Great Room of the Society of Arts,* T06572, purchased 1992, Tate, London.

was now rising on the other side of the Atlantic to set an example for the whole world, as shown by the bell, a symbol for universal fame at the time, just like the light of the biblical "city on a hill" in Jesus's sermon.

Armed with a torch instead of a bell, the Statue of Liberty would be far more aggressive than Barry's feminine figure, yet, as soon will be clear, she too announces a resurrection. Like the phoenix of the oriental myths, she would bring to the West the colors of the "divine star" of the oriental sun. Like Dionysus, she would celebrate sacrifice as the path to salvation; like Saturn and Chronos, she would symbolize the Golden Age and freedom for all, including slaves. And finally, like Hermes, she would symbolize transition. Appropriately guarding a threshold, she signaled to newcomers that there would be an initiation. But what kind of initiation did she have in store?

CHAPTER 7

THE ATELIER OF
THE EXILES

O<small>N AN UNKNOWN DAY</small> between 1843 and 1845, Charlotte and her sons ventured into the Nouvelle Athènes, a leafy green suburb on the outskirts of the city especially popular with intellectuals and artists. Their destination was a rural-looking mansion standing in the shade of a large cedar at 7 rue Chaptal. They walked through a short and narrow lane, between ivy-laden walls, and suddenly found themselves in a beautiful sunlit courtyard adorned with red and pink roses. Lower buildings could be seen on the left and right, but an imposing white mansion, with tall green shutters, dominated the courtyard.

It was the house of the Dutch-born painter Ary Scheffer and his only daughter, Cornélie, a slender girl of aristocratic demeanor, with short, off-blond hair and dark, inquisitive eyes. It may have been Cornélie herself who opened the door for Charlotte, because she lived in the house until her marriage in 1845 and, even then, would frequently return to copy her father's works and pose for his paintings. Or perhaps the Bartholdis were welcomed by one of Scheffer's many valets. For, as contemporaries noted, "socially, Scheffer had a very important position"; his paintings sold everywhere in the world.[1] What matters here is that entering rue Chaptal was for Auguste a transformative experience. As soon will be clear, Scheffer's atelier was a time machine of sorts, filled with painted or sculpted memories of past crusades for liberty in America, Greece,

and Italy—a place where portraits of Lafayette and other resistance heroes hung from the walls and the air was filled with stories of Garibaldi, Mazzini, and Daniele Manin. Under rue Chaptal's spell, Bartholdi would be introduced to the worlds of Garibaldi's Redshirts, Lord Byron's poems of liberty, and the abolitionist crusade, worlds that he had not experienced personally but which would come to influence his life and art.

Indeed, if one wishes to appreciate what made the Statue of Liberty so appealing to resistance fighters from José Marti and Emma Goldman to those of our own time, it is worth exploring the nooks and corners of 7 rue Chaptal and considering carefully the life and works of its owner, Ary Scheffer, a man who would shape Auguste's artistic imagination until the construction of his colossus and beyond. Scheffer was a man of many paradoxes. Despite his sophistication and the luxury of his house, he was born poor. His father had been a portrait painter and his mother a miniaturist from Dordrecht; both artists and devout Protestants, they taught their children that art and religion were one and the same thing, if a painter could take his or her subjects from the Bible. Scheffer would live up to his parents' expectations, and part of this religious inspiration would touch the young Bartholdi. But even before Bartholdi started painting under Scheffer's supervision, an instinctive bond of mutual understanding had developed between them, for they had much in common.

Like the young Auguste, Ary had lost his father at an early age and been raised by a loving mother, Cornélie, who, not unlike Charlotte, was prepared to sacrifice all she could to ensure her son's education. But Cornélie was even more destitute than Charlotte and, had it not been for the king of the Netherlands, who admired her husband's art and assisted her financially, she could have done but little for her children. The king's help changed everything: with his generous funding, Cornélie packed what little she had and moved to Paris, where Ary studied painting under the guidance of Pierre-Narcisse Guérin, one of David's most promising followers,

while enjoying free meals in the Saint-Simonian soup kitchens and sharpening his "business sense" to sell his pictures.[2]

The turning point in Scheffer's career came when his work attracted the attention of the great Parisian art patron Baron Gérard, who arranged rich commissions for him and, more importantly, introduced him to the noble and liberal spirited Duke Louis Philippe of Orléans, the future king of France. Seduced by Scheffer's elegant ways and knowledge of English, the duke hired him as an art tutor for his stubborn daughter, Princess Marie, who was shocking the world of high society by "donning man's attire and riding horseback astride."[3] At the time, Scheffer was a young and charming man, "tall, slender, with a thoughtful, handsome face" made even more so by his oval-shaped golden spectacles and unruly black hair.[4] Scheffer's firm but gentle manners worked their magic, and Marie began enjoying her lessons with him; resisting painting, however, she convinced him to let her try her hand at sculpture. Soon enough, it was clear that Marie had a talent that nobody had ever suspected, but also that her affection for Scheffer went beyond a pupil's devotion for a teacher.

The duke did not seem to notice. After all, Scheffer was not only a skilled artist, but also a republican activist, and the duke needed his support to formalize his allegiance with the Left and prepare his ascent to the throne, in 1830, as the people's king. Like other republicans, Scheffer wore the red coat of the Garibaldini (the Italian revolutionary Giuseppe Garibaldi's militia) and conspired against the Bourbons in the name not only of the republic, but also of the "nation." What kind of nation? Scholars have recently emphasized that the early champions of European nationalism were more interested in condemning foreign intrusions than in exalting national superiorities. And, indeed, Scheffer defended the Irish from the British, the Greeks from the Turks, and the Polish from the Russians in the name of cosmopolitanism, or "globalism," as some might say today, rather than chauvinism.[5] He worked with, and tutored, Greek, Italian, Polish, and Irish expatriates, and his

mentor, significantly, was none other than Lafayette, the hero of America's war against the British, the first such campaign of national independence.

Of course, Lafayette was older then, and in many ways different from the man he had been. When Scheffer befriended him as a member of the Haute-Vente (the French branch of the Italian Carboneria), he was no longer a passionate fighter, nor even an idealist, but an aged man, and a mystic of sorts, who discussed "art, literature, politics and religion" with liberal protesters from all over the world in his Château de La Grange. The Lafayette of later years was, in effect, possessed by a sort of "holy madness," a sense of religious obligation to pursue liberty and equality everywhere.[6] Scheffer was well aware of this change, which he immortalized in his 1818 portrait of Lafayette: immersed in the dark, romantic atmosphere of La Grange's forests, the former captain looks more like a philosopher absorbed in thought than a statesman or a freedom fighter.[7]

But Lafayette was ever the political subversive, and his money and protection were crucial for young schemers like Scheffer, who roped him into a number of their conspiracies, not all of which were equally successful. During one attempted military coup in Belfort (not far from Colmar), for example, Lafayette barely managed to escape falling ingloriously into the hands of the police.[8] He did not take it personally, however, and when the Bourbons left France in 1830, it was Scheffer who accompanied him to Paris, where he was to become commander of the national guard. At Lafayette's orders, Scheffer crossed the city on horseback, leaping over barricades to the cheering of bystanders, to deliver a message to Louis Philippe of Orléans, offering him the French crown in the name of the newly elected Chamber of Deputies.[9]

By the time Charlotte went to call on Scheffer on the rue Chaptal, however, his revolutionary days were long gone. Now in his fifties, he was still handsome and had elegant, although shy, manners; the beard had given way to a small mustache, and Scheffer's

curly hair, now graying and receding on his forehead, highlighted his thinning features and hinted at hidden sorrows. One source of grief was the loss of his mother, who had lived with him until her death and raised his illegitimate daughter, Cornélie. The other sorrow resulted, surprisingly, from the establishment of the Orléans regime itself. Upon taking the throne of France, Louis-Philippe had cut off all friendly relations with Scheffer. The official reason was that he was afraid of mingling "with the people in a political way"; the unofficial one was that his daughter was growing too fond of the rebellious painter, and her passion seemed to be reciprocated. The king's decision plunged the two lovers into a deep depression; the princess would languish in her "melancholy," "a prisoner in the great palace," until her marriage with the duke of Wurtemberg, in 1837, and her precocious death two years later.[10] As for Scheffer, he locked himself inside his house and spent the rest of his life painting scenes of pain and solitude drawn from Goethe's *Faust* and Dante's *Divine Comedy*. Strikingly, Scheffer's women often had Marie's oval face and long, raven-black hair; others had the cameo-like face of his daughter, Cornélie.

Some of these paintings could still be seen in Scheffer's private study, the *petit atelier* (the low building to the right of the family mansion), when the Bartholdis first went to rue Chaptal. But new students were usually not allowed into those rooms, for the small workshop was Scheffer's temple. The centerpiece and soul of the room was a grand piano, at which Cornélie or Scheffer's exiled friends Frédéric Chopin and Franz Liszt would play, accompanied by the crystalline voice of the opera singer Pauline Viardot, while Scheffer filled his melancholy canvases. "If we have ever heard the mysterious bonds that unite the two arts [painting and music]," the art critic Charles Blanc once noted, "it is in this atelier."[11] Dotting the walls, as if to cover up the scarlet wallpaper, Scheffer's paintings conveyed the emotions of the music with which they were imbued, capturing haunting scenes of suffering and loss. One in particular would impress the Bartholdi brothers when they were finally admitted

into the petit atelier. It was a large and lustful painting showing Paolo and Francesca, the errant lovers whom Dante encountered in the fifth canto of his *Inferno,* tempest-tossed by the winds of the underworld. Alabaster-white and naked, partially covered only by an immaculate sheet and her long raven-black hair, Francesca da Rimini lies in stark contrast to the dark, muscular chest of her distraught lover Paolo Malatesta. Every detail in the painting was meant to direct the viewers' gazes—even those of Dante and his guide Virgil, observing the image from a dark corner of the painting—to the purity of Francesca's shape.

There were personal reasons for Scheffer's maniacal obsession with the story of Paolo and Francesca. Forced by her father to marry Gianciotto Malatesta as a means of sealing a political alliance, Francesca had fallen in love with her husband's brother Paolo instead. Enraged, Gianciotto had killed the star-crossed lovers, whom Dante subsequently condemned to forever be swept by storms in Hell, just as they had been swept by the winds of passion in life. Francesca was thus the ultimate icon of desire and passionate will, and Scheffer's *Francesca* was a sensual portrait of Princess Marie herself, who similarly had sought to defy her father's wishes. Yet Francesca had also long been considered a symbol of national liberty, first by the Piedmontese patriot Silvio Pellico, then by the British poet and politician Lord Byron, an admirer of Pellico.[12] Scheffer ennobled Francesca's rebellion to the point of depicting her not as a damned soul—a sort of Eve, expelled from Eden—but as an angel (albeit a voluptuous one). "How noble and pure those two," Charles Bartholdi would later comment; with their eyes closed, he said, the two lovers "were one soul alone."[13]

By then, Charles Bartholdi would have his own personal, romantic reasons to be charmed by the painting. Earlier, when he and his brother were new students at rue Chaptal, however, all they knew about passion and pain, rebellion and rebirth came from the glimpses of orientalist stories they had encountered in family books or seen embodied in Parisian monuments. Scheffer's *Francesca,*

a bold and sensual introduction to the world of symbolism, must have come as a shock to them when they first saw it. For Scheffer (like Ballanche, Laboulaye, and Lafayette) believed that the same truths could be accessed from symbols drawn from the most hetero-geneous contexts, narratives, or even mediums: musical, pictorial, monumental; Western and Eastern; feminine or masculine. There was only one story of eternal sacrifice and spiritual resurrection for them, a story endlessly refracted and retold through Christ's pas-sion, Orpheus's death, and France's history of political oppression alike. Scheffer's *Francesca* represented one of the many reverbera-tions of this cosmic rule; a small and private one, perhaps, but a truthful one all the same.

Scheffer had painted other "reverberations" in earlier years, some of which certainly were accessible to the Bartholdis. In the *Burghers of Calais* (1819), for example, he had portrayed the "six burghers" condemned to death for resisting the invaders during the English occupation of Calais in 1346–1347. Dressed in white, with nooses around their necks, they were being led to the gal-lows in a way reminiscent of Rembrandt's *Christ Presented to the People*.[14] The Bartholdi brothers may have seen similar scenes at the Musée du Luxembourg, where Delacroix's famous *Mas-sacre at Chios* exalted the Greek rebellion by portraying women, children, and the elderly abandoned on a beach among the bod-ies of the dead, barely distinguishable from them. It was under the effects of such a forlorn scene that Scheffer had painted his own 1828 tribute to the Greek War of Independence depicting the heroic suicide of *The Suliote Women*: amassed on the precipice from which they have witnessed the massacre of their husbands at the hands of the Turks, they gather to hurl themselves into the sea, their children still clinging to their breasts.[15]

When the time came, Auguste too would celebrate national inde-pendence through episodes of cruel sacrifice. The Statue of Liberty would become a colossal example of this practice, although, by the time it was made, Bartholdi's nationalism would have come to

betray more chauvinistic elements. The Statue of Liberty would also keep traces of her ancestor *Francesca*, even though it may be difficult now to imagine how Francesca da Rimini's lustful beauty might have found expression in stern Miss Liberty.

IF THE PETIT ATELIER was the temple of Scheffer's love for Marie, memorialized by the painting of Francesca and the melancholic notes of Chopin's melodies, the *grand atelier* was Scheffer's inner sanctum. It stood on the right side of the lane leading to the painter's mansion. This studio was not open to all of Scheffer's students, most of whom were sent instead to the minor workshop "on the opposite side of the street."[16] Yet a select few, like Auguste, would eventually be invited in to discover "a real studio, or workshop," where Scheffer's most talented pupils completed their master's paintings by copying "his manner."[17]

The grand atelier had dark red walls, all decorated with strangely shaped bottles, deer heads, and miniatures, warmed by a great black stove that hissed and crackled in the middle of the room as Scheffer's privileged students ate fresh pastries, chatted, and painted in an environment of familiarity and camaraderie, waiting for their master to check on their work.[18] Most of them were exiles, daughters and sons of political expatriates whom Scheffer was trying to protect. Because they were often left alone—men and women, French and foreign, without awkwardness or embarrassment—they sometimes talked about politics. But most of the time they focused on their work, because, unlike other art studios, where social rules were often transgressed, Scheffer's was a "sanctuary," as Charlotte Bartholdi put it, full of admiration: "no one smoked, there was no trouble; people spoke briskly, but without unseemly laughter, like in a salon."[19] Only when Scheffer and his brother entered the atelier, which happened just once or twice a day, did the students rise and await the master's comments with apprehension.

Scheffer initiated his students to the art of copying early enough. At first, he only asked them to reproduce "little portraits" he painted, before moving on to his more complicated works. Copying was at the core of Scheffer's way of teaching.[20] This was, in part, a legacy from the neoclassical tradition, which depended on the basic ability to copy plasters and live models.[21] Yet, as some of Auguste's fellow students noted, Scheffer took some liberties in teaching neoclassical drawing. First of all, his pupils were allowed to use "the whole range of colors given them, blue, red, yellow, etc. and [they] had to combine them, so as to imbue the color of the cast with reflections from the surrounding objects."[22] It might be said that the long-term consequences of this early training are still reflected today in New York Harbor by the beautiful green pallor of Bartholdi's Statue of Liberty, by "the ageless patina of the copper . . . shaded to a green-black, parts . . . dark blue, parts olive."[23] Of course, many other factors—some technical, some aesthetic, some commercial—would come to shape the creation of the statue. But it is beyond doubt that Bartholdi's eye as a painter could explain what the writer Ian Frazier still considers the true magic of the Statue of Liberty, that is, its capacity to seamlessly blend with "the bruise-blue of the clouds, the faded green of the leaves of the island's London plane trees, the crayon green of the lawn, the forest-green seaweed on the rocks, the jade green of the waves."[24]

Bartholdi learned his sense of color in Scheffer's studio. But he also learned something else, which would eventually result in another of the statue's most unique characteristics: its "clonability," the simplicity with which it can be, and has been, reproduced in different formats, colors, and contexts. For, despite the romanticism inspiring his paintings, Scheffer was a skilled businessman; as a former Saint-Simonian and someone who had made a luxurious living by selling his art, Scheffer had transformed his grand atelier into an artistic factory of sorts, where his works were made in multiple copies for the market, at first by his students and, later, as of the early 1840s, also by printers and professional photographers.

It is somewhat ironic that such an experiment in reproduction was conducted in the middle of the Romantic era, which has been famously described as obsessed with "authenticity" and uniqueness.[25] But Scheffer never thought that his works were less authentic or unique because they were produced in multiples. If anything, reproduction was for him a way to address the global community of liberals whom he had befriended through Lafayette, from the United States to Latin America, from Britain to Greece, Poland, and Italy.

Auguste was introduced to the possibilities implied in reproduction and printing from the moment he first put foot in rue Chaptal. Indeed, by that time the typographic studio of Luigi Calamatta, between the rue d'Amsterdam and the rue de Londres, had already become an extension of Scheffer's atelier. While working on a reproduction of Leonardo da Vinci's *Mona Lisa*—the first proper reproduction of an artwork destined to become at least as famous as the Statue of Liberty—Calamatta also reproduced Scheffer's *The Shadows of Francesca da Rimini and Paolo Malatesta Appearing to Dante and Virgil*.[26] A second engraver, Louis Henriquel-Dupont, was working on another of Scheffer's masterpieces, *Christ the Consoler* of 1837, while Bartholdi was attending the atelier. It was the first time that Bartholdi observed how a piece of art truly could be made an international icon.

With his long brown hair, parted in the middle, and an oval face shaded only by a light beard and a thin mustache, the Christ in Scheffer's *Christ the Consoler* has a very special role to play in our story. First of all, as soon will be clear, it was a direct ancestor of the Statue of Liberty, a symbol of religious liberty that was reproduced and cloned across the world through the systematic use of prints and other media. It was reproduced everywhere from Latin America to the United States, in England, Italy, Germany, and Poland.[27] "Scheffer alone," Theophile Thoré wrote in 1846, "has the privilege of universal admiration."[28] Second, Scheffer's *Christ the Consoler* brought together for the first time, ideologically if not physically, the main characters of our stories: Laboulaye and

Bartholdi. We don't know if Laboulaye ever visited rue Chaptal or, if he did, under what circumstances his meeting with Scheffer took place. But we do know that he admired Scheffer's art and was particularly fond of his *Christ the Consoler,* where Jesus was portrayed as "a personal God, a consoling God" who liberated man by making him in his own image.[29] Laboulaye was right on this point. Scheffer's Christ looks truly human: immersed in an aura of glowing light, he shows the stigmata on his right hand to a "suffering humanity," giving them comfort for their troubles, while in his left hand he holds a long chain, taken off the wrists of a member of the Polish resistance, who is wounded, close to death, and lying on his country's flag.[30] "Complainants" are arranged to the right, to the left, and at Christ's feet. In the foreground of the group on the left, a mother bends over her dead son; behind her stand three figures, identified as a suicide, a castaway, and an exile.[31] In the center of the composition, crowned with laurels, the sixteenth-century Italian poet Torquato Tasso—author of *Gerusalemme liberata*—sits facing Mary Magdalene, the biblical sinner, shown here with the features of Marie of Orléans and of Francesca. On the right stand the oppressed; a Polish rebel and a black slave, in turn flanked by a Greek, a serf, and an ancient Roman slave wearing the Phrygian cap of emancipation.

It is easy to see how Scheffer's *Christ the Consoler* would resonate in a cosmopolitan society of activists, and not only because it was crowded with revolutionaries, nationalists, exiles, and slaves. Scheffer also judiciously drew parallels between their suffering and that of Christ. Jesus Christ was the "patriot" par excellence for Scheffer's nationalist friends, especially members of the Charbonnerie, for whom dark woods, secret rooms, and private homes had provided the setting for successive rites of passage and initiation, ceremonies that would play out the life of Christ, from his trial to his Passion on the cross.[32] As for the abolitionists, they rejoiced to see Christ represented in the act of freeing a slave from his chains, because the scene clearly referred to their leading argument, that of

the equality of men in the face of God. Christ, they often repeated, had died "to pay the price of [men's] ransom for the eternity," not only for educated men, but also for men who did not have "either traditions or souvenirs of glory."[33]

Laboulaye had a deep admiration for Scheffer, whom he suggested understood that "form and color are but a shell, and that it is necessary to look higher for eternal beauty."[34] He praised Scheffer's compassion and piety, of course, as well as his style, which was becoming every day more essentialist and severe under the attentive eye of his friends and disciples. True enough, Scheffer had always tried to avoid the chromatic effects of his predecessors, such as Antoine-Jean Gros or Théodore Gericault, but, as Bartholdi himself would witness, his distance from them had increased even further over the years. Indeed, Scheffer's *Christ the Consoler* is compositionally bare compared to *Francesca* or his earlier paintings. To paint *Christ*, Scheffer adopted a drier brush stroke, reduced the amount of shading, and eliminated backgrounds. His works acquired an almost sculptural appearance, which, in turn, simplified their technical reproduction even further.

During the late 1840s and early 1850s, Bartholdi witnessed his master change style yet again, embracing a harder and less colorful scheme, and abandoning the voluptuous figures of the past to approach the style and religious inspiration of the Gothics. The most striking example of this evolution is Scheffer's 1847 *Christ the Remunerator*, probably one of the least known antecedents of the Statue of Liberty. Dressed in a pink cassock beneath a white toga, this Christ looks like a statue crowned in light, towering at the center of the scene with arms outstretched, the right hand pointing to the place of the elect and the left separating the penitent from the damned. On the right side of the canvas, almost colorless, stand "the elect," whom Scheffer described in a letter to his cousin as follows: "first of all [you see] the work (*travail*), charity giving bread and clothes to suffering humanity . . . Then the good Samaritan." "At the back, . . . the patriot who, full of gratitude, raises his broken

chains and sword to heaven; at the front, the doctor who teaches Christ's law, religious exaltation, prayer, then the pure of heart and of spirit." To the left, "in the shadow," we find "the tyrant with a voluntary slave at his feet, who picks up gold in the mud"; behind the tyrant, "rebellion with a torch and dagger, then hypocrisy, blasphemy, pride, and lust." In the forefront, Scheffer painted the penitents (Paul of Tarsus, the prodigal son, and Mary Magdalene), who were to be separated from the obstinate sinners and saved.[35]

Nothing in the scene was particularly reminiscent of the frightful atmosphere of Michelangelo's *Last Judgment*, from which it descended. The need to simplify and sharpen the outlines had, in fact, led Scheffer to return to pre-Renaissance painting or sculpture, emulating its angular style and lack of perspective. Only the draping effects on Christ's tunic, which Auguste would imitate in the Statue of Liberty's cloak, brought to mind Raphael's religious and secular figures, in particular *Christ's Charge to Peter*. But Scheffer further simplified Raphael's garments, taking inspiration perhaps from the famous Gothic figures that the sculptor Peter Vischer the Elder had placed over the tomb of Saint Sebald in the Nuremberg cathedral, statuettes that retained all the severity of Gothic art (in the folds of their garments, for example), yet anticipated the Renaissance taste for form.[36]

Praised by Van Gogh and eventually transformed into Rio de Janeiro's colossal signature statue *Christ the Redeemer*—a sort of tropical sibling of the Statue of Liberty, equally imposing and sublime—Scheffer's *Christ the Remunerator* would tour the world in the form of etchings by Dupont's student, Auguste Blanchard.[37] From the England of Carlyle and Mazzini to the America of Emerson and Thoreau, images of *Christ the Remunerator* helped spread the idea that man was the maker of his own destiny, not because of his virtue, as Rousseau had argued, but because he was made in God's image and therefore capable of love, charity, and freedom. Scheffer's remunerating Christ had nothing of the "biting reality of the *Dies irae*," as the Catholic scholar Charles Lenormant would

recognize. Like *Christ the Consoler*, he was a pure "symbol" more than "a reality," a representation of the "earthly plant elevating itself to the unknown God."[38]

When Charlotte Bartholdi saw *Christ the Remunerator*, she was awestruck: "How admirable is his Christ!" she gushed in her diary, "What a genius that man is, I cannot even reveal the admiration that strikes me when I enter into that sanctuary called his atelier!"[39] She soon became an assiduous visitor to Scheffer's atelier and house. There, she befriended the cellist Auguste Franchomme and the Alsatian painter Eugène Gluck, whom she often invited to her house along with Scheffer; other times, they would go to concerts and horse races. Charlotte was ecstatic over the dinners that Scheffer organized, which she praised as "magnificent"; the "conversation [was] very interesting . . . music, painting . . . literature, *voilà* a world I like!"[40]

It seemed that Scheffer in turn had a certain soft spot for the Bartholdis. Was it Charlotte's charm? She was still an attractive woman, whose independence must have reminded him of his own mother's strength of character. The portrait Scheffer would paint of Charlotte in 1855 instinctively reminds us of Leonardo's *Mona Lisa* (then in the process of being printed in thousands of copies by Scheffer's friend Calamatta) or of Scheffer's own earlier portrait of Chopin's lover, the writer George Sand. Like Leonardo, Scheffer spent hours working on his subjects' hands, and those of Charlotte—the right leaning on an armrest, the left resting on her lap—were so lifelike as to reveal their most minute movements and even the fine texture of her skin.[41] Sitting in front of a curtain, left slightly open on the right to show a castle perched on a mountain (perhaps Saint-Ulrich Castle at Ribeauvillé), Charlotte dominates the painting as a beautiful and sturdy matron, wearing a dark dress with a deep neckline, over which a black veil falling in two bands on her shoulders (not at all unlike those appearing on the Statue of Liberty) elegantly wrapped her complicated coiffure, but not so much as to conceal the copper-hued reflections in her curls (those,

too, are reminiscent of the statue's original hair). It was a concession to a sensuality that her hardened features and stern countenance seemed to accentuate, rather than diminish.[42]

Perhaps convinced by his mother's admiration for Scheffer's *Christ Remunerator,* or attracted by the fact that it was one of his master's most experimental works, one made in bold violation of neoclassical rules, Auguste initially thought of turning *Christ the Remunerator* into a bas-relief.[43] But faced with the difficulty of sculpting all the figures surrounding Christ, he changed his mind and worked on Scheffer's 1835 *Francesca da Rimini* instead. This project would, strikingly, be one of his very few renderings of a female body before he first modeled the Statue of Liberty in clay years later. We do not know when Auguste started working on his *Francesca,* which he finished by 1853. Certainly before then, however, he had embarked on another "translation." Around 1814, under the influence of a growing interest in Orphism, Scheffer had painted Eurydice dying in Orpheus's arms, her sensual head and naked breast resting on his bent leg, while he, bereaved, crouched over her lifeless face. It was, in many ways, an anticipation of Scheffer's *Francesca,* the erotic portrait of two deceased lovers still caught in an act of intimacy. But Auguste, who was reinterpreting and translating the painting in a climate of religious austerity, instead produced a more chaste religious statuette depicting the Good Samaritan bent over the body of the wounded Jew.[44]

Auguste's decision was indicative of how things had changed in Scheffer's life and ateliers. Indeed, he would go on to sculpt a bas-relief, titled *Lord's Day,* that took the form of a revised copy of a drawing the German painter Carl Christian Andreae engraved to accompany a religious canticle entitled *Sonntagslied* (Sunday song or Lord's day song). If Auguste had learned one thing from Scheffer, it was that art could move from one medium to another, and that sculptures and gigantic paintings (like Scheffer's Christs) could be extracted from, and turned into, smaller prints. But he must also have started breathing in the orientalist atmosphere of Paris, for French

poets considered Germany a sort of antechamber of the East, the Rhine one of its European gates, and the "German cathedrals" a sort of European equivalent of the "Pyramids of the Nile."[45] With time, Auguste would himself cross the Nile to contemplate the African orient. But his starting point was Germany, which he represented through two attached plaster plates, the external one portraying a figure in the foreground dressed and combed in the medieval style (with traits not unlike his own), who, seated in the vault of a cloister with his shoulders turned against the observer, looks toward another scene sculpted in the lower plate and representing—as Régis Hueber has brilliantly suggested—Andreae's original illustration, namely a Sunday procession walking toward a cathedral.[46] Quite opportunely, Bartholdi represented himself as a spectator in the foreground, observing the procession from the outside, as if wondering about its nature. And yet Bartholdi might also have had personal reasons to choose his subject. Had it not been Ursula Sonntag ("Sunday," the pagan name still used by the Germans for the "Lord's Day") who brought the pharmacy into the Bartholdi family? A pharmacy that the Bartholdis had associated with a sign depicting the sun? With a sculptural joke, the likes of which there are plenty in his oeuvre, Bartholdi may well have depicted himself in the role of the medieval viewer contemplating the Sunday (or Sonntag) procession.

The *Lord's Day* would not be Bartholdi's last autobiographical "rebus." The Statue of Liberty too contains its share of encrypted references to the history of the Bartholdi family and of Alsace in general. Decoding them will require further engagement not only with Bartholdi's origins but also with his adventurous experiences as an artist beyond the world of Scheffer's eclectic atelier.

CHAPTER 8

MONSTERS OUT

CHARLOTTE, Charles, and Auguste would return to their Colmar home, on the rue des Marchands, every summer. They saw old friends and organized evening dinners in their little house on the Lauch River, where Chinese lanterns painted the water and the boats floating on it with improbable colors. A regular among their guests was a certain Louis Philippe Henri Hugot, the city librarian and scion of a Strasbourg banking family. Hugot had come to Colmar as an archivist in 1837 in possession of a rare diploma from the École des chartes, but almost no one in the province had met him then. He had a brusque manner and a sullen air, accentuated by a beard and a pair of long spectacles embellished with a thin golden frame. Yet by the late 1840s, he had earned the respect of the whole city, the Bartholdis included.

It is impossible to understand Auguste's fascination with Germany and the Orient without taking into account his friendship with Hugot. Indeed, judging from Hugot's letters, German scholars must have encouraged him to promote the city's Gothic heritage upon his arrival, which implied opening the library's attic and bringing out into the open its "boutique de bric à brac," that is, its notable collection of medieval and early modern "horrors" that had been spurned by the neoclassical artistic sensibilities of recent generations.[1] Alongside troves of old volumes, a dusty, stuffed crocodile had passed the years in the company of sundry deer antlers, dried fish, and even a sea urchin, all of which originally would have belonged to some long-neglected curiosity cabinet. There were

also clocks, rusty suits of armor, bundles of medieval manuscripts on hardening parchment, and numerous painted panels of religious subjects, many characterized, as were to be expected, by diaphanous virgins and a morbid fascination with the Passion of the Christ.[2]

It is quite possible that, though the attic was kept locked by Auguste's former art teachers, Charlotte and the boys took advantage of Hugot's generosity to sneak in and peek at its eccentricities. Here, in the prohibited rooms, artistic renditions of human figures featured "bony limbs, often badly attached, and emaciated, ending in long, thick extremities"; a "defect," it was said, "particularly evident in their sharp-fingered and knotty-jointed hands, and they always seem[ed] to have narrow feet, which [were] reminiscent of a monkey's." Not all these works were equally precious, but some, Hugot knew, had to be saved, and quickly. A group of them, in particular, needed attention. They were the engravings of the famous Martin Schongauer, an Alsatian artist who, in the wake of Gutenberg's discovery of moveable type, had replaced the old wooden boards used for printing with copper or steel plates incised with a cutting tool called a graver, or burin.[3]

Schongauer's discovery, which was itself important and would influence the construction of the Statue of Liberty in innumerable ways (beginning with its copper skin), was even more significant if considered from the perspective of the competition that was then dividing Colmar from its neighboring cities. Across the border in Bavaria, the city of Nuremberg could boast of being the birthplace of Albrecht Dürer, and use this fact to inaugurate "a new liturgy in the memory of the artist."[4] Nearby Strasbourg had recently inaugurated David d'Angers's statue of its most glorious citizen, Gutenberg—a bronze monument celebrating not only the discovery of printing but also the power of universal access to knowledge, particularly biblical knowledge. Without these rivalries, Hugot would have never made his mark on Colmar and, therefore, on Bartholdi.

If Strasbourg had chosen Gutenberg as their darling, Colmar would choose Schongauer, the inventor of burin engraving. As early as 1787, on the frontispiece of Michel Huber's *Notices générales des graveurs*, J. W. Mechau had portrayed the apotheosis of the art of copper engraving: an obelisk rising up to the clouds, under the protection of the pope and emperor, while cherubs carried an image of the most famous of engravers, Martin Schongauer, toward heaven.[5] But now, new icons were needed to capture the public's imagination. In 1846, Hugot therefore sent the young Austrian painter Joseph Mösl to Munich on a mission to reproduce Hans Burgkmair's Renaissance portrait of Schongauer, something that would attract tourists to Colmar much like the already famous self-portrait of Albrecht Dürer posing as Christ was attracting visitors to Munich.[6]

At the same time, Hugot set out a new collection of reproductions for the perusal of art students. Interestingly, they were copies of the most representative works of the Italian Renaissance, most notably Nicolas Chaperon's fifty-four tables of Raphael's images from the Vatican *loggia* (also known as the "Bible of Raphael"), the *Five Sybils* of Michelangelo, and his *Last Judgment*, to which the "horrible" Gothic works from the library attics would soon be added.[7] To expedite the addition, Hugot invited the city's intellectuals, lawyers, and other notables to form a trust, the Schongauer Society, to care for and enrich the collection. Its logo showed a woman from Schongauer's engraving *Shield with a unicorn, held by a woman*: seated in medieval garb, with rich vestments and a turban, she rests on her legs a large shield on which Hugot replaced Schongauer's original unicorn with a *Morgenstern*, or "morning star," the spiked medieval weapon seen in one of the seals and the coat of arms of Colmar (Figures 8.1, 8.2).[8] It was a symbol of strength, one that the humanist Jacques Spiegel de Sélestadt traced back to the legend that the ancient Greek hero Hercules supposedly had stopped in Colmar, drunk too much of the local wine, and forgotten his weapon there the next morning.[9] The reference to the wine was appropriate, because Colmar's white wines were famous in Alsace, France, Germany, and Switzerland. But, as

already mentioned, wine was also an ancient symbol of freedom, and
so was Hercules. As Creuzer once noted, Hercules was venerated
by the Romans as *libero* and as an alter-ego of Saturn set free from
the Tartarian abysses.

Future chapters will elucidate how the Statue of Liberty is
intimately connected to Colmar's Morgenstern and the myth of
Hercules. But for now it need only be clear that Bartholdi's early
career in many ways started the moment that Hugot founded the
Schongauer Society and gave it a logo with Herculean implications.
Charlotte was one of the first members of the Schongauer Society
when it was founded on June 10, 1847, and she joined partly because
it was a sign of her prestigious position in Colmar society, and partly
because, despite Auguste's young age (he was only thirteen at the
time), she probably expected Hugot to recruit him as one of the
town's artists, in case Auguste decided to become a painter or a
sculptor. Hugot's plan to rediscover the Gothic face of Colmar was,

FIGURE 8.1. Martin Schongauer, *Seal of the Schongauer
Society*, engraving, Cabinet des Estampes, Inv. No. 296860,
Bibliothèque Municipale Colmar.

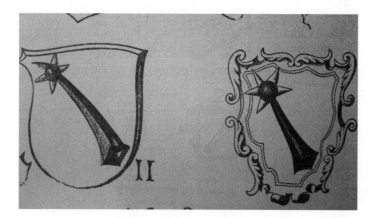

FIGURE 8.2. *Seal of Colmar* (page detail), in André Waltz, "Les Sceaux et Les Armoiries de la Ville de Colmar," *Annuaire de la Société Historique et Littéraire de Colmar* 11 (1961): 7–24, Inv. No. 266089, Bibliothèque Municipale Colmar.

indeed, a wonderful opportunity for young artists like Bartholdi to prove their talent. There were statues to be built, and new rooms to be opened. Perhaps, too, it was rumored, the old Dominican Abbey of Unterlinden, which had been deconsecrated at the time of the French Revolution—but was, as Charles Bartholdi would put it, still a place of "invisible spirits, full of murmurs, rays, smells, lovely visions, fascinating images, strange sounds, supernatural glows, [and] wonderful songs"—could be turned into the home not only of the Schongauer Society, but of the city museum as well, which would finally leave the old galleries of the municipal library.[10]

Charlotte certainly knew that Hugot's influence extended well beyond the library's walls, to the mayor's committees and the municipalities' decision rooms. Indeed, he was involved in some of the monumental projects most recently approved by the municipality of Colmar, including the statue of the local eighteenth-century *philosophe* Pfeffer and the monument to Napoléon's aide de camp, Jean Rapp, whom Auguste's grandfather Charles Bartholdi had cared for after he had been wounded at Leizkam. It could very well be

that Charlotte had been ready to draw on her family's historical friendship with the Rapp family to appropriate the commission for her son when the project was still in the hands of a sculptor of Alsatian origin named Guillaume Lavallette.[11] We will never know when precisely Charlotte embarked on her project to build Auguste's career in Colmar, or for that matter how dismayed she must have been when her first attempts failed. It was soon clear, however, that she would stop at nothing short of a revolution to achieve her goals.

SOON ENOUGH, revolution occurred. On February 23, 1848, while the Bartholdis were in Paris, the people of the French capital rose up by torchlight. At dusk, while hunched over their tables working, students of the Louis-le-Grand (the Bartholdis' high school) were distracted by shouts coming from the street: "Des lampions! Des lampions!"[12] They ran to the windows to behold a sight worthy of those turbulent times in European history; all of rue Saint-Jacques was lit by undulating waves of torches and lanterns, rising and falling on the street as a raging river of protesters flowed by.

Barricades had earlier been set up in place de la Bastille, and others in the place de la Madeleine the day before. Laboulaye reacted during those fateful days by locking himself in at home to angrily denounce communist agitators, looking for alternatives in esoteric doctrines and the American Constitution. Charlotte probably kept her two boys home too, but it is hard to imagine them not slipping away (as they regularly did even in normal times) to witness the first signs of the revolutionary uprising. To see a city completely illuminated at night—"multiple, infinite lights, as many as the stars"—was rare in the age before gaslight, and, as one contemporary observer put it, "the day, by then vanished, reappeared like an immense festival."[13]

But if it was a festival, it was a rather macabre one. Marie d'Agoult (otherwise known as Daniel Stern) felt as if she were

wandering through Dante's *Inferno*. In front of her, amid a barren wasteland of corpses, she saw a cart carrying the dead as it made its way through the crowd. Drawn by a white horse, it carried five corpses arranged in "horrible symmetry." On the shaft stood an "enfant du peuple," pale and with eyes "blazing and fixed," who, with his "arm outstretched, almost motionless, just like one would represent the spirit of vengeance," was holding a torch and projecting its "reddish glare" on the supine body of a young woman "whose neck and bosom, both livid, [were] spotted with a long trail of blood." From time to time, another worker, placed behind the cart, embraced this lifeless body with his muscular arms and, while "shaking his torch amidst small flames and sparks" and turning "a ferocious look on the crowd," shouted: "Revenge! Revenge! The people are being killed!" To which the crowd, in unison, responded: "To arms!"[14]

A similar spectacle was repeated the next night, after a day even more frenzied than the one before it. In the morning, throngs of people stormed the Tuileries; men and women desecrated the throne and the royal bedrooms, rummaging through drawers and applying the queen's cosmetics to their own faces. Bartholdi's mentor, Scheffer, had never loved the king, but he still felt bound to the Orléans family. Donning the uniform of a commander of the national guard, he joined Lafayette's grandson, Oscar, to defend the monarchy and escort the royal family out of the Tuileries. In the place de la Concorde, he stopped to throw his *shako*, or plumed military hat, into the air, shouting, "The king is leaving, long live the king!"[15] But the crowd paid no heed. People surged on to the place de la Bastille, where they had brought the dead bodies from the day before, and burned the throne at the foot of the column topped by the *Génie de la Liberté*, the statue-sepulcher of Orpheus-Hermes with the torch in his hand.[16] It was, in its own way, a ceremony celebrating liberty through the memory of the death and sacrifice of those who had fallen in previous revolutions. Having paid their tribute to death, the revolutionaries roamed the city into

the deep hours of the night, ready, depending on one's perspective, to sow freedom or terror by the light of torches and lanterns.

The revolutionary days of 1848 came and went too quickly to occasion artistic festivals like those that flourished in the early 1790s. The only statues of liberty to make their appearance, besides the mortuary statue of Hermes-Orpheus, were some flesh-and-blood theatrical versions of "Liberty" and the "Republic." Moving around the Tuileries during the looting on February 24, for example, d'Agoult ran across a prostitute with "a pike in her hand and the red cap [of liberty] on her head," posing motionlessly in the vestibule, "with her lips closed, eyes fixed, like a statue of liberty." She saw another of these "déesses de la liberté" (goddesses of liberty) riding along the quai d'Orsay, a red flag raised high: she "harangued the dragoons who still occupied the Pont de la Concorde" as though wishing to imitate the Marseillaise Liberty of the Arc de Triomphe, a female warrior leading the volunteers to the front with a cry of battle.[17]

Bartholdi may not have seen any of these living Liberties personally, but they were undeniably a part of the cultural moment. Soon after the end of the Revolution, too, he would become familiar with a huge canvas depicting one of them: in Delacroix's *Liberty Leading the People*, a woman steps on a barricade, a French flag raised in her right hand and a rifle in her left. Colossal and statuesque, Delacroix's goddess, often said to be the blueprint of the Statue of Liberty, wears the red, Phrygian cap just like the revolutionary Liberties of old. She is also armed like some of the most aggressive Liberties of those times, including Colmar's own Minerva. But the analogies end there. First, Delacroix's Liberty does not have a neoclassical body, but instead displays generously wide hips and an ample bosom. She looks like a strong-willed prostitute, a rebel and martyr falling for the nation, rather than a slave displaying the signs of her emancipation. Armed citizens and children run alongside her, trampling the bodies of the Revolution's martyrs at the foot of a barricade. Positioned higher than the figures around her, the

corpses lie at her feet forming a sort of pedestal for Liberty, alluding to the resurrection of the dead and national rebirth following its sacrifice on the altar of war.

So well did Delacroix's old *Liberty* capture the spirit of future revolutions that Victor Hugo still had her in mind while observing this scene from the uprising of 1848: a "young, beautiful, terrible, dishevelled" prostitute hitching up her dress and climbing the barricades faced the national guard head-on: "Fire, you cowards, if you dare, on the belly of a woman!" A great number of bullets then struck her, and she fell, Hugo reminisced, "letting forth a great cry."[18] By then, however, Delacroix's *Liberty* was no longer on display. Its radicalism was too much to bear for King Louis-Philippe, who had bought it so he could hide it in his attic and then return it to Delacroix with the prayer not to expose it again. In a sense, Delacroix's *Liberty* was one of the many casualties of Louis-Philippe's desire to lessen his revolutionary profile and reassure his moderate supporters. Another was Scheffer's relationship with Princess Marie.

Thus the revolutionary prostitute with the big hips and Scheffer's sophisticated if still shapely *Francesca* had surprisingly similar origins, though their fates would diverge as *Francesca* became ever more visible thanks to Calamatta's prints, while Delacroix's *Liberty* soon would be hidden again by the republican government, which turned out to be artistically far more timorous than one might have expected.

If Bartholdi ever saw Delacroix's *Liberty* before 1848, it was only briefly, although it is true that the painting would come to influence the Statue of Liberty. For the moment, however, Bartholdi was exposed to, and fell for, the more moderate art of the republic. But what kind of art was it? In Flaubert's *Sentimental Education*, the artist Pellerin prophesized that "once the workers pool together their spirit," Paris "will be covered with gigantic monuments."[19] Three months would pass before the first fruits of these ambitions were realized. On May 20, the provisional government (a liberal majority with only two socialists) celebrated the Festival of Concord

in the Champ de Mars. A colossal plaster personification of the Republic was erected for the occasion, wearing a draped garment and a Phrygian cap, her left hand resting on the altar of the mother country (like those seen at the time of the French Revolution), and her right hand holding a sword and leaves (or a wreath).[20]

But the public monuments and the festival itself spurred only limited enthusiasm. The excitement of the French Revolution, when people would flock to public squares to see the ruling classes swear loyalty to the nation and carry effigies of Liberty in triumph, was a thing of the past. Now workers celebrated liberty by burning the victims of a new revolution under a golden angel lifting a torch. For Liberty had become a colorful, funerary statue, like the *Génie de la Liberté* of place de la Bastille, an Orpheus ready to sacrifice himself while initiating the masses to the knowledge of liberty. And the Orpheus-Liberties did not carry picks or swords, for the torch— the symbol of sacrifice and initiation—was enough to convey the idea of emancipation. One could push oneself so far as to imagine that, had Scheffer's *Christ the Consoler* or *Christ the Remunerator* been transformed into statues at that time, the revolutionaries might have carried the victims to their feet as well, juxtaposing the suffering of the French martyrs to that of the Christian heroes whom Scheffer had placed around his Christs. As d'Agoult mused, Liberty could even be "the corpse of a woman," because the death of a common woman had "more power . . . than the most valorous army in the world."[21]

BETWEEN 1830 AND 1848, liberty became a mystical affair. Whether its proponents were Catholic, Lutheran, Masonic, or pagan, liberty became tethered to the idea that, as a divine being, man could achieve regeneration on earth through all sorts of allegorical knowledge and, importantly, sacrifices. But could this same concept be used to explain the official meaning of republican liberty to the citizenry? The republicans thought it was possible,

but they also wanted to make sure that mysticism did not produce monumental devils like the Genius of Resistance on the Arc de Triomphe, or the excessive monsters of the place de la Concorde. So they promised a reward for the artist who could paint, sculpt, or engrave a "beautiful, virginal, noble and pure" image of the Republic, even if "many infernal angels would make [her] red."[22]

Auguste was too young to take part in this challenge, but Charles Landelle, another student of Scheffer's, painted the Republic as a farmwoman crowned with laurels, an olive branch in her left hand, the handle of a sword poked in the ground in her right, and chains at her feet. Armand Cambon opted for a halo of rays around Liberty's head, putting a flag and a sword in her left hand, and a model of two hands clasping each other in a sign of fraternity (but also Freemasonry) in her right; he also added a rainbow behind her shoulders.[23]

Designed by the sculptor Jean-François Soitoux (1816–1892), the winning Republic monument wore a tunic draped in the classical style, covered with a Roman garment; it resembled the official toga of a judge. The statue also held a wreath in her left hand and a sword in her right, but the sword was lowered with the point touching a small column, upon which were placed a printing press, a carpenter's level, a beehive, and a copy of the constitution, while a king's crown was thrown to the left, as if she had just kicked it away. Finally, a star placed on top of the statue's head (above another laurel crown), and the priestly bands falling over her shoulders, referred back to a world of mysteries and Masonic initiations (Figure 8.3).[24]

Given his closeness to Scheffer, it is possible that Auguste approached the Revolution from the side of the moderates, like Scheffer's student Landelle or even Soitoux. It has, indeed, been suggested that Auguste had learned to sculpt in Soitoux's studio, even if so far no other documents have been found supporting Bartholdi's claim of being Soitoux's student. The only evidence comes from the fact that Bartholdi himself suddenly, after 1872, began

listing Soitoux and Scheffer as his teachers in the guidebooks of the Salons, the art exhibitions of the Académie de Beaux-Arts of Paris. Perhaps Auguste's letters referring to Soitoux have been lost, or he began to use his name in 1872 out of mere opportunism. After the fall of the empire, after all, when Soitoux's *Republic* came to occupy its current seat on the quai Malaquais, it would have been useful for Bartholdi to associate his name with a republican artist.

Sure enough, the Statue of Liberty exhibits striking similarities to Soitoux's *Republic*, including the priestly bands, her postural steadiness, and even the draping of the lower part of her tunic. But Bartholdi could well have been inspired by the statue without attending Soitoux's atelier, or for that matter visiting it only briefly. For Scheffer had himself taken care of instructing him in the art of draping, as all of the young Alsatian's works soon would reveal. In the specific case of the Statue of Liberty, one may note already now that the upper fold of its robe recalls that of Scheffer's *Christ the Remunerator*, and that her rigidity is closer to Scheffer's *Christ* than to Soitoux's *Republic*. Even more strikingly, under the pointed star, Bartholdi's statue wears a diadem or a crown, which the *République* pushes away from her feet. If anything, with her arm raised to lift a torch, the Statue of Liberty looks more like a late sibling of the monarchic *Hermes* on the July Column, funerary and sexually ambivalent, than a close relative of Soitoux's *République*. With one important exception: the frown on the Statue of Liberty's face has little of the ethereal look of *Hermes* (or even of the severe *République*) and rather recalls the monsters on the Arc de Triomphe and the violent energy of Delacroix's *Liberty*, who was destined, like France itself, to die in the trenches and be resurrected. As Diderot had once said, there is a violence in sculpture that is unknown to other arts—the Muse of sculpture is, indeed, "violent, but silent and hidden."[25] As will be clear, Bartholdi's Muse was particularly violent and, at the same time, particularly hidden. But the question remains: where did Bartholdi meet her? And from which medium was she born?

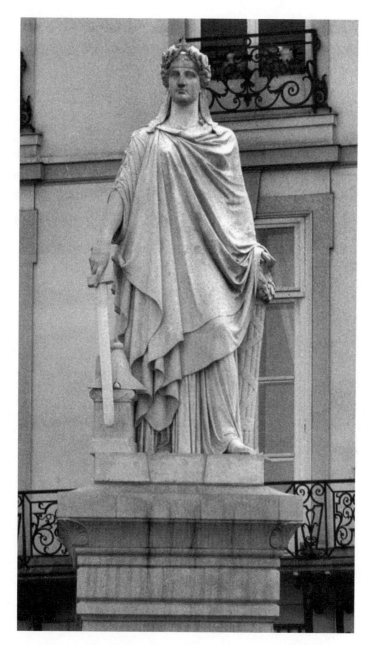

FIGURE 8.3. Jean-François Soitoux, *La République*, 1848–1880, marble, quai Malaquais, Paris.

CHAPTER 9

LIGHTHOUSES OF
THE WORLD

Bartholdi met his Muse in Alsace, but she would soon accompany him for long journeys across the world. At first, she probably lay hidden among the treasures of the Bartholdis' library in Colmar, both those visible, like the models of Greek and Roman statues he was asked to copy as a child, and those hidden in its attic. And yet there was one work in particular that must have captured Auguste's attention for the immensity of its size, as well as the brightness of its colors and the monstrosity of the creatures it depicted. It was the *Isenheim Altarpiece*, a colossal altarpiece made of a series of large panels anchored to a central box filled with wooden statues. The German artist Matthias Grünewald had painted the panels (the statues were the work of the Alsatian sculptor Nikolaus Hagenauer) at some unspecified point between 1512 and 1516, in a style that was no longer Gothic and not yet Renaissance. It was just the kind of style Scheffer had grown interested in of late, but more imaginative and daring. Indeed, Grünewald had excelled in painting monsters, deformities, and prodigies, as Hieronymus Bosch had done, but with more drama and great depth of color and shadow, as if he wanted to sculpt them on the canvas.[1]

The altarpiece was long thought to have magical powers. The Order of Saint Anthony had commissioned it for its convent in Isenheim, which is situated on the old Roman road connecting Germany to Rome and was renowned for healing people affected

with Saint Anthony's fire, or shingles. Upon their arrival, pilgrims were brought to the altarpiece and asked to sit in front of it to observe its images in devout silence. Some kind of miracle was expected to occur once the pilgrims began contemplating the figures portrayed on the panels. Grünewald had depicted bodies swollen with pustules and carbuncles, and Christ too had a pitiful look: scrawny, hanging from the cross, his body terribly disfigured by wounds. It was a frightening sight, of course, but an uplifting one as well, because the story ended in a panel representing the resurrection of a gigantic, muscular Christ. Most of his wounds now gone, this powerful Christ rises from an opened sepulcher; lifting his arms to the sky and showing his stigmata to the observers, he levitates in the air, while behind him a huge, radiant sun shines in a starry Jerusalem night, making his brown hair appear blond and projecting orange shadows across his scarlet tunic.

It will be worth remembering this commanding image when we turn to discussing the advertising of the Statue of Liberty, for Bartholdi would subtly allude to the kinship between his colossus and this most famous element of Colmar's artistic heritage. For the moment, however, it suffices to know that the Isenheim tables probably were Bartholdi's earliest and most spectacular introduction to representations of the exotic. The sight of grimacing monsters and pestilential monks may well have frightened the young Bartholdi when he first saw the dusty altarpiece in the shadows of the library's attic. In 1847, however, as Hugot brought the canvases out into the light of day, the work would have offered more to Bartholdi, now an artist in the making with a growing curiosity for Gothic and Renaissance aesthetics. Further, Scheffer's *Christ* must have been still fresh in his mind as he explored the scenes of Grünewald's panels. Their Christs were similar in that they both emphasized the most human and suffering aspects of their subject, but Grünewald had indulged in details and colors with the same determination with which Scheffer shunned them. Auguste may have been attracted by Grünewald precisely because of his excesses, which were par-

ticularly evident in the backgrounds of the Isenheim paintings. They were striking, exotic landscapes, a sort of imaginary East of biblical wonders, whether it was the fairytale cliff overlooking a castle on a lake at the shoulders of a Madonna joyfully playing with her child in a mock Bethlehem; the desert where Saint Anthony was assailed by a band of creatures, half animal and half human; or the ghostly surroundings where Grünewald had set the meeting between Saint Anthony and Saint Paul.

In one way or another, the landscapes were a noble token to the weariness of the pilgrims who had walked long distances to admire the masterpiece. Indeed, the Isenheim altarpiece itself was one of the most eccentric testaments of medieval travels to and from Alsace. Of course, in Auguste's time, the range of Alsatian exploration had widened considerably. A notable example was the Alsatian Napoleonic general Jean-Baptiste Kléber, who in 1798 had opened the way to the River Nile, and so, indirectly, to France's exploration of the "Orient." From the port of Marseilles, Alsatians ever since had traveled to and traded with Alexandria, returning to Colmar laden with exotic souvenirs of their journeys that the librarian Hugot would eventually exhibit in the city museum on behalf of the Schongauer Society.[2]

Napoléon's imperialism had also led Alsatians to sail across the ocean and settle in French Polynesia and the Antilles. The case of the former Colmar admiral Armand Joseph Bruat, who had left his city to fight in the West Indies, govern the Marquesas Islands in Polynesia, and then become governor-general of the Antilles, was renowned in all of Alsace. Auguste must have known that, in the wake of Bruat, others from Alsace had resettled in the West Indies to work for the flourishing sugar industry.

Of this world of far-off colonies and exotic exploration, Auguste Bartholdi had seen only relics, and though he may have felt an urge to emulate his countrymen's travels, Charlotte could not afford to take her sons on a "grand tour," as rich families were still inclined to do. For a while, she contented herself with exposing her children

to the world of museums. But Scheffer, who was a traveler himself and had recently been to London to contemplate the Parthenon's bas-reliefs, might have suggested to Charlotte that the time had come to introduce her children to foreign art. Either on Scheffer's advice or on her own initiative, between July 25 and July 26, 1851, during the school holidays, Charlotte and her sons boarded a train for London.

ON JULY 27, according to Charlotte's notes, they were southwest of the city, walking the galleries of Hampton Court, the sixteenth-century palace where Henry VIII had honeymooned with three of his six wives. There, they saw an exhibit of "panels of the old masters, Titian, van Dick [sic], Poussin," which impressed Charlotte. Alongside was one "panel of Correggio's of a woman with harmonious tones and a sublime expression," together with a "painting on cartoon" by Raphael.[3] Charlotte must have felt particularly proud to show her children the original works of Raphael, because only prints of his Vatican frescos were on display in Colmar. And Auguste may well have recognized the severe shape and pale colors of Scheffer's *Christ the Remunerator* in Raphael's *Christ's Charge to Peter*. With his palms open, Raphael's Christ, covered in a white and richly draped tunic and with his arms raised symmetrically to indicate Peter on the one hand and the sheep (the believers) on the other, was clearly an archetype of Scheffer's *Christ Remunerator* and, indirectly, of our statue. But not everything Bartholdi saw in London reminded him of Scheffer's style or inspiration. The next day, for example, on July 28, when he visited what Charlotte called the "Musée de peinture," he must have been equally struck by the dissimilarity of the British style with that of his master.

Although today the museums are divided, the National Gallery and the Royal Academy (the English Academy of Fine Arts) were then part of the same building in Trafalgar Square. In the left wing of the building (occupied by the National Gallery), Bartholdi

would have seen Claude Lorraine's languid beaches and unreal marinas, Titian's forests populated with pagan gods, Poussin's tormented skies, and Rubens's colorful and jumbled masses.[4] Just across the hall he could have admired the chromatic experiments of the avant-gardes on display in the Royal Academy, from the pre-Raphaelites' faux-medieval canvases with their brilliant lacquers, to the shadowy, dreamlike works of contemporary landscape painters. Bartholdi would not long resist the temptation to imitate this riot of color and emancipate himself from the rigor of line practiced in Scheffer's studio. While still in London, or immediately after his return, he depicted the changing of the guard in front of Buckingham Palace by juxtaposing white, red, and black brushstrokes, and portrayed the queen's horses and guards from behind, as they left all in a row. He used bold strokes for the nearer figures and increasingly weaker strokes, until they were mere dots, for the farther ones. Was this a first sign of revolt against his teacher, Scheffer, who was gradually removing landscapes from his own paintings?

In fact, not even Scheffer had completely abandoned his earlier, more vibrant style. He knew that the sober, pre-Renaissance-like lines that he had applied to his later Christ were not apt for representing worldly and baser, even evil, subjects. Corruption demanded asymmetry and confusion, not composed stasis. For example, Scheffer claimed, "the higher and more prominent the ear is, the more it denotes bestiality and brute force," and, in general, the effect of spiritual grace derives from certain harmonies in the "play of contrasts between the parts," for instance when "the right shoulder and the left hip are raised."[5]

Scheffer would become enthralled by the possibility of combining the two styles—the harmonious and the chaotic—to portray situations of moral conflict or to symbolize philosophical doctrines. So Scheffer himself might have encouraged Bartholdi to practice his color in order to portray the most corrupted aspects of human life; and he might have directed him to the British Museum to see how sculpture could be made to perfectly simulate movement and

life. Scheffer, of course, could not foresee that Bartholdi would be so fascinated by the movement, color, and violence of profane art as to adopt it as a permanent feature of his work.

But this all lay in the future. For now, Bartholdi was still strolling around London. In the "Musée National," as Charlotte called the British Museum, the pediments, friezes, and metopes that Lord Elgin had removed from the Parthenon between 1801 and 1805 were on display alongside pieces of colossal statues from Egypt and, more recently, Assyrian giants.[6] These were sculptures that knew how to imitate reality. The Parthenon friezes revealed a scrupulous attention to nature, which seemed to contradict the eighteenth-century myth that Greek art was a purely intellectual creation. As the German art critic Gustav Waagen would comment when looking at the Parthenon's metopes after their transfer to the British Museum, the marble let the texture of flesh, the solidity of bones, the thickness of veins, and the tension of muscles filter through. Instead of covering the bodies with heavy draping, the tunics of the statues fluttered with a tenderness of movement that contrasted with the "sharpness and precision" of muscles, bones, and veins: as if soaked, the tunics clung to hips and breasts in soft lines; instead of being depicted at rest, the bodies were preferably shown in movement.[7] After visiting the British Museum himself, a year earlier than the Bartholdis, Scheffer was left intoxicated by what he had seen and hastened to write his daughter: "Nothing in art, dear child, comes close to this beauty, this nobility, this *truth*! These supernatural beings must have existed; they live still in their pieces! Until these marbles are seen, it is impossible to have an idea of them."[8]

Mixed in with Scheffer's words was the melancholy feeling of lost opportunity—if only he had seen the metopes in the British Museum in his youth, his art might have taken a different direction. But Auguste's whole life lay ahead of him. He was still young, and the Greek style was only one of many varieties of sculptural "naturalism" in the ancient world.

Egyptian architects had opted for a sort of stylized naturalism, of which the British Museum offered famous examples, beginning with the two gigantic lions in red granite ("corallino" in Italian) that guarded the entrance of the Egyptian wing. Although their "action was true to nature," they were made with "the severe rectilinear, architectonic style of Egyptian art." Inside the museum, lined up in the middle of the gloomy main hall, lit only with low lamps, were two colossal heads, that of Thutmose III in red granite and the even more imposing one of Ramses II. Also exhibited from the first statue was a powerful arm, one displaying "a knowledge in the indication of sinews and muscles, of which the ordinary monuments of Egyptian sculpture give no idea." The heads were incredibly accurate too; that of Ramses, in particular, betrayed "friendliness and mildness," thanks to the "drawing up of the corners of the mouth."[9]

This was not Bartholdi's first exposure to "oriental" art. He had already seen its reverberations in the latest artistic expressions in Paris, in the statue of Hermes on the July Column and in the obelisk in place de la Concorde. But in London he probably had his first, real sense of what such oriental art used to be, with its striking mixture of frightening dimensions and realistic detail. According to Hugo, the "Orientals" had not invented anything; they had simply imitated nature's creativity, for it was nature itself to generate new forms by combining existing ones in unexpected ways: the glorious and the plebeian, the sublime and the grotesque, and so forth.[10] Bartholdi would further explore oriental naturalism in Egypt, for which he would soon set sail to admire sarcophagi, columns, and statues in their own contexts.

Meanwhile, London had more examples of how orientalist tastes for the colossal could be adapted to the now-urgent task of representing political and national values. It is hard to say precisely when Charlotte and her children left London, but it was certainly before August 8, 1851, when Charlotte's diary resumes. So we are left to wonder how they occupied their time after visiting the British Museum, since it is difficult to imagine that, after such a long rail

journey, Charlotte and her children stayed only two days in the British capital. All the French guidebooks to London at the time, especially those sold in Paris train stations, contained a section on the Crystal Palace, a brand-new building, made entirely of glass, that had been finished in the spring and was then hosting the first international exhibition of industry and commerce ever held in the world.[11] Charlotte could not ignore the event, not only because all French guides directed their readers to it, but also because several Alsatian textile manufacturers were exhibiting at the show.[12] So it seems plausible to assume that Charlotte and her sons braved the crowds to visit the Crystal Palace, or, even if not, that they at the very least had a good idea of the wonders it showcased and the brave new world it represented.

After walking in silent awe in the dim light of the British Museum, among colossal heads and under the timeless gazes of marble gods and goddesses, the Crystal Palace must have seemed a fanfare of noise and color. It was a sort of large, luminous, and noisy bazaar, and never before had so large a number of people who did not speak the same language (some fifteen thousand manufacturers and merchants of various nationalities) come together for such a long period. The building was essentially a long corridor covered in glass and divided into two floors, each displaying rows of galleries along the sides. A ventilation system ensured air circulation, while rainwater was channeled from the rooftops and collected in special "sacks" for cooling. A sewer system carried waste into a ventilated tank, which supplied fertilizer for the geraniums. Within the building itself, trees grew and birds flew in the sunlight that filtered through the glass and reflected off the statues and water fountains, flooding the whole interior.[13] This brightness was spectacular at sunset, when the light of gas chandeliers located within reflected off the water of the fountains and glowed through the glass so as to make the palace itself look like an enormous lighthouse. Indeed, the sheets of glass that coated the building's surfaces had been manufactured by the Chance Company, the only British producers

of "optical glass"—glass with a low index of refraction and dispersion that acted like a lens.[14]

The Bartholdis may or may not have known it, but the Crystal Palace was the closest the British had come to realizing the industrial dreams of the Saint-Simonians. As previously discussed, Saint-Simon and his followers had hoped to connect the whole world through infrastructure projects that would facilitate financial and commercial transactions. But they had hoped that Paris, not London, would be the global capital of an interconnected world. Bartholdi's industrial ancestors, like the businessman Frédéric Sohenée (the brother of Jacques-Frédéric Bartholdi's father-in-law), or Jacques-Frédéric himself, were enthusiastic about the project and would have rejoiced at the thought that their young descendants—Charles and Auguste—would one day walk through a universal exhibition of technological discoveries, amid a chaotic display of global goods.[15] Yet before following the Bartholdis along an imaginary tour of the exhibition, it is worthwhile to go back in time and consider what the Saint-Simonian project had looked like when it was embraced by the Bartholdis' ancestors.

THE BEST WAY to do so may be to peek in on one of the seances that the heirs of Saint-Simon used to hold in the early 1830s at 145 rue Ménilmontant on the outskirts of Paris, in a large, imposing house with a haunted air located atop a hill covered with olive groves.[16] Here the disciples were all clothed in the "habit of solidarity," that is, a hat; white trousers; a dark blue, almost purple dalmatic; and a red vest "that, since it buttoned on the shoulders, could only be put on with the help of a brother."[17] In one of these dresses, lulled by the crickets singing among the olives, Charles Duveyrier had told his comrades about his dream: Paris was shaped like a man on the march, its body ornamented with gardens, banks, shops, and factories, its air filled with beautiful melodies. The core of the new Paris was occupied by a colossal temple shaped like a woman and

placed on the city's "solar plexus" (the center of human emotions according to Hinduism). In his occult rapture, Duveyrier saw fire and sparkles escape from the colossus's mouth and, rising in the air, create "a world of stars." Fire and the color red were Saint-Simonian symbols of industry.[18] Not surprisingly, the colossus was wearing a mantel of "violet fire, like the great sea of the Indian islands," thrown over her "left shoulder and over the whole left side of her body." Down her back, her dress continued with an elegant train, which opened up on the ground to form an amphitheater for public events; on the front the "bends of her shoes" provided the entrances for industrialists, on one side, and intellectuals on the other, while priests and other people entered from the middle.[19] The goddess's right hand, turned toward the city's industrial buildings, rested on a globe with a crystal top, which, at night, reflected the green and yellow lights of "the beautiful countryside" onto the cityscape. The colossus's crown was made of a "headband of buildings," and her scepter, in the shape of a "sharp pyramid," was a flame, "a huge lighthouse whose light would spread out far and wide, making visible, in the middle of the night, the smile on her face" (Figure 9.1).[20]

It is perhaps hazardous to suggest that Duveyrier's mystic dream anticipated the Statue of Liberty, even if the similarities between the two figures are striking. For example, they both carry a crown (contrary to Soitoux's *Republic*) as if they were queens, and both are associated with symbols not only of urban growth, but also of natural prosperity. The Saint-Simonian lady, too, is a fiery, red colossus projecting yellow and green lights from her globe onto the sea and the city, while the Statue of Liberty's copper mantel radiates red and purple reflexes across the blue harbor and the green pastures of Bedloe's Island—at least it did when it was first assembled in New York and before oxidation rendered it a bluish-green color more evocative of the surrounding waves.

Duveyrier's dream certainly anticipated the Crystal Palace of light showcased at the international exhibition of London: it was

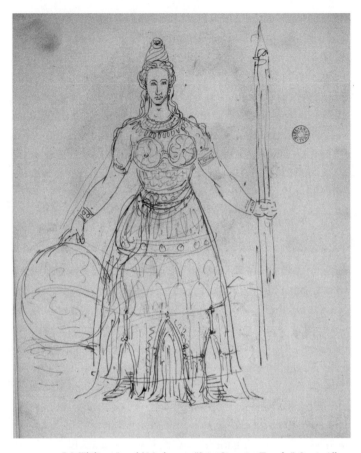

FIGURE 9.1. P. J. [Philippe-Joseph] Machereau, "Saint-Simonian Temple," 1832, in *Album de dessins par Machereau*, Ms. 13910, Bibliothèque de l'Arsenal, Paris.

a luminous spot on a vast expanse of green, where sunlight was refracted into the most violent nuances of red and moonlight became endless hues of gold and silver. The Crystal Palace was indeed a sort of lighthouse, inside which glass galleries displayed the treasures of the earth entire; it was, as one observer put it, a "lighthouse of the world."[21] Similarly, outside Duveyrier's woman-lighthouse, glass galleries twisted like garlands around her ball gown and, walking inside them, one could see "the glass roofs of printer's

shops, multicolored tents of kiosks, . . . theaters and coffee shops, and concert halls, all gathered around the Étoile like fantastic jewels"; one could also glimpse the "great factory" sites concentrated along the right leg of the urban colossus, which ended with a foot in the Parisian suburb of Neuilly-sur-Seine. On the horizon, Duveyrier saw "the parabolic curves of the foundries and forges . . . the cylindrical chimneys that opened their throats full of fire, like snakes standing erect on their tails, their torsos red-hot from the melting of lead, and magicians' hats covering levers, great wheels, and boilers."[22]

THE CRYSTAL PALACE WAS, in the end, a conceptual relative of the Saint-Simonian vision of Paris, and one can fruitfully imagine what scenes Bartholdi might have observed, had he ever walked along the galleries of the famous British exhibition. Accessing the Crystal Palace from the eastern entrance, one was welcomed by the cheerful sight of fine china vases displayed across the corridor from American raw produce and musical instruments; further down, French machinery was presented face to face with French furniture. Everything in the European section revealed a growing interest in Renaissance art, the same art that Bartholdi had admired earlier in the city museum. This time, however, it was blended with all sorts of things: furniture, porcelains, jewelries, and clothing. The effect must have been almost overpowering. It was like taking a giant leap back in time, into the Europe of the early sixteenth century, with cherubs, imps, Greek gods, and sirens peeking out from the malachite doors of the Russian section, from the sideboards displayed by the French, and from the textiles brought by Alsatian manufacturers.

But as one walked down the central transept and past the Renaissance-like fountain showering water down from a high shaft of conch shells and crystals, this geographical chaos gave way to the systematic exposition of British colonies and industry.

The Indian section, in particular, was set up as a virtual voyage into an imperial dream à la Kipling. There was a colossal, brocade-covered elephant, topped with a canopy made of silver threads, and a whole apartment decorated in the style of an Indian palace, in which stewards "illustrated the various activities and the castes of the Hindus."[23]

There were leaps back in time, but there were also leaps forward. Amid the Renaissance-style furniture and textiles, visitors encountered models of major infrastructure projects that had yet to be built. They gaped in awe at the gigantic wood-and-metal model of the suspension bridge designed by Charles Blacker Vignoles to cross the Dnieper or the less spectacular ones of the Britannia Bridge, Brunel's Bridge, Seeley's fountain in "artificial stone," and a series of lighthouses. For all we know, the Bartholdis might have lingered in reverent contemplation in front of these futuristic works or, in one of their walks along the corridors, even crossed paths with Édouard's brother Charles Laboulaye without knowing it. For Charles, too, was there, not to take in the sights but to exhibit his printing type and observe that of his British competitors. If Bartholdi did visit the Crystal Palace, he must have been fascinated by the gigantic zinc statues of Queen Victoria erected by Jean-Pierre Dantan on a sixty-eight-foot pedestal, and even more so by the German ones.[24] Braced for attack, the classicist Johann Halbig's enormous lion (fifteen feet long and nine feet high), which almost blocked entry to the Zollverein (customs union) of the German states, was placed at the entrance of Lindau Harbor, on the Bodensee, as a sort of commercial sentinel, a very first archetype of our New York statue. Trailing behind the lion-sentinel was a series of colossal equestrian statues dominated by the famous *Amazon* by the Berlin sculptor August Karl Eduard Kiss, depicted on horseback at the most dramatic moment of her fight with a lion.[25]

Visitors were speechless in front of these colossal monuments, which simulated movement and glorified the German nations in ways that were difficult to reconcile with the cosmopolitan and

pacific nationalism of those days. But what about Bartholdi? If
he did visit the Crystal Palace, was he, too, struck by the violence
of German monuments? Was this where he saw the possibility
of entrusting statues (like Halbig's lion) with the supervision of
political and economic borders? The appearance of the lion and
other aggressive statues at the Crystal Palace is hard to explain in
light of the atmosphere of peaceful exchange that was trumpeted
by the exhibition's organizers. Indeed, they made a point of claim-
ing that artists and businessmen could exchange ideas in complete
freedom inside the palace, and that people everywhere should be
able to trade without constraints. The Crystal Palace thus adver-
tised the virtues of free communication and the abolition of tariffs.
The show's guides explained that commerce and industry united
the world in a universal network of exchanges that rose above
international jealousies and, strikingly, in no way depended on the
political interests of individual nations. For precisely this reason,
it was said, states should lower their barriers to trade by reducing
customs duties and eliminating, or at least drastically cutting, tar-
iffs, so that goods could flow according to the laws of international
supply and demand.[26]

It was ironic that the same universal exhibition advertising free-
dom of trade between nations also could display some of the first
powerful statues dedicated to national supremacy in the modern
world. This contradiction would, eventually, reappear in the Statue
of Liberty, a symbol of America's national strength and prestige,
but also a monument to commercial liberty and transnational
friendship. For now, however, Bartholdi's mind was too full of
artistic impressions to rest on the geopolitical questions of trade,
freedom, and nationalism that would absorb him later in life. For
the moment, it was time to return to the Continent.

As SOON AS they arrived back in Colmar, the Bartholdis began
packing their bags once more, and on August 11 they set out for the

castles of the Loire Valley. The trip would plunge them into the Renaissance France of Francis I, from which they emerged on August 17, in Bordeaux. From there, they headed south along the French coast to Bayonne, on August 23, then across the Pyrenees to take a stab at painting *en plein air* in an untouched landscape.[27] After a horseback ride to the Cirque de Gavarni, in the central Pyrenees, the three split up: Charles and Auguste went wandering about in Spain, while Charlotte waited for them, probably in the Pyrenees. Between the Pyrenees and Spain, they discovered a red, picaresque landscape full of cliffs, waterfalls, and mountains, in some places rocky and others, snow-capped. Frédéric-Auguste would not see a similar landscape again until 1870, in America. The two boys returned on September 10, "enthused" by what they had seen and drawn. Their tour continued as they traveled to Catalonia, in the Val d'Aran, before taking a route through Bagnères-de-Luchon, Toulouse, and Montpellier to arrive back home.[28]

CHAPTER 10

HIDDEN DEVILS

THE BARTHOLDIS' visit to London was followed by a period of momentous change for the family. In 1852, Auguste dropped out of school and almost simultaneously refused to attend church with his mother, causing her deep anxiety. In her diary, Charlotte confessed that she suffered from the way her children were neglecting her, "like little birds who know how to fly do not care for what they leave behind."[1] She was losing her children, or so she thought, which was quite normal given that they were nearly adults. But Charlotte kept looking for ways to keep them for herself. On September 28, 1852, she promised herself to "continue doing all she could to still be useful to them while they will want it." And, sure enough, Charlotte had resources to make herself useful to her children. Her vineyards back in Colmar were bearing fruit and she had lands to rent. But she also had time; time to read Goethe's *Faust* ("which seems to interest Auguste") out loud and to hire an architect to "construct an atelier" in the rue D'Aumale (which in the end would not happen).[2]

As for the children, and however neglectful growing children can be, they still seemed to care for their mother, probably more so than Charlotte realized. Both insisted that she have her portrait painted by Scheffer, for example; to her diary, Charlotte confessed that she did not like the idea, for she "always thought that Charles would do it one day." But Charles was not motivated, so Charlotte in the end began posing for Scheffer in April of 1853. If ever she felt something more than pure friendship for her children's teacher,

it was then, during those hours she spent alone with him, sitting uncomfortably in a chair under his penetrating gaze. At night, before going to sleep, her thoughts went to Scheffer, so "charming, amiable": "what an artist," she commented, "what a talent."[3] At first, Charlotte liked posing for Scheffer and felt the hours flying by. Gradually, however, she began to be bothered by the more frequent embarrassed silences. Was it a sign that they were growing fond of each other and, therefore, more nervous to spend time alone together? Charlotte blamed herself for these embarrassed moments; to her diary, she confessed that "she did not like herself, nor her conversation." Scheffer suggested that she try "another grand hairstyle," but Charlotte resisted. In the end, he would portray her as a beautiful matron, sitting in an elegant room overlooking a castle. Scheffer was no longer a bachelor (he had married Sophie Marin, the widow of general Marie-Étienne Baudrand, only three years earlier), but he might well have reciprocated Charlotte's affection, for she too noted that "the portrait was too flattering."[4]

This story has some retrospective importance for us, because it is often said that Bartholdi gave his mother's face, as represented by Scheffer, to his Statue of Liberty.[5] Originally, this thesis was based on an anecdote, which dates from after Scheffer's death and after the statue had been completed. The anecdote is set in a theater in Paris, where a friend of Bartholdi and a supporter of the statue, the senator Jean Bozérian, spotted a beautiful woman in the lobby, "a woman of imposing aspect," in whose features he immediately recognized "the Statue of Liberty enlightening the world." It was Charlotte, and Bartholdi hurried to tell his friend that Charlotte was, indeed, "the statue's mother."[6]

It is difficult to know if this episode is true; later, I will discuss the possibility that Bartholdi used various models to sculpt the Statue of Liberty. For now it is most important to understand that making a colossus always involves some form of deformation, because works of that scale and height create optical effects that artists can only partially control. As Auguste had already learned from the

Egyptian statues exposed at the British Museum, colossal art is by definition stylized and synthetic; sculptors need to straighten and simplify natural lines in order to accommodate them to gigantic proportions, that is, they have to depart from their original models. Even so, it is impossible not to notice that the Statue of Liberty's straight nose and her "grand coiffure" (with curls surrounding her face and bands falling on her shoulders) were those exhibited by Charlotte in Scheffer's portrait.

In any case, the story of Bozérian and Bartholdi probably reveals more about Charlotte's charm than about the statue's origin. Charlotte was indeed quite popular with her male acquaintances. Artists, intellectuals, and politicians were all attracted to her, both in Paris, where she was often invited to Scheffer's selective dinners, and in Colmar, where Hugot introduced her into his circle of art collectors, artists, and administrators. The mayor of Colmar, Charles-Joseph Chappuis, regularly paid visits to Auguste and Charlotte when they were in Colmar, and it may have been during one of these visits that he confided in them that the government in Paris finally was interested in funding the statue of the Napoleonic general Rapp that long had been delayed for lack of money.

This brings us back to Colmar and the provincial origins of Bartholdi's success. Auguste's career clearly benefited from a combination of factors: Charlotte's charm and ambition, the longstanding connections between the Bartholdi family and the Napoleonic establishment, and finally, Colmar's competition with the neighboring city of Strasbourg, which required major investments in public art. We don't know exactly how Bartholdi came to replace Lavallette as the executor of Rapp's monument. We only know that, on May 8, 1852, Bartholdi himself knocked on the door of General Marnier, Rapp's old assistant who, since 1848, had been part of the Parisian committee established to follow the progress of Lavallette's monument. The Council of Colmar, Bartholdi informed the retired general, had decided to take the commission away from Lavallette, and had entrusted him with the task

of completing Rapp's monument. Marnier was speechless, but the rest of the committee quickly accepted the decision: "if indeed the young Bartholdy [sic] has become the Colmar committee's man," one of them commented, "there is no doubt that the rest of us of the committee in Paris can only bow to [the decision]."[7] It was perhaps a sad outcome for the Parisian commissioners, but a clear one nonetheless: Bartholdi was now Colmar's man, and he would remain so until the construction of the *Rapp* monument and, as we will see, well beyond it.

SCHEFFER WAS APPARENTLY not involved in the Bartholdis' promotional efforts, but he was happy to help with the actual work on the *Rapp*, which started in January 1853 in rue d'Enfer and finished a year later in his brand-new atelier in the rue Vavin 40 (one of Charlotte's "useful" gifts to Auguste). Because Rapp could no longer pose for his statue, having died in 1821, Bartholdi used a "live model," a certain Galali (whom Charlotte paid thirty francs per hour), to shape the general's body. Curiously, Bartholdi made very little use of Rapp's existing portraits to sculpt his face. Once, Charlotte's diary reveals, he visited Rapp's nieces to inspect a portrait of the general kept in their house, but decided against using it.[8] After all, Bartholdi had learned from Scheffer, inspiration could be found in nature as well as in the works of other artists, sculptors and painters alike.

Because *Rapp* was Auguste Bartholdi's first colossal and military work (the first of a series eventually leading to the Statue of Liberty), it is worth examining its making with some care. As always, Bartholdi's first source of inspiration was Scheffer, who was then busy painting yet another Christ: an ethereal and luminous figure on the slope of a mountain, pointing his finger toward heaven (in a gesture yet again reminiscent of Raphael), while a dark, burly devil next to him pointed down toward the Earth. It was a beautiful composition, but the devil—everybody agreed at the time—was more beautiful

than anything else in the picture. He was not only pointing to the Earth; he was fraught in his attempts to persuade and corrupt Christ, depicted as if perched castle-like upon the mountain's crest. The devil's desperation was betrayed by the tautness of his muscles and rigidity of his arms, which shot down in front of him, turned alongside his torso. The philosopher Ernest Renan, future husband of Scheffer's granddaughter, explained the devil's beauty: "the devil is easier to express than good, inferno easier than paradise." Helping Renan's case was the fact that examples of corruption and ambition were more widespread than those of sanctity. In this specific case, Renan added, what made Scheffer's devil so charming was his humanity, and more in particular the "immoral skepticism" of "the ambitious, the political, the worldly." The devil, he concluded, was an evil general who "wanted to conquer the world with lies, violence, and contempt."[9]

As it turned out, Bartholdi was no less fascinated than Renan by his master's devil. Perhaps it was the effect of familial readings of Goethe's *Faust*, or maybe it was his discussions with Scheffer himself, who was increasingly convinced that evil was inseparable from good and that rebellion (as Francesca's case so eloquently demonstrated) often concealed the seeds of the sacred. Whatever the case, when the time came to start his *Rapp*, Bartholdi clearly had his eyes fixed on Scheffer's devil—and he knew that the devil was not a biblical figure, but rather the symbol of every aspect of secular life. Even if no documents have survived proving Bartholdi's conscious decision to base his *Rapp* on Scheffer's devil, their striking similarities are evident from even the most cursory comparison (Figure 10.1). Both figures are portrayed in the act of twisting their tense bodies to the left, while their feet are firmly grounded to the floor and their thigh muscles strain in the effort to resist their busts' brusque movements. The only differences are that *Rapp* is standing on a flat surface instead of balancing on a mountaintop, and his face does not betray an anxious (somewhat fearful) effort to convince, but rather a resolute determination to resist.

We know from Bartholdi's preparatory sketches that he tried different positions before settling on the definitive one; in one of them, for example, Rapp advances with his right foot, while resting his left arm along his bust and stretching his right arm laterally outward in an authoritative gesture, as if wanting to block an enemy. In another sketch, the general leans against his left leg while putting the right leg forward, holding a sword aloft. At some point between these sketches and the completion of the definitive statue, Scheffer must have suggested, either in person or by example, that Bartholdi twist the statue's bust, thus conveying this unnatural movement to the legs and arms. Charlotte's diary sheds limited light on this process, but does inform us that, on August 1, 1854, Scheffer advised Bartholdi to change the position of Rapp's left arm, plausibly to echo his own devil.[10]

Scheffer, however, was not the only mentor advising Bartholdi during his work on the *Rapp*. By April 1853, Auguste was still sculpting at home, in rue d'Enfer, while also sharing a temporary studio with his friend and colleague Baptiste-Eugène Dock.[11] Charlotte was probably happy to pay the rent for Dock, for she was growing tired of the mess her son was making in the house while working on his sculptures. "This is impossible," she wrote in her diary. "The dining room is all cluttered. What should I do?"[12] Bartholdi too must have felt constrained by long hours of work side to side with an upset mother. But he was also eager to find new inspiration outside of Scheffer's atelier. After all, even if he was a talented teacher of sculpture, Scheffer was essentially a painter. At some point, perhaps under the effect of the colossal sculptures he may have seen at the Crystal Palace or at the British Museum, Auguste must have realized that he needed a real sculptor to work with, particularly now when he had to complete the *Rapp*. But who?

The spirit of this moment can be guessed at from a series of entries in Charlotte's diary. On April 2, 1853, Charlotte notes that the Alsatian painter Gluck, one of Auguste's friends at rue Chaptal,

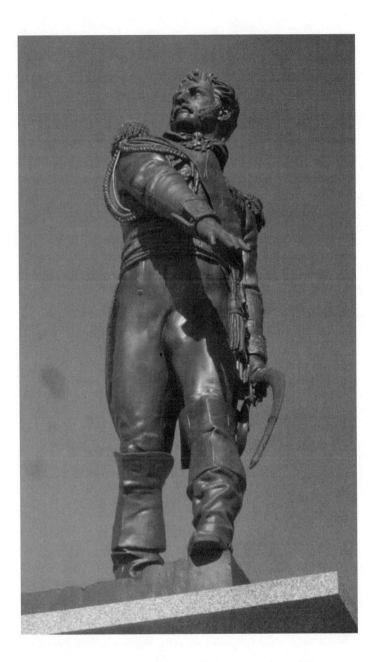

FIGURE 10.1. [Frédéric-] Auguste Bartholdi, *Monument Rapp*, 1855–1856, bronze statue on stone pedestal, avenue de la République/boulevard du Champ de Mars, Colmar.

had talked to him about "Édex the sculptor" and comments that
Auguste "wants to go to his atelier." "Édex," as Charlotte called
him in her letters, was no other than Antoine Étex, the famous
artist behind some of the most powerful statuary groups on the
Arc de Triomphe, and more specifically the "demon" or "angel
of vengeance" with the flame on its head, the notoriety of which
had helped spread the rumor that Étex himself was a cursed artist
(see Figure 6.1). Indeed, French artists were not generally fond of
Étex, and Charlotte may have objected that turning to him was a
betrayal of his old friend and mentor Scheffer. But then again, she
was probably also tempted by the prospect of seeing Auguste work
permanently at a proper sculptor's studio rather than in her apart-
ment in rue d'Enfer. In any case, the following day, on April 3,
1853, Charlotte decided to follow her son to the atelier and ask for
advice from Scheffer directly. This was probably not the outcome
the young artist had wished for, because his predicament suddenly
became a question between his mentor and his mother; hardly
an ideal situation for anyone. Predictably, Scheffer's answer was
to state coldly that he "wish[ed] that Auguste [would not go] to
any sculptor," and recommended that he continue to work "at
home."[13]

Scheffer had his own reasons to dislike Étex. First, there was a
question of style, for, no matter how far Scheffer was departing from
tradition, his figures still bore the signs of neoclassical composure.
Étex, by contrast, was a self-taught artist who loved to openly chal-
lenge canonical tastes. The son of a hardworking decorator and
a dressmaker, he had studied art under his father's guidance in
Paris, without enrolling at the academy and while working as a
decorator to earn some money on the side. While working on an
ecclesiastical commission in Reims, he had stumbled upon Jean-
Auguste-Dominique Ingres, a patron of neoclassical and religious
art who had been impressed enough by his work to introduce him
to the smooth, inexpressive, and graceful style of the neoclassical
sculptors. Sculpture, Ingres used to say, was "the art of form *par*

excellence" and as such was resistant to any temptation of expres-siveness.[14] But Étex had witnessed the limits of such a vision first-hand when, between 1831 and 1832, he had visited Italy. After all, the faces of all of Michelangelo's colossal statues expressed rage, pain, and sadness. Étex, however, was "locked" in silent contemplation at the sight of *Il Penseroso* (the thinker), a sculpture that Michelangelo had made for Lorenzo de Medici Chapel in Florence featuring a giant with its face resting on its hand, its eyes turned toward the ground, as if a sad thought kept its whole body taut. Étex emerged from the Medici Chapel with his "head ablaze" and a fever that kept him in bed for days.[15]

Étex probably lacked the philosophical education necessary to understand the original meaning of Michelangelo's *Penseroso*, which was sculpted in the same fifteenth-century Florence that had seen Hermetic and Neoplatonic texts reintroduced to the Western world from Byzantium. Had he been familiar with these traditions, he would have known that the *Penseroso*'s saturnine appearance was suggested to Michelangelo by Neoplatonic intel-lectuals, according to whom all the spirits under the influence of Saturn (which the Platonic author of *Epinomis* had thought to be a star of the sun or the One) had a clearer intuition of God.[16] But that was a negligible detail, for what mattered to Étex was the way in which Michelangelo had been able to give such a "melan-cholic" and pensive expression to a piece of marble. Indeed, the *Penseroso*'s appearance reminded Étex of the sad destiny of great sinners, like Lucifer and Cain, whom the British poet Lord Byron had exalted for the nobility of their suffering and for the creative character of their disobedience. So, while still in Rome and under the spell of Michelangelo's masterpieces, Étex had started working on an enormous statue of a "Cain-Penseroso." Seated and with his face turned toward the ground, absorbed in painful thought, Étex's *Cain* was colossal in size and surrounded by his children, the race "accursed by God."[17] When he first saw it, Ingres had felt outrage at the idea that someone could imbue public statues with

such expressions of sadness or desperation, even going so far as to suggest destroying Étex's *Cain*. But Étex resisted and continued working on a whole family of cursed figures to be situated in public squares and buildings.

One of the most famous was certainly his genius of resistance for the Arc de Triomphe, a winged spirit—the "spirit of the future," as Étex called it—topped with a burning flame, which was shaped like the pine cone topping Bacchus's thyrsus and representing divine fire.[18] Its scowling face, as expressive as those of the *Penseroso* and of *Cain*, associated the angel with a long line of rebels and disobeyers. The similarity was so obvious that when the Minister Adolphe Thiers saw it, he exclaimed: "but yours is the spirit of revolt, not of the future!"[19]

Even if rarely associated with the Statue of Liberty, Étex's devil is one of its closest relatives. The story of their kinship started at the time Scheffer was painting his *Temptation of Christ*, and Bartholdi was working on his *Rapp*, while Étex's diabolic spirit was still a paradigmatic figure of devilish resistance. In fact, there are good reasons to suppose that Scheffer himself might have been inspired by Étex's spirit in the portrayal of his own devil. Étex had already noticed Scheffer's interest in his works, and was not pleased with it. It was a long story, dating back to 1835, when Étex had displayed a bas-relief, *Paolo and Francesca*, at the same salon in which Scheffer had exhibited his *Francesca da Rimini*. The timing was unfortunate, but Étex did not seem to believe in coincidence and had accused Scheffer of plagiarism. At the end of the salon, *Paolo and Francesca* was returned to Étex in pieces, without explanation, and Étex, who was aware of Scheffer's animosity, thought he had orchestrated the whole matter.

We will never know how things stood. It is difficult to deny, however, that Scheffer's devil had much in common with Étex's vengeful spirit, though not so much his expression, which was manipulative and smooth rather than outraged. Instead the posture of Scheffer's devil was the issue, for Scheffer's devil turns his bust

to his left, while stretching both arms in the same direction, one parallel to the other, very much like Étex's evil genius slightly turns to the right with two outstretched arms following the bust, the left shoulder higher than the right. We know already that Bartholdi had sketched his *Rapp* after observing Scheffer's devil. Given that work's similarity with Étex's vengeful angel, one should not be surprised to learn that Bartholdi's *Rapp* too looked like the devil of the Arc de Triomphe. The question is whether these similarities were simply the fruit of Scheffer's original "plagiarism" or whether they resulted from Bartholdi's personal relation with Étex.

There is no direct way to establish if Bartholdi ever followed Scheffer's order to sculpt at home and avoid Étex's studio, but we have two indirect testimonies. One comes from Étex himself, who at the end of his life, the year after the Statue of Liberty was unveiled in New York, would proclaim that Bartholdi had been "his pupil after having worked for a few months with his friend, Arry [*sic*] Scheffer."[20] In fact, Bartholdi spent more than "a few months" with Scheffer, and one may wonder why Étex, who had never mentioned the Alsatian artist in his autobiography, decided to refer to him so late in his life. Was it that, after the construction of the Statue of Liberty, Bartholdi had become prestigious enough to be added to the list of his former pupils?[21] More plausibly, Étex did not entirely invent his past relationship with Auguste Bartholdi, but was prompted to acknowledge it by Bartholdi's sudden fame. For there is no denying that, after 1853, Bartholdi's style changed dramatically: if his *Bon Samaritain* and *Francesca* imitated the sober style and religious inspiration of Scheffer's mentorship, his next monuments, starting with *Rapp*, betrayed the same violent passions characterizing both Étex's spirit of resistance and his *Cain*. The *Rapp*, for example, did not show the fearful and unctuously persuasive look of Scheffer's devil, but rather the resolute expression of Étex's spirit of resistance on the Arc de Triomphe. Could it be, then, that Étex himself helped Bartholdi work on *Rapp*'s face when Charlotte was not in the atelier? If so, this would be neither

the first nor the last time that Bartholdi hid something from her to keep the peace.

SCHEFFER AND ÉTEX were not the only visitors at Bartholdi's studio on rue Vavin. There were journalists too, and at least one of them had been brought there, once again, by Charlotte. Indeed, while her son was working on the *Rapp* and trying to harmonize Scheffer's devout art with Étex's charming iconoclasm, Charlotte was campaigning and canvassing public opinion in favor of his monument. This time, she did not feel that the approval of mayors and librarians would be enough. Journalists had become ever more powerful in France, and their backing would be indispensable if Bartholdi was to win commissions in Paris. So she turned to August Nefftzer, a journalist from Colmar who had covered American news for the pages of *La Presse* and had bitterly condemned the expansion of slavery in the New World. A friend of Édouard Laboulaye and probably, like him, a Freemason, Nefftzer would eventually be the one who put Bartholdi in touch with Laboulaye and, in so doing, implicitly made the construction of the Statue of Liberty possible.

But there is a second reason why one should evaluate Nefftzer's role in the making of the Statue of Liberty: he would, either directly or indirectly, provide both his friends, Laboulaye and Bartholdi, with some of the basic religious and political meanings that would inspire the making of the statue. These would be controversial, permeated by both racial prejudices and commercial ambition. Curiously enough, these prejudices took shape in landlocked Alsace, rather than in the port of New York, where the statue eventually would meet desperate expatriates and poor immigrants. Yet life could be grim in Alsace, too, particularly if one were not born to a rich family like Auguste. Contrary to the Bartholdis, Nefftzer was indeed born in poverty, though his parents recognized his intellectual gifts early and sent him to Strasbourg to

study theology and prepare for the priesthood. What they had not expected was that the winds of heterodoxy were blowing there from Tübingen. Having learned Hebrew and a bit of Arabic, Nefftzer encountered a number of recent works in Strasbourg that would have horrified his parents, beginning with *The Life of Jesus* (1835) by David Friedrich Strauss. The book (at least in its first two editions) challenged a common way of thinking according to which the Bible was to be treated as a "special" book, read in the light of pure faith, undisturbed by doubts instilled by the laws of science and reason. Strauss had instead used the Bible as a common historical document to reconstruct Jesus's life and show that it was a collage of myths from the Old Testament.[22] Seduced by Strauss's books, Nefftzer eventually lost his faith and the desire to become a priest. At university seminars, where apocalyptic texts were widely discussed and analyzed, he meditated on the possibilities of demonstrating the Persian origins of some of the apocalyptic myths contained in the book of Revelation and the apocryphal gospels. But, lacking money, he was forced to look for work. He found a job as a preceptor in Ribeauvillé, the Alsatian village where Charlotte was born, and then, in 1842, moved into a Fourierist colony in Cîteaux, Burgundy.[23]

The "colonists" were followers of a famous utopian of the early nineteenth century, Charles Fourier, a contemporary of Saint-Simon who believed that societies evolved from the savage stage to an apex of "harmonic" well-being, before painfully declining only to dissolve in a final conflagration. Fourier cared for productivity as much as Saint-Simon did, but his approach was more hedonistic: he believed that if men and women were to be happy and productive, they needed to follow their hearts in choosing their partners and jobs. And yet there were some restrictions. If lesbianism and homosexuality were widely accepted among Fourier's followers, trading, banking, and lending were prohibited because they bore the stigma of Judaism, and Jews—Fourier argued in a deplorable passage—were "all parasites, merchants, usurers, etc." and should

be forced "to productive work and not be admitted unless at the proportion of one hundredth," meaning one Jewish family for every hundred "agricultural or manufacturing families."[24]

Despite Nefftzer's interest in Jewish and biblical studies, he probably shared Fourier's racism. In any case, life in Cîteaux was made bitter by the many conflicts within the Fourierist establishment, and Nefftzer did not stay for long.[25] In those years, the expansion of large communication networks, railroads, and telegraphs had accelerated the spread of news and investments in the press provided a good return, not only for journalists and newspaper owners, but also for printers and publishers, which increasingly ran newspapers like businesses—to boost sales, they cut prices and increased the number of page-three advertisements.[26] After an apprenticeship at Colmar's *Courrier de Haute-Rhin*, Nefftzer wrote to Émile de Girardin, the director of the famous *La Presse*—the *éminence grise* of the newspaper world—to ask if he could join the editorial staff as a specialist in classical and modern German literature. Girardin said yes, and Nefftzer moved to Paris with his family. Thanks to the help of Parisian friends, he cast off his provincial air and made a name for himself as sub-editor of *La Presse*. Persuasive and pleasant, with a "joyous" laugh (like a "Swabian's," it was said), a bushy blond head of hair, and the stocky physique of a mastiff, Nefftzer so won the trust of his director Girardin that, between 1846 and 1850, he was first put in charge of the *feuilleton* section (a crucial part of the newspaper that attracted readers with serial novels) and then with an even more delicate mission: organizing the Strasbourg campaign in favor of Girardin, who had run for the legislative assembly elections in the department of Bas-Rhin. Nefftzer secured Girardin's victory, but a few months later, when Louis Napoléon became president of the Republic, both men were forced to leave *La Presse*, banished respectively to prison and exile. In prison, Nefftzer abandoned the paper's educated republicanism to join ranks with political rebels like the anarchist Pierre-Joseph Proudhon and Victor Hugo.[27]

When Charlotte contacted him, presumably during 1853, Nefftzer was once again a free man and *La Presse* was back to being a successful newspaper. Under his management, circulation rose from 21,000 in 1851 to 42,216 in 1855. New journalists joined the editorial staff, while the novelist and art and theater critic Théophile Gautier continued to write the *Salons* column. Nefftzer resumed his reports from Germany, but now a new column was introduced, the *Bulletin hebdomadaire*, which gathered the week's news published in foreign languages, even that from the Chinese-language papers of San Francisco. It was in this section that Nefftzer informed readers of the inexorable march of the United States to the West and South, attacked the spread of slavery, and reported on U.S. presidential speeches.[28]

Nefftzer called on Charlotte during one of his visits to Colmar, on October 13, 1854, specifically to talk about Auguste.[29] We do not know what they discussed, but afterward Nefftzer started to frequent Bartholdi's Paris studio in order to follow the final touches on the *Rapp*. It is difficult to imagine that Nefftzer, fourteen years Bartholdi's elder and known for his charm, did not share his vision of art with Bartholdi, a vision closer to that of the organizers of the Crystal Palace exhibition than to Scheffer's devout aesthetic, one that hewed more to Étex's heresies than to Scheffer's piety. As a former Fourierist, indeed, Nefftzer believed in the possibility of piecing together the story of Jesus's life as a profane history; as for Bartholdi, he was increasingly becoming estranged from religious matters.[30] Even if Auguste's personal beliefs are unknown, we are told that, after his baptism, he held off celebrating his First Holy Communion until he was seventeen and, in the meantime, went to church only sporadically, and with little conviction. When he did go, Charlotte was relieved, although she could not resist the temptation to complain about his bad habits in her diary. "It is the only day when my sons still go to church," she noted on returning from a Good Friday service.[31]

Thus the religious open-mindedness that prevailed at *La Presse* must have attracted Auguste. Celebrated writers for *La Presse*, such as the novelists Gérard de Nerval, Jules Janin, and Théophile Gautier, were neo-Renaissance pantheists who in their youth had walked pet lobsters on a leash and lapped up the Arab myths brought to light by the *Bibliothèque orientale*, the apocryphal gospels, the Apocalypse, and world folklore. They were as fond of the Orient as Ballanche or Creuzer, but their approach was different. For they did not seek to bring Christianity back to its monotheistic and Eastern contemplative roots; their ideal Orient was ancient, polytheistic Greece, which they thought had been corrupted by the spread of later philosophies. The group gathering around the *Presse* was rather fond of paganism. If Nefftzer was particularly interested in the Old Testament's apocalyptic legends, Jules Janin had demonstrated that the cults of Venus, Juno, and Diana were still alive in France, only masked under the Christian liturgy associated with the Virgin Mary.[32] Gautier had protested against the "repress[ion] of these young gods, these smiling geniuses, these celestial ephebes with shapes of such an absolute perfection" by Christian monotheism.[33] Like the Fourierist friends of Nefftzer, Gautier thought that a wider pantheon of gods and goddesses meant a broader inspiration for poets and artists in general, who could mix their stories to create new imaginative patterns or even collective idols, in which all the world's gods and idols overlapped, from Isis to the Madonna, all the way to Astarte (the Babylonian goddess worshipped by the Jews during their Egyptian captivity and later repudiated). But the poet Louis Ménard found that the benefits of paganism went beyond the domain of artistic inspiration. Polytheism, for him, was intimately connected with a liberal and republican policy. Otherwise, how could one explain that, "still young and strong, Greece had given us the Iliad and the Parthenon and an even more beautiful thing, the republican city," while later, "consumed by the superhuman efforts of its genius" and infected by "Eastern philosophy and super-stitions," Greece only "bequeathed its belated son, the Verb," the

root of monotheism and intolerance? The conclusion was obvious: "when one establishes a monarchy on earth, the Republic can no longer be left in the sky."[34]

Apparently, Nefftzer was impressed by the possibility of reading the political history of the East from a Fourierist perspective. Like Menard, who used Jews and Muslims as paradigmatic examples of the vicious relations between monotheism and monarchy, Nefftzer did not have much sympathy for the "annals" of the Jewish people, which he thought were not "the most beautiful and brilliant of the antiquity." He did not even find flattering what he described as the Jews' natural inclination toward "the sensual and sanguinary cults" of their neighbors. What struck Nefftzer instead about the Jewish people was their "prodigious tenacity" in "maintain[ing] their own nationality": wherever they were, and despite their polytheism, Jews had been able to change their doctrines and languages (Aramaic, Greek, or Syrian) to pursue what was best for their nation.[35] No matter how fond they were of Baal and Astarte, Camos and Moloch—as the apocalyptic texts revealed that they had been—they gathered around "Moses's God," the "God of the exodus from Egypt," in which they appropriately recognized "the God of independence and conquered homeland."[36] Expelled from the Bible, the devils of their prohibited religions continued to survive in the apocryphal texts, some of which—Nefftzer discovered—were contemporary with the New Testament. The prophets of the apocalypse, by contrast, became champions of the coming of a future Messiah in the *Book of Daniel* and the *Gospel of John* alike.[37]

Hiding the devils to build a monarchy and defend the nation: this was what, Nefftzer argued, Jewish scholars had done in their apocalyptic texts. Perhaps he discussed the matter with Bartholdi while the artist was working on his *Rapp*, high on a ladder in rue Vavin. It is ironic that *Rapp* too, in his own way, was a devil in disguise. But he was a devil all the same, and by using him as a model for his *Rapp*, Auguste was seemingly rediscovering the polytheistic

roots of sculpture. It would not be the last time that Bartholdi's monuments would hide a devilish spark or a pagan reference. Astarte and Baal would make their way to the Statue of Liberty too, and, with them, a new idea of nationhood.

As the champion of a religion of happiness and paganism, Nefftzer may have been immune to the art of suffering and sacrifice to which Scheffer had initiated Auguste. He and his Fourierist friends rather urged artists to combine the sentimentalism of the Romantics with neoclassical formalism to pioneer a new way to depict nature, one that could combine formal rules and the imagination. That manifesto was essentially a challenge to God, an encouragement for artists to invent new or never-before-seen forms ("cynocephali, winged lions, griffins, smiling and mysterious sphinxes") or give exceptional dimensions to existing objects (towers, statues), as Egyptian civilization and, more recently, Renaissance artists had proved they could. "After living too much in God"—Esquiros commented—"the Christian has died in the eyes of nature."[38]

Bartholdi was not one to withdraw from a challenge, not even one against God. Besides, he had seen examples of this pagan, neo-Renaissance art not only in Hittorff's colossal fountains in the place de la Concorde, but also in the Egyptian statues in the British Museum, and (maybe) in the furniture and fountains exhibited at the Crystal Palace. It was probably Nefftzer, a devoted Germanophile, who ultimately convinced Bartholdi to put down his chisel and go to Germany. Even from second-hand accounts of the Crystal Palace, Bartholdi would have known that a new art was taking shape in German studios—an aggressive, colossal art that tapped into the bellicose temperament of the pagan gods of the North.

Bartholdi boarded a train for Munich on November 1, 1854.[39] While there he experienced the famous museum of plaster casts, the Glyptothek, where multicolored sculptures from the pediment of the temple of Aphaia (on the Greek island of Aegina) were kept, providing striking evidence that antiquity was "colored," and not made of white marble as the neoclassicists seemed to think. But as

Charles Laboulaye would explain, "the brilliant Munich school" had also produced "imitations of the edifices of ancient temples, which made the city seem a real museum of monuments, of beautiful works of a particular character." These "were distinguished by the use of color that, on frescoed walls, as on brick and stone ones, produced something of an oriental character."[40]

Bartholdi had never been to Athens, but he would find a modern version of it across the Rhine. Whereas in London he had seen ancient Greece displayed in the museums—where, according to Étex, the "beautiful [and] so pink marbles of Paros" were hidden, "shameful, trembling, and frozen"—in Munich, Bartholdi must have felt he was living and breathing the Athens of old.[41] While the Glyptothek had introduced him to some of the colorful, perfumed air that Hittorff had brought from Selinunte, the Ruhmeshalle (Hall of fame) was the new Parthenon, a completely white portico housing the busts of famous Germans, including one of the Alsatian engraver Schongauer. Facing the Ruhmeshalle against a rural backdrop evoking the Greek hills, now long gone, stood the *Bavaria*.

The dark, Germanic twin of the Athena that Étex had sculpted for the Arc de Triomphe, *Bavaria* belonged to a series of bronze, bellicose figures that the Zollverein had displayed at the Crystal Palace. Although her sword is not unsheathed, she holds it in plain sight, with the hilt under her bust and the tip pointing out, while the Bavarian lion crouches at her feet. The *Bavaria* itself is more than sixty feet high and wears a tunic covered in part by a bear pelt; she looks down at the virtual audience gathered at her feet, while her raised left arm grasps an oak crown.[42] Colossal, bronze-made, pagan, and completely hollow inside, the *Bavaria* was the first modern statue that dared to compete with the inventive genius of the ancients. She was a "barbaric" and metallic version of the *Athena Parthenos*, the golden statue with a shield, armor, and helmet, holding a statuette of victory, which Phidias had placed inside the Parthenon. But with sword in hand and a lion ready to pounce at her feet, the Bavaria was more aggressive than her Greek predecessor. Her

alter-ego was perhaps the *Athena Promachos*, Phidias's other statue,
which was said to have been built on the slopes of the Acropolis
to celebrate the victory at Marathon—an impressive fifty feet in
height (without the pedestal), her helmet and lance could be seen
from as far away as Cape Sounion, on the southernmost tip of the
Attic peninsula.[43] But the *Bavaria* also brought to mind another
famous statue of the ancient world, the Colossus of Rhodes, the
hollow bronze giant said to have stood at the entrance to the port
of Rhodes, crowned with solar rays (Helios was the patron god of
the island) and holding a torch or a bowl of burning embers in
his raised right hand.[44] Until only a few years earlier, the local
population had spent hours watching in amazement as the blocks
of the *Bavaria* took shape, one after another—first the head, with
flowing hair styled in a bun above the nape of the neck, then the
torso wrapped in a bear pelt, and then finally the rest of body, hid-
den under her garments. Photographs from the day (inevitably
evoking the even more spectacular construction of the New York
statue) still immortalize the groups of workers as they climbed on
top of the head and its bun, mounted on a cart, and were carried
in triumph toward the site of the future statue.

The *Bavaria* had been unveiled only a year earlier, and it is likely
that Bartholdi went to Munich primarily to see the statue and climb
its many stairs to view the panorama through the goddess's eyes.
When he returned to Paris, he finished his *Rapp*. He had it cast
in bronze, like the *Bavaria*, and decided that it, too, would be a
colossus, a monument standing nearly twenty-six feet (including
the thirteen-foot stand). It would be Bartholdi's first military colos-
sus. Others would soon follow, and the most famous of them would
be the Statue of Liberty.

QUEEN OF THE SOUTH

"Operation Rubicon" sprang into action at the stroke of midnight on December 2, 1851. It was named after Julius Caesar's famous crossing of the Italian river Rubicon, in 49 BCE, an illegal move designed to trigger a civil war in the Roman Empire. "Alea iacta est," the Roman general was said to have uttered in recognition of the irreversibility of his gambit; "the die has been cast." Napoléon's act was illegal too: at dawn, those who were suspected to be enemies of the coup—seventy-eight men in total—were rounded up and arrested, then military units occupied the Chamber of Deputies and saboteurs put the national guard out of commission.[1] The coup was a strategic success, but hardly a popular one. Forty-six years after Napoléon's victory at Austerlitz, deputies and common people alike resisted the newly established regime.[2] The deputies held responsible for the popular insurgence, from the Count of Falloux to Tocqueville, were arrested, while the writer Victor Hugo, who had gone in person to the Parisian suburb of Faubourg Saint-Antoine to incite its inhabitants to rebellion, was punished with exile.[3] Those arrested en masse in Paris or in the provinces were given summary trials and deported to penal colonies like Devil's Island, in French Guiana, and in Algeria, where many were destined to die of hunger and disease.

At first, Louis-Napoléon showed a certain discomfort at adopting an imperial title, and decided that France would remain a republic. But as his example soon made clear, republics can all too easily be opaque covers for despotic regimes. "In a government with a

democratic base," Louis-Napoléon claimed as early as 1839 (arguably laying the foundations for the first populist regime in modern history), "only the leader has the power to govern; moral force derives from him alone."[4] And so, whether his embarrassment at becoming emperor at a single stroke was sincere or not, Napoléon III exhibited a marvelous nonchalance as he changed the constitution to suit himself. He secured a ten-year period of rule, after which nothing prohibited his reappointment; he also reintroduced universal male suffrage (which a law of 1850 had suspended), but made elections insignificant by retaining the power (exercised in the national interest, of course) to nominate ministers and designate candidates for parliamentary elections. Furthermore, the new constitution gave him the authority to propose legislation, and conferred exclusively on him the power to declare war and sign treaties of peace or commerce. The ministers he appointed, his "assistants," were accountable individually to the emperor alone, and could be dismissed only by him. No checks or balances to his rule existed—the *cabinet particulier* and the government were merely there to assist him; all executive power was concentrated in the hands of the emperor.[5]

Untouchable with his new powers, Napoléon III went on to dismiss the country's most prestigious professors: Edgar Quinet, Jules Simon, Jules Michelet, and Émile Deschanel all lost their posts, while students were forbidden to grow beards. By an imperial decree of January 9, 1853, Laboulaye was exiled along with other right-wing Orléanists.[6] The reason is unclear. Perhaps it was punishment for the dissent that Édouard had voiced in his lessons, although he had given up his course on American history in 1850 because it was considered too subversive, and begun teaching French legal history instead.[7] We may never know why he was exiled, but, judging from what little is contained in his dossier in the French state archives, we know that, following the decree, it seems he sailed up the Rhône River, almost certainly heading for Switzerland.

Paris, in the meantime, was enjoying a facelift. As already mentioned, Saint-Simonians had been encouraging urban renewal since the 1830s, when they had first conceived of the idea of redesigning Paris according to a blueprint envisioning the city as a mystical human body. In practice, their plan implied the destruction of the "old Christian temple, ruined and dilapidated, and its cloister of beggars' houses" from the historical center of Paris, and the construction in its place of a park, poetically described as "a mane of trees," which would fall "in tresses of avenues on both sides of the long galleries." The tresses would crown the head of the male-shaped Paris, which was supposed to lie where the temple formerly had been located. In the rest of the historic center, the "ditches" would be covered over to form "a broad chest," an "endearing heart" in which "sorrows and joy vibrate."[8] The temple-lighthouse in the shape of a woman would be built here, on the chest, not far away from the Square du Temple, among gardens and ponds; the hills of Roule et Chaillot (now occupied by place Charles de Gaulle and place du Trocadéro respectively) would correspond to the city's hips, while markets would line the right arm of the city, from the old temple up to the Saint-Ouen railway station, where the city's "big hand" resting on the Seine would serve as a "wide storage where the river would pour the provisions to quench the city's thirst and fill its stomach." The city's left arm would follow the course of the Seine and then bend inward, toward rue de Vaugirard, where Duveyrier thought of building special scientific and industrial schools. Industries would light the skies red over Paris's right leg (up to Neuilly), while nursing homes would be placed along the left leg, ending in the Bois de Boulogne.[9]

Napoléon stuck to this plan the best he could. His goals in this were not purely aesthetic. Like the Saint-Simonians knew all too well, part of the need to renovate Paris was sanitary. Fresh water had to be channeled to the city center from Champagne (sixty miles away from Paris), gas had to be more rationally distributed, and the sewage system needed to be modernized and covered.[10] Financial interests were also at play; the Péreires and other friends or relatives

of Napoléon were investing in the city's reconstruction. Napoléon started from the medieval center. Soon after the coup, he and his most trustworthy consultant in the enterprise, the Alsatian prefect of the Seine George-Eugène Haussmann, razed medieval buildings and tore up old streets to pave the way for new avenues, built along two central axes. The rue de Rivoli was extended to the east toward the faubourg Saint-Antoine, on the *rive droite*, and to the Champs-Élysées and the place de l'Étoile to the west; on the *rive gauche* the rue des Écoles was so prolonged as to almost connect the École Polytechnique with the Collège de France. At the Châtelet, the east-west axis met the north-south one connecting the Gare de l'Est to the Observatoire through the boulevards de Strasbourg, de Sébastopol, and de Saint-Michel.[11] The result looked like a mutilated version of the Saint-Simonian anthropomorphic city, with the head still resting in the former medieval center, the hips at the Étoile, the right arm pointing north (though without the hand on the Seine), and the left leg connecting the Étoile to the Bois du Boulogne through the brand-new avenue de l'Impératrice (now avenue Foch). But the left arm (connecting the Châtelet with the Observatoire through the boulevard Saint-Michel) was straighter, and the right leg broken, because the avenue de la Grande Armée departing westward from the Étoile stopped at the Porte Maillot, before reaching Neuilly.

Even building this mutilated body was challenging. Special permission allowed builders to work day and night. "The teams took over from each other, the hammers did not stop beating," Zola recounted; "the machines kept up a constant whistle, the sound seemingly loud enough to blast and scatter the plaster."[12] Huge gas lamps cast shadows of the ruins onto the walls of the houses left standing, conjuring up images of war. Indeed, the scene resembled the nocturnal devastation of 1848, except that this time the destruction was lit not by torches, but by gaslight.

THIS WAS THE NEW Saint-Simonian Paris, in fieri. Still missing was a temple—but not for long. On May 15, 1855, on the Champs-

Élysées, between the place de la Concorde and the city's hips (l'Étoile), a French version of the Crystal Palace opened its doors. Placed quite far from where Duveyrier had located the city's breast—at the Square du Temple—the building was constructed to the design of Jean-Marie Viel by an English company. Enclosed within the perimeter of the Palais de l'Industrie, it resembled a huge, Renaissance-style box with a greenhouse inside, of which only the glass roof showed. Over the entry arch towered Elias Robert's statue of *France*. Dressed in a Roman-like toga, standing and crowned by seven solar rays, she was a colossus with arms outstretched to bestow a laurel crown on *Arts* and another on *Industry*. A fading, pinkish photograph of the entrance of the Palais can still be seen today in the Bartholdi museum. If nothing else, it indicates that, at some point in his career, Bartholdi had been intrigued by the monumental group crowning the main doors of the Palais, and perhaps this interest eventually led him to equip his Statue of Liberty, too, with Roman garments and a solar crown.[13]

There were numerous other plausible sources of inspiration awaiting Bartholdi beyond the archway. Inside, the effect was somewhat overpowering; to cut costs, the York Company had completely separated the masonry from the iron parts of the building, without taking into account that the different characteristics of the materials would generate structural imbalances. The result was that crowds jostled for space, oppressed by the intolerable heat. Still, there was a lot to praise. Wares of different nations were showcased inside five long corridors. The central nave featured the grandest pieces, such as colossal fountains and immense stained-glass windows produced by Saint-Gobain of Paris and by Belgian manufacturers. The stained glass lent a dark golden-blue hue to the whole place and made the enormous lighthouses at the center of the transept stand out. The Lepaute lighthouses (one of which had been commissioned by the United States) were displayed alongside a collection of lenses; but one could also see the Sautter revolving lighthouse and finally the one built by Chance (the same company that had supplied the blown glass for the Crystal Palace). All

of them were clear signs of the ongoing race among European countries to control the seas, although the fiercest rivals were the British and the French. Their rivalry would, in due time, come to shape the dynamics of the Statue of Liberty's funding campaign.

Everything had started one year earlier, in 1854, when the French steamship company the Compagnie générale maritime began competing directly with the British Royal Mail and Cunard lines. Significantly, the line was owned by the Péreire brothers, who had invested a significant part of the Crédit mobilier's capital in it. The international exhibition was a media launch for this maritime project as well as for associated enterprises such as mailing and trading services across the Atlantic (to North and South America), building and arming steamships, and "tying through more numerous threads the colonies to the mother-country."[14] One can only guess, but it is quite probable that the Laboulaye brothers and their founder or printer friends welcomed the event, because it matched their dreams of extending French financial linkages across the world. But not all French colonialists were enthusiastic about the Péreires' maritime project. Suspecting the Compagnie maritime of monopolistic designs, they obstructed its work by reinforcing international trade with non-American countries.[15]

By contrast, no shadows fell on the industrial side of the Paris exhibition, since industry had become the real forte of the French economy. Outside the Palais itself, a long arcade ran along the Seine. On the ground floor, it hosted mineral and metallurgical products, agricultural goods from foreign countries, food and chemical products, and raw materials shipped in from the colonies. Then came the most impressive and spectacular section of all, that of the moving machines:

> iron masses of every kind of shape were working the most resistant metal, the hardest stone, the most difficult wood like the finest threads and lightest fabrics . . . [in] this long gallery . . . movement is everywhere [and] reveals the means

by which man has learned to harness the power of water and of steam to his needs.[16]

It was yet another triumph of the imagination for Saint-Simon's followers, who had dreamed of seeing working foundries and forges lined up along the right leg of the city-colossus. Édouard Laboulaye must surely have visited the Palais, where his brother was exhibiting his typefaces—letters in Arabic, Greek, Italian, and French, along with elaborate initials with elves tangled around the legs of letters or strange creatures dancing above or below them—and where printers were showcasing their latest presses. As for Bartholdi, if British exhibition criteria had been adopted, his *Rapp* would have been on display alongside the machines. Yet French exhibitors did not appreciate the admixture of art and industry that had held sway in London. So they had placed the *Rapp* in front of the main entrance to the Palais de l'Industrie, on the Champs-Élysées. On September 10, 1855, *La Presse* ran an article by Nefftzer, written under the pseudonym Pierre Pétroz, complementing the "wholly military energy" of Bartholdi's *Rapp*. At the end of the year, too, Théophile Gautier, art commentator for *La Presse* and the *Moniteur* (and a friend of Nefftzer's), wrote that upon leaving the Palais, he found himself looking at the *Rapp* "with a proud disposition."[17]

Napoléon III, Jerôme Napoléon, the generals Marnier and Schramm, the viscount Cavaignac, and other distinguished members of Napoléon's entourage had all contributed to financing the *Rapp* statue.[18] Nefftzer's and Gautier's gushing praise finished the job, for now that the most illustrious men of the regime knew that their money had been well spent, Bartholdi could hope to win commissions from them for all kinds of busts and paintings. On July 12, for example, he sent General Marnier his bas-relief copy of Scheffer's *Francesca of Rimini* so it could be delivered to Napoléon III's superintendent of fine arts, Count Émile de Nieuwerkerke.[19] After becoming a Colmar celebrity in Paris, Bartholdi set out to conquer the rest of France and—why not?—even France's colonies, where,

along routes opened up by traditional and Saint-Simonian bankers, urban and industrial investments were growing.

ONE OF THOSE dependencies was Egypt, where the French and the British had been competing for cotton for the last thirty years. Their competition had started in 1821, when Muhammed Ali Pasha had increased the Egyptian production of cotton by applying the peasants' *corvée* (or forced labor) to its cultivation in state-owned lands and strictly monitoring its cultivation on private lands.[20] At first, the British had capitalized on Egypt's growing production by selling their spinning machines to the pasha, but they soon realized that enabling the Egyptians to sell textiles on the European market was not in their interest. The French, by contrast, had been among the first to buy Egyptian textiles and to send their engineers to Egypt when the pasha had sought to free himself from British influence. The British had retorted by signing a treaty with the Ottoman Empire in 1838, one drastically reducing Egyptian duties so as to let the British sell their goods there.[21] By 1855, when the Palais de l'Industrie opened its doors, British business was flourishing in Egypt, and the British Bank of Egypt had just been established to the great affliction of the many French private bankers then active in that country.[22] As French bankers considered a new offensive, the French spinning machines in which they were heavily investing were beautifully displayed at the Palais de l'Industrie, along with images from Egypt captured by a growing number of artists.

The most striking photographs were undoubtedly those taken by Maxime Du Camp during his 1849 documentary journey to Egypt with Gustave Flaubert.[23] But there were paintings too, and some of them were the work of artists, including Karl Girardet, who had never set foot in Egypt. In effect, only a handful of French artists had undertaken the journey to the Middle East by 1851, and the few who had had returned with the impression that "the Orient" was impossible to convey, or, at the very least, that a brand-new style of

art was needed to portray it. This disorientation is difficult to rec-
oncile with what is often described as Europe's mechanical or even
brutalizing assimilation of "the Orient" to Western expectations.
But nineteenth-century Europeans dealing with Eastern cultures
were often less confident in their languages or artistic skills than
scholars are willing to recognize. Take, for example, Nerval, who
had traveled to Cairo, Beirut, and Constantinople in 1843. Some-
time later, he had recalled the wonder that struck him every time he
woke up in the morning and "open[ed his] senses little by little to
the vague impressions of a world that is the perfect antithesis of our
own."[24] This was also Flaubert's impression when, six years later,
he traveled to Cairo with Du Camp. Upon his return, he claimed
that he would have to learn the art of literary description anew in
order to convey to the public the landscapes he had witnessed.[25]

Truthful or not, the new scenes of Egypt and the Middle East
exposed at the Palais de l'Industrie must have been a source of infi-
nite wonder for a young and curious artist like Bartholdi. He was
probably awestruck by the sight of the distant world that had pro-
duced the colossal marvels on display in Paris and London. But he
might have looked with particular curiosity at Du Camp's photo-
graphic exhibition. Indeed, at some point during 1854, after trying
in vain to get Charlotte's and Scheffer's approval to visit Étex, and
while still working on the *Rapp*, Bartholdi had manifested a new
interest in photography. We don't know much about the circum-
stances of this new passion, although it is very possible that it was
a natural development of his work with Scheffer, who had taught
his students that any piece of art could be "cloned" and sold by
the hundreds of copies. As discussed earlier, Scheffer relied on the
help of his students and famous printers to reproduce his works and
circulate them throughout the world. But of late he had come to
depend ever more on a new form of institution: the Maison Goupil,
on the rue Montmartre. Goupil's American office would be one of
the most ardent sponsors of the Statue of Liberty in New York. For
now, however, the Maison was a Paris-based agency that bought

the rights to artists' works, made reproductions, and sold copies on French and international markets alike.[26] The Maison was not very different from how Flaubert had described the premises of Jacques Arnoux's journal *Art Industriel*: a place (significantly located on "boulevard Montmartre") where artists converged to converse in front of prints and paintings, browse new arrivals, and ponder the future of art or politics.[27]

It was probably in an environment like this, at Maison Goupil, that Scheffer and his associates had first weighed the pros and cons of photography and discussed its applications. Scheffer himself had started enlisting photographers in the reproduction of his works in 1851, and Goupil photographers were the first to use "calotype" photography to reproduce paintings.[28] Perhaps Bartholdi had even happened upon one of these discussions in person, sparking his interest in photography. Whatever the case, he began taking photography lessons at the latest on July 30, 1854, the date when Charlotte concluded a long page in her diary by noting, as if it were nothing, that "Auguste is gone to a lesson of photography." His teacher might have been the famous photographer Gustave Le Gray (who worked for Goupil and had taught photography to Maxime Du Camp), or someone else at Goupil's, but soon enough Bartholdi became an independent photographer and set up his own laboratory in a little kitchen, inside the family home of Colmar, where he would develop the negatives of photos taken of family and friends in their large garden on the Lauch, in the surrounding countryside, or even in the atelier.[29]

Auguste's interest in photography, much like his earlier curiosity regarding Étex's expressive sculpture, was the symptom of larger issues. On the one hand, Scheffer's atelier in rue Chaptal was clearly becoming too limited a space for his artistic vision; on the other, Bartholdi's omnipresent mother seemed less and less capable of acknowledging his growing need for independence. Since July 1854, Charlotte's complaints about her two children had become more frequent in her diary, and her outburst of pain more dramatic. She

seemed dissatisfied with everything her sons did: they were idle, lazy, and they came home late. Isolated, Charlotte slowly convinced herself that their new desire for autonomy was a consequence of ingratitude and even malice. "Ever since they were born," she once complained, "I could not breathe anything but the air that surrounded them, but now they are happy only where I am not . . . These children were my life and I am nothing for them." And then: "I don't want to live anymore."[30] Charlotte's account of July 2, 1854, is emblematic of her daily travails. She woke up to a "wonderful day" and "wanted to go to the country, but it did not seem her children wanted to go there with her."[31] "It is very hard," she protested. It was equally hard for her to be in their atelier while both Charles and Auguste were outside riding, or to wait for them to play the usual trios with Scheffer's musician friends, only to realize that they were too tired to join in. Similarly, it is all too easy to imagine the disappointed look on Charlotte's face when she would put her book away after Auguste showed clear signs of impatience during their "morning readings," or when she would tell him that she "was very unsatisfied with what is going on at the atelier," for "nothing is done in there."[32]

Charlotte found comfort in the reading of literary magazines like *La revue des deux mondes* and classical works such as Cicero's letters, but in very little else, for her network had been comprised solely of her children's teachers and friends; with her children gone, she found herself without a social context, either in Paris or in Colmar. And solitude made her troubles appear even bigger than they were. The shadow of madness was slowly creeping into the Bartholdi family's life, and, though Auguste Bartholdi would not seem to be touched by it, it would soon manifest itself in harrowing ways.

AT SOME POINT DURING 1854, Bartholdi's interests were piqued by a handsome painter of the new generation, one of those who had sought to capitalize on the surging fashion for the mysterious East

without taking the time to go there. He was Jean-Léon Gérôme, a slim man of thirty already notorious for his uncontrollable temperament. Someone must have warned Bartholdi that Gérôme was not a recommended acquaintance for a young man of "good character and a certain naïveté," as a colleague would soon describe Auguste.[33] At the same time though (and no matter how touchy he was), Gérôme was also praised as someone who "knows how to attract the whole world," for he was "kind, always cheerful, and love[d] company." In the evening in Gérôme's studios on the rue de Sevres and the rue Fleurus, "you have fun cheaply; you laugh like crazy for nothing. Friends come *en masse*."[34] One can hardly imagine a more striking alternative to Scheffer's pious studio, nor a more attractive one. Yet it was Scheffer and his circle of friends and professionals who most probably brought Gérôme and Bartholdi together. Both shared a passion for photography, and they had certain physical similarities as well. Both quite young and slim, they were sartorially savvy and impeccably groomed, combing their raven hair and waxing their mustaches with meticulous care. Yet there was something in Gérôme's eyes—a shrewd sparkle—that contrasted with Bartholdi's more candid expression.

Gérôme's master was Charles Gleyre, the first French artist to travel to Egypt and Syria after the Battle of Navarino (during the Greek War of Independence) opened up the sea routes of the eastern Mediterranean in 1830. For a while, Gérôme had taken the shrewder route of relying on his master's sketches (as well as those he himself had made in Naples) to depict the Middle East, without actually going there. But Gérôme's reserve about visiting exotic places was due more to a lack of financial resources than determination. Indeed, when the minister of education in 1853 appropriated a large sum of money to sponsor artists willing to display works at the exhibition of 1855, Gérôme had decided to apply with a subject set against a pastiche of Italian, Greek, and Israeli backgrounds. His plan, if he won, was to use part of the money to travel and document those places. He maintained the promise: after winning, Gérôme

left for Russia with a friend in February 1853. The experience was disappointing, however, and his plans were compromised by the Russians' ambition to expand into the Ottoman Empire and by France and Britain's resistance to it. After the so-called Crimean War was declared, in October 1853, Gérôme and his companion escaped Russia and stopped in Austria, to then follow the Danube's course to the Balkans. After a short stay in Paris, Gérôme was back on a boat, this time headed for Romania and the Black Sea; there were soldiers everywhere, and Russian troops were forcing civilians to join their army. But this was not enough to scare Gérôme away; he bravely proceeded to Constantinople, sketched his subjects, and returned to Paris by way of Malta.[35]

Bartholdi met Gérôme in 1854, and probably saw the first results of the latter's ethnographic journey reflected in his winning project, *The Era of Emperor Augustus: The Birth of Jesus Christ*. This historical composition was meant to please Napoléon III by celebrating Augustus's empire (clearly, a blueprint of Napoléon's own) as one of universal peace between countries and harmony between temporal and spiritual powers (note the newborn Christ placed under the emperor). The multilayered structure descended directly from Gérôme's reading of the seventeenth-century bishop and philosopher Jacques-Bénigne Bossuet, who had described Augustus in the act of "dominating" the "people from the Cantabrian Mountains and Asturias," while "Parthians, terrorized," surrendered, "the Ethiopians asked for peace," the Indians sought an alliance, and so forth. It was Bossuet's conclusive phrase that gave Gérôme his key idea: "all the Universe lives in peace under his [Augustus's] power, and Jesus Christ is born."[36]

One may wonder whether Bartholdi ever compared Gérôme's *Augustus* with Scheffer's *Christ*. Each in its own genre, both paintings were meant to be global icons addressing a variegated universe of religions and nationalities. But no signs of religious piety were to be seen in Gérôme's canvas: at the center of his composition, the emperor and a newborn Christ symbolized the allegiance of

temporal and religious powers, which the Holy Roman Empire had established during the Middle Ages and Napoléon III wanted to resurrect in the present. It was the victory of the political over the spiritual, of reason of state over piety. How did Bartholdi react to his friend's religious coldness and spiritual aloofness? He was probably too taken by the variety of faces, bodies, and expressions drawn by Gérôme around Augustus's throne to care about ideological issues. After all, even if Étex may have taught Bartholdi to imbue neoclassical statues with expression, neither he nor Scheffer had taught him to portray ethnic variety. Gérôme was different. He had stories to tell of dangerous travels, stories that would have made Auguste's journeys to London and Germany seem rather pedestrian. And Bartholdi had always wanted to travel east. At the onset of the Crimean War, Charlotte had written in her diary that Auguste had traveled to Calais to witness the "boarding of soldiers for the Baltic" and had quickly completed "sketches of everything [he had] seen."[37] That was something of an accomplishment given the time and the circumstances, but Bartholdi was eager to do more.

For a while, after his return from Constantinople, Gérôme had been busy completing the canvas for the international exhibition, but soon afterward he began planning a third journey, this time to Egypt, and with new partners. We don't know precisely when, but at some point between 1854 and 1855, Bartholdi must have expressed his desire to follow Gérôme on his next expedition, a desire he plausibly kept secret from his mother. By then, Bartholdi had become a good photographer and this skill, along with his flattering admiration for Gérôme, must have qualified him for the job.[38] It is very possible that part of Gérôme's generous earlier funding was still available; if not, at least his connections were, because, on October 23, 1855, the minister of education and religious affairs, the Saint-Simonian Hippolyte Fortoul, announced that the government would fund Gérôme's and Bartholdi's trip as an expedition to study the antiquities of Egypt, Nubia, and Palestine, with the aim of furnishing "the photographic reproduction of the principal monuments and most

remarkable human types of these various countries." Four days after the mission was officially announced, the minister of foreign affairs wrote directly to the former vice-consul at Alexandria and consul at Cairo, Ferdinand de Lesseps (who, as we have seen, eventually would be one of the main speakers at the inauguration of the Statue of Liberty), to ask him for a letter of introduction for Bartholdi, in the hopes that it might make the young man's stay in the Middle East "as pleasant as possible."[39]

The minister was acting wisely, for at the time, few Frenchmen in Egypt were as powerful as Lesseps. His status, however, was due less to his consular connections than to his current financial interests. Indeed, some years earlier, Lesseps had resigned from his official diplomatic post and thrown himself into the financial frenzy fueled by Saint-Simonians. In 1854, two years before Auguste sailed for Egypt, the Pasha Said had engaged Lesseps for the excavation of the Suez Canal, and, soon enough, Lesseps would create a joint stock company to finance its construction. His marketing skills were such that he would sell all the shares long before the project was completed.[40]

Because of this, Lesseps was a crucial contact for the young delegation, and Fortoul wanted to make sure that they had his backing before sailing to Cairo. He informed Lesseps that Bartholdi and his friends intended to stop in Alexandria, where— Latour recommended—Lesseps was to put Bartholdi in contact with Jules Lacour, a "pure Parisian" transplanted to Alexandria and almost certainly a merchant by profession.[41] Bartholdi, meanwhile, obtained a loan of twelve thousand francs from the Pastré family of shippers and bankers in Marseille. The main commercial middle-men between Alsace and Egypt, the Pastrés in turn put him in touch with their branch in Alexandria and their partners in Cairo, the Sakakini.[42]

Everything was set for their departure when Gérôme announced that he had to stay on in Paris for a few more days. Bartholdi, who received the news in Marseille, embarked anyway. On November

8, 1855, he boarded the Pastré Company's mail boat, the *Osiris*, together with the painter Édouard Imer and fourteen members of the "international scientific commission" traveling to Cairo to decide on a definitive strategy to dig the canal. Bartholdi's decision to depart turned out to be the right one, because Lesseps himself was part of the group. It is difficult to know if they ever struck up a personal conversation during the long voyage and, if so, about what. Lesseps was, after all, a famously conceited man, with very little time for ambitious youngsters like Bartholdi. Perhaps he entertained him with his plans for the Suez Canal, although if he did, he probably left out a number of crucial details that might have diminished the originality of his project, including that his plan had originally been formulated by the engineer Prosper Enfantin, the former chief of the Saint-Simonian colony at Ménilmontant, where Duveyrier had dreamed of his new Paris. Enfantin's Saint-Simonians had, indeed, traveled to Egypt in the early 1830s, at a time when Lesseps, then the French consul in Cairo entrusted by the pasha to impose a severe diet on his overweight son Said and ride in the desert with him, was secretly feeding his protégé plates of macaroni.[43]

The story that Lesseps plausibly hid from Bartholdi went as follows: on April 15, 1833, the ship *Clorinde* had disembarked a group of Saint-Simonians in Constantinople; after an argument, the party split up, and a number of them eventually reached the Egyptian desert.[44] Dressed all in purple and red, this curious group of people had sailed to "the East" in search of the "woman-messiah," the lady to which the woman-temple-lighthouse of Paris was meant to be dedicated. But who was the "woman-messiah"? And why was she to be found in Egypt?

ADDRESSING THESE QUESTIONS now is important, because the Statue of Liberty still bears testimony of the Saint-Simonians' quest to find the "woman-messiah" in the desert. The "woman-messiah" was the woman-worker par excellence, the champion of women's

emancipation. But why was she supposed to be in Egypt, one may ask—the place, according to orientalist narratives, of sensual pleasure, erotic excesses, and male domination? Essentially, the Saint-Simonians disagreed with this interpretation. Working in Egyptian fields, they claimed, emancipated the female *fellahs* (farmers) from the harem without depriving them of their grace, allowing them to expose their bodies, but also teaching them fortitude. The Alsatian journalist Edmond About (a future sponsor of the Statue of Liberty and a critic of French and British colonialism in Egypt) would reinforce this theory by letting one of his Egyptian characters explain that, in Egypt, veil and leisure were only for aristocratic women. Most women peasants "ha[d] legs, feet and arms naked: what was better than to cover oneself with a long blue shirt as one's only wardrobe?"[45]

For the Saint-Simonians, however, the emancipation of oriental women was not only a result of their occupation. It was also the fortunate consequence of their ignorance of the Bible. The Saint-Simonians were even more radical in their idea that, in order to work and be free, women should stop reading the Bible, because the Christian religion was based on the patriarchal subordination of women to men. The few women admitted to Enfantin's gatherings were those who, "unlike the virgins of Raphael," were not veiled, those who had deserted "the confessional and the holy mass for the dazzling communion of the ball," those who had never once opened the Gospels. To enter the rue Ménilmontant community, in other words, women had to be "rebellious angels," not unlike Byron's Devil or Scheffer's *Francesca*—"daughters of Satan whom [the Church] had crucified in their spirit, being unable to crucify them in the flesh."[46]

Enfantin had sent his men to look for this disobedient creature in Egypt, where women worked hard in the fields and dirtied their hands, without (presumably) losing their feminine sensibility. A laborer, the woman-messiah would wear jewels like a queen. "Will she live in a palace?" the Compagnons wondered, "the daughter

of kings, . . . will she have to reconcile the popular masses with the throne?" or, "will she be found amidst the dust of the fields or the mud of the city?"[47] Chanting songs and invocations, the Saint-Simonians kneeled before every female *fellah* they came across, but in doing so they roused the anger of the sultan and the French consul, both of whom agreed on expelling them to Smyrna. Here one of them, Émile Barrault, established a center of faith, but then abandoned the city after a heated argument and, taking other dissidents with him, headed for Alexandria, where Enfantin had planned to join the mission in September.[48]

Enfantin brought with him charts and numbers. Though he cared deeply for the woman-messiah, it turned out that the true reason for his visit had more to do with major engineering projects than finding an ideal mate. Enfantin knew that two canals would be enough to link the whole world together and manifest their worldwide economy of freedom: one was the Suez Canal, in Egypt, joining the Red Sea to the Mediterranean; the other was the Panama Canal, in Central America, connecting the Atlantic Ocean to the Pacific. He began in Egypt and got to work digging the canal, always willing to organize concerts and feasts to alleviate the labor. But his enthusiasm could not entirely make up for his lack of organizational skills, and when workers disappeared into the desert, taking off with their tools, his efforts to replace them with soldiers from the regular army came to nothing and the project was abandoned.[49]

Enfantin's efforts would have been for naught had it not been for his Saint-Simonian friend Michel Chevalier, who dusted them off for the journal *Revue des deux mondes* between 1844 and 1847. Enfantin himself returned to work on the project by creating the Société d'Études pour le Canal de Suez, but the times were not ripe as long as the Abbas Pasha, a religious extremist hostile to Europe, was in power.[50] The Saint-Simonians' only hope of success in Egypt depended on the youngest son of the previous pasha, Mohammed Said, the "fat prince" whose affection Lesseps had earned through

long rides and clandestine macaroni during his consular years. In 1844, Said had been banished by the new, authoritarian Abbas and resettled in Paris, and Lesseps had immediately realized that he could benefit from Said's disgrace by becoming one of his closest friends there. Lesseps's cousin, Eugénie de Montijo, had also become Napoléon's wife and, therefore, the empress of France. This, along with ten years of regular visits to Said and Abbas's murder in 1854, eventually did the trick. Recalled to Egypt to become the new pasha, Mohammed Said asked Lesseps to return as well. Once there, Lesseps waited for the best occasion to speak alone with the pasha and convince him of the necessity of building the canal. The occasion finally presented itself when Lesseps joined a royal expedition to the desert and, one early morning, had a vision:

> To my right, the East appeared in all its limpidity; to my left, the West was dark and cloudy. All of a sudden, I saw a rainbow, in all its lively colors, appear on this side, bridging the west with the east. I swear that I felt my heart beat violently, and I had to stop my imagination, which already saw in this sign of the alliance spoken of in the Scriptures the premonition that the moment had arrived of the veritable union between the West and the East and of the success of my project.[51]

Lesseps had his visions in the summer of 1854. One year later, when he met Auguste on the *Osiris*, he was going back to the desert with an international commission to decide which of the Saint-Simonian solutions for the canal would work best. One envisaged a canal straight from Suez to the Mediterranean, the other a longer canal connecting Suez to Alexandria. The mission was a challenging one, and there was no time to lose. So as soon as the *Osiris* left Lesseps and Bartholdi in Cairo, their paths diverged: Lesseps and the members of the commission proceeded to the digging site (where they would opt for the straight project), while Bartholdi remained

in the port to wait for Gérôme, who joined him on December 3. A few days later, they set sail along with Imer, the lawyer Péronnère, and the painter Eugène Deshayes, aboard a rented *dahabeah*, or traditional Nile river passenger boat, named the *Yafer Pacha*.[52]

THE *YAFER PACHA* hoisted its sails for Aswan on December 10. On its way to the first temples, the vessel sailed past what had been the legendary city of Antinopolis, which the Emperor Hadrian had built on the spot where his young lover, Antinous, was said to have drowned. Twenty years earlier the sight of the ruined city had left many a merchant and the rare visitor breathless with awe, but, since then, Ibrahim Pasha had demolished what was left of the ancient city in order to use its stones to build a refinery. So on December 19, when the *Yafer Pacha* docked at Sheikh 'Ibada and the group walked to the ruins of Antinopolis, or Antinoë, there was no longer any trace of the triumphal arch, the portico, or the three Roman temples of old. Bartholdi dashed off a sketch that translated into pictures what Flaubert had said of the place: "holes, gray mounds, a palm here and there—the Arabian mountain chain in the background—the ruins of a bath that seems in all respects an Arab bath—on the ground, trunks of marble columns."[53]

After seven days of sailing, the *Yafer Pacha* landed at Qena, a center of cotton manufacturing that supplied vast sectors of Europe's flourishing industries. Auguste and Gérôme ventured into the bazaar, where goods from across the Arab world and the Red Sea region were traded and young Nubian girls offered themselves to foreigners for *baksheesh*, the local term for a small sum of money. There, they made sketches of faces and costumes, and, who knows, followed beautiful veiled women to the doors of their houses, as Nerval had done before them. At Qena, but on the opposite side of the Nile, rose the Temple of Hathor with its famous *mammisi* (sacred birthplace). Surrounded by a mix of Christian basilicas and Roman buildings, the Temple of Hathor was a huge box-shaped

edifice built in the first century BCE. The facade featured a series of columns surmounted with capitals bearing the face of Hathor, the goddess of motherhood, whose bovine face Auguste photographed (either during his ascent of the Nile or later on his way back to Cairo). On the other side of the temple was a Roman-age *mammisi*, propped up by columns ending in leaf capitals, on top of which monstrous figures of the god Bes, half monkey and half lion, grinned contemptuously.

The German philologist Creuzer had found these goddesses of fertility and pain frightening; for him, the Greek goddess Eileithyia was "the first mother and the first spinster," a "terrible and wicked" goddess.[54] But Bartholdi had gone to Egypt as a photographer, not a philologist, and in that ancient place of pain and pleasure he discovered a new kind of architecture, one that he may have first seen in London. The colossal sculptures in the British Museum, however, were ghosts in the spotlights of its dark halls; wrenched from their original settings, they were mere shades of their former selves. In the desert, Bartholdi must have realized that the statues, buildings, and colors of the landscape formed an inseparable whole. Huge as they were (by weight, they comprised a third of the whole column), the faces of Hathor could be independent sculptures, yet the architect had decided they should surmount still larger columns, which in turn were colored and carved like a painter's panels. There was only one explanation for this choice: in ancient Egypt, to be an artist meant also being an architect; it meant making supporting structures, sculpting anthropomorphic statues, and decorating walls with figures and colors.

There was plenty to think about among those columns and their monstrous faces. For if it was true that the British Museum had unveiled to the likes of Scheffer (and probably Bartholdi as well), the possibility of bringing life and expression to statues and bas-reliefs, or to add grotesque details to an imitation of nature, the Egyptian ruins offered an entirely different sensibility. Here, in the shadow of gigantic anthropomorphic temples, which still bore

traces of their once bright colors, Bartholdi stood face to face with a titanic form of art that used color, shape, and size to produce a single comprehensive effect. It was proof that artists could master architecture, painting, sculpture, geometry, and technology alike. It must have been an empowering experience—at least for Bartholdi. His traveling companions cared little for the temples and how they were built.

Gérôme had grown a beard and, when they landed in Qena, had his head shaved; seized by Nerval's mimetic instinct, he hoped to be mistaken for an Egyptian: "I am dark enough for it," he said.[55] Bartholdi was clean-shaven and wore his hair in a turban, although his colorful cotton clothes were perhaps a bit too vibrant for local conditions. A photograph from the time depicting him and Gérôme side by side may suggest something more than a simple friendship.[56] Little is known of Bartholdi's sentimental life at the time. Not long after his Egyptian trip, Charlotte would begin sending clear signals of wanting her son to select a future wife, but he seemed to inhabit predominantly male circles, and men were the subjects of his works. With the exception of his bas-relief of Scheffer's *Francesca da Rimini*, no traces of Gérôme's curvaceous models can be found in Bartholdi's works. In Egypt, where the women were always covered but the men were tanned and more lightly clothed, Bartholdi seems to have developed a fascination with the male body, which would grow into a marked disposition for sculpting Michelangelesque physiques and nude men, both young and not so young. This in itself says nothing certain about his sexual and romantic preferences, but it does suggest that it was the Egyptian journey that led Bartholdi to explore a more erotic dimension of art, previously absent from his works, and that this eroticism found expression in Bartholdi's fascination with male bodies.

Life onboard the *Yafer Pacha* was a rather monotonous affair, punctuated only by the occasional hunting expedition, the amazingly dramatic discovery of a mummy (which the group unwrapped to look inside), and stops at coffeehouses. None of the passengers,

in their letters and diaries, appears to have been bewitched by visions like those of Nerval or Flaubert, who saw in the temples and pyramids gigantic vestiges of a long-lost civilization, perhaps one that, according to apocryphal myths, had populated the earth before the arrival of humans. And yet, years from then, Bartholdi would remember to have been "filled with profound emotion" in the presence of Egypt's gigantic sculptures, because they were witnesses "of a past that to us is almost infinite, at whose feet some many generations, so many millions existences, so many human glories have rolled in the past."[57] These words date from 1885, and were directed at the same American public as the Statue of Liberty. It was the closest Bartholdi ever got to revealing his statue's formerly Egyptian identity. And perhaps he said too much, for one could easily interpret his words to mean that not even the crossing of the ocean had helped the Statue of Liberty shed her African past. Is she, like the statues Bartholdi saw in Egypt, intended to survive the vicissitudes of time, to be a testament to future generations? In the end, will the backdrop for the Statue of Liberty be less a busy port than a desolate wasteland?

The Egyptian colossi certainly give the impression of being survivors of some apocalyptic conflagration. This was, at least, Flaubert's impression when he visited Karnak, with its colossal, "bell-shaped" columns, running in two rows around the hall of the Temple of Amon (god of fertility and the sun). Flaubert imagined himself in a ghost town, one once inhabited by superhuman beings. Walking along a passageway lined by columns, he imagined that it used to be a palace for "giants," with "stone grates still on the windows" that gave "an idea of formidable beings."[58] Perhaps Bartholdi had similar impressions when the *Yafer Pacha* left him and his companions at Luxor to visit the famous colonnade of Amenhotep III, the western portico with its papyrus-shaped columns, and the various buildings (halls, altars, storehouses) of the sanctuary of Amon. Images of the main entrance to the temple, reproduced in prints and engravings, had traveled all around the world, showing two colossi "buried to

the chest" on either side of the pylons, against a wall depicting scenes of war, while a third colossus was completely buried except for its "polished granite cap, which sparkles in the sun," as Flaubert said, "like a pipe of German porcelain."[59]

But here Bartholdi did not focus his lens on the temple, nor on the statues. It was the obelisk that he admired, "the brother" of the one standing in the middle of place de la Concorde, where— Bartholdi wrote to his friend Émile—"we were together only three months ago."[60] The adaptability of Eastern monuments to Western cityscapes struck a chord with Bartholdi, who increasingly became interested also in the surroundings of Egyptian art, which he so far had contemplated only outside its natural context. And context, he came to realize, mattered a great deal. Indeed, it was impossible to pass through the ruins of ancient Egypt without, on some level, contemplating the passing of the eons and the present's inevitably apocalyptic future. It was like capturing a glimpse of the face of the earth after a cataclysm had destroyed it. Yet Bartholdi seemed to prefer Egypt's lost past to its present. He lamented the "awful disorder" of the country's cities, which offended his eyes with images of rusting machines, "cavalry trumpets, . . . instruments of astronomy along with torn butts of rifles" piled in the harbors. Like a good orientalist, Bartholdi was more disgusted than fascinated by the urban chaos and the people who lived in it. Shamelessly, he approved of the fact that "we Europeans are autocratic with the [local] people," and confessed to have himself "entered everywhere and hit all those who gave the impression of not understanding him."[61]

Bartholdi seemed to find his bearing, not to mention inspiration, among ruins. At Luxor, he took pictures of the high pigeon lofts; the court and boat of Amon, Prisse's garden, where Flaubert and Du Camp had been greeted with bouquets of roses; and the old medieval mosque.[62] But his true epiphany came at Thebes, where he glimpsed the world's grim future. Nerval, too, had seen his own and the world's destiny in places like Thebes. For him, it had been as if he were chased by one of Albrecht Dürer's famous

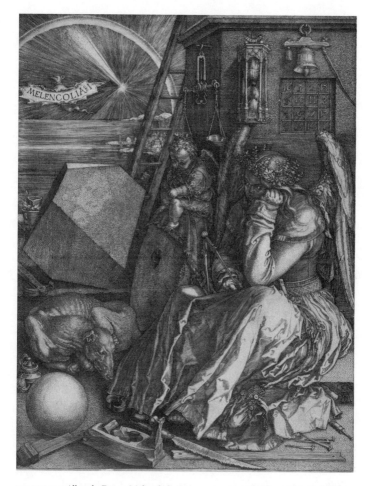

FIGURE 11.1. Albrecht Dürer, *Melancholia I*, 1514, engraving, 24×18.5 cm, Harris Brisbane Dick Fund, 43.106.1, Metropolitan Museum of Art, New York.

figures: the sullen angel, both man and woman, with long hair, angelic features, and a frowning face, sitting with knees bent, while behind it, on a cerulean background, a comet (symbol of the apocalypse, according to Saint Thomas), a bat, and the sign of Libra (announcing the end of the world) can be seen, in what was a kind of pictorial pendant to Michelangelo's *Penseroso* (Figure 11.1).

Bartholdi's vision was more composed. His mood was of course deeply melancholic, but not to the point of neglecting the details of his architectural surroundings. The epiphany occurred at the Ramesseum, the mortuary temple erected west of the city in honor of Ramesses II, where fragments of the colossal statue of the pharaoh were scattered in the sand — "two vast and trunkless legs of stone . . . near them, on the sand, half sunk, a shattered visage . . . [with a] frown . . . wrinkled lip, and sneer of cold command" — about which the British Romantic poet Shelley once penned his celebrated verses on the evanescence of human greatness.[63] Bartholdi photographed the broken statue of "Ozymandias," but he seemed more interested in the line of human-shaped pillars depicting Osiris, not far from the fallen giant. Like the columns of Dendera, these pillars were structural features of a building yet looked like statues, real statues, with their arms folded across their chests, their hands clasped to hold a shepherd's crook and whip. Bartholdi took a picture of the colossal statue lying in pieces on the sand next to the surviving columns. Like many of his photographs, he probably intended it for Gèrôme to make a popular painting out of, but he may also have been attracted to the statue by a technical insight, namely that colossi could have architectural functions too. Though imbued with human features, they could also serve architectonic purposes as columns, pillars, towers, and even buildings.

Considerations of this kind would eventually shape the Statue of Liberty's function and inner metallic structure, even if the monument itself would stand alone as a traditional statue. At the time of his Egyptian journey, however, Bartholdi was only just starting to think about architectural longevity and holistic art. Finally, in Thebes, he had a crucial revelation. Walking along the melancholy ruins of the city, he came to the site of what was once the most spectacular temple-tomb of Thebes. The work of Amenhotep III, the temple was said to have housed hundreds if not thousands of statues of all sizes and materials; it was so large it seemed capable of holding the floodwaters of the Nile. Little remained of

the temple except for two sixty-five-foot colossi in quartzose sand-stone that guarded the entrance (and were periodically submerged); they had survived the centuries nearly intact. These colossi were "portraits" of the pharaoh, positioned (as is often the case with Greek monuments as well) at the point where the sun rises at the winter solstice. Legend has it that, in antiquity, when the sun dis-appeared, ceremonies of silence and pain were held around the colossi, but, with the return of summer, when the sun inundated them anew, one of them (the one divided in two by a long crack and with a face still not completely weathered by the wind) greeted the rays with its voice, while the sacred birds left the sepulcher of Osiris to announce "a new life" and the priests' chants filled the rocky valley. Seven notes were said to come out of the colossus in response to the "seven vows" pronounced by the priests, one for each known planet, one for each string of Orpheus's lyre.

The colossi captured Bartholdi's eye, for he took a large picture of them, the first of a still-standing Egyptian statue since he started his ascent up the Nile.[64] The most obvious reason for the picture was that Gérôme intended to paint them, which he subsequently did. Another, more appealing explanation is that Bartholdi, like so many other tourists, had been seduced by the astrological myth associated with the statues. According to an old legend (some even say an Egyptian one), the speaking colossus was a likeness of Memnon, a strikingly handsome Ethiopian king and son of the goddess of dawn Eos who, having come to the aid of Troy with his African troops, armored entirely in bronze, met with death at the hands of Achilles. As the son of Eos, Memnon corresponded to the "morning, daybreak, source of light," but he was as dark as an Ethiopian, indicating "the uncertain boundary that separates day from night." Perhaps it was the idea of a stone giant being able, simply by virtue of its position, to evoke the passage from night to day, from darkness to light, that attracted Bartholdi. The colossus, Creuzer had said, was a "solar watch" or "gnomon": "the symbol on earth of eternal light."[65]

Bartholdi's fascination with the myth of Memnon would eventually influence the meaning and structure of the Statue of Liberty, a colossus crowned with seven solar rays and intended to shed light at night or dawn. But I would argue that the colossi shaped Bartholdi's imagination in a broader way as well, by convincing him both that architecture could be used to serve a variety of figurative purposes, and that, in colossal form, it could withstand the travails of time and bear testimony to future generations. This, after all, was the lesson to be learned at Egyptian archaeological sites, where decorative yet functional constructions such as pillars continued to convey meaning after millennia. The colossi of Memnon were a paradigmatic example of this total and immortal art. Even if they were not weight-bearing columns, but leaned against an entry wall, they had been built in such a way as to outlast the wall, its pylons, and the whole temple that rose up behind them. They had withstood earthquakes (as the crack on the speaking colossus revealed), the endless floods of the Nile, perhaps periodic ablutions, and the incessant *khamaseen* wind. To uncover their secret meant grasping the secret of the immortality of art—a secret that, in the nineteenth century, would have permitted statues to be constructed that would last until the end of time, until the apocalypse.

If nothing else, the Ethiopian roots of the myth of Memnon led the travelers to descend into the so-called black heart of Egypt. As the boat neared Esna, the landscape changed, the Ptolemaic style mixed with the Roman, and the blue blouses of the *fellaheen* gave way to white garments, which contrasted with the ebony-colored faces of the people.[66] Bartholdi's mission was to study not only "the principal monuments," but also "the most remarkable human types of these various countries," that is, of Egypt, Nubia, and Palestine.[67] The men and women proved to be more forthcoming in front of a brush or pencil than in front of the camera lens, but they were not "easy to pose" in any case. Bartholdi found that the problem was more serious with subjects of the "feminine sex": even when it seemed that they were posing, Bartholdi wrote, they did not "stay

in position for an instant."[68] With great virtuosity, he managed to collect a notebook full of sketches and drawings of a remarkable number of young and old men and women (though the women are rarer), variously dark and light skinned. Meanwhile, he continued to take photographs of numerous columns, the cylindrical ones of the vestibule of the Temple of Horus (the solar son of Isis and Osiris), half buried by the desert, and the equally sunken, but even more imposing, ones of the Temple of Kom-Ombo, dedicated to Horus and Sobek, the crocodile god.

THE PARTY ARRIVED in Aswan on January 7 and remained until January 15. While there, Bartholdi and Gérôme took their camera and charcoal crayons and made their way through the streets of the city. They visited the courtyard of a dyer, with copper buckets full of indigo, henna, and alizarin (the red tint used by Mulhouse merchants to paint floral motifs on Indian cloth); ate freshly picked dates and salted fish; and bought rubber, ostrich feathers, and wooden blocks from Ethiopians, Nubians, and Sudanese who had come to the banks of the Nile. In the markets they saw their first Bisharin, nomads with "coppery skin and large black eyes, who traveled around a bizarre, little known land, extending from the south of Aswan to the Red Sea."[69] Bartholdi had already heard of these places from Kuhlmann, a young man from Colmar who had visited the area in 1849, en route to the Zanzibar consulate, as well as from a French trader he had met on his trip from Marseille to Alexandria named Vayssières, who had visited Abyssinia and Yemen in 1848 and who now, in 1855, was headed for Sudan. It was he who transformed Bartholdi into an "authentic Arabist," inspiring his deep curiosity for the Arab and North African world.[70]

Bartholdi saw very little of that world during his cruise along the Nile. But neither was he in any rush to turn back. He still had time to see non-Romanized parts of Africa, visiting (on January 15) the island of Philae, a fortress of the Theban dynasties against

Abyssinian incursions, where the Temple of Isis (not yet submerged by water) rose up, showing where the Egyptian and African worlds joined. The closeness of the waters to the temple had given rise to the belief that the tomb of Osiris, whose remains Isis had crossed the seas to search, could be found on the island. At that point, it was said, the Nile flowed "from under the feet" of Isis. But Philae was also one of the first places where, in the Ptolemaic era, the cult of Isis had assumed the syncretic aspects around which Apuleius would construct his famous fable of magic and adventure, *The Golden Ass.* Here Isis had come to be called the "Queen of the People of the South" and "Queen of the South."[71]

The *Yafer Pacha* went no farther than Philae before changing course and returning through headwinds to Cairo. But Bartholdi's thoughts remained with Philae and the southern world, and the Arab one he could see from there. Perhaps tested by living in such close quarters with his traveling companions, Bartholdi considered leaving them and turning not toward Palestine but to the south, or even crossing the Red Sea to reach Yemen, which exerted a "magnetic attraction" on him.[72] But there were other facts to consider as well. Charlotte's letters from Colmar were filled with anxiety and requests to come home early.[73] The reason for her anxiety, she wrote him, was that the *Rapp* had been sent back from Paris and, all wrapped up, was waiting in Colmar to be inaugurated later in August. The plain truth, however, was that she could not stand the idea of being separated from her son. She even wrote to the Egyptian pasha to ask him to find Auguste and deliver him her letter.[74]

But the pasha, alas, was not one of Charlotte's male friends in Colmar, gallantly submitting to her requests. And this time, Auguste did not hurry home. Sure enough, the separation weighed on him as well, and made him write to Monsieur de la Rozerie, a relative of the minister Fortoul, to explain that he had given up the idea of going to Palestine and Syria during the cruise along the Nile. But Auguste still thought he had time to make another, shorter

trip before returning home to Colmar. To de la Rozerie, Bartholdi expressed his intention of journeying to Suez, and from there embarking for Hejaz—the region of the sacred places of Islam—in order to then cross the Red Sea on his way to Suakin, one of the coastal centers of the Sudan.[75] But he did not. Instead, around April 4, 1856, we find him in Aden, on his way to Mocha and with the secret intention of visiting Sanaa, the capital of the old kingdom and a dangerous place where a young man should not venture alone, as his colleague, the painter Léon Belly, had warned him.[76]

Sure enough, those were areas in which both the French and English had important trade interests. Bartholdi was probably informed about how and why the French were in the region during his two days in Cairo, if not earlier, when he was traveling from Marseille to Alexandria. Among the members of the Suez Canal commission, whom Bartholdi had met on the *Osiris* and with whom he had ventured up to Cairo, was the great French expert on Middle Eastern trade Barthélemy Saint-Hilaire. Even circumstantially, however, Bartholdi would have learned that nearly all the Red Sea trade revolved around one key commodity: coffee. No longer grown in Mocha, but in Hudaydah and Luhayyah, the coffee trade had come to be concentrated in the Arab markets of Jeddah or in their coastal branches, with most coffee then shipped through the English port of Aden.[77]

As he made preparations for his journey in March, Bartholdi visited Old Cairo. He toured the city with Belly to discover new faces and new monuments. Perhaps with him, perhaps alone, he visited the pyramids and the Sphinx, but he neither photographed nor drew them. He limited himself to carving, "in a small corner my initials with the date 1856."[78] This was the last sign Bartholdi left before disappearing on his travels. He was probably not alone, although it is now impossible to identify his companions. We know, however, that, at some point during his Arabian journey, Bartholdi lived in a house in Mocha (already famous for its coffee) with a certain G. B. Périer. It is Périer himself—a mysterious character about

whom we know very little except that he boasted of an exclusive knowledge of the Arab world—who reminds Bartholdi, in a letter of February 1857, of the time spent together in a house in Mocha and of his fears when Bartholdi announced to him that he wanted to reach Sanaa, where Englishmen were often robbed, killed, or burned alive.[79] As it turned out, Bartholdi did not listen to Périer and braved the dangerous road from Mocha to Hudaydah without informing his friend. He did not venture alone, though. He was almost certainly accompanied by the secretary of one of the leading trading houses operating between the Red Sea, the Sudan, and the Ethiopian border: it was the house of the brothers Sawa, Greek businessmen who enjoyed the protection of the French consulate and worked for the British. Maybe at Aden, maybe at Mocha, Bartholdi drew the portrait of Sawa's secretary, then left a fearful Périer to secretly take the road for Sanaa (or Sheba), where Europeans were viewed with suspicion and had more than once been the victims of aggression. Hudaydah was the point of departure for caravans heading to Sanaa. A drawing of Girgis Sawa suggests that Bartholdi may have been hosted by him before joining the caravan to Sanaa.[80] But it seems he was intercepted by locals who, suspicious of his cameras and equipment, forced him to return to Hudaydah. The last portrait that Bartholdi had time to draw before leaving the realm of Sheba was of a woman with long, narrow eyes, crowned with some sort of diadem, a star or cross drawn on her forehead and hair gathered up at the nape of her neck and wrapped in a scarf (Figure 11.2). Perhaps he was impressed by her beauty, or maybe she was a relative of the Sawa family. Who knows, she might have reminded him of the Saint-Simonian woman-messiah that supposedly awaited the world in the region. Whatever the reason, Bartholdi had, so far, honored no other model, and certainly not a female one, in this way. Depicted from the front and in profile, the *jeune femme* looked like a girl of noble birth, and her hairstyle in the back would resurface decades later, without the curls but otherwise almost identically if seen in profile, on the Statue of Liberty.

FIGURE 11.2A (*left*): [Frédéric-] Auguste Bartholdi, "Fille du royaume de Sanaa — (Arabie)," (1856), graphite on gray-blue paper mounted on hardback support, 0.265 × 0.198 cm, Musée Bartholdi, Colmar.

FIGURE 11.2B (*right*): [Frédéric-] Auguste Bartholdi, "Fille du royaume de Sanaa — (Arabie)," (1856), graphite on gray-blue paper mounted on hardback support, 0.263 × 0.198 cm, Musée Bartholdi, Colmar.

BARTHOLDI RETURNED to Colmar after Charlotte insisted that he be present at the inauguration of the *Rapp*, which was wrapped in the cloister of the Unterlinden and waiting (somewhat embarrassingly, it would be said, given the commander's former military might) to be installed on his pedestal. In Colmar, people rejoiced over the allies' victory in the Crimean War, but grieved at the news that, before reaching France to celebrate his victory, Armand Joseph Bruat, the former Napoleonic admiral, had died of cholera while his ship was rounding Cape Matapan. Bruat had become governor of the French West Indies and lately assumed the command of the French Navy in the Black Sea during the Crimean War. Bartholdi must have suspected that Bruat's tragic death would bring a golden opportunity for him, for soon enough public subscriptions were open for the erection of a monument in the admiral's honor. The *Rapp*'s success had made Bartholdi

famous in Paris; now its unveiling in Colmar would consolidate his prestige in the city and lay the groundwork for him to be awarded the *Bruat* commission. Either by choice or fate, Bartholdi was to become Colmar's official sculptor of war heroes.

Tellingly, the unveiling of the *Rapp* was set for August 15, 1856, the feast day of Saint Napoléon. The holiday was widely observed all over Alsace, but the people of Colmar also decided to bring forward to that day the agricultural fair, usually held on September 8, so as to make the celebrations more solemn. The night before, on August 14, a large transparency showing Napoléon at the battle of Austerlitz was exhibited in the main street, which ended in the Champ de Mars. It was lit by a thousand Chinese lanterns, which possibly also lined the other streets of Colmar that day.[81] Never before had a monument brought to that remote corner of France attracted such important people, like the great Napoleonic general Marnier. An envoy was even expected from *Illustration*, one of the greatest illustrated magazines in Paris.

The generals and journalists expected a military opening, perhaps with the recital of a prayer. Instead the festival began with a procession of workers, local authorities, and firemen with their band, who crossed the city jubilantly bearing pyramids and triumphal arches of vegetables and flower garlands. They headed toward the fields, where farmers (their oxen yoked) challenged each other to see who could plow the most and the fastest. Only after the contest, at around two in the afternoon, did the real Napoleonic moment, the military parade, begin. It ended at the feet of the monument to Rapp, still hidden under a drape. Around the shrouded statue stood the textile industrialist Hartmann, patron of the fine arts and of the Schongauer Society; General Schramm, president of the Paris committee; and of course Marnier, General Rapp's old aide-de-camp. At the sign of the mayor, the veil dropped, and the colossal *Rapp* appeared. In the commotion of the moment, Rapp's relatives, seated near Charlotte, probably did not notice that the *Rapp*'s face looked almost nothing like the good old general. Expressive in its

features, it was the face of evil as Étex would have depicted it, with Rapp shown "standing on the bastions of Danzig, in an attitude of defiance: head high, hair disheveled . . . his left hand holding his sword, his right making . . . a gesture of indignation."[82]

General Rapp's heroic stand at Danzig would take on even nobler significance as France emerged triumphantly from the siege of Sevastopol. In Alsace, however, the memory of Napoléon I and the Grande Armée was associated with times of economic boom as well as military success, and so it was that industry, agriculture, and art that was paraded in celebration of the *Rapp*. The procession was opened by six horses pulling a cart full of fruit, flowers, and young girls who cast smiles and roses to the crowd as they rolled by. Then came representatives of the various trades, each accompanied by symbols. There were the saddlers; the shoemakers, with a great glass sphere topped by a shoe; the glassblowers, with a sea of glass stars of every color; and after them the watchmakers. Then came the winemakers—some of whom were purchasers of Charlotte's grapes—who also happened to be the real heroes of the feast, carrying a symbolic Noah's Ark, two images of Caleb and Joshua, and the "grapes of the promised land." The children held up barrels overflowing with "luxurious grapes that the sun [had] caressed ahead of time, while other youngsters put them in the press" or gave out the first wine of 1856 to taste.[83]

It was the white wine of the region, sweet and fruity, that Switzerland and Germany knew all too well, and that, according to the myth, had made Hercules drunk. If the Péreires' Compagnie générale maritime's design to improve naval connections between France with America succeeded, the Alsatian Riesling and Traminer could easily be sold in America from La Havre or Bordeaux along with other Alsatian products. Indeed, French goods were reaching the four corners of the earth thanks to Napoléon III's industry and economic policies, particularly his 1851 treaty of free commerce with England. With the expansion of France's maritime ambition, its ports had become magnets for all kinds of entrepreneurs and

speculators. And in the competition that ensued among them to build small-scale versions of Paris on the sea, opportunities were arising for young sculptors to find high-paying commissions. So we should not be surprised if, after the inauguration of the *Rapp* monument, Bartholdi turned his sights first to Bordeaux—the city that more than any had become emblematic of the wine trade and of exports to the New World—and finally, to the New World itself.

CHAPTER 12

FABLES OF MADNESS

WHILE BARTHOLDI was still busy learning sculpture in Scheffer's atelier, Laboulaye had made an astonishing discovery, the circumstances of which — if not its exact timing — would remain impressed in his mind for the rest of his life. Laboulaye was "rummaging among the old books exposed for sale on the quai Voltaire — the year was either 1852 or 1853 — when he was suddenly attracted by the title of an English book sitting among long rows of wooden trays," side by side with "the strangest jumble of old books." He leafed through it, rushed to buy it, and then, "with his eyes still fixed on its pages [he] resumed his walk towards the Champs-Elysées," where he sat down and devoured the book to its last page. Afterward, he paid a visit on Armand Bertin, the editor of the *Journal des débats*, and suggested that he should present the book to French readers.[1]

The book in question was a collection of the sermons of the Reverend William Ellery Channing, a famous Unitarian minister of Boston. Unitarians were known for rejecting the dogma of trinity, but Channing added to that rejection by stressing his belief that men could redeem themselves through their reason, because God had made all rational men "in his own image" and had given them the liberty to find the truth by going down different roads and exploring different religious philosophies. Reading Channing must have given Laboulaye the flattering, but also slightly surreal, impression of reading his own thoughts.[2] For Laboulaye, too, believed that redemption was to be gained in this life, that men were made in God's image, and ultimately, that world religions shared the

same kernel of truth. The similarity was striking enough to attract Laboulaye's attention. But there was more.

Not long before Laboulaye discovered Channing, something had happened in France, a deep movement of conscience that had changed the way the French thought about humanity, and the institution of slavery in particular. Chronicling the misadventures of Uncle Tom, the young Harry, and Harry's mother, Eliza, three slaves trying to escape from Kentucky, and their white benefactors, Harriet Beecher Stowe's *Uncle Tom's Cabin* had made a deep impression on French public opinion.[3] The French, too, had written harrowing novels inspired by American slavery, such as Gustave de Beaumont's *Marie, ou l'esclavage aux États-Unis* (1839) and Prosper Merimee's *Tamango* (1829), but none of them had equaled or even approached the success of Stowe's novel.[4] With eleven print runs in 1852 alone, it was also adapted into popular plays and repeatedly performed in French theaters. Images of blacks tied to trees and tortured by their master's sons, of husbands being separated from their wives and children to be sold, shocked a France accustomed to the softer voices of its own abolitionists. Most French abolitionists were, indeed, gradualists, who asked for the progressive emancipation of slavery and disapproved of the British Abolition Act, which in 1833 had banished slavery from most parts of the British Empire and ordered the payment of indemnities to slave owners. The few French radicals who supported the British methods doubted the progressives' "false" ways and did little to cooperate with them.[5]

We don't know when Laboulaye first entered the ranks of the abolitionists. It is possible that, without the fuss made by Stowe's novel, he would hardly have noticed Channing's sermons. Indeed, as he explained, Channing's thesis of man's divine nature was principally intended "to attack slavery" and its spread through the world.[6] Yet Laboulaye was puzzled by the actual policies of abolition that Channing advocated, for Channing's plan was to emancipate all American slaves at the same time, but keep their liberty "nominal"

until they learned "to regulate themselves." This learning, Channing advised, was to happen in free public schools or in specialized institutions for professional and adult education that would last until the freed slaves were ready to become active citizens.[7] Channing was quite clear on this point, but not clear enough for Laboulaye, who wished that the reverend had been even "more explicit" about the fact that to "emancipate the slave and make an active citizen out of him were two different things."[8] Immediate emancipation clearly disturbed Laboulaye, who thought that Channing's project of state tutorship had to precede any other forms of enfranchisement.

Laboulaye's skepticism had to do with what he had learned from Channing, but also from Stowe. After publishing *Uncle Tom's Cabin*, Stowe had gathered a series of firsthand documents to prove the historical veracity of Uncle Tom's story. Published under the title *A Key to Uncle Tom's Cabin*, Stowe's documents proved an irreplaceable source of evidence for Laboulaye. Part of the anthology aimed to demonstrate that growing international demand for Southern cotton, rice, and sugar was prompting planters to transform slavery into a flourishing, expansive "industry," whereby owners would breed slaves to sell on the world market.[9] This was one of the many bleak scenarios that were circulating; another consisted in having freed American blacks sent to Africa to colonize the continent.[10] Laboulaye had learned from Channing that the project of African colonization had won the support of notorious figures in America, including the Kentucky statesman Henry Clay. As for Stowe, her *Uncle Tom's Cabin* ended with the protagonist George Harris moving to Liberia.[11] Stowe would come to regret her choice in 1853. By this time, however, Laboulaye had already developed a clear idea of the extent to which Northerners shared the Southerners' bias against blacks.[12] Indeed, it was Laboulaye's conviction that Americans "had an antipathy for the blacks that people from Catholic colonies, namely Spanish, Portuguese and French, had never shared." The way in which black slaves were treated in the

French West Indies revealed the weakness of Laboulaye's point. Yet despite all his patriotic biases and cultural generalizations, Laboulaye was (although awkwardly) close to revealing a shameful truth that Americans, even enlightened ones, would have liked to keep secret: namely that "the black was looked at with horror and disgust by Americans, . . . in the free states and in the South alike."[13] Laboulaye certainly was prescient, because historians are only now starting to reveal the whole extent of racial prejudices in the Northern states, but he was also strategic in his choice of arguments and sources.[14] For assuming that whites' prejudices against blacks were deeply engrained in the American population was the natural premise of Laboulaye's next argument, which was that "immediate" emancipation would have resulted in outright racial war in America.[15] The only alternative he could imagine was to postpone emancipation until, as Channing had suggested, a public educational program could "straighten" the "souls that slavery had bent" and help black people realize their intellectual and spiritual potential.[16]

Later Laboulaye would sketch a second and gloomier alternative involving black segregation. For now, however, the discovery of Channing widened his political horizons in ways he never could have anticipated even a few years earlier. For example, Channing had shown that publicly funded education could elevate not only blacks, but the poor in general to "the dignity of other human beings."[17] Immediately, Laboulaye saw the opportunity to solve the social question in France without resorting to socialist solutions or touching the institution of private property. But Channing had not been alone in championing this cause, and following his example, Laboulaye turned to other reformers, such as the Massachusetts educator Horace Mann, the former governor of Massachusetts, and Harvard president Edward Everett, who had supported "free, public schools" ("common schools"), where rich and poor were equally instructed in how to be good citizens.[18] Mann and Everett were secular figures; still, they shared Channing's evangelizing way

of spreading ideas and converting others by traveling across the country and addressing popular audiences, using a more accessible vocabulary and a less frightening approach. Laboulaye not only made their ideas his own; he also emulated their style. As he had done with Franklin in the past, he now played the role of a Boston reformer in Paris. With the backing of the Société Franklin for the establishment of public subscription libraries and the Société de travail, Laboulaye toured France giving popular lectures on the topic of public education, adult education, and the importance of public libraries.[19]

Laboulaye's theatrical performances and the novelty of his plan earned him a place of relevance among the rising generation of liberals. By 1857, when Émile Ollivier, a brilliant lawyer from Marseilles, stood as an opposition candidate for election to the Napoleonic parliament, Laboulaye had refined his new American persona, borrowing generously from Channing and his Massachusetts colleagues. Liberals started to notice him, and Auguste's friend Nefftzer, who had just become director in chief of the Presse, rallied the whole magazine behind him. He liked Laboulaye, Neffzter said, because he "possessed a rare thing in France, the just and lively intelligence of liberty."[20] Nefftzer, however, had other, more theoretical reasons to be supportive of Laboulaye, such as their common interest in German scholarship. As mentioned earlier, Laboulaye was a devout scholar of German philosophy, mysticism, and legal history, while Nefftzer had studied under the influence of Strauss. So at the end of 1857, Nefftzer asked Laboulaye to collaborate on the establishment of the Revue germanique, a journal founded by Protestant, Jewish, and liberal Catholic scholars as a forum to establish a cultural bridge between French and German intellectuals with a particular focus on biblical exegesis.[21] Laboulaye was happy to accept. He immediately became part of the Revue's committee, a position from which he helped Nefftzer find contributors and review articles. It is possible that, in exchange for his services, Laboulaye asked a personal favor of Nefftzer. And it

was probably as the result of this favor that Laboulaye met Bartholdi for the first time.

LABOULAYE'S AND BARTHOLDI'S paths had come close to intersecting many times, but what eventually brought them together was neither art nor politics. It was Nefftzer and the mental illness of Auguste's brother, Charles. Last time we saw him, Charles was studying under Ary Scheffer and accompanying his brother on his furtive expeditions across the city. Charles was as talented as Auguste, perhaps even more so, but his spirit was more restless. Charles had always worried Charlotte because his "heart"—she said—was "excessively sensitive"; "it was necessary to prepare him to receive the many disappointments of the world," for the "good boy cannot endure anything bad." But Charles "learned easily," having "an excellent memory and a desire for study," strengths that Charlotte said came from his father, who had taught him at the age of five to read in two languages and to do "a little writing and mental calculation."[22] After secondary school, Charles enrolled in law school, but worldly life took him away from his studies and he became sullen and gloomy. "He becomes more intractable every day," lamented Charlotte; "not one day have I happened to see him good, kind, or obliging." But these were also the torments of a possessive, overprotective mother, unable to control her son's life. "Where is he?," she would ask when he was not at home. "Who is he with?"[23]

Charles was, in fact, running into trouble in Paris. Perhaps as early as 1855, he was living with a rich German widow, a certain Mrs. Heller, a diamond dealer who kept him for three years and then asked Charlotte for 11,500 francs to reimburse her for old loans.[24] Charlotte defended her son and blamed his troubles on the temptations of the capital city. The best thing to do, she thought, was to take Charles away from Paris and back to Colmar. It helped that, because of Haussmann's work at rue d'Enfer—on the left arm

of Haussman's anthropomorphic Paris—the Bartholdis already had to leave their apartment for a while. Meanwhile, Auguste contacted his friends in Paris and Colmar to help Charles establish a magazine of his own, the *Curiosités d'Alsace*. It is difficult to know with certainty who assisted Bartholdi in the process. Historians Robert Belot and Daniel Bermond rightly suggest the names of Auguste's journalist friend Nefftzer, but Nefftzer's major contribution to Charles's career may have consisted in introducing him to Laboulaye, his real benefactor.[25]

Little is known about how Nefftzer introduced Laboulaye to Bartholdi. But a detail so far neglected by scholars might shed new light on the story. Indeed, in the first issue of the *Curiosités*, Charles acknowledged his debt to Laboulaye in a way that leaves no doubt as to the help that Laboulaye gave him in creating the series. Laboulaye, Charles wrote, was "a unique man, a man unique for his heart as much as for his learning and talent." But what did Laboulaye actually do to help Charles? Perhaps he put him in contact with the printers that eventually agreed to publish the *Curiosités d'Alsace* in Stuttgart, Strasbourg, and Paris, because the Laboulayes were still in business with most of them. But Laboulaye certainly also gave Charles the inspiring idea behind the *Curiosités*, namely that "it is good to remain faithful to one's own country of birth," and that "love for a village only makes one love the whole country more." This was an idea that Laboulaye himself had drawn from one of his earlier mentors, Charles de Savigny, a German jurist who had explained national systems of laws as the emanation of their underlying institutions. Quite interestingly, between 1812 and 1864, Savigny's attention to local and popular expressions of national culture had inspired two of his former students in Marbourg, the brothers Jacob and Wilhelm Grimm, to collect and edit folktales from all over Germany. Laboulaye too, as soon will be clear, was a collector of fables. And so was Charles, who set out to use his journal as a way "to penetrate into the intimate and individual life of our fathers . . . to catch them off guard, so to speak, in their homes, in

their families, in the very midst of daily activities, in the midst of the people and all things around them."[26] In fact, it was all an excuse to focus on the mystical curiosities of local tradition, such as the "marvelous and prophetic signs that appeared in the sky in 1610" (comets or nocturnal lights), or the ghosts that were said to haunt the old convent of Unterlinden—"invisible spirits, full of murmurs, rays, smells, lovely visions, fascinating images, strange sounds, supernatural glows, [and] wonderful songs."[27]

It is difficult to give an idea of the full extent of Charles's fascination with symbols, which was a major driver behind his passion for Colmar's antiquities and his journeys to the city archives of Munster and Basel. In the *Curiosité*, Charles discussed some of the documents he had found on these research expeditions, such as ancient Alsatian seals, among them one from Colmar dating from 1214, which he found strikingly beautiful. It represented a "fantastical animal," a lion with a trifurcated tail "surmounted by three objects, which seem to be three maces."[28] Because a spiked club weapon (also known as a "Morgenstern" or morning star) was still present in Colmar's seal at the time of our story, and figured in the seal of the Schongauer Society, Charles must have been particularly intrigued by the 1214 seal (see Figures 8.1, 8.2). Indeed, he noticed that "the city of Colmar had always put on its coat-of-arms the symbols of strength," and traced this connection back to the previously mentioned humanist tale, reported by Jacques Spiegel de Sélestadt, according to which Hercules had stopped at Colmar, drunk too much of the local wine, and left his club behind.[29] Charles's fascination is not without relevance for our story, because, as later chapters will show, references to Hercules's weapon, the Morgenstern in Colmar's more recent seal, and wine eventually made their way to the Statue of Liberty.

Before then, however, Charles would presumably give other iconographical advice to Auguste. Among Charles's papers, we still find the crest that he designed for the Bartholdi family. An open hand, with the palm shown to the viewer, is placed at the

center of a shield, surmounted by a crown and the sun. The shield is divided into two fields, resembling a noble coat of arms. Above the sun, and continuing on a band at the top of the crest, reads the motto "numquam devius, en dextra fidesque" (never far from the righteous path, here is my right hand and loyalty). The Bartholdis were not a noble family, but they were an old family of local renown whose genealogy Charles had traced back to Italo-German ancestors, whose seal, he claimed, showed a helmet surmounted by a hand, and to a Protestant branch, represented by a shield displaying three helmets, one of which had a hand raised to lift an arrow. Apparently, Charles took the hand from both seals and the crown from the latter one, then added a sun, the symbol of the Sonntag pharmacy, to the result. A crown still adorns the black brass gate that originally graced the family's Colmar home, and is now displayed in the entryway of the Bartholdi house on the rue des Marchands. But the hand, and the loyalty it represented, might also have been a Masonic symbol. It may indeed be conjectured that, by adding the hand to the sun, Charles was alluding to his family's old connections to La Fidelité, the Masonic lodge of Colmar.[30] The family tomb at Colmar cemetery shows the extent of their Masonic connections: an Egyptian obelisk, decorated with the family symbols—sun, arrows, and helm—hosts the remains of Auguste's ancestors. At its side, a lower, truncated pyramid decorated with two shaking hands, a classical symbol of Masonic affiliation, honors the tombs of Auguste's father and two of Auguste's brothers who died early in infancy, one of them bearing the name Frédéric-Auguste, like the sculptor.[31] These Masonic allegiances extended to the Parisian branch of the Bartholdi family as well, as testified by a wooden box that Madame Sohenée gave Auguste's father that features a minuscule pair of shaking hands on the lock. It is not surprising, therefore, that the same symbol would appear in brochures printed by Bartholdi and his friends during the fundraising campaign for the Statue of Liberty.[32]

Indeed, both Charles's drawings and the family's connection with Freemasonry would leave their mark on the Statue of Liberty, mainly in virtue of the fact that Auguste Bartholdi liked to "sign" his works. He was like those fifteenth-century craftsmen who used to leave some secret, personal reference to themselves in their works. After sculpting his family's emblems in the bas-relief of the *Jour du Seigneur*, Bartholdi would sign the Statue of Liberty too. But how? Maybe by making her crown look like the sun of the Bartholdi insignia? Or by emphasizing her powerful hand—the same hand towering on the Bartholdi's seal of arms and Masonic symbols?

All of this was still in the future. First the Bartholdis would have to deal with Charles, whose troubles were getting worse with the passing of time. Gradually he started suffering from outbursts of rage and explosions of physical violence, followed by extended periods of apathy. The trigger seems to have been the missed opportunity to become general councilman at Ensisheim, despite the recommendations of the many friends of the Bartholdis in Paris and Colmar.[33] But there was more. At some unspecified point after 1855, Charles had become romantically involved with a certain Fanny Spire, née Dreyfus, who lived in Colmar together with her parents and a son she had from a previous relationship. But Charles was not only seeing the woman; he had become involved with her family and indebted once again, after borrowing money from Mr. Dreyfus to buy jewelry for his daughter. He was hoping to restore his reputation by getting the position in Ensisheim, but then heard the news that his application had been rejected. Charles was with Fanny and her son on a train to Colmar when, in August 1862, he suffered his first episode of madness.[34] But where was Auguste?

As it turns out, he was dealing with other matters, in which Laboulaye again was involved, albeit indirectly. After the inauguration of his *Rapp* monument, Bartholdi had turned his sights on Bordeaux, where he had planned a colossal Renaissance-style

fountain, in the same vein as Hittorff's and those exhibited at the Crystal Palace and the Palais de l'Industrie. It was to be a fountain of beaten bronze, built on two tiers. The bottom would feature seahorses bridled and tamed by trumpeting Tritons. On top, the Naiads representing the rivers of the Gironde would be depicted at the moment when they submitted to the triumphant Oceanus-Neptune, whom Bartholdi was planning to sculpt in ways reminiscent of Raphael's and Scheffer's Christs, but also of Gérôme's Augustus: wrapped like the Christ Redentor in a soft and minutely draped tunic, the Ocean would raise his right arm to grasp a trident with a domineering pose that was rather inspired by the seated Auguste in Gérôme's canvas (except that from Neptune's trident "a great horn of abundance [would] flow").[35]

The critics were intrigued. In 1859, for example, Jules Janin, a friend of Nefftzer who had become Bartholdi's comrade and a fixture at *La Presse*, praised him in the magazine *Illustration* by describing the fountain project as part of an ancient Renaissance scene with the "queens of the Midi," who appeared in the fables collected by Nerval, seated around it. Janin imagined the fountain "before an immense port, completely full of tumult, of agitation, of the comings and goings of a great trade, starting here to spread across the whole universe."[36] Janin could not have been more explicit about the real significance of the statue. It was the symbol of commerce, and especially of trade between France and America. Located in Bordeaux, famous for its red wine and location on the Atlantic, the ocean that divided the Old and New Worlds, Bartholdi's fountain was an indirect tribute to the interests of wine-growers and their trans-Atlantic trade. It was no accident that, seated among the judges of the commission, was Charles Laboulaye, the brother of Édouard and nephew of an international merchant.[37]

Bartholdi's career was off to a good start. After Colmar and Paris, he was now succeeding triumphantly in Bordeaux, under the appreciative eyes of famous journalists and the newly acquired mentorship of the Laboulayes. But a black cloud was approaching

on the horizon. To start with, the municipality of Bordeaux deci-
ded to wait with the execution of the fountain, and it was clear
that hostile forces were conspiring against his success. Bartholdi,
however, had other projects to follow. One was in Marseille, where,
in 1858, the city council had decided to complete the construction
of the Palais de Longchamp. The monument had been launched
under the July Monarchy to celebrate the building of the Canal
de Marseille, which channeled the waters of the Durance River
to the city; at the Longchamp hill, a waterfall was created, around
which Bartholdi proposed building a neo-Renaissance palace,
with two quadrangular wings united by a colonnade, to house an
art museum and a museum of natural history. But Bartholdi had
less luck here than in Bordeaux, because his project was first dis-
carded and then plagiarized by the eventual winner, Henri-Jacques
Espérandieu. Faced with one frustration after another, Bartholdi's
career seemed to be taking the same turn as that of Étex, the cursed
sculptor whom Scheffer had accused of plagiarism. In fact, when
a hearing about the artistic plagiarism eventually was held at the
civil court of Marseilles in 1863, Bartholdi would think of asking
Étex to testify in his favor.[38] For unknown reasons Étex was in the
end replaced by two other architects, Louvier and Sabatel, but his
shadow would still loom over Bartholdi's misadventures.

 This disappointment would weigh on Bartholdi for the rest of his
life. For some reason, however, Bartholdi showed signs of bitterness
and frustration even before his failure at Marseille. The *Lutte de
l'homme avec sa conscience* (Struggle of man with his conscience),
for example, a work that he began sketching during his Egyptian
journey, showed a Michelangelesque man, naked (but for a strate-
gically placed drape at his side), his face twisted with rage, depicted
as he sought to escape a terrible force; behind him stood another
man, one with a feminine face and long hair, laying a hand on his
shoulder.[39] Perhaps the struggling man was his brother; perhaps
he was an alter ego of Cain in his battle with Abel, a Prometheus
trying to break free from the chains with which Jupiter had bound

him, or a Lucifer rebelling against God. Bartholdi was quite famil-
iar with these histories of damnation and rebellion, which his
master Scheffer had found so inspiring. Other traces of evidence
suggest that Bartholdi might have conceived of the painting in
Scheffer's atelier, even if he had sketched it in Egypt. Indeed, the
expressionless face of Bartholdi's *Conscience* is the same as that of
the kneeling figure on the right of Scheffer's *Christ the Remunera-
tor*, but it also reminds us of the face of the prone figure to the right
of his *Christ the Consolator*.[40] It is quite possible that, along with
the faces of some of Scheffer's characters, Bartholdi had absorbed
something more from the time he spent with his mentor, includ-
ing the idea that concrete figures (either biblical or mythological)
could be used to symbolize abstract concepts. But what was the
idea behind Bartholdi's *Lutte de l'homme?* Was he trying to express
the painful sense of guilt about leaving Charlotte, Scheffer, and his
old life behind to travel to Egypt and embrace Gérôme's art? Or
was he rather portraying himself as a Prometheus fighting to free
his inspiration from current expectations and limitations? This
second explanation seems supported by what the Colmar illustrator
Charles Goutzwiller noticed at the time about Bartholdi, who—he
claimed—was "rolling in his head projects of grand monuments,"
almost as if he wanted to set for himself goals so arduous "as to make
their realization seem problematic."[41]

The *Lutte de l'homme* was also charged with a violence and
eroticism all but absent in Scheffer's work, begging the question of
what other influences may have contributed to its creation. Some
of these influences were probably the results of Bartholdi's friend-
ship with Gérôme, who filled his paintings with plump odalisques
and pubescent boys. Gérôme might even have been involved in
Bartholdi's initiation to eroticism in nonacademic ways, but we
may never know. Scheffer, however, remained Bartholdi's master
until his death, in 1858, for his influence is still explicit in a group
that Bartholdi finished only a year after his death: the *Génie dans les
griffes de la misère* (Genius in the grip of misery). This time, a naked,

winged spirit with a flame on his forehead and his right arm raised and bent behind his head struggles to stretch out and break free from the arms of a man who, crouching on the ground, keeps him from flying. This time it is quite possible that the disappointment with the municipality of Marseille weighed on Bartholdi while he sculpted this torn statue, which so clearly expressed his frustration at being held back by jealousies and baser passions. Indeed, the *Génie* conveyed sentiments of suffering and frustration like few other statues did at the time, with the notable exceptions of Étex's genius of vengeance on the Arc de Triomphe (Figure 6.1) and his *Cain*. With a flame on his head, Bartholdi's *Génie*, which looked very much like a self-portrait (psychological if nothing else), was clearly a relative of Étex's, another child of the Promethean stock. But Étex and Scheffer were not the only sources of inspiration behind the statuary group. Indeed, Bartholdi's *Génie* had the neoclassical grace of Auguste Dumont's *Génie de la Liberté* even without carrying his torch or his chains. Was Bartholdi trying to convey the painful, even mortuary essence of his personal struggle for independence? If so, it is of some relevance for our story that, when the time came to design his own tombstone for the Montparnasse Cemetery, Bartholdi decided to add to it a sort of female sibling of his *Génie*, this time with the right arm outstretched, just like the Statue of Liberty.

CHARLES'S FIRST EPISODE of schizophrenia, in 1862, led Auguste to drop everything and look for a home where his brother could be cared for. He took him to Dr. Jeanne-Pierre Falret, in Vanves, in the Île-de-France, where Charles became stubbornly mute and spilled out his disconnected and anguished thoughts in long screeds in Latin, German, and French, written in tiny Gothic script. Charles continued to live, but in the enchanted world that he himself had brought back to life in the *Curiosités d'Alsace*. It is easy to imagine how Charles's illness drastically changed Auguste's role in the family and worsened Charlotte's dependence on him. For

now there was nobody with whom to share Charlotte's suffocating attentions, and her watchful eyes were now permanently fixed on her youngest son and his ability to mediate between Charles and herself. It must have been terribly hard for Auguste, who spent most of his time either watching his almost silent brother or consoling his mother, who continued to hope that Charles would be healed and restored to his normal self.

If one were to take Charlotte's critical comments at their face value, Auguste was not born to either work hard or apply himself with any resilience. But now, exhausted by his daily sessions in Vanves and by his mother's obsessive effort to understand the reasons for Charles's illness, he turned to his art as a form of release. Even working in Colmar, and for Colmar, suddenly appeared more attractive than it had been just a few years earlier. And he could always count on the help of the librarian Hugot and the Schongauer Society. The Bartholdis were probably still hoping to get the commission to build a statue of Schongauer, given that Lavallette's winning bust had been left on display in the Unterlinden convent since 1851, without anybody asking him to produce a marble version of it. Their hopes were well grounded, and with Hugot on their side, it was finally decided that Bartholdi would replace Lavallette as the official sculptor of the *Schongauer* monument in 1861.

The first problem Bartholdi had to deal with was choosing a style suitable for the cloister. As someone used to transferring figures and styles from canvases and prints to solid marble, Bartholdi decided to look to Schongauer's prints for inspiration: he wanted to sculpt the statue in the same style that Schongauer had used to engrave his drawings. Scheffer could no longer help him, because he had died in his house on the rue Chaptal three years earlier, but Bartholdi always kept his works in mind. The one he finally put his eyes on was Scheffer's *Dante and Beatrice*, another spiritual painting, this time illustrating the point in the *Paradiso* where Dante explains that, in contemplating Beatrice, he had had the impression that God had adorned heaven with another sun.[42] Scheffer had placed Beatrice

in a raised position, illuminated by rays of light, as if crowned by the sun, while Dante was below, wearing a red cloak and looking at his guide with fearful admiration. Dante was part of Scheffer's gallery of sinners, characterized by dark colors and asymmetrical features so as to distinguish them from the purity of godly souls. Still, Dante had a noble composure that Scheffer's other sinners had not. This anomaly alone may have induced Bartholdi to model his *Schongauer* on Scheffer's *Dante*, but he may also have made this choice because Dante was dressed in medieval garb suitable for the Unterlinden abbey, and his cloak was a beautiful and sharp crimson that he easily could replicate in the monument by using the red sandstone of the Vosges.

The final statue can still be seen in Colmar, hidden behind the side walls of the Unterlinden Museum. Schongauer's tunic has flared sleeves, just like the one worn by Scheffer's Dante, and it falls in the same oblique folds that Scheffer had given his Christ of the *Temptation*. For the rest, however, *Schongauer*'s archetype was the statue *Gutenberg* erected in Strasbourg in 1840—one of the Statue of Liberty's forgotten ancestors.[43]

D'Angers had portrayed Gutenberg with a very long beard, like that of a prophet, presenting a page proof of the Bible, on which the words from Genesis "Fiat lux" (Let there be light) were engraved, while behind him was a bronze replica of the press on which the page had been printed.[44] It is difficult to imagine that such a statue has something in common with Lady Liberty, but the New York colossus in many ways is a larger and more abstract version of the *Gutenberg*. The *Gutenberg* has a page from a book sporting the engraving "Fiat lux," while the Statue of Liberty holds a real torch (the torch of wisdom and revelation) and keeps an engraved tablet in the other hand. *Gutenberg* is a monument not only to the civilizing role of printing, but also to two kinds of Lutheranism: orthodox Lutheranism and its ambition to replace religious hierarchies with the devotees' direct access to the Bible, and mystic Lutheranism (or Böhmianism, as one influential variant was called) and its design

to understand God through the medium of biblical metaphors (such as the light of creation in Genesis).[45] Was the Statue of Liberty also an icon of Lutheran faith? Would she, too, celebrate popular enlightenment? Except for the fact that the statue also was sponsored by mystic Catholics, Protestants, and agnostics (a mysticism that was more widespread across nineteenth-century religious groups than is normally assumed), the Statue of Liberty was going to be everything the *Gutenberg* statue had been in its own time, and more. And this because much of Bartholdi's career, until the building of the Statue of Liberty and beyond, had been marked by the longtime consequences of the historical rivalry between Strasbourg and Colmar.

The details of this rivalry are crucial for our story. Indeed, the statue of Gutenberg did not merely aim to establish Strasbourg's primacy in the world of printing and literacy, not to mention in matters of religious tolerance; two of the four bas-reliefs attached to the *Gutenberg*'s pedestal explained that the consequences of the Strasbourg-born discovery went even further, to the America of Benjamin Franklin, who was represented next to a printing press in the act of holding up the Declaration of Independence to an assembled crowd, and to Africa, where emancipated slaves were portrayed gathering around a printing press. *Gutenberg*, too, aimed to be a global icon. Which brings us to a third element that *Gutenberg* and the Statue of Liberty have in common: their reference to American liberty, in all its forms.

Between the *Gutenberg* and Lady Liberty, however, there was *Schongauer*, a work that was certainly less ambitious in scope, but nonetheless kin to both. On a medievalesque pedestal that Bartholdi had placed on a Gothic-style fountain (which Germans tore down during World War II), Schongauer holds an open book with a gesture that seems to suggest he is turning the page, while he delicately removes a copper plate from a trial proof showing his own print, the *Crucifixion with Four Angels*.[46] If one looks carefully, engraved in Schongauer's book is the Virgin Mary at the foot of the

cross, with angels gathering around Christ and one angel holding a chalice to his wounds to collect his blood. Instead of showing the whole scene, Bartholdi focused on the chalice and the Virgin. Perhaps it was a random choice, but it may also, along the lines of the *Gutenberg* statue, contain the key to unlocking the meaning of the entire piece. It is striking, for example, that Schongauer is standing with his shoulders slightly bent, his head turned faintly down to the side, in the position betraying the thoughtfulness, but also the melancholy, of the fifteenth-century Madonna of the *Crucifixion*, with her face turned down and back gently arched. The *Schongauer* was also unmistakably effeminate.

One way of interpreting the statue would be to suppose that it exalted the educational, liberating, and even redemptive power of the printing press. Yet there is nothing in the *Schongauer* statue to suggest a similar celebration of the public purpose of engraving. Instead, like so many of Bartholdi's other works, the *Schongauer* says more about its creator than about the ideals it was designed to celebrate. By revealing, on the proof page in the statue's hand, the engraving that he took as his starting point for the statue itself (the Virgin of the *Crucifixion*), Bartholdi gives us insights into his own approach to sculpture, which was nearly always inspired by carved or painted figures, as well as his preference for androgynous models. But it was hardly meant as a revelation or a confession, for the statue was placed too high for any observer to see what was on the proof sheet, and the cross-references between the statue and copper-sheet were too subtle to be easily put together by cursory visitors. Instead, the *Schongauer* seems to represent a joke between Bartholdi and the few friends who had seen the statue up close and discussed it with him, some of whom also happened to be Charles's former collaborators at the *Curiosités*. It was these friends whom Bartholdi depicted in the little Gothic statuettes on the four columns that surrounded the pedestal of the statue, each one representing an allegory; each one emulating the style of one of Scheffer's favorite artists, the German sculptor Peter Vischer: Hugot, the

founder of the Schongauer Society, was "Learning"; the librarian Briele was "Painting"; the local artist Goutzwiller was "Engraving"; while Bartholdi himself was "Goldsmithing," Colmar's noblest art.[47]

In the long run, Bartholdi's passion for the goldsmith's craft would express itself in the making of his Statue of Liberty as well as in his subsequent (and unfulfilled) dream of painting his colossus in gold, like the *Hermes* of the July Column.[48] For now, it is enough to remember that the entire *Schongauer* monument, which is supposed to celebrate the man's discovery of copper engraving, was in reality a coded tribute to the Bartholdi family and to the arts and crafts that had developed around it in Colmar. Schongauer was, indeed, red, like the garb of Scheffer's Dante, but also like the copper plates used for engraving and like some of the wine produced in Colmar. Schongauer himself had celebrated the local wine in a famous religious panel known as the *Virgin of the Grapes*, and wine was in the chalice of Christ's blood that the angel holds in the *Crucifixion* that Bartholdi reproduced on Schongauer's proof sheet. In this way, the *Schongauer* fountain was a marmoreal tribute to Colmar's local history and a sculptural reflection of the historical research that Charles Bartholdi had conducted for the *Curiosités d'Alsace*. The Statue of Liberty herself would eventually bring a similar Alsatian tribute to America, encrypted in the statue's rays and originally red mantle.

Soon enough, Bartholdi found that he liked building fountains as much as sculpting military icons, and he was able to combine these two passions when the town of Colmar offered him a commission to sculpt a statue of Admiral Bruat, the Colmar war hero who had died on his way home from the Crimean War. Bartholdi received the commission in 1863, the same year in which the judges were deliberating on his allegations against Espérandieu at Marseille. Perhaps because of the timing, the *Bruat* monument showed some similarities with Bartholdi's project for Palace de Longchamps. He decided to adopt the same Renaissance style; this time, however, the admiral's colossal bronze statue topped a pylon at the center of

a large fountain decorated with allegorical figures. The water fill-
ing the fountain was a symbol of the admiral's maritime victories;
at the center of it, but raised on a tall column, Bruat would look
out toward the horizon, a scarf on his left arm and a map rolled up
in his right hand. Around him, Bartholdi would place four figures
representing the continents in which Bruat had served, all of them
showing their backs to the pylon, as though they had sprung from
the admiral's map. America and Africa would be two muscular
savages, the first shown with a star over his forehead, showering
the ground with gold from a cornucopia and trampling the idols
of the past; the second with an incredibly melancholic expression
that, although devoid of any active political message, nurtured
abolitionist sentiments in some of Colmar's younger residents.[49]
Finally, two female figures would represent Asia and Oceania—a
Phoenician woman with long eyebrows, lying sensuously on a tiger
pelt, for Asia, and a beautiful woman with almond eyes and sensual
lips for Oceania.

Very little was left of that monumental group after German
troops marched into the city in September 1940 and destroyed the
geographic allegories. But the people of Colmar rescued Bruat's
statue and, in 1958, placed it on top of a new stone fountain, from
which the admiral still overlooks the park and imagines the oceans
and lands stretching beyond it, as though wondering where to
send the French navy on his next expedition. Indeed, as head of
the navy, Bruat had sent ships all around the world, from Senegal
to Algeria (where he had distinguished himself in the siege of
Algiers), from the Marquesas to Tahiti, from the Antilles (where
he had served as governor-general) to the Black Sea. Bruat's ships
opened the way for bankers and industrialists, who set up trading
posts in the colonies and were now expressing their gratitude by
contributing to the cost of the statue. Besides the contributions of
8,387 francs by the town of Colmar, 2,500 francs by the "imperial
family," and 3,000 francs by the Ministry of the Imperial House,
funding also came from the "ports of war"—a total of 7,526 francs

from the "colonies of Cochinchina [southern Vietnam], the Gold Coast and Gabon," and 7,912 francs from Martinique, Sénégal, Réunion, and French Guiana.[50] Though exquisitely local, the *Bruat* was undeniably global, in its symbolism as well as in its funding. Indeed, the rich bourgeoisie of Colmar also had major interests in these colonies and Bartholdi, once again, used the monument to encrypt this story of local imperialism into the monumental fountain. The encryption is to be found in the original allegory of Oceania, whose face reproduced the beautiful features of a local woman named Émilie Leblond. The daughter of a French businessman in Veracruz and a Mexican mother, Leblond was one of the many trophies of French commercial colonialism in Central America, and she had just married the Colmar notary Jules Mathieu Saint-Laurent (incidentally the great-grandfather of the fashion designer Yves Saint-Laurent).

America—whether the alluring land of financial investments or the savage and masculine frontier of the gold diggers—was still a topic of remote interest for Bartholdi, who divided his time among his mother, Charles, and his studio in Paris. After each visit with his brother, Auguste recounted to his mother his conversations with Charles, nearly word-for-word, with almost maniacal precision. In his copious, and somewhat harsh, letters, he lingered on his brother's silences, his eccentricities, his appetite, and quoted Goethe to explain to his mother that "the courage to see the sadness of the situation" was preferable to the lightness of ignorance, because "if courage is painful, it gives strength." When Charlotte begged him to take Charles to a medium to help restore his reason, Auguste explained that he did not believe in "somnambulists and augurs," because "if it were possible to penetrate the mysteries, God would have given that power to our intelligence and not abandoned it to the sad faculty of our imagination."[51] Despite her resentment, Charlotte was forced to accept her son's decision. But only to a certain point. When Auguste was convinced by doctors and lawyers to assume Charles's guardianship rather than give it to

Charlotte, she replied that "it was too much for her to be treated like one of those hopeless women."[52]

By the end of 1865, Auguste had found some distraction from the doleful conversations with his mother. After the unveiling of the statue of Bruat, perhaps thanks to the intercession of the admiral's widow, Bartholdi made the acquaintance of many high-profile figures, such as the celebrated Edmond Jurien de la Gravière, who had just returned from a mission to Mexico, and the Marquis Nicolas-Charles-Victor Oudinot, commander of the French mission to Rome that had dashed the hopes of Italian republicans. Isolation and madness were now a distant memory. Bartholdi dined "here and there," seeing "everyone in the world." In the spring of 1865 he did not even return to his home in Colmar, but spent the entire time in Paris, "to keep my relations with many people."[53] One of the imperial bureaucrats he came to know in those days was the son of the famous Napoleonic general Jean Thomas Arrighi de Casanova, duke of Padua and senator for Corsica — another descendent of the Bonapartist heroes whom Napoléon III had put in the Senate. He commissioned from Bartholdi a statue of his father to be placed in the city of Corte, on the island of Corsica. Bartholdi jumped at the chance and set off for Corte to have a look around. Before arriving, however, he took a detour, one that would take him first to Naples, then to Rome, and, finally, to Florence, the city of Dante and Beatrice.[54]

CHAPTER 13

CUCKOO APOCALYPSE

In addition to traveling across France and giving talks on universal education and individual emancipation, Laboulaye liked to spend his time writing fables. Ever since the early 1850s, French children knew that either on Christmas Eve, or January 1, their parents would summon them around the fireplace and read aloud one of Laboulaye's many fables printed in the newspaper *Journal des débats*. Usually, his fables came from Italy, Scandinavia, Russia, Germany, or some other, more distant region. But in 1859, while helping Nefftzer assemble the first issues of the *Revue germanique*, Laboulaye decided to delve into the *Arabian Nights* and the Koran. He "surrounded [himself] with Arabic and Persian books" and tried "to live in thought in the desert" in the hope that "a ray of Eastern sun" would enter "into [his] canvas," or at least into the fable that he was writing.[1]

The fable in question, *Abdallah ou la trèfle à quatre feuilles* (1859), told the story of the young and handsome Bedouin Abdallah and his search for a magical four-leaf clover. It was said that Eve had stolen the clover as she was being cast out of the Garden of Eden, and that God had scattered its leaves throughout the world as punishment for her disobedience. Instructed by his mother, Halima, "a true Muslim," that there "was no wisdom, strength, or consolation except in God," Abdallah goes on a quest to retrieve the scattered leaves, which, if found, will give him eternal wisdom. He finds the "copper leaf" in a well dug to water a field and make a garden (symbol of private property and agriculture); the "silver

225

leaf" inside the magical amulet given to him by a young black slave girl whom he saves (symbol of friendship and charity); the golden leaf in the amulet of an enemy he faces unarmed (symbol of love); and the diamond leaf at the moment of his death (symbol of God).

Abdallah is clearly an Eastern Orpheus who taught his people the property of land and the rules of familial love and social solidarity, but his message of charity was reminiscent of Christ's. The "ray of sun" that had struck Laboulaye during his orientalist readings had revealed to him clear analogies between paganism, the Koran, and the Old and New Testament. Upon sifting through world folklore with a fine-toothed comb, Laboulaye had clearly found proof of what Cousin and Channing had argued before him, namely that all religions—whether pagan, Judaic, Muslim, or Christian— shared some universal kernel of truth, one ultimately incompatible with slavery and personal subjection. This common truth would, in time, decisively inspire the architects of the Statue of Liberty. To appreciate how this universalist mythology of the Old World came to be connected with America, however, one has to follow Laboulaye on a curious, "mesmeric" journey, one that transported him in 1863 to, of all places, the state of Massachusetts, at a time when the Civil War was still raging.

LABOULAYE'S MAGICAL VOYAGE to America was inspired by his discovery of Channing. Another, more immediate trigger was the outbreak of the American Civil War on April 12, 1861, at Charleston, where seven Southern states (which had previously proclaimed their secession) fired "on the [Union] flag" of Fort Sumter—"such a mere speck in space" when seen from the Battery, Henry James would notice years later.[2] Laboulaye was drawn to the Northern side along with Gasparin, Martin, and other gradual abolitionists, most of whom Bartholdi would soon meet at Glatigny.

At this early point in the war, the men were dismayed by Lincoln's timid approach to abolition. Although he had declared

himself against slavery on many occasions, Lincoln was far from convinced that blacks easily could live side by side with American whites and endorse—not to mention live up to—their principles; the only solution for America, Lincoln had concluded, was to "free all the slaves and send them to Liberia."[3] This, however, was not what shocked Laboulaye. His disappointment came from the fact that, on September 23, 1862, Lincoln emancipated all the slaves in the rebel states without making any statements regarding their fates in the North or in the Confederate territories currently occupied by Northern forces. Frightened by the possible reactions of French abolitionists to Lincoln's timidity, the president of the Loyal National League, Francis Lieber, wrote a public letter to the president of the Comité français pour l'émancipation des esclaves, the Catholic Augustin Cochin, as well as his colleagues Laboulaye, Gasparin, and Martin. Lieber explained that Lincoln's prudence on the issue of slavery was born from the limited constitutional powers he enjoyed as president, not from a personal lack of sympathy for the question of human rights. Since he had made the Emancipation Proclamation as "commander-in-chief of the army and navy of the United States," Lieber explained, Lincoln was unable to take decisions regarding territories not involved in the rebellion. His proclamation, in short, was a "measure of war" and not a declaration of rights. And yet, he concluded, to the extent that such rights were granted, Lincoln's proclamation had a "much wider and more important scope," because it would be "a ground of *right* to freedom for the slaves."[4]

Laboulaye and his friends were conciliatory in their response, but not convinced. It was clear, they said, that "Lincoln and his friends were not abolitionists . . . their program went no further than stop, and shut it out from the territories." But they also acknowledged the Union's recent openness toward the abolitionist cause, and instead of criticizing Lincoln for his caution, they decided to accept his actions for what they promised. It was necessary to "steer and strengthen those who were thus entering on the good path," to

"urge them on their liberal tendencies, so that, the first step taken, they should take the second, and then go on to the end." But Laboulaye and his friends were clear on what they were expecting as the ultimate result of these efforts: "no more plans of colonization abroad, no more disabling laws, no more inequality."[5]

If nothing else, Laboulaye must have felt empowered by setting the liberal goals to which Americans should aim. In their response to Lieber, he and his colleagues generously recalled that what Lincoln had done so far "yielded nothing in grandeur to what which your fathers accomplished with the aid of LAFAYETTE and under the guidance of WASHINGTON."[6] A generous remark implying a selfish equation: if Lincoln was the new Washington, then Laboulaye and his friends were the new Lafayettes. But one last act was needed to make the equation credible: somehow, Laboulaye had to cross the ocean and visit America himself. This journey, along with Bartholdi's future excursion to the United States, would define the meaning of our Statue of Liberty, and particularly so the meaning of her flame.

UNION AGENTS and spies were not the only Americans criss-crossing France in those years. As early as the 1850s, American mediums and occultists followed similar paths within France and indeed across Europe, as they promised to establish contact with the souls of the dead, and sometimes even to read the future. The most famous of these mediums was the handsome Daniel Dunglas Home, an international man of mystery, of Scottish origin, with big black eyes, a thin moustache, and unruly raven-black curls that spilled over onto his forehead. Home arrived in France in 1856 and dedicated an entire year to touring the country and showing off his magical skills. Wherever he went, illustrious families, including that of Napoléon III in Paris, invited him to their homes, where séance tables and other tools of the spiritist's trade were prepared for him. Under his power, candelabra toppled over and ethereal hands were laid on tables, walls trembled, and voices from the other side made themselves heard.[7]

Home did not use his supernatural powers to cure people, but he considered himself the instrument of a new revelation. Indeed, it was a common belief in America "that God did not just speak to the ancients, that revelation did not come at a single moment, but instead comes continually, in forms suited to the progressing needs, capacities, and tendencies of humanity."[8] Bartholdi was skeptical, but we know that Charlotte trusted people like Home and even hoped they could cure her son Charles. As for Laboulaye, he was intrigued by all manifestations of human madness, because he claimed that "the more I have come to know men, the more I realize that nothing is truer than their dreams and nothing more reasonable than their follies."[9] Perhaps Charles's illness, which manifested itself at approximately the same time that Laboulaye was planning his mystic journey, influenced his decision. What we know is that, in 1863, one year after Charles's internment at Vanves, Laboulaye recorded his magical voyage in the form of a fable; the fable of a man who lost his mind, but understood the world as a result.

Although possibly inspired by Charles, the fable was about Laboulaye, renamed Daniel Lefebvre, and his understanding of American laws and traditions, not to mention their crucial place in human history. The story goes like this: a believer in the "natural phenomenon" behind spiritism, but not in the rituals built around it to "lead" people "by the nose," Daniel Lefebvre (Édouard Laboulaye), a rich Parisian living in the fashionable rue de la Chaussée d'Antin, receives an invitation to visit the studio of one Jonathan Dream. Like Daniel Home, Dream is an American "spirit and transcendental medium," who welcomes his clients in 22 rue de la Lune, "a fine suite of rooms, at the bottom of a drawing room, hermetically closed, but blazing with light." With his "melancholy gaze and inspired countenance," Jonathan confirms the suspicions of Daniel, who publicly voices his doubts regarding the medium's efforts to evoke de Maistre, Hippocrates, and Nostradamus, and challenges Dream to send him to Massachusetts, in America. Moreover, he is to go with his family and indeed the entire city of Paris.[10]

The medium maintains his promise: the next day, Daniel is awakened by the smell of the cookies his wife is baking in the kitchen, only to find himself in a completely new world and among different people. His cold and formal wife has been turned into an affectionate lady; his two shy children into two extroverted students and active citizens. His name is no longer Daniel Lefebvre. People now call him Daniel Smith, and on his shelves the books by Diderot and Montesquieu have been replaced by the popular *Pilgrim's Progress* by the seventeenth-century Puritan writer John Bunyan, which tells the story of a common man's ascent from his baser world of prejudices to the celestial truth of the New Testament.[11] What Daniel does not understand yet is that, like Bunyan's hero — appropriately called Christian — he too is escaping from a corrupted world (in France) in search of salvation (in America). In Bunyan's story, Christian leaves his wife and children behind because they could not understand his fears for the moral decline of their city. Laboulaye, too, believed passionately in the institution of the family to follow Bunyan's lead, but resolved the dilemma with an interesting sleight of hand: Daniel leaves his Parisian wife — a conformist, always wishing to "do like other people" — and their children only to find them again in America, but with new and improved characters. One wonders whether Laboulaye's real wife ever read *Paris in America*, for the way in which Daniel's Parisian wife was described — a snob only willing to live "in a suite of rooms a hundred and ten steps high, in a princely hotel" and so forth — was hardly flattering.[12] Alas, Laboulaye's wife remains a historical enigma, though what little we do know about her suggests she was more like the American than the French version of Daniel's wife, since she was active in a number of charitable initiatives on behalf of the freed slaves, but also in the education of young women, for whom she wrote a quite popular life of Joan of Arc in 1877.[13]

Daniel would soon find his way out of the dark, but without going through Christian's torments. For while Christian is a Puritan, Daniel is a mystic: like Laboulaye, he is a follower of Krause,

Ballanche, and other visionary Protestants like Jacob Böhme, whose theory had inspired d'Angers' *Gutenberg* in Strasbourg.[14] Böhme had argued that it was the desire or will of a "fundament" (*Grund*) that led the divine principle (which was "formless, or even chaotic") to turn into a "divine that has form and definite limits."[15] The first stage of knowledge in Böhme's cosmology is symbolized by the light of the first day of creation, a kind of solar *quinta essentia* (considered to be the matrix of all other natural elements) that d'Angers had portrayed by giving Gutenberg the book of Genesis opened on its first page. Böhme's second stage is that of vision and corresponded to the great biblical prophecies of Shem, Abraham, Moses, Enoch, and Ezekiel, which are glances (in the Neoplatonic sense) into the bright mirror of wisdom, fatally obscured by the fall of man. The third stage comprises the subsequent victory of harmony, represented by Christ's return to the world and his demonstration that suffering is an intrinsic part of creation and existence.[16]

One way of looking at Daniel's journey to America is to treat it as a parable of Böhmian salvation, the story of a man who finds God by following his own will and visions. Because individual will, in Böhme's cosmogony, originated in the baser, demonic parts of the human soul, one should not be surprised to know that Daniel's journey started amid flames. A terrible fire engulfs the city and traps a child in a flaming building. Driven by an irresistible impulse to rescue him, Daniel rushes headlong into the fire and braves the flames. The trail of one particular "tongue of red flame, which cut through the night" leads him to the room where the little boy is still trapped, and from which he saves him.[17] This act of heroism earns Daniel great public acclaim, and he is dubbed the "fireman" for his ability to master both physical fire and the metaphorical flames of the will. Articles are even written about him in newspapers, one of America's most important civic institutions (as Tocqueville had stressed in his *Democracy in America*), and when Daniel visits the offices of one of these newspapers, he finds another "infernal

kitchen," this time full of printing presses and moveable types, just like (one may guess) in the workshop of Laboulaye's brother.[18]

The proprietor of this particular American newspaper, a certain Mr. Truth, would guide Daniel out of the devilish zones of his soul and toward its visionary parts. Truth is not a "founder of types," like Laboulaye and his brother, nor does he have the Mephistophelian air that one might expect of an infernal printer. But he is not even one of those tough reporters that had so frightened Tocqueville when he visited America back in the 1830s. Daniel finds in Mr. Truth a kind of American Virgil, or a version of Bunyan's Evangelist, one who casts off the guide's cloak to put on a reporter's cap and enlighten Daniel as to the subtle links between America's civil liberties and its freedom of the press. Daniel is still a long way off from his final initiation, and feebly protests in defense of Cousin's conviction that "private life should be hermetically immured."[19] But Mr. Truth argues that society is made up solely of private lives, interconnected with each other by the press; "in a community wholly occupied with its business and interests," he continues, journalists are the only ones working as the "echo of society" and, through this means, are the ones who awaken the "most torpid consciences."[20] If the press echoed social voices, however, what kept society together? The answer was to be found in Channing's orations, but Laboulaye decided to have Daniel's son, Henry, summarize Channing's thesis for his father and present it as something he had learned at school, namely that "the morality of Christ leads to democracy; that is, to fraternal equality, and respect of the most obscure individual."[21] Henry's brief speech has the desired effect, for soon enough, Daniel starts having prophetic visions. The background is a torchlit parade celebrating his candidacy for an administrative position:

> All the firemen, in full dress, and each carrying a torch in his [sic] hand, defiled [marched] under our windows, with music at their head. The young men of the city, dressed in uniforms and varied costumes, accompanied them with

long poles, surmounted by Chinese lanterns. In the midst of the procession an immense banner, with a lighted transparency, showed to the amazed crowd two species of black devils, emerging from the flames, with white bundles in their arms. The names Green [the other candidate] and Smith [Daniel Smith], written under these figures, gave a human meaning to this infernal scene, which was applauded as it passed. The woman and child whom we had rescued were drawn in an open carriage by four white horses, the whole adorned with lanterns and inscriptions. It was a triumphal march — a procession worthy the palmy days of Eleusis.[22]

Is Daniel a prophet, a new Ezekiel? While the macabre electoral procession passes beneath his window, Daniel's daughter, Jenny, entertains the family with readings from the Apocalypse — the same passages that Nefftzer recently had discussed in the *Revue germanique*.[23] Appropriately, given her father's name, Jenny reads from the Prophet Daniel, the noble Hebrew who lived at the court of Nebuchadnezzar and was recognized by the king as God's true messenger due to his extraordinary talent: interpreting a premonitory dream about a statue with a golden head, silver chest and arms, bronze belly and thighs, iron legs, and feet of iron and baked clay, which was smashed by a rock that came to cover all the earth. According to Daniel, this was a symbol of the succession of the four empires, Babylon (gold), Medo-Persia (silver), Greece (bronze), and Rome (iron), and of their final destruction at the hands of the "fifth empire," the kingdom of God.[24]

Listening to the story of the Prophet Daniel, Daniel must wonder whether he, too, was destined to undertake such a mission. Just as the Hebrew Daniel went to Nebuchadnezzar to announce the end of the oriental kingdoms at the hands of the God of the Jews, so Daniel has been sent to America to announce an apocalyptic conflagration. But what kind of empire was he supposed to announce?

Nefftzer had claimed that apocalyptic books were designed to make the religion of the Jews fit their political needs by sacrificing their

beloved Babylonian pantheon to the altar of a national god. Was
Laboulaye interpreting Daniel's visionary experience in America
as a blueprint for France's future return to the continent? And what
kind of return was on Laboulaye's mind? An ideological return,
like the one implied in the patronizing tone he had used in his
letter to Lincoln? Or was he rather thinking of a political return,
one to be pursued through economic imperialism and perhaps even
formal colonies? Of course, the case of the French had little to do
with that of biblical Jews; the French were in search of colonies,
while the Jews were in search of a homeland. But Nefftzer had
told his readers that Hebraic monotheism had been triggered by an
ambitious project, namely that of "religious regeneration and domi-
nation over other peoples."[25] As a reader and friend of Nefftzer,
Laboulaye was partial to his interpretation of Jewish apocalyptic
literature. His fable, too, reflects this idea—for Daniel's first vision
seems to suggest that Laboulaye has begun to consider the ostensi-
bly expansionistic vocation of the Jews as a blueprint for France's
aspirations in America.

 Daniel's second dream gets closer to revealing the real nature of
Laboulaye's ambitions. With nerves still shaken by the ceremony,
Daniel goes to the window to see the town wrapped in stillness, the
moon illuminating with "its pale light the mute and closed houses,"
the silence broken only by "the ticking of a wooden clock at the
foot of my bed." Perhaps because of the silence, perhaps because
of the Virginia tobacco he has smoked, Daniel notices the cuckoo
clock becoming "animated": "a grating of pullies and groaning of
chords and wheels announced that the hour was about to strike."
But then something magical happens, for the clock opens itself to
show a marvelous scene, one not only embodying the teachings of
Daniel's Puritan books and Laboulaye's mystic readings, but also
anticipating future reasons for erecting a colossal French statue
in America:

> A cock of painted wood, perched on the top of the clock,
> flapped his wings and uttered three shrill cries. A door

opened abruptly below the cock, and showed me Paris, the Seine, and the Hotel de Ville in 1830. Lafayette, in a blond peruke, blue coat, and white pantaloons, was embracing, at the same time, a foot soldier, a gendarme, and a tricolored flag, on which was written, in letters of gold, LIBERTY AND PUBLIC ORDER. Eleven times the clock struck, eleven times the brave Lafayette nodded his head and waved his flag; then the door closed, the Gallic cock flapped its wings and crowed more shrilly than ever, and the vision disappeared.[26]

Daniel awakes at this last sound, and the vision forces him to realize how pitiful is the French dream of establishing liberty on the basis of public order. The Americans never thought of public order, yet their liberty was never threatened. But Daniel's dream nonetheless suggests to him that France, represented by the *coq gaulois* shrilling from the clock, still has something to teach its brethren across the Atlantic. Did not Lafayette, the main protagonist of Daniel's vision, put his reputation, family honor, and friendships on the line in service of the American cause? Did not Laboulaye and his abolitionist friends just lecture Lincoln and the Americans on how to finally achieve complete liberty by emancipating the slaves?

Lafayette was a figure from the past, but something in Daniel's vision seemed to point to the future as well. If the cock was an emblem of France, it was also (according to the Book of Matthew) a biblical symbol of sin, repentance (from Peter's betrayal of Christ) and apocalypse, as Bunyan had summarized it in a famous passage of his *Pilgrim's Progress*.[27] To Matthew's question of "What may we learn by hearing the Cock to crow?" Prudence answered: "Learn to remember Peter's sin, and Peter's repentance. The cock's crowing shows also that day is coming on; let then the crowing of the Cock put thee in mind of that last and terrible Day of Judgment."[28] The early American colonists knew these words by memory, and had even engraved rising suns on their tombstones in remembrance of the final judgment.[29] Even if Laboulaye had never seen these gravestones, he had read Bunyan well enough to know that the cock

announced the apocalypse and the rising of a new sun. But Daniel is not Laboulaye; at this stage of his formative journey, he is still in the dark as to the meaning of the symbols he has just seen, and, before he can even attempt an interpretation, he is whisked away to his next experience in the narrative.

CONTINUING HIS MYSTIC JOURNEY, Daniel is introduced to Massachusetts's religious associations and visits the churches that, in America, were free to proselytize through the practice of charity. Daniel visits all kinds of Christian denominations, but he also enters a Buddhist temple. Ridiculing the ways of the French liberals, Daniel ventriloquized Laboulaye with disgust: "I accept Lutheranism, Calvinism, Judaism, and even Mahometism, provided it does not come from Algeria; but to go further is no longer liberalism, but paganism."[30] Yet Laboulaye (like Nefftzer) was a bit of a pagan himself, and congratulated the Americans on their tolerance. He therefore lent his voice to a Chinese religious figure as well, who proclaimed that "liberty is like the sun, it shines for all." Years later, during the inauguration of the Statue of Liberty, Chinese American critics of the government would have rejoiced at reading those words and the following ones: "The Americans send missionaries to China," the Buddhist says, "why should not the Chinese send missionaries to America?"[31] Daniel frowns at the idea of erecting a Chinese pagoda in the Champs-Élysées, now moved to Massachusetts, but Laboulaye would later think of Chinese and Muslims alike while designing the Statue of Liberty with Bartholdi.

In the end, Daniel realizes that it is freedom of worship that makes America the "New Jerusalem" and Massachusetts one and the same with Mount Zion, the place where Christian finds the Celestial City in Bunyan's *Pilgrim's Progress*—the place where the church had "reconquered evangelical independence" and broken "this adulterous chain which Constantine imposed on her to the misfortune of the world."[32]

In the Bible, the real Daniel has a vision, this time of the apocalypse itself:

> I saw in the night visions, and, behold, one like the Son of
> Man [the Messiah] came with the clouds of heaven, and
> came to the Ancient of Days, and they brought him near
> before him. And there was given him dominion, and glory,
> and a kingdom, that all people, nations, and languages,
> should serve him: his dominion is an everlasting dominion,
> which shall not pass away, and his kingdom that which shall
> not be destroyed.[33]

According to Nefftzer, Daniel's apocalyptic vision was the apotheosis of Jewish monotheism; it was the triumph of God, the Ancient of Days, who was meant to keep the Jews together as a nation and extend their power across the world. When Jenny reads Daniel's dream, Daniel has a sort of epiphany; he finally understands the sense of his mission, namely that of being a witness to the American apocalypse: "Christianity, whose funeral knell is sounding in Europe, I saw in America, younger, stronger, more triumphant than ever."[34] A century earlier, the British engraver James Barry had drawn Liberty dying in Europe and being reborn in America, just like the phoenix (Figure 6.2). We don't know if Laboulaye ever saw that particular picture, but it is striking that Daniel interpreted his biblical vision in a way so clearly reminiscent of Barry's engraving. And, interestingly, in this act of the fable, the curtain falls on a kneeling Daniel praying to see "Old Europe imitating Young America."[35]

The next and final step in Daniel's conversion happens after visiting an American court, where he encounters new legal practices like the presumption of innocence and the appeal to a jury. In the past, Bunyan had chastised the law as a device of deceit, while Tocqueville had praised it as the bulwark of American democracy. Daniel found the law in America to be modeled on the Gospels

and the evangelical principle that "all weakness is holy": "all misery is sacred . . . , with the child, the woman, the poor, and even the guilty, the authority ought to distrust its power, and fear to be too much in the right."[36] Daniel could have easily used the exact same vocabulary to describe Scheffer's huge *Christ* sculptures, which are surrounded by sufferers, sinners, and saints. But this is hardly surprising, since Scheffer's Christ was a symbol of the very same apocalyptic regeneration that Laboulaye was expecting in America. It would be Bartholdi's task to give his mentors' apocalyptic reveries a monumental form.

DANIEL IS JUST STARTING to settle into his mystic dreamscape when Jonathan Dream seizes him by the hair and transports him to Sirius, the sailors' star, from where he is forced to contemplate the world below and to learn that "when the body has grown old, the soul, always young and active, throws off a decrepit covering and takes flight to a better world, to seek a new form for its immortal energy."[37] The belief in reincarnation was widespread in the nineteenth century, particularly among spiritists, mystics, and Saint-Simonians. Laboulaye had many friends who shared these beliefs, like Gasparin and Henri Martin, but it is difficult to know how much he agreed with them, if at all. Jonathan Dream is clearly a despicable figure in Laboulaye's novel, but he is also the only one to show Daniel the road to religious and political redemption. Instead of revealing to him the fate of the living after death, as was commonly done at séances, he reveals the future of an entire city (perhaps an entire nation, Paris and France) after the end of the world, a dream about the possibility of rebuilding Paris in America. It was an imperial dream, as apocalyptic dreams had been since the beginning.

From Sirius, Daniel contemplated the dark ocean below. The vast blackness was broken only by a "speck of light" coming from the *Arabia*, a British liner that, he learns, "sailed from Boston the

day I carried you to America."[38] It was a harsh wake-up call: the British Cunard Line rather than the Compagnie transatlantique was dominating trade on the Atlantic. What came next was even worse: rejecting Jonathan's teachings, Daniel abruptly cut the lock of hair that held him in Jonathan's power and plummeted to earth. Once adrift in the ocean, Daniel frantically searched for a light in the darkness—a light that was probably a stand-in for one of the many "flames" that the Protestant faith had lit in America. The historian John Bancroft once had claimed that the Protestant revolution initiated in Europe had come to fruition in America, where the light of God's mystic wisdom had entered "into the houses of the common people." This light, Laboulaye had once said, quoting William Bradford (the second governor of the Plymouth Colony), "will attract many people, maybe the entire nation."[39] But would Daniel be able to find it? Bartholdi would help Laboulaye light his own nocturnal flame in the years to come, when the idea of a colossal lighthouse at the gateway to America took form. Meanwhile, however, Daniel swam in the dark. He was rescued by Jonathan once again, but only briefly, because never really having trusted the medium, Daniel punched him, sending him away once more.

Daniel is still looking for that apocalyptic light when, after awakening in his bed in Paris and unable to convince his friends and doctors of the veracity of his voyage, he is shut up in a mental asylum. Imprisoned in a little cell, every morning he gets up to see the dawn:

> What is that luminous point that pierces the horizon and seems to drive away the fleeing shadows? It is the New Jerusalem, the city of the future. There, all is changed; the last vestiges of paganism have disappeared; the individual commands, he is king. Respected by all as he respects others, he is the sole master of his actions, alone responsible for his life, he has nothing to fear from the laws. The Church has re-conquered evangelical independence . . . the Gospel is

the charter of liberty . . . the press is free . . . Truth, justice, liberty, you shine in this new sky like pacific stars; before you are eclipsed the scourges of old Europe—despotism, intrigue, and falsehood. France, happy and proud, blossoms out in abundance and peace, it is the example and envy of nations; there it is glorious to live, it is sweet to die.[40]

The New Jerusalem in America was clearly France reborn across the Atlantic, the new France to be reclaimed and rebuilt by new means beyond the ocean, where the French colonies had used to be. The French Paris is no longer Daniel's true home. That home is back on the other side of the Atlantic, where a light now shines, as if to salute him and remind him of his mystic voyage.

Popular traditions and biblical legends often associated the apocalypse with "physical and moral horrors, . . . war, famines, plagues, but also eclipses." It was said that, on the day of judgment, "an extraordinary star would rise in the sky, the Savior's star," the comet that "evangelical history shows us in the legend of the Three Kings."[41] Significantly, in the apocalypse of Saint John, the resurrected Christ presents himself as Lucifer, which was also called (like the star Venus) "morning star" or "the light bringer." This same apocalyptic star was now shining in the western sky, while Daniel was watching it from its window. In this position, he cut much the same figure as Dürer's mad, melancholy angel, which had so tormented Nerval during his Egyptian journey (Figure 11.1). This time, though, the "black sun" is not a veil over the waters of the Nile; shining bright on the Atlantic coast, it is the symbol of the New American Jerusalem, not the buried world of Egypt. It was a symbol of Laboulaye's ambition to return America to France.

Were Daniel and Laboulaye already dreaming of the Statue of Liberty, a French colossus wearing a comet on her head on the American coast? It would be tempting to believe so, but nowhere in his fable did Laboulaye demonstrate any ambition of transforming the "living" thing he sees, the light diffusing "in the most narrow

street an indescribably happy light"—"liberty"—into a monument. If anything, he scorned monuments, and particularly gigantic ones, as exercises in "immensity" and "uniformity."[42] To his French doctor, who exposes the Saint-Simonian plan of celebrating the greatness of France by remaking and extending Paris so as to transform it into "the promenade of human race," all decorated with colossal and uniform statues—of "Glory," "Victory," a "Walhalla, a gigantic Parthenon"—Daniel-Laboulaye (who only believes in the financial and imperialistic corollaries of the Saint-Simonian creed) replies with skepticism and even disgust. Prophetic as Laboulaye was when it came to political issues, he most certainly could not have imagined his future collaboration with an architect who was downright obsessed with the colossal, nor the eventual transformation of Daniel's apocalyptic light of liberty into a Saint-Simonian temple on the other side of the Atlantic.

THESE TWO CONTRASTING views of art would meet soon enough. Laboulaye's magical journey had led him to an America of strong-willed and enlightened people. To use Böhme's expression, it was a reign of fire (will) and light (revelation). Almost simultaneously, Bartholdi went in search of the same elements by way of a different route. The fire of will, after all, was the fire of disobedience that Prometheus had stolen from the gods; it was also the fire of passion that had brought Francesca to reject her father's will and the fire of patriotism that led oppressed nations to rebel against their oppressors. Bartholdi held this fire of will aloft after Scheffer's death. Chained to the rock and devoured by an eagle, his 1863 Prometheus was a tribute to the Polish and Lithuanian resistance against the Russians, as well as a protest against Napoléon III's failed intervention on behalf of the insurgents.[43] But Bartholdi's Prometheus was not a pure soul like Francesca; angry and vengeful, writhing in pain, he was a sinner. It was clear already that Bartholdi had decided to follow Étex's violent inspiration over Scheffer's more

theoretical style. And where could he better cultivate it than in Italy, the country of Michelangelo's melancholic or angry titans, but also of Pompeii and the Catacombs? Like Egyptian statues, Michelangelo's tombs too would reveal to Auguste the secret of a form of sculpture built to face the end of days.

NOT UNLIKE GREECE, Italy was still considered part of the "Orient," a place where disorder lived side by side with passions and excesses. On March 31, 1865, Bartholdi was in Marseille, the port where, ten years earlier, he had embarked for Egypt. This time, however, he was not alone, but in the company of the town councilor, Gustave Rozan, and his family, as well as a painter named Vassal. Together they were ready to set sail for the enchanted region of Campania, where traces of the mysteries of Isis and Orpheus could still be found. Gérôme had once gone there to sample a preview of the wild, sunny landscapes of the East; Nerval and Gautier to encounter the pagan gods; and the architect Henri Labrouste to study the design of the buildings and their bizarre decorations. Bartholdi, instead, was going to Campania as a painter, to transfer onto paper the effects of a light that caressed the sea and the land, producing colors that did not exist in France. It was that hunger for color that kept Bartholdi above deck all night, just to catch a glimpse of the port of Civitavecchia, and to see the "rising of the sun, which made the town emerge, little by little, out of the darkness."[44] Colors were not the only thing that interested Bartholdi in Campania, however: just like during his Egyptian adventure, he was attracted by a morbid desire to spy on death. Destroyed by a catastrophe, Pompeii was intact under the ashes, with ovens that still had bread in them and pots on the stoves. This made it a kind of "architectonic mummy," even more so than Thebes. Indeed, everything in Pompeii gave the macabre sensation of a living city, frozen in time by the eruption of Vesuvius, and it took no great flight of fancy to imagine (as Nerval and Gautier had done) that,

at night, once the tourists left the city, its theaters again filled with people, its shops with merchants, its temples with the adepts of the mysteries of Isis and with the gods of old.[45]

Bartholdi went straight to Pompeii, bypassing Naples, in what seemed to him "the most exciting of our excursions." For Bartholdi, visiting Pompeii felt like "stepping completely into the intimate life of the Romans; you believe you can see them."[46] He returned to Naples only to visit the "Studj" museum, where "sistrums, cymbals, a gilt Venus, and basalt idols" had inspired in Gautier a story of reincarnations and ghostly loves in ancient Pompeii. But Bartholdi was seemingly immune to similar temptations. In the evening he went to the theater with friends, to then plunge straight into the Campanian countryside the next day. As if drawn by the "combination between the lovely, scintillating appearance" of the sea and "its somber companion [Vesuvius], nearby blowing smoke that covered the city from time to time, and making rivers of lava run around it," he left the city for the countryside.[47] Heading directly toward the giant dark mass of Vesuvius, he had the impression, when he reached it on April 8, of seeing "an immense plate of macaroni" rise up before him (perhaps on account of the hunger caused by the long ascent). But the macaroni left a lot to be desired—it was covered in a "black sauce, all broken and torn," and in some places, the surface of the volcano was all contorted, "bringing to mind Michelangelo's painting of the Last Judgment." Climbing higher, onto "a boiling ground," Bartholdi finally reached the mouth of Vulcan's home—"a ring of rocks colored red and sulfur yellow, with bluish tints," surrounding a "black mound of ashes and slag."[48]

Black macaroni, all "broken" and "torn"; strips of "contorted" landscape that looked burned, boiled; a red and sulfur-yellow scene covered with ashes and rocks. The gastronomic note notwithstanding, Vesuvius struck Bartholdi with infernal and apocalyptic images worthy of Michelangelo. But this was a theme of all Bartholdi's journeys. To the contemporary mind, tickled by thoughts of the

devil and by the prospect of the end of the world, volcanoes were gates to unearthly and enchanted worlds. Nerval, for instance, had imagined that "the temple of fire" was hidden in the bowels of the earth, where man's pre-Adamite forebears, demons of fire, wrought metal and erected bizarrely shaped statues—statues of "old giants," of "colossi . . . that represented the sacred customs, the sublime proportions and imposing aspect" of antediluvian titans.[49] Laboulaye had located the kingdom of smelting and fire in an American Paris, between red-hot furnaces, houses engulfed in fire, and printing workshops, but he had painted it in the same reddish and sulfurous hues that colored Nerval's metals.

On April 9, Bartholdi left the "shadows" of Vesuvius for the "eternal city" of Rome. Charlotte had inspired him to undertake this second part of his trip, telling him how she had always dreamed of "strolling there" with him and that she could not understand how Ary Scheffer had "never gone to that Eden of the arts."[50] This was all the more surprising when we consider that Scheffer had been so inspired by Raphael's frescoes in the Vatican when painting his saints. But Scheffer was a Protestant, and shared the Protestants' diffidence toward the city of the popes. Bartholdi was more agnostic, or perhaps his curiosity trumped his religious perplexities. Besides, he was also a pupil of Étex, who had had his strongest artistic raptures in Rome.

So Bartholdi went to drink from the fountain of his masters, of Scheffer, who was inspired by Raphael's precision and grace (but never saw his Roman frescoes), and of Étex, who was rather seduced by Michelangelo's brutality and passion. In the Vatican rooms, Bartholdi found some of Raphael's frescoes "even more beautiful than I had thought." But his natural preference was for Michelangelo's sculptural and animated artistic style. He studied the *Last Judgment* in the Sistine Chapel and then, after "a quick run across different parts of the city," visited the Capitoline Hill

("quantum mutatus ab illo," — how "changed from what it was"), the Baths of Caracalla, the Pincian Hill, etc. But none of these monuments affected him as much as the Egyptian colossi had. The Roman Forum, where "there was more grandeur," seemed to him now to be nothing but a "mass of ruins"; even the Coliseum, although "the most colossal thing known of its kind, like most other ruins, does not produce the impression that one expects from it." Paradoxically, given the future directions of his art, Bartholdi did not seem to have any passion for colossal art in and of itself, nor was the mere sight of ruins enough to drive him to melancholy, like a Romantic poet. As a true painter, however, Bartholdi was sensible to the ruins' backgrounds. It was ghost cities like Thebes and Pompeii that attracted him, because their ruins, isolated and distant from inhabited centers, seemed to bear witness to the end of the world more than simply the end of an era. It was the isolation of the ruins from real life (impossible to find in Athens or Rome) that ensured that, instead of just talking about the past, they anticipated future cataclysms and, in so doing, gave proof of the immortality of architecture.

In order to find apocalyptic architecture in Rome, Bartholdi had to descend beneath the earth, into the Catacombs. On April 12, he spent three hours underground, where he rediscovered, for the first time after days, his true passion for architecture. He studied the structure of the galleries "either ascending or descending," and pointed out their "total lack of regularity" in his notebook. Proceeding along the corridors, he noticed walls "rippled with horizontal niches" that would have been "full of the bodies of the first Christians," and explored the "rooms" where "religious services were celebrated" to spy, on the walls, what remained "of some very imperfect paintings."[51]

Only one monument, besides the Catacombs, truly captured Bartholdi's attention. Not surprisingly, given his mortuary interests and those of his mentor Étex, it was not the Belvedere Apollo, the Laocoön, the Discobolus, or the "statues of Canova" that attracted

him, but Michelangelo's *Moses*, sculpted for the tomb of Pope Julius II, in the Church of Saint Peter in Chains (Figure 13.1).[52] Standing before the *Penseroso* in the Medici Chapel, Étex had been struck with fever and chills; Bartholdi, by contrast, did not experience these raptures and found the statue of Moses "poorly designed." He was right—Michelangelo's *Moses* is certainly one of the most disturbing renderings of Moses in the history of sculpture. Moses is seated, with his head tilted to the left and his right leg slightly raised, "as if about to rise up, his proud head straight on his shoulders, his hand resting on the Ten Commandments under his arm." Moses grabs his beard, which falls "in heavy waves onto his chest, his nostrils dilated, and his lips affected as if trembling with words."[53]

According to Freud, Michelangelo depicted Moses at the moment when, having just come down from Mount Sinai with the Ten Commandments in his hands and his face still "radiant because he had spoken with the Lord," he caught his people by surprise as they worshipped the golden calf. According to others, Michelangelo's *Moses* was an expression of the same superstitious world that revolved around the pagan idols; he was a bestial figure, said the historian Jules Michelet, taken from the Apocalypse of Daniel, "subtly bestial and superhuman, as in the days close to creation, when the two natures were not yet fully separate."[54] It is difficult to say how Bartholdi interpreted the statue, but he concluded that it was "as beautiful as one imagines it when looking at the illustrations." Perhaps through the mediation of Étex, Michelangelo had been Bartholdi's real source of inspiration all these years. The muscular bodies, the wrathful or suffering faces of his statues, had served as antidotes to the static nature of Scheffer's paintings, and helped Bartholdi give his sculptures a life of their own. Perhaps, too, Bartholdi would keep this Moses in mind when the time came to give a face to the Statue of Liberty. For, if one looks closely, the Statue of Liberty also has thick and sensual lips, is tense with her narrowed eyes frowning, and has her hand on a book, in this case the Declaration of Independence rather than the

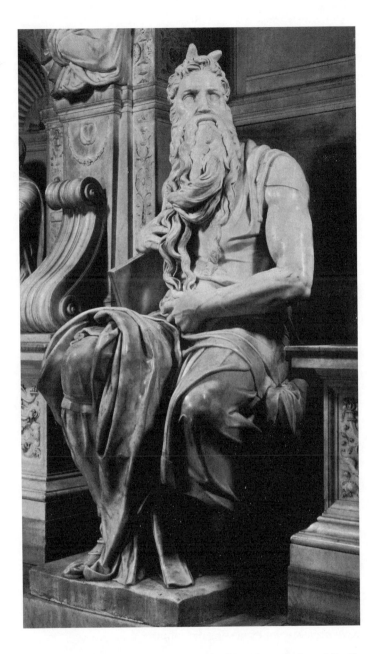

FIGURE 13.1. Michelangelo Buonarroti, *Mosé* (detail from the tomb of pope Julius II),
1514–1517, marble, Basilica di San Pietro in Vincoli, Rome.

Bible. One could say that her look is stern, but there is more to it: there is anger, even scorn. Perhaps, like Moses, with his "radiant head" and indignant expression, the Statue of Liberty is portrayed in the act of announcing a new world in America. But if so, what kind of world was it?

All of this still lay in the future. On April 18, 1865, after seeing off the Rozans, Bartholdi and Vassal took a pontifical coach to Livorno. Bartholdi went to Livorno this time in order to return by boat to Corsica and get to work on his monument to General Arrighi, yet another of his Napoleonic statues, but he would repeatedly return to Livorno from Corsica to collect mail from his mother.[55] Doubtlessly, he took advantage of these trips to visit Florence and admire Michelangelo's *Penseroso*, which would soon inspire him to build a statue in the Egyptian and funereal style. But Bartholdi also visited the Villa Demidoff and wandered around the enchanted park of Pratolino, among grottoes, trees, and statues that seemed to emerge from the very belly of the earth. He stopped at one statue in particular, which he photographed: the *Appennino* by Giambologna, a giant carved out of a cliff, towering over a body of water. Knees bent, like a child crouched on the beach, the colossus seemed to be drinking and eyeing its own reflection in the water, bristling with the lumps and irregularities of the rock. It was just the sort of monster that Nerval imagined living beneath the surface of the earth, bizarre creatures created by antediluvian spirits of fire.[56] The *Appennino*, instead, was connected with water; someone even suggesting that it was a hidden icon of the Nile river, its head reminiscent of a crocodile.[57] It is hard to know whether Bartholdi was aware of this. What matters for our story is that his interest in the *Appennino* reflected a methodological interest in artistic questions of size and monstrosity, and maybe already the awareness, soon formalized by Hugo in the *Orientales*, that grotesque characteristics were necessary for expressing the sublime.[58]

THE VEILED VALKYRIE

THE YEAR 1865 proved to be a quiet one for Bartholdi and Charlotte. No major event, not even the end of the American Civil War, disturbed their peaceful world. Two years earlier, Auguste had sculpted Charlotte's bust in terra cotta: straight and stern, she looks into his eyes with determination, elegant curls adorning her temples and two lace ribbons falling on her shoulders. Not long afterward, Bartholdi started working on a second bust that is no less significant for our story: the bust of his friend Laboulaye.

The Union victory had strongly reinforced Laboulaye's political position. With his role as friend of the American blacks now established, he founded a French association for the relief of the newly emancipated slaves.[1] Around the same time, he ran in the Strasbourg elections, and Bartholdi agreed to sculpt his bust for the occasion. It was probably during his work on Laboulaye's sculpture that Bartholdi started visiting his friend more often, and maybe even taking part in his receptions at Glatigny.[2]

IF THEY EVER TOOK PLACE, Bartholdi's visits are not registered in Charlotte's or Bartholdi's papers, though there is a curious gap in the archive between December 1865 and 1869. Did someone seek to remove evidence of the facts leading to the earliest projects for the Statue of Liberty? It is possible. The consequence for us is that, with Laboulaye's letters still in private hands, the reconstruction of the earliest encounters between Laboulaye and Bartholdi (and of the

Statue of Liberty's earliest life) is left to Bartholdi's later testimony and educated guesswork.

As mentioned earlier, Bartholdi would claim in an 1885 story for the *North American Review* that he had first heard about the project of sending a statue to America as a token of Franco-American friendship, in December 1865, while a guest at Laboulaye's villa in Glatigny. Nothing in Bartholdi's tale suggests that he was asked to commit to the project then and there. Laboulaye's ideas were probably still vague, and nothing was done or said during that dinner suggesting that the monument was to be realized in the immediate future.

Bartholdi claimed that the project interested him so much that it "remained fixed in [his] memory."[3] Because no letter about the dinner has survived, it is difficult to confirm Bartholdi's testimony. What we do know, however, is that Bartholdi had on his mind at the time pressing projects that made Laboulaye's monumental ideas for an American gift seem very remote. Indeed, within two years a new international exhibition would open its doors in Paris, one that would be dominated by the Egyptian pavilion and the French hero in Egypt, Ferdinand de Lesseps. And while sketching Laboulaye and chiseling away the terracotta for his bust, Bartholdi was dreaming up an oriental monument to seduce the pasha and the epic engineer.

The Universal Exhibition in Paris was inaugurated in the spring of 1867. Just months before its opening, the military drills and polo matches of the Champ de Mars were set aside for a garden of wonders, which would set the stage for a new glass and cast-iron Palais des Expositions. Viewed from on high, from a hot air balloon for instance, the Palais looked like a diamond set in a green ring, but inside it was a labyrinth of gray iron and machinery. Seven "radiant sections" were organized around a central garden, each dedicated to different products of the same nation, ranging from "ethnographic collections" to a "series of vast mechanical or manual workshops."[4] Other passageways

branched off from the central garden, dividing the arcades into sections dedicated to the various nations. Visitors could therefore choose either to walk the length of the arcades, comparing the achievements of different countries in one field of industry, or take the side streets, as it were, and see all the products of a particular country. When they got tired or hungry, restaurants located in the outermost arcade served up the best international fare, including Russian caviar and salmon, which few in France had ever tasted, and Bohemian beer, otherwise impossible to find in Paris.

But the exhibition did not stop at the walls of the Palais. For the first time in the history of the event, the garden hosted a kind of open-air display city. Small, low buildings of every shape and color, housing workshops and showcasing diverse crafts for the public to see, welcomed the visitors as they first entered from the Grande Porte. Glassmakers made glass; cabinetmakers built furniture; jewelers cut diamonds; goldsmiths gilded metals, and iron-founders cast iron in a furnace fit for a biblical Tubal-Cain, the blacksmith ancestor of humanity according to the Bible.[5] The workshops stood in the proximity of a lake, in the middle of which an island of fake rocks made of cement, connected to the shore by a bridge, featured one of the most intriguing objects of the whole exposition—one that Édouard Manet would immortalize in his *View of the 1867 Exposition Universelle*.[6] It was a 196-foot tall iron lighthouse rising over the minarets, the furnaces, and the towers scattered here and there all over the garden, but also over all the other lighthouses on display. And there were many of them—lighthouses on pylons of twisted iron, and lighthouses perched on towers and pyramids, painted in red and white stripes.[7]

"Visitors less partial to . . . spectacular shows of mechanical activities" found their way to the opposite sector (between the rue de la Motte Piquette and the Boulevard de l'Est), to see the Jardin Réservé, with its saltwater and freshwater aquariums, gazebos, "botanical dioramas," and all kinds of greenhouses and artificial

lakes.[8] Others continued along the rue de la Motte Piquette to enter into something of a real labyrinth, which stretched as far as the eye could see. A world within a city, it was complete with streets, avenues, and squares, but the houses were built in the styles of all the countries of the world. Going through the gates and getting lost in its meanderings meant going "around the world"—not in Jules Verne's eighty days, but in just a few hours. There were Norwegian *hytter* (cabins), Russian homes in the Moorish Revival style, Bedouin tents, caravanserais, Egyptian temples, minarets, Chinese pagodas, Moorish pavilions, and reconstructions of Mexican ruins. Around the more mysterious buildings, groups of "natives" posed motionless under the curious gaze of spectators; Mexicans were seated on the Aztec tombs of Xochicalco, Arabs rested in their tents, and Turks drank coffee.

The real masters of the world city, however, were the Egyptians. Wrapped in white tunics and sporting rich headdresses, they whiled away the time chatting in their caravanserais, lingering around the temple, or wandering among the bales of cotton on display. All of this self-confidence derived from the fact that, unlike Turkey, or Russia, or other "exotic" countries, Egypt had obtained the right to build as many as four pavilions within the New Babel. In one of them, Lesseps did the honors and showed visitors photographs, "relief plans," and designs of the Suez Canal, while, in a dark and circular room at the end of the pavilion, a diorama gave viewers a preview of what it would be like to cross the canal.[9] Next door at the Salamlik, a typical guesthouse shaped in the form of a Greek cross, the Khedive Ismail (who had succeeded the peaceable Mohammed Said) had recreated an Egyptian vice-regal palace in which he received crowned heads of state under a dome reminiscent of the Hagia Sophia in Constantinople.[10] A few meters away, an "avenue of the sphinxes" led to a reconstruction of the Temple of Isis in Philae, where an array of mummies, sarcophagi, and statues had been put on display by the archaeologist Auguste Mariette, including a polished black diorite statue of a seated Pharaoh Khafra, with

priestly bands falling along the sides of his neck and an enigmatic smile on his face.

The Egyptian quarters were a must for all visitors to see, but especially for Bartholdi. The exhibition's judges had accepted two of his paintings, one of which was a *View souvenir d'Egypte* (almost certainly a painting made from one of his Egyptian sketches), and a statue of Champollion the Younger, the translator of the Rosetta Stone.[11] Positioned between the caravanserais and the temple of Philae, Champollion was depicted with his left foot on the colossal head of an Egyptian statue, his elbow resting on his left thigh, while holding his chin in a moment of reflection. He was Michelangelo's *Penseroso* transported to the ruins of Egypt; melancholic and withdrawn—or so the critics said. Champollion was described as the symbol of "man, the man of all ages, with his thirst for knowledge . . . which makes him conscious of his own power, and which arms his will against the most impenetrable mysteries."[12] But exactly what mysteries was Champollion searching for among the Egyptian pavilions in the Champ de Mars?

The Egypt presented at the exhibition was not the pensive place that European adventurers had explored at the beginning of the nineteenth century. From the outbreak of the American Civil War, when the United States had produced 4,673,770 balls of cotton annually, to 1865, when the American production had dropped to 500,000 balls a year, Egyptian exports (mainly consisting of cotton) had increased dramatically, from 4 million sterling (in 1863) to 14 million sterling (in 1865). Egyptian cotton briefly enjoyed its advantage over British cotton from India as well as French cotton, John Stuart Mill had once explained in private conversation, because Indian cotton was too dirty and sandy after having been "carried across stones and bushes to the harbor," while the fibers of French cotton from Algeria were too short. As a result of these developments, by 1864, cotton farms covered 40 percent of lower Egypt and would progressively spread throughout all of the delta and, in some spots, into upper Egypt.[13] Such rapid growth in agriculture was largely

driven by pressure from French and British banks and enterprises, which pushed for Egypt to increase its agricultural production for European consumption. Financed by English, French, Austrian, and Italian bankers, the viceroy's family and other big Egyptian landowners bought machines for separating and spinning cotton yarn, expanded cotton farming, and built canals to irrigate the plantations farthest from the Nile. Since 1863, railroads and telegraphs had started connecting the cotton fields of the delta with the emporia of Alexandria, while the Suez Canal, excavated using the most advanced machinery ever seen (like steam dredges and steam lifts), would soon bring to Alexandria cotton from as far afield as India. Egyptian pashas, in turn, had rewarded their European benefactors by provisioning their garrisons with guns and cannons from America, France, and Britain.

The Egyptian economic miracle was applauded in Germany, where the paper *Ausland* noticed that it was "interesting that a barbarian ha[d] achieved within a few years what Napoleon and the entire continent were unable to accomplish since the beginning of the century."[14] This miracle, however, was made possible by a harsh exploitation of a slave workforce (to which we will return in due course), and by British and French investments. This investment component explains why the organizers of the universal exhibition gave Egypt so much space and symbolically placed its four pavilions along the Circulaire des Deux Mondes. Their purpose was to show people that Saint-Simon was right, that finance could globalize the world and build bridges across countries, as demonstrated by industrialized Egypt, now a channel between East and West, between the Christian and Muslim worlds. True enough, the Saint-Simonians and Saint-Simon himself were rarely mentioned, but Lesseps had become their most illustrious spokesman. Self-assured in his own pavilion, he greeted his guests by illustrating the merits of the canal with words worthy of Father Enfantin himself. Possibly, he repeated the words that he had used some years earlier while addressing Napoléon III:

Steam, rail, and electricity have shortened distances; the Occident, constricted by too narrow limits, suffocated by the marvels of its own industry, sought a grander outlet and a grander career. It felt that it had to find it outside of wars and revolutions . . . This is the wind of the century that blows our sails and will lead us to port.[15]

The "wind of the century" was, obviously, blowing eastward. And the eastern port par excellence was that of Suez, where the waters of the canal emptied into the Red Sea. Lesseps reveled in telling how, when construction work had finished and the waters of the canal could finally be seen spilling into the Red Sea, Egyptian workers had taken their European colleagues by the hand and chanted, "The Christians are also children of God. They are our brothers."[16]

Bartholdi may have already heard similar words from Laboulaye, who was adamant that Muslims, Jews, and Christians could find a way to coexist in peace, particularly in the French colonies. Indeed, like Lesseps, Laboulaye thought that religious integration was primarily needed to soften the impact of European nations in the Middle East. None of them, however, especially Lesseps, thought of making the cultural meaning of the canal clear to its future users. This symbolic emptiness was striking at the exhibition. Entering the Suez Pavilion from the main entrance, visitors found themselves before a relief model of the canal, arranged in such a way as to give the impression of "arriving from India and penetrating into the canal from the Red Sea and city of Suez."[17] What was missing was a lighthouse to welcome ships to the canal, and a monument preparing their passengers for Egypt's technological progress. The exhibition of course displayed a variety of lighthouses, and, even before then, the Egyptian khedive had commissioned a number of lighthouses from French factories. None of these, however, were monuments in the classical sense, for none had the power to communicate ideas or principles. At some point

during the exhibition, Bartholdi must have realized that he himself could build a lighthouse that would also look like a gigantic monument. But how, and what might it represent?

We know very little about the exact circumstances in which Bartholdi settled on the project, but we know that he started working on it at some point during 1867. The Musée Bartholdi in Colmar has kept the earliest evidence of this enterprise: a terracotta model of a fellah, bearing the title *L'Égypte éclarant l'Orient* (Egypt enlightening the Orient) or *l'Egypte apportant la lumière a l'Asie* (Egypt bringing light to Asia), and two inscriptions: "AB," for Auguste Bartholdi, and "1867." Waves splash up against a large pedestal, on top of which a tower supports a huge fellah raising her right arm to lift a lantern, while her left arm is resting along her hip. Dressed in a tunic, the woman wears a veil revealing her forehead, which drapes down onto her shoulders and forms two lateral folds next to her temples. A door opens on the fellah's pedestal, as if Bartholdi already knew that his woman was going to be empty inside, like a temple or a sanctuary. To make his intention clearer, he modeled four small characters in clay and distributed them by the temple's entrance: two standing against the pedestal's wall, one leaning against the doorpost, and one crouched a bit farther away. The realism is striking, for just by looking at the figures seated or standing around the woman-temple, one can imagine future visitors seeking refuge from excruciating heat in the shadow of the colossal goddess. Clearly, Bartholdi had copied them from some of the sketches he had made during his Egyptian journey, more than ten years earlier.

It is puzzling that Bartholdi had waited for so long to translate his "ethnographic" sketches and photographs into a monumental project. Some of them he had generously shared with Gérôme, who had not hesitated to transform them into commercial paintings; others he had used to paint Egyptian scenes, such as the one that had appeared at the 1860 Salon under Bartholdi's pseudonym Amil-

car Hasenfratz. It was the painting of a coffeehouse on the edge of the Nile, shaded by palms and with a view of the river. At the foot of the stairs leading to the coffeehouse were two veiled fellaheen dressed in blue: one carried a vermilion amphora on her head and held it steady with her left hand, while the other crouched down to wash clothes.[18] Yet so far, Bartholdi had been reluctant to use his Egyptian studies to mold an "ethnic" monument. The only exception was his *Lyre du Berbère* (1857), a bronze representing a scene from Abyssinia, with two almost naked musicians listening to each other's melodies. One, kneeling on the ground and with an expression of deep beatitude painted on his face, plays the Kissar (an Ethiopian lyre), while the other, half laying down near him, sings and keeps the rhythm with his hand.[19] It is difficult to think of a more drastic alternative to the statue of Champollion, a classical sculpture transported into an Egyptian background.

In many ways, Bartholdi's model for the fellah-lighthouse was a relative of the *Lyre* rather than the *Champollion*. But it would be useless to try to find among his sketches the exact picture that he used to model his woman-lighthouse. In one of his drawings, for instance, the fellahs seem to be playing a game, holding a single amphora up above their heads as they stand around each other; in another, a fellah turns her back on Bartholdi, her hands clasped behind her head to hold up an amphora. Further, during the ten years that had passed since Bartholdi's return from Egypt, the fellah had become a widespread icon of French ambitions in Egypt, even more so than at the time of the Saint-Simonians' misadventures in the desert.

Veiled fellahs with loose tunics could be seen everywhere at the 1867 exhibition, as well as outside of it. Lesseps, for example, had a portrait of a fellah mother placed prominently high on the left wall of his pavilion; it showed a woman holding a baby in her right arm, while balancing a jug on top of her head with her left. But one of the most popular fellahs was Charles Landelle's *Femme fellah*, dressed in a bottle-green dress with a plunging neckline, a

black veil fastened tightly around her forehead (almost like a head-
dress) and falling onto her shoulders and back. While on exhibi-
tion at the Salon of 1866, Landelle's fellah had caught the eye of
Napoléon III, who had purchased it on the spot.[20] This theatrical
act had made the fortune of Landelle and his fellah, but also,
indirectly, of Bartholdi. The Maison Goupil had ordered more
than fifty reproductions of it, and had sold the prints all over the
world, from the United States to Algiers. A copy of Landelle's fel-
lah also appeared at the 1867 exhibition, just to put other portraits
of similar subjects in its shadow. Bartholdi, then, did not need to
go back to his drawings to find inspiration for his fellahs, for they
could be found everywhere. Moreover, he would have known that
if he wanted to capture the emperor's or the khedive's attention with
an Egyptian project for the canal, he had better choose one of the
most popular fellahs available in Paris salons or exhibitions as his
subject. The real challenge, however, was how to create a light-
house in human form, something that, as historians were starting to
discover just then, not even the ancients had attempted.

IN CONTRAST TO HIS MOTHER, Bartholdi was not a voracious
reader. Still, a book from his home library in Colmar might shed
some light on his earliest steps toward the construction of the fellah
and, ultimately, the Statue of Liberty. The book was Léon Renard's
Les phares (Lighthouses), which was published by Hachette in 1867
as part of the series *La bibliothèque des merveilles* (Library of won-
ders) under the supervision of the Saint-Simonian and mystic editor
Édouard Charton. Renard was librarian of the Dépôt des cartes et
plans de la marine and, as an expert in maritime history, he was in
close contact with those in France who were aiming to expand the
French mercantile navy and employ French capital abroad. Louis
Hachette was one of them, and, even if he had died in 1864, his
staff at the publishing house still shared his enthusiasm for France's
global expansion. As a former Saint-Simonian, Hachette's editor

Charton had an additional reason to be intrigued by Renard's book: lighthouses were an old topic of interest for Saint-Simon and his followers. It is more difficult to say how and when Bartholdi first encountered Renard's *Les phares*, although it is quite possible that he bought it at some point during 1867 in order to plan the building of his lighthouse. Short and well-illustrated, *Les phares* was, indeed, a suitable choice for someone like Bartholdi, who wanted to know more about the history of lighthouses, but had little time or patience for reading about them.

Renard explained that the very first lighthouses were built in Lower Egypt and served not only as points of observation and for signaling, but also as solar temples, which sailors decorated with votive offerings, and where a fire was permanently kept alive. Indeed, they were also known as "fire towers."[21] It is worth keeping this technical-historical approach in mind while considering Bartholdi's reason to entrust his Statue of Liberty with a flame. But Renard's description of famous *phares* could also explain Bartholdi's earliest sketches of the fellah. The most important of the Egyptian lighthouses, Renard explained, was the Lighthouse of Alexandria, considered one of the "seven wonders of the ancient world." Located on the isle of Pharos, seven *stadia* from the mainland, the lighthouse was an enormous building. According to Renard, it was like the Tower of Babel, which Herodotus had described as a colossal building made of eight towers, each placed on top of the other, and a spiral staircase running on the outside and leading to the sumptuous temple in the top room.[22] Renard did not mention the statue depicted on the lighthouse on some Alexandrian coins, for he did not believe the ancients had ever attempted to build anthropomorphic lighthouses. Modern archaeologists, by contrast, argue that the statue indeed existed, but that it was placed outside the lighthouse. Interestingly for our story, some have suggested that it may have portrayed Isis, then honored as the protector of sailors and the inventor of sails, steadying a sail with her right, raised arm, while her tunic and the sail waves in the wind.[23]

It is worth keeping this image in mind for later, when Bartholdi arrives on Bedloe's Island to sketch a first image of the Statue of Liberty in his notebook, her dress billowed by the wind like a sail, her arm raised like a mast. For now, it is enough to note that Renard's insistence that no ancient lighthouse was ever made with anthropomorphic features might have encouraged Bartholdi to take on the challenge. But—one may wonder—what about the famous Colossus of Rhodes, the mythical statue of Helios that the Rhodians were said to have built in their port to celebrate their victory against Cyprus? Renaissance artists had depicted the colossus astride the harbor and crowned with solar rays, with its right hand raised to hold a torch and the other holding an arrow or spear, but by Bartholdi's time it was instead believed (and Renard agreed) that the colossus was never meant to be a lighthouse (Figure 14.1). Some maintained that it stood with its legs together, measured 111 feet high, and was not situated at the port after all.[24] Renard explained that it could not have been a lighthouse, for lighthouses had a defensive, not decorative purpose, which was why the lighthouse of Alexandria had walls built around it. Similarly, the lighthouse of Boulogne (an ancient octagonal fort said to have been built by Caligula on the French side of the English Channel) became a lighthouse-fortress during the English occupation, when the French built two ramparts around it, "one of brick, the other of clay and outfitted with artillery pieces."[25]

Quite appropriately, as soon will be clear, the Statue of Liberty would stand on a military fort and would be surrounded by cannons. But what about the fellah? Her name, *Égypte apportant la lumière à l'Asie*, was clearly evocative of Saint-Simon's and Lesseps's dreams of connecting the West and the East into an integrated scheme. It was a dream of solidarity, and yet, Edward Said tells us, this very dream hid the project of knowing and controlling the Orient once and for all.[26] Sure enough, the fellah's maquette of 1867 was meant to be looking toward the East with determination, if not with severity. She certainly had very little of the erotic

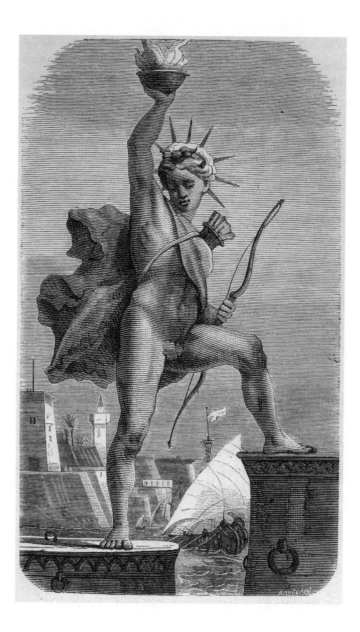

FIGURE 14.1. Jules Noël, *Colossus of Rhodes According to a False Tradition*, in Léon Renard, *Les Phares* (Paris: Hachette, 1867).

nuances that had become so popular in France and abroad. Sure, her headdress is reminiscent of Landelle's fellah, whom Napoléon III had been so taken by, but beneath the veil, her face could not be more different. Roughly shaped in the terracotta, the fellah's features are resolutely and distinctly masculine. Was this simply an effect of the roughness of the model? Or did Bartholdi intend to build an androgynous colossus already in 1867?

We know that Bartholdi had a special fascination with male bodies, and the Saint-Simonians had always believed in the mystic combination of male and female qualities. Still, it is the fellah's pose more than its gender that matters here. For her arm is thrust up with a resolve that starkly contrasts with the suppleness with which the fellahs of most French painters held their amphorae on their heads. The fellah is unique also in the context of other monuments with which Bartholdi might have been familiar. Take, for example, Dumont's feminine *Génie de Liberté*, the golden Hermes that had already inspired Bartholdi's *Génie dans le griffes de la misère* and would continue to fascinate him. The fellah is raising her torch like the *Génie*, but her gesture is not as elegant. It is rather reminiscent of Delacroix's *Liberté guidant le peuple*, the voluptuous prostitute running on the trenches with her right arm raised to brandish a French flag. For all we know, Bartholdi may well have been inspired by the *Liberté*, which in 1863 had been unveiled at the Musée du Luxembourg after having been hidden from public eyes for almost thirty years. Auguste had five years to study the work before molding the maquette for the lighthouse. The result was astonishing, for his fellah brandished her huge lantern as if it were a flag of national liberty. Was the fellah a symbol of the French (or Western) possession of Egypt and its future eastward expansion? Or was it rather a symbol of liberty? But, if so, what sort of liberty, and from whom?

As will be clear, proof of Bartholdi's intention to use the fellah as a symbol of liberty is easy to find in a later phase of the Egyptian project. It may be that, initially, Bartholdi simply applied a well-

established symbolism of progress to his fellah, one celebrating the spread of French technology in Egypt and, through Egypt, to the entire world. After all, the Saint-Simonian Duveyrier had planned to honor French productivity and knowledge by erecting a woman-lighthouse, one that, emanating sparks of fire around her, would cast beams of light on the new Paris. Like the Saint-Simonian colossus, Bartholdi's fellah was meant to be a giant. Engraved on the pedestal was the prospective height: forty-three meters. But then it is enough to look at the few people Bartholdi had modeled at the fellah's feet, on top of the pedestal, to realize that he had a large-scale project in mind. This should not surprise us, for the reading of Renard, combined with his experiences visiting Egyptian colossi and the *Appennino*, must have triggered Bartholdi's desire to create something never accomplished in the past: a giant that was also a lighthouse.

Not even the latest colossi built by contemporary artists in the effort to compete with the ancients had a sparkle of light in them. Yet they all exhibited the aggressive features that Bartholdi gave to his fellah. One example was Schwanthaler's bronze *Bavaria*, which Bartholdi had seen in Munich years earlier, a hollow statue representing an Amazon with her left hand raised to lift a wreath of oak leaves, as if ready to honor some Germanic hero. The other was the French *Vercingétorix* of 1865, an almost forty-four-foot copper monument to the Gallic chief who was defeated by Caesar in one of the most memorable battles between Romans and Gauls in all of antiquity; his face showing the same features of Napoléon III, only disguised under savage, long hair and sloping moustaches, Vercingétorix leans on his sword and contemplates what was thought to be the old Alesia with a melancholic and vengeful look (Figure 14.2).[27] A similar look appears on the Statue of Liberty, as she, too, mourns France's lost empire in America. Bartholdi would not give any official explanation for his statue's mood, but the architects of *Vercingétorix*, Aimé Millet and Eugène Viollet-le-Duc, inscribed on their statue's pedestal the words that

Julius Caesar had attributed to his enemy in his *De Bello Gallico*: "Gaul united, / Forming a single nation / Animated by a common spirit, / Can Defy the whole Universe."

The third monument that might have inspired Bartholdi was the *Hermannsdenkmal*, a copper statue of Arminius, the Cherusci chieftain who defeated the Roman legions in 9 CE. Its sculptor, Ernst von Bandel, started building the statue in 1838, but his work was long stalled by the absence of funds and only completed in 1875. Even so, technical and detailed projects and prospectuses of the *Memorial of Arminius* had begun to circulate in print in the early 1860s. The similarity between the *Arminius* and the future Statue of Liberty are quite striking, so striking that, as mentioned, Kafka would confound the statue's torch with a sword.[28] Plausibly, however, the fellah was meant to look like the *Arminius*, even more inside than outside. For Bandel's plans revealed very early on that the *Arminius* would be shaped by thin copper layers attached to an inner iron pylon, with an additional structure departing from the shoulder to support the arm.[29]

The fact that Bartholdi may have been inspired by the *Arminius* long before building the Statue of Liberty, while still working on an Egyptian project, is fascinating in itself. Even more surprising, though, is that neither the *Arminius*, nor any of the other modern colossi, were symbols of liberty. They rather glorified a nation's military strength, and the *Arminius* more so than most: as Bandel wrote on his sword—meant to attract powerful bolts of lightning during storms—"German Unity, My Strength / My Strength, Germany's Might."[30] How could Bartholdi associate this nationalistic approach with the globalism of the Saint-Simonian message? Sure enough, Saint-Simonians too thought of Paris as the center of an interconnected world. But they framed their theory in terms of friendships and cooperation, not supremacy and submission; they thought of commerce, not of wars. They also dreamed of muscular and industrious fellahs, but their masculinity was more sensual than aggressive. Bartholdi's fellah, by contrast, looked more like a triumphant or vengeful warrior. Was this a sign that he was slowly mov-

FIGURE 14.2. Aimé Millet, *Vercingétorix*, 1865, copper statue, archaeological site of Alésia, Alise-Sainte-Reine, Côte-d'Or, Bourgogne.

ing from the global aesthetics of Saint-Simonianism to embrace
the chauvinism of contemporary nationalism? Or was he simply
portraying the national implication of Saint-Simonian discourse?
After all, when Bartholdi's friend Edmond About arrived in Egypt
in 1867, he first thought of his mission as one of "helping Europe
in bringing light to a corner of Africa, working toward the progress
of a country, the history of which is a long decline."[31]

ON MARCH 23, 1869, Bartholdi wrote to his mother from Paris
that he was devoting himself "entirely to [his] Egyptian business,"
although, as opposed to other projects, "the advantage of this one
is that it is proving impossible." In saying so, Bartholdi was being
superstitious. In reality he was "securing for himself every possible
support" and making sure he would be ready at a moment's notice
to "seize the opportunity." In effect, while Bartholdi was writing
to his mother, all his efforts were focused on winning over the
Napoleonic entourage to get the funding he needed for the Egyp-
tian lighthouse. After Émilien de Nieuwerkerke, the intendant
des beaux-arts who had acquired Bartholdi's bas-relief of Dante's
Francesca, promised Bartholdi his "support," the artist felt he had
"taken the bull by the horns."[32]

Five days later, Bartholdi boarded a ship in Marseille and headed
to Egypt for a second time. It was March 29, 1869. Sailing past Strom-
boli over indigo waters, he painted the volcano in watercolors, just
as he had painted Vesuvius in the past. Fourteen years on since
his first voyage to the East, he would tell his mother that it was "a
pleasure [for him] to see that climate, that sun once more," yet
he doubted that he would experience "all the same sensations as
before."[33] He was right. What awaited him at the other end of the
Mediterranean was no longer a formative experience or journey
among the pyramids and tombs of Egypt, but a hard sell, because
this time he was out to convince the statesmen and industrialists
there to finance the projects he had developed from those original

studies. His old traveling companion from Marseilles, Rozan, had obtained letters of reference for Bartholdi to present to certain French men operating in Egypt.[34] But of course Lesseps and Ismail would be the toughest nuts to crack.

The first leg of Bartholdi's trip took him to Alexandria, where the ship docked at dawn on April 4. As usual, Bartholdi went above deck in the dead of night to catch the first light of the sun as the ship entered the harbor. As he waited, he sat down quietly and nibbled "on a chocolate bar to satisfy [his] material appetites."[35] After enjoying the show, Bartholdi disembarked and threw himself into the hot and crowded metropolis. Lesseps was in town, but he was not in a good mood when Bartholdi knocked on his door. He received him coldly and was quick to dampen his "enthusiasm." Two days later, the two men found themselves on the same train to Cairo, but although they sat together in the same compartment, Bartholdi thought better of bringing up the subject of his lighthouse project.[36]

The above-mentioned journalist Edmond About probably informed Bartholdi that he had met Lesseps in Alexandria a few months earlier. About had not been favorably impressed: construction work on the canal was being managed by "about fifty or sixty amateurs who have breakfast in the morning, dine in the evening, go to sleep at night, and drink champagne to the health of the good people of Europe. When they don't have a cent left, Lesseps pulls out his pickaxe of massive gold, pretends to inaugurate something, and hey presto! a hundred million francs rain down from heaven." Lesseps had no intention of sharing that booty with Bartholdi. Nor was he pleased by the prospect of an ambitious young man coming along to steal the spotlight from him just then, when work on the canal was winding up and everyone was idolizing him as the "genius" of progress.[37]

Once in Cairo, and thanks to the efforts of the merchant Barrot, Bartholdi managed to secure an audience with the khedive. The meeting took place in the royal palace in Giza, "on the street of

the pyramids." After two hours of waiting, he was admitted to the audience chamber by the omnipresent Mariette (a familiar and somewhat sycophantic presence ever since the time of the universal exhibition). In the chamber, Bartholdi found the khedive, a certain scholar named Burguières, Ismail's private physician, and two servants. Lesseps, predictably, was nowhere to be found. It was not a good sign, and Bartholdi quickly understood that little would come of the meeting. He rolled out the drawings he had brought along and showed them to Ismail, together with the terracotta maquette. The viceroy was clearly enthusiastic. As Bartholdi would write to his mother, "He looked [at them] with interest, I explained [them] to him, and he told me he would prefer to see the luminous apparatus moved above the head, in the manner of the fellah women." What the khedive probably meant was that Bartholdi ought to sculpt the fellah in the act of holding the light as if it were a water pitcher or a vase. Used to seeing his region described through sensual and even erotic orientalist lenses, the pasha must have been struck by Bartholdi's masculine and energetic fellah; he would have been even more surprised to imagine that her powerful frame rested on the examples of Germanic and Gallic warriors.

Whatever the case, Bartholdi did not like the khedive's suggestion. "So as not to contradict him," Bartholdi said that the viceroy's suggestion was "easier," but as he confessed to his mother, Ismail's idea was "less appealing."[38] Then Bartholdi asked Ismail "permission to leave him the . . . drawings and see him again on his trip to Paris in two months." "With a modest greeting," the khedive dismissed him. "And there you have the result of my endeavors," Bartholdi concluded; "as you see it is nothing great, but it is something."[39] He did not leave the model with the viceroy. From his letters it would seem that he was busy looking for other patrons. "Among the works being made in Cairo," he wrote to his mother, "I see many things to do and will try to get myself a little work."[40] Between April 9 and 10, he was in the company of Mariette, first in the bazaars of Cairo, then on a visit to the pyramids (which he

had seen briefly on his first trip but had not photographed) and finally to Saqqara.

French diplomats, merchants, and artists in Egypt formed a close-knit social circle. They lived in the same stylish neighborhoods in Alexandria and Cairo, entertained themselves with cruises along the Nile, and danced and feasted along the banks of a canal still under construction. One evening, at the theater in Cairo, Bartholdi bumped into Lesseps again. Perhaps to win back his favor, this time Lesseps expressed "great kindness and sympathy" and invited him to journey along the isthmus together.[41] During the trip, Bartholdi befriended the Austrian and Russian consuls and the painter Riou, whom he had met along the way, and went to Ismailia, where a banquet full of "pastries and wine, as in Paris" was waiting for them, followed by music and singing.[42] The party then stopped in Port Said. That day, he rode "flat out" all the way to Giza, only to board a boat again and sail back down the canal; at night, he danced under the open sky.

It was all "Monsieur de Lesseps' boutique," as About put it.[43] Yet it was more than that. Bartholdi stood in awe before the "élevateurs," a kind of steam-powered crane, and marveled at the changed landscape. It was not the Egypt he had seen on his first trip in 1855. Or, if nothing else, the views of shipyards and ironworks, and smoke hanging heavy on the horizon, distracted Bartholdi from less seemly sights. In Port Said, on April 13, Bartholdi was struck by the "enormous blocks, which seem to have been cast away and recomposed in a jumble by the hands of giants."[44] But as impressive as it all looked, the reality was quite different. Had they met in France, About would probably have told Bartholdi that the French and British colonizers, having successfully lined their pockets, were actually preparing to abandon Egypt. Behind them, they would leave piles of garbage even higher than those that had upset Bartholdi during his first voyage: warehouses covered in weeds, "a few hundred machines, many yet to be unpacked, . . . [and] iron ruins, the least picturesque and least durable of all."[45] Egypt was no longer a place to go looking

for commissions, but Bartholdi did not yet know that. When he arrived in Suez on April 17, he set out with Lesseps on a steamboat on a "tour of the harbor, [to] see the dams and the great works." Bartholdi took particular interest in the dams and, as he put it, took note of "everything that could be useful for the lighthouse project." It would be his last look around before heading back to France, and Bartholdi was sad to leave Suez on April 18. He got up early to "watch the sunrise over the Red Sea, which is wonderful; the lights that play, change, and turn to dust in the mountain chain of the Sinai and, on the other side, on the Djebel Attacka [sic] they have revived in me all the impressions that I had of this place fourteen years ago."[46] In his heart of hearts, Bartholdi may have known that this would be a final farewell, but he remained optimistic. "In spite of feeble beginnings and the little support and encouragement" he had found, he wrote to his mother from Cairo, "I'm not giving up yet."[47]

Bartholdi spent the last few hours before his departure strolling around Cairo. He bought a whole box of photographs as a final souvenir, then he embarked for the last part of his journey. On April 22, he left for Alexandria, from which, on April 24, he sailed to Venice, Italy's eastern gateway.[48] Like Flaubert before him, he too seemed to believe that Venice was the natural conclusion of a trip to the Orient, a place where the *longa manu*, or long hand, of exotic pantheons still could reach. This, at least, seemed to have been Bartholdi's impression during the first night of his voyage, when he wrote a letter to his mother telling her how he was watching "the stars, trying to remember our studies of astronomy": "then my mind wanders, I believe I see you in the distance, behind the horizon, I imagine what you are doing and tell myself that you are asking where I am."[49] Astronomy and astrology were passions of Bartholdi's father, Jean-Charles, who "admired the stars with such ecstasy" that when he spoke of them, he seemed "the most learned person in the world."[50] After her husband's death, Charlotte had taught their children to recognize the stars and constellations, but she added a touch of her own mystical inspiration,

for she thought that the souls of the dead could be found among them.[51] It was a starry sky that welcomed Bartholdi to Venice, just as dawn was breaking: "the rising sun, beautiful in appearance; the morning mists, the sun's irradiations that come to caress with all their shadings of light the city on the horizon, the snowy peaks of the Alps." Enchanted by the morning's spell, Bartholdi headed straight to a deserted Saint Mark's Square to admire the basilica in all its brilliance of light and color. There he was enthralled by the bell towers "blazing and reddening in the sun, while shaking off the night mists."[52]

The red hues of Venice were not those of the Egyptian sands, nor of the dry lava in Naples, nor of the walls of the houses in Pompeii. Inside Saint Mark's, Bartholdi was taken by the "red tone with golden effects," which, mixed with the light reflected off the mosaics, produced "blue rays of sunshine, made to attract the painter." As the English, who filled their museums with Canaletto and Tintoretto, knew so well, Venice was the city of color. And so Bartholdi went to the art gallery (probably the Accademia), to see the works of these painters and those of Paolo Veronese, whose warm yellows and Titian reds had influenced Scheffer since his earliest canvases. Bartholdi ignored the white and expressionless statues of Canova, too similar to those of Ingres and Pradier to satisfy his fiery tastes, and dwelled instead on the equestrian monument to the great *condottiere* Bartolomeo Colleoni, in the Campo Santi Giovanni e Paolo, "one of the most interesting statues" and one "that most people were hardly looking at . . . there is an artist's fire in the statue and the pedestal is very remarkable."[53]

From Venice, Bartholdi headed for Switzerland. Along the way, he stopped in Arona, on Lake Como. Perhaps he wanted to visit the place where, according to his brother, Charles, the Bartholdi family had originated.[54] Luckily for Auguste, this was also the place where Giovan Battista Crespi had built his 1698 *San Carlo Borromeo*, or *Sancarlone*, a gargantuan figure sixty-six feet tall, standing on a pedestal that adds another forty-six feet.

Crespi's architects, Siro Zanella and Bernardo Falconi, had cast
the saint's head and hands in bronze; for the rest, however, the
benign giant, portrayed in the act of blessing the faithful with his
right hand while holding a book in his left, was made of embossed
sheets of copper attached with harpoons and iron beams to an
inner core of bricks that extend to the statue's neck. Tourist guides
discouraged ascending the statue, which was said to be dangerous
and unsuitable for claustrophobic visitors. But Bartholdi presum-
ably neglected their advice, because none of the copper colossi
ever built (*Vercingétorix* and the *Arminius*) could be visited inside.
While climbing the *San Carlone*, Bartholdi was probably assailed
by what a contemporary account defined as the curious sense of
"being inside a chimney, lit from a window above, placed behind
the saint's head."[55] Perhaps, while climbing the statue, he thought
of how to improve on Crespi's design for his fellah. Perhaps, too,
he suspected that the fellah would never be realized, and began
thinking of how to apply Crespi's methods to future projects.

CHAPTER 15

HEMISPHERIC CONVERSION

In the imaginary kingdom of Gobemouche—Laboulaye told his young readers in his brand-new fable—the young and beautiful Prince of Badauderie, Jacinthe, suddenly became king without knowing anything about politics or strategy. His inexperience was taken advantage of by a group of schemers intent on teaching him how to plunder the country, spreading ignorance and gagging the press. Quick learner that he was, Jacinthe would have probably become one of the most dreaded kings Gobemouche had ever known, had his fairy godmother not decided, in a rather unconventional way, to show him the greed that had spread across his realm. The very next day after his coronation, she transformed Jacinthe into a poodle, which nobody recognized as the king. After being mistreated and humiliated, Jacinthe realized the authoritarian schemes of his former consultants, and the ignorance in which his subjects were forced to live by a government that exempted itself from the burden of "tak[ing] care of public matters." Eventually, Jacinthe returned to his human form and claimed the throne in Gobemouche. Immediately he set out to redress the injustices of his predecessors and counteract the unhappy consequences of Gobemouche's old motto, "Hurray for money and pleasure: everything is in them," by teaching his people the importance of liberty and solidarity.[1]

The story reflected Laboulaye's views of the French regime of Napoléon III. Sure enough, it was a court of miracles. But it was

becoming weaker by the day, as if Napoléon's own fairy godmother was trying to convince him of his earlier misdeeds by befouling his present achievements. First, in 1862, Napoléon had taken advantage of Benito Juárez's insolvency to send an occupying force to Mexico. In 1864, to further consolidate the French presence in Central America, Napoléon then helped his protégé, the Austrian Maximilian of Hapsburg (brother of the emperor Francis Joseph), to establish a Francophile monarchy in Mexico. Within three years, however, Maximilian had fallen into the hands of the guerillas of Benito Juárez and was condemned to death in a summary procedure.[2] Thus France's dream of reconquering its American empire ended on a blood-soaked and inglorious note. But it was not the only dream to be shattered in those years.

In 1867, a severe financial crisis followed the bursting of a real estate bubble that long had been fueled by speculators. Heads tumbled at the Paris *bourse*, and not even the Péreires were spared. They had to face serious losses in their real estate investments, and were forced to resign from the administration of the Compagnie générale transatlantique after the French parliament questioned their decreasing profits.[3] Faced with an increasingly confident opposition, Napoléon III—like a poodle restored to his human body—began to make concessions. First, he gave the opposition the right to criticize the government, and ministers the right to defend themselves before the deputies; then he loosened his grip on the press and public gatherings. This was enough to shift dramatically the political balance of power. In May 1869, when called to the polls, 3,355,000 people voted for the French opposition.[4] Laboulaye was not among those elected, but his firmest ally, Émile Ollivier, became the most powerful man in government. Napoléon III tasked him with forming a new ministry, his only instructions being that it should reflect the majority of the legislature or at least be "homogeneous" with it.[5]

And homogeneous it was. Ollivier excluded extreme Bonapartists and the far Left, selecting only men on the center Left of the politi-

cal spectrum—"honest" men who believed in the need to liberalize trade and give more space to the Catholic Church. Then he got to work to codify the liberal concessions granted by Napoléon III and (with the emperor's approval) transform them into constitutional amendments. It was a sort of reissue of the Additional Act that Benjamin Constant had presented to Napoléon I in a desperate attempt to make the dictatorship more liberal. Napoléon III was no less impressed with Ollivier's work than his uncle had been with Constant's. But since the French Empire remained a plebiscitary monarchy, the only way to give legal validity to Ollivier's amendments was to submit them to the people's judgment. The radical Left opposed them with all its strength, accusing the centrist republicans of betraying the principles of parliamentarianism in order to reach a pathetic compromise with Napoléon III. But the moderate republicans held to their usual argument that an alliance with the emperor was the last line of defense against the "red revolution."

To some extent, revolution was indeed in the air all over France. "The winter will not pass without gunshots," Napoléon III wrote to his wife, then traveling to Egypt; "unfortunately the country cannot stand liberty."[6] No major gunshots were heard, but the fear of revolution was tangible and drove many moderate republicans to align themselves with the emperor and vote in favor of Ollivier's proposed constitutional amendments. Among them was Laboulaye, but his "yes" vote would undermine all the popularity he had accumulated over his years of opposition. Students mocked him and brought up the story of a silver inkpot given him as a gift by the electors of Strasbourg to demonstrate that Laboulaye was a corrupt politician, one who accepted gifts from his electorate in exchange for political favors. Laboulaye defended himself by quoting Constant's famous phrase "revolutions are hateful to me . . . because liberty is dear to me." But this time, even Constant's mantle would offer no protection. One day in the early spring, Laboulaye entered his classroom, lecture hall seven at the Collège de France, to

find that the room had been invaded by the "irreconcilables" who wanted to "silence the professor and his students." The room was crowded "to the doors and the stairs." When the ladies, who as always "were sitting at the foot of his [Laboulaye's] chair, left their spot, a crowd took their place and one of them wrote with a chalk on the blackboard":

Laboulaye, apostate — course ended on account of apostasy.

Despondent, Laboulaye returned to his house in Glatigny to wait for better times. In a letter to the Collège, he asked for his courses to be suspended, at least temporarily. It was March 27, 1870.[7]

BARTHOLDI, TOO, was going through hard times, although his worries had none of the pathos of Laboulaye's political misadventures. Rather, he had long wondered if there was a way he could make his fellah more appealing to the Egyptians, without introducing the "ruinous" modifications suggested by Ismail. It was obvious that, one way or another, he would have to change her. Time was limited, however, because he was also working on a new project that would establish his fame as the nation's wartime sculptor. Two years earlier, on the deck of the ship that had brought him from Corsica to France, he had enjoyed reading Napoléon III's *Histoire de Jules César*, which essentially was a reinterpretation of Caesar's Gallic wars from a Saint-Simonian perspective.[8] For a long time, the French had considered the Gauls a "race" of merchants inept at war, and had attributed the greatness of their own people to their Germanic conquerors, the Frankish initiators of the Merovingian dynasty. But then the Saint-Simonians had convinced Napoléon III that the Gauls were superior to the Franks precisely due to their entrepreneurship and, surprisingly, their military genius. Had the Gallic chieftain Vercingetorix not defeated Caesar at Gergovia,

to then unite all the Gauls against him in Alesia? Sure enough, the Romans had taken terrible revenge at Alesia by laying siege to the city and isolating Vercingetorix and his people from their expected reinforcements through an improvised fortification. Still, Napoléon III painted Vercingetorix as a great strategist and emphasized his love for national independence; he even ordered and closely supervised a series of excavations at Saint-Germain, between 1861 and 1862, to shed light on the hypothetical site of the city of Alesia.[9] Yet, his unbounded admiration of Vercingetorix notwithstanding, Napoléon III was emperor and, as heir to the title and prerogatives of Caesar, thought it was the Romans who had given order and culture to the "savage hordes, who did nothing but bring devastation." As such, in his *Histoire de Jules César*, Napoléon III invited his readers to acknowledge that French "civilization [was] due to the triumph of the Roman armies; institutions, customs, and language all [came] to us from the conquest."[10]

Bartholdi was not convinced by Napoléon's plea for the Romans, but Vercingetorix intrigued him a great deal. It is not difficult to imagine Bartholdi, seated on a chair on the ship's deck, now and then putting down his book to fantasize about Vercingetorix, the Gallic "military genius" and France's defender against Roman invaders. In 1865, the municipality of Clermont-Ferrand had set up a committee to commission a monument dedicated to Vercingetorix. That same year, Bartholdi's colleague Aimé Millet and the architect Viollet-le-Duc completed in Alesia the colossal and melancholy *Vercingétorix*, in which the king rests on his sword while contemplating the place of his defeat (Figure 14.2). But Bartholdi had a different idea of the Gallic hero. He sketched a victorious knight on a horse in full gallop, his right arm raised holding up a sword, ready to strike against the Romans. Its gesture was the same as the fellah's, and, like the fellah, it evoked the images of both Delacroix's *Liberty* and Bandel's *Arminius*. Indeed, there are no doubts that Bartholdi's *Vercingétorix* was a symbol of armed resistance to imperial oppression like the *Arminius*, because both

were meant to reenact a provincial rebellion against empire. But where Bandel celebrated Germany national supremacy in the world, Bartholdi's *Vercingétorix* commemorated national independence. The latter was, in effect, the basic political ideal that Scheffer had instilled in his students while teaching them color and perspective all those years ago. Yet there was something profoundly violent about Bartholdi's *Vercingétorix*, something one would not have expected from a disciple of Scheffer, the painter of tortured bodies or afflicted souls. Because he would expiate his rebellion with captivity and death, Vercingetorix too belongs among those tormented souls, but Bartholdi chose to portray his rage, not his suffering. Like some of his previous works—*Lutte de l'homme avec sa conscience* and the *Martyr moderne*, the angry giant chained to the rocks—*Vercingétorix* was moved by fiery fury, not the sacrifice of atonement (Figure 15.1).[11]

This Promethean element should not be neglected. At the unveiling of the Statue of Liberty, Reverend Storrs would be among the few to glimpse this aspect of its architect's personality, as reflected in a colossal monument that seemed to rival nature and creation itself. As we saw, that glimpse was enough to make him tremble. Was it because of the fire held aloft by the statue? Or the hubris of attempting to build such a colossus to begin with? It is difficult to say, but certainly Bartholdi's Statue of Liberty, *Vercingétorix*, and the Prometheus-*Martyr* chained to the rock were artistic relatives, not only because of their common link to the mythology of fire, but also because all display a similar frown. It was as if, little by little, Bartholdi was moving from the art of endurance and martyrdom, into which Scheffer had initiated him, toward a new, violent art of action. This change of focus precipitated a change in style, for Bartholdi seemed more and more inclined to abandon Scheffer's abstract style for the expressiveness and dynamism of Étex and his Italian sources of influence. But France was changing as well: the winds of war were blowing across its lands with renewed strength. Would they affect the fellah, too?

FIGURE 15.1. [Frédéric-] Auguste Bartholdi, *Vercingétorix*, 1902, bronze, Clermont-Ferrand, Puy-de-Dôme, Auvergne-Rhône-Alpes.

Bartholdi was still thinking of his *Vercingétorix* while promoting his fellah in Egypt and, later, when he visited Italy. Indeed, he had *Vercingétorix* in mind, not the fellah, when he started looking for equestrian statues, such as the one of the mercenary captain Bartolomeo Colleoni, in Venice. In the end, *Vercingétorix* would bear little resemblance to the composed equestrian statue of Colleoni, for Bartholdi was more attracted to dynamic models, like Bernini's *The Vision of Constantine*, which he had probably seen during his visit of Saint Peter's Basilica in Rome, or *Le cavalier de bronze*, the equestrian statue that the French sculptor Falconet had made for the Russians in 1777.[12] This time, however, Bartholdi was not content with finding inspiration in older sculptures or paintings. If he had learned anything in Egypt, it was that, like painters, sculptors could copy from nature. So, back in Paris, he began to sketch horses at the races, at the "horse market, [and at] the circus," as well as ancient helmets, lances, and equipment unearthed by the archaeological dig at the site of historical Alesia.[13] The end result was

a creative juxtaposition of anachronisms, with Vercingetorix given a Bronze Age helmet and an Iron Age sword, while his horse's reins were more recent, from the times of the Gauls and the Romans. There are anatomical inaccuracies too, for Bartholdi sculpted part of the horse as if it were in the act of jumping, rear legs raised to lift its upper body, while the front legs simulate a gallop.[14] Yet all the hours spent in circuses and museums had not been in vain, for, in one way or another, Auguste was able to portray Vercingeto-rix's movements, and his horse's stride, in innovative ways. Indeed, everybody at the 1870 Salon noticed the *Vercingétorix:* his twisted torso was reminiscent of the *Rapp,* while his face, deformed by rage, recalled Rude's shouting war-god guiding the French volunteers on the front on the Arc de Triomphe.[15] The difference is that Rude's genius of war turns his head toward his raised left arm, away from his outstretched right hand, while Bartholdi's *Vercingétorix* looks back toward his raised right arm, sword aloft in his charge. The result comes across as a dynamic, equestrian version of Ernst von Bandel's *Arminius,* the blueprints for which Bartholdi certainly had observed and studied years earlier.

VERCINGÉTORIX was still on his mind when Bartholdi began to amend his vision of the fellah to better suit the pasha's requests. This stage of revision is documented by a watercolor as well as by a photograph. Buried deep in Bartholdi's papers, still safeguarded in the archives of his museum, these records (apparently dating from 1869 or 1870) show a very different fellah from the one Bartholdi had first modeled and sketched in 1867. Against a background of day and night respectively, the new fellah is dressed like the original, but her position is different. Instead of raising her right arm and leaning on her left leg, she raises her left arm while lean-ing on her right leg. Her hand raises not a cumbersome lantern, but a torch; under a heavy necklace, her breast is bare (or simply covered by a transparent dress), but her face is still masculine.

Finally, a crown can be glimpsed under her veil, from which (as the nocturnal drawing reveals) five bright rays shine.[16] This finding opens up a mysterious chapter in Bartholdi's life. On the photograph of the nocturnal drawing, an anonymous note reads: "Project for the Suez Lighthouse—presented to the Khedive 1869." Perhaps Bartholdi had presented more than one project to the khedive, and the nocturnal image was a photograph of one of them. If so, however, why did the khedive feel the need to ask him to move the luminous contrivance on the fellah's head? More probably, Bartholdi showed only one project to the khedive—the fellah with the lantern—and left the drawings with him, while bringing the maquettes back home. While in Colmar (or Paris) and as a way to meet the khedive's request to move the light onto the statue's head, Bartholdi painted the aquarelle of the fellah crowned with light. Finally, at some unspecified point later in his life, he wrote the date 1869 under the picture and added that it was the project presented to the khedive. Perhaps he simply got the date wrong, or misremembered, or perhaps he purposefully altered it. But if so, why? One plausible reason is that he wanted to increase the chronological distance between the two monuments once he had begun working on the Statue of Liberty, because they bore many resemblances. The real question, then, is what made the Statue of Liberty look so much like the fellah?

Clearly, Bartholdi's Egyptian monument began to really resemble our Statue of Liberty once the need to move the fellah's light from her hand to her head had introduced two further symbols to the model: a luminous crown resembling either a sun or a star, and the flame itself. Sure enough, there were plenty of reasons to associate a colossal lighthouse, wherever it was built, with fire and sunlight. As Renard had explained, they were both legendary symbols attributed to the very first lighthouses or "fire towers," the Colossus of Rhodes included. In the nineteenth century, however, these symbols were invested with new religious and mystical meanings. Did not Ballanche compare Orpheus and Euridice to a beacon of

civilization in Samothrace? Did not Böhme use fire to represent the common origins of sin and divine will, the vehicle that eventually carries the soul to God's solar perfection? But fire was also a crucial symbol for contemporary orientalists interested in ancient mysteries. Volney and Creuzer had, after all, demonstrated that fire symbolized the sun and, as such, represented the earth's liberation from winter (and death), and, therefore, resurrection: Prometheus's sin brought the fire of liberty to men, while the phoenix burns every night and resuscitates every morning to give life to the world. Finally, Demeter incarnates the liberating strength of the sun, which sets Proserpina free from the darkness of the underworld and illuminates the infernal passages with her torches. Significantly, in the Homeric hymn dedicated to her, Demeter is first portrayed searching for her daughter Persephone with "torches ablaze in her hands," and then with Demophoön, the son of Metanira, buried in her arms "like a brand in the fire's might."[17]

With a torch raised to light the gulf and her head crowned by a luminous diadem, the new fellah looked like an oriental goddess. But did she also represent liberty, like the old Roman statues of Demeter and Proserpina?[18] It is difficult to say, since Bartholdi also may have associated the statue with the sun in an effort to personalize it with a signature symbol associated with his family and his hometown. If the sun, indeed, was the old insignia of the Sonntag-Bartholdi pharmacy to which Auguste had already alluded in his *Jour du signeur*, the nocturnal sun also loomed behind and above the prismatic and apocalyptic Jesus in Grünewald's *Isenheim Altarpiece*, which was becoming one of Colmar's most famous pieces of art.

Another influence might have contributed to the new, and subsequent, fellahs. A brief mention in a hitherto overlooked letter of November 1869 shows that Bartholdi regularly visited Laboulaye at the time. Their friendship was such that Charlotte could direct her son to an article of Laboulaye's and share her appreciation with him and with the author himself.[19] A year later, Bartholdi would

write to Laboulaye that he had "read and continued to read his works."[20] Is it possible that, at some point between 1867 and 1869, Bartholdi shared his Egyptian project with Laboulaye in order to hear his thoughts on it? After all, Laboulaye had already helped Charles Bartholdi launch his journal. And as someone with influential friends in the government and among bankers, Laboulaye could help Auguste navigate the intricacies of Egyptian diplomacy, probably even better than the powerful Nieuwerkerke, who so far had showed little influence with the pasha, at least on this matter.[21]

In a letter to his mother written shortly before his departure (the first after the two-year epistolary gap of lost documents), Bartholdi alludes to leaving behind an "uncertain business" other than the Egyptian matter, one "that might have good results, but also bad ones."[22] He then reassures Charlotte that he is following her advice and leaving this project aside. But which project is it? At some point in 1869, either before or after the drawing of the watercolor, the khedive's silence must have convinced Bartholdi that his chances of building the fellah in Egypt were slim. We don't know how Bartholdi reacted to this new situation, but some hints may appear in a subsequent letter to Charlotte. "I see," Bartholdi would write his mother, "that you think the same principles cannot be applied in the two hemispheres."[23] Clearly, Bartholdi's way to overcome the pasha's hesitation was to look for alternatives in the Western Hemisphere. This is the point at which his relationship with Laboulaye becomes crucial. For if Bartholdi's 1885 testimony is true, and Laboulaye had indeed suggested to Bartholdi and his friends the possibility of building a Franco-American monument in 1865, then Bartholdi's American alternative was the construction of a memorial to American Independence.[24] Was this the alternative he mentioned to Charlotte before leaving for Egypt? The answer is yes, but so far there is no way to prove that Laboulaye had first suggested the American project to Bartholdi in December 1865. On the contrary, it is quite possible that Laboulaye had tailored the

Franco-American project to save Bartholdi's fellah and make sure it could be used in a different "hemisphere," probably around 1868–1869. If so, then Laboulaye may also have helped Bartholdi design the fellah in such a way that it could be utilized both in the East, in case the pasha changed his mind, and in the West.

This would also explain why Bartholdi later would refer to the applicability of two principles to two different "hemispheres," in a letter to Charlotte of 1870. Indeed, it is easy to imagine that Bartholdi and Laboulaye had dedicated some of their discussions, not to mention their now lost correspondence, to determining whether certain global principles (such as Saint-Simonianism or the mysteries of Krause and Boehme) could be applied to the fellah so as to make her equally suitable to East and West. From Ballanche to Krause, most of Laboulaye's mentors had claimed that modern America would see the old mysteries finally made accessible to the people at large. What mattered, then, was not the country in which the statue was placed, as long as she stood on a border, at a crossroads of the world. But why, in the end, was the border so important?

The answer has to do with mythology. Physical and metaphorical borders were considered places of transition, filled with magical meanings and divine influences. From this perspective, it did not really matter which border the statue was placed on, for the fellah's torch would in any case become a symbol of passage, and the statue itself would become one and the same with the gods of the ancient mysteries (Demeter, Hermes, Orpheus, Dionysus, and so forth), known for overseeing transitions ranging from the most profane (like commerce) to the most existential (including death). Dumont, quite emblematically, had associated Hermes, the god of messages and transitions par excellence, and his torch with the column-sepulcher of the victims of the French revolutions. If placed at the Suez Canal, the fellah, holding a torch like Dumont's *Hermes*, would have been an envoy from France, the carrier, through Egypt, of French progress to the East; if placed in

America, she would become the herald of French civilization and economic expansion to the New World.

Given the missing documentation, it is difficult to prove that Laboulaye and Bartholdi reached an agreement on this point. Yet we have some clues suggesting that, while discussing the question of his monument's adaptability to the West and East with Laboulaye, Bartholdi indeed was experimenting with mythological symbols of commerce and transition. In this regard, a project for a couple of bas-reliefs that Bartholdi sketched for the international exhibition of 1867 is of particular interest. These works, which are now held by the Bartholdi Museum in Colmar, immortalize an often-overlooked phase of Auguste's preparation of the Statue of Liberty.[25] In one of them, the figure of *France*—a powerful and masculine woman wearing a Roman toga and crowned by a diadem—stands in front of a ship, the mast and sails still visible; she raises both arms laterally, like Élias Robert's *France* at the entrance of the Palais de l'Industrie, but also like a crucified Christ (Figure 15.2).[26] Her connection with the sail is evocative of *Isis Pharia*, the statue of Isis supposedly placed near the beacon of Alexandria to protect the sailors. But another detail suggests that Bartholdi's *France* was intended to be a relative of the statue of Alexandria and other statues of mystical divinities connected with transition and death. In her hands, she carries something that looks like a sistrum, the musical instrument usually connected with Isis, but that may also have been a caduceus, Hermes's staff with two snakes curled around it, symbolizing science, as well as commerce, travels, exploration, and the mysteries of life and death.

Even though the project never went anywhere, Bartholdi did not discard it. Why? I would argue that the answer relates to Bartholdi's ongoing dialogue with Laboulaye over the questions of liberty and commerce. Even if Laboulaye was critical of Saint-Simonian utopianism, he shared with Saint-Simon and Enfantin the belief that the future was moving toward global integration: because "God had planted truth everywhere in the world," Laboulaye said, it was

not important if the secret of universal wisdom was revealed to him by "some *hadij* from the West or the East."[27] There was only one religion of liberty, and it was the religion that Daniel Lefebvre had learned from Christian and Buddhist preachers in America and the religion that Abdallah had learned reading the Koran in the desert, talking to "heretic" Persians and discussing Kabbalah with the Jews. In one way or another, these characters were all God's envoys: Laboulaye sometimes linked them with Hermes, sometimes with Moses, a messenger himself—God's messenger among the Jews. The universal religion of truth, Laboulaye once claimed, was "the unwritten word that God consigned to Moses on Mount Sinai" and that he later dispersed "to the four winds of the earth" in order to punish humanity for its hubris.[28]

Indeed, with a halo around her head and fire in her hand, looking over the Red Sea, Bartholdi's fellah could very well have been an icon of Hermes or Moses. Bartholdi had, after all, bid Egypt farewell while the sun was rising over the Red Sea and the lights "turn[ed] to dust in the mountain chain of the Sinai." Laboulaye held vast stores of biblical knowledge on which he might have drawn during his conversations with Bartholdi to argue that a statue of Moses would perfectly incarnate the fusion of Eastern and Western civilizations and, therefore, could sit equally well in Egypt or America. And as a Freemason and a Catholic, Laboulaye was certainly familiar with the apocryphal history according to which Moses had been an adept of Isis, the goddess of the "ancient fire." Plausibly, Laboulaye would also have known that, according to the linguist and Freemason Nicolas Bonneville, Moses's initiation was signaled by the "flaming rays of his halo," which (along with a burning heart in his right hand) brought light where before there was only "darkness, abyss and decay."[29] The Bible offered nothing to contradict this story, but, according to Laboulaye and Bartholdi's friend Nefftzer, it gave it a patriotic, even nationalist twist. Had God not revealed himself to Moses as a burning bush, and had he not guided him and his people to liberty in the form of fire? As the

FIGURE 15.2. [Frédéric-] Auguste Bartholdi, *Allégorie de la France Victorieuse par le travail et l'étude (?)*, n.d., colored plaster cast, Musée Bartholdi, Colmar.

Bible put it, "The Lord went before them by day in a pillar of a cloud, to lead them the way; and by night in a pillar of fire, to give them light; to go by day and night."[30] Thus, as Nefftzer had claimed, Moses's religion was the foundation of the Jewish nation and its expansive ambitions: "The God proclaimed by Moses, the god of the exodus from Egypt, is also the God of independence and conquered homeland (*patrie*)."[31]

If Nefftzer had not done it already, Laboulaye might easily have told Bartholdi about these Masonic and biblical stories to help him design and refine the symbols of Hermes or Moses in his fellah. The goal was to use Moses as a metaphor for the encounter of fire (Isis, Orient) and sun (knowledge, West), of will and vision, and, eventually, of a nation with its colonies. Holding God's fire and crowned by God's knowledge, Moses would have made a perfect symbol for the encounter of East and West and, indirectly, for the glorification of France as the nation finally reunited with its possessions, safe from the threat of British intervention.

It is, in short, quite possible that as early as 1867, before Bartholdi's journey to Egypt, Laboulaye encouraged him to associate his fellah with some kind of mythological figure, such as Hermes, Isis, or Moses. This stage of Bartholdi's thought is, indeed, reflected in his project for the exhibition of 1867, where France itself was presented as Isis or Hermes, and in the later stages of the fellah. In 1869, Bartholdi concentrated above all on the position of her legs, hips, and breasts in an effort to bring the figure to life and give movement to her arm. In one version, the fellah raises the torch in her left hand, her arm proudly aloft, while her right leg is bent and her left is placed so far back from her torso that it seems to give her body a twisting movement. In another version, she grasps a kind of incense burner in her right hand and bends her left leg, pushing her torso backward. Following yet more experiments, Bartholdi put the flaming torch in the right hand of the fellah and moved the bend from the left leg to the right. But with respect to the photograph, the real novelty of these fellahs was something else:

they all showed symbols of liberty, in the form of either potshards or broken chains.

It is hard to say why Bartholdi decided to introduce such an open reference to violent emancipation in his later models. Indeed, and no matter what the Saint-Simonians had said regarding the emancipation of hard-working Egyptian farmers, fellah women were essentially serfs, fettered by the same chains that bound their peasant fathers and husbands. The *Revue historique de droit français et étranger*, which Laboulaye edited with his banker friend Wolowski, had vocally denounced the injustices behind Egypt's recent industrial progress. "Tied to the land," the Italian lawyer Domenico Gatteschi, a resident of Alexandria, had explained in the *Revue*, fellaheen could not own it, but only rent it; they had "to work for the State and could not leave their village," unless shepherded elsewhere by state bureaucrats to perform "useful" work.[32] Gatteschi was right. Before the arrival of the Europeans, the viceroy would send emissaries to conscript men into the army or draft them into the work teams building irrigation canals on the Nile. After the French and the British arrived, the fellaheen worked for them. Between 1859 and 1863, more than sixty thousand peasants excavated the Suez Canal bed under the vigilant gaze of Egyptian soldiers. Often left to sleep without bedcovers or a tent, many died of hypothermia and other maladies.[33]

Then, in 1863, emboldened by soaring cotton prices, Ismail abolished forced labor. It was a great sign of progress, but also a major breach of the original contract under which Egypt had agreed to supply the canal company with workers. An international court duly sentenced Ismail to pay extravagant damages, which he did by taking out loans with French bankers. Lesseps used the windfall to fund new investments in labor-saving machinery and efficiency improvements and to hire free labor. Technically speaking, the machines showcased in his pavilion were the result of Ismail's abolitionist politics and his diplomatic blundering. But things were more complicated. For everybody knew that, had the

viceroy not (largely) abolished forced labor, Lesseps would simply have continued exploiting the fellaheen. Now he was taking the credit for having saved the fellaheen from brutal labor by introducing engine-powered "dredges" onto the work sites.

The khedive was taking credit too, which could explain why Bartholdi had already given his fellahs a broken vase to hold, probably as a sign of abolitionism. But the broken vase was absent in the only fellah that was explicitly destined for the khedive, while it reappeared in later versions. It has often been implied that all of these new maquettes were meant for the Suez lighthouse. And yet, as the former curator of the Musée Bartholdi in Colmar has rightly pointed out, none of these models are labeled with the words "Egypt bringing light to Asia." More plausibly, they capture a crucial phase in the fellah's transformation into the Statue of Liberty, and in Bartholdi's relationship with Laboulaye. As someone who had publicly condemned slavery in both Egypt and America, Laboulaye may at the very least have suggested to Bartholdi that, since abolitionism was an issue common to both East and West, turning the fellah into a symbol of Egyptian emancipation would make it easier, if necessary, to meaningfully transfer that image to post–Civil War America.

CHAPTER 16

REVENGE

CHARLOTTE WAS FRIGHTENED. The very idea of seeing her son leave for America upset her, and Auguste knew it. So even if Laboulaye's offer to move the Egyptian fellah to America was tempting, he resisted it for a while. But then, when no news came from the khedive, he realized that he was running out of options and began preparing his travels to the New World. The planning for this journey probably began in great secrecy during the winter of 1869, since Bartholdi already was discussing the pros and cons of his upcoming American trip with his mother in late May 1870. "I would hate to cause you such anxiety. It is quite involuntary on my part. I belong to a generation for whom a trip to the United States appears no more dangerous than going to Bordeaux or to Corsica; I've already told you [in a lost letter] how such a plan seems quite simple and natural to me, but, since you do not share my same peace of mind, I shall abandon it." Charlotte coldly explained that her only concern about the project was the possibility of "disappointment" and she left him free to do "as he believed" with respect "to the voyage to America."[1] In his reply, Auguste, still offended, noted a certain "contradiction" between Charlotte's observations pertaining to his "*rêves d'Amérique.*" With a decisiveness bordering on ire, he wrote:

I repeat, this project is an excellent thing and I believe in it profoundly; whatever I do, I will make a material profit and have a lovely voyage. Yet!!! [underlined twice] if I am

not certain that <u>you absolutely</u> share my peace of mind and
my assuredness, [. . .] I would not be able to do it and it
would paralyze me, so <u>it would be useless.</u>"[2]

Charlotte was probably less optimistic than her son regarding
the "material profit" arising from the proposed voyage to Amer-
ica. Was she expecting to advance him more money to cover his
expenses, as she had done in the past? Was this one of the reasons
for her skepticism about the journey? It is difficult to tell, but Bar-
tholdi's letter demonstrates quite clearly that he was tired of Char-
lotte's emotional blackmailing and that, once again, the desire to
escape from her was itself a reason for his travels.

In July 1870, a misjudgment by Napoléon III led France into a
war with the rapidly surging Germany of Otto von Bismarck, and
distracted Bartholdi from his models. After less than two months
of fighting, the Germans defeated the French at Sedan. Napoléon
III surrendered to his enemies, his wife fled to England with the
help of the famous American dentist Thomas W. Evans, and a radi-
cal republican government installed itself in Paris, led by Jules Favre,
Jules Ferry, Léon Gambetta, Ernest Picard, Gaston Crémieux, and
Emmanuel Arago. It was September 4, 1870. The French rejoiced;
Victor Hugo returned from exile with all of his retinue to celebrate
the end of the empire. Their jubilation, however, would not last
long. As the Germans began their march on Paris, France was
caught in a long, drawn-out siege. Bartholdi's name appears among
those of staff of the national guard of the Seine. He is registered
as a captain, and we know from Bartholdi's later diary that he was
determined to fight. But he was also worried about his mother,
because the latest news was that Prussian troops were approaching
Colmar with two hundred cannons, so he asked to spend three
months with the Colmar national guard. (He begged his mother
to keep the whole matter secret and to tell her neighbors, in case
they inquired about his comings and goings, that he had been hired
by the magazine *Illustration*.)[3] Finally, on September 5, the day

the republican government was proclaimed, Bartholdi presented himself to the new prefect of Alsace, Jules Grosjean, a man "full of good sense and greatness," to be assigned somewhere near Colmar. A close look at the young national guardsman must have convinced Grosjean in an instant that, with his delicate and spoiled air, Bartholdi would not be much help in a war zone. So he charged him with the task, as the sculptor would put it, of "following my inspiration according to circumstance." Then, maybe on second thought, Grosjean asked him to send the Francs-Tireurs resistance fighters from Saint-Denis to the Horbourg bridge at three in the morning. Bartholdi was clearly worried and asked for authorization to "take cartridges in case of need." Indeed, the Germans' arrival was imminent and it was expected that the invasion would have catastrophic consequences.

Bartholdi followed the orders and sent the Francs-Tireurs of Saint-Denis to the Horbourg bridge and some scouts to Ladhof, because "the path to Horbourg was already under surveillance." At 3 A.M. he added reinforcements, sending a lieutenant and ten guards to the prefecture and other men to the telegraph. It was rumored that five thousand Germans had arrived in nearby Jebsheim, but since the scouts brought no word of having seen the enemy, the commander, Tainturier, presumed they were on their way to Brisach (in German, Breisach) and so left the emplacement in Horbourg. As for Bartholdi, he seized the occasion to go home, "take off his uniform, get changed and have something to eat." It was around the time he was having breakfast with his mother that the guards at the Horbourg bridge engaged German troops in a bloody skirmish. The Francs-Tireurs fired, "retreating from tree to tree," while in Colmar cartridges were requisitioned from everywhere.[4] Bartholdi walked to the bridge and tried to convince the guards to retreat and the Francs-Tireurs to hide in the mountains. Resisting would have been foolish, even if perhaps correct "from a national and absolute point of view," since there was no one in Colmar, not even among the national guardsmen, who knew how

to "hold a rifle." "It would have resulted," he said, "in a frightful tumult, the national guards would have been massacred, and the city burned by the enemy."[5]

The Germans (Badensers, to be specific) entered the city in triumph, marching to the town hall "in two lines, bayonets forward, cavalry in the lead," with their prisoners lined up behind them. Around noon Bartholdi was (yet again) having lunch with his mother when the Germans knocked on their door—not to arrest him, as he feared, but to rest after the Horbourg battle. Still "soaked to their belts" from fighting in the river, they fell asleep in the inner courtyard (on mattresses that Charlotte found for them) after having emptied barrels of wine, asked for bread, eaten, and sung "heartily."

As it turned out, Colmar had been lucky. When, two weeks later, German troops entered Strasbourg, the city was reduced to a pile of rubble. There was "general indignation," Bartholdi noted in his diary, and he was right. France was enraged. The Société des gens de lettres raised money to buy France a symbolic cannon and, to mobilize the public, sent actors into the French squares to read excerpts from *Les châtiments* (The punishments), an epic poem by Hugo about the story of the French nation, from the tyranny of "Napoléon the small" (*Nox*) to its final illumination (*Lux*), or the country's resurrection under the auspices of a new "star."[6] Hugo's poems were offensive, cruel, painful; recited in an occupied France, they awakened sleeping sentiments and allowed the Société des gens de lettres to raise enough money to acquire their cannon. "That this cannon be implacable, dazzling, and terrible," Hugo hoped, "and, when the Germans hear it rumble, and should ask: who are you? It will respond, I am the lightning bolt! And my name is *Châteaudun*," the French city long besieged and then burned by its own inhabitants at the order of the Germans.[7]

Bartholdi gathered up his belongings and moved to Tours, where, on October 7, the provisional government sent the minister

of internal affairs Léon Gambetta on board the hot-air balloon *Armand-Barbès*.[8] Bartholdi told his mother nothing of the incredible welcome reserved for Gambetta, but others remembered this moment as one of intense celebration and hope: "one would have said that all friendly republics had decided to meet at Tours, the representatives of the Spanish Republic and the American volunteers carrying the flag of the United States to acclaim Garibaldi and Gambetta."[9] Even if he was soon to celebrate one of these international friendships—between France and America—with a colossal statue, Laboulaye seemed little interested at the time in this transnational exchange of solidarity. If anything, he was struck by its surreal aspects. The Tours of those days appeared to him as the backdrop to a warlike carnival, where arms and personages of all sorts were on parade—franc-tireurs "dressed like bears, some like Arabs, artillerymen, knights."[10] Gambetta was less poetic than Bartholdi in his devastated reaction to the same spectacle. What was to be done, he asked, with all those Francs-Tireurs, national guardsmen, and volunteers, who had neither military training nor appropriate weaponry? How were they to be joined with the forty thousand regular soldiers employed in the combat zones? He was still grappling with these problems when the Italian unification-hero Giuseppe Garibaldi offered to send his Italian Redshirts to fight alongside the multicolored band of French volunteers. This complicated Gambetta's life further. Indeed, the world knew that Garibaldi was a "hot head" and a bit of a prima donna; these weaknesses had already troubled the American Unionists when Garibaldi had volunteered to participate in the war on his own terms.[11] In the end, Gambetta put Garibaldi in charge of the Italian volunteers spread between Marseille and Chambéry (Piedmontese, Ligurian, and Neapolitan immigrants who worked on the docks) to form, together with other volunteers, the Army of the Vosges. But Gambetta was still looking for someone to put by Garibaldi's side to keep him in check and report his actions to the government.

Meanwhile, Bartholdi told his mother of his relations with "nearly all the men of the government, generals of all kinds, and the people you meet here and there." It seems that the provisional government had wanted to make him a prefect, but he refused. Instead, he accepted the mission of inspecting the "mobilization of the National Guard in the East and in the South," which basically meant procuring weapons, ammunition, uniforms, and food for the soldiers. With the news of Garibaldi's arrival, however, the government immediately assigned Bartholdi to the old general's army, and probably tasked him with keeping an eye on the larger-than-life figure. Gambetta himself sent Bartholdi a note that formalized his role as "delegated . . . senior squadron leader of the National Guard, alongside General Garibaldi, with the title of squadron leader of his staff," and the "special mission of ensuring the needs of the Army of the Vosges and the execution of the government's orders."[12]

Even if his job was to keep him in check, Bartholdi took an immediate liking to Garibaldi and his Italian comrades, who— Colonel Bordone would later protest—were continually marginalized and deprived of resources by French generals.[13] Bartholdi was aware of this discrimination and put all his energies toward procuring food, men, guns, cartridges, and horses for the army. When not busy looking for munitions and arms, he found himself in the difficult situation of mediating between Garibaldi ("a little senile," he admitted) and Gambetta, or even between Garibaldi and his staff.[14] He felt alternatively discouraged and exhilarated by the whole enterprise of accompanying Garibaldi to Dijon, Dole, and Besançon, traveling with Garibaldi's sons Menotti and Riciotti, his son-in-law Stefano Canzio, and his friend Joseph Bordone, while "patrolling" and conducting "interrogations" of locals.[15] This entailed sleeping in cold hotels, with freezing wind blowing through the windows, and eating small rations of bread on trains stuck under the snow; but it also meant enjoying the views from "picturesque railways" and from the cathedral of Bourges (alas, not even the war dulled Bartholdi's architectural hunger), while feeling the pleasure of

"being useful" and advancing in the military hierarchy.[16] Indeed, Bartholdi became a soldier through and through. It was almost impossible to distinguish him from his new Italian friends, dressed as he was like a Garibaldino, with riding boots, blue pantaloons, and a puffy-sleeved red woolen shirt. Clearly, Scheffer's past as an armed conspirator had left an enduring mark on Bartholdi, even more so than his austere and biblical inspiration.

THE NEED FOR GUNS was growing more urgent by the day. While "the workshops cast cannon" and "women [made] a million cartridges a day," more rifles needed to be produced (the French were manufacturing a mere 15,000–18,000 a month) and more regular soldiers needed to be recruited, or an auxiliary corps established (as the Americans had done during the Civil War). Money, however, was in short supply, and the Banque de France refused to print new paper money, so Gambetta borrowed 250 million francs at 7 percent interest on the French, British, and American securities market.[17] It is telling that most of the French debt was bought by the American bank J. P. Morgan through its London and Paris offices, which were also among the largest groups involved in the American arms industry.[18] Even more interesting, E. Remington & Sons, the gun-making firm in business with Morgan, trusted its delegate Thomas Richardson to negotiate with the American government for the dispatch of weapons to France. Richardson managed to gather 37,000 Springfield guns from 1866, check their technical performance, and send them to France; he also added a load of cartridges specifically manufactured for the French market by governmental order.[19]

This second cartridge order was a bit riskier, because sending weapons produced by the American government to support the French was a violation of the international law of neutrality, which allowed private firms to trade arms only with belligerent countries. But had not the French violated neutrality in order to help their

American brothers in the past? Between September 3 and November 7, seven vessels left American ports for France with a total of 378,500 guns and carbines, 55 cannons, 5 Gatling battery guns, and 2,000 pistols.[20] By December 22, the *Ville de Paris* had already made a round trip and was ready again to leave for Le Havre, loaded with more "arms and munitions of war"; the *Ontario* from Boston had arrived; and the *Erie* (also from Boston) was expected. "All of England and the United States were working for France," the French merchant Le Cesne (one of the most trustworthy traders of American cotton in Europe) would recall years later.[21] Men like Bartholdi were employed at the lower levels of this war machine to pick up cargo and gather information at railroad stations and ports.[22] Still he heard the echoes of American military engagement in the war. On November 18, for example, he meditated strategies to "get rid" of "the correspondent of the *Daily News*"; a few days later, on December 6, he boarded a train that was carrying an "American company." And yet one has to wait until January 26 and 27 to find a more concrete reference to weaponry he had picked up from the *Lafayette*. Bartholdi did not document much except that, on the first day, he boarded the ship to "watch the unloading," then concluded the day with a train journey and an evening at the theater to see Giuseppe Verdi's *Rigoletto*. On January 27, he returned to the *Lafayette* to unload more weapons and have them assembled. Bartholdi's war journal is an extremely succinct summary of his movements and thoughts, with far fewer digressions and anecdotes than his other diaries or correspondence. Later, however, in his 1885 memoir for the *North American Review*, Bartholdi would tell readers that his trips to the ports during the Franco-Prussian War had allowed him to learn more about America. The American "officers," Bartholdi would explain, had spoken to him "of the demonstrations in the United States in favor of Germany." He had first received the news "with pain," only to be cheered up when one officer told him that the "clamorous demonstrations [of joy for the German victory] were the work of Germans who had been in

America for only a short period of time," because "those who had long been in the United States respected the traditions of their country" and they "were too much Americans and citizens of a great free people to feel any hatred for France or to enjoy the misfortune of the nation that had helped to create their new country, whose prosperity they were enjoying today."[23] Things were obviously more complicated, but Bartholdi's knowledge of America was so rudimentary that the officer's explanation satisfied him completely. His last expedition to Bordeaux would be in late January 1871, just as the Germans, after their conquest of Metz and Dijon, were closing in.

As the Germans approached Paris, their outrage with the U.S. government grew, as did their determination to stop the supply of arms to the French. Remington even had the idea of filling hot-air balloons with weapons to supply Paris with spare parts for its guns, but the plan ultimately proved unsuccessful.[24] On January 18, after a long siege, German forces entered Paris, marching proudly down the streets of a deserted city. Kaiser Wilhelm had himself crowned emperor in the Hall of Mirrors in Versailles. Gambetta's hour was up, and the pacifist liberals, who had always opposed the war, went straight to Tours to tell him so. The former Orléanist minister Adolphe Thiers brought gruesome news of the siege of Paris. He told of people reduced to eating their cats and of butchers who sold cat, dog, and even rat meat. Not even the antelopes and the elephant in the Jardin des Plantes were spared, Thiers recounted; they were butchered into steaks and cooked. In other words, the era of revolution and resistance was over; the Parisians wanted peace. Another pacifist republican, Jules Favre, crossed the Seine and went to Versailles to negotiate an armistice, while Gambetta packed his bags and headed home to Saint-Sébastien.

It was January 28, 1871. On February 13, Bartholdi accompanied Garibaldi to the Grand Théâtre in Bordeaux, where he was expected to attend a peace committee. The atmosphere was tense, because,

as Thiers had correctly predicted, people were tired of heroism and of resistance. In this climate of rising nationalism, they were also suspicious of foreigners like Garibaldi. Bartholdi had "regrett[ed] these separations [between] French and Italians" during his service in the army of the Vosges.[25] Now he found it heartbreaking to see Garibaldi—a "hero of two worlds" like Lafayette—with his white poncho and red shirt, booed, howled at, and publicly humiliated. "Unworthy conduct," Bartholdi noted in his diary, relating also of how, at the moment when he and Garibaldi were taking leave of each other, they both had "tears in their eyes."[26]

With both Garibaldi and Gambetta out of the picture, Bartholdi left Tours—which had become the court of Thiers, his wife, and his sister-in-law—and returned to Colmar. An "absolutely peaceful" assembly emerged from the elections of February 8 around Thiers, the hero of peace and compromise. In his negotiations with the Germans, Thiers was able to save Belfort, but was forced to cede Alsace and Lorraine to Germany. On February 26, the financial terms of the surrender were disclosed. France had to pay Germany five billion francs at 5 percent interest after deducting the value of the railroads of Alsace and Lorraine.

The highest price of peace was thus paid by the Alsatians who, along with their compatriots from Lorraine, became part of Germany as of February 1871. It was, Bartholdi explained to his mother, "the burial of Alsace," which now seemed to him like "a sick woman who expires."[27] Together with his friends the Alsatian deputies Édouard Koechlin and Auguste Scheurer-Kestner, Bartholdi signed a manifesto calling for the restitution of Alsace, appealing to the same rights of self-determination that, not much earlier, the Greeks had invoked against the Turks and the Poles against the Russians, with all declaring "null and void a pact that compels us without our consent." A few years later, at the funeral of the mayor of Strasbourg, Émile Küss, Bartholdi would hear Gambetta's call to republicans to unite around "patriotic thoughts of revenge that will be the protest of law and justice against force and infamy."[28] The

association was clinched. Gambetta's radical republic signified the redemption of the fatherland, while the weak Orléanist liberalism of Thiers meant reason-of-state pragmatism. Bartholdi opted for Gambetta, turning his back on the compromises of the Napoleonic regime. From that moment on, his monumental art would acquire a military and violent identity that would never be shed.

The American officers whom Bartholdi had met at the port had given him only a partial explanation of what was going on. The bigger picture involved a financial triangle that linked Paris, London, and New York. The provisional government of Tours had been able to access these international networks thanks to its minister of justice Adolphe Crémieux, a liberal lawyer and a Freemason active in the Alliance Israélite universelle (AIU), who enjoyed a personal friendship with the Rothschilds.[29] But the Rothschilds continued to back the new French government even after the collapse of the provisional government and the signing of the surrender—indeed, it was their support that enabled Thiers to hold on to Belfort for France. In March 1871, Thiers would turn to the Rothschilds once again to finance the payment of the country's new war debt.

The Rothschilds were busy drawing up just such a plan when the people of Paris rose up. On March 26, Blanquists and Jacobins declared the "Paris Commune," which appropriated all the workshops abandoned by their proprietors during the siege and prohibited nighttime work for bakers. The Republican government sent in troops and two hundred cannons from Versailles, where it had installed itself, to retake the city, but the Communards fought fire with fire. For days flames devoured the Tuileries, where the Communards had piled up carts of gunpowder, liquid tar, petroleum, and turpentine, before spreading to the rue Royale and the rue de Rivoli, to the city hall, the court of audit, and the justice building, giving what looked like a preview of the apocalypse, or, as a Richard Wagner might have put it, a "twilight of the gods."[30] Even more so than in 1848 and 1851, women now took an active part in the uprising. They could be seen on the barricades and at the

rallies, and the legend soon spread that they were the true culprits behind the conflagration of Paris—the "pétroleuses," communist women who, with a bucket of petroleum in one hand and a torch in the other, brought fire and destruction, not unlike the mythical plague-bearers of old.

With a torch aloft and a frown on her face, the Statue of Liberty would recall those fearful figures, which destroyed, but made space to rebuild anew. After all, duality is implicit in fire, an element known for its purifying as well as destructive properties. And one can guess that, if any of Böhme's mystic beliefs ever reached Bartholdi through Laboulaye's writings, they probably brought him to see the statue's fire as simultaneously creative and destructive: the burning fire of the *petroleuses* (or *petrolistes*, as Bartholdi would call them) and the purifying fire of knowledge. Bartholdi was appalled by the devastation that had taken place during the Commune. And he was not the only one. As historian Bertrand Tillier has argued, no revolutions had destroyed as much as the Commune did. Instead of creating new monuments or paintings, like the French Revolutionaries had done, the Communards devastated the old. Delacroix's *Paix* and Ingres's *Apothéose de Napoléon I* burned in the fire that engulfed the city hall; Théodore Chassériau's *Les bienfaits de la paix* was destroyed along with the court of audit; and Landelle's *Femme fellah*, the painting so beloved by Napoléon III, suffered the same fate in Saint-Cloud. Even the column in the place Vendôme was knocked down by order of Gustave Courbet, the "David of the Commune," who had proclaimed himself "president of the arts." While photographers like Nadar and painters like Manet remained behind to document the massacre, most artists—including Bartholdi—fled Paris. He was back in Colmar a few days before the Paris Commune was declared, and would return only at the end of the so-called bloody week, when seventy thousand men, led by Marshal MacMahon, stormed Paris through the gates of Passy and Saint-Cloud to regain control of the city and carry out mass arrests, shootings, and summary executions on street corners.

As for Laboulaye, it is reported that he took refuge in Bolbec, in Normandy, and that, when the Germans showed up at the gates of the city, he organized an ambulance service. What is certain is that Laboulaye, as much as Thiers, came out of the carnage of the Paris Commune politically and psychologically strengthened. The supplementary elections of July 1871 brought him nearly a hundred thousand votes. His life's dream had finally come true. As fearful of legitimism and right-wing monarchist nostalgia as of the radical and revolutionary anticlericalism of the Left, he became one of the leaders of the center Left, the *centre gauche,* a more conservative republican party mostly made up of former Orléanists who had embraced republicanism during the 1850s and 1860s. Drawing on Benjamin Constant, Laboulaye warned of the dangers of Parliament's centralization and wrote up his own draft constitution based on separation of powers, administrative decentralization, economic liberalization, and religious toleration.[31]

But politics, Thiers believed, was supposed "to be completely subordinate to financial issues."[32] His idea was to launch French bonds on international markets, and he looked to his privileged relationship with the Rothschilds of London to do so. Yet Thiers was not alone in government, and pressures to cut the strings with the Rothschilds were growing ever stronger. A certain impatience was mounting among French banking circles with the near monopoly that the family firm enjoyed between Tours and Versailles, an impatience that was often accompanied by unpleasant insinuations about the lack of authenticity of their patriotism. The Rothschilds were awarded the commission for the first installment of war debt, but then had to share the payment of the other installments with other banks. Which ones? "French establishments," explained Mazarat of Credit Lyonnais, which were laying claim to "the place which they must legitimately take in French affairs."[33] As it turns out, behind these patriotic institutions (Banque de Paris, Crédit foncier, the Société de dépôts et de comptes courants, Comptoir d'escompte de Paris, Credit industriel et commercial and Crédit

lyonnais among the others) lay the financial backbone of the future Statue of Liberty, as well as the original structure of the banking and publishing interests that had contributed to the birth of Charles's foundry and publishing enterprise.[34]

THE MAKESHIFT WAGON carrying Bartholdi back to Paris, after an absence of nearly two months, ran into several Prussian patrols. "The Prussians," Bartholdi recalled, "were everywhere." So it was a relief to see the skyline of Paris appear in the distance, topped by "a few columns of smoke." It was May 28, the last day of the "bloody week." Fighting continued in Belleville, in the worker "ghetto," but the richer quarters to the west, shrouded in smoke, were slowly returning to normal. In vain, Bartholdi tried to enter the city by the Saint-Denis Gate and eventually gave up, only to try again, two days later, by the western Point-du-Jour Gate. His wagon cut a sorry path through "ruined fortifications, gutted houses, twisted gas pipes, and felled trees." When he reached his home studio in rue Vavin, he found everything as he had left it; pieces of chalk resembling the handrails of a staircase were lined up on shelves, statues mounted on tripods stood awaiting their finishing touches, and there was his writing desk of heavy wood. It was all untouched except for one window, which had been broken by soldiers firing down "on insurgents," and Charlotte's beautiful mattresses, which they had laid along the walls.[35]

Bartholdi jotted down a letter reporting back to Charlotte, who had remained in Colmar, and then went out into the city. He crossed the Seine to explore the hotspots of the uprising, still shrouded in a heavy veil of smoke. The rue de Rivoli lay in ruins; the blackened shell of the Tuileries Palace was reflected on the lake like a toothless monster, and the carcass of the Palais d'Orsay gazed just as forlornly at its own reflection in the Seine. It was there, in the Palais d'Orsay, the seat of the Court of Audit, that Émile Zola described some of the most dramatic scenes of the fighting playing out: "gallon-loads

of petroleum had been poured down the four staircases, in all the four corners, and flowed in streams along the course of hellish currents." In the blink of an eye, an "immense fire, the most enormous, the most frightful" had seized the "giant cube of stone, which began to vomit forth flames from the two storeys of porticos."[36]

The people of Paris did not seem to remember, or want to remember, the inferno. "The Parisian," Bartholdi explained to his mother, was "happy to be left free," free to be able to walk through the city again without fear of bullets and fire; with his wife on his arm, "he goes to see the feats of the *pétrolistes* [*sic*], puts his finger in the holes left by bullets, [and] is startled to see an unbroken window hanging from the fourth floor" of a destroyed house. Bartholdi also enjoyed this freedom to wander, but he had not returned to Paris to stay there. With 350 francs in currency, 2,800 francs in gold, and 8,351 francs' worth of bonds in his pocket, he was looking for a passport. Ever since France's surrender, when the Germans had closed the door of Alsace "in his face," he had been contemplating leaving France. For a while he stayed in Switzerland, perhaps to visit the nursing home where Charlotte was hoping to send Charles. Switzerland, though, was too close to France. What Bartholdi needed was an adventure to take him away and make him forget "all the sad memories of the past year."[37]

At least, this is what Bartholdi would tell his American readers in 1885, on the eve of the Statue of Liberty's inauguration. He would also recount that his chats with the American officers at Bordeaux, back in 1871, had made him think about Laboulaye and his American project. More plausibly, as I have argued, Bartholdi and Laboulaye had never stopped talking about it after 1868, even before Bartholdi had left for Egypt. But this was a secret that Bartholdi did not want to share with anyone, least of all his American readers. The Statue of Liberty's future owners only needed to know that Laboulaye had last mentioned the possibility of building a Franco-American monument at Glatigny in December 1865. It was, of course, unlikely that, in 1885, Bartholdi's American audience

would be particularly well informed about the two years he had spent working on a failed Egyptian project between 1867 and 1869. In case they did, however, Bartholdi's story would not arouse their suspicions, because it claimed that nobody had worked on the American project between 1865 and 1871. And yet, there was something in the way Bartholdi told the events of 1871 that seriously undermines the credibility of his whole testimony.

His account went as follows: encouraged by what he heard from the sailors in Bordeaux, Bartholdi convinced himself that Laboulaye had been right, that evening in 1865, to acknowledge the strong ties of friendship linking Americans and French. The time was ripe, Bartholdi began to think, for building a French monument to send to America, so he decided to return to Glatigny to discuss with Laboulaye the possibility of implementing his old idea. Quite surprisingly, as if nothing had changed over the previous six years, Bartholdi once again found himself face to face with Laboulaye's coterie of abolitionist friends: Henri Martin, Louis Wolowski, Agénor de Gasparin, "and other distinguished men." They "talked again of American sentiment, of the shipments which the Americans had made to Paris, of the diverse opinions which prevailed in America." Some asked why so many Americans supported Germany, and Bartholdi related "everything that he had heard on board the Transatlantic ships," about how, in America, it was German immigrants who supported the Prussian cause, but not all of them, only those who had immigrated recently. Such talk would reinforce in Laboulaye and his friends the conviction that it was finally a good time to begin working on a Franco-American monument. So they told him:

> Go and see that country. Study it and bring us back your impressions. Propose building a monument together with us to our friends over there, a joint work, in memory of the long-standing friendship between France and the United States. We will raise funds in France. If you come up with

some good idea, a plan that raises enthusiasm among the people, we are convinced it will be a success on both continents, and we will accomplish a feat that will have widespread moral consequences.[38]

If indeed it ever took place, the meeting must have been held in March 1871, at some point between the signing of the French surrender that ended the Franco-Prussian War and the outbreak of the Paris uprising. But in the tumult of those frenetic days, when would Laboulaye have found the time to bring together those old friends (not to mention Gasparin, who was very sick, and would die two months later in Switzerland) to discuss the Statue of Liberty project? Even less likely is the prospect that Laboulaye would have promised to launch a fundraising campaign for America in a recently besieged, war-weary France that was preparing to repay war debts to Germany.

A more reasonable hypothesis is that Bartholdi and Laboulaye discussed in writing an earlier "American project," which was then interrupted by the war. Indeed, this is the impression given by an 1871 letter from Bartholdi to Laboulaye that miraculously has survived to this day:

> I have spent some time putting my affairs in order, but with the hidden intention of changing scene. I think this would be the right time to make the trip about which I have had the pleasure of speaking to you, and I have arranged things so as to depart at the end of the month for the United States. Therefore I appeal to you, dear Sir, for all your support, as you have so generously promised me. I am writing to ask you for some letters of introduction that can accredit me with the associations, the press, and the government. I hope to meet "connoisseurs," or find important works to do, but above all I hope to bring to completion the project for a monument in honor of Independence. I have read and continue to read

your works on the subject, and I hope to do justice to your friendship, which will be my sponsor. I will do my best to glorify the Republic and Liberty.[39]

This letter belies Auguste Bartholdi's 1885 narrative in three ways. First of all, it tells us that the 1871 meeting never took place or, if it did, it went differently from what Bartholdi later wanted his American audience to believe. For nowhere in the letter does he mention a fundraising committee or a formal agreement, according to which he was expected to go to America and report back to Laboulaye and his friends. Which brings us to the second inaccuracy in the 1885 narrative: Bartholdi was not sent to America; he went there of his own initiative, on a private journey that was meant to "bring to completion the project for a monument of Independence," but more generally to make his name known among "connoisseurs" who could commission to him "important works." Finally, there are no doubts that Laboulaye was Bartholdi's sponsor, but the letter refers to an ongoing discussion between the two, which, as we know, must have started in 1867 or 1868. And this discussion, Bartholdi reminded Laboulaye in his letter, was about offering a memorial to American Independence, one "glorify[ing] the Republic and Liberty."

It was the first time that Bartholdi was explicit about the meaning of his and Laboulaye's American project. But his description was still rather vague. For, one may wonder, what kind of liberty was the statue meant to represent? Indeed, if the statue represented American independence, it could not truly represent American liberty, unless as a partial conquest, one not including the abolition of slavery. And the republic? The United States were certainly not a republic in 1776, when the Declaration of Independence was signed. Even more importantly, which one of Bartholdi's former fellahs represented an American republic and an American liberty? As I argued previously, the artist had sculpted and re-sculpted his later fellahs between 1869 and 1870 to make sure they could apply

equally well to Egypt and America. The war suddenly interrupted this process, and we cannot be sure which one was meant to be the American maquette. One might assume that it was the only one wearing Roman attire and no longer covered by a veil, but instead a simple diadem or crown, not unlike the one worn by the *France victorieuse* in Bartholdi's plaster for the exhibition of 1867 (Figure 15.2). Bartholdi's new fellah lifts her right hand to brandish a torch, while holding a broken vase in the left hand, lowered along the hip. She looks Roman but not classical: with her left hip higher than the right, and her right leg bent, the fellah embodies the sort of asymmetrical pose that Scheffer had advised him to use for evil and mundane characters. Still resolute like a warrior, she is definitely more erotic than the original fellah. Why? Probably Bartholdi thought that, as consumers of orientalist art, Americans would appreciate eroticism more than the Egyptians would. But at which point would they have consented to identify themselves and their own nation with an orientalist icon? And at which point did they need to know that their icon had orientalist origins?

THE AMERICAN SCENE

On May 29, 1871, Bartholdi knocked on Laboulaye's door in Glatigny. This time, however, he was not there to take part in a fancy social reunion; one day after his unsuccessful attempt to enter Paris by the Saint-Denis Gate and two days after kissing his mother good-bye, Bartholdi called on Laboulaye to pick up the letters of introduction that he had been promised and to bid him farewell. As usual, Laboulaye greeted him with kindness and expressed enthusiasm for the enterprise — "he encourages me in person just as in his letter," Bartholdi wrote to his mother, reaffirming in his diary, "I have seen Laboulaye, very encouraging."[1] With Laboulaye's blessing, he went to Rennes, where his assistant, a certain Simon, had been waiting for him. Simon was an old man with tanned skin creased by deep wrinkles, thick gray hair, and a pipe made of dark wood that was his inseparable companion. It would have been easy to confuse him with an old sea dog; in truth, he was a land man who had worked for years in the studio of David d'Angers (the sculptor of the *Gutenberg* in Strasbourg) and, after 1866, appears to have been employed full-time at Bartholdi's side. Together, the two had transformed the small model of the *Vercingétorix* into a colossal plaster cast for the Salon of 1870, and Simon had probably similarly advised the artist on the fellah-*Liberty*. Which was why Bartholdi wanted him by his side now that he had to find a place for the statue.

After spending the morning with Simon and his family, Bartholdi and his companion rode to Brest, where the "big liner" — opportunely

named after the naval magnates Péreire—was expected for the next day, on June 10. While on the vessel, Bartholdi had plenty of time to think about his project. To his mother, he wrote that the weather was nice and the journey pleasant; in his diary, meanwhile, he registered a long chain of unfortunate days ("Very bad—vessel damaged") and bad or foggy weather. Mostly, Bartholdi practiced his English "on several Americans who are on board," and whenever he learned new phrases, he would walk "on the deck alone mumbling them, as a parish priest recites his breviary." It must have been an amusing sight for the other passengers, who soon grew attached to this stranger with the strong accent and grand ambitions. Other times, they would meet him on deck or in the fumoir reading some of the books he had brought with him, such as Hugo's *Les châtiments*, which had been published in France for the first time on October 20, 1870. "During the voyage," Bartholdi would recall years later, "Hugo's *Les châtiments* was my constant companion."[2] Tellingly, *Les châtiments* was the poem in which Hugo both described the suffering endured by the French under the "little emperor," Napoléon III, and anticipated the regeneration of France and of the world as a whole. The messenger of this regeneration was a "morning star," which Hugo claimed to have seen on a beach at the ocean's edge. "I fell asleep at night on the seashore," Hugo explained in "*Stella*," or "Star," Bartholdi's favorite among the poems, and a "cool breeze awakened me, I came out of my dream, I opened my eyes, I saw the morning star" that was "shining deep in the distant sky in a soft whiteness, charming and infinite." Lulled by the waves of the Atlantic, Bartholdi read Hugo's vision of the encounter between the ocean and the star: "the Ocean, which resembles people, went towards her, / And roaring in a deep voice, watched her shine, / and seemed to be afraid of making her fly off." Struck by the passage, Bartholdi underlined the words "[the star] is the angel Liberty, it is the giant Light."[3]

Perhaps Bartholdi saw a similarity between Hugo's nocturnal star and the apocalyptic light that Daniel sees in Laboulaye's *Paris*

in America. Whatever the case, Bartholdi stood on deck as his ship entered New York Harbor with Hugo's words still ringing in his mind. He was curious to see "if the beams of light of the lighthouse would be visible" and eager to catch the morning light as it emerged "early, through the fog." "We sighted land," Bartholdi would tell his mother, "the sky became pink—a multitude of small sails seemed to plow through the water." Then his fellow passengers "pointed towards a column of smoke across the bay—it was New York!"[4]

With the ship anchored in the "lower part of the bay," Bartholdi and Simon bided their time waiting for the quarantine officers to board the ship. As they did, they calmly contemplated New York Harbor. Entering New York in 1871 was not the futuristic experience that it would become only thirty years later, at the turn of the century. There were no "tall buildings," nor, as Henry James would put it in his *American Scene*, "the multitudinous sky-scrapers standing up to the view, from the water, like extravagant pins in a cushion already overplanted."[5] The sensation was, instead, one of entering a world beyond time, in which glimpses of the future mingled together with the traces of a colonial past. "Arriving in New York does not give a precise idea of the grandiose beauties of the nature of the New World," the Saint-Simonian feminist and homeopath Olympe Audouard had said upon disembarking in New York a few years earlier, the memories of her Egyptian journey still fresh in her mind. With a travel history behind her not unlike Bartholdi's, Madame Audouard had noted that, upon entering the port of New York, "the city appears at first at its crudest," without "any beautiful monument offering itself to the view of those who arrive"; all that one saw was a "multitude of flat roofs, topped by a thousand chimneys, as in the cities of the Orient."[6]

As it happened, orientalist stereotypes could be equally applied to the East and the West. For America's colonial past still weighed on Audouard when she visited America, as it previously had weighed on famous British travelers such as Francis Trollope and Charles Dickens. Americans, for them, were not only "sly, grinding, selfish,"

or of "dull and gloomy character," but also quintessentially filthy.[7] "Dirt, untidiness, and noise," Trollope once said, were the main descriptors of the vast American West, while Washington's god was "King Mud," and Pittsburgh was "the dirtiest place I ever saw."[8]

Bartholdi was hardly immune to these preconceptions. No sooner had he set foot on American land than he found himself expressing concern for "the American character," which—he thought—was "hardly open to things of the imagination." Later, too, he would look down on the callowness and naiveté of American architecture and lament the absence of public hygiene. Contrary to Audouard, Bartholdi saw nothing in the port of New York that reminded him of the ports of Alexandria or Suez. He did, however, share with her the feeling that the port needed a monument. But where should it be placed?

Perhaps it was when the ship approached New York, or when it stopped at Ellis Island to wait for the quarantine officers, that he drew an outline of the bay on a piece of paper and marked on it, with crosses and dots, the sites that seemed particularly suitable for a statue (Figure 17.1). He drew a cross at the head of Sandy Hook (a narrow stretch of sand jutting out like a spur from the coast of New Jersey) and a dot on the coast of Coney Island, almost facing Sandy Hook. One "red dot," however, marked a site "that longed" for a statue: it was Bedloe's Island (today renamed Liberty Island), "that little island occupied by a fort" in the shape of a star, which, situated opposite Manhattan, offered a unique view of New York Harbor.

Probably, during one of their conversations, Laboulaye and Bartholdi had agreed that placing the statue on America's maritime border would have eased the conversion of a fellah into an American icon of liberty. Indeed, if the original fellah was meant to represent the integration of Eastern and Western civilizations in the Eastern Hemisphere, which the Suez Canal was supposed to accomplish, a border-guard fellah in America could very well be the icon of a similar encounter in the Western Hemisphere. And this

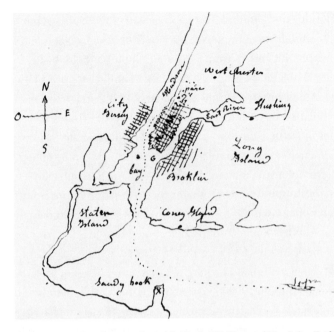

FIGURE 17.1. [Frédéric-] Auguste Bartholdi, "Bartholdi's Illustrated Map," 1871, Frédéric Auguste Bartholdi Papers, MssCol 223, Manuscripts and Archives Division, the New York Public Library, Astor, Lenox, and Tilden Foundations.

would have been true wherever Bartholdi had placed his colossus: either on the Atlantic, where the Statue of Liberty would welcome Europeans and Eastern Europeans into the West, or on the Pacific, where she would address immigrants from China and other parts of East Asia. In due time, as soon will be clear, Bartholdi would consider the possibility of placing the colossus in Washington, Philadelphia, Boston, or even San Francisco. None of these cities, however, would compete with Bedloe's Island, which captivated Bartholdi like few places had done before. Had he lived earlier, Henry James would have contradicted him: "the [New York] islands, though numerous, have not a grace to exhibit, and one thinks of other, the real flowers of geography in this order, of Naples, of Capetown, of Sydney, of Seattle, of San Francisco, of Rio, asking how if *they* justify a reputation, New York should seem

to justify one."[9] Bartholdi had not seen all of these places, but he was certainly more impressed by New York than by Naples or, in time, San Francisco. Ironically, the French Bartholdi had fewer orientalist prejudices against America than the American James had. American nature truly fascinated Bartholdi as if it had quasi-mystical powers. He certainly did not consider it aesthetically inferior to the European nature or even "degenerate," as European intellectuals had suggested since the eighteenth century.[10]

Bartholdi might have developed his mystical attraction for America upon his arrival, under the inebriating impressions of his very first vistas. Or he might have reached this stage gradually, after reading American philosophy and examining the paintings of American Romanticism. Ralph Waldo Emerson, the guru of that movement, had once argued that nature was not God, but alluded symbolically to his presence or, better still, betrayed the divine intelligence that had created it. Bartholdi may not have read Emerson directly, but Emerson's ideas had certainly inspired the painters of the Hudson River School, which already were famous in France when Bartholdi was a young painter. These national Romantic artists had painted New York Harbor, the Hudson River, and the East River as if they were cloaked in a mystical, timeless atmosphere; as if they were backgrounds for biblical stories or stages of future miracles.[11] A few of them, like Edward Moran in *Statue of Liberty Enlightening the World*, had let sailing ships and steamboats intrude into their scenes, but their ships' sails looked like ghostly shadows chasing each other against bleeding sunsets, with their smokestacks sending unearthly vapors up from the sea.

Bartholdi must have had these images in mind while approaching the bay: as he explored the harbor with his gaze and became overwhelmed by a sense of wonder, he couldn't help but follow the sails and puffs of black smoke as they crossed the sky in unpredictable patterns. Already from the ship's deck, he could see "the East River and the Hudson dotted with ships as far as the eye can see," and immediately imagined his statue rising among them, "the

masts and spars of the vessels" looking "like the cross-hatchings of a pen-and-ink drawing."[12] For Bartholdi was a painter, but he was also a sculptor, one who often had found his subjects in his mentors' paintings. Yet now, for the first time on Ellis Island, he was imagining his future sculpture as a painting—an imaginary painting of course, adumbrated with quick strokes: a colossus surrounded by two-story "ferry-boats" sailing "from one side of the harbor to the other, full of people and covered with flags, emitting deep-toned blasts from their whistles."[13]

Bartholdi's attention to technology was part of a contemporary ideology of progress, but to this he added the surrealist touch of a Renaissance-style painter. And like many Renaissance painters, Bartholdi thought that God was manifested in the most awkward and bizarre features of nature: not in the blue sky or in the desolation of a landscape devoid of humans, but in the ship's anthropomorphic shapes: the ferries looked to him like "colossal flies" and the yachts gliding "over the surface of the water . . . like marchionesses with their long trains." But even the bay's coastal outline had an evocative shape, if seen from Bedloe's Island. At the virtual point of convergence of the East and Hudson Rivers, which divided New York into three parts, Bedloe's offered a clear view of Manhattan, New Jersey, and Brooklyn, which were still three autonomous municipalities, but "seem and indeed are a single large city." Bartholdi got lost in surreal phantasies about spatial lines and even suggested that God himself had divided the land by two rivers "to explain the mystery of the Trinity."[14]

This description was intended for Charlotte, his constant (although distant) companion during his journey. Even more so than during his Egyptian and Italian expeditions, he now collected the most comic and bizarre observations and sent them to her. Bartholdi's need to communicate with his mother only grew more intense the farther he went from her. This strong affection did not escape his interlocutors on board the ship, or later those in the United States. The impression he gave was that he "loved his

mother better than life."[15] Clearly, he was worried about Charlotte's isolation in Colmar, among German enemies and away from her son. But he did not seem to act out of piety alone. Bartholdi's letters from America reveal a new solidarity between the two: "in spite of the numerous longitudes that separate us," he assured her—and he seemed sincere—he felt closer to her than ever before.[16]

BARTHOLDI NEXT EMBARKED on his New York adventure with Simon. On foot, they followed the carriage of the French-American passenger Henri Maillard, the proprietor of La Farge's Hotel on Broadway, where they had been invited to stay for the rest of their vacation. Pulling their bags and trying not to lose sight of Maillard's carriage, Bartholdi and Simon found themselves "right in the middle of the jumble of tracks, wagons, omnibuses, overstuffed luggage wagons, light trucks with wheels that seem like circular spider webs, among crowds moving in a great hurry down rudimentary streets that had already been neglected, on a pavement furrowed with tracks like great wounds, inaccessible streets, telegraph poles on every side of the street, uneven street lamps, signals, wires, garlands of flags stretched over the streets, shops that faced the street directly, as seen in fairs." Then, all of a sudden, the hum of the city grew more distant, and the houses more forlorn; perhaps they had entered the German ghetto, on the Lower East Side, without realizing it. A bit curiously, Bartholdi found the general effect "somewhat Chinese."[17] He, of course, had never been to China, but—as Said tells us—Europeans had grown accustomed to consider chaos as a quintessential characteristic of the Orient. Not only was chaos thought of as Chinese, but poverty and precariousness were too: "broken sidewalks, buildings of various sizes like on the outskirts . . . houses eight or two stories tall, and shacks." When Bartholdi and Simon returned to the main street, the orientalist impressions faded, but not for long. As they approached Broadway, they saw rows of "very tall" houses, their walls of sandstone or of "painted

cast iron, or stone or brick." Bartholdi took mental note that the
city's predominant color was a "reddish gray or gray"—which he
later would choose for the Statue of Liberty's color—and its style
was "difficult to define—Anglo—Marseillais—Gothic—Doric—
Badener."[18] Bartholdi might have thought that the more varied the
city's style, the easier it would be to relocate a former fellah to New
York, even if (he must have realized a bit too late) this particular
fellah now looked rather Roman.

"For three days," Bartholdi and Simon traveled about "by omni-
bus and ferry-boat and otherwise—with remarkable ease." As they
proceeded, they added new points to the map of possible locations
for the Statue of Liberty. From Staten Island, which they visited
on June 22, Bartholdi realized that Bedloe's Island "seems to me
the best site."[19] But he was also interested in two inland areas. On
June 23, he and Simon made their way to Central Park accompa-
nied by the "captain of the park," a certain Mr. Mills. The name
notwithstanding, Central Park—"the pet and pride of the city"—
was, at the time, found on the northern edge of the city, and looked
somewhat like an English landscape painting, with picturesque
bridges over a stream and rows of trees screening out traffic that
did not yet exist. The plan was to decorate the city's parks (Central
Park and Prospect Park, still under construction) with statues of
the heroes of every ethnic community that had made a home in
New York. The British already had a bronze statue of Shakespeare,
the Germans one of Humboldt, and the Dutch were working at
the time on a bust of the novelist Washington Irving. But no one
as yet was planning to erect a statue of a French hero. Bartholdi
judged the statues already installed in Central Park to be rather
"mediocre," and probably did not expect much more from future
ones either. By contrast, he was enthusiastic about the "rocks and
ponds, adapted very well to the plan" of the park, and lingered
willingly at the "high points" of the park to enjoy the "superb
panorama of the two great rivers and the country beyond them."[20]
Was he considering an inland site for his lighthouse? After all, none

of the gigantic statues of the ancient and Renaissance worlds (the *Colossus of Rhodes*, as we have seen, the statue of Charles Borromeo, the *Appennino*) or even their modern remakes (the *Bavaria*) were placed off a coast. They were found in panoramic locations, on lakes, on hillsides, promontories, in front of colossal temples. Even very recently, between 1856 and 1860, the French had placed a fifty-five-foot Virgin Mary, cast from the bronze of cannons taken at Sevastopol, on a rock almost 2,500 feet high in Le Puy-en-Velay.

Bartholdi thought the matter over for some time. He probably imagined the statue on Summit Rock, in the western end of the park, from where, at the time, one could still see across the Hudson to the New Jersey Palisades, or on Great Hill, where he contemplated a wonderful, almost unhampered view of the Hudson. It is tempting to imagine the statue there today, embraced by the greenery and framed by tall buildings, or even in Mount Prospect Park, a spot from which, on June 24, Bartholdi had taken in the expansive view from Manhattan to Long Island. As we know, things turned out differently. But at the beginning of his trip, and despite his weakness for Bedloe's Island, Bartholdi was open to different possibilities. The only thing that kept troubling him was the way Americans were reacting to his project. During the few days that he had spent in New York, Bartholdi discovered that what had initially appeared to him as a lack of imagination in truth was a simple consequence of the American vocation for business. "Business. That is the great word, repeated so often as to be a little tiresome." Soon enough, he would withdraw his severe verdict, because businesspeople would be among the statue's most determinate supporters. For now, however, he thought that the secret was to find "a few people who have a little enthusiasm for something other than themselves and the Almighty Dollar."[21] Laboulaye had thought of that too: most of his letters were addressed to the more intellectual and politically minded members of the private clubs that had sponsored and supported the Unionist cause, such as the Union League Club; to diplomats;

and to the translator of his book *Paris in America*, Mary Booth, rather than to bankers or businessmen. What neither Bartholdi or Laboulaye could foresee was that the torrid heat of the coming summer would drive most Americans out of the city in search of cooler climes.

The extent of the problem revealed itself early enough. On June 23, after a number of unsuccessful attempts, Bartholdi finally got hold of Mary Booth. But neither she, nor his host, the "superintendent of the art department of the Harper publishing house," were particularly encouraging. "Little hope in this direction," noted Bartholdi in his diary. He tried again with another intellectual and propagandist who had campaigned for the Union, professor Vincenzo Botta, a renowned figure in postwar New York. With his shoulder-length hair and little round spectacles, Botta was "tall, imposing of physique and physiognomy."[22] He was born in Cavallermaggiore, a small town in Piedmont, Italy, and had been a professor at the University of Turin and a member of the Sardinian parliament. Tasked by the government to write a report on Germany's educational system, Botta had set sail for New York in 1853 to first study the American system, but, once there, he had fallen for New York's lively cultural scene, and even more so for poet Anne Charlotte Lynch's wit and beauty. Lynch was renowned for her charms, but few remember today that Botta succeeded where Edgar Allan Poe and other illustrious suitors had failed.

After their wedding, the Bottas opened their home to some of the most famous intellectuals and artists of their time, from Ralph Waldo Emerson to the Norwegian violinist Ole Bull. But it was not only artists they protected. During the Civil War, their salon had become something of a branch of the Union League clubs, for the Bottas had put their money and their pens at the service of the Union and of Lincoln. The same philanthropic spirit would lead Mrs. Botta to donate funds in support of the women and children of Paris during the Franco-Prussian War. Laboulaye could not

possibly have ignored their generosity, but he was probably more attracted by their relations with the Union clubs, whose members were art connoisseurs and influential politicians. He must have thought that, even if five years had passed since the Bottas had collaborated with the Union, they could still put Bartholdi in touch with its leadership.

As it turned out, the Bottas showed no real interest in Bartholdi's project, and he himself thought that they were "not exactly [his] ideal": "They wangle something from me for their album—they ask me to dinner—and there you are!"[23] It is of course possible that the Bottas did not really understand Bartholdi's statue. After all, his English was still rudimentary, and the monument's purpose was complex and slightly contradictory. Perhaps Bartholdi had thought that offering America a memorial of 1776 dedicated to liberty and the republic would be a straightforward affair. But Unionists like the Bottas might have been puzzled by the idea of mobilizing the Union clubs for a monument celebrating the Revolutionary War rather than the Civil War and the abolition of slavery. On his part, Bartholdi too was puzzled, for the Bottas, who had been informed of his Alsatian origins, made him work "on a horrid medallion in cheap terracotta, a portrait of Mrs. Riplay, a German."[24]

Bartholdi would hide the disappointment of these early encounters from his mother. The more optimistic narrative he sent her chronicled that he had been "well received" by those still in town and that, while waiting for others to come back, he had "stud[ied] the American mind."[25] Instead, Bartholdi had continued to look for possible sites for his statue and to meet with people. On June 25, he marked with a dot Westchester County, thirty-seven miles north of Central Park, where some of New York's wealthiest businesspeople had built mansions overlooking the Hudson. Then he met with the French consul, Monsieur de Luze, who invited him to his home along with other diplomats; went back to the Bottas; and gave the art dealer Knoedler some of his bronzes to sell.[26] Except

for Knoedler, Bartholdi's interlocutors all showed the same cold indifference, which forced him to rethink his whole plan. "Decidedly, I am going to change my tactics," he noted before going to sleep on the night of June 27.[27]

It took unexpectedly little for Bartholdi to come up with a new strategy and put it into practice. The French consul had probably informed him that the Cercle de l'Harmonie, the French club in New York where most Franco-American traders met to socialize and dance in luxury, was eager to finance a "commemorative monument in 1876." Indeed, in five years' time, the major American cities would organize festivities of all kinds to celebrate the centenary of independence. Until that moment, Bartholdi might have thought that his big colossus was his main chance to take part in those celebrations. But his conversations with de Luze convinced him that he could make a name for himself in America by building separate monuments for the occasion, in cities across the country, while working on his colossal project for New York.

It all worked like magic and—Bartholdi announced to his diary—"the idea takes hold."[28] The Bottas were the first to hear about Bartholdi's new plan, on June 28, and it was probably thanks to their mediation that he was invited to present his project at the Union League Club, then quartered on Union Square. Had he stuck to his new strategy, he would have simply introduced himself as a French sculptor working on a French memorial of 1776 for the city of New York. Instead, it seems he could not resist the temptation to introduce his other, much larger project for a lighthouse of independence, a memorial to "glorify the Republic." It was a mistake. Everybody at the Union League Club listened politely to his plans for a future colossus, but when it came to a formal endorsement of the project, all he received were "vague, cold" words that did not imply any clear support.[29] Bartholdi realized that he was in no position to push the point. As he wrote to his mother, "With respect to my project, I mustn't insist on trying to get it to catch on right away." The statue would doubtlessly require a "laborious"

process in order for it to see the light. So he decided to move on "to the second part of [his] plan," which consisted in "going around, traveling, seeing as many people as possible. The relationships built in this way will be even more precious as a result, and perhaps in the end the principal project will find completion."[30]

CHAPTER 18

STELLA

Bartholdi left his New York friends with a promise: he would get down to work on the project for "a commemorative monument" for the French club Cercle de l'Harmonie. As for the "Statue of Independence," he was beginning to realize that Bedloe's Island was, after all, a dead end. Ironically, that was the moment in which the Bottas, who gradually had been warming up to the project, decided to help. They explained to Bartholdi that the politicians and businessmen who had fled the heat of New York could be found on the beaches of New Jersey, in particular Long Branch, the "queen of beaches." The U.S. president, the Republican Ulysses S. Grant, had a residence there, where a whole entourage of friends, bureaucrats, wheelers and dealers, and hangers-on of all sorts would meet over the summer. The Bottas also had a house in Long Branch, and they offered to take Bartholdi there.

On July 1, he found himself on a ship bound for Sandy Hook (a few short miles from Long Branch) with Simon, the Bottas, and two Frenchmen. Like other European travelers of the time, Bartholdi was speechless when he saw his ferry, which looked to him like a "floating house," but one equipped with an engine, "clean and shining like the inside of a watch." There was a "restaurant, baggage service, carriages with their horses"; "richly decorated staircases" leading up to "an upper floor, [. . .] where there are two large concert halls, rich in décor," and everywhere "statues, golden plasterwork . . . hundreds of bird cages full of canaries," which brightened the rooms with their song.[1] But Bartholdi stayed on deck, avoiding

the temptation of the great rooms and concert halls. The formal explanation was that he was continuing to search for possible sites for his monument. In truth, he was simply giving his farewell to Bedloe's Island and New York, for no sooner had Bartholdi boarded the ferry than he longed to "see the bay of New York" again.[2] His eyes fixed on the empty spot on top of the island's star-shaped fort, Bartholdi savored the moment, lulled by the engine's rush and the distant sound of the orchestra.[3]

When the Bottas and Bartholdi arrived at the Long Branch ocean-front, they found it crowded with businessmen in their Sunday best, sporting bowler hats (instead of top hats) and walking sticks with golden handles. With their wives on their arms, they could be seen strolling or riding in carriages, or enjoying lunch al fresco on the terraces of the waterfront's great hotels. No matter how hard he tried, Bartholdi, with his French fashions, did not exactly blend in with the crowd. He took up residence in the most popular hotel of the moment, the Mansion House, just opposite the pier, and took carriage rides alone. Simon often stayed behind, but he did not seem to regret it, for he had "such an excellent, kind nature"; so much so, that Bartholdi doubted he could "have any other companion on this journey."[4] In fact, Simon's isolation meant that he was spared Bartholdi's many embarrassing moments, such as when he went for a bath in the ocean only to realize that his bathing suit was "too skimpy" for prudish local tastes.[5] Partly because of his eccentricity, and partly because of his broken English, Bartholdi spent two days in Long Branch without getting to know anyone significant and spending way too much money. Luckily, he was not easily discouraged. If it was politicians that he wanted to meet, Washington was filled with them, and Laboulaye had written letters of introduction for some of those who counted the most.

One did not go to Washington, as Henry Adams put it, to see the sights, as in Paris, or to breathe the scent of money, as in New York.[6] Washington was Adams's "native asphalt," home to the Capitol, the White House, and little else. Yet Bartholdi and Simon found more

grass than asphalt when they arrived there at night, "accompanied by an orchestra of frogs and grass-hoppers." The next day, the sounds of nature were replaced by those of trumpets and firecrackers, because July 4 was the "*fête* of Independence." They could see the "immense lay-out of very wide avenues" all wrapped in flags. But many more avenues had to be built, because Washington was a growing city. A special decree had launched a series of works to develop the city along the lines of its original eighteenth-century plan, drawn up by Pierre Charles L'Enfant, a French architect who had come to America with Lafayette. The French touch did not escape Bartholdi. The wide tree-lined boulevards reminded him of Versailles, and the Capitol—"beautiful from far off"—brought to his mind Paris's Panthéon.[7] But he also noted, not without a certain satisfaction, that Washington was growing, and there was room for new monuments, even colossal ones. Right then, men were busy at work on the Washington Monument, "a sort of obelisk that will become taller than the Strasbourg cathedral," built with "stones from every part of the world."[8] He did not find it "beautiful," but thought its "intention" was "poetic." This was certainly a compliment, as he himself had been trained to use art as a medium for poetry. Yet so far, Bartholdi had confined poetry to private, sentimental sculptures, such as the *Génie dans le griffes de la misère*. The question that he must have asked himself while observing the Washington obelisk grow taller under the gray sky was whether public art, too, could be intimate and poetic on such a scale. At some point during his journey, maybe in Washington, in the shadow of that growing obelisk, Bartholdi must have asked himself if there was a way in which colossal statues could be made into something more than historical monuments, if they could convey the more abstract political ideas of Laboulaye's works, or the vengefulness of Hugo's poems. Whatever the case, Bartholdi would never erect his monument on the flat plain of the National Mall, for a truly global icon required, in his imagination, access to waterways, either through rivers or on the sea. In this sense the Potomac was a better option, being a river

that is like a miniature sea, or—better still—like a "lake" because it was lined with "bays on each side."[9]

Once again, Bartholdi needed the help of the city's most prominent citizens to get things moving. And in Washington, as in New York, the summer had driven most of Laboulaye's friends away from the city; most, but not everybody. Charles Sumner, the old Republican senator from Massachusetts, and one of the party's great heroes, was enduring the excruciating sun. Exceptionally tall for those days, and with a strong, sturdy build, Sumner could be heard thundering against the abomination of slavery in the halls of the Senate as early as the 1850s. Except for his height, it was impossible to imagine a person more different from Lincoln. Indeed, when Lincoln was assassinated and Andrew Johnson took over the helm of postwar Reconstruction, Sumner became a magnet for those radical Republicans who thought that former slaves needed to be defended against the discriminatory laws still in force in most of the Southern states, and helped to integrate into white society. He died in 1874, before seeing his bill granting "equal and impartial enjoyment of any accommodation, advantage, facility, or privilege" pass, five years later.[10] But Sumner's posthumous success lasted only nine years, until the Supreme Court declared his bill unconstitutional in 1883. One had to wait until the Civil Rights Act of 1964 to see Sumner's will finally accomplished and the Statue of Liberty chosen as the protector of the minorities' struggles for freedom and equality. Was this later encounter between Sumner and the statue purely coincidental? Or was it the result of a complex plot of transatlantic narratives that Bartholdi had incorporated into his colossus? The fact that the statue held the Declaration of Independence, which Sumner considered the ground of America's commitment to political equality, certainly mattered in the process. But Laboulaye, as we know, had a more conservative view of the American Declaration, and he would have certainly not expected his statue to become an icon for the struggling black minorities. And what about Bartholdi?

Auguste had seen the indirect effects of this race war on his way to Washington, without really understanding their cause. In the Long Branch hotel, for instance, he had found "an immense hall full of [blacks]," which clearly scared him for their sharp contrast "with the whiteness of the blonde guests and their *toilettes*."[11] These were African Americans who had left the South to escape the reach of racist laws and had found employment in humble, low-paying jobs as waiters in Northern restaurants and hotels. They were not the mahogany-bodied Ethiopians whom Bartholdi had so admired in Egypt, but freed slaves reduced to commodities and relegated to the margins of society. Rather than feeling pity for them, he was disturbed by the way in which they were sharing public spaces with whites, albeit in subordinate positions. His notes betrayed fear and loathing: "every guest has a monkey behind his chair," he wrote to his mother, and "the only way to get rid of it," he added, "is to send it to the kitchen to get something."[12]

When Bartholdi knocked on Sumner's door on July 5, the senator was busy trying to ward off the race war in the South and convince moderate, pro-Lincoln Republicans of the goodness of his own ideas. The meeting with the Alsatian sculptor must have been a pleasant diversion for him. Sumner, Bartholdi wrote to Charlotte, "loves the arts, knows all the literatures," while in his diary he noted: "an enthusiastic, intelligent man—he loves France—seems interested in the project."[13] Their conversation may also have turned to politics, French politics, in which Sumner had nurtured a keen interest ever since he had taught law at Harvard as a young man. Perhaps they shared a similar admiration for Gambetta's republicanism (which was not especially to Laboulaye's tastes) and for his intransigence toward the Germans, although it is hard to believe that this alone could reconcile the differences between a provincial Frenchman frightened of African Americans and Sumner, a radical reformer who believed that black people could be integrated into white society. Yet a friendship was formed. In the five days he spent in Washington,

Bartholdi dined several times with Sumner, and in the evenings went on "charming walks among the entrancing hills." Once, probably after discussing and comparing the American losses during the Civil War and the French losses in the Franco-Prussian War, Sumner took Bartholdi to see a cemetery of thirty thousand soldiers not far away from Washington, on "the beautiful property of General Lee."[14] The sight of "rows of white stones under the trees, extending into the distance as far as the eye can reach" reminded Bartholdi that different wars had exacted similar tributes from both French and Americans. He had felt something analogous the day before, while visiting "Washington's tomb" with Simon. "The sight of this tomb," he had confided to his mother, "after the deep impressions I have received from the spectacle of this great country, filled me with emotion." So did the sight of the "room in which Washington died, and Lafayette's room."[15]

It is difficult to say precisely how these visits influenced Bartholdi's perception of America and its relationship with France. Sumner certainly played a role in Bartholdi's sudden appreciation for the interrelation of American and French politics. Very possibly, however, the old Harvard professor lectured his young guest on more than the despondent subject of war. Indeed, it is possible that they discussed the plights of American blacks during their long walks or over dinner. Sumner must have said something about the question, and, whatever it was, it had its intended effect, for, on his last day in Washington, Bartholdi abruptly decided to attend a black church service at the city's Methodist Church. His reaction could not have been more different than his alarm at seeing black waiters in his Long Branch hotel. Although amused by the black speaker's gesturing, he was deeply impressed by the service; it was "fun, but demanded respect" because it was carried out by "people, slaves until yesterday, who turn their mind to an ideal, who have faith, and who are so *violently* moved by what is moral."[16] And violence, as we know, was becoming a virtue to him.

But Sumner was not merely a skilled politician. He was also precociously media savvy, and his first idea, after hearing of the lighthouse project, was to get journalists interested in the cause. Their first appointment was with George William Curtis from *Harper's Weekly*, who was "not very enthusiastic."[17] But things turned out differently with John Weiss Forney, editor-in-chief of the *Philadelphia Press* and friend of Laboulaye's who agreed to meet Bartholdi in Philadelphia on July 10.

If New York was little "more than a hotel and a port" and Washington was the seat of government, Philadelphia was a city still basking in the light of past glories. For tourists, it was the city in which the Founding Fathers had signed the Declaration of Independence, the home of Benjamin Franklin and the peaceful Quakers. But behind the historical gloss lay a dynamic, fast-growing economy. Philadelphia's factories, especially those making textiles, were small and relied on rudimentary technologies. Yet precisely for this reason, Philadelphia's textile entrepreneurs were able to contract or expand their output according to economic fluctuations. Sure enough, Philadelphia remained a second-rate city with respect to the "great metropolises," but the kings of Wall Street did not disdain it. Though modest in appearance, Franklin's home town was sitting on large amounts of capital that had been accumulated by selling blankets, wagons, ambulances, bullets, ships (including the new iron-clad type), and uniforms to the Union Army.[18] Bartholdi did not suspect that the city hid such wealth, however, when he first arrived in Philadelphia on a horse-drawn carriage on the morning of July 10, 1871. American cities were all beginning to look the same to him, and he could not stand the heat. Philadelphia, in particular, did not impress him; it was "perhaps larger than New York," but with fewer inhabitants and "large parts were still unbuilt."[19]

Forney at the *Philadelphia Press* was a dubious character and certainly one of those who cared for the "Almighty Dollar" more than Bartholdi would have liked. Born in Pennsylvania Dutch country, Forney had shown a precious talent for transforming

local newspapers into profitable enterprises, often by associating
them with political institutions. At first, he collaborated with the
Democrats, but only until President Buchanan failed to reward
his services with a political position. Frustrated, Forney shifted to
Lincoln's side in the late 1850s, where he felt gratified and was well
rewarded. Bartholdi met Forney while he was still a Republican,
before he switched back to the Democrats in 1878. Those were busy
times for Forney, who had to combine his still lively journalistic
activities with administrative duties as "collector of the port" of
Philadelphia. So he asked his son to take Bartholdi to the Grand
Hotel Continental—an enormous structure that comprised the
hotel as well as a "bazaar" full of shops, telegraph offices, hair-
dressers, and shoe shiners—and to the headquarters of the Union
League Club of Philadelphia.

After all that travel, and despite the city's discouraging aspect,
Bartholdi found that people were expecting his arrival, and that the
waiters had been working for hours polishing the silverware and
preparing a welcome meal. He was surprised; nowhere else in
America had given him such a warm welcome. But Philadelphia
was different. It was the place where the Declaration of Independ-
ence had been signed and where the memory of the Revolutionary
War was honored with a vast collection of memorabilia exhibited
at Independence Hall, with all its "interesting souvenirs" and the
"window from which Independence was proclaimed." Bartholdi
might have also visited Carpenters' Hall, the seat of the city's craft
guild called Carpenters' Company where the first Continental
Congress had met. The building was "somewhere behind," a sort of
small "corner"—one of the few places in America, James would say,
where one could rest and think.[20] Bartholdi was less philosophical.
If, however, he ever rested in front of Carpenters' Hall, he probably
remembered an anecdote that Laboulaye had told in his *Histoire
des États-Unis*: at the Constitutional Convention of 1787, Franklin,
then an old man with thick, roundish glasses and long gray hair,
had been intrigued by the chair on which George Washington had

been sitting for the entire convention. It was a nice wooden seat, on the top of which "there was a quite ugly painting representing the sun." It was the coat of arms of the Carpenters' Company, the builders of Carpenters' Hall, representing a half sun surrounded by rays. Laboulaye did not say that the drawing was the same one engraved on certain tombs in colonial Massachusetts and was possibly inspired by John Bunyan's apocalyptic images of resurrection as a dawn announced by a crowing cock. He simply recounted that Franklin had pointed out the image and mused: "Painters declare that in their art it is difficult to distinguish a sun rise from a sun set. Many times during this session . . . I have looked at the painting without being able to say if it was a dawn or a sun-set; but I am now lucky enough to see that it is not a sun that goes to sleep, but a rising sun." It was, Laboulaye explained, "the sun of liberty rising on America and the entire world."[21]

Perhaps, then, at the sight of Carpenters' Hall and its symbols, Bartholdi thought of the possibility of adapting his fellah to America by adding a star on her head. This solution had the advantage of matching Bartholdi's readings of Hugo's *Stella* quite nicely, since the poem portrayed the apocalypse as an awakening star above the ocean. But all of this is speculation. Indeed, we don't know if Bartholdi ever experienced such epiphanies in Philadelphia. If he did, however, he was in the right city, for Philadelphia fell for his project right from the start. "The New York project," Bartholdi wrote, was "strongly approved by those who had seen it." For some reason, however, Forney and those at the Union Club had imagined that Bartholdi had come to America forever, "to find a home and a republic for himself."[22] They proposed he could "settle in Philadelphia and take charge of the city's work of art." But Bartholdi answered that he could "be useful to them even if I stay in France." Forney had told him that Fairmount Park would be the site of a universal exhibition in 1876, where all the nations of the world would showcase their latest innovations and technology, while simultaneously celebrating the centenary of the American

Declaration of Independence. Emphasis would be given not only
to the Revolutionary War, but also to the alliance between France
and the United States. The park commission was already planning
the festivities, and Bartholdi was invited to take part in the efforts.
Out of fear of remaining empty-handed, he agreed and asked his
friends in Philadelphia to help him locate a suitable site for his
monument. He was clearly overbooking his schedule, but continu-
ing to court this enthusiastic group might mean that he could erect
his colossal lighthouse in Philadelphia if his New York negotiations
fell through.

Thus Forney and the other members of the Union Club took
Bartholdi to the city park, perhaps promising a vista as scenic as
that offered by Central Park or Bedloe's Island. Philadelphia even
had two rivers, like New York. To be exact, it was located between
them, with the Schuylkill to the west and the Delaware to the east.
On two sides of the Schuylkill was "an ancient forest" that, after
1799, the City of Philadelphia had begun to acquire, piece by piece,
to create a park within which to enclose the city's water reserves.
This was Fairmount Park, which Bartholdi crossed over and over
again, back and forth, on foot and by boat almost every day until
July 15th.[23] There he found "superb views—very old trees, perfect
rolling hills, neat tracts of woodland, and beautiful streets that are
all the more groomed the closer they get to the city." But only one
spot offered a view anything like the one that had captured his
imagination at Bedloe's Island: Lemon Hill. It was the oldest prom-
ontory in the park, the place where, almost a century earlier, the
merchant Henry Pratt had built a sumptuous oval-shaped mansion
alongside a lemon orchard. The house was falling into disrepair,
but the site rose up above a bend in the river that looked like a
gulf. As Bartholdi noted, "something could be done there," and
it was certainly the place that he would praise and visit the most
after Bedloe's Island.[24] On July 14, two days after his first visit, he
returned there, again writing that "something could be arranged."
He did not say what, precisely, could be arranged, and he himself

may not have known whether he meant a monument for the Centennial or the colossus of Independence originally meant for New York. In any event, there was a moment, however brief, in which Bartholdi presumably sketched the Statue of Liberty on Lemon Hill, if only in his mind, and seemed to like it.

Of course, Forney's favors had a purpose. As a collector of the port, who plausibly was already involved in the preparation of the 1876 Centennial, he expected Bartholdi to help attract French businesspeople, artists, and merchants to Philadelphia. Yet Bartholdi probably sensed too that Forney, at home in both Washington and Philadelphia, could help him navigate political and business circles like few others. So when Forney offered Bartholdi, who was bound for New York, to meet at Long Branch and help him find new contacts, he agreed. Not much earlier, the Bottas had failed miserably in a similar attempt. Forney, however, represented a formidable ticket into the high society frequenting the beach, including, at the time, the U.S. president himself, who was vacationing there with his entire entourage.

But first, Forney and Bartholdi agreed to knock on the door of the summerhouse of Tom Murphy, the president's faithful squire. Murphy was hardly a commendable character. As head of New York's customs bureau, he administered one of the most infamous dens of corruption in the city, and everyone knew that the president had appointed him mostly because of their shared love of horseracing. Only one year later, Murphy and his associates would be implicated in a famous financial and political scandal that threatened to bring down the president himself. But for now, Tom and his friends were enjoying the breeze on a seaside terrace at Long Branch, where Bartholdi showed up on July 18. From there, he, Forney, and General Horace Porter set off on foot for President Grant's summer house. The "sovereign of the United States," as Bartholdi called him, vacationed in a "simple cottage" overlooking a garden with an ocean view; the garden was "as big as a man's hand," and with "few flowers and no trees." Grant liked to give a

rustic, manly impression of himself, which, when added to his
reputation on the battlefield, had helped him win the election.
He was especially renowned for his military feats during the Civil
War, when he captured Vicksburg, opened a path for Union troops
along the Mississippi, and confronted General Lee in a series of
battles that culminated in his final victory at Appomattox. With the
hoarse voice of an inveterate smoker, Grant introduced his guests
to his family (including his grandfather, seated next to a spittoon),
then took Bartholdi out on the terrace, where he listened to his
proposal with interest and promised to submit it to Congress. This
was no small promise, and Forney, who was already something of
a mentor to the artist, decided it was time to broach the subject of
the statue with Murphy's political and business associates. Bartholdi,
who seems to have had more intuition this time, was reluctant. Yet
that evening, the two went back to Murphy's house, which they
found "noisy" and full of "real Yankees." As the noise died down,
Forney seized the moment to present Bartholdi's "photographs"
(presumably of the Statue of Liberty's maquettes), but had little
success. Perhaps unsurprisingly, the businessmen and politicos at
the party had little interest in the large woman with a torch and
broken chains, which Bartholdi now increasingly tended to present
as a "moral work." Seeing the audience's "glacial interest," Bartholdi
hastened to "gather his things and leave as soon as possible."[25]

Bartholdi left Long Branch on July 19 with the frustrating feel-
ing of being misunderstood. Rather than contradict him, Forney
simply renewed his offer to work toward a project for the city of
Philadelphia. Bartholdi promised he would work on something
for Fairmount Park, then returned to New York, where he cre-
ated sketches of a "super gate to the main entrance at the foot of
Green Street" and a series of "drawings showing the necessities
and capabilities of Philadelphia in the matter of fountains in her
various squares and spaces."[26] One of these fountains was meant
for "the Centennial": "to be cast in iron," it embodied "Light and
Water, the twin goddess of a great city" in the form of "three colos-

sal nymphs of exquisite form" lifting "a wide circular shield into which the water falls from other figures, while ten lamps held up by as many beautiful arms shed light at night from their gas-globes, as they inspire harmony in the day," while water was "flowing forever."[27] With its nocturnal light and ever-flowing water, the fountain could conceivably be seen as a monumental twin of the New York colossus. But Bartholdi had another twin of the future Statue of Liberty in mind.

While not working on his Philadelphia projects or meeting with New Yorkers, Bartholdi drew his *La malédiction de l'Alsace*. It was an allegorical Alsace, portrayed with a child clutching her side, bent over the body of a slain young man while holding her arm up in midair to threaten the Germans.[28] It was the sketch of what soon would become *La malédiction d'Alsace*, which Bartholdi would present at the Salon of 1872. Even if he had traveled to America to find distraction from his dark thoughts, Bartholdi clearly still mourned the loss of his homeland, Alsace, to the Germans. Indeed, he hoped to sell the drawing in America "for the relief of distress in France."[29] He probably also realized that his Alsace, with her arm raised in a threat, and his statue of Independence (no matter where it was meant to go, New York or Philadelphia), with her arm raised to lift a torch, had more in common than first expected.

Extra work for Philadelphia and France had, however, consumed too much of the time he had hoped to dedicate to the "object, the important side of my journey."[30] So he caught up with his work; he contacted the commanding officer of the fort on Bedloe's Island, a certain Colonel Merillon, and paid a visit to Frederick Law Olmstead and Calvert Vaux, the two architects in charge of work in Central Park.[31] The two men were not particularly welcoming and they reacted coldly to the idea of a colossal, anthropomorphic lighthouse, but Bartholdi was not surprised: "I had simply aroused their jealousy," he explained to himself, not without a certain pride. Nonetheless, he confessed, "the waters are getting a little troubled." What was he to do? It was at this point that the Bottas,

who continued to be his most faithful allies, decided to introduce him to the famous New York businessman Richard Butler.

A typical Midwesterner, Butler had lived in New York for twenty-five years and worked for one of the city's most respectable commercial enterprises, William H. Carey & Company, the first firm to import "fancy goods," toys and beads directly from Europe (and particularly Germany and France), bypassing the European middlemen who operated in America.[32] So Butler knew Europe well, and was on good terms with many of its businessmen, but at home, a great big leafy estate, he ate little and spoke almost exclusively of "religion, high principles, and so on." Famished, Bartholdi participated little in the conversation ("this sort of thing deprives the soul of the calm necessary for the contemplation of noble arguments," he lamented in a letter). But he found something familiar in the moralistic tirades of his Puritan hosts, something that made him think of the severe and devout environment in which he himself had grown up, between his home in Colmar and Scheffer's studio.

Despite the meager food he was offered, Bartholdi was deeply grateful to Butler for reminding him that his colossus ought to have a moral meaning, at least if it were to succeed in America. A similar epiphany happens to Felix, the dissolute painter of Henry James's *The Europeans*, who leaves the European *bohème* to make himself a name in America, only to find himself face to face with the moralism of his new friends and associates. Unlike Felix, however, who ends up corrupting his American relatives, Bartholdi made American moralism his own. The United States, he confessed to his mother, brought to mind "the principles you inculcated in me."[33] Bartholdi probably had the principles of severe Protestant morality in mind, the same ones that had undeniably nurtured his mother's high expectations (toward herself and her sons) and complicated his own relationship with her. In France, it was easy to get distracted from those principles, because artists—as Hugo knew all too well—could choose among so many different subjects, oriental or Teutonic, sacred or profane. But in America, the climate was more

austere. Did Laboulaye prepare Bartholdi for this transition? After all, Laboulaye's mystic sources all converged toward one truth: that America was meant to be the future site of a global initiation, because Protestantism (first French Huguenot, then Puritan) had uniquely prepared Americans for liberty.

It was lucky that Bartholdi became aware of his newly developed moral inspiration just before leaving New York for Boston and Cambridge. Massachusetts was the stage of Laboulaye's spiritual apocalypse in his *Paris in America* for a reason: it was Winthrop's "city upon a hill," an example of morality for all Americans and the world in general. Where, if not in Massachusetts, was Bartholdi to get his inspiration to accomplish a moral work? He himself felt quite ready to brave a new city, now that he was "beginning to get used" to explaining "plans and drawings . . . in English." Maybe also as a result of this increased familiarity, Bartholdi was getting along better with his interlocutors. Before leaving, he decided to meet the architects of Central Park again, on July 28, and found them "rather delighted with the combination I have worked out for the monument at the entrance of the park."[34] By then, he was already referring to his New York statue as "my work of sculpture," which "will become a great work of moral importance."[35]

While New Yorkers were still discussing the possibility of erecting a French monument in Central Park for the Cercle de l'Harmonie, Bartholdi thought it wise to continue his journey across America to make a name for himself and find a place for his lighthouse, in case he did not succeed in erecting it on Bedloe's Island. It is telling that his first stop was Boston, the very same place where Felix, the Jamesian painter, learned the ways of Puritanism. On the evening of June 29, Bartholdi boarded a brand-new "Pullman train car" with his assistant, Simon, who, all this time, had never left the New York area. The following morning they arrived in Boston, an upper-class bastion and "ancient city of the Puritans." Sunday in Boston, Bartholdi would soon learn, was "worse than anywhere else, . . . not a sound to be heard, not a person to be

seen." Bartholdi almost thought he was in "Pompeii," a dead city in stasis, inhabited only by ghosts. But then, in the afternoon, the city came to life once more, and he visited all the public landmarks: the Museum of Natural History, the Public Gardens, the Conservatory of Music. While he enjoyed the reddish bricks with which most of the houses were made, he found the streets old and the city quite dirty.[36] Clearly, Bartholdi did not particularly like Boston, but he was there for something more than a tour. While speaking with friends in New York and Philadelphia, he had learned that someone there was working on an idea similar to his own, namely a colossal, allegorical statue framed by a mystical landscape seemingly stolen from the canvas of a Romantic painter. Bartholdi went to Boston in the throes of a burning curiosity, perhaps one tinged with alarm.

For Americans, Boston was the country's "European" city. The stereotypical Bostonian of a James novel was educated in Europe, spoke at least two languages, had studied at Harvard (if only for a few years), and adopted European ways. But Boston also had its fair share of impoverished families, and the artist Charles Hammatt Billings belonged to one of them. He had not studied at Harvard, nor in Europe, and certainly could not aspire to a role worthy of a James novel. Yet precisely because of his lack of a formal academic education, he had been free to learn and explore a host of different arts and styles. Like Bartholdi, Billings was versed in all the fine arts, from drawing to engraving, sculpture, and painting. As a sculptor, he wished to erect an "eighth wonder" by the seashore to commemorate the landing of the Pilgrims in Plymouth. But rather than a monumental group depicting the Pilgrims' arrival, as might have been expected, Billings had the idea to build an allegorical icon, the *National Monument to the Forefathers*.[37]

Billings took Bartholdi to Plymouth's Pilgrim Hall, where a model of his proposed *National Monument* was on permanent display inside. Bartholdi was probably speechless when he saw it: the statue looked almost exactly like his Romanized fellah, except that it was more graceful and feminine in form. Her wavy hair tied

back and parted at her forehead, on which lay a star, she raised her right hand to point to the sky, while in her left, resting along her side, she held a closed Bible. She was dressed like a Roman matron, with a long mantle draped over her breast, from her right shoulder down to her left hip. Seated on four buttresses arranged around the pedestal were allegorical figures of Liberty, Morality, Law, and Education; at the base of each stronghold four marble bas-reliefs would have illustrated each principle with episodes taken from the story of the Pilgrims.

Billings's monument was certainly an example of how a historical monument could be turned into a moral or religious one. Bartholdi must have known it, for he confessed in his diary that he had hoped to find "a fulcrum for [his own] efforts" in Billings's project. Even more significantly, he did not mention his encounter to Charlotte, as if the knowledge that someone else had come close to his idea could lower her esteem for her son. Perhaps, at some point, he had hoped to work with Billings to transform the model into a statue carrying their names. But there was "nothing to be done," he wrote peremptorily, and added, rather disdainfully, that Billings was "too limited an artist for me to associate myself with his work."[38]

Indeed, little could be done. Billings had been waiting for funding to erect his monument since 1850, and the necessary amount had not yet been raised. Billings's misfortune might have convinced Bartholdi that Boston was not a place where his colossus could be erected. Yet Boston and nearby Cambridge were the cities in which some of Laboulaye's favorite educators, such as William Channing, Horace Mann, and Edward Everett, had lived and worked. All of them were dead by then, but Laboulaye still had friends there, like the biologist Louis Agassiz, a Swiss scholar who had studied in Germany and France before landing at Harvard. Famous for his administrative talent, but also admired for his taxonomy of prehistoric fish and his theory that the earth had once been covered in ice, Agassiz did not make an impression on Bartholdi, who talked

with him briefly before visiting "several insignificant people who nevertheless may be necessary to the accomplishment of my main work."[39] Things went differently with the poet Henry Wadsworth Longfellow, the "Lamartine of America," as Bartholdi called him, to whom Agassiz might have directed him in an effort to help (without, it must be said, getting into much trouble himself).[40] Bartholdi took the ferry to Nahant, a tied island in Massachusetts Bay, and walked to a cottage "which stands on a bluff near the ocean," where Longfellow used to spend his summers composing poetry while contemplating the sea. With his white hair falling on his shoulders, moustache, and beard—he had "a face somewhat like Garibaldi," Bartholdi would notice—Longfellow had been to Europe enough to know how to welcome a guest from the Old World.[41] He was a well-known professor of modern languages at Harvard, the translator of Dante's *The Divine Comedy,* and the son-in-law of the textile magnate Nathan Appleton. Yet despite his social prestige, Longfellow did not send anyone to welcome Bartholdi when he knocked on the door of his cottage, rather the professor opened it "in person." It was a pleasant surprise, which made Bartholdi feel immediately at ease among all that wood and the windows overlooking the sea.

At the time, Longfellow was sixty-four. He did not show his age, but the still quite recent and dramatic death of his wife, Frances (who had burned to death while trying to seal locks of her children's hair inside an envelope with hot wax), had broken his spirit and left shadows around his eyes. Longfellow saw ever fewer people, and spoke ever less. For the occasion, however, he had invited a relative of his former wife, probably her brother Thomas Gold Appleton, himself a famous patron of the arts. Bartholdi thoroughly enjoyed Appleton's conversation and their ride back to Boston, and it was probably because of this ride that Appleton later would decide to support the Statue of Liberty. What ultimately mattered to Appleton, however, was Longfellow's verdict about the Alsatian's art, which was nothing less than enthusiastic. Bartholdi

had presented his project to him with few words, but made sure to include a reference (the first documented one, so far) to the fact that the Statue of Liberty was meant to be made in bronze: "a bronze colossus on Bedloe's Island to serve as a lighthouse by night." Longfellow found it "a great plan," showing Bartholdi "the greatest cordiality and much enthusiasm for [his] project." After dining, the two men lingered on the terrace to drink and smoke cigars, watching the sun "setting over the small island, in the sea."[42]

Before leaving his Bostonian friends, Bartholdi had one more thing to do: visit the painter John La Farge in Newport, another resort on the sea where "there is a great deal of display—which seems to be one of the keenest delights of the Americans."[43] La Farge was a real Bostonian—he had trained in France, where he had made friends with Flaubert, read the *Revue des deux mondes*, and lectured at Harvard. "Reserved and inquiring and critical in approaching people," La Farge had a "somewhat ecclesiastical" appearance, Bartholdi noted. La Farge—his son would remember—"loved France, he loved things French, and he had a French type of mind." But, when it came to painting, he thought that it had to be an intellectual activity, "a matter of the brain," rather than traditions or schools. With Bartholdi he spoke of "art, politics, and religion," leaving him with the curious sensation of having spent time with a painter "whose paintings [he had] not seen."[44] There was something in La Farge's ecclesiastical ways and intellectual vocation that may have recalled Scheffer, who also had sought to elevate art to the level of philosophy or theology. But La Farge was no Scheffer; his style was more experimental and, before Bartholdi's departure, he gave him "Japanese albums." These albums, as we will see, would prove essential later, when Bartholdi sought to give a new, more exotic face to his New York colossus. For the moment, however, he looked at them with cold indifference and, when La Farge introduced him to Richard Morris Hunt, the future architect of the statue's pedestal, Bartholdi was no more impressed: "Met Mr. Hunt, architect from New York, who brags a little, pleased with himself."[45]

Bartholdi could not know yet that the Newport artists were precisely the people he eventually would need most to make his name as an artist and architect in America. For the time being, however, even more than La Farge and Hunt, Bartholdi needed the help of Henry Hobson Richardson, a friend of both men based in New York. Richardson had studied in Paris, but was deeply attracted to the Romanesque art he had found in southern France and the neo-medieval style favored by many British painters and aesthetes. When Bartholdi visited him in New York, with letters from his Newport friends, he was favorably surprised. Richardson was not a bragging artist like Hunt; with big features and a benign face, he was happy to help Bartholdi. He talked to him "about work to be done," probably in Trinity Church, the Episcopal church that he was about to build in Boston's Back Bay with a mixture of styles drawn from Syria, Byzantium, Rome, Spain, and France.[46] Bartholdi told neither Charlotte nor his diary what Richardson expected of him, but, whatever it was, he was satisfied and decided that the moment had come for him to take a break from New York and the U.S. Northeast. Simon, too, apparently needed a break. On August 9, Bartholdi mysteriously alluded to an urban "adventure" involving "pickpockets who [kept] watching us" and to "Simon's lack of self-control." Clearly, Simon needed a distraction, and Bartholdi thought that a trip to the western states might do them both good.

CHAPTER 19

ADORABLE WOMAN

In the old days, Bartholdi and Simon's long journey westward would have entailed first a stagecoach, then a ride by horseback into the more remote regions, where the men would have been armed with pistols and knives to fend off bandits. But in postwar America, the railroads covered and connected the farthest reaches of the continent. The Erie Railroad linked Jersey City to Buffalo, before continuing all the way to Chicago, where the Burlington Route would take passengers across the pastures and goldmines of the American West all the way to Denver. Bartholdi enjoyed his ride to the Allegheny more than most things he had done before in America: "You follow charming valleys along the Delaware," he wrote to Charlotte; "occasionally the railroad climbs very high and you see the valleys in the distance." Those were "enchanting glimpses" during which he curiously felt like he was back at home. "In certain places these mountains," he confessed, "recall the Vosges; they are of sandstone of a similar character." It was pink sandstone, just like the one he had used to sculpt his *Schongauer*, the statue of the first copper engraver in Colmar. Building a statue in copper would be a further step toward the union of France and the New World, for America had copper too, as Bartholdi would soon discover on his way across the United States.

From Buffalo, Bartholdi and Simon—like Tocqueville and his traveling companion Gustave Beaumont forty years earlier—sought refuge from the hustle and bustle of city life in the wilderness of Niagara Falls. But now that a railroad connected New York to

345

Buffalo, the falls were no longer a place of "profound and terrify-
ing darkness, occasionally interrupted by a glimmer of light," as
Tocqueville had described the area to his mother in 1831.[1] Instead it
was a giant tourist trap, with stalls selling Indian carvings, an elevator
taking visitors up and down the cataracts, and a firm supplying yel-
low raincoats to watch the falls from below. All this did not bother
Bartholdi. He did all the touristy things—he had his photograph
taken with Simon, pants and jacket all crumpled, sitting together
on a rock along the riverbed not far from the falls; he took the eleva-
tor; and he even donned the characteristic yellow raincoat, which
he also sketched for his mother. As for the falls, they were exactly
as he had imagined them, and he painted views from both the top
and the bottom, with juxtaposed brushstrokes reminiscent of the
works of certain English watercolorists.[2]

Bartholdi, however, was no watercolorist; nor was he a Roman-
tic landscape painter. And he certainly did not have the conser-
vative vein of his Bostonian friends. He loved the towers and
elevators crisscrossing his pictures, if not the real ones, then at
least imaginary ones. In a certain sense, he viewed the falls with
the same eyes of the tourist who had sailed up the Nile a few years
earlier. There, pylons and columns had intrigued him; here, eleva-
tors and docks. Clearly, Bartholdi had a Saint-Simonian appre-
ciation for technological innovation. It could be the effect of his
exchanges with Lesseps, but also the long-term result of his drawing
practice at Colmar under the teachers of industrial design. For how
else could we explain his ecstasies in Buffalo in front of a set of
mechanic contrivances meant to let "the great volume of freight"
transit "from the West to the East"? Or his admiration for the "gray
structures called grain elevators, warehouses . . . a considerable
number of small vessels, . . . wooden docks, platforms covered with
open-front retail shops"? It was a feast for Bartholdi's eyes, but not
as much as the 885-foot railroad bridge suspended over the falls,
which linked the American border to Canada. He walked it on foot,
then crossed it again by train, two days later, en route to Chicago.

"Marvelous work," he wrote, watching the panorama from the window of the train car.[3]

The farther west he went, the clearer Bartholdi could see the advance of technology. After Lake Ontario, for example, the landscape became flat and monotonous, a long succession of "farms, properties, fields, and forests," but civilization had spread even there, as evidenced by a desolate landscape of felled trees reminiscent of "immense cemeteries." From lake to lake, Bartholdi made his way to Chicago, which greeted him with "a combination of movement" that he had not yet seen in America—"maritime, terrestrial, pedestrian, and, I could say, subterranean."

It is not that Bartholdi had never before seen ships, telegraph poles, tunnels, and bridges. On the contrary, he had seen all these technological wonders at the great universal exhibitions from an early age. But exhibitions were static. What Bartholdi saw in Chicago, even more so than in New York, was an unprecedented concentration of technology at work. It all seemed alive. The telegraph wires were like "spider's webs," "the whistles of locomotives and steamships make a continuous sound like that of an Aeolian harp" (a symbol of music according to Goethe), while "a vast population hurried about, in the throes of what could perhaps be called business gripes."[4] Walking the city from "east to west," he saw "inhabited houses moved on rollers," shops open until late at night, *cafés chantants*, saloons, and billiard halls. And there were metal colossi in the form of "two tunnels under the river, and another tunnel under the lake bed, extending 3,000 meters from the shore."[5]

Laboulaye had once bluntly declared that only Americans in the North were the true heirs of the Founding Fathers, suggesting that the South was not part of the Union. But in fact, he had friends all over the continent, including the West and the South. In Chicago, for instance, Bartholdi encountered General Philip Sheridan ("more soldier than I had anticipated") and the railroad magnate William B. Ogden ("a businessman, in terms of art almost

a zero").[6] Bartholdi had letters even for people in San Francisco and St. Louis. But the more he saw of America, the more ambitious his funding plan became. So far, he had traveled to Philadelphia, Washington, Boston, and Newport with the apparent project of finding support for his major colossal project, while making himself a name with new commissions, mostly related to the anniversary of 1776. By the time his train reached Chicago, however, Bartholdi had devised yet another plan: organizing "committees and correspondents for the great work [the Statue of Liberty in New York] in every city." The statue, in this way, would not have been a child of the North only, but of a reunified America. To realize this ambitious plan, however, Bartholdi had to work hard and use all the money he had brought with him. Which meant that he no longer would be able to entertain Simon. It was painful for him to see his companion board a train in Chicago for a return trip to New York, but taking him farther would have weighed too heavily on Bartholdi's already slim budget, and on Simon's already exhausted state. On August 17, Bartholdi was alone. His next appointments were in San Francisco, but he decided to take a detour to Salt Lake City to visit the Mormons there on the way.

It took four days to reach the place, and it was a most adventurous trip, something—Bartholdi specified to Charlotte—that a European would count as "an extraordinary experience."[7] First, you had to travel to Omaha on small and cramped cars, not unlike "hospital wards," where you would sleep and get undressed behind curtains, near other men and women. Bartholdi did not seem put off by it all; if anything, it was one of the first times that he showed a certain amused curiosity for the opposite sex. In secret, he watched the way the women on board slipped off their clothes behind the curtains and removed "mountains of fake hair," which in America continued to be the fashion. At Omaha, the passengers descended momentarily to cross the river by boat, but when everyone was again back on board, Bartholdi returned to studying the nature outside his window, now dominated by great prairies. It was "nature at its

most savage," almost primordial. He was nearly overwhelmed by the new sensations, but as he progressed to the Rocky Mountains, Bartholdi again encountered that sense of redness—one mixed with shades of gray—that had struck him first among the brick houses of New York and Boston, then again in front of the Allegheny's sandstone. At the foot of the Rocky Mountains, he gave Charlotte a new fast-forward chronicle of changing colors and shapes: "red rocks extravagantly shapeless, scorched land, gray grass, rusty grass, red moss." More burnt, and redder than the land around Vesuvius, the Californian soil shared a certain apocalyptic appearance with the Neapolitan one, accentuated by "skeletons of old hoop-skirts, . . . , skeletons of cattle, . . . a few dusty furrows." This time, however, this open-air cemetery was not a work of nature, but a trail made by lines and lines of "emigrants who, for month after month, dragged themselves over these endless spaces in order to cross the vast continent."[8] Perhaps Bartholdi saw the desolate trail as a symbolic path of exile more generally, one that he could imagine himself walking in his flight from a Germanized Colmar. But then the scene changed yet again, and he found himself closer to the Rocky Mountains, among scenes that were often "diabolical—something out of a fairy tale":

> We begin to cross plateaus which are 8,000 feet above sea level. Soon horizons of billowing mountains are visible. Then the road plunges into valleys and gorges. We go from one ravine to another through deep outs, with occasional tunnels. On either side of us are masses of enormous rocks. The views are magnificent.[9]

The fairytale to which Bartholdi alluded may well have been a biblical one, for, the farther into the mountains he ventured, the more he felt as if he were approaching a new "Mesopotamia," the biblical land of idolatry and bondage.[10] It was the Mormon leader Brigham Young, he explained to Charlotte, who had "led

his followers into this Mesopotamia" and convinced them to live according to his creed. Surprisingly, Bartholdi did not entirely skim over the details of Young's unorthodox social rules; he told Charlotte all about Young's polygamy (sixteen wives and forty-nine children). More he did not say, though he encouraged her to read up on the topic in the *Dictionnaire de la conversation* if she was interested. Still, it says a great deal about Charlotte's open-mindedness that her son so easily could share his experiences in a heterodox Christian colony. As for Bartholdi, curiosity and ambition certainly helped him brave the fact that Young was someone who "knows to take advantage of human stupidity."[11] But Young was also a magnetic personality, and Bartholdi could only praise him for the fact that this relatively new society (established in 1847) already had a temple, a theater ("as big as the one in Colmar"), "fine carriages, spectacular toilettes, side by side with toil and business." It was intriguing to see "women elaborately and smartly dressed . . . wearing gloves, walk through the dusty, roughly built streets, in company with filthy miners."[12]

Clearly, Bartholdi was ready to turn a blind eye to idolatry in the name of progress: he accepted to sculpt Young's bust, only to be frustrated by his subject's "fuss" and delays. Unceremoniously, he "told him, politely, to go about his business," and decided to keep the preparatory sketches he had drawn of Young "for himself."[13]

In San Francisco, where Bartholdi arrived on August 25 after a long journey across the "Sierras," houses sprawled for as far as the eye could see, then vanished into the hills and in the sand of roads under construction, lined with dilapidated wooden shanties, "like those of an abandoned carnival." The saloons were full of gamblers and prostitutes, adventurers of all kinds, in whose wake had come bankers, entrepreneurs, and speculators. San Francisco was one big roulette wheel; a lot of money was changing hands. With any luck, Bartholdi could win new backers for his statue, but everywhere he went, little interest was shown, so he amused himself by exploring the city and its surroundings with a group of Frenchmen he

had met on the train. Together they visited the local Chinatown and walked down Waverly Place, "the street of painted balconies," where the sight of Asian prostitutes all made up, offering their bodies by the light of lanterns, met with his disapproval: "not very moral," was his comment, "in fact, incredibly immoral." America, he noted though, "should be seen at all its levels."[14] But as immoral as some of these "levels" were, they revealed a piece of the whole that Bartholdi had not yet seen. After so many encounters with Chinese workers and families traveling to Japan, he realized that San Francisco in turn was the gateway to yet another world, one still unknown to him. He could only peek into that mysterious realm, through his occasional encounters in San Francisco or through La Farge's Japanese drawings, which only now began to acquire greater nobility in Bartholdi's eyes. There was also the problem that, precisely because San Francisco was so different from anything he had seen in the past, he could not find the best way to advertise his project to the locals. "To sum up," he coldly noted in his diary, "in San Francisco I have found less encouragement for my project than anywhere else."[15]

Fittingly, Bartholdi's journey was approaching the end in San Francisco. He therefore took the time, both in his diary and in letters to his mother, to make some general reflections on his travels in America. Some of these reflections were inspired by what Forney would define as Bartholdi's "cosmopolitan humanity," for example when he confessed that it was "really a very good thing to see the world in its various aspects, to encounter customs and ideas from an outside viewpoint." It was a proper thing to say, but Bartholdi immediately gave it a surreal twist by adding: "I some-times have the feeling that I am observing our globe hanging in the immensity of space. Human affairs seem so small—it is a lesson in perceiving and weighing the truth." There was only one visitor, so far, who had observed America while hanging from the stars, and this was Daniel, Laboulaye's fictional character in his novel *Paris in America.*

There were, in fact, many ways in which Bartholdi observed America with Daniel's eyes. For both, the country was a living fairy-tale, a religious one for sure (much in the style of John Bunyan's *Pilgrim Progress*), saturated with moral lessons of self-improvement, but a fable all the same. And Bartholdi may have agreed with Daniel, and before him Dante, that one needed to experience evil, and see Hell, before reaching the stars. For Bartholdi described the Rocky Mountains, with their skeletons and ruins, as "diabolical" places filled with prohibited idols, a collection of "scenes" through which one had to venture before returning to the threshold of the East and the New York Trinity.[16] It was clear that America's most "orientalist" part was the West, not the East. And a statue symbolizing their union, wherever it was placed, had to be copper-hued and devilish like the Rocky Mountains, but also spiritual like Boston and New York.

Not even in the deepest reaches of the far West did Bartholdi stop thinking of the great "moral work" his statue would prove to be. If anything, the promiscuity of the sleeping cars, the nightclubs of Chicago, and the gambling dens and Chinese brothels of San Francisco had only strengthened in him the idea that the statue would serve an educational and moralizing purpose in America. This moral idea, Bartholdi now wrote Charlotte from San Francisco, was the same one that his mother had taught him. "I have felt—of late years," he wrote her on August 29,

> that my ideas were developing; I appreciate more and more the rightness of the principles which you have inculcated in me. But, in thinking of the time and space and circumstances which have gradually developed my ideas in the past few years, I sometimes wonder how you were able to have such sound intuition.[17]

But what was this intuition? Something Bartholdi had heard from Sumner, Longfellow, and Butler must have resonated with

the education he had received from his mother—a Lutheran education that Charlotte had expanded to include not only the ideas of Voltaire, Madame de Staël, and Goethe, but also the mystical theories of Gasparin and Laboulaye. It was quite an achievement for a provincial girl who had raised her children with very little outside help. For those convinced that the Statue of Liberty bears a resemblance to Charlotte's face, Bartholdi's acknowledgment of his mother's help should be kept in special consideration. Indeed, he might have given his American colossus his mother's features precisely as a way to express his spiritual debt to her.

But that was still in the future. Bartholdi was now in the American West, and did not want to leave it. Exotic places always appealed to him in powerful ways. In Egypt he could not resist the temptation to reach the Queen of Sheba. Here, the desire to brave the burnt red landscape was so strong that, on August 30, Bartholdi decided to leave San Francisco to stay for a few days in Stockton, California, and make it a base from which to explore the heart of the Sierra Nevada Mountains. Throughout the Civil War years, and for some time afterward, Sierra Nevada mines had supplied the Union army with the copper for its cartridges and weapons. In Stockton, Bartholdi boarded the brand-new Copperopolis Railroad, which had been finished only a few months earlier. At Milton, he alighted and took a stagecoach through the forest, on a long, bumpy, and dusty ride to a hotel tucked away behind the trees, in the middle of nowhere. In all likelihood it was the Calaveras Big Tree Grove Hotel, located in a little wood that divided the San Antonio Creek from the Stanislaus River. Arriving in the dead of night, he could only just make out the hotel in the moonlight; wandering around he found himself in the thick of giant trees, which he described to Charlotte as "the old patriarchs of the American forests," the gigantic sequoias, America's true "colossuses." In his biblical journey across America, Bartholdi had left Mesopotamia behind to find himself among the wooden icons of the founders of the Israelites. He stood in awe of these tawny-barked giants, wondering to himself

"what effect such a sight had on the first man who came upon it without any warning."[18] Egypt had given him a glimpse of the apocalyptic future of human civilization, of how its ruins would look to earth's new inhabitants. Standing before these venerable giants, Bartholdi felt he was seeing the world at its very beginnings.

AFTER RETURNING TO STOCKTON, Bartholdi resumed his journey to Jersey City. On the road, he found more "diabolical scenes — red rocks sprouting from the earth in strange forms," while "the sun was setting and this fantastic landscape melted away into the distance and the night."[19] Along the way, he decided to stop in St. Louis, the old French colony sold by Napoléon to the United States as part of old Louisiana. It was evening when he arrived on September 14, but still early enough to make out the "masses of bricks, [and] railroads" and hear "the huffing and puffing of some steamships, their lights reflected on the river."[20] He could not return to France without setting foot in the old colony, where Laboulaye had set up a number of meetings for him. But even here, the voice of his mentor held little sway: "thermometer of interest in my projects, 25 degrees." From St. Louis, Bartholdi returned to New York, where he visited Central Park again and spoke at length with Butler about moral topics. Finally, after a quick visit to Newport, where La Farge resumed his conversations on Japanese art, and to Boston, where Longfellow greeted him again, Bartholdi returned first to Philadelphia, and then Washington.[21] Here he had his most authentic intuition: while contemplating John Trumbull's paintings at the Capitol, he immediately understood that the most common mistake an artist might make when representing America was propriety. Trumbull's works, he noted, were too "proper" to represent America. He might have addressed the same criticism to Billing's *Monument to the Forefathers*, which depicted a woman too severe and polite to be American. For the country — Bartholdi had realized on his journeys — was "an adorable woman chewing

tobacco."[22] America was a paradox; a beautiful woman with no manners; a filthy place filled with diabolic images of death and fire, but also one of pristine primordial nature and technological perfection; a place of moralism, but also of transgression. Eventually Bartholdi would have to confront this interpretation with Laboulaye's more idealistic portrait of the New World. But in the end, the Statue of Liberty, masculine and feminine, devilish and saintly at the same time, would be a close rendering of Bartholdi's original impression. She would not chew tobacco or smoke, but her build, her resolute face, her pose, and, as soon will be evident, her hidden weapon, would still betray much of the roughness that qualified and even characterized his vision of America as an "adorable woman."

Back in New York once again, Bartholdi said "farewell to the harbor and Bedloe's Island," and embarked for France. It was October 7, 1871.

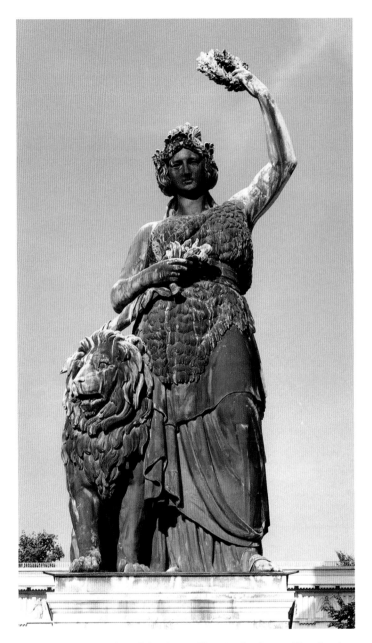

PLATE 1. Ludwig von Schwanthaler, *Statue of Bavaria*, 1850, bronze, Theresienwiese, Monaco.

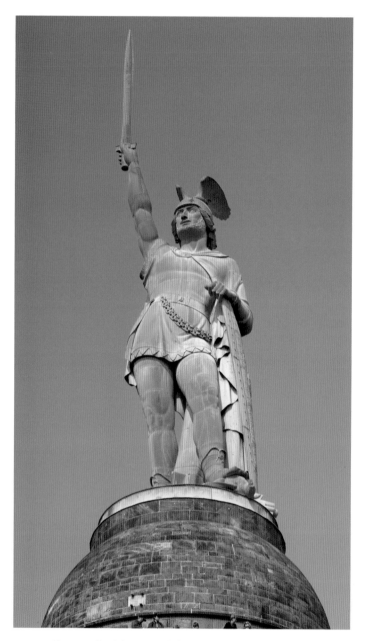

PLATE 2. Ernst von Bandel, *Memorial of Arminius*, 1875, copper, Teutoburg Forest, Detmold.

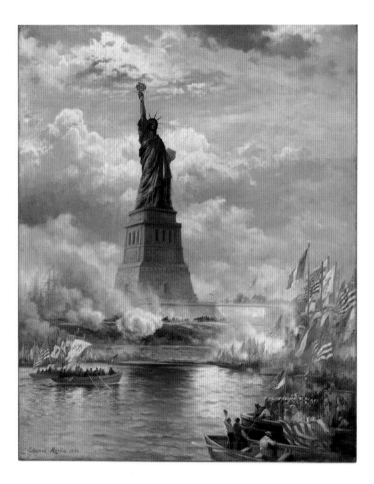

PLATE 3. Edward Moran, *Statue of Liberty Enlightening the World*, 1886, oil on canvas, 125.73 × 99.06 cm, J. Clarence Davies Collection, 34.100.260, Museum of the City of New York.

PLATE 4. Jean-Jacques Karpff, *Scène de la Révolution Serment Civique*, n.d., oil on canvas, 85×69.2 cm, Inv. No. 88-RP-312, Musee d'Unterlinden, Colmar.

PLATE 5. Auguste Dumont, *Génie de la Liberté*, 1836, golden bronze, July Column, Place de la Bastille, Paris.

PLATE 6. Ary Scheffer, *The Shadows of Francesca da Rimini and Paolo Malatesta Appearing to Dante and Virgil*, 1855, oil on canvas, 171×239 cm, R.F. 1217, Musée du Louvre, Paris.

PLATE 7. Ary Scheffer, *Le Christ Rémunérateur*, 1847, oil on canvas, 62.7×84.3 cm, Inv. No. 9845, Centraal Museum, Utrecht.

PLATE 8. Raphael Sanzio, *Christ's Charge to Peter*, 1515–1516, watercolor on paper mounted on canvas, Victoria and Albert Museum, London.

PLATE 9. Eugène Delacroix, *Le 28 Julliet. La Liberté guidant le Peuple (28 Julliet 1830)*, 1830, oil on canvas, 260×325 cm, R.F. 129, Musée du Louvre, Paris.

PLATE 10. Ary Scheffer, *Portrait de Madame Anne-Marie-Augusta-Charlotte Bartholdi*, 1855, oil on canvas, 151 × 102 cm, Musée Bartholdi, Colmar.

PLATE 11. Matthias Grünewald, *The Isenheim Altarpiece: The Resurrection*, 1512–1516, oil and tempera on lime-tree, 229.2×152 cm, Inv. 88RP139, Musée d'Unterlinden, Colmar.

PLATE 12. Ary Scheffer, *The Temptation of Christ*, 1851–1852, oil on canvas, 136×95 cm, M.I. 285, Musée du Louvre, Paris.

PLATE 13. [Frédéric-] Auguste Bartholdi, *Les Colosses de Memnon*, Temple of Amenhotep III, Thebes, 1855, photograph on hardback support, Musée Bartholdi, Colmar.

PLATE 14. Jean-Léon Gérôme, *The Era of Emperor Augustus: The Birth of Jesus Christ*, 1855, oil on canvas, 620×101.50 cm, RF 1983-92, Musée de Picardie, Amiens.

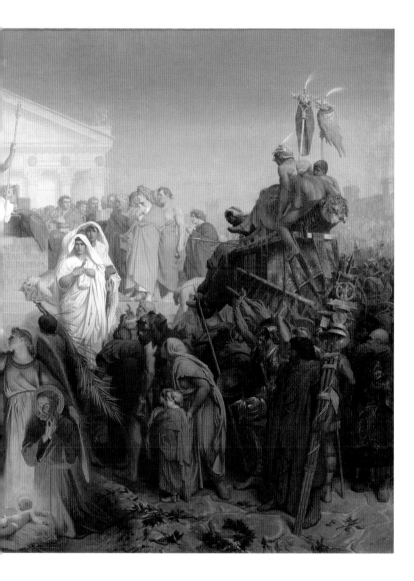

PLATE 15. Charles Bartholdi, Seal of the Bartholdi family, Musée Bartholdi, Colmar.

PLATE 16. [Frédéric-] Auguste Bartholdi, *Le Génie dans les griffes de la misère*, 1859, bronze group on bronze base, Musée Bartholdi, Colmar.

PLATE 17. Frédéric-Auguste Bartholdi, *Charlotte Bartholdi*, 1863, terra cotta, Musée Bartholdi, Colmar.

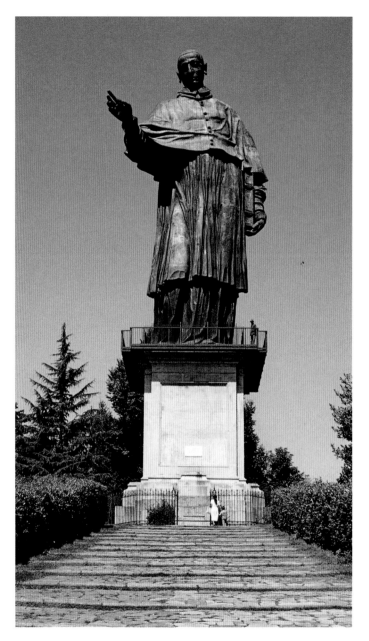

PLATE 18. Giovan Battista Crespi (Il Cerano), *Colossus of San Carlo Borromeo*, circa 1574–1632, copper, bronze and granite statue, Arona, Piedmont, Italy.

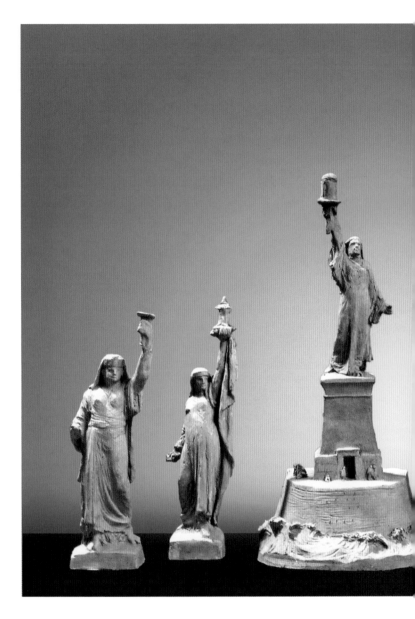

PLATE 19. *From left to right*: terracotta with no title, signed and dated "AB [mono-gram]—1869"; terracotta without title, signed and dated "AB [monogram]—1869"; *L'Égypte éclairant l'Orient* (also called *L'Égypte apportant la lumière à l'Asie*), terracotta, signed and dated "AB [monogram]—1867"; terracotta without title, signed and dated

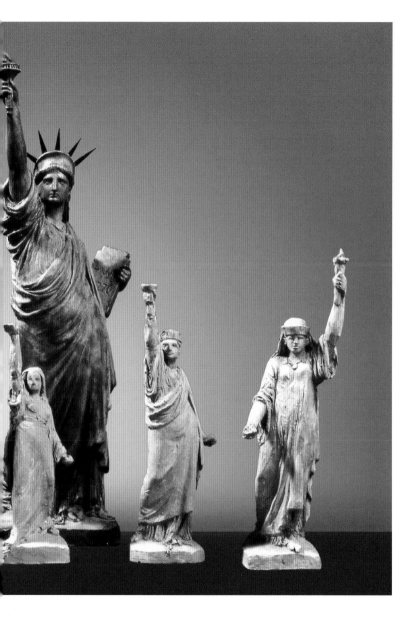

"AB [monogram]—1869"; *Modele du Comité,* bronze, 1875; terracotta, signed and dated
"AB—1870"; maquette of the *Statue de la Liberté,* without title, date, signature, probably
"Modèle du Comité"; terracotta, without title, signed and dated "AB [monogram]—
[18]70," Musée Bartholdi, Colmar.

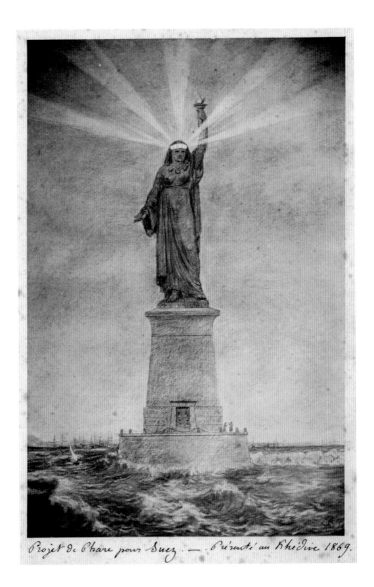

Projet de Phare pour Suez. — Présenté au Khédive 1869.

PLATE 20. [Frédéric-] Auguste Bartholdi, lost drawing, photograph from *Photographie du projet de phare du Suez*, 1869, albuminate paper on cardboard, Musée Bartholdi, Colmar.

PLATE 21. [Frédéric-] Auguste Bartholdi, *Projet pour le "monument funéraire des gardes nationaux,"* 1872, terracotta and metal, Musée Bartholdi, Colmar.

PLATE 22. [Frédéric-] Auguste Bartholdi, *Mystère d'Isis*, 1874, terra cotta relief with traces of polychrome, Musée Bartholdi, Colmar.

PLATE 23A. Charles [-Alphonse-Achille] Gumery, *La Poésie*, 1866–1868, maquette in gilt wood for the façade of the Opera Garnier, Paris, Musée d'Orsay, Paris.

PLATE 23B. Charles [-Alphonse-Achille] Gumery, *L'Harmonie*, 1866–1868, maquette in gilt wood for the façade of the Opera Garnier, Musée d'Orsay, Paris.

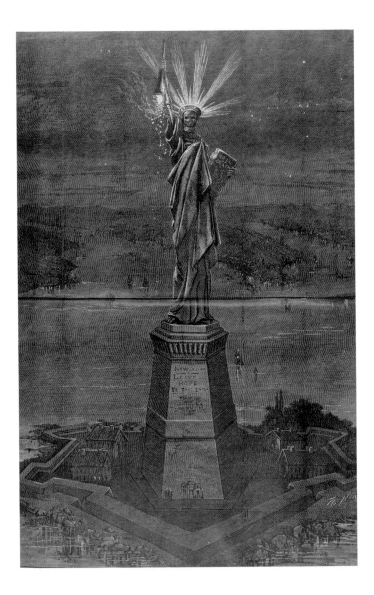

PLATE 24. Thomas Nast, "The Gates of Hell," *Harper's Weekly*, April 2, 1881.

AUTOPSIA

Bartholdi's American tour had done nothing to dull his rancor against the Germans. Finding himself "exiled from Alsace," where he "still had all his interests," upon his return he channeled all of his rage into a colossal work commemorating the valiant resistance of the citizens of Belfort during the German siege from November 3, 1870, to February 18, 1871.[1] It was a giant lion in red Vosges sandstone, the same copperish-red that Bartholdi had found in the Allegheny and Rocky Mountains. This lion too was to be placed inside the mountains, as if it were part of them—a massive figure, like the *Appennino*, trapped inside the rocks. Facing "the great rock" that "the men of 1871" had defended from the Germans and "saved . . . for France," the lion—probably "the largest figure of its kind in the world"—looked like a wounded animal, but one still ready to pounce to defend its territory, or even like a dead one captured in the moment of resurrection, rising to take its supernatural vengeance.[2] If the lion could speak, it might have used the words that Hugo had addressed to his humiliated homeland: "go down, because the day will come, go down, because the time is arriving / because you will rush forward, great afflicted people, / . . . like a jaguar fallen into a trap."[3] Bartholdi had a copy of the *Châtiments* with him during his American journey, so it may be that some of Hugo's anger, symbolized by his apocalyptic *Stella*, was to spill over into the American statue project as well. Yet little is known about when and how Bartholdi resumed his work on it. All we know is that, after returning from New York

in 1871, while busy preparing the *Lion*, he became absorbed by two even more rage-filled sculptures that apparently had little to do with the New World.

The first was a monument to celebrate the soldiers of the national guard slaughtered by German forces on the Horbourg Bridge. It was a macabre monument destined for the cemetery of Colmar. Still visible today among the real tombs of Colmar's citizens, it was made to startle the viewers with a funerary stele and two tombstones lying flat, all wrought from the same red sandstone of the Vosges, from which a single arm in bronze emerged from between the slabs to reach for a sword placed on the sepulcher. The dead of Horbourg, the monument made clear, would rise from their graves to exact their revenge.[4] The second was the *La malédiction de l'Alsace*, which Bartholdi had sketched during his American travels and transformed into a silver group upon his return.[5] When the journalist from the *Gazette des beaux-arts* saw *La malédiction* at the Salon, he observed that the "violence of the gesture, of that long outstretched arm" gave "full expression to the sentiment" and had much to say "about the sense of legitimacy that had outlived the unjust defeats and the wound that nothing will help heal."[6]

Bartholdi would probably have continued dwelling on Alsace's disgrace, had it not been for the statue he had promised the French colony in New York. Everything had been left vague on that front when he had left America. Yet not long after his return to Paris, he was met with a surprise. The president of the Republic, Auguste Thiers, had decided to make a gift to the French citizens of New York, as a way to thank them for their contributions to the armaments and funding of the Franco-Prussian War. Because Bartholdi was now a famous artist in France, and his interest in America well known, Thiers asked the director of the École des beaux-arts, Charles Blanc, to entrust Bartholdi with building a bronze statue of Lafayette to be given to the French citizens of New York. This fit Bartholdi's agenda well, because he was still convinced that New York needed concrete proof of his merits before accepting his colossal

lighthouse. So he designed something as grand as the lighthouse, although more complex: two allegorical statues, probably America and France, placed under a triumphal arc topped by an equestrian statue.[7] But this project did not last long. If Bartholdi wanted New York to accept the lighthouse soon, he needed to finish his "trial-monument" quickly. Hence the decision to ultimately make a smaller statue. The result was a skinny and nervous-looking Lafayette, slanting on the deck of his ship's bow—curly waves still visible at the sides—and resting on his left leg, while bringing his right hand to his chest, swearing loyalty to his American friends, and offering his left hand in a gesture of friendship. Never had a monument more accurately reflected the mood and spirit of its creator. Bartholdi, too, was nervous and hopeful when sculpting it; longing no less than the real Lafayette to capture American sympathies, he confessed to his mother that the monument was giving him "many worries," because it was so important "that it came along well." And the more he got involved in the project, the more anxious he became: "I am attaching to it so much importance that everything [about it] makes me nervous."[8]

It was typical of Bartholdi to inject his sculptures with his own moods, his own story. In this case, however, he felt something deeper, as if the statue was becoming part of himself. Childless, and with no family except for Charlotte, he probably wondered what it would be like being a father. The sense of exhaustion and anxiety that the *Lafayette* caused him was part of the answer. *Lafayette* became Bartholdi's "bebé," someone (or something) to worry about but also identify with. And it was probably no coincidence that he impressed the signs of his own anxiety on his bebé's features. In his own time, Lafayette had been the messenger and vehicle of a new friendship between France and the United States. Plausibly, Bartholdi thought that he could use his own (and more recent) experience as artistic envoy of a liberal and sympathetic France to understand how Lafayette felt upon arriving in the New World. The experiment worked surprisingly well. Indeed, by the time

Bartholdi was sculpting his "bebé," Lafayette's universal fame had obscured the fact that when he first landed in America, he was a young soldier with little experience, who had written worried letters to his wife on board his vessel and found none to welcome him in Georgetown Bay. Bartholdi probably ignored all of this, but he knew what it meant to go to an unknown country and try to win the trust of foreigners. This was enough to give him a deep insight into Lafayette's sentimental life, one eventually resulting in a most unusual monument. In fact, the *Lafayette* does not embody the impetuous young hero many would have expected, but rather a kind and worried soldier trusting in luck; raised to look above the horizon, Lafayette's eyes are lost in contemplation of something that clearly escaped his understanding.

Bartholdi, too, must have felt lost, though this time in France. For a while, Thiers's sympathy had convinced him that he was moving in the right direction. As if to confirm this impression, many former American friends who came to visit him in Paris in the early 1870s expressed enthusiasm for his *Lafayette*. One was Senator Sumner, whom Bartholdi welcomed at rue Vavin by organizing a dinner with the historian Hyppolyte Taine and other friends. At the time, the artist was already working on the bas-reliefs for the bell tower of the First Baptist Church in Boston. "By following the usage of Medieval artists," Bartholdi explained in a letter to his American friend, the poet Longfellow, I have introduced "in my work various portraits." Longfellow himself would impersonate the allegory of "religious education," while the Laboulayes would lend their faces to the "friends of the United States."[9] Taking advantage of Sumner's stay in Paris, Bartholdi asked him to pose for a portrait to include in the Bostonian bas-reliefs, this time into the scene of *Baptism*. Months later, the painter La Farge knocked on his door. It was the summer of 1873, and Bartholdi asked him to endure the heat to pose for his Bostonian project, to which La Farge also was contributing by making the stained-glass windows and frescoes inside the church.[10]

In hindsight at least, those were wonderful days for Bartholdi, who could toast to his future success in the company of American and French friends and take long walks, drink wine, and draw sketches with the likes of La Farge in the hills of Colmar, in Plombières, and even in Switzerland.[11] But there was a point, in 1873, when Lafayette's worried face came to reflect its artist's anxiety to a greater degree than ever before. In May 1873, the general Patrice MacMahon, the hero who had marched against the Commune and executed its leaders, was elected president thanks to the joint support of conservatives and monarchists. Bartholdi was not so much bothered by the new government's conservatism as by its instability and lack of focus. As he told his mother, "I would like to take care of my grand project for America, but with all the political uncertainties and emotions that are growing after the return of the assemblies, people only think of that and this is quite natural. One hopes that it is going to end well, and this is what counts."[12]

It is hard to identify what, in the end, really mattered the most to Bartholdi. Was it the future destiny of his country, or the New York project? In the past, Bartholdi had undoubtedly assumed that the nation's political fate came second to his personal projects. Alsace's sorrowful fate had widened his political horizons, but letters like this suggest that he was still focused on his work in ways that made a dispassionate approach to politics impossible for him. Luckily, history was moving in a direction that promised to help him, the Statue of Liberty, and France at the same time. Two events in particular would prove directly useful for Bartholdi's New York project. In 1873, his cousin Amédée Bartholdi was nominated French minister plenipotentiary in Washington, D.C., a position from which he could promote the proposed lighthouse monument among diplomatic and government circles. Second, the Philadelphia Centennial Commission asked Forney to organize the European part of the exhibition.

This alone, however, was not enough to ensure the success of Bartholdi's work in New York or Philadelphia, because Forney's

campaign to raise French interest in the exhibition (and, indirectly, in his Philadelphian works) depended on France's political climate. And Bartholdi was right on one point at least: MacMahon's conservative government was not the ideal background against which to advertise the American event, though MacMahon himself had good reasons to cherish such a statue, since his wife was a descendant of Charles de Castries, one of the young officials who had sailed to America along with Nailles and Lafayette.[13] Laboulaye, however, had something in mind to make the government more liberal, without sending MacMahon home. He proposed a bicameral republic with a strong president, like in the United States, but with the addition of a premier. Laboulaye's personal efforts to establish such a system failed in February 1875, when his proposed constitutional amendment for a republic "with two chambers and a president" was outvoted by the Catholic Henri-Alexandre Wallon's suggested amendment for an indirect election of a president "by the Senate and the Chamber of Deputies."[14] The French Constitutional Laws of 1875 would formalize the new republican system. When Forney visited Bartholdi in Paris, only two months after Wallon's move, he found him finally "out of his gloom."[15] Plausibly the artist's improved mood had to do with the (well-founded) expectation that a liberal republic would benefit his "grand project" in New York. It certainly benefited Laboulaye and his friends, who would soon increase their influence in parliament, but it would profit the United States as well, which would find it easier to negotiate with France's reborn third republic.

Forney saw the effects of this renewed friendship in each of the French cities he visited to advertise the Centennial. Since August 1874, when he had started spinning his web in Paris, "the rapid growth of the sentiment in this beautiful capital in favor of the exhibition" had become "very obvious." Everybody in France seemed busy preparing loads of carriages, "glass, silk, lace, cotton, wool, steel, iron, and gold and silver work." Martel, a brandy producer and member of the National Assembly, was making prepara-

tions to carry his liquors across the Atlantic, and the "Masons of France" were planning to send their "best mechanics and artists . . . at an early day for the purpose of practicing their various trades and professions during the Exposition."[16] In June, the French chamber finally voted to subsidize the French participation to the Centennial with six hundred francs, a sum that would be distributed by the minister of finance Léon Say and the head of the department of international exhibitions de Someraud. Three months later, the representative of "many important interests" would even apply to the "Minister of the Marine to establish another line of steamships between Le Havre and Philadelphia.[17]

It may have been around this time, between June and September 1875, that Forney encouraged Bartholdi to capitalize on the general enthusiasm to advertise his statue as a piece of art destined for the Centennial. Bartholdi had always done his best to resist Forney's somewhat intrusive excitement, but France's positive reaction to the Centennial might have changed his perspective on the matter. A sign of this shift is visible in one of the maquettes for the lighthouse project that he molded around this time, taking the form of a woman with a serious and even angry visage, holding under her left arm the tablets of the Declaration of Independence (instead of the piece of vase), while broken chains lie at her feet. The last detail was present in the earlier maquette that Bartholdi plausibly had produced before leaving for the United States. This time, however, the statue's diadem shows a series of columns, as if Bartholdi meant to create a balcony inside the statue's crown or, at least, a structure through which the light to be installed inside its head could shine.

One wonders how Laboulaye reacted to Bartholdi's decision to replace the earthenware with the Declaration and to keep the broken chains—the last direct symbols of emancipation left in the statue—under the statue's gown. But what if Laboulaye himself had suggested such an arrangement? For if it is true that he had fought bravely against slavery in France, Egypt, and America during the

Civil War, it is also true that he was a moderate abolitionist at heart. And his moderation had become even more pronounced after the end of the Civil War, as shown by a revealing chapter in his 1867 fable *Le Prince-Caniche*.

One of the most interesting journeys on which the story's fairy godmother takes her prince godson after transforming him into a poodle is to Monrovia, the colony of freed black slaves founded in Liberia by the American Colonization Society. Here, the prince, who still believes that "liberty is a question of race," is lectured by a wise African on the merits of a liberal society with "a free church, a free school, free newspapers, free banks." Liberia, according to the African, was "a republic, perfect in itself, that administers itself in liberty through the participation of all citizens." Should we interpret the Monrovian's endorsement of deportation as a sign that Laboulaye too was supporting a black recolonization of Liberia? Most probably yes, because the enthusiasm with which the African promised that "with God's help one day [Liberia] will eclipse Europe and America," her "talisman" being "American liberty," did not betray any sarcasm on Laboulaye's part.[18] If anything, it revealed admiration. Which is quite surprising, given that he had earlier accused American abolitionists of being racially intolerant toward blacks and had embraced the progressive policies of those working to help assimilate freed slaves into American society. Was he becoming intolerant himself? Or was he endorsing the point of view of Lincoln and other more tepid American abolitionists for opportunistic reasons?

With the passing of time, Laboulaye was probably reconciling himself with segregationist positions, without ever recanting his former beliefs in the theoretical possibility of creating multiethnic and multireligious communities. This development may have resulted in the choice of keeping the statue's only symbol of emancipation, the broken chains, under her gown. Or perhaps Laboulaye and Bartholdi had decided that moderation was the best solution if they wanted to prioritize the statue's actual construction and make sure

that its design conformed to the ideologies to be advertised in Philadelphia. Some of these ideologies were compatible with the liberal point of view—fair competition, freedom of commerce— while others were more problematic, such as the freedom to move semi-enslaved workforces across the world. Contesting this freedom would have affected the success of the Centennial in dramatic ways, since some of the most powerful supporters of the event in France, like the Compagnie générale maritime, were still drawing great profits from a "neo-slave" enterprise, namely the transport of Indian and Chinese workers (who were formally free, but practically slaves) to the French sugar plantations of the West Indies.[19]

If revising the look of the statue was a crucial step toward its presentation to the American public at the Centennial, another was actually finishing it in time for the event. Forney had told Bartholdi that an American vessel was expected at Le Havre in the winter of 1875 to pick up the French works to be exhibited in Philadelphia.[20] But how could he hope to finish his statue (along with the luminous fountain for the Centennial) by December 1875? There was another problem, for the colossal statue was meant for New York, not Philadelphia. One plan was to lay the monument's foundation stone "during the Centennial ceremonies" scheduled in New York on July 4.[21] Simultaneously, Bartholdi was hoping to send to the Philadelphia Centennial "one part of this colossal figure, the arm alone," which—Forney commented—looked "like the mast of a ship."[22] We don't know if Forney came out with this description on his own, or if Bartholdi suggested it to him. But it was a very appropriate way of describing the statue on the eve of the Centennial, when French naval companies and international merchants from Europe were seeking to strengthen economic ties with America. Forney was certainly among those who first suggested to Bartholdi and Laboulaye that, if they had any chance to find donors, it would be in these business circles.

One can only wonder how Bartholdi, who had once tried to avoid those who liked "the Almighty dollar a bit too much," felt

about now actively seeking their help. But it is one thing to sponsor a project, and quite another to pay for it. Bartholdi seemed to believe that wealthy patrons were bad connoisseurs, but good donors. Besides, when it came to monument building, it was regular practice in France and elsewhere to set up committees tasked with such things as seeking donations and organizing fundraising campaigns in newspapers, at home, and sometimes even abroad. There were no fixed rules for forming committees, but they were usually comprised of local councils in the towns where monuments were to be built. The council members often had a direct interest in the undertaking—statesmen in the case of statues dedicated to politicians or generals; or intellectuals, journalists, and artists in the case of monuments to leading cultural figures. The case of the Statue of Liberty was somewhat different, not only because it was intended as a gift to a foreign nation, but also because the fundraising campaign was coordinated not by an administrative authority, such as a municipality or a district, but by a private group of friends. Laboulaye and Bartholdi, however, found it relatively easy to bend the traditional practices to their new needs, because most of their friends had official positions in the French or American governments. All they did was invite them into a private, transoceanic committee, which they called the "Franco-American Union."

By September 1875, the Franco-American Union was ready to start its work, and Bartholdi held a reception at his house on rue Vavin to consult "upon the necessary arrangements." Laboulaye, who was "too much engaged in his legislative duties" and "too essential to his party in France," could not join his friends, but Forney, who was among the union's members, remembered later that he met there Edmond About, the Alsatian journalist who had penned riveting pages on Egypt's industrial decline and was then reporting for the "dashing republic paper the *Paris Dix-Neuvième Siècle*"; the historian and "Grand Master of five hundred thousand Masons

in France" Henri Martin (whom Bartholdi had allegedly met at Laboulaye's house in 1865); and other foreign guests, such as the journalist and businessman Walter McMichael of Philadelphia and Gratiot Washburn Jr., the son of the American minister in Paris.[23] Plausibly, Forney himself had introduced McMichael and the Washburns to Laboulaye and Bartholdi along with other Americans involved in preparations for the Centennial. We don't know if Bartholdi managed to invite all of them or only a few. Certainly, however, the Statue of Liberty's funding machine was larger than what Forney's account suggested. First of all, it included a large contingent of Freemasons. This was to be expected, of course, given the crucial role played by the American Union lodge in sponsoring the Revolutionary War and by the fact that the funding committee itself was called "union."[24] Forney had met at least three of Bartholdi's Masonic friends, namely Laboulaye, About (whom Forney himself describes as a "prominent Mason"), and Martin.[25] But the union's Masonic contingent was larger, including the Alsatian Jean Macé, a writer of fables and president of the Ligue de l'einsegnment for the advancement of free, public, and lay education, and Victor Borie, a Catholic journalist and banker who, in his youth, had become famous for being the lover of George Sand. Other Masons were plausibly to be found among the members of Society of the Cincinnati (an association established in 1783 by officers of the Continental Army and their French allies to perpetuate the memory of their collaboration), which was represented in the Franco-American Union by politicians with aristocratic lineage like Oscar Lafayette, Jules de Lasteyrie, and Paul de Rémusat.

Unfortunately, given the secrecy with which relevant documents are still guarded, it is difficult to know how many of the union's members were Masons. What they all shared, however, was political influence as well as social or intellectual prestige. The Masons whom Forney had met at Bartholdi's house were writers, journalists, journalists-turned-bankers like Borie, and politicians. But the union also included lawyers, such as the Coudert brothers, who were in

the process of establishing their American office of international consultancy in Paris; and diplomats, such as the American minister in Paris Elihu B. Washburn, Bartholdi's cousin Amédée, and the French ambassador in Rome, M. De Noailles. In addition, Laboulaye could not forget to invite famous personalities of the American world in Paris. One was William Waddington, the French-born, Cambridge-educated son of a British cotton manufacturer who had settled in France. Probably a Mason himself, Waddington was soon to become France's prime minister. But the reason for his sympathy for the union had much to do with his latest marriage to the writer Mary Alsop King, who happened to be the daughter of the president of Columbia College Charles King and the granddaughter of the Federalist Rufus King. Family connections also played a role in the union's decision to invite Cornelis de Witt, the son-in-law of Guizot who had written a (rather bad) book on George Washington in 1839. And then there was Hyppolyte de Tocqueville, grandson of the famous author of *Democracy in America*.[26]

Forney must have informed Laboulaye and Bartholdi that America was "the second best customer of this great nation [France]," particularly of the "silk men of Lyon, the winegrowers of Bordeaux, the sardine-packers of Marseilles, the iron, steel, glass, cotton, wood, and wool manufacturers, the jewelers and weavers, the paper- and book-makers, and the indescribable variety of inventors and producer[s]."[27] Yet it is surprising to find that only a few of these business interests were represented inside the union: the Bordeaux wines by Jules De Lagorsse, secretary general of the Société d'encouragement à l'agriculture; and the production of iron and steel by the Union member Charles-Frédéric Dietz-Monnin, a cousin of Bartholdi who also happened to be the president of the Chambre syndicale de la quincaillerie and an associate of the Japy hardware and clock factories at Beaucourt and Besançon. The other businessmen in the union, Borie and Laboulaye's old friend Wolowski, were only indirectly associated with French industry. Still, as bankers, their presence in the union was crucial to Bar-

tholdi's and Laboulaye's scheme, because banks (at least certain kinds of banks) were the only agencies able to channel foreign money into the union's chests. Once again, Forney might have been the union's source on the matter, for he would later register in his diaries that, much like the French merchants were eager to present their products to American consumers, so too American bankers were looking forward to selling their securities in Europe.

American securities had started to appear in European financial markets in the wake of the Civil War, in the late 1860s. Sold mostly by American businesspeople of European descent, such as the Seligman brothers, the Drexels, and the Morgans, U.S. investments had offered only low profits. But returns on financial investments were quite low everywhere at the time, particularly in countries like Egypt where most global investors had concentrated their "dead capital" after the outbreak of the American Civil War. Wolowski and his Crédit foncier was, as previously mentioned, among the earliest French investors in Egypt. Yet European capitalists, disappointed by Egypt's (and Turkey's) insolvency, were increasingly hoping that Americans "could and would pay all their suspended interests, and be strong enough to make good all their obligations in the future," so that all European "dead capital" could converge in the United States.[28] It was Forney's hope that the Centennial would provide a place where European merchants could reach an agreement with American investors. Wolowski and other banker friends of Laboulaye's probably hoped the same. Their hopes were reinforced by the general expectation that the Centennial would happen at a time of poor harvests in Europe. In this case, Forney thought, "European gold" coming "to the United States to pay for our breadstuff" would put back in motion "American industries" and indirectly allow each state to "rise and repay the original investors."[29]

Either Forney or Wolowski might have updated the union on the status of French foreign investments. And this probably facilitated Borie's nomination to the position of treasurer to the union. For Borie

was the former secretary general of the Comptoir d'escompte (the bank established by friends of Charles Laboulaye), and the actual managing director of the Société des dépôts et comptes courants, an institution founded by controversial figures but boasting good relations with a wide network of foreign investors.[30]

The involvement of the Société in the funding of the Statue of Liberty is important for our story. The Société was founded by the Catholic banker Armand Donon, a figure surrounded by rumors and controversy. His cousin André, for one, had made headlines when he was accused, and later acquitted, of parricide; his trial, the famous "Donon-Cadot" case, had gripped all of France, including Balzac, who famously attended the trial to seek inspiration for his novels. Pierre-Armand, however, had a less troubled youth than his cousin. Before entering the world of finance and business, he studied law and economics at the celebrated Collège Sainte-Barbe in Paris. Donon had made his fortune during the Second Empire, together with his first associates, Charles de Morny and Jules Gautier, by investing in French coal mines, German copper mines, and steel foundries in Linz, Coblenz, and in the Rhine and Loire regions. Under the leadership of Morny (who dreamed of extending the Grand Central railway from the Massif Central toward Paris in one direction and toward Zaragoza and Madrid in the other) and with the help of British friends like William Gladstone, Donon and his colleagues had started investing in Spain and Portugal, where Donon was still personally active at the time of our story.[31]

It was normal at the time for financiers to manage a private bank and a couple of joint-stock banks at the same time. In 1859, for example, Donon and his partners had founded the Crédit industriel et commercial; four years later they set up the Société des dépôts et comptes courants. Although they soon lost control of the Crédit industriel, the partners teamed up with its new owners to establish other limited-liability finance companies in key places such as Bordeaux (where Donon's associate Gustave Delahante had acquired the Bacalan forges to build iron and ultra-thin copper-

sheet hulls for ships), Marseilles, Lille, and Lyon, but also in Paris, where the Société financière de Paris was founded in 1872.[32] Donon was an astute businessman and a master at installing his business and political associates on his companies' boards. His cronyism would reap many rewards, such as when his Société des dépôts and the Crédit industriel won important quotas of France's 1870 war debt, alongside big names like J. P. Morgan and the Société générale. But Donon was also a skilled banker who had familiarized the French with certain financial techniques that he had learned from his British-American friends, the most important of which was the use of the check. Also known as "l'homme-chèque," Donon used his expertise to expand the range of his business in the province, but also to capitalize on growing American interest in French investments (and vice versa). So, in 1872, he opened an American branch of his Société des dépôts, the American Agency, in 2 Place de l'Opéra, one of the most fashionable districts in Paris.

The managing director of Donon's Société des dépôts was Borie, who also happened to be the treasurer of the Franco-American Union. It is not surprising to find, then, among the few surviving documents of the union, the draft of a decision to deposit the funds raised for the Statue of Liberty "at the American Agency of the Société des dépôts et comptes courants, 2 Place de l'Opéra," which would provide "its service [as a] gratuity to the project" and pay "2% interest until the day of their use." The Franco-American Union's records also specify that "to facilitate the centralization of funds, all circulars should state the name of the agency's corresponding bank in the departments or abroad."[33] Donon's political connections in France and overseas were undoubtedly a boon for the Franco-American Union. But along the way, something convinced the union that the Société could not be their only financial partner, at least not formally.

ONCE THE FRANCO-AMERICAN UNION was formed, and its allegiance with the Société established, Bartholdi and his friends

passed to the second part of their project: presenting the idea for the statue to the public and asking for donations. This is what, in the Union's original translation, French citizens read in their newspapers when they woke up the morning of September 28, 1875:

> America will very soon celebrate the Centennial Anniversary of her Independence. This date marks an epoch in human history; to the New World it records its sublime work, the foundation of the grand Republic; to France, one of the most honorable pages of her history.
>
> We believe, as well as our friends of the United States, that it affords a solemn occasion to unite France and America in a common manifestation. Notwithstanding the long past time, the United States like to recall to mind an ancient fraternity in arms; the name of France is always honoured by them. The great event, which will be performed 4th of July, 1876, permits us to celebrate with our American friends the old and sincere friendship which so long united both nations.
>
> . . . A French artist rendered that idea in a project worthy of its purpose and which has secured all approbations; in going to America he came to an understanding with our friends and prepared all the means of execution.
>
> The question is to elevate in commemoration of the glorious anniversary an exceptional monument. In the middle of the harbor of New York, on an island that belongs to the Union of the States, in front of Long Island, where the first blood was shed for Independence, a colossal statue will rise up, standing out in space, framed on the horizon by the great American cities of New York, Jersey City, and Brooklyn. At the entrance of that vast continent, full of new life, where ships meet from all parts of the world, it will look as springing up from the bosom of the deep, representing *Liberty Enlightening the World*. At night a luminous aure-

ole projected from the head will radiate on the far-flowing waves of the ocean.

The monument will be erected by both nations, associated in this fraternal achievement as they were formally to carry out the independence. We shall amicably offer our American friends the statue, and they on their side will meet the expenses of the pedestal. Thus we shall consolidate by an eternal remembrance the friendship sealed by the blood of both people's forefathers.

Let us unite to celebrate this fête of modern people: We must give to this manifestation the fervor which it requires in order to equal the ever memorable past events. Let each one bring his obole: however trifling each person's offering may be, it will be received with thanks. Let the number of subscribers show the sentiments of France.

We shall organize our list in volumes, which will be offered to our American friends.[34]

Clearly, the union had chosen its words with care. First of all, it had avoided any mention of the Philadelphia Centennial. Not knowing how long the statue would take to be completed, the union probably had thought it wise to refer readers to the generic festivities marked by Americans in every city. Second, the insert reported that "in going to America," Bartholdi had come "to an understanding with our friends and prepared all the means of execution." Yet, as we know, his acquaintances in New York had never formally agreed to place the statue on Bedloe's Island, or for that matter to pay for the pedestal. There were certainly no acts passed, on either the state or federal level (it would eventually fall to Congress), approving any of these things. Finally, and quite surprisingly, the statue, which Bartholdi had once referred to as a monument to independence, liberty, and the republic, was exclusively described as a memorial of the Revolutionary War: a monument to the "friendship" between French and Americans,

one "sealed by the blood of both people's forefathers." This sim-
plification certainly promised to avoid the confused reaction that
Bartholdi had received from his America interlocutors a few years
earlier. After all, the War of Independence was a war for liberty that
had made the Americans' 1787 constitutional transition to repub-
licanism possible. And the statue's name, one apprehends for the
first time, was now *Liberty Enlightening the World*.

No picture accompanied the description, and one wonders why
the words did so little to fill the gap. The Franco-American Union
painted the idea of the statue with vague, although deeply evoca-
tive, strokes. It promised, for example, that "a luminous aureole
projected from the head will radiate on the far-flowing waves of the
ocean." No mention was made of the broken chains, not even
of the Declaration of Independence or the flame, or, for obvious
reasons, its longer Egyptian history. One could speculate on the
reasons for this choice. The most plausible motivation has to do
with the Masonic origins of American Independence and, of course,
of the New York project itself. The union could have never declared
the Masonic nature of its project explicitly, for secrecy was part of
the Masonic code. But the name *Liberty Enlightening the World*
was clearly inspired by a stereotypical allegory that Masons had
always used to indicate the triumph of knowledge over ignorance.
"Darkness," Albert Gallatin Mackay had explained only a few years
earlier, "is intended to remind the [Masonic] candidate of his igno-
rance, which Masonery is to enlighten; of his evil nature, which
Masonery is to purify; of the world, in the obscurity of which he
has been wondering, and from which Masonery is to rescue him.
Light, on the other hand, is the symbol of the autopsy [from the
Greek, "seeing with one's own eyes"], the sight of the mysteries,
the intrusting, the full fruition of masonic truth and knowledge."[35]

It is revealing that, as a way to introduce their future colossus to
the public at large, the union had decided to focus on its Masonic
meaning alone. They probably counted on surprising their read-
ers, because it was not often that a group of Masons sponsored one

of their icons among the public at large, out of their "sacellum" or "most secret place," by asking that "each one bring his obole: however trifling each person's offering may be."[36] And yet, anyone familiar with French and German mystic literature, especially with the works of Ballanche and Krause, or with Laboulaye's lectures at the Collège de France, would have understood the meaning of the initiative: the colossal statue was meant to be the first of those Masonic idols that, according to Krause, would be pulled out of private lodges and exposed to the public at large for its general initiation and regeneration; but particularly for the benefit of the poor and the weak, the plebs to whom Orpheus had promised regeneration. Like the poet-musician-god Orpheus and his descendants (from Virgil to Ballanche and Hugo), the statue was meant to incarnate the modern poet, marching ahead of his people to light their path: "high [above the world], he [the poet] dominates the era in which he lives and fills it with light; the future is also in his mind, he embraces all human generations from a single point of view."[37]

Like a mystical poet-god, the statue would become a colossal symbol of "autopsy" (or the full revelation of mystery), a term that some Freemasons considered synonymous with "resurrection." It was quite easy to see how, if framed by a dark background, the statue's solar crown could symbolize regeneration or apocalypse, like Lucifer, a comet or a morning star. But was there anything in the statue, except for her dark background at dawn or at dusk, that would suggest a deeper relationship with initiatory sacrifice? The union helped the readers make an association by explaining that the statue was a sepulcher of dead soldiers, "both people's forefathers," whose martyrdoms had "sealed" the friendship between French and Americans.

By the time the advertisement was published, artists and intellectuals were, as previously mentioned, used to identifying liberty with sufferance or even sacrifice and death. Still, a monument dedicated to liberty that did not present any of its subject's most

salient symbols, like the broken chains, was quite unusual. Despite its mystical appearance, the *Hermes* on the July Column nonetheless seemed proud to wave his pieces of chain in the air. Yet the Statue of Liberty hid hers: bearing the name of Liberty, she was pure resurrection and revelation. Iconologists often call the process by which two icons come to have the same symbols but different meanings "pseudomorphosis" or even (to imply an even more dramatic transposition of meanings and styles) "synthomorphosis."[38] Classical examples of pseudomorphosis came from medieval or Renaissance art, where, for example, Father Time figures with Saturn's attributes and blind *putti* recall ancient Cupids. But cases of pseudomorphosis were common in modern art as well. One example is the *July Column of Paris*, on top of which Hermes holds the flame of a Masonic sun even if it is named a Genius of Liberty. A second example is James Barry's engraving of American Freedom, discussed earlier. It still holds a scepter, like Liberties did in the eighteenth century, but the scepter is surmounted by the bell of Apocalypse, representing the "resurrection" of European liberty.

The Statue of Liberty is the culmination of the pseudomorphic process inaugurated by Barry. But how many in France were able to appreciate the cryptic meaning of the colossus? And how many among those who understood it were actually ready to accept it? It is difficult to imagine a time and place in modern times where such a figure could have been built in a public space without arousing suspicion, particularly as a gift from one nation to another. The 1870s, in particular, were years of growing conservatism and religious intolerance. While touring Europe to advertise the Centennial, Forney had wondered if the Western Hemisphere was "on the eve of a great religious controversy." The signs were everywhere, but particularly in Madrid, where the papal nuncio had protested against the religious toleration of the Spanish constitution, and in England and France, where Masons had been "ostracized."[39] In this "great religious controversy," as Forney had called it, the Franco-American Union clearly sided with Freemasonry. There

were millions of Masons scattered across Europe, Forney had said, and many of them were about to sail for Philadelphia to develop commercial relations between France and America. Members of the union must have thought that Masonic and commercial interests would be enough to finance the monument, if spiritual concerns kept small subscribers from donating. Yet if the statue spoke the symbolical language of Freemasonry openly, her commercial message was harder to decipher. The only things hinting at a commercial connection were her maritime context, as Bartholdi had understood the minute he had entered New York Harbor, and her raised arm that, as Forney put it, looked like a ship's mast. The union, however, found a more poetic way to explain this. To union members the Statue of Liberty, placed "at the entrance of that vast continent, full of new life, where ships meet from all parts of the world," would look as if she were "springing up from the bosom of the deep." Were they encouraging a comparison between the statue and Isis Pharia, the Egyptian goddess of the island of Pharos, protecting commerce and sailing? Or did they rather have Venus in mind, emerging from the waters as Botticelli had painted her in his famous *Birth of Venus*, which Bartholdi had seen in Florence?[40] After all, the ancients had often identified Venus with the "morning star" guiding sailors home, like a beacon, and Renaissance philosophers thought she symbolized love (fire) and the knowledge (sun) of god.

WHATEVER THE CASE, the reference to Isis and Venus emerging from the sea, amid ships coming from the four corners of the world, reinforced the statue's poetical meaning, while preparing the final announcement that addressed international merchants and businesspeople in particular: "subscriptions [would] be centralized by the SOCIÉTÉ GÉNÉRALE, rue de Provence, 54, Paris; by all her Parisian or departmental agencies or by the bankers who are their correspondents."[41] Simultaneously, the final list of the union's members published in the newspapers showed a slight

difference compared to the one drafted earlier: Victor Borie had been replaced by De Lagorsse as the union's treasurer. Borie was still in the union, but, for some mysterious reason, the committee had chosen to keep its relations with Donon's Société des dépôts secret. Did this mean that they had replaced the Société des dépôts with the Société générale? Or had they rather decided to keep their relations with both banks while advertising only those with the Société générale?

Founded in 1864 by a group of bankers interested in the Comptoir d'escompte's earlier plan of bringing small savings into national industry, but also in extending French investment abroad, the Société générale was a truly national bank. By 1870, it had fifteen branches in Paris and thirty-two in the provinces. No other bank could compete with such a network of financial channels, which promised to track checks donated for the statue from even the remotest parts of France. The Société générale had also been (like the Société des dépôts) one of the big French banks to join J. P. Morgan in granting a loan to France to pay off its debt with Prussia.[42] And two years later, in 1872, the Société générale had opened an English and American office to sell American securities on French markets and vice versa. That the union did not mention the Société générale's English and American office in its public appeal, as it had mentioned Donon's American agency in its earlier plan, did not indicate an overall strategy per se. As we soon will see, all the agencies—the Société's American Agency, Donon's American Agency, the Société générale, and the Société des depots—were most certainly involved in the union's scheme. As France's truly national bank, however, the Société générale had important advantages over the others, particularly as the union began to insist on the Statue of Liberty's "patriotic" profile.

THE DEMOCRATIC
WATCH

ON AUGUST 16, 1875, Bartholdi awoke to disturbing news: an almost eighty-two-foot statue of *Arminius*, the Cherusci chieftain who had defeated three Roman legions in the Teutoburg Forest in 9 CE, was being inaugurated in Germany as a symbol of its triumph over France and the birth of its new empire. It was a memorable event; twenty to thirty thousand spectators had come from every corner of Germany to see the martial statue unveiled, its right arm raised to lift its victorious sword and the left resting on a tall shield standing on the ground. It must have been particularly irritating for Bartholdi to know that Germans not only had stolen Alsace from France, but also had beaten the French in the race to build the world's largest monument. For the *Arminius* was precisely that: added to its pedestal of 93.9 feet, which looked like a round, classical temple or *monopteros* with Gothic columns, the statue was the tallest monument ever created by a modern sculptor. And it was also one of the more nationalistic. Indeed, three of the pedestal's niches were inscribed with words glorifying the crucial moments leading to the birth of the present empire: first Arminius's triumph over the Romans, then the Prussian victories against Napoléon, and, finally, Emperor William's victory over the French in 1870–1871. Back in the 1840s, when Ernst von Bandel was struggling to get funding and attention in a country that seemed little interested in his project, nobody would have foreseen such a bright future

for the *Arminius*, and the same had been true in the 1860s, when von Bandel had decided to himself pay for the first copper sheets to apply to his statue's inner core.

Quite ironically, in those same years, Napoléon III had generously sponsored the work of the sculptor Aimé Millet and the architect Emmanuel Viollet-le-Duc, who were collaborating on another patriotic statue in embossed copper: the *Vercingétorix* (Figure 14.2). It may be that, without the successful inauguration of the *Arminius* and the story of its rivalry with Millet's *Vercingétorix*, the Statue of Liberty would have looked different today, for Bartholdi and Laboulaye clearly wanted to outdo von Bandel and replicate Millet's success on a larger scale. The first signs of this new development were caught by the *Petit journal*, where, on September 28, 1875, it was announced that the New York colossus was to be cast not in bronze, as Bartholdi had anticipated to Longfellow, but in "embossed copper," just like the *Vercingétorix* and the *Arminius*.[1]

Embossing of lead and copper, namely the raising of reliefs on very subtle sheets of hot metal, used to be a fashionable technique during the Middle Ages and the Renaissance, when artists thought that embossing was "a colossal goldsmith's trade" and that statues, from this perspective, could be considered titanic jewels.[2] One of the most striking examples of embossing on a vast scale is Giovan Battista Crespi's *San Carlo Borromeo*, which Bartholdi had visited during his Italian journey. Crispi's architects had cast the saint's head and hands in bronze; for the rest, however, the huge and benign figure, portrayed in the act of blessing the faithful with his right hand while holding a book in his left, was made in embossed sheets of copper attached with harpoons and iron beams to an inner core of bricks reaching to the statue's neck.

We don't know if the architect of Millet's *Vercingétorix*, Viollet-le-Duc, had ever climbed *San Carlo Borromeo*, but his project was to make the medieval and Renaissance techniques fashionable again in modern France, where artists still believed that emboss-

ing was limited to jewels or clock-making and never dreamed of applying to statues a technique usually reserved for pendants and clock cabinets. Little is known of Bartholdi's personal reaction to Viollet's project, but one can presume that any project aimed at elevating the status of goldsmiths to that of artists pleased him, since, after all, Colmar was the birthplace of Schongauer, one of France's most famous goldsmiths and engravers. Interestingly, when Bartholdi had built the monumental fountain dedicated to him, in 1867, Viollet-le-Duc had expressed admiration. But the *Schongauer* was made in stone, although of a red, copperish variety. Viollet-le-Duc, on the contrary, was primarily interested in revisiting metalworks and familiarizing French artists with technical problems relating to lead and copper, for these metals shared an extraordinary sensitivity to heat and cold. "If it is not let free," Viollet-le-Duc lectured, "if it is permanently attached [to a surface,]" lead (but he might well have referred to copper) "buffs up when exposed to the sun and tears off the fasteners when exposed to cold weather."[3]

It is important, at this point, to remember that a huge statue like *Liberty* would present the problem of heat sensitivity on a hitherto untested scale. One effective way of seeing it is to observe the Statue of Liberty in the evening of a warm day through a powerful dental camera. These cameras normally identify gum infections by spotting slight differences in temperature inside the mouth. But they can also be used to measure heat signatures in the environment on a larger scale. Seen through such a camera, the statue appears like a burning white mass, emanating heat to its surroundings. Even if unable to visualize it, Viollet-le-Duc was highly aware of the phenomenon. So his advice was to fix the metal "energetically enough so that it does not collapse," but also to "let it free to dilate or tighten according to the changes in temperature."[4] This meant that Crispi's plan of attaching copper sheets to a brick structure could be further improved by replacing the bricks with a lighter iron structure. This, at least, is what Viollet did when the

time came to build Millet's *Vercingétorix*, which was the first colossal statue in embossed copper ever produced in modern times, and the first known copper statue attached to an iron structure in the history of architecture.

It must have been comforting for Bartholdi to think that, if von Bandel had built the biggest statue in the modern world, Viollet-le-Duc had created the first colossal statue in iron and embossed copper. And this consoling thought would have dramatic consequences for the development of the funding campaign for the New York project. No matter how poorly the Franco-American Union might have reacted to von Bandel's success, no signs of their frustration are visible in the subscription calls of September 28. But it was only a matter of time. As Forney noted, Laboulaye had been too busy so far to be actively involved in the funding campaign. When he finally found the time to do so (at some unspecified point after the subscription appeal was published), he wrote a personal note to a number of possible subscribers:

> You will certainly appreciate the spirit of this work, the appropriateness of our demonstration, and the importance that it has for our relations with the American people and to show how Lafayette's country, *patrie*, has remained faithful to her ancient traditions. It is a patriotic work, one having as its object the honoring of the glorious memory of our fathers and tightening the links uniting us to our friend nations; [this work] calls for the interest of all those who desire that France has the first place among the memories and affections of the United States.
>
> Our cities, our societies, our industrial establishments, our big commercial houses will care for the honor of figuring on the lists to be sent to America.[5]

The letter was accompanied by a booklet of forms, which the union's friends were asked to circulate so that interested parties

could write their names on them and indicate how much money they were willing to donate. The filled-out forms were then collected and sent to the union. We don't know to whom Laboulaye addressed his letters, but they were probably the same people and organizations that he described as wanting France to have "first place among the memories and affections of the United States," namely chambers of commerce (which Laboulaye sometimes called "cities"), "societies, our industrial establishments, our big commercial houses." There was nothing really surprising about Laboulaye's bold decision to approach the world of business. After all, the union's calls for donations had already trumpeted how the statue could be used to advance the interests of French merchants in America. Indeed, one wonders why Laboulaye did not do more to highlight the nature and the extent of those interests. It seems that all that concerned him at the moment was to stress that expanding French commerce in America was a patriotic, noble act. The statue, consequently, was "a work of patriotism."[6]

Clearly, something had changed in the union's agenda since September, when a *Liberty* emerging from the waves had been sponsored not just as a sepulcher memorializing Franco-American losses during the Revolutionary War, but also as a cosmopolitan icon of international commerce. And it is ironic that, of all the union's members who could have penned the patriotic appeal to French businessmen, Laboulaye was the one who did it. In 1861, he had republished Benjamin Constant's essay "De l'esprit de conquête et d'usurpation," the main goal of which was to demonstrate that commerce and credit protected the citizens by making government "dependent" on their money.[7] Slightly later, Laboulaye had agreed with Benjamin Franklin that "restrictions to liberty of navigation and commerce will never give an advantage equal to the damage that they will cause."[8] But that was before protectionist Prussia had humiliated France and the emperor had celebrated its triumph by erecting a patriotic statue rivaling Bartholdi's New York lighthouse in height and colors.

Now, Laboulaye was clearly struggling to remain truthful to his former cosmopolitan ideals. For how could one believe Constant's earlier dictum that commerce had united nations and uprooted patriotism when powerful and colossal statues of national suprem-acy were sprouting across Europe?[9] Even where metallic colossi had not yet sprung up, such as in Britain or America, govern-ments and merchants alike were increasingly viewing commerce as a vehicle for conquest. The French, according to Forney, were among the few who so far had abstained from this mercantile war, not because they were morally superior, but because France had "not been a successful colonizer," nor had "her people been eager and steady emigrants." France—Forney concluded—had "contrived and invented, and waited for her customers to come to her." Because this situation had given excessive power to "middle-men" and added an "extra charge" on French articles, Forney explained, creating a direct commerce with America was a way "to change this localism by opening a market where she [could] meet her competitors face to face."[10] What Forney did not say, however, was that, in the present situation, it was almost impos-sible for France to meet its competitors face to face, for at least two reasons. One was that America was levying heavy tariffs on most French merchandise; the second was that the United States was smuggling its own products all over Europe through "England, Germany and Belgium" by taking advantage of these countries' commercial openness with France.[11]

Given the situation, it is easy to understand why Laboulaye came to see the expansion of French commerce in America as a patriotic enterprise. Indeed, any agreements between France and America that promised to lower American tariffs and limit American smug-gling would help France. One might even wonder whether the union already had an agreement in mind while collecting funds for the statue. The answer, as later chapters show, is encrypted in the giant's skin. To find it, one should start from the skin's metal-lic nature.

The choice of copper as the medium for the statue's external shell had commercial implications. Of course, there were technical reasons for making the statue in copper. Viollet-le-Duc and von Bandel had both used it to build their colossal statues—the *Vercingétorix* and the *Arminius*—because it was a light metal that suited colossal proportions and could be easily put in shape around a metal core. In certain circumstances, it even allowed embossers to copy the features of a small model onto a large statue without relying on a full-size plaster cast.[12] But commercial reasons were in play too, and the member of the union who most eagerly championed these reasons was probably Bartholdi's cousin, Charles-Frédéric Dietz-Monnin, "the chief of the manufacturing interest," as Forney had once called him.[13] A clockmaker, Dietz was the president of the Chambre syndicale de la quincaillerie, a position that gave him much prestige and a wide perspective on France's industrial sector. This might explain why, in 1875, he was among the few union members planning to go to Philadelphia, and his reason to embark on such a long journey was that he wanted to investigate American watch-making, which was said to be much more advanced than the French one and "impossibly" cheaper. Dietz-Monnin's answer to the American threat was to build cheap watches himself—"democratic watches" as he called them—but to make them elegant, by adding, for example, a layer of golden paint. Yet there were still obstacles to overcome in order to accomplish Dietz-Monnin's plan. Besides American smuggling activities in Europe and the high tariffs that were protecting U.S. merchandise domestically, Americans recently had become the main providers of copper to an ever-expanding world market.

Indeed, copper was a key industrial metal in the late nineteenth century. It was used in the manufacture of not only watches, but also boilers, sugar and alcohol distillers, nails, screws, pins, locks, lamps, gauges, and of course telegraph wires, one of the principal tools of globalization itself at the time. Only slightly less conductive of heat and electricity than silver, but much cheaper, copper could

be easily drawn into pipes and wires—quite beautiful wires, in fact, with nuances of burnt red that jewelers in Saint-Denis, Paris, had discovered already in the 1840s. In the 1850s, Charles Laboulaye and his colleagues had produced characters cast with new alloys that included higher proportions of copper. Édouard, too, participated in the general enthusiasm. But he channeled his passion for copper into his fables. For example, one fable describes a poor, industrious, but unlucky farmer who visits Destiny only to discover that it changes its status every day: one day its house was a "magnificent palace" and its chest was filled with gold; another day Destiny lived in an "ordinary house" and the chest was filled with silver; on yet other days, the house was "a wretched hut," with wooden chests filled with pebbles and copper. The laborious farmer was clearly born in the day of copper, the metal of the poor and the industrious on their way up in life.[14] No wonder that the Statue of Liberty, which represents the initiation and resurrection of the people at large—but particularly the "plebs" addressed by Orpheus or Christ—was to be made in copper.

As modest as copper was, the growing demand for transmission cables had nonetheless pushed its price sky high, at least until 1872, when the copper price started plummeting worldwide.[15] The drop was an effect of the worldwide panic triggered by wars (the Civil War in America and the Franco-Prussian War in France), speculation, and European rearmament, but most of all by the exploitation of yet new copper reserves on Lake Superior, in Michigan. During the American Civil War, the union had used most of the copper reserves of Copperopolis, California, but the brand-new Michigan mines could supply copper enough for cartridges, rifles, cannons, and sheathing for ships.[16] Americans protected their new copper reserves by taxing imported copper with high duties, and owners of mines discarded excess copper in the lake to keep prices elevated.[17] Still, the downward trend of copper prices was almost impossible to stop, and the French thought they could take advantage of it.

Plausibly, Bartholdi had caught a glimpse of this situation even before the union decided which material the statue should be made of. Some of his Bostonian friends, beginning with Longfellow and Appleton, were indeed friends of businessmen who had invested heavily in Michigan copper, like Louis Agassiz's son Alexander, who had recently become the director of the Calumet & Hecla mines. Perhaps while conversing with Longfellow in front of a roaring fire (or the sea), or maybe while riding home on Appleton's carriage, Bartholdi had learned that Michigan copper was one of those commodities that could be helpful to France and should perhaps be a part of a renewed Franco-American friendship. For in contrast to the United States, France had no copper reserves (with the exception of some deposits in the Vosges, which lent the mountains the reddish tinge Bartholdi loved so much). French manufacturers (Dietz included) had imported copper from Russia until 1861, when the emancipation of the serfs had destroyed the market and forced France to rely on Chilean and Bolivian copper imported by British middlemen.[18] By the time Laboulaye reached for his pen to draft an appeal to France's business community, French copper manufacturers had come to resent British media-tion even more than American tariffs, and as passionately as Ger-man military expansionism. For them, there was no question that emancipating French copper markets from British involvement would be a patriotic mission.

Laboulaye's patriotic invitations, then, were probably meant to appeal to France's deeply nationalist copper magnates. One of the most famous was Léon Estivant, the owner of a plant in Givet, on the border between Belgium and France, which produced copper sheets and pipes for the shipyards in Le Havre and other entre-preneurs in France. In 1860, Estivant and the caster Émile Laveis-sière (whose foundries at Saint-Denis had produced the cannons for the siege of Paris) were the only two industrialists to be inter-viewed by the Conseil supérieur de l'agriculture, du commerce et de l'industrie over the advantages and disadvantages of a free-trade

treaty with Britain. Estivant was not a free-trader, but neither was he a protectionist. He was a "resignée," as the future prime minister Jules Simon would define people like him, that is, a businessman asking for a reduction, rather than the drastic abolition, of tariffs.[19] Personally, Estivant preferred to describe himself as a "patriotic and not a selfish industrialist," one who resisted the British monopoly on world copper by emulating its industrial techniques. The British metal magnates, Estivant had once explained, regularly "met and agreed [on] policies from which none of them has to depart." One of their most successful methods, he argued, was to combine casting and rolling operations in one establishment, so that they could control the price of copper by adjusting quantities of one or the other. The result was clear for all to see in French ports, where British boats, loaded at Swansea, delivered cheap copper from Le Havre to Bordeaux.[20]

But Estivant did more than simply emulate the enemy. In 1858, he bought the Clarke mine and the Bells mines, in Copper Falls, Michigan, where, as Alexander Agassiz once described it, "the metal is found in its native state, scattered through the rock in small particles, and less frequently in great tangled masses."[21] Indians treated these pieces of copper as benign divinities that kept their waters filled with fish and guarded them with sirens and other magical beings. These presences probably escaped Estivant, who managed the mines from his office on avenue de l'Alma in Paris and through the aid of a local agent, Fred W. Nichols.[22] We don't know when Laboulaye's letter reached him, but we do know that, on October 10, 1875, Leon Estivant sent a first donation of a thousand francs to the Franco-American Union.[23]

It was a sign that Laboulaye had struck the right chord, and other encouraging signs would follow. Indeed, even before Estivant's donation reached the union, another big name in the copper sheet business, Pierre-Eugène Secrétan, also decided to help. Not much is known about Secrétan, except for his tremendous influence on the Franco-American Union and the building of the statue. He was

born in Saulx, in the Haute-Saône, in 1836, the son of a master road-mender and a (not otherwise known) woman named Françoise Drouhin.[24] In 1886, by the time the statue was being inaugurated in New York Harbor, Secrétan would be celebrated as the man who had "transformed the copper industry and conquered France's supremacy in this field, where she used to be England's tributary."[25] Mystery still shrouds the beginning of Secrétan's astonishing career, except for the fact that, at thirteen, he helped his mother in a copper factory as an apprentice.[26] It is sometimes suggested that his marriage to Cécile Overnay, the daughter of an officer at the Ministry of the Navy, might have encouraged him to use his ability with copper works for military purposes. Whatever the case, in 1869, Secrétan opened a huge copper and brass mill a few miles northwest of Paris, in an industrial district of Sérifontaine, surrounded by low hills, the Epte River, and the Paris-Dieppe railway line. Some years later, to meet growing ministerial demand for munitions, Secrétan opened a second mill in Castelsarrasin, near Toulouse, to produce brass plates for bullets, along with copper sheathing for ships and trains, alambics, tubes, and tin foils.

When Laboulaye's personal call for funding reached Secrétan, he was in the middle of negotiations to merge his business with that of another famous metal magnate, Émile Laveissière, who sold both copper ore and metal, smelted in his Saint-Denis and Petit-Poigny foundries, near Paris, and in his Deville-les-Rouen foundry. As a typographer who used to cast his own type from copper, tin, and other metals, Charles Laboulaye had been a frequent visitor of Saint-Denis foundries, of which he had fond memories: "on every door," he recalled, "you would see the address of a printer, an engraver, and an enameller," all of whom were busy creating precious and costume jewelry.[27] Both Secrétan and Laveissière were planning to sail to Philadelphia: one to exhibit "the specimens of his work" in brass and copper inside "an exceptionally elaborated pavilion"; the other as a member of the organizing committee.[28] It is easy to understand, then, why both of them were drawn into the

union's cause. Nineteen days after Estivant announced his donation, the *Courier de France* reported that "a major metals industrialist" had "offered, by way of donation, all the copper necessary for the casting," roughly "27 tons." For mysterious reasons that soon will become apparent, the newspaper was not authorized to reveal Secrétan's identity at the time. But Bartholdi knew very well who the new benefactor was. In fact, he went to see him in person, in part to warn him of just how big an expense he would incur:

> I have to warn you, sir—Bartholdi said—that the statue will measure 27 meters.
> So what?
> This means that 27 tons of copper will be needed; in other words, this will be a gift fit for a prince . . .
> I am not a prince—the industrialist replied, smiling—but I love liberty, I love America and, being able to do it, I want to show that a Frenchman can rival the Americans in patriotism. I am standing by my donation. On one condition: I ask that you do not publish my name in the newspapers.[29]

Secrétan's donation was worth an astonishing fifty thousand francs—a nice stroke of luck for the committee, but also a curious move from an industrialist who did not want to use the donation to advertise his name in France and America. The union, however, did not seem suspicious. Now that the lords of metal were on board, it was time for the next steps. Bartholdi had to make the very last, definitive maquette of the statue to present to the public at an official dinner, and Secrétan had to find the copper to roll in his mills.

CHAPTER 22

OPEN TOMB

O<small>N</small> N<small>OVEMBER</small> 6, 1875, about two hundred formally dressed gentlemen gathered in the foyer of the Grand Hôtel du Louvre, which was famously owned by a syndicate led by the Péreire brothers. In the dim light of the hotel's luxurious dining room, Laboulaye sat "at the head of the high table," where Lafayette's and Rochambeau's nephews cordially made conversation with President of the Republic Patrice MacMahon, Bartholdi, John Forney, Elihu Washburne, the American minister in Paris Robert S. Schenk, the American minister in London, and the life senator and free trader Jules Simon, along with the French ministers Léon Say, Henri-Alexandre Wallon, and Alfred de Meaux. The remaining members of the union were sitting at the other tables, where they played host to personalities from the worlds of theater, politics, literature, and finance. Among the most illustrious guests, journalists spotted the director of the Paris Opéra, Olivier Halanzier; the director of the Comédie-Français, Alexandre Dumas; the musician Jacques Offenbach; the Milanese banker Enrico Cernuschi (cofounder of the Banque de France in 1869); and the baron of Soubeyran, deputy governor of the Crédit foncier (the bank of Laboulaye's old-time friend Louis Wolowski and the Péreire brothers).[1]

Under the soft lights, guests waited to be seated in the hall of ceremonies, where the first bronze copy of the Statue of Liberty, the famous six-foot "Committee Model," was to be unveiled. It was not the statue that Bartholdi had sketched in preparation of the Centennial upon his return from America. This bronze version

remained a severe lady, but her body was straighter: she still held a copy of the Declaration of Independence (dated JULY IV MDC-CLXXVI) under her left arm, while broken chains lay at her feet. But she was crowned with a star now, a diadem bearing seven long, pointy rays (seven being the cords of Orpheus's lyre, symbol of cosmic harmony) from which two sacred bands hung, as if she were a priestess of Isis, Ceres, Venus, or Bacchus. Gazing straight into her observers' eyes, with a long, proud neck, her eyebrows were lowered to indicate sadness, while her mouth, short and firmly closed, denoted determination, but perhaps also repressed rancor. Any suggestion of movement had now disappeared from the upper part of her body, but with her left hip slightly higher than the right one and a little twisted, the statue was still showing some of the eroticism of her older sisters.[2] Yet for some curious reason, the statue's rigid and severe bust overshadowed the eroticism of her posture. Not even the statue's dress helped to highlight her feminine grace. Sure enough, her cloak could be a woman's *palla*, the shawl that Roman women would wear over their chitons. But Bartholdi draped both layers of cloth around the statue so as to cover most of her body, like Scheffer had done with his Christ's attire, particularly in his *Christ Rémunérateur* and the Christ tempted by Lucifer.

The similarity between the statue's latest model and Scheffer's sculptures of Christ probably went unnoticed, even if a careful reading of the union's advertising from 1875 should have revealed the existence of a link between Christ and the New York lighthouse. More likely, the attention of the people sitting at the Louvre, on that night of November 6, was drawn to symbols that the union's advertisement had not mentioned. The torch and the tablet of the Declaration seemed straightforward: there was nothing more transparent than a light and a book, or a tablet, as a metaphor of wisdom and "faith." One of the most common dictionaries of icons ever used by artists, Cesare Ripa's 1593 *Iconologia* represented knowledge as:

a young lady in an obscure night, dressed in turquoise; in
her right hand she holds a lamp filled with burning oil, and
in her left a book. She is young, because she dominates the
stars, that do not make her grow old, and neither do they rob
her from the knowledge of God's secrets, which are alive
and eternally true.[3]

Ripa's turquoise young lady was obviously Venus, the starred god-
dess who led men to God through the admiration of beauty; Venus's
book was the Bible; and the lamp was "the intellect's light, which,
thanks to God's particular gift, burns in our soul without getting
consumed."[4] Ripa specified that faith, too, could be represented in
the same way, because one had to love God in order to know God.
Union members had already hinted at the similarity between the
statue and Venus, so their friends were probably not surprised to see
that Bartholdi's bronze model had all the attributes of the Renais-
sance symbolism of knowledge-faith-love.[5] All except one, for her
book was not the Bible but the Declaration of Independence. For
Laboulaye, the Declaration was the manifesto of America's capacity
to make individuals free, while keeping them spiritually integrated
into their own nation. As for Bartholdi, his political allegiance with
the Alsatian movements clearly inclined him to see the Declaration
as a document of national independence and armed resistance. In
an era of rising nationalism, their two visions were starting to blend.
Still, those present may have had some doubts as to the real meaning
of the revelation that the statue clearly was promising.

Another complication arose from the diadem resting on the stat-
ue's head, under its rays of resurrection. France had finally become
a republic, like the United States, but it is possible that the union
had decided to be purposefully ambivalent and let the statue be an
icon of republic and monarchy alike, for at least two reasons: first,
because Laboulaye thought that the American republic was a mon-
archy in disguise; and second, because the United States was not
yet a republic when the Declaration of Independence was signed,

and France had been a monarchy at the time of the Revolutionary War. After all, the name of the statue was Liberty, not Republic, and liberty, the wise Pazza explained in one of Laboulaye's fables "King Bizarre and Prince Charming," "is like sunshine."[6]

Laboulaye had once claimed that the sun of liberty shone in America and France alike, despite their institutional differences. Yet one wonders how many among those present were aware of the subtle links connecting the statue to Laboulaye's writings. Laboulaye's works had been published and republished in America and France to the extent that probably at least some of the union's friends were spontaneously able to connect the statue to Daniel Lefebvre's magnetic journey to Massachusetts (where a star shining in the dark prophesized a French rebirth in America), or with Laboulaye's *History of America*, in which Franklin supposedly interpreted the rising, apocalyptic sun on Washington's chair as a sign of America's future ascent. It is significant, however, that when his turn came to take the floor at the end of the dinner, Laboulaye tactfully avoided any reference to his own works.

As for Bartholdi, he kept a surprisingly low profile at the dinner. Forney recounted that the Alsatian artist had worked tirelessly behind the scenes along with the international lawyer Coudert to prepare the event, but when it came to mingling, Bartholdi let Laboulaye do the honors.[7] The organizers might have thought that Bartholdi's English still was not adequate for an international dinner, but his silence meant that most of those present would remain ignorant of the statue's Alsatian background. Laboulaye cavalierly suggested that Bartholdi's work on the Belfort *Lion*, an icon of French revanchism against Germany, had shaped his conception of the statue. But this would not have been sufficient to clarify the complex links connecting the Statue of Liberty to Alsatian history and ambitions, if Bartholdi had not found himself other, more powerful means to do so.

ONE OF THESE MEANS WAS Bartholdi's allegiance to Freemasonry. A year before helping Forney and Laboulaye set up the Franco-

American Union, Bartholdi had been initiated to the mysteries of the Lodge of Alsace-Lorraine. He documented the moment in a curious scene in clay. It showed a room with a domed ceiling and three figures inside. In the middle stood a man dressed as a pharaoh, his arms crossed over his chest, while two men, one on either side of him, spoke to him. On the left, as seen by the viewer, an old, bearded man, dressed in medieval costume and with a soft cap on his head, holds a scroll and explains the symbols inscribed on it, pointing a finger at what seems to be a particularly important point; on the right a kind of pageboy wearing a medieval-style cap and with a snake beneath his feet holds a book under his arm and gestures as if to be more persuasive. Above the pharaoh, a star rises from the skylight, surrounded by rays of light, while two columns separate him from the other figures; one column is topped by an ibis (a symbol of Thoth-Hermes, the Egyptian priest) and the other by a statuette of Isis crowned with the diadem of Horus (a sun between two ox horns) and a baby on her lap. On the left a third, lower column culminates in a sun, under which a medieval pageboy holding a book reads the bearded man's scroll.

One way of interpreting the niche is to identify the medieval pageboy as Bartholdi, and the older man showing him the scrolls as a Masonic initiator. If so, the scene is the only surviving document of Bartholdi's initiation to Freemasonry, which must have taken place at some unspecified moment in 1874. The Lodge of Alsace-Lorraine, where Bartholdi was initiated, has an important history. When the Germans annexed Alsace, the kaiser ordered all the Masonic lodges in Alsace-Lorraine to break their ties with the Grand Orient de France and join the German grand lodges. Instead, the Masonic patriots of Alsace and Lorraine gathered in Paris to form a single Alsace-Lorraine Lodge, under the protection of the Grand Orient.[8] It was a peculiar association and its radicalism aroused suspicion within the Grand Orient itself from the very start. "What kind of institution—free, religious or other—is it that has made such a gesture after the war?" was the question on everyone's lips among the French Freemasons. The question was legitimate,

because it was above all a shared grief for their lost homeland and the desire to win it back that united the patriots and revanchists who had come together to form the Alsace-Lorraine Lodge.

Revanchism was still alive and well in the lodge in 1874, and Bartholdi's niche included some hidden references to it. Behind the story of the pageboy reading the scroll from the older initiator, for example, lay another, more profound tale, one taken from Exodus. It was the account of how Aaron helped Moses, who was "slow of speech, and of a slow tongue," to convince the pharaoh to allow the Jews to leave Egypt.[9] Doing as Moses told him, Aaron threw down his staff, whereupon it became a snake, like the one beneath the feet of the pageboy depicted on the left side of the clay room, while the idol of Isis, which towers over him from the top of the column, seems to foretell of Aaron's future fall into idolatry, when he showed the golden calf to the Hebrews in Moses's absence.[10]

Bartholdi may very well have depicted himself as Aaron (with a solar symbol evocative of the Bartholdi coats of arms on the lower pillar next to him) and an older Freemason as Moses. As for the figure of Isis, it could allude to Aaron's idolatry, but it could also stand for something more intriguing, either the Masonic conviction that Moses was an adept of the mystery cults of Isis, the goddess of the "ancient fire," or the biblical tale of Exodus, in which God guided Moses "by night in a pillar of fire" away from the Egyptians, into the land of liberty.

Bartholdi only alluded to Moses's association with Isis without making explicit her connection with the sacred fire of national liberty. But fire was already a recurring theme for Bartholdi, and it became even more important during his collaboration with Laboulaye on the making of the fellah Statue of Liberty. Laboulaye may have told Bartholdi that the biblical and Masonic iconology associated with Moses was applicable to both "hemispheres": in the "Orient," where France was expanding its "nation" in Egypt in a new rivalry with Britain, as well as in the West, where the French were trying to reclaim their lost influence on the New World after

having helped it become free from colonialism. The question here
is whether Bartholdi's initiation into the patriotic Masonic lodge of
Alsace-Lorraine had persuaded him to turn the statue's fire into a
symbol of Alsatian and French independence from the Germans.

Many later observers thought just this. The Cuban indepen-
dence fighter José Marti, for example, would genuinely be con-
vinced that Bartholdi's monument in New York was a sorrowful
virgin, "every inch" of whose body was crying "Alsace! Alsace!," for
what she wanted most was "to demand Alsace back for France rather
than illuminate the freedom of the world."[11] But as we know, things
were not that simple. The Statue of Liberty was the fruit of an
eclectic project, one meant to celebrate American independence,
the Franco-American allegiance, the Civil War, the abolition of
slavery, universal education, and moral regeneration all at the same
time. But Marti saw something that would escape many critics ever
after: the statue's promise of regeneration included the promise
of its enemy's ruin. Until this point, Bartholdi's design to fill his
statue with anti-German meanings had remained between him and
Laboulaye. Now, finally, he could make his intentions public.

AT THE LOUVRE ON NOVEMBER 6, 1875, Bartholdi made sure
that the atmosphere was infused with mystery. In the middle of
a long shelf that ran along the wall, under a decorative canopy,
there rested a cube. Seen from afar, it might have been an ancient
sarcophagus or a Christian altar. But above it hung a sheet of
transparent paper with a large drawing on it. According to French
journalists, it showed a "colossal monument that will stand at
the entrance of the harbor" in New York; according to English
reporters, one could see "the arms [sic] of the statue . . . emerg-
ing from the waves of the sea."[12] In both cases, the scenographic
arrangement was meant to evoke a scene of rebirth. If only the arm
was portrayed on the sarcophagus, it is possible that Bartholdi was
trying to refer the public to his *Voulminot* monument, the morbid

tomb from which the arm of a resurrecting victim of Germany's 1871 invasion was portrayed grasping for a sword. Whatever the case, the glossy display, suspended as it was over the fake sarcophagus-altar, must have made quite an impression and certainly evoked biblical scenes of resurrection. And this impression was probably made all the more dramatic by the fact that, behind the image, a light made the rays of the crown (or of the torch) shine like a sun in the night.

The *Times* was intrigued. It jeeringly commented on the "great figurative role" the statue's arms played at the banquet, plastered all over the invitations and menus.[13] The choice was easy to explain in light of the union's latest decision to send only the statue's arm to Philadelphia. But the English journalists hinted at another, more occult explanation, one having to do with the union members' connection to Freemasonry. Their intuition was well grounded: everything at the Hôtel du Louvre on that evening of November 6 spoke to the union's allegiance with Freemasonry. Indeed, it was impossible to walk into the hotel that night without having the uncanny sensation of entering a Masonic meeting preparing for some future initiation. But initiation to what, exactly? For obvious reasons, Bartholdi had decided to give a prominent role to his own lodge, that of Alsace-Lorraine, the logo of which (already engraved on the tomb of Bartholdi's father and on the lock of the old wooden box given to him by his Parisian relative Madame Sohenée) could now be seen on the menus and the sarcophagus-shaped base of the statue's depiction: two hands clasped in sign of friendship above a six-pointed star (the famous Star of David, or hexagram), everything surrounded by "flaming" solar rays. The variation from the symbol of the Alsatian lodge, where the hands were framed inside the star, was so subtle that few among those present probably realized it.[14]

As we know, it is quite possible that Bartholdi had the history of the Jewish exodus in mind ever since he first sketched the fellah for the pasha. Yet never before November 6 had he exposed such an association to the public; never before had the union's friends seen the statue side by side with Jewish symbols. The connection

was clear for all to see: with a star crowning its head (and despite the star being seven-pointed rather than six-pointed), the statue was either Moses following the fire of God into the promised land or David himself, the warrior king, proud after conquering Jerusalem and gathering the Jews under his wisdom and laws. We will later see how the statue, who represented a civilizing poet-priest like Orpheus or some other divinity of revelation, could be also be seen as a warrior, hiding its weapon from the viewers' sight. For now it is enough to know that, for Bartholdi and other Freemasons of the Alsace-Lorraine Lodge, Israel was France and Moses's people were the Alsatians. But what about Laboulaye and the non-Alsatian members of the Union? For they too had an enemy . . .

CHAPTER 23

CHILDREN'S TORCH

THE *TIMES* JOURNALISTS were deeply intrigued by the dinner at the Hôtel du Louvre. So they did some digging and found out that Laboulaye and his friends had started the funding campaign for the statue immediately after the "the first committee appointed to make arrangements for the Philadelphia Commission had finished its work."[1] The *Times* sarcastically pointed out the coincidence, but the union had never made a mystery of the ties linking the statue to the Centennial. On the contrary, it had continually advertised them. The night of November 6 was no exception. The soirée began with the public reading of "the cable dispatch to president Grant that Frenchmen of all parties had joined their American brethren in their hearty preparations for the Centennial year."[2] The cable's text has not survived, but we know that Laboulaye had written to Grant two weeks before the gala at the Louvre, on October 26, 1875, to recall the visit that Bartholdi had paid him in 1871 and to remind Grant that he had then pledged to submit the subject to Congress."[3] Because neither Grant nor the union had done anything on that front yet, one can guess that both Laboulaye's telegram and the union's general insistence on the kinship between the statue and the Philadelphia Centennial were meant to encourage the president to make his necessary appeal to Congress.

Had the *Times* known about this background, it would have probably been less surprised to see that, on the very night of November 6, Mr. Owen himself, the British executive commissioner in Philadelphia, took the floor to give all those present the news "that

the most liberal concessions had been made for foreign exhibi-tors at the Centennial," or to hear Forney say that the French participation in the Centennial was an "occasion to give a new direction to commercial relations, the inevitable result of these fantastic influences that ceaselessly tend to re-approach these two remote worlds" of France and America.[4]

The statue, in other words, was the envoy of a specific French movement asking for the liberalization of Franco-American com-mercial relations. The guests sitting at the banquet were offered a taste of this future alliance: the restaurant's chefs had done their best to give a practical example of how French ingredients, and especially French wine, might improve American cuisine. They tried to surprise the guests with dishes that evoked the longstanding friendship between France and America: "croust-ades à la Washington," lamb chops accompanied by French *petit pois* (the former fittingly evocative of the Jewish exile and Passover), but also pan-fried chickens from Carolina and "veal filets Lafayette." Fine Bordeaux flowed freely from small carafes, while Haut-Sauterne and Cos d'Estournel 1865 accompanied the main dishes.[5]

There was apparently nothing in the hermetic statue shining on its Masonic altar at the end of the room that, by itself, spoke for that mundane world of wines and braised meat. If anything, the transparency of the statue recalled images of death and resur-rection. Later, however, when the statue would start taking shape in the Monduit workshop in Paris, all red in her copper garb, her connections with the French winegrowers would become clearer. For red was the color of grapes, but also of the ancient statues of Dionysus, the plebeian god of wine mysteries whose followers had killed the aristocratic Orpheus. As for copper, it was, in addition to being democratic, a kind of "medical" metal at the time: French wineries were using it, with lime and water, to cure their vines of certain fungal diseases (like oidium), which most probably had reached Europe from the other side of the Atlantic. Much like cop-

per could cure France's vines, in short, it might also cure France's relations with the United States.[6]

For obvious reasons, none of the speakers that evening mentioned the embarrassing subject of oidium (or of the equally threatening pest phylloxera), not even Lagorsse, the union's treasurer, who was already envisioning a future in which France would be forced to import grapes from Algeria, where the dreaded pests and fungi had not yet arrived.[7] But it is also true that, after the introductory remarks and Forney's words on Franco-American economic collaboration, it became clear that not all those present considered the statue a pure symbol of international commerce. Indeed, some of them thought that it also reflected a special way of thinking about French internal politics.

Laboulaye was one of the most notable representatives of this approach. Writing to President Grant two weeks before the party, he had confessed that the "manifestation" of enthusiasm raised by the statue was meant to reinforce ties among liberals in France and "fortify us [the liberal party] in the work of regeneration which we endeavor to accomplish in our country."[8] The statue, in other words, was intended as a political device, an oriflamme, to reinforce Laboulaye's construction of a new liberal party in France, one offering an alternative to the autocracy of the Right and the communism of the Left. Since few speakers took the floor at the Hôtel du Louvre that evening, it is difficult to say how many in the union shared Laboulaye's commitment to this project, and to what degree. But judging from the recorded speeches, most union members were aware of Laboulaye's intention to use the statue as an instrument of liberal propaganda in France, and supported that approach. Take, for example, Henri Martin, the only other Franco-American Union member (beside Laboulaye) invited to give a speech that night. Without being as explicit as Laboulaye had been with Grant, Martin tried his best to prove that the statue could be used as a sort of manifesto of French liberalism. First, he stressed how the newly born French Republic had deep ties with America.

These were not racial ties, of course, because the Americans were Anglo-Saxons and the French were Latin, but ideological ones. "Ideas," he said, "had been common between us since the earliest times." The French were the first not only to translate those ideas into books, but also to "put them into practice in conditions that were less fortunate and more difficult" than American ones. Now, finally, the moment had arrived in which France could base "a free society" on those old ideas, a society "founded on justice and the respect of rights."[9]

Given the occasion, it was striking to see how little Martin talked about America. But the Statue of Liberty itself, he explained, was only half American: placed "at the entrance of the New World and turning towards the Old World," the statue raised "in the air its torch to give Europe back the light it had received from her."[10] Martin could not have been more explicit in his plan of using the statue and its symbolism as ideological platforms to create consensus in France. Laboulaye, as will become clear, would be even less subtle.

It was lucky that Elihu Washburne, who took the floor between Martin and Laboulaye, was a diplomat. For diplomats were less concerned with party logistics and could talk about subjects in more measured tones. That said, Washburne's talk also brought a gust of lively, anecdotal wind to the proceedings. Or at least this was his intention: because he spoke in English to a hall brimming with Frenchmen, his verbal peregrinations may have been lost to many. First, he brought his audience back to the time when Benjamin Franklin, Silas Deane, and Arthur Lee had proposed a Franco-American friendship to the French foreign minister Charles Gravier de Vergennes on December 23, 1776. Then he moved on to Franklin's sojourn in Paris, indulging in stories about his popularity with French ladies and his eccentric choice to never switch his "shad-bellied coat" from the "Quaker city of Philadelphia" for more sophisticated French fashions. At these words, guests must have turned their eyes towards Laboulaye. Wearing a Franklinian coat and with his long, thin hair falling over his shoulders

for the occasion, he had sought to present himself as the ghost of Franklin come back to bless the occasion. But Washburne continued his story to the time when "the martial spirit of France was ignited" and "armed men seemed to spring from the ground." In the sober silence of the Hôtel du Louvre, Washburne made the guests again hear "hammers close . . . rivets up," and "ring[ing] in the dockyards" by quoting a few lines from Longfellow's poem on the founding of the American navy:

What anvils rang, what hammers beat,
In what a furnace, what a heat.
Were forged the anchors of our hope![11]

For "the story-seeker" this was probably the most poetic, yet most obscure, moment of the evening.[12] It is hard to imagine most members of the audience knowing Longfellow's "O Ship of State," or being able to understand how courteous Washburne had been in turning Longfellow's patriotic hymn, originally meant to celebrate the work of American goldsmiths like Paul Revere, who had applied the first layers of copper to American ships, into a grateful homage to French shipyards. For it almost seemed impossible, Washburne commented, that "in so little time" France "had armed and put to sea sixty-seven cargoes, sixty-one frigates or corvettes, loaded with arms, provisions, the very best among French youth" to face waves and thunderstorms and "give a helpful and charitable hand" to their American friends.[13]

Read with the eyes of posterity, Washburne's message was more than a generous tribute. It also offered an insightful analysis of the statue's meaning and context, since the Statue of Liberty clearly was anchored in the world of navigation. Its raised arm was meant to look like a mast, and its dress like a sail, as if Bartholdi had sculpted his statue according to the ancient descriptions of Isis Pharia or Sea-Venus (Venus rising from the sea). Indeed, as those present would learn in later phases of the funding campaign, the very way

in which copper sheets would be heated in forges and hammered onto the statue's skeleton would come to draw explicitly on tested techniques of naval engineering.

As a diplomat, Washburne further knew something that would be wasted if revealed now, something related to the maritime interests connecting the statue to the world of banks, hotels, railways, and transatlantic trade. There was namely a deep financial link between the statue and the maritime companies, a link that eventually would help Laboulaye organize a successful funding campaign. When it was his turn to speak, Laboulaye shed little light on this, instead explaining once and for all in what sense a statue meant to represent American and French naval interests also could work as an icon of French liberalism. For this, ultimately, was the real conundrum.

Laboulaye began with Franklin: "with long hair, without powder, his dark costume, without stripes," he lectured, "Franklin was the most able among the diplomats; he very quickly gained the friendship of the French government, and not only of the government, but of the whole nation." Given Laboulaye's Franklinesque attire, the encomium sounded almost self-referential. What followed was even more so. Soon enough, Laboulaye turned to the topic of Franklin's friendship with Voltaire to tell the story of how, introduced to the American's grandchild, the old French philosopher had "put his hands on the head" of the boy and said: "God and Liberty."[14] One may wonder whether any of the American guests that evening knew that "God and liberty" had been the motto of Laboulaye and his liberal Catholic or Protestant friends for the preceding twenty years. If they did, it probably helped them make sense of why, throughout Laboulaye's speech, Americans were given credit mainly as the first to start the practice of liberty, with the implication that they drew everything else from earlier French examples.

Given Laboulaye's speech, a listener would also be forgiven for wondering whether his project grew out of his love of America or from his tangible rancor toward Britain. His bias may have been skillfully disguised in the first part of his speech, but it became impos-

sible to ignore as he moved back from the epics of the Revolution and cases of memorable Franco-American friendship (Franklin and Voltaire, but also Washington and Lafayette) to an earlier time, when the British had won the Seven Years' War and seized France's colonies in America. Laboulaye's story, which he said he had learned from Lafayette himself, went like this: the French army had just arrived on Rhode Island, and Washington was reviewing ships and crews in the region. Lafayette trailed the general's inspection tour and, when the general finished his job and decided to return to his quarters, joined him. In each village they passed, they found "children who walked with burning torches in front of processions." Washington put his hand on the head of one of these children and, turning to Lafayette, said, "The future is dark; I am not sure that we will make it; if we don't, these children will avenge us."[15]

One can only guess the impression that Laboulaye's anecdote made on the audience. Clearly, he was suggesting that the statue, too, with its flaming torch raised to the sky, represented some kind of future revenge. But what sort of revenge, and for what? Washington described the children's torches as emblems of the vengeance they would take against the British if the Continentals and their French allies failed during the Revolutionary War. But what was the sense of recalling Washington's promise of revenge once the war was over, and the Franco-American alliance had proven victorious? Laboulaye, of course, had his own reasons to resent the British, but he did not reveal them immediately. Rather he commented on Lafayette's story with a biblical metaphor that, despite subsequent rounds of applause, must have puzzled some of those present:

> After all this time, alas, we are looking for our promised land! The Jews were kept for forty years in the desert before entering into this happy place; as for us, who have been appealing to it these last eighty years, one can only hope we will get there.[16]

Laboulaye's comparison between the French and the Jews was particularly suited to the stars of David decorating the menus and the sarcophagus over which the transparency of the statue had been hung; it even resonated with the tasty lamb prepared by the hotel's chefs. Laboulaye may have used the Jewish experience as a metaphor for France's territorial losses to the Germans. But one could guess there was more to it, for when the time came for him to close his speech, he did not allude to the Franco-Prussian War: instead, because most of those present were already planning to attend the Philadelphia Centennial, he simply advised them on places to visit. It started as a form of neutral advice, but it ended with a political message. Indeed, Laboulaye's list included Niagara Falls, Canada, the Mississippi, St. Louis, and New Orleans, namely the places of the former empire that France had established and subsequently lost in America. The Nouvelle France, Laboulaye continued, was the region where 63,000 Frenchmen had lived before the British forced them "to abandon [their] possessions in America." Even if Nouvelle France was no more, Laboulaye continued, 1,200,000 French speakers now lived in Canada, since the country "has remained faithful to the memory of her motherland; she piously preserves its language, the laws and the customs; and yet you will see that the fact of being neighbor of America has given her the practice of liberty." Indeed, Canadians still had vivid memories of "our soldiers, our colonists, our Jesuit and Franciscans missionaries who bravely walked these solitudes while converting Indians," even discovering the Mississippi.[17]

Laboulaye clearly had difficulty concealing his bitterness. For him, France's expulsion from America was as tragic as the Jewish exodus from Israel. The Le Figaro journalist in the audience was shocked, not so much by the implausibility of the comparison, but by the ease with which Laboulaye celebrated the feats of France's monarchical era and the accomplishment of the Jesuits: Laboulaye's "more or less precise historical remarks," wrote the reporter, would be, "by sensible people, found to be of very bad

taste."[18] But Laboulaye continued unperturbed: those present—he said—should descend the river to St. Louis, "the third capital of the United States," originally founded by "us Frenchmen," or go even further down to "Nouvelle-Orléans," where "you everywhere will find the names of [the French explorers] Cavalier de la Salle and d'Iberville."[19] Then, perhaps anticipating *Le Figaro*'s criticism, Laboulaye claimed that the Franco-American Union's initiative was "not a matter of party," because it concerned both "the old and new France," the France of Louis XVI as much as that of the Third Republic.[20] Indeed, Laboulaye explained, nobody could deny that France's "old monarchy" had helped Americans win their independence at the exact moment it was dying out: like the sun, the French monarchy, cast "a last ray of gold and crimson in a milder sky."[21]

Laboulaye's words probably satisfied the lingering doubts of all those who wondered about the Statue of Liberty's monarchical symbols. For now, everything was clear: as one of the most time-sensitive icons ever built by man, the statue was meant to symbolize America's new hope at dawn and the fading glory of the French empire at dusk. It was a romantic idea, but it was also a wise political play, one meant to create a platform uniting republicans and monarchists, conservatives and progressives alike, around a project of mild internal liberalization and external expansionism at the expense of the British. For if Laboulaye had anything in common with the copper magnates who had contributed to the statue, it was a visceral hatred of Britain's colonial empire, and an equally strong desire to challenge it.

These shared sentiments were probably what had aligned Laboulaye with the copper magnates in the first place. As mentioned earlier, some of those magnates, like the Estivants, had their mines in Canada, which might explain why Laboulaye made so many references to that region in his speech. By the time Laboulaye was giving his talk, the Estivants had probably already started gathering the copper they had promised to the union. Later, at some point in 1876, they would send the third biggest shipment of copper

registered at Copper Harbor since 1845. Was it the copper for the statue? Because the Estivants' invoice gives no indication of the copper's recipient, it is difficult to prove that the cargo was meant for the Franco-American Union.[22] Odds are this was the case, however, since modern analyses of copper samples from *Liberty*'s upper body have found them to be rich in arsenic. Only certain mines at the time were extracting copper with this concentration of arsenic: American and French mines on Lake Superior, and the company of the Frenchman Ernest Deligny near Huelva, in Spain, which recently had passed into British hands and eventually would become the world-famous multinational Rio Tinto.[23]

As Estivant had lamented, most of the copper used in French rolling mills was British in origin. But one may surmise that, given the statue was meant to be a political manifesto as well, one assert- ing French resistance to Britain's financial expansionism across the world, the union had made an extra effort to keep British copper out of the mixture from which the statue's thin skin would be made. Indeed, various entrepreneurs had been seeking to eman- cipate France's industry from British mediation since at least the 1850s, with the most successful being the Péreire brothers, who were shipowners, founders of the Compagnie générale transatlantique, and owners of the Hôtel du Louvre where the November banquet honoring the Statue of Liberty was held. They had been loading their ships with American copper since at least 1856.[24] One way of triangulating the origins of the statue's copper, and answering whether it hailed from Michigan mines (or, even more precisely, from French mines in Michigan), would therefore be to demon- strate that the Péreires were directly involved in the funding of the statue. Their indirect participation is demonstrated clearly enough by the Franco-American Union's reliance on banks that were con- nected to the Péreires' enterprises, such as the Société générale, or by the simple fact that the dinner in honor of the statue was held in the Péreires' hotel. But, as soon will be clear, even more concrete evidence of the Péreires' relations with the union can be found.

Missing from the speeches at the Louvre was the interpretation of the statue as we know her today, Lady Liberty, the benign mother of exiles. Sure enough, Laboulaye alluded to her benign nature when he reminded the public that, because she was made of "Virgin copper" rather than with "cannons taken from the enemy" (like the German *Bavaria*), she was "the fruit of work and peace."[25] It was a statue of liberty after all, and, as previously mentioned, Pazza had claimed in Laboulaye's fable "King Bizarre and Prince Charming" that "liberty" was like "sunshine," because it was "the happiness and fortune of the poor."[26] This last remark was probably too democratic to be repeated at dinner, while the previous one simply was false, because copper was an important provision for the defense industry as well. But it helped impress upon everyone the idea that the statue was connected to peace and democracy, rather than to imperial expansion and military revanchism.

In fact, like Venus or any other mystical divinities representing death and resurrection, sin and sanctity (from Bacchus to Orpheus, from Demeter to Persephone), the statue was an icon of war and peace, revenge and absolution alike. We don't know which side of the statue's personality the Americans who were present at the dinner decided to endorse. Only Forney publicized his opinion, namely that the statue would soon be "the first object that will strike the voyager's sight after his transatlantic journey, and the last he will lose sight of to go to a far country." What would the statue's meaning be by then? It would become a "hospitable emblem for all those who [would] come to study our institutions, or spend their lives under our peaceful influence." Forney prayed, too, that "divine providence [will] preserve that emblem of peace among men until the end of time."[27]

CHAPTER 24

THE PHANTOM OF
THE OPERA

Subscriptions had started flowing into the Franco-American Union's coffers even before the banquet at the Grand Hôtel du Louvre. Newspapers reported most donations in francs: 1,000 from Le Havre, the port of departure for many of the transatlantic ships sailing for New York; 500 from the river port of Rouen, where bales of cotton were packed off to Le Havre for further shipment across the ocean; 500 francs from the Chamber of Commerce of Valenciennes, home of the famous Denain-Anzin steelworks; and 500 from textiles manufacturers in Lille (where the union's previous banker, Armand Donon, had significant financial interests). Along the Canal de Garonne and its tributaries that carried the wine of the Languedoc to Bordeaux, also an oceanic port facing America, lay the hub of Agen, which offered 250 francs. And, on the Rhone River—which flows from Switzerland to Marseilles (home of sardine packers exporting for American markets), passing through Lyon (a center of the silk industry and important bastion of the banker Donon)—the river port of Vienne, from which silks and agricultural products of the Rhone Valley made their way to the world, donated as much as 5,000 francs. Many traders donated individually, such as the tailor Dormeuil of Rubaix (500 francs), the Champagne producer Kinkelmann of Rheims (100 francs), and the chocolatier Menier, who used ultra-thin sheets of tin (made with the

same procedure that prepared the copper for the Statue of Liberty) to wrap his chocolates.[1]

To all these donors, who hailed from the world of industry and international business, one must add the Cincinnatis, led by the family Rochambeau, who gave more than 1,000 francs; the president of the Republic, who donated 1,000 francs for public as well as personal reasons (as mentioned previously, his wife was a descendant of the Franco-American hero De Castries); and the ministers, who gave 500 francs.[2] Joining forces with these specific business and government interests was a third group of donors consisting of cities that had received American funding during the Prussian occupation, such as Amiens (3,000 francs), Peronne (200), Lyon (1,000), and Vaucluse (200).[3] More donations were expected, but Bartholdi had no time to wait for them. He had to start working immediately if he wanted to present at least a piece of the statue in Philadelphia.

He thus installed himself in the rue de Chazelles workshop of Monduit, Gaget, Gauthier & Company, the casters who had been made famous by Viollet-le-Duc's rediscovery of the art of embossing on a large scale. Their workshop had already given birth to France's most famous statues in hammered copper, like Millet's and Viollet-le-Duc's *Vercingétorix*, and the three statues topping the newly inaugurated Paris Opéra: Millet's *Groupe d'Apollon*, and Charles-Alphonse Gumery's *L'Harmonie* and *La Poésie*. The general expectation in Paris was that the Statue of Liberty would show striking resemblances to these statues, because it would emerge from the same forges and under the skilled supervision of the same craftsmen. A journalist at the *Petit journal* had already warned the public that Bartholdi's colossal monument would be identical to Gumery's *Poésie*, a Roman matron crowned by a starry diadem, leaning on a long stick with a torch at its top and holding a wreath with her right hand, which still can be seen on the right corner of the Opéra.[4] This was an exaggeration; judging from *Liberty*'s maquette, the New York colossus would be less graceful and sym-

metrical than the *Poésie*; besides, Bartholdi had probably already found inspiration in Robert's Roman-like *France* at the entrance of the Palais de l'Industrie, which also exhibited a Roman tunic, the crown with rays, and a left leg that one could see bending under the thick tunic.[5]

But Robert's *France* was made in marble, the *Poésie* in copper; Robert's *France* represented national grandeur, while the *Poésie* represented poetry (or symbolic revelation) through the symbols of ancient mysteries (sun and torch) according to a pattern that was already familiar to Laboulaye and Bartholdi. Having been assembled by the same casters who were now building the Statue of Liberty, it is almost impossible that the *Poésie* did not attract Bartholdi's attention as early as the late 1860s, when he was working on his fellahs. One further element that invites such speculation is the fact that Gumery's earliest model showed the *Poésie* holding a book under her right arm, in a pose that closely resembles the one due to appear in the Statue of Liberty. If Bartholdi was ever tempted to give the *Poésie*'s imposing appearance to his own statue, he must have been reassured by the thought that Gumery's statue was a purely decorative element that, given its placement high on the Opéra's roof, would hardly attract the attention it deserved. We know for sure that, in actually constructing the statue, Bartholdi and his helpers at Monduit would straighten the statue's hips and make her position more rigid and imperial. The final effect was striking: dressed like a Roman matron, holding a torch in her hand and with a halo around her head, straight and severe in her stance, the Statue of Liberty would look like an enlarged clone of the *Poésie*, although the way she held her book rather evoked the *Harmonie* with Orpheus's cither under her arm.

In 1876, however, nobody could really tell what the statue would look like when it was finished. At Monduit's, the attention was still focused on the materials themselves. Secrétan had probably started rolling the metal sheets for the arm between September and November 1875, by relying on the provisions that either he or his

caster friend Laveissière had at hand. The copper they had in stock was almost certainly as impure as that which they were expecting from Canada, because Viollet-le-Duc had made a point of telling French artists and architects that impure copper was more resistant to rust and that it even gave an ancient patina to metalwork by recalling the materials used by medieval masters.[6] The Statue of Liberty would prove Viollet-le-Duc right; even today observers are amazed by the beautiful hues of its copper skin. As for Bartholdi, he must have felt reassured that his mentors' political friendships matched his artistic expectations so well.

But then another problem arose, namely that of planning the longer funding campaign in Paris after the end of the Philadelphia Centennial. For there was no doubt that the Centennial had been the most powerful force behind the union's ability to attract funding so far. But the Centennial would close its doors in November 1876, plausibly many years before the completion of the colossus. So the union had to find an alternative source of funds to complete the statue's lower body. To help in this effort, Bartholdi decided to invent virtual copies of the statue, not unlike those that he and the union had made for the dinner at the Hôtel du Louvre: luminous transparencies, smaller models, and logos, to which one could add lights and special effects, perhaps even scenographies. The basic toolkit for making these virtual copies of the statue was to be found in theaters, rather than in ateliers or studios, for scenographers were specialists in the art of giving life and reality to the ghostly. And Bartholdi didn't need a copy of the Statue of Liberty. He needed its phantom.

Jean-Baptiste Lavastre, the head set designer at the Paris Opéra, recently celebrated throughout all of Paris for his suspenseful staging of *Hamlet*, immediately set to work on painting "a panorama of New York city and Bedloe's Island." In the meantime, Bartholdi contacted the architect Charles Peignet, whom the Compagnie du Midi (a society co-owned by the Péreires) years earlier had entrusted to build a universal and permanent exposition at Auteuil. The project

had been dropped, but Peignet was still on good terms with the entrepreneurs involved in such exhibitions, and Bartholdi asked him to make "the hills on the foreground and the floating boats" for an emerging maritime panorama, very much in the style of those exposed at the Palais de l'Industrie in 1855 and 1867. Next Bartholdi needed "a plaster model of the statue." This he did not have time to make himself, so he asked Louis Villeminot, an assistant of Viollet-le-Duc, to make it for him. The result was beautiful, and the union suggested exhibiting it in the atelier of the Franco-American artist Narcisse Poirier, in boulevard de Vaugirard.[7]

In the meantime, Bartholdi had assigned Lavastre another job, namely to produce an eleven-foot-long canvas with glossy inserts of the kind that was used in theaters to simulate changes between night and day in dark environments. This time, however, the transparency showed an image of the statue on Bedloe's Island and, "in the background, New York, Jersey City, Brooklyn, and the Hudson and East Rivers."[8] It was a two-dimensional double of Miss Liberty, an icon that would precede the Statue of Liberty first in Paris—on stage, in conference halls, and at industrial exhibitions—and then in New York.

The image was first presented to the people of France on November 19, 1875 at the Palais de l'Industrie, the venue of the first French universal exhibition, where the stuffy old rooms were now hosting an international show of naval and maritime industry, mostly sponsored by the Compagnie Maritime, over which the Péreires had reestablished control after the crisis of the late 1860s.[9] As a background for the Statue of Liberty, it was picture perfect. The exposition had opened its doors in July, four months before Lavastre completed the simulacrum of the statue, and visitors were still pouring in in large numbers. There were days when ticket vendors counted sixteen thousand visitors.[10] Given that the Franco-American Union had decided to charge five francs per ticket to see Lavastre's effigy, listen to the old poet Taillade read his composition for the event, and watch a show of naval signals and fireworks, this

meant that, on a busy day, the union could gross as much as eighty thousand francs.

Lavastre's canvas hung in the central hallway—the same hallway where, twenty years earlier, the lighthouses and giant glass windows of Saint-Gobain had been exhibited. The space had always been criticized for being too dark, but it was the perfect venue in which to replicate the Statue of Liberty's radiant halo, simulating the mythical metaphor of initiation and resurrection while alluding to the astrologic expressions of Venus and Isis as "morning stars" guiding lost sailors across the sea. A pretend seascape unfolded all around the canvas, with rocks and streams, and among them "ships of every size . . . optical and maritime instruments, every kind of glass product, various copper objects." Surrounded by real and model ships, the glimmering icon of liberty looked like Venus, the bright star of navigators worldwide, which the ancient Egyptians identified with Isis-Sothis and the Christians with the Virgin Mary, the "Stella Maris." But, as should now be clear, the links between the Statue of Liberty and the world of maritime industry were not purely symbolic. Indeed, explicit connections were scattered throughout the exhibition. The most evident clues were to be found among the copper instruments surrounding Lavastre's transparency. Resistant to corrosion, and toxic enough to reduce incrustation (therefore increasing the ship's speed), copper was one of the most promising materials for ship builders all over the world. During the decade leading up to the Centennial, French naval engineers had been particularly insistent on the necessity of covering the wooden hulls of their ships with copper sheathing. Significantly, one of those was Édouard's brother, Charles Laboulaye, who had encouraged the French and British navies to compete as early as 1861, when he and his associates had sketched a plan to make French transatlantic liners more competitive on world markets. The idea, partially borrowed from the legendary British engineer Isambard Kingdom Brunel and first presented in Charles's *Dictionnaire*, was to use a double engine to move the

propeller and a wheel on the boat's side, and to reinforce the ship's hull by using "internal armoring" in iron, or "even better, crossed iron sheets."[11] The second part of the plan resonated with a ship-building method that had been patented by the architect Lucien Arman for the Bordeaux shipyards in the 1840s. Arman's technique consisted in shifting the boat's center of gravity backward in order to reduce water resistance and using a copper-clad iron framework for the hull.[12] The beautiful copper used for these Bordeaux ships was of a red variety, precisely like the sheets that Secrétan was sending Bartholdi. It was not entirely surprising, therefore, that on April 30, 1876, twenty days after the first appearance of Lavastre's effigy at the Palais, the Bordeaux Chamber of Commerce donated 150 francs to the Franco-American Union.[13] Arman could no longer be involved in the donation, because he had died three years earlier and his enterprise had gone bankrupt, but Bordeaux's shipyards were still producing vessels for the Compagnie transatlantique, some of which were exhibited alongside the statue at the Palais de l'Industrie.[14]

All these facts suggest that French naval magnates were empa-thizing with the project of the statue and doing their best to sponsor it, even if none of their names appeared on the lists of contributors published by contemporary newspapers. It was no accident, for example, that the union's bank, the Société générale, was also the bank of the Compagnie transatlantique, or that the Hôtel du Lou-vre, which was co-owned by the Péreires, had hosted the inaugural gala for the campaign to fund the Statue of Liberty. For some rea-son, however, the Compagnie and their associates in Bordeaux and Le Havre preferred to hide their donations in an intricate web of banks and institutions. There could be many reasons for this desire for anonymity. But did the statue really need names to advertise France's naval interests in America? After seeing the statue's simu-lacrum surrounded by ships and copper instruments (and in the retrospective light of Washburne's quotation of Longfellow's poem on ships' copper cladding at the statue's inauguration), one could

easily have guessed that pertinent analogies existed between the
statue and France's transatlantic liners, and that they were technical
and related to the materials with which *Liberty* was to be made.

Earlier, in 1875, the union had decided to hang Secrétan's cop-
per plates on the statue's interior iron skeleton, and, at the time,
nobody had commented that a similar procedure was being used to
build ships. Yet many must have realized it, particularly the metal
magnates who provided the union with its copper and iron. On
May 13, 1876, the *Illustration* publicized the union's building plans
by announcing that the statue's inner core would be divided into
"compartments or chambers formed by iron beams up to her waist."
Not surprisingly given Bartholdi's links to the Monduit factories
and his interest in hammered monuments, the plan was assigned
to Viollet-le-Duc, who also suggested filling the statue with sand
to ensure its balance.[15]

So the statue was to be made like a ship (ballast included), one
of those vessels that had brought French articles as well as low-cost
labor from India, China, and Africa to the United States over the
past decades, and American staples (like copper) back.[16] Proudly
emerging from the sea and shining like a *Stella Maris* guiding
sailors home, the statue would speak for the bravery of France's
captains and the quality of the goods they carried. Indirectly, how-
ever, she would also advertise the Compagnie's imperial agenda of
"re-attach[ing] through many links the colonies to the motherland,
and open[ing] an unlimited career to the energy and expanding
power of the national genius."[17] It is very possible that Laboulaye
had kept French naval interests in mind all along, ever since he
had first called on the country's "patriotic" businessmen for help.
Whatever the case, naval tycoons and their trading partners ended
up being the union's staunchest allies in the funding campaign
alongside the magnates of iron and copper.

Lavastre's canvas suited perfectly the alliance between the union
and maritime interests. But the union soon discovered that the
maritime metaphor could be applied to other forms of navigation

as well. Indeed, a mere month after the naval exhibition, in a snow-blanketed Paris bedecked with Christmas trees, the statue's effigy made a second appearance. Most likely, it again took the form of Lavastre's canvas. This time, however, it appeared alongside the celebrated balloonist Wilfrid de Fonvielle, who was holding a show on *Air Crashes: The Life and Dangers of the Great Balloonists.* Just who built Fonvielle's hot-air balloon (and, even more importantly in this context, its copper basket) we do not know, but it must have been someone close to the union. One could guess that the initiative was the brainchild of Victor Borie, the former treasurer of the Franco-American Union and the managing director of Donon's Société des dépôts, who was an associate of the Catholic politician Alexandre Bixio, an expert hot-air balloonist. Since hot-air balloons were an important part of the French rearmament program at the time, we can presume that at least some of their parts may have come from Secrétan's Castelsarrasin foundries, which specialized in military supplies.

The transition from sea to air travel required little effort for the painters of the statue, for the image of a *Stella Maris* guiding sailors and pilots fits both contexts equally well. But Parisians may have been somewhat puzzled to see their benevolent phantom, the navigators' *Stella Maris*, sponsor military aircraft and preside over a talk on aviation disasters. The Masons inside the union, by contrast, must have found it exceptionally appropriate, because death was considered a form of initiation that was required to reach the salvation (or resurrection) anticipated by the statue. Whatever the case, not long after the aviation show in Paris, another picture of the statue (presumably another *Stella Maris*) appeared in an exhibition in Cairo, where the ships of the Compagnie des messageries arrived from the Bacalan yards to load cotton, and where Americans had been selling their Remington guns since the 1860s. As contemporary sources reported, French, Italian, and American merchants in Cairo, who would become among the statue's most generous patrons, were introduced to the Statue of Liberty through

"a series of experiences" of ascending balloons.[18] Center stage this time was the famous American balloonist Rufus Gibbon Wells, who thrilled audiences in Cairo at Christmas with a series of "aerial experiences," followed by a talk at the Hotel Shepard, which he later would repeat in France as well. The proceeds from all his shows went to the Franco-American Union.[19]

After the Egyptian show ended, the union had five months to exhibit its simulacrum before a ship picked its members up at Le Havre to carry them to Philadelphia. While Lavastre and Peignet were working on the panorama to display at Narcisse Poirier's studio, the union managed to organize a last French appearance of Lavastre's first transparency. On April 25, the brand-new Paris Opéra hosted a fundraising event of grand proportions, one that apparently had little to do with the world of finance and industry, although a glance at the ladies and gentlemen walking in that night suggested otherwise.

THE PLACE DE L'OPÉRA was designed to give a touch of Renaissance elegance to the Bourse quarter, as part of the ongoing urban renewal of Paris at the hands of Napoléon III and Haussmann. But for the entire duration of the French Second Empire, such elegance would elude Parisians as the opera house remained firmly under the wraps of its iron scaffolding. It was only in 1874, when construction work finally ended, that the building was unveiled to reveal what curiously appeared to be a cross between an ancient temple (brightly colored, as the Parthenon was thought to have been originally) and a Renaissance villa. The floors, handrails, and pediments, red, green, and mottled marble, as well as hardstone, had been sourced from all over Europe, from Russia to Italy; the statues were bronze or polychrome; and the candelabra, also of bronze, were shaped like intertwined women, each with an arm raised to support a bowl.

Yet what made the opera such an appropriate venue for a celebration of the statue was not only its elegance. First of all, the

opera house, with its dome and an inside core entirely built in cast metal, had been largely financed by the same people supporting the Statue of Liberty. The Monduit foundries (where the statue was being produced) had donated sixteen thousand francs to the opera house, and additional funding had come from the Schneiders, manufacturers of locomotives, ships, and patrons of the Société générale; Lucien Laveissière, with his copper foundries; Dietz-Monnin, the Alsatian textile magnate related to the Bartholdis; and the industrialist Adolphe Japy. The Talabot and Secrétan families were also regular subscribers to the Opéra, suggesting that they, too, may have contributed iron and copper to the building's construction.[20] In fact, most of the supporters of the Opéra were in one way or another connected to the Franco-American Union. What brought them together? Certainly their extensive interests in the extraction and casting of metals, which had been used to construct the opera house and were to be used to build the statue. But the Opéra was also a particularly suitable place to present Lavastre's painting before it was brought to America, because Garnier's opera house was built like a great architectural metaphor for the Orphic mysteries, the very same represented by the statue of the *Poésie* sculpted in copper on the roof; the very same to which the Statue of Liberty proudly would allude.

The union's guests probably realized this kinship the moment they entered the Opéra's side door on the ground floor and embarked on a metaphorical ascensional path through the building. They first entered a circular underground chamber fashioned with mosaic floors that reflected the light of a circular chandelier hanging from the ceiling and of other candelabra placed here and there around the room. From a niche, a beautiful bronze *Pythia* watched them furtively. The statue had the look of a drunken Bacchant rapt in delirium, and had been sculpted by the famous Swiss artist Adèle d'Affry, duchess of Castiglione Colonna, better known by her pseudonym Marcello, who had modeled *Pythia*'s sensuous body after her own. On the ceiling, around the chandelier, starred female heads very similar to the statue's appropriately pointed the way to

the auditorium, announcing the *autopsia* (the final revelation) to be received on stage. To get there, however, the guests had to proceed along a torchlit staircase as if they were being initiated into some ancient mystery of Orpheus, Isis, or Bacchus. It was a perfect set for Lavastre's phantom, which waited on stage with its halo of revelation like a beacon in the dark. Before then, however, the public had to go up the staircase leading to the main entrance, where bronze caryatids held warm lamps in their raised arms. Looking up, starry faces (again similar to the Statue of Liberty's, though not as stern) could be seen in bas-relief along the contours of the ceiling. Upstairs, above the caryatids, was the immense, circular auditorium, decorated with gilded figures, many of them, the highest and most oblique, again crowned with rays.

After their ascent, audience members took their seats in front of the stage. When the curtain was raised, all they could see was a dark hall, adorned with medieval banners and gilded saints—it was Lavastre's set for *Hamlet*, ready for the third act.[21] Nobody was there to explain to them how the statue's internal skeleton would be made. The canvas of the Statue of Liberty hung center stage, while French and American flags had been fixed on either side of the room. On stage, sitting in a semicircle in front of the canvas, was a group of men turned toward the throne from Gaetano Donizetti's *La favorite*. On it, Édouard Laboulaye sat comfortably, "dressed in a kind of tunic with a high collar, all buttoned up, revealing only a white profile."[22] Clean-shaven, as always, his long gray hair "worn long and brushed back," he again invoked the image of old Franklin, a Quaker, or a minister of mysteric cults.

The amateur choirs of the Seine district, some six hundred in all, then marched out on stage, "old, young, white, black, blond and brown, bearded and clean-shaven, small, and large," all dressed in black except for their white gloves and ties.[23] The orchestra struck up the overtures from Rossini's *William Tell* and Daniel Auber's *Muette de Portici*—two stories of love and rebellion set in humble fishing villages on the shores of Lake Lucerne and the Gulf of

Naples, respectively, against backdrops of wars for national libera-
tion. Many among the public had already seen the statue's effigy at
the Palais de l'Industrie, surrounded by ships and glorifying French
global finance. But now the Statue of Liberty seemed to have a differ-
ent purpose, for the music surrounding her told stories of political
freedom, not of economic expansion. Now she was William Tell
himself, triumphant after having braved the storm and killed the
evil bailiff Albrecht Gessler, or Masaniello, Fenella's brother, lead-
ing a Neapolitan revolt against the Spanish viceroy. But the statue
could also be Fenella herself, who, seduced by the viceroy's son
and aware of her brother's imminent death, threw herself into the
Vesuvius, only to reemerge as a ghost with the fire of her sacrifice
in her outstretched arm.

One can only speculate about how Bartholdi reacted to the
statue's appearance on the opera's stage. The sight of the effigy
against a backdrop of great rebellions and redemption may have
brought him back to the years he had spent in rue Chaptal, listen-
ing to his master under an imposing painting of Francesca da
Rimini, the heroine condemned to death by her father's political
interests and transformed into an angel by Scheffer's brush. Before
Lavastre's painting of the statue appeared at the Paris Opéra, it was
difficult to tell whether Francesca's liberating sacrifice had influ-
enced Bartholdi in the making of his *Liberty*. It certainly influenced
the making of its simulacrum, for on stage the subject of Lavas-
tre's painting, standing and lifting the symbol of her sacrifice and
resurrection amid the darkest passages of Donizetti's *La favorite*,
became a victorious Francesca, escaped from Hell to shed light
from the heavens.

On that night, however, the phantom-statue also represented
other kinds of sacrifice. The Franco-American Union had originally
asked Hugo to write the words for the cantata "La Liberté éclairant
le monde," composed by Gounod, the famous author of *Faust*. Old
and ill, Hugo had left the task to Émile Guiard, who gave the statue a
sorrowful and masculine voice. The choir (composed only of men)

sang of Liberty's fire-born soul and of her bronze limbs. Given the context, it is worth asking whether Laboulaye ever informed Guiard about his plan to insist on the statue's peaceful profile. In effect he did, and Guiard would follow that direction, although he must have known that mythical gods and goddesses demanded sacrifices before granting peace. So Guiard melancholically highlighted the statue's military nature, but only to recall the sacrifice of French and American soldiers to the cause of independence. The colossus, the chorus chanted, was there to commemorate those who had fallen during that war, "bequeathing" to the Statue of Liberty "the Flame of the Sacred Fire that must not perish":

> They fell, bequeathing to me the Flame
> Of the Sacred Fire that must not perish!
> They fell, and my Light is their soul,
> Those who, valiant, died for my cause.
>
> I prospered under their guardianship,
> Through them my arms are triumphant
> And I am rising, Immortal,
> On the grave of my children!

Guiard's gloomy interpretation of the statue as a monument to the dead—victims of the Revolutionary War—did not contradict the union's description of it as a war memorial to the "first blood . . . shed for Independence." The statue, then, was a grave or a mausoleum. The union had already suggested Liberty's mortuary meaning at the Hôtel du Louvre, where the statue's transparency had been suspended on a sarcophagus. And those familiar with Bartholdi's art were certainly not surprised, for, much like his mentor Étex, he had always remained fond of funerary art. Both had mastered the sepulchral arts after admiring Michelangelo's tombs, and drew on them to give unique expressions to their own statues. What was surprising, however, was Guiard's

interpretation of the statue's halo, the symbol of Masonic resur-
rection and *autopsia:*

> My bleeding forehead has many wounds,
> But the Universe has known my Benefits
> And I threw away the torch of the battles
> To take in hand the Torch of Peace!
>
> I send afar in the dark night,
> When all my Fires are lit,
> My Rays toward the sinking ship
> And my Light toward the oppressed!

The poem's meaning was impossible to miss: crowned with
thorns, the red, copper-hued statue was meant to recall and cel-
ebrate Christ's sacrifice and revelation. Its pointy crown was made
of spikes or thorns: it was an instrument of torment and sacrifice,
anticipating Christ's resurrection announced, according to the Bible,
by a shiny star in the night, the "morning star" of Lucifer (but also
Isis or Venus). As eventually will be clear, the pointy crown could
also be seen to represent a second, even deadlier weapon, but Guiard
may not have known this at the time. What mattered to him was that
Christ's suffering (in turn patterned on those of the ancient myster-
ies of Orpheus and Bacchus) was the blueprint for all the other
sacrifices, not only those of Finella and Francesca, but also those of
French soldiers at battles from New York to Yorktown. Perhaps this
was all it took to reveal the analogy between the Statue of Liberty
and Scheffer's *Christ the Consoler* and *Christ the Remunerator:*
standing straight (or almost straight) on a place of death, the Statue
of Liberty and the *Christ* figure simultaneously celebrated sacrifice
and promised future regeneration, their own and those of others.
Rising from the water, like Christ from baptismal water, the Statue
of Liberty was the icon of a purified soul.

MISCENDO UTILE
DULCI

NEAR RUE DE CHEZALLES, where the Monduit factory was located, Haussmann had placed a garden of marvels for the mansions of the great bankers. All the famous banking dynasties (the Cernuschis, the Oppenheims, and the Camondos) would soon enjoy a first-row view of an emerging marvel of another sort, namely the Statue of Liberty. For the moment, however, very little could be seen except for the pieces of wood and sheets of copper stacked in the Monduit's courtyard.

To assemble them, Bartholdi and his men followed a procedure first patented by Viollet-le-Duc in 1865 to build his *Vercingétorix*. Before then, embossers were used to produce a real-size plaster model and cast it in bronze before covering it with lead. With copper, Viollet-Le-Duc had discovered, one could skip the bronze casting entirely, for the embosser only needed a smaller (1:10) plaster model of the final statue to begin the process. Starting from the model, the artist measured its prominent parts and marked them with little tacks, which were necessary "to establish the relations among the different parts of the work to be executed." Next a graduated frame was placed on top the model so that the artist could "bring back all his measurements through a plumb line." This operation was essential for the artist or craftsman to know the exact measure of each part of the statue so as to cut them from copper sheets, after having "estimated the quantity of material that is required by the

reliefs and hollows present in the part to be embossed." Finally came the actual hammering of copper. With lead, things were easier because the embosser would hammer metal onto a surface that "already had the shape one wants to give to the final work." The job of the copper embosser was harder, for he or she had to reproduce the model's shapes by eye, trusting a certain "sentiment of the form"; that is, like a sculptor, a copper embosser did not follow templates, but simply created his or her own lines and curves on the copper surfaces by alternating between "stamping" (hammering the material on a table), "recooking," and cooling the metal before placing "the concave part [of a sheet of it] on a round, two-beaked anvil and hitting it . . . in order to [shape and] extend the copper while always managing the edges."[1]

Given the dimensions of the New York colossus, someone at Monduit (perhaps Viollet-le-Duc or Bartholdi himself) suggested abandoning hammering by free hand in favor of a more mechanical procedure. The option they eventually agreed on required making full-size wood and plaster models of the statue's parts, from which wooden templates could be made. Once removed from the plaster, the embossers could hammer the copper onto the templates to produce individual segments of the final Statue of Liberty without relying on "their sentiment of the form." This certainly accelerated the hammering part of the process, but it slowed the measuring part, since it was more complicated to take measures of a life-size model than of one just one-tenth the final size.

The first step involved enlarging the original maquette presented at the Hôtel du Louvre to four times its size, that is, to the dimensions of the Statue of Liberty still found on the Pont de Grenelle in Paris today, which is itself about a quarter of the size of the New York version.[2] After that, the first model (model A) was divided into sections, each of which was measured with a plumb line; the vertical plumb measurements were then reproduced, on four times the scale, on taut wires suspended around a pedestal that also measured four times the size of model A.[3] This was simple in theory, but dif-

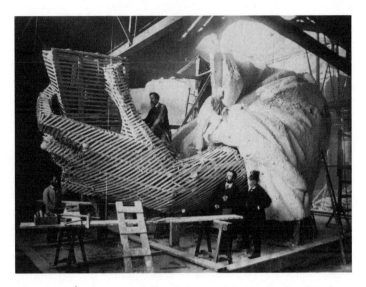

FIGURE 25.1. *Étapes de la construction de la statue de la liberté, ateliers "Monduit et Béchet—Gaget et Gauthier successeurs—la main gauche en bois,"* n.d., albumen print affixed to a cardboard mount, Musée Bartholdi, Colmar.

ficult in practice, because every point in space required at least six different measurements, three on the original model, and three on the enlarged one. But the sections, which measured around eleven feet in length and contained around 300 principal points and more than 1,200 subsidiary ones, received around 9,000 measurements each, all done with a compass and ruler. Once detected inside each section, the fundamental points of each piece were subsequently joined by a structure of lumber and sticks, and covered over with a layer of plaster (Figure 25.1).

The final effect is difficult to convey, unless one looks at surviving pictures of the statue's construction inside the Monduit factory (Figures 25.2, 25.3). Divided into numerous disparate parts, each present in various sizes, the statue offered a singular spectacle, as if its component parts were scattered among magical mirrors, which either enlarged or reduced them to abnormal proportions. It was almost as if the tiny inhabitants of Swift's Lilliput had decided to

immortalize the giant, Gulliver, and were proceeding toward their goal by way of progressive enlargements. For marketing reasons, the Lilliputians of Monduit had started from the arm and the torch, because they were to be cast in plaster, covered with copper, and shipped off to Philadelphia for the Centennial Exhibition as soon as possible. Bartholdi and his workers attached the sheets of copper supplied by Secrétan to the wooden cast of the arm using levers; afterward, sitting astride the cast, they beat it with "goldbeaters' hammers" and "beating sticks." Where the sheets had to be bent around curves, the sheets of copper were heated in a forge and welded together with blowtorches. Finally, the workers delicately peeled the copper sheets off the casts and bolted them together. Afterward, they would destroy the wood and plaster casts to make room for new ones for the head and bust, and so on.

While the workers toiled to dress the arm in copper and insert metal sheets into the giant forge like slices of bread into a toaster, a newspaper reported that the plaster monster lay dismembered and in disarray—a colossal right "ankle" here, a "calf thick like a cedar, never seeming to end" there; "a few meters further up, there's the thigh, as thick as an Armstrong Gun, then the hip, a real gulf; the folds of the drapery can hold entire barrels of water; the chest swells and assumes titanic proportions." The neck rose from the shoulders like the "trunk of an oak, and on these shoulders, which could not fit between the two walls of the Rue Coquillière, stands the magnificent head of the goddess, with a vigorous nose, haughty eyes, and graceful mouth; the arm is straight like an enormous suit of armor and holds the torch."[4]

It was not long before the Parisians discovered the real statue's aggressive appearance, which Lavastre had carefully concealed in his transparency under the guise of a sweet Madonna. It was lucky that Philadelphians and their guests would be spared from the spectacle of Lady Liberty in pieces, like a deconstructed war machine. But the association of the statue's powerful arm and elegant but masculine hand, and Lavastre's *Stella Maris*–like woman would

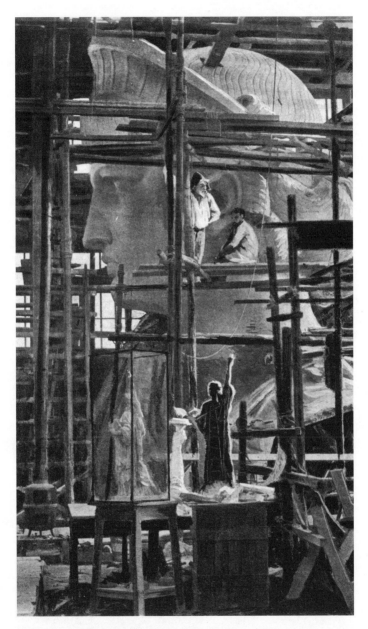

FIGURE 25.2. Charles Marville, *Construction de la tête de la "Statue de la Liberté,"* plaster model, 1876, albumen print affixed to a cardboard mount, not signed, Musée Bartholdi, Colmar.

anyway have been a source of puzzlement. Indeed, no one could tell for sure whether the statue's image would maintain its meanings across the ocean after being separated from the theatrical backdrops of Finella's and Tell's stories, Guiard's poetry, and the transatlantic liners of the Compagnie of the brothers Péreire.

It may have been with such thoughts in mind that Bartholdi boarded a ship of the Compagnie transatlantique; for the second

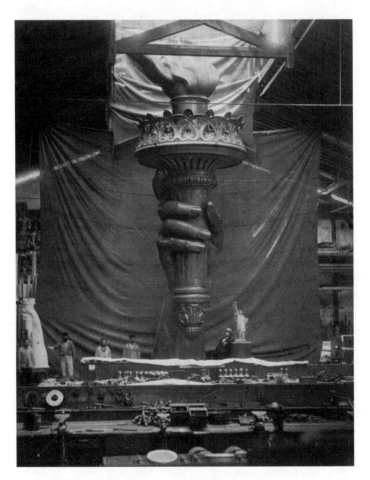

FIGURE 25.3. E. [Emmanuel] Flamant, *Le flambeau de la "Statue de la Liberté,"* Les Ateliers Monduit, n.d., Musée Bartholdi, Colmar.

time in his life, he was on his way to New York, where he landed on May 17, 1876. Last time he visited the city, Bartholdi had been with Simon. This time, he disembarked the ship hand in hand with a woman, Jeanne-Emilie de Baheux de Puysieux, who would be his constant companion during the voyage and beyond. A petite woman with a permanent smile and nervous demeanor, her dyed hair and tight corset betrayed a desire to appear younger than she really was—Jeanne was in fact over forty, five years older than Bartholdi.

We know very little about Jeanne, except for the misleading account that Bartholdi himself would later give his mother in an attempt to soothe her rancor toward the younger woman. He would recount that he had met Jeanne briefly on his first trip to America. They found each other again during Bartholdi's second visit to the New World, when he traveled to Montreal, Canada, to escape the heat of the American summer (a trip he did not record in his diary or letters). Suffering from bouts of dizziness, Bartholdi—so the story went—had wired the La Farges to ask for help and they sent him their relative and his old acquaintance, Jeanne. Seeing her come to his aid, he thought she was like "a ray of sunshine" entering his life. It was not that Jeanne was particularly charming or beautiful; on the contrary, Bartholdi would say, her looks were affected "a little by the trials and tribulations of life and age." She was not even particularly clever or witty, but this, he would write in what sounded like an unfortunate attempt to win his mother's goodwill, was the result of an unhappy upbringing. For Jeanne allegedly came from a family of industrialists of aristocratic lineage, but her father's bankruptcy and mother's untimely death had left her destitute. She had been adopted by a Canadian woman, Bartholdi continued, who took her back to Montreal to escape the Communard riots of 1871. The woman, a miser with her money and with her affection alike, invested little in Jeanne's education and treated her like a lady-in-waiting. When she died, Jeanne was left with no inheritance, and had to live off the meager handouts she was given by her stepbrothers and on what she could earn working as

a governess or housekeeper. Yet despite all those years of suffering and frustration, a pain-stricken Bartholdi would write, Jeanne had not become embittered; instead she had a pleasant character and was "gifted with the ability of resigning herself" to her lot.[5]

What parts of Bartholdi's story are true? How much of his affection for Jeanne was sincere? He had rarely expressed interest in women before Jeanne mysteriously appeared by his side. Reading his story, one has the clear impression that he felt some sort of obligation to find a female partner on the eve of his American debut, and that Jeanne was an understanding friend promising to become a faithful and undemanding wife rather than a passionate partner. But where did they actually meet? The absence of any reference to Jeanne in the diary from Bartholdi's first journey to America suggests that he had probably lied regarding the place of his first encounter with her. More probably, as has been suggested, he met Jeanne in France after his return from America, but concealed her existence from his mother Charlotte for strategic reasons.[6] Jeanne, in turn, might have concealed from Bartholdi some details of her personal story, for example that she had already been married and had had two children with her divorced husband.[7]

Or perhaps Bartholdi knew about Jeanne's mysterious past and did not care, as long as Charlotte was not informed of the matter. Whatever the case, Bartholdi was still keeping their relationship a secret when he left for America with Jeanne and Lavastre's transparency of his colossal lady. After the pair landed in New York on May 17, 1876, Jeanne boarded a train for Philadelphia at his side. She was with him at Fairmount Park, walking along the aisles of the Centennial building, a long, low construction made entirely of glass and steel, just like the Crystal Palace and the Palais de l'Industrie, but bigger than both of them. Unlike the concentric layout chosen by Parisians for the 1867 exhibition, the Americans had opted for a decentralized plan or—as some critics suggested—a disorganized one. With the exception of the artworks, which were displayed in Memorial Hall, and agricultural produce, which was assigned

a place in the aptly named Agricultural Hall, everything else was mixed together in the most chaotic of ways.

Haphazardly strewn between Machinery Hall and Agricultural Hall were the McCormick and Wood agricultural machines for which the United States were famous all over the world. There was wallpaper in one place, chocolate in another, cigars here, soap there, looms and textile machines everywhere.[8] All the machines were working, simultaneously—machines for drilling stone and sawing trees, typesetting machines churning out thirty thousand copies an hour, machines for producing fake hair, sewing machines, and even machines spewing water from all sorts of heights—producing a dull, monotonous, mechanical roar. Outside, on the streets, the buzz of the working machines mixed with the sound of pianos being played simultaneously in the various different areas of the exhibition, with the overall melody given by a colossal organ, and by the powerful voice of what was simply described as "a queen of Irish music."[9]

For the first time, Bartholdi was not simply a visitor, nor just an exhibitor, but a commissioner for the industrial arts. It was a prestigious role that not all European artists would have accepted lightheartedly at the time, since many in the Old World still harbored certain misgivings about American "art." One of these goes back to Tocqueville's *Democracy in America*, where it was claimed that democracies nullified the desire to excel that animated people living in aristocracies. There would be no Raphaels in a world made on the American model, Tocqueville had forecasted, because democracies would lead individuals to privilege "the useful over the beautiful" and to make sure that "the beautiful be useful."[10] Bartholdi, however, was hard to convince: he had been raised by industrial designers in a place, like Colmar, that was filled with evidence of the successful fusion of craftsmanship and art. So now, at the Centennial, Bartholdi wasted no time among American paintings and sculptures, which he considered second-rate imitations of their European counterparts. Instead he went straight to the focal point of the event, which consisted of a steel heart

that pumped and powered all the other mechanical exhibits on display: the epochal Corliss steam engine.

RIGHT IN THE MIDDLE of Machinery Hall, the engine was a colossal, rotating beam engine that could have come straight from the pages of Jules Verne. Its two massive cylinders, forty-five feet tall and placed side by side, produced all the electrical and mechanical power in the exhibition. Pumping out 1,500 horsepower in normal times, it could be pushed to do the work of 2,500 horses and weighed seven hundred tons. Built on a giant platform fifty-six feet across, the Corliss really was the powerhouse of the exhibition. Its basic version, which was developed by George Henry Corliss in Providence, Rhode Island, was of more modest dimensions, but still gigantic compared to normal engines. The Corliss's flywheel, sometimes painted in bright colors, often red, could do a hundred revolutions per minute, but the engine's most precious part was to be found in the four valves of its cylinders, and in the valve gear, which kept the steam admission distinct from the exhaust, thus ensuring the highest levels of thermal efficiency ever achieved by a steam engine. The Corliss was also the first steam engine capable of automatically controlling the amount of steam admitted into its cylinders, where connecting rods transformed rectilinear motion into circular motion. Therefore, the centrifugal governor responsible for the steam's intake could regulate the revolutions of the flywheel located between the two vertical motors to offset any sudden change of movement.

The Corliss steam engine was not art; it was not even industrial art. Yet Bartholdi saw in it the supreme expression of American artistic genius. He was probably ignorant of the intricacies of the valve mechanism and the working of the centrifugal governor, but he followed the lines of its shape as if they were verses of a poem or notes in a melody: his eyes indulged in the parallelogram of forces, gears, and connecting rods it embodied, much like, before, he had been mesmerized by the straight lines of iron bridges and the tower

stacks of steam engines. It was then that he understood where and why Tocqueville had been wrong: in America, he noted, "works of great importance [were] realized with the help of fire," not of marble or by brushstroke.[11] Clearly, the reference was to the fire of technology and industry, which had molded American railway tracks and wagons, but also to the fire of Prometheus, an icon of the human desire to imitate and surpass the gods. Given Bartholdi's past fascination with the classical myths of rebellion, the sight of American machines may well have reminded him of the Promethean qualities of the country's new industrial art. And perhaps it was then that he began to think that his Statue of Liberty could also be advertised as a symbol of American industrial ingenuity, if the fire was promoted as an emblem of Promethean ambition.

But it was not only a question of symbols. In its own way, the statue too was an industrial artifact, a lighthouse made with the embossing techniques that artisans usually applied to the making of jewels or clocks—yet it was also a piece of art, a colossal piece of industrial art. As such, it certainly represented a dramatic departure from some of Bartholdi's previous works, most of which were public monuments with no industrial use (*Rapp*, *Vergingétorix*, the *Lion* of Belfort, for example), but not all of them. Indeed, Bartholdi had placed his Bordeaux Neptune, his *Schongauer*, and his *Bruat* on Renaissance-like fountains for a crucial reason, a reason founded in the principle that Bartholdi had seen inscribed in Karpff's portrait of the revolutionary statue *Scène de la Révolution* at Colmar, when he was still a young student: "Miscendo utile dulci" (mixing the useful with the pleasant).[12]

It was probably the influence of Lesseps and the huge elevators by the Nile that had made Karpff's industrial teaching interesting again in Bartholdi's eyes. But something in the American scene had also sparked the artist's imagination in unexpected ways. First it had been the sight of American ships, which reminded Bartholdi of the bizarre creatures designed by medieval and Renaissance artists just by mixing existing shapes. Then it had been the monumental

Corliss, in front of which Bartholdi had a real epiphany. After contemplating the thundering steam engine at length, he confessed:

> You can see great and beautiful lines, decompositions of movement, a general harmony that give this machine the beauty and almost the suppleness of the human body.[13]

Bartholdi was in awe. American engineers had been able to challenge nature itself by giving a mechanical rendering of human shapes and impressions. Corliss's human face appeared from a combination of inanimate objects—valves, levers, and tubes—which might have reminded Bartholdi of the way in which Renaissance artists sometimes painted human faces by juxtaposing fruits, flowers, and vegetables, or sculpted them as if they were born from rocks and rivers.[14] Maybe the Corliss took Bartholdi back to the sense of wonder that he had experienced in front of Giambologna's *Appennino*, which seemed to tear itself out of the living rock in the Villa di Pratolino, in Tuscany, or for that matter the Egyptian colossi on the Nile Valley in Egypt, for all of them were fantastic creatures made from the unusual combination of natural shapes. Whatever the case, Bartholdi was convinced that American engineers had borrowed heavily from the anthropomorphism of Renaissance art, because he commented that they had a talent that only "experimenters and craftsmen" like Michelangelo had had before them.[15] In his eyes, Americans were the "ultimate *oseurs*; sometimes they get it wrong, like all those who look for something; but among the infinite numbers of their efforts, there are always some that honor their spirit of invention."[16]

It may have been a portrait of the American people, but it was a self-portrait as well. Bartholdi, too, was an oseur, and the Statue of Liberty an example of his daring. For who, if not an oseur, could have thought of making an embossed colossus, the tallest in the world, which hosted a lighthouse inside, looked like a ship—sailing fast, with her mast cutting the horizon and her sails pulled by the

wind—but had a human face and body? Like a "technological"
Michelangelo, Bartholdi was joining the copper of ships and the
iron of rails and bridges to create an artistic "marvel" from materials
normally confined to industrial uses.

These thoughts probably kept Bartholdi occupied for a time, at
least while writing his report for French authorities on the Centen-
nial's industrial art. But his contemplations were interrupted when
he received a letter from the Monduit workshop informing him that
things were not going according to plan. Sometime in March or
April, while workers were moving an enormous plaster cast from
one shop to another, it had toppled over and broken; time would
be needed to fix it. This was not good news, but there was nothing
he could do except take the train and go to New York, where other
business awaited.

Six years earlier, Bartholdi had left New York with the prom-
ise that he would build a statue of Lafayette for Central Park. In
1873, as mentioned, the French prime minister Adolphe Thiers
had urged the French community in New York to donate a monu-
ment to the city, and had even offered to pay for the statue. The
Cercle de l'Harmonie had pledged to find the money for the ped-
estal, but in three years, nothing had been done on that front. Ever
more anxious, Bartholdi had contacted the Cercle's founder and
president, Alphonse Salmon.[17] He and Bartholdi had met at the
Cercle in 1871, when Salmon's approval was necessary to get the
Cercle involved in the making of Lafayette's statue. At the time,
Bartholdi did not comment on his meetings, but this is not the only
mysterious aspect of his friendship with Salmon, which—according
to a recent revelation—would have consequences for the Statue of
Liberty's appearance, especially its facial expression.

With a thick beard and black, piercing eyes, Salmon was prob-
ably one of the most elegant businessmen Bartholdi had ever met.
Having arrived in America at age twenty-six from the little village
of Donnelay, Lorraine, where Jewish men like him were forced to
specialize in the trade of animals and farming staples, Salmon had

become a famous New York tailor and the inventor of adjustable shirt collars; as a rich businessman and president of the Cercle, he was certainly in a position to help Bartholdi connect with local business circles, while sharing with him the burden of Lorraine's and Alsace's German occupation. It was more than reasonable, then, that Bartholdi should turn to him again in 1874 and ask for help in sponsoring the Franco-American Union.[18] Apparently Salmon took his commitment very seriously, for, at some point in 1875, he arrived at Bartholdi's studio. Arm in arm with him, Nathalie Salmon argues in a recent book on Bartholdi's secret model, was a woman of thirty. Her name was Sarah Coblenzer, and she was the widow of Alphonse's former friend and colleague Sam Laubheim, who was himself a Jewish merchant of European origins who had met and married Sarah in Los Angeles. Bartholdi had never been to Los Angeles, but he had learned from his trip to the United States that California was not a place for the sort of ladies he knew. It was a land of gamblers and gold seekers and, of course, a few, daring women. Sarah was certainly one of them: a widow and single mother of two, she was accompanying Salmon, who was not her husband, on a trip to Paris. She probably knew that Salmon was in love with her; as for Bartholdi, the story goes that, when he first saw Sarah, he was struck not so much by her beauty as by her monumental aspect, for indeed she was tall and well made. Her face had marked features, maybe even too powerful a jaw and chin, but her straight nose was like that of a Greek or Roman statue.[19]

Which brings us back to the age-old question of the true identity of the statue's model. If one looks at Sarah's portrait, taken when she was no longer young, it is easy to note a resemblance between her powerful features and those of the Statue of Liberty. Yet Charlotte too had a beautiful, straight nose and a severe countenance, and Jeanne might well have posed for the statue's body. The fact is, as Bartholdi would later explain, "when one makes a fantasy head, one always thinks of known people, whose physiognomy could fit the subject."[20] What is striking in our story is that the Statue of Lib-

erty, a colossal woman celebrated by many as the icon of victorious feminism, exhibited the features of such unconventional women: Sarah, the single mother who married twice and traveled more than once across the ocean; Jeanne, the poor, French divorcee with two children who eventually remarried to a bourgeois, visionary artist in a parlor of Newport; and Charlotte, the provincial widow who raised two children and helped one of them to become a celebrated sculptor, a traveler between two worlds.

The range of models may be expanded. Auguste's brother Charles could, as has recently been suggested, also be added to the list. Indeed, the statue's virility, its "virile tenderness" as someone called it, her low eyebrows and deep sockets, a large jaw and a lower lip pushed forward in a frown, make her look very much like Charles in a picture taken by Auguste in 1861.[21] But Auguste too had low eyebrows and deep sockets. After all, he was the statue's creator and might well have wished to sign his art. Yet if one looks closely, the analogies between the statue's face and those of Charles and Auguste are especially noticeable before the face was mounted on the body. Seen from the front, as she was supposed to be seen, her features are less monstrous, but also less Bartholdiesque: her jaws look slimmer, her eyes shallower and slightly curved downward.

Ultimately, what matters here is that, as an icon of America, a place both crude and sophisticated — "an adorable woman chewing tobacco," as Bartholdi put it — the statue demanded male and female aspects. She had to look like one of the unconventional women toward whom Bartholdi felt so attracted. It could have been Charlotte, Sarah, or Jeanne, but more likely it was a mixture of them all, a hybrid character embodying ideas of strength and of untraditional femininity. But the statue also required a touch of vehemence — not unlike that of Charles — because, as someone had noticed at the time, she had been inspired by a "violent Muse."[22]

Whatever happened between Bartholdi and the Salmons in 1875, it must have been significant enough to induce Salmon to espouse the union's cause as his own. Sarah may have posed for the statue,

or Bartholdi may have pledged to return Salmon's help by "ensuring him a quite predominant position" in the future international exhibition that would take place in Paris three years later.[23] Whatever the case, Salmon left rue Vavin strongly motivated to help the union. To start with, he paid to have Lafayette's statue transported across the ocean on the transatlantic liner *Amérique*.[24] Things did not go entirely smoothly after that, however, for when Bartholdi arrived in New York after visiting the Philadelphia Centennial, he found that his beloved "baby" was laying neglected in a corner of Central Park, devoid of a pedestal, just as the city was busy preparing for Independence Day celebrations. This time Salmon renewed his efforts, however, not only to solicit the making of the pedestal but also to help Bartholdi with the statue's colossal arm. Indeed, in a desperate letter, Bartholdi asked Salmon to advance the money necessary to pay for the arm's freight. Next Bartholdi went back to his colossal lady. He had packed his Statue of Liberty transparency into his bag of tricks when leaving for New York, where the architect Henry Wilhelm de Stucklé, another member of the Cercle who originally hailed from Lorraine, had invited him to contribute to the July Fourth preparations by inserting his "Monument of Independence" in the program of festivities. Thanks to Levastre's canvas, Bartholdi was able to oblige, with the image draped over the façade of the Century Club, which overlooked Madison Square, just across from the Worth Monument.[25]

BARTHOLDI MUST HAVE BEEN worried by the improvised ceremony. The differences between the statue's appearances in Paris and New York could not have been more striking. In Paris, he had had the time and leisure to plan the gradual unveiling of the statue, first at the Palais de l'Industrie, where it had spoken to mineral and naval interests, then at hot-air balloon shows, where it had addressed the world of air travel, and finally at the Paris Opéra, where it had sung in front of Masons and metal magnates against

a theatrical background of death, liberty, and rebirth. But here, in New York, Lavastre's panorama was hung in a square, with no preparation, no knowledgeable public, and no wealthy audience.

From a certain point of view, it was a key trial. If, as Krause had anticipated, America was the place where Masonic, Orphic secrets could be revealed to the people at large, then there was nothing to do but expose them and wait. But the trial did not go well: with her bright head, the statue was a frightening vision for the Americans, who had not been prepared by previous appearances. What they saw, painted in the Lavastre's cloth, was not a beautiful Venus emerging from the water or a tender Madonna helping sailors, but their evil alter-ego, either the morning light of a comet announcing disaster or a Lucifer. In the glow of a "gigantic limelight lamp" placed on the other side of the street, the statue was transformed. Amid the hoots and howls, fireworks streaking across the sky, bright electric lights, and general hubbub of the Fourth of July celebration, the canvas glowed, one American journalist put it, like a window overlooking "a Midnight sun," a symbol universally known for its connection to the apocalypse and for its power to evoke melancholy and devilry.[26]

A year later, *Life* ran a cartoon entitled "The Next Morning" showing the statue amputated and headless, her clothes full of holes revealing her iron ribcage, surrounded by shipwrecks in the wake of the world's end. It would be the beginning of a long and still thriving tradition of such depictions across an almost infinite spectrum of media—as a blogger recently put it, "the Statue of Liberty" remains "the quintessential icon of disaster."[27] Later on, but still before the statue's arrival in New York, Thomas Nast would draw the statue with a skull instead of a face, her torch turned down, and solar crown glowing in the dark, with "Gates of Hell" written underneath and the caption "Abandon all hope, you who enter here."[28] It was a curiously appropriate interpretation, which traced the statue back to its true poetic meaning, that of an Orpheus shedding light on man's painful condition, of a Demetra walking in the underworld of death

and misery. But where was the part about redemption through the light of poetry and natural harmony? For some reason, American audiences obsessively concentrated on the statue's dark side — the side of death, sacrifice, and initiation — without being able to see her brighter side. For a while, the statue in their eyes represented death without redemption, sacrifice without revelation.

As we shall see, elements of this stigma hang over her even today. And it certainly did in the late 1890s, when it was rumored that "*Liberty* was haunted during the night and had become an object of terror for all fishermen, ferrymen and seamen in New York Harbour." *Liberty*, it turned out, did not only offer hospitality to men and women from all over the world; after sunset, she also hosted ghosts of every kind, who were said to "flutter in the harbor and indulge in a hellish saraband."[29]

AT SOME POINT DURING the Centennial, Auguste and Jeanne headed back to Newport to visit the painters of the new American school of art. Bartholdi was welcomed back into the same refined, convivial atmosphere that he so fondly remembered, but the La Farges were worried by the impropriety of their relationship and insisted the two be married. And so they were, in the parlor of the southern wing of the La Farges' home, overlooking the sea.[30]

The routine at the La Farge household had not changed. Bartholdi would work in the morning, swim in the afternoon, and chat around the table after dinner. Now, as then, the statue was still a dream or a vision. This time, however, he had to create a public representation of his vision, and create a virtual double for the statue better suited to American tastes than Lavastre's ghostly transparency. At that time, La Farge was experimenting with a type of impressionism inspired by Japanese prints, based not on the juxtaposition of colors but on a kind of dotted stroke. Bartholdi would use the same technique to depict the Statue of Liberty at sea on a large linen cloth to be displayed in Philadelphia, beneath

the giant mechanical arm that had been shipped from Paris. It was a very simple seascape, without lights or special effects, and without any of the sentimental grandiosity of the Romantics or colorful irregularities of the French impressionists. At the same time, almost certainly through La Farge, Bartholdi contacted the Franco-American painter Edward Moran, whose maritime paintings, as I have argued, might have shaped the way in which Bartholdi had envisioned New York Harbor—and the statue in it—since his first arrival in the United States. Edward too felt inspired by the painters of the Hudson River School, and his portrait of the statue among ships of every shape and size, *The Commerce of Nations Rendering Homage to Liberty*, was probably the closest he could get to portraying Bartholdi's original dream of the statue standing on Bedloe's Island. More prosaically, however, Moran's painting was meant to introduce the Americans to the statue's economic and maritime meaning, as Lavastre had done in Paris by hanging his transparency at the Palais de l'Industrie.[31]

Meanwhile, the "ill-fated arm" had finally reached Philadelphia. It was mid-August, and there was much to do to install it on site and prepare it for the public. The thirty-nine-foot arm was a marketing stunt, and the central part of the second stage of the campaign to promote the statue. At its base stood a gazebo selling photographs of the statue, as well as lithographs, copper medallions, medals, and tickets to climb a makeshift ladder up to a viewing platform. There was nothing extraordinary in all of this; Bartholdi was doing what his mentors had done before him, Scheffer with his photographs and reproductions of the *Francesca*, Gérôme with the pictures of his orientalist paintings. But Bartholdi went one step further. He copied Moran's painting of the statue onto postcards, turned the statue into a statuette (sold for a princely three hundred dollars), and created a logo from the image, which he would copyright that same year with the U.S. government. He then licensed the logo to foundries (such as the Avoiron company in Paris) for the production of copper-plaster and cast-zinc souvenirs, some of which

included, for the most patriotic French donors, a Phrygian cap instead of the star.[32]

All that was missing was "just the spark, it is necessary, I am waiting for it."[33] Although there are no photographs that document his display, Bartholdi must have chosen the same lighting solution he would later use on the finished statue, one involving a series of arc lights around the torch, supplied by a French exhibitor. Once the torch was wired and ready to be lit, Bartholdi did something that would turn out to be a masterstroke. Alongside the arm, Bartholdi decided to exhibit the two maritime paintings of the statue—his own, in the Japanese style, and Moran's more classic, Hudson River Style work extolling free trade. Together, the items wove a compelling image of a burgeoning global trade between East and West, revolving around a core Franco-American axis. Perhaps he even reiterated the words he later would write in his report on the Industrial Arts:

> The day when the United States reduces its customs duties to moderate levels, the consumer country will profit— competition will oblige the producer to improve his products, and if the duties are levied regularly, state coffers will lose nothing.[34]

It was all an enormous success. Brimming with enthusiasm, Philadelphia's businessmen proposed launching a new fundraising campaign for the pedestal and the remainder of the statue. They had, after all, never given up hope of having the statue placed in their own city.[35] It was this threat of seeing the Statue of Liberty stolen from under their noses that finally stirred New Yorkers from their slumber. Contrary to what had been claimed in the fundraising appeal, Bartholdi and Laboulaye had not actually gained permission to put the statue on Bedloe's Island; they had not even formed a committee to arrange it. Yet just the idea that Philadelphia, a city that had always thrived off of state and federal protectionism, could

adopt a statue that was a symbol of free trade had New Yorkers up in arms. It was an affront, shameless and "villainous," and, as the *New York Times* put it, a "violation of the laws of nature." New Yorkers denounced the spurious Philadelphia committee as "sea raiders" and railed at the cheek with which they had not only "loaded their conversations with pretentious maritime terminology," but even "passed off the Delaware River as a 'port.'"[36]

Playing the two cities off against one another and exploiting their venerable rivalry once again proved to be a winning move. The same could be said of the decision to solemnly inaugurate Lafayette's statue, now finally ready, in Central Park, in September 1876. Around this time, Bartholdi also began to organize the American committees. On December 28, 1876, five days after he had eaten a hearty French meal at a party thrown at Delmonico's by the Sons of New England, at which Mark Twain was also present, a group of illustrious New Yorkers that included William Evarts, lawyer for the great railroads; John Jay (descendant of his namesake); William Appleton; and president of the New York Chamber of Commerce Samuel Babcock, announced the inauguration of the American funding campaign. The Franco-American Union had recently published the complete list of French municipal donations, which amounted to 125 cities giving a total of approximately 22,500 francs.[37] Now it was New York's turn to organize the funding campaign for the pedestal. As a way of symbolically formalizing New York City's adoption of the colossus, on January 2, 1877, the lawyer Evarts (who would give his speech in honor of the statue eleven years later) entertained a group of businessmen and lawyers with a talk on the importance of erecting the Statue of Liberty on Bedloe's Island rather than anywhere else. Behind him, Moran's huge painted allegory, now safely back in New York, reminded everyone present of the Statue of Liberty's most durable economic message, namely that global free trade (or at least low tariffs) was superior to the protectionism and international isolation that for so long had characterized American political economy.[38]

CHAPTER 26

ADVICE TO ALL NATIONS

Bartholdi left New York with a troubled mind. Sure enough, he had accomplished his mission and assured a future for his Statue of Liberty. But no news was coming from Washington as to its ultimate location, and he was getting worried. On March 2, one day before the president was authorized to decide on a site, Bartholdi wrote to Salmon to direct him on how to manage the funding campaign in America. His tone was authoritarian: "activate the French"; "distribute the prospectus prepared by Henri de Stucklé [Salmon's friend at the Cercle] for the sale of earth ware models (the big one of one meter)"; copies of the statue "must procure us money." There was something of the field marshal in how Bartholdi approached the tasks at hand: "one has to energetically make fire" and draw attention to the larger copies for sale, he ordered Salmon, but hold back on the sale of smaller statues until the next part of the fundraising campaign. That next part was a mission for Stuckle, to whom Bartholdi had given clear instructions: "before leaving, he has to make his best to fan the fire of subscription and activate the selling of the statues." And Stucklé was not to forget to accompany his prospectus "with autograph[ed] letters to people who, one supposes, could buy" such models of the statue.[1]

Bartholdi's orders reveal something rarely mentioned in books about the Statue of Liberty, namely that the initiative of gathering money for its pedestal was mostly left to French communities and

451

circles in America. True enough, committees were formed in each of "the most important cities of the thirty-nine states," but Bartholdi, Salmon, and Stucklé had arranged things so as to guarantee that ultimate control of the funding process lay in French hands. First, "presidents of all French societies in each city" were de jure also members of the statue's committee. And second, each of these French societies could nominate their own representatives to the general committee in New York, the name of which, significantly, was the "Union Franco-Américaine — Statue de la Liberté — Comité française de New York."[2]

At least two things strike the eye here: first of all, and though the statue was still formally named *Liberté éclairant le monde*, the Franco-American Union now explicitly referred to it as "the Statue of Liberty," a name that Laboulaye and Bartholdi had never used in French media; instead, they had referred to the colossus simply as a "commemorative" or "patriotic monument." Second, the New York committee was curiously described as a "French committee," even though many of its members were not French. This was probably what Salmon had asked for in exchange for his services and those of the other members of the Cercle de l'Harmonie. In any case, given that the general committee's agenda was complex and multifaceted, it was soon decided that smaller subcommittees charged with specific tasks had to be created. One would prepare "a national appeal to make known the desirability of remembering the long and uninterrupted friendship between France and the United States in order to obtain full participation from our citizens"; another was to ensure "the immediate interest and cooperation of the chambers of commerce, boards of trade, mercantile exchange and other organizations in the principal cities of the various states"; a third subcommittee had the task of dealing with the press as well as printing and circulating pamphlets and other materials; a fourth was to decide what initiative or other action would be necessary and to make sure, using the appropriate channels, to acquire the best site and ensure the best maintenance

and care for the statue; and a fifth was set up to deal with "every question relating to the artistic and practical execution of the work in the construction of the statue and its pedestal."[3]

The American machine was thus put into gear. Fundraising appeals were placed in newspapers large and small throughout the country, and two hundred limited-edition terracotta statuettes were offered as prizes to the first two hundred sponsors who donated more than 1,250 francs in France or 300 dollars in America. The original model of the statuette could be seen at Knoedler's, the New York branch of the Maison Goupil (reseller of the works of Scheffer and Gérôme). It was, in fact, the Maison Goupil's idea to produce less expensive copies of the original work in order to make them easier to sell.[4] But the complex system of Franco-American funding was once again kept in motion by exhibitions and the banks. Just as the Franco-American Union had ridden the wave of the 1876 exhibition to launch its fundraising campaign and promote the image of the statue, so too the American committee would take advantage of a new universal exhibition, planned for Paris in 1878.

In October, Bartholdi and Jeanne returned to Paris, now bound together in holy matrimony. Charlotte was outraged, but Bartholdi had other things to think about. As he feared, "everything ha[d] broken down" in France.[5] Although the Franco-American Union had officially closed its fundraising campaign after the night at the Paris Opéra, another 150,000 francs were still needed to reach their goal.[6] So a new appeal was launched in the newspapers, and new virtual appearances of the statue were scheduled to raise more money. This time, Bartholdi decided to show in the Jardin des Tuileries a diorama, probably the same one that Lavastre had made as the background of Peignet's plaster copy of the Statue of Liberty and sent to Philadelphia. The diorama offered a fantastic view of New York Harbor from the upper deck of a ship, the sea all around crisscrossed by "an incredible quantity of moving ships" and, in the middle of the scene, the Statue of Liberty. On deck alongside the spectators,

puppets "dressed in the Yankee style" smoked and chatted, while a doll in a captain's uniform, with an American flag stuck in its hair, triumphantly embraced the wheel.[7] As billed on posters advertising the attraction, designed by the set designer Chèret and hung all over Paris, admission to the pavilion and diorama cost one franc on weekdays and fifty cents on Sundays. They depicted a statue with a vaguely stylized female face, placed, as usual, against a dark background and with a vibrant crown on its head.

THE PAVILION OPENED its doors to a France on the verge of constitutional crisis. Formally a republic, the country hung in the balance between a presidential system and a parliamentary one, with many worrying that it risked regressing into a monarchy. To block the royalists, center-Left forces were looking to forge an alliance with the radical republicans, something the royalist president, Patrice de MacMahon, was doing everything he could to stop. His efforts were undermined, however, by Pope Pius IX, whose vocal campaign for the temporal power of the Holy See only reinforced the position of the anticlerical statesman Léon Gambetta. As the divide between conservatives and republicans deepened, in May the president encouraged the resignation of Jules Simon, on whom he had counted to divide the Left, and replaced him with the Orléanist Albert de Broglie, a descendant of the very general who first had sent French troops to Revolutionary America and was too much of a republican to follow the agenda of the extreme right.[8]

Faced with a parliamentary revolt, the chamber was dissolved and general elections called in the hope of a conservative victory at the ballot box. The gambit, however, failed: a republican majority was returned to parliament and moderate republicans, supported by radicals, were restored to government. The outcome was welcomed by Laboulaye and the Franco-American Union, and all the key posts in government remained safely in the hands of allies and acquaintances linked to industrial and banking groups. The finance min-

istry went to Léon Say, who had interests in the Mediterranean shipyards and in the Decazeville coal mines; the education ministry went to Agenor Bardoux, member of the board of directors of the Orléans railroads and of Crédit industriel et commercial (the old bank created by Donon); and Jean Casimir-Périer, of the famous banking and insurance dynasty, was appointed undersecretary of state.[9]

After the tensions of the May 1877 elections, all sides were looking for a truce, and what better way to unite the French and help put their differences behind them than another universal exhibition to be held in Paris? The Philadelphia Centennial had worked as a perfect fundraising mechanism for promoting the Statue of Liberty on both sides of the ocean. Now it was the union's hope that something similar could be done in Paris. But the past rarely repeats itself quite so neatly. The plan was that William Evarts, the secretary of state who was also a member of the union's New York committee, would be appointed commissioner general at the Universal Exhibition of Paris. Evarts was willing to take on this role in part because the general climate in the United States was favorable to the exhibition; it was generally agreed that "at this time, when the foreign trade of the country is growing, the public interest requires a large representation of American manufactures at the World's fair." But the U.S. Congress was very busy in 1877, and some thought it was an "unfit moment to communicate with Congress on the subject."[10] This was not the conviction of S. C. Lyford, chairman of the board, who in February solicited an appropriation in Congress by reminding those present "of the national advantage" that would arise from displaying America's "national wealth and resources and the beneficence of our free institutions, under the observations of the people of Europe, who will assemble at the international exhibition at Paris in 1878."[11] But Lyford's request would not remain consequential for long.

Lyford's request was particularly untimely because it was made on France's behalf when Congress was dealing (among other things)

with French ambitions to establish a presence in Central America. President Ulysses S. Grant had tried to limit these ambitions since 1869, when he had affirmed the Americans' exclusive right to build a canal in Central America. But where exactly? On the basis of reports sent to him by an interoceanic canal expedition in 1876, Grant had bet on Nicaragua, while Lesseps, indifferent to the technological challenge entailed by it, had pushed for Panama. In March 1878, one month before the French exhibition opened its doors, Lieutenant Lucien Napoléon Wyse finally obtained for the French a concession from Colombia to build and operate a canal, which after ninety-nine years would pass into the hands of the Colombian government.[12] One can imagine how some of the American members of Congress felt about declaring their friendship with a country that was trying to ruin their plans in their geopolitical backyard all the while professing affection with the gift of a colossal statue. And it is ironic that behind the tensions threatening to interrupt work on the 1878 exhibition and the statue was Lesseps, who in turn was connected with the same banks that were backing Laboulaye and the Franco-American Union. Along with the Comptoir d'escompte and the Crédit industriel et commercial, the Société générale was already a member of the banking syndicate underwriting the securities issued for the Panama Canal project, before investing its own capital in the venture in 1878.[13]

Not all Americans resented the situation, particularly not those selling American railroad securities in France, such as Drexel & Morgan; Duncan, Sherman, & Company; Morton, Bliss, & Company; Auguste Belmont & Company; and Winslow, Lanier & Company, all of whom wrote to the Franco-American lawyer Frederic Coudert asking him to do his best with the French government to ensure their presence at the exhibition.[14] Congress went along and appropriated $200,000 for the exhibition and for free delivery of American articles on American vessels. As the result of this legislative action, on December 15, 1877, William Evarts was

nominated general commissioner. Even so, he was so outraged by Congress's delay that he was tempted to decline the offer.[15] In the end he did not, though he would come to regret this choice, because $200,000 turned out to be too modest an appropriation to provide for the construction of the U.S. pavilion at the exposition and for the transport of all the goods and machines across the Atlantic. The general commissioner in Europe, Cyrus McCormick, inventor of the mechanical reaper, hurried to Paris hoping to still be in time to find French architects willing to design and build the American pavilion (and to negotiate some extra space for his agricultural machines).[16]

McCormick would soon be disappointed. For the moment, however, congressional approval was enough to fuel the subscription campaign for the statue. Indeed, and despite its flaws, the American attendance at the Paris exhibition helped pave the way for Bartholdi's project. Between February 28, 1877, and May 15, 1878, a joint resolution of the House and Senate was reached that authorized the president to reserve a spot for the colossal Statue of Liberty on Bedloe's Island, near the military fort, and to provide for its perpetual maintenance.[17] All that was missing was the statue itself. Three years after the launch of the French fundraising campaign, Bartholdi still had not finished it. With the 1878 Paris exhibition just around the corner, the pressure was mounting, and Bartholdi decided to showcase what he had almost completed: the head with its crown of solar rays.

The 1878 Paris Universal Exhibition was the first to be held in a republican France. The venue was in the Place du Trocadéro, in what can only be described as a cross between the Coliseum, a synagogue, and an Orthodox church. The Palais du Trocadéro was a circular building, surrounded by minarets and Indian, Persian, and Italian-style monuments. Along its corridors and in the immense garden were old statues of Liberty, the likes of which the French had long since forgotten—solemn and white, their stares were blank and their limbs harmonious. Bartholdi had always found them too

pallid and inexpressive. His own statue would instead be massive, colorful, and menacing—just how much so could be gauged from the size and intense copper-red color of the head showcased at the exhibition. Outside, in the Champ de Mars, another colossal building (one occupying more than 240,500 square meters) had been erected and connected to the Trocadéro through a bridge. Placed "on the edge of the grass carpet connecting the Iena bridge to the Exposition's steps," the statue's head and bust made quite an impression; inside, visitors could pay an admission price to climb the stairs and reach the observation deck in the crown.[18]

Bartholdi's statue was a mechanical monster. It had little in common with the original statues of Liberty, those graceful, emancipated slaves with Phrygian caps and chains paraded by the French revolutionaries. But in the frenzy of republican enthusiasm that pervaded the exhibition, few seemed to notice. All agreed that the statue was a *Liberty* in the French tradition. To reinforce this general perception, the organizers of the exhibition decided to place the statue right in front of the *République* that Auguste Clésinger had built in the Champ de Mars. It was difficult to find more different figures: one serene and graceful, the other masculine and fierce; one holding an olive branch, the other wearing a star of the apocalypse or a crown of thorns on her head. As the cart carried the statue's colossal bust and head, with its pointed halo and "monstrous" eyes, someone seeing it at the Champs-Elysées cried out: "Vive la République!"[19] But where was the Phrygian cap? And what could be said about that large face that, seen up close, was clearly masculine in its features and, as one observer noted, had a "curious hardness of expression"?[20]

Americans, too, dutifully visited the statue, and their chaperone was McCormick himself, who also played tour guide to French visitors through the galleries of the exhibition to the U.S. pavilion, where some of the latest advances in American industry were proudly displayed. As a potential seller of mechanical reapers to French farmers, McCormick was eager to show off his products at

the exhibition. In general, so were American farmers, who already had begun loading their pork meat onto French refrigerator ships bound for the legendary wholesale market of Les Halles, in Paris. In the end, and despite all the delays, representatives from every state and 307 exhibitors from New York alone had come to Paris. But the absences were notable too. It was ironic, for example, that Millet's statue *America*, at the Palais du Trocadéro, looked like an Indian surrounded by the instruments of agriculture and maritime commerce. For almost no representatives of America's maritime industry, which had played such an important role in Philadelphia, could be seen in Paris. There were American artists, engravers, educators, booksellers, and piano makers. But the exhibition, hosted in a very simple building guarded by a statue of Washington, was certainly "not among the most brilliant."[21] Friends of the statue were probably not surprised to find there cutlery from Tiffany's and objects in embossed bronze as well as copper clocks and Remington guns, since their statue was a gigantic relative of copper works, clocks—and even guns, which were so important for establishing Franco-American friendship between 1778 and 1871. But in the end, what was on display in the U.S. pavilion was a mere shadow of what America had become. And visitors knew this well, for, as a general warning in a guide to the exposition put it: "Advice to all nations being late on the road of progress: America threatens more than one European industry."[22] The United States was not merely catching up, it was forging ahead.[23]

Viollet-le-Duc was the mastermind behind the magical world that had emerged from Champ de Mars to the Trocadéro. That world would also prove to be his last achievement; he passed away in his villa in Lausanne in 1879. The consequences of his death for Bartholdi were not hard to imagine. It was Viollet-le-Duc who had first suggested dividing the body of the statue into compartments to be filled with sand up to her waist, and without him, Bartholdi was unsure how to build a structural framework capable of withstanding the horizontal forces (frontal and lateral) created by the winds

and the temperature ranges to which the statue would be exposed. But Bartholdi had been intrigued by colossi since the time he had traveled to Egypt, if not earlier, and had spent hours contemplating the secrets of so-called oriental architecture. One of the things he had learned was that buildings and statues were not enduring in and of themselves. Besides the pyramids and the Sphinx, the only surviving colossi from ancient times were pillars and columns, many of them anthropomorphic in appearance. There was a reason that colossal statues, like the famous Ozymandias from the Rames-seum, had fallen, while the nearby pillars, shaped like Osiris, had remained standing, or why the colossi of Memnon had survived while the temple they propped up had collapsed around them. Unlike statues, pillars were self-supporting structures, capable of resisting the ravages of time. The trick, therefore, would be to turn the statue into a pillar.

Still, unlike the ancient Egyptians, Bartholdi also had to deal with the problem of aerial currents produced by ocean winds. He himself must have been struck by the number of mechanical problems that were involved in the making of his statue. But opti-mist that he was, he probably took it as a sign of the grandness of his project, which in essence entailed making a machine with a human face. So he turned to modern engineering for help. Pylons capable of withstanding wind and water had already been invented. Made of iron, the French and English had been using them since the 1860s to build their lighthouses and suspension bridges. The iron magnates financing the Statue of Liberty may have directed Bartholdi to France's leading expert on the construction of iron bridges and structures, but, given the man's stature, he could well have thought of him on his own, for it was none other than Gustave Eiffel. A friend and associate of Donon's (they had both attended the Collège Sainte-Barbe), Eiffel had mastered the prob-lem of structural elasticity—a mastery he first demonstrated to the broader public in 1855 at the first Paris exhibition, where he had performed elasticity tests on the metal structure of the Machine

Gallery in the Palais de l'Industrie. However entertaining, those calculations had also allowed him to determine the value "of an elastic module applicable to the compound pieces used in metallic engineering."[24]

As a man, Eiffel had a number of self-doubts, which he concealed very well. With his high chin and proud look, he shared with Bartholdi the fact of coming from a wealthy but provincial family, and of having spent his formative years in academic institutions outside the capital. Rejected by the École polytechnique, he had taken courses at the École centrale des arts et manufactures and completed his education by taking private lessons with engineers from the Saint-Simonian schools. Marginalized from the most prestigious schools and academic circles, Eiffel had developed an ambition that bordered on megalomania, and which was reminiscent in many ways of that which had led Bartholdi to embark on the Statue of Liberty project. For both men, the world of universal exhibitions would provide a backdrop to, and vehicle for, their respective careers.

While Bartholdi grappled with the statue in 1879, Eiffel had recently finished the construction of the famous Maria Pia arch railway bridge across the Douro River in Portugal, a model of which had already been exhibited at the Paris Universal Exposition of 1878. The bridge project was part of a much larger enterprise in which Eiffel had invested capital from his own firm, Eiffel & Cie. Behind the venture, financed by Donon and the Société financière de Paris, were the iron and railroad industrialists tied to the Société générale, to the Talabots, to Eiffel's firm, and to the locomotive manufacturer Schneider-Creusot.[25] Thus both of the banks behind the Statue of Liberty—the Société financière (associated with the Société des dépôts) and the Société générale—were involved in the Portuguese railroad project.

This might have played a part in the union's decision to reach out to Eiffel in 1879, just after they had learned of Viollet-le-Duc's death. Bartholdi found him at work on a new viaduct project, the

Garabit, for a railroad through the Massif Central, along with one of his newest hires, Maurice Koechlin, a young scion of the Alsatian iron industry. With his gaunt face, Koechlin looked like a Protestant minister, but he also had the wild eyes of a crazed mathematician. He had been a precocious and highly talented student of Carl Culmann, the inventor of statistical graphics, a geometrical method enabling the solution of problems in statics by assuming equivalence between the vectors of forces and the sides of polygons.[26] Drawing on this novel method, Koechlin offered Eiffel a brand-new formula for calculating material stress and, specifically, the buckling of metallic girders. Thanks to this method, Koechlin was able to introduce key innovations to the Garabit viaduct (with respect to the Maria Pia bridge in Portugal) by using box girders for the pylons instead of balusters and by increasing the rigidity of the girders to maximize their wind resistance.[27] Similar calculations would, needless to say, also prove useful for a colossal statue placed out at sea, and throughout 1880 Koechlin worked on applying the formula to the statue.[28]

By then, it was clear that the original plan of anchoring the statue's copper cladding to an iron structural frame, like that of a ship, had to be amended. If anything, the statue was more like a standing bridge: a tall, vertical body exposed to the wind's pressure. So Keochlin suggested bolting the statue's copper sheathing to what was essentially the pylon of a railroad bridge. The procedure would be explained in 1883 by the civil engineer Charles Talansier, three years before the inauguration of the statue. He would tell his readers that the statue's pylon had four attachment points, each supported by three bolted braces that were "cemented to depth of 15 meters."[29] The pylon would be anchored only once, in America when the pedestal was built. Meanwhile, the Monduit-Gaget workshop was producing the copper cladding by using three hundred pieces weighing, altogether, 800,000 kilograms. In America, Talansier explained, their connections would be reinforced by using flat copper rivets "invisible on the statue's exterior surface."

In France, however, the copper sheets were already attached to the pylon by using flat iron bars, which were bolted to the inside of each sheet "to avoid deformation." This was a crucial point, for "as these bars were connected to each other through bolts wherever they intersected, they formed a real wire that rested directly on the [iron] framework."[30] This meant that, beneath its outer skin of copper, the statue had a second, inner skin made of iron, with a different coefficient for expanding and contracting compared to copper, which kept it anchored to the framework inside and preserved the statue from stress induced by environmental factors such as wind and extremes of temperature.

In fact, however immobile its appearance, the statue was made to be in continuous motion. While its internal pylon could move horizontally, so as to absorb the force of the wind, its internal casing moved up and down, as though breathing, according to variations in temperature. It is tempting to imagine that Bartholdi had foreseen all of this after his encounter with the Corliss, the moving machine with a human face. In fact, as a reader and a friend of Viollet-le-Duc, he certainly knew that copper should be let free to expand and contract, to breathe, so to speak; but the sight of American machines might have pushed his inspiration in directions unknown even to Viollet-le-Duc. More precisely, it might have prompted Bartholdi to envisage his statue as a machine in action, as a perpetual-motion mechanism.

In the meantime, however, Bartholdi had to deal with the more mundane (and yet no less important) details of how to procure the iron necessary for the project's completion. Where did the iron for the statue's framework come from? Unlike the copper of its skin, the iron used for the statue's bones does not seem to have aroused the slightest curiosity. The most plausible hypothesis is that the union's iron provisions came from the mines in the Loire Valley operated by Creusot et Decazeville, a Schneider Group company that produced railways and ships (the latter in Bordeaux).[31] Theoretically, the Creusot and Decazeville group might have also bought the

iron on the British market, because British iron was cheaper and the Schneiders had done so in the past.[32] But this is implausible for at least two reasons. First, the Schneiders were as determined as the French copper magnates to resist British competition as best as they could. Indeed, it is very unlikely that they would have chosen Britain to source the iron to build an icon meant to incarnate France's revenge against British imperialism. And then there was a question of quality. According to Émile Martin, owner of the *fonderie* of Fourchambault, at Nièvre, "le Creusot had better minerals than the British establishments." Martin concluded: "when it comes to good quality iron, and all the world needs it, one should not go to England."[33] In short, chances are that the union had insisted on good quality iron inside their statue, at least to make a political point.

If so, everything was coming together: the statue's bones were made with Loire iron, cast by Loire coal. It was pure, French metal, fused with pure, French coal. All around the iron, the statue's torch, face, and bust would be covered in precious French-Canadian copper. But what about her lower body and her gown? Between 1878 and 1879, Bartholdi finished covering his statue's upper body and was waiting to use new copper provisions for covering the pylon's lower part. This is presumably the stage when he decided to straighten his statue compared to the still quite erotic position of the previous model he had produced. Perhaps it was the desire to imitate the elegance and commanding aspect of Gumery's *Poésie*, or the necessity of simplifying the application of copper sheets onto Keochlin's straight pylon, or both. Whatever the case, the resulting figure also resembled Scheffer's *Christ* statues or Gérôme's *Augustus*, except that, with time, the oxidation of copper would turn the statue's dress turquoise, the color of Venus's tunic (according to the Neoplatonist Pico della Mirandola) and of the ancient statues of the Virgin Mary.

What kind of copper would dress the statue as Venus or Mary? Scientists have found that the copper covering the statue from her

waist to her feet has a lower arsenic content than the copper used to cover her head and right arm, which were the first parts of the statue Bartholdi completed. Viollet-le-Duc would have discouraged such a choice for the lower parts, because he had a preference for the impure but beautiful copper rich in arsenic, such as that extracted in Canada or in Spain (from the British-led multinational Rio Tinto's mines at Huelva). The answer might very well be that the Clark mines no longer had provisions to offer and that British-controlled Rio Tinto was not a suitable choice for political reasons. The purer copper of the statue's gown is said to come either from Montana, where the Anaconda Copper Mining Company would begin operations in 1882, from British mines in Chile, or from mines at Visnes, on the Norwegian island of Karmøy.[34]

The odds that the copper for the statue's robe came from Chile are small because of the Franco-American Union's explicit anti-British agenda. If the union decided to make an exception and buy from the British, it would have made more sense to get their impure copper from Rio Tinto, which would have suited the statue better. The Montana option would have been more tempting, particularly for Secrétan, who, in 1878, only two years after starting his collaboration with the union, had bought the Estivants' operations in Givet. Three years later, in 1881, he would partner with the Laveissières, the Estivants, the Arbels, and Japy to create the Société industrielle et commerciale des métaux.[35] Formally, the purpose of Secrétan and his allies was to reduce competition between French producers in the face of falling copper prices. But it is likely that they had conceived the new company from the start as a scheme to undermine the centrality of the London Metal Exchange for international markets. In 1882, when the newly opened Anaconda mines began selling their copper on the London exchange, Secrétan was on his way to becoming the largest copper buyer on the world market—but he still largely depended on the British. Historians tell us that Secrétan would start buying copper directly from American companies, without passing

through London, only in 1887, one year after the inauguration of the statue. This is certainly another reason to believe that, unless Secrétan had managed to establish a private, undocumented agreement with Anaconda before December 1887, he probably did not buy the copper for the Statue of Liberty from Chile or Montana.

The Norwegian option was probably a good compromise. We know that, as of 1865, the Visnes mines were operated by a French mining engineer from Metz, Charles Defrance, on behalf of a Norwegian-Belgian *Antwerpen Gruvelselskap* (Antwerp mining company).[36] No documents have survived to connect the firm to any specific bank, but the fact that a French engineer was running the Visnes mines for a Belgian establishment at the time of our story is an important piece of the puzzle. There was only one major Franco-Belgian bank in Antwerp at the time: the Banque de Paris et des Pays-Bas, the future Paribas, which was established in 1879 from the merger of the Banque de crédit et de dépôt des Pays-Bas (founded in Amsterdam and Paris in 1872 by some of Biesta's and Laboulaye's friends to channel French capital toward Europe) and Cernuschi's Banque de Paris, which in turn was a sort of bastion against the Rothschilds' dominance.[37] It is true that most of the copper from the Visnes mines was refined in Antwerp to produce sulfuric acid for the textile industry. But this does not necessarily rule out the possibility that some of the Visnes copper was used to build the statue. Besides, as we know, the banker Cernuschi, who had interests in the Norwegian mines, had been present in the funding campaign since its solemn inauguration at the Hôtel du Louvre on November 6, 1875. He contributed to its funding, and clearly shared Laboulaye's neocolonial ambition to compete with not only the British, but also the Rothschilds.[38]

It is possible, then, that the statue wore Norwegian copper because of the union's agreement with Cernuschi. If so, part of the old dispute between French nationalist bankers and the Rothschilds, intensified in particular in the wake of the Franco-Prussian War, would be reflected in the statue's gown. And because this dispute

was mixed with ethnic and religious antagonisms, these too may have become part of the colossus. This may seem paradoxical, since the statue spoke the language of the Jewish exodus and, with time, would be sponsored by Jewish intellectuals. But this was another consequence of the statue's composite nature: man and woman, old and young, good and evil, monotheistic and pagan, the statue was an exiled Jew, bearing the racist message of some nationalistic bankers and intellectuals; she wore a Roman toga, but was born in the desert. And yet her new, American backdrop would hide the statue's exotic, mythological past; her misleadingly classical appearance would reassure people regarding her Western nature.

With the pylon yet to be built and the Statue of Liberty's copper shell yet to be completed, the Franco-American Union was short of money, and it had run dry all of its main sources of funding—politicians, the aristocratic heirs of the heroes of the War of Independence, Freemasons, and industrialists. On January 8, 1879, union member Henri Martin played his last hand. He asked Charles Lepère, the interior minister, to hold a national lottery, with copies of the Statue of Liberty put up as prizes. In France, lotteries were frowned upon, because they were considered a kind of gambling. Unlike in America, where certain forms of public betting were tolerated, a French law of 1836 had banned all lotteries without a charitable purpose. By this time, however, the influence and reach enjoyed by Laboulaye and his friends were practically limitless. Senator Jean-Claude Bozérian, a heartfelt supporter of the cause (not to mention the first to compare Charlotte to the statue), explained that the statue was a work of "charity" (of benevolence if not of beneficence), because it represented the friendship between two peoples divided by an ocean, but united by feelings of mutual gratitude. Obviously, the friendship between the two peoples had nothing to do with the charity that each showed to their weakest and least fortunate citizens. And Bozérian could have rather quoted Laboulaye saying that liberty was "the happiness and fortune of the poor."[39] But he did not. It was not necessary, because the

government was already convinced: on May 9, 1879, a "Commission for the Franco-American Lottery," chaired by Bozérian himself, was established to organize the event. Before going ahead with it, however, Bozérian decided that a public celebration should be held to launch the initiative and establish the lottery's charitable credentials. Thus on May 11, 1879, a "great parade for the benefit of the poor" was held in Versailles, on the boulevard de la Reine. Posters advertising the event cast the Statue of Liberty against a new historical background. With the posters' beautiful Gothic lettering, the statue was no longer associated with the occult Renaissances of Shakespeare and Hamlet, but rather the world of medieval fairs. It was a fictitious Middle Ages that provided the backdrop for a series of parade floats, each representing the regions and nations of the world. There was a European float, preceded by Hungarians on horseback; then came Asia, represented by sixteen Indian women, odalisques, Japanese knights, and "groups of Chinese knights"; Africa followed, with three African knights ahead of Abyssinian Amazons, "black, on foot with their weapons," and Arab knights; after which came Mexico and the Americas. The naval world came next, led by Australia and followed by groups of savage warriors, "the Oceania float," a Pacific vessel, and then symbols of the various "maritime nations," including Norway and Sweden.

Pulling up the rear of this fantasy parade was an enormous globe topped "by the statue of the sculptor Bartholdi," carried by the "great cart of the world." This was yet another way of linking the statue to the world of long-distance trade and the great trade routes, except that, this time, the centerpieces were not means of transport — ships, railroads, hot-air balloons — but people. And almost all of them were colonized peoples — Indians, Abyssinians, Mexicans, and South Americans. Even Europe was mostly represented by countries "colonized" financially by French banks, such as Spain, Italy, Belgium, Hungary, and Scandinavia. Thus, for the first time, the statue revealed her true imperial identity. She was still the Stella Maris, Virgin Mary, or Christ, protector of the oppressed and the

poor (significantly, a "fund for the poor" case, drawn by four horses and led by brigands, closed the parade), but, with her Morgenstern, she was also a symbol of French colonial might.[40]

In at least one sense, though, the statue in the parade was the "statue of the poor," which meant that Lady Liberty could be presented by the Franco-American Union as a basis for the lottery. It proved to be a tremendous success. In the two months following the parade, three hundred thousand lottery tickets were sold at one franc each. Winners could look forward to thirty-five thousand francs in prize money and more than five hundred other prizes valued at fifty to four hundred francs—including Sevres porcelains, costume jewelry (made by the Japy firm), Italian ceramics, fine crafts, and Goupil engravings of works by Da Vinci, Ingres, and Gérôme. If one paid the cost of admission, one could admire these prizes at the Palais de Châteaux d'Eau, where they were displayed thematically, in the Japanese Room, the Louis XIII Room, and so on.

In this way, the Franco-American Union raised the funds it needed to complete the statue, and was able to announce to the American government that the fundraising campaign was over and "the appeal undertaken by the Franco-American Union . . . accomplished." On July 4, 1880, Independence Day, the members of the Franco-American Union met at the Hotel Continental, owned by the mysterious Catholic banker Donon, to officially inform U.S. Consul Washburne that the fundraising campaign was closed.[41] It was a grand party, attended by many big names in French business, some of whom had barely been involved in the campaign. They included the affable and ever stylish old Ferdinand de Lesseps, the Suez Canal developer who had boycotted Bartholdi's Egyptian project and who was now going to put his signature on the Panama Canal. But what was he doing in Donon's hotel? And why was he interested in the Statue of Liberty?

Meanwhile, new storm clouds were gathering on the horizon. One year after the fundraising campaign officially was closed,

financial markets around the world were shaken by a new crisis. Bartholdi was piecing together the statue's shell of (probably) Norwegian copper onto the Koechlin-Eiffel pylon when he received news that the French government, on February 21, 1881, had banned the import of all American goods.[42] The official reason was that American exporters had shipped spoiled pork to France, but, in reality, the causes of this French retreat into protectionism were much older and much deeper. As some of the newspapers had warned at the Paris exhibition of 1878, the rise of mass production in America represented a major threat to French industry and commerce. All of a sudden, Japy watches, precision-crafted by hand, had to compete with mass-produced American ones, and the inlay furniture produced by French craftsmen had to go up against replica "pre-Raphaelite" tables and chairs churned out by American machines. In response to the French embargo, the American government was no less resolute, banning French wine on the grounds that it was "bad for your health."[43]

This was a major rift in international relations and bad news for the Franco-American machine put into gear by Laboulaye and Bartholdi — for nearly all of the merchant "friends" of the statue were producers of wine, textiles, and crafts, which were sold at a great profit on the American market. But there was nothing to be done; until 1887, import tariffs would only continue to rise. It would be against this backdrop of a fully fledged trade war and economic depression that the Statue of Liberty would be erected and the final campaign to raise funds for the pedestal waged.

CHAPTER 27

THE IDEA

W ILLIAM EVARTS lost no time in setting the American subcommittees to work to raise funds for the statue's pedestal and garner widespread support among corporate lawyers. High-profile people began to appear in the subscription lists published by the *New York Times,* including the Drexels, the great Peter Cooper (founder of the American Industrial League), and his son-in-law, the iron magnate Abram Hewitt. On January 14, 1883, at a fundraiser for the statue, the Astors appeared—John Jacob Astor III was the "real estate mogul" mentioned by newspapers—and even the couple William Kissam and Alva Vanderbilt, heirs of the Commodore, who had just had a mansion fit for kings built on Fifth Avenue.[1] A month later, on March 26, 1883, they gave one of the most expensive and wildest costume parties in history, with Cornelius dressed as Louis XVI and Alva as "Electric Light," with a long gown covered in diamonds and her right arm raised like a Statue of Liberty, holding aloft a glowing lightbulb.[2]

Meanwhile Charles Pratt bought the rights to a logotype of the statue to advertise Astral Oil Kerosene (a product the Americans hoped would supplant British competitors in South American markets), and the Centaur Company even offered $25,000 to place banners for their laxative Castoria on the statue's future pedestal.[3] Even though the American committee had created subcommittees tasked with targeting the fundraising drive toward the various professions (printers, shopkeepers, and so on), and had originally intended to attract Franco-American businessmen, the advertising

possibilities associated with the statue were clearly attracting American corporate interests.

The statue was completed in Paris in the spring of 1884. Parisians had watched with fondness as the colossus took shape day by day, casting its growing shadow over the rooftops of the city. Laboulaye, however, would not live to see the long-awaited day when the statue was finished. He had drawn his last breath a year earlier, after a lengthy illness, passing away in silence and bequeathing to Bartholdi the Statue of Liberty and his dream of a French apotheosis in America and the world.

But the statue's other spiritual mentor, Victor Hugo, whose poem "Stella" had inspired the statue's thorny headpiece, was still alive. Laboulaye was already dead when Hugo first entered Bartholdi's workshop. Frail and white, he raised his head to contemplate the colossus crowned by his star of revenge. Even if he knew little about banks and copper, Hugo must have felt that the violent and threatening behemoth was also his work, a creature of his "spitted" songs, *Les châtiments*, as well as a sort of his alter ego, the poet-patriot walking ahead of his people and making light on the dark path of expiation, towards resurrection. Hugo did not say anything or, if he did, nobody reported it. But two years later, on his deathbed, he would still find the strength to write to Bartholdi:

> Form is everything for the sculptor and still it is nothing. It is nothing without the spirit; it is everything with the idea.[4]

It was a brief, yet clear acknowledgment of the statue's spiritual nature. Bartholdi had been searching for an idea—a moral idea—with which to infuse his colossus since his first journey to the United States. But what was it? The fact that Hugo could recognize it at first glance is telling. He could probably see his own *Stella* reflected in the giant's star; he could remember that night, on the ocean, in which he "fell asleep . . . near the seashore" to wake up at the sight of the "morning star, . . . shining deep in the distant sky

in a soft whiteness, infinite and charming."⁵ Indeed, the idea was Hugo's, and Bartholdi had first found it while reading his verses on the deck of the *Pereire* on his way to New York. But it was not only Hugo's idea. It was the gnostic, Böhmian, Masonic belief in the coexistence of good and evil that had inspired French poets and intellectuals for the last century. It was the idea that, according to Hugo, had helped French artists encounter oriental gods and goddesses without being devoured by them, and to brave an imaginary world of oriental marvels—a world that, like "the old cities of Spain," had everything in it, "bizarre tops" and "burning chapels," mosques—without losing their way.⁶

One look at the statue, and Hugo may have found himself transported into that same world again, all the oriental stories known in the West flashing in rapid succession in front of his tired eyes: furious Moses guiding his people away from Egypt toward the Promised Land; the Bedouin Abdallah (the hero of Laboulaye's Muslim fable) finding the fourth and golden leaf of Eve's magical clover in the ecstasy of death; Demeter desperately searching for her daughter in the dark of night; Dionysus brandishing the fire of *autopsia* (revelation) in front of his drunk Bacchants; Orpheus, in Samothrace—a "shining lighthouse that will light up islands and seas from afar"—instructing the plebs to music and order; Venus (or the soul) ascending to the knowledge of God from the passion of love and sin; Satan, or Lucifer, inspiring one's soul to sin, but also to desire and create; Christ's resurrection from the baptismal waters and sacrifice on the cross.

Who else could see the collection of stories and sentiments behind the statue so clearly, and with such rapture? In France, the Franco-American Union had done its best to sponsor the statue in ways that left no doubt about its Masonic and mythical identity. But the union's shows were intended only for select groups of people. The question remained open as to what would happen once the Statue of Liberty was moved to America, where it was supposed to carry a message for everyone. The statue's first

encounter with the American public, by proxy through the inter-
mediation of Lavastre's transparency, had not been encouraging.
Perhaps, like Laocoön in Virgil's account of the Trojan horse,
some Americans were suspicious of France's intentions in the
project. It would be hard to blame them, given events of the times
as well as the statue's mysterious look and foreign origins. What is
more surprising is that the union's friends, too, were afraid of the
colossus. And their fears would soon infect the statue's identity
in the New World.

THEIR INTENTIONS WERE GOOD: like the statue's sponsors had
done in France, the American committees decided that, in order
to fund the pedestal, it was necessary to invent a series of virtual
clones of the statue to exhibit on public occasions. But the con-
struction of these alter egos was a delicate matter, one in which
prejudices and suspicions could dramatically distort the meaning
or "idea" of Bartholdi's colossus. The first appointment was at the
theater. On January 27, 1884, the wives of New York's bankers and
businessmen organized an exclusive evening of *tableaux vivants*
at the Madison Square Theater. There, the statue was cast in
the sad and erotic roles of the literary heroines who throughout
the nineteenth century had embodied liberty, and showed what
it meant to be without it. They were the "burning stars" that,
in "A Dream of Fair Women," the English poet Tennyson had
described as navigating, as if "in a balloon," across the centuries
of literature—Helen of Troy, "divinely tall, and most divinely
fair"; Euripides's Iphigenia, who was condemned to die by her
father as a sacrifice on the altar of the gods in exchange for favor-
able winds for Greek warships; Shakespeare's Cleopatra, trapped
between love and power politics; Rosamund, the cruel queen,
in medieval garb, followed by the daughter of Jephthah, with a
fluttering scarlet gown, and gold cymbals; Margaret Roper who,
dressed in black velvet, appeared carrying the head of her father

Thomas More; and finally Joan of Arc, decked out in plumes and heavy armor.[7]

Only Dante's *Francesca* (Scheffer's heroine and the soulmate of his beloved Marie d'Orléans) was missing, but parts of her story—her sin and sacrifice—were reflected in those of other unfortunate and yet heroic female figures celebrated that night. And yet, what about Francesca's resurrection, which Scheffer famously had depicted on canvas? In Paris, at the Opéra, the union's men had made sure to identify the statue with narratives of individual and national revelation. No matter how sad the story behind the statue might have been—Christ's sacrifice on the cross, Finella's death in the volcano—it was always followed by triumph, emblematically symbolized by William Tell's victory over the evil Gessler. At the Madison Theater, by contrast, only the dark side of the statue was brought to light, and the dominant note was one of melancholy and death, even malice and deceit, as Helena of Troy, the beautiful queen who had triggered the war between Greeks and Trojans (with which we began), appropriately was among the figures re-evoked on stage. Even Edward Moran himself, who had painted the first depictions of Bartholdi's earliest visions of the statue, placed it in a nocturnal landscape, dimly lit by the moon and the lights of ghostly ships. And so, in the dark and with its torch lit, the statue would continue to evoke the subterranean world of Dante in the American popular press—a decrepit Dante, waiting in vain for the pedestal, or an aged Dante standing upright, holding the lamp with a stiffened arm (Figure 27.1).

Things would not stay this way forever. At some point in 1883, the committee had already decided to publish a small book of poetry and stories about female liberty, the proceeds from the sale of which would go to the Statue of Liberty. The poet and Dante-lover Emma Lazarus, ward of a well-off Jewish family, dedicated a poem to the statue that forever would change the way in which the colossus was perceived, verses of which are now famously engraved on a plaque inside the statue's pedestal:

Not like the brazen giant of Greek fame,
With conquering limbs astride from land to land;
Here at our sea-washed, sunset gates shall stand
A mighty woman with a torch, whose flame
Is the imprisoned lightning, and her name
Mother of Exiles. From her beacon-hand
Glows world-wide welcome; her mild eyes command
The air-bridged harbor that twin cities frame.
"Keep, ancient lands, your storied pomp!" cries she
With silent lips. "Give me your tired, your poor,
Your huddled masses yearning to breathe free,
The wretched refuse of your teeming shore.
Send these, the homeless, tempest-tost to me,
I lift my lamp beside the golden door!"

Lazarus's poem was a brusque departure from the stories of cruelty and deceit put on stage at the Madison Theater. In her verses, the statue reclaimed her maternal and benign personality: she was again Demeter looking for Persephone in the dark world of her kidnapper; Venus or the Virgin guiding lost sailors home; Christ receiving the penitent; and, finally, a savior of the poor and the unfortunate that, in his fable on Prince Charming, Laboulaye had once associated with the "sunshine" of liberty. Perhaps Lazarus recognized the harrowing story of her own people in Bartholdi's colossus, looking for her own nation in the light of God's fire. But could she ignore the other side of the statue's personality, that of the seductress and unfortunate daughter, victim of a society that revolved around the interests of husbands and fathers? How could anybody describe the statue's eyes as "mild," when their severity had already struck more than one observer as ominous? Indeed, what happened to the statue's terrifying signs of the apocalypse? Her Black Sun?

It seems clear that the Americans, the elect people whom Krause and Laboulaye thought were capable of being initiated without secret ceremonies, did not see the statue the way it was intended. (Neither

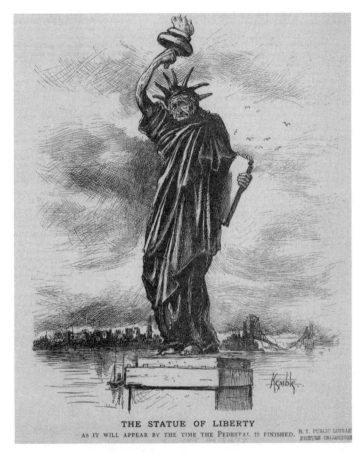

THE STATUE OF LIBERTY
AS IT WILL APPEAR BY THE TIME THE PEDESTAL IS FINISHED.

FIGURE 27.1. Edward Winsor Kemble, "The Statue of Liberty as It Will Appear by the Time the Pedestal Is Finished," *Life*, January 17, 1884, Art & Picture Collection, the New York Public Library, Astor, Lenox, and Tilden Foundations.

did the French, but the statue was not meant for them.) Their revelation had, in short, not gone as planned, and where earlier interpretations had been too dark, Lazarus's vision was much too benign.

Bartholdi, however, did not want to hide his statue's more funerary aspects from the American public, and indeed sought to highlight them whenever he could. To underscore the statue's morgue-like traits, he wanted the pedestal built like a medieval tower, or like a pyramid, or even like the colossal mortuary monuments

of Latin America, at Chinkultic, north of Veracruz, reconstructed
in Paris for the 1867 Universal Exhibition. In a series of interim
works, William Hunt Morris, the architect engaged for the task
by the American committee, first tried to develop the idea of a
tapering tower decorated with loggias on all four sides, then that
of a step pyramid, then a combination of the two, with a shorter
tower emerging from the pyramid. Then, on July 31, 1884, while the
fundraising campaign was still open, Hunt submitted three propos-
als to the American committee. In the first, the statue stood on an
undecorated pedestal resting on a Doric-style base (all placed on top
of a short pyramid); the second and third projects featured a tower-
like structure made of rough rock, decorated with Doric columns
of polished stone on each side. The second project also envisioned
a frieze, which ultimately was discarded in favor of the simpler and
more sophisticated design of the third, winning proposal.

MEANWHILE, IN MAY 1883, a company of workers landed at Bed-
loe's Island to excavate the site where the statue would stand. To
direct their work, the administration appointed Charles Pomeroy
Stone, the future leader of the October 1886 military parade in
honor of the statue. When we last saw Stone, he was fighting in Egypt
as a mercenary soldier. There, he had convinced Ismail, the khedive,
to nominate the American arms manufacturer Remington as Egypt's
supplier of weapons, and then to use his guns to invade and occupy
nearby Sudan and Abyssinia—thus ensuring the continued growth
of the Egyptian arms market, as well as a role for himself in his true
profession of mercenary. Together with the former Confederate officer
William W. Loring, renowned for his violence and hot temper, Stone
had overseen the occupation of Gura, which had cost the Egyptian
army fourteen thousand lives. Such losses would not discourage the
khedive, however. When Stone was packing up to return to the United
States, the fighting was continuing in Saati, in Eritrea.[8]

Back in New York, rather than hushing up his experiences in
Egypt, Stone had decided to profit from them by giving a public

address on his military exploits. Generously, he had donated the proceeds to the Statue of Liberty.[9] Just like Lesseps before him, Stone had silently entered the statue's story, and in an equally inexplicable way, unless we recall that the friendship between America and France in large part had been based on exchanges of arms. The same had been true of that between America and Egypt, and Stone had been one of Remington's men in the Egyptian effort. Having been a soldier in America and a mercenary in Egypt, Stone was a perfect candidate to supervise the arrival of the statue in New York, since Miss Liberty, like him, was an armed sentinel with a secret past in the "Orient." We still have to see where the Sentinel's weapon is hiding. As for Stone, despite suspicions about his past, the secretary of the Treasury John Sherman (related to at least two members of the American committee) put him in charge of the statue's assembly on Bedloe's Island. Maybe Stone's exemplary service for the Remington Company in Egypt outweighed the disappointment of his military service during the Civil War?

Whatever the reason, Stone was now in charge of the Bedloe's Island construction site, which had begun to look something like a western mining town of old, with its wooden shacks, railways, and haunts. And, like a mine, the statue's excavation site was hiding surprises for Stone and his men. First of all, their machines had to go deeper than expected, and to tear down the ruins of the antique fort built on the island.[10] This was a problem, at least from a financial point of view, for the campaign was beginning to show signs of fatigue. On December 4, 1883, the American committee had raised a total of $97,102.46, but it was not enough. New York businessmen proposed raising $50,000 in revenues from the citizens through a one-off tax, but the proposal was vetoed by Grover Cleveland, the Democratic governor of New York at the time.[11] Money was urgently needed to start the excavation work, but where to find it?

The American press, especially in New York, proved remarkably unwilling to get behind the campaign for the statue. Even though some big names in journalism, such as William Ellery Curtis, were linked to the New York lawyers sponsoring the

statue, and though Bartholdi had managed to forge contacts with a number of journalists over the years, the newspapers would not espouse the committee's cause—and cartoonists continued to delight in caricaturing the statue's most Luciferian traits. Another blow came when the statue's supporters were seen feasting at a dinner for the Republican presidential candidate James G. Blain—a "banquet fit for a king"—right when they were begging for subscriptions for the pedestal fund. Many began to grumble that those same rich men of New York City could drum up the money themselves.

The situation finally changed in 1883, when the Democrat Joseph Pulitzer bought the *New York World* and launched a completely new campaign from its pages. Tall and skinny, Pulitzer was the son of a Hungarian merchant, half-Magyar and half-Jewish. His father had died when he was still a boy, and, after his mother remarried, Pulitzer immigrated to America and enrolled as a soldier in the Civil War; when the war was over, he settled in St. Louis and started a career in journalism. No one would have bet a single cent on the success of the *New York World* after learning that a Hungarian—he was called "the great Phizzel"—had bought it from the great financier Jay Gould, but the move proved a masterstroke. It would also secure the success of the Statue of Liberty—but one whose looks and meanings were inflected yet again.

While the French, on the other side of the Atlantic, were proving reluctant to relinquish Miss Liberty to the Americans, and New York's rich magnates were imagining the statue in the world of their own luxurious mansions, Pulitzer proposed a new approach to break the impasse. His idea was to make the Statue of Liberty an icon of the average American. From the pages of the *New York World*, he associated the statue with the common people, many of them expatriates, and invited them to contribute what little they could:

> We must raise the money! The *World* is the people's paper, and now it appeals to the people to come forward . . . the Statue . . . [in France] was paid in by the masses of the French

people—by the working men, the tradesmen, the shop girls, the artisans—by all, irrespective of class or condition. Let us respond in like manner. Let us not wait for the millionaires to give us this money.[12]

Pulitzer's words were false. In France, no less than in America, the statue had been financed by rich businessmen with their hands on the reins of government. But he lied for a reason, and that reason was to construct yet another virtual identity for the statue. Pulitzer's underlying idea was to disentangle the statue from the occult auras cast over her by French mystics and intellectuals. The statue would no longer symbolize eldritch reveries, apocalyptic forecasts, weeping mothers, and sinful women, although she would still be a protector of exiles and expatriates. She would be a friend of Uncle Sam, the tall man dressed in the American flag who, since 1812, had appealed to the average American Joe. This explains the more rustic appearance and ruddy cheeks the statue acquired through the New York World's campaign. Compared to its former sepulchral self, the difference was like night and day.

The subscriptions offered by the "common people" were not enough to close the appeal and Pulitzer had to backtrack and ask the rich to donate, too. Even so, Pulitzer's approach would enable him to close the fundraising campaign on August 11, 1885, with $102,000 raised, from a total of 121,000 people. To mark the occasion, the New York jeweler Tiffany, who had already donated to the long-distance appeal for funds from France, was asked to produce a Testimonial Torch—a silver sculpture, mounted on a pedestal, that would represent the torch on a globe.

WORKERS LOADED and unloaded materials arriving by sea, constructed formwork, and poured cement; wagons loaded with materials ran over wooden trestle bridges; and soon a steam-powered elevator would take them even higher, to install the "Eiffel pylon" and, bolted on top of it, the red copper shell of the goddess. Two

solemn events were held once the foundation and pyramid were
finished on May 17, 1884. The first occurred in Paris, on July 5, 1884,
when Bartholdi presented the now complete statue to the American
minister Levi Morton "in the name of the French government"
(somewhat oddly, given that the government had played no role
in the original project). One month later in the United States, on
August 5, 1884, the laying of the monument's base was officially
celebrated. Originally scheduled to happen in 1876, for the cente-
nary of Independence, the event had been postponed indefinitely
but now had arrived: more than five hundred people gathered on
that day around a six-ton granite block held by a pulley, under the
pouring rain — as though to foreshadow the inconveniences of the
Statue of Liberty's official inauguration day two years later. Soaked
and uncomfortable, but nonetheless there, all the city's wealthiest
citizens turned out for the curious event (including Cyrus Field,
Evarts, and Pratt). Not far from the suspended stone rested a cop-
per box. The Grand Master of the New York Lodge, William A.
Brodie, put on his Freemason's apron, then took a silver trowel and
spread some mortar on the spot where the stone, still suspended by
cables attached to a steam engine draped by French and American
flags, was to be set. The orchestra played *Hail Columbia* and the
Marseillaise, while General Stone stepped up to the copper box.
Slowly, Stone opened it. Within it were "copies of the Constitution
and Declaration of Independence, a number of medals, a list of
the Grand Lodge of the Freemasons of the state, the newspapers
of the day, and other articles considered important."[13]

There was also a coin in the box on which the following words
could be read:

If anyone tries to haul down the American flag, shoot him
on the spot.

These words of General John Adams Dix were more suitable
to a borderland sentinel than to a tender mother. But, as Bartholdi

had said, America was a woman chewing tobacco; perhaps she was also a woman ready to open fire. Bartholdi, for one, hoped that she would direct her aim at Germany; Laboulaye, if alive, would probably have opted for the British. But what if, like a true Trojan Horse, she would end up shooting the Americans themselves?

In any case, Dix's advice was placed, together with the other documents, in a groove made in the cement. Then the steam engines were cranked up and the stone was put in place, forever enclosing the copper box between the pyramid and the base of the pedestal.[14] Still today, one can see the reverberation of those bellicose words in the statue. Where, one may ask? In her skin, which is made of the same copper used to make cannons and cartridges, in the military fort that is her home (a sort of martial clamshell for a bellicose Venus), and in the cannons surrounding it.

But Sentinel's real weapon is to be found somewhere else: on her head, where the star of Hugo seems to hide a terrible instrument of destruction: the Morgenstern, a medieval club covered with spikes. It was Hercules's club, the one figuring in Colmar's coat of arms, recalling the story of the hero's intoxication with the wines of the region (see Figure 8.2).[15] Indeed, since the time of Louis XVI, Colmar's golden Morgenstern has appeared against a half-red, half-green background, like the liveries of Colmar's administrative personnel, while the Statue of Liberty, also born red, would soon become green.[16]

The coincidence between the statue's apocalyptic symbolism as the "morning star" and Colmar's iconic weapon has long escaped observers, but it cannot have escaped Bartholdi, particularly because he always smuggled encrypted references to himself and his private story into his monuments. This time, however, Colmar's Morgenstern was not only a signature. It also contained a political message, a message of vengeance similar to the one Bartholdi had already instilled in his cursing *Alsace* and his colossal lion of Belfort. It was a promise of revenge against the Germans

on behalf of Colmar, but also on behalf of the Bartholdi family
personally, to whom the statue is an almost megalomaniac tribute.
After all, their sun, from the insignia of Bartholdis' eighteenth-
century pharmacy, shines on her head, and the statue's crown and
raised hand derive from the family's old coats of arms. But the
torch adds a spark of revenge, such as the one which Washington
had kindled in the American children lighting his path to the
battlefields, to fight against the British.[17]

IN 1885, Bartholdi began dismantling the statue in Paris. It was a
risky decision, because some of the money necessary for the con-
struction of the pedestal had not yet been raised. Officials in Bos-
ton, sensing opportunity, offered to buy the statue for their harbor.
One can easily imagine the Statue of Liberty now, standing high
on one of the islands in the harbor or, perhaps, overlooking the
restoration of the USS *Constitution*, one of the first ships commis-
sioned by the early republican government that is now resting at
dock.[18] Baltimore and Minneapolis followed suit, with Minneapo-
lis leaders suggesting a location along the Mississippi River. One
wonders whether Mark Twain, who had been present at some of
the meetings of the Franco-American Union, would have agreed
to see the statue erected along his beloved river, a backdrop for
Huckleberry Finn's joyrides. As for the French, many would have
loved to see the landmark commemorate their past presence in
Louisiana. Indeed, the Statue of Liberty was just one step ahead
of France itself, preceding it in the economic penetration of the
Americas — not just Central and Latin America, around which Les-
seps's business interests gravitated, but also North America, with
its copper and iron.

For Parisians, however, who had become fond of the statue and
had hoped to hold onto it, its departure was a terrible loss. Bartholdi
and his assistants packed up 214 crates, numbered them, and put
them on seventy carriages, forming a peculiar funeral procession

from the center of Paris to Rouen, where the statue, divided in blocks, set sail for America on the frigate *Isère*. Today, it is often said that the statue almost sank during the voyage, and, in the usual apocalyptic vein inspired by the colossal size of *Liberty*, historians wonder what would have happened if the statue had sunk. Would expeditions have been organized to recover it? Would they have found it? Might she have become a colossal, political version of the *Christ of the Abyss* off the Ligurian coast near San Fruttuoso? A *Liberty of the Abyss*?

Though the crossing was difficult, the *Isère* made it safely to its destination of New York. Edward Moran's portrayal of the frigate's arrival in port has all the trademarks of an eighteenth-century naval battle. With the *Dispatch* in the lead, followed by the *Omaha*, the *Powhatan*, and the *Flore*, the *Isère* was flanked by the *Patrol* and the *Atlantic*, while the guns of the fort where the Statue of Liberty would be placed thundered in salute, receiving in response eighteen volleys of rifle fire. In 1893, Bartholdi would pose proudly for a photo with the very same guns (Figure 27.2).

Indeed, the *Isère* was welcomed with a thousand honors. But then everything had to wait until the remaining money was found, namely until August 11, 1885, when Pulitzer finally gave the news that "one hundred thousand dollars" were available to finish the pedestal.[19] Then work started almost immediately. Bartholdi himself arrived to oversee the operations, which were complicated by the fact that the numbers on some of the boxes were unclear or even wrong, and that the pieces did not fit perfectly on "Eiffel's pylon." Like bees buzzing around a hive, the workers labored around the statue, hanging from the invisible threads of steam cranes, while the pieces of the "monster" lay on the ground, like the limbs of a dismembered colossus—like the very ruins that originally had helped inspire the Statue of Liberty. As for the lighting, in September 1885 Edward H. Goff, president of the American Electric Manufacturing Company, offered to supply a series of arc lights that would be placed inside the observation deck.

Goff was another of the dubious figures who was associated with the neocolonial schemes of the Franco-American Union. A promoter of the Canada Agricultural Insurance Company of Montreal, and very close to Catholic circles, Goff was much loved by the local clergy and had built himself a solid reputation in the city. That would change when he fled Montreal in 1878, leaving the coffers of the company nearly empty. He then moved to Boston, where he refashioned himself as a local agent of the Union Pacific Railroad, a firm vouched for by the lawyer Evarts (one of the American sponsors of the statue), before getting involved in the emerging electrical industry. When the offer to provide lighting for the Statue of Liberty was made, Goff had only recently left behind him a bankrupt electricity company based on the Thomson-Houston distribution system, a system subject to frequent interruptions and more suitable for public than private use. Meanwhile, Edison had patented the incandescent light bulb and the Canadians had launched an investigation into Goff. Still on the loose, he founded yet another company, which he incorporated as the American Electric Manufacturing Company. Then, in 1885, he added to it the Fuller-Wood Electric Company, which rather interestingly was registered to the businessman William Appleton, one of the friends Bartholdi had made through Longfellow.

By 1886 Goff's reputation lay in ruins.[20] So the Lighthouse Board gave the project to Lieutenant John Millis, who at first thought of arranging the arc lights, with a reflector, inside the torch and incandescent bulbs in the crown, while other arc lights were to be placed around the pedestal to illuminate the statue from below. Then Millis considered lighting the torch from within, with windows cut and paned with glass for the light to shine through. A trial run in mid-October 1886 showed that the light was too dim to be seen — but not for birds, which, attracted to the light, crashed into the torch in flocks. The newspapers once again jumped at the chance to highlight the statue's Luciferian character by depicting masses of dead black birds on the observation deck, inside the torch,

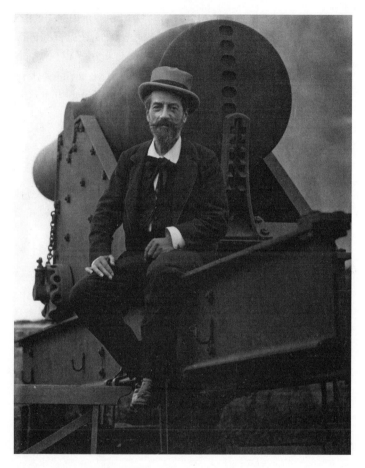

FIGURE 27.2. J.-J. Lewis, *Auguste Bartholdi (1834–1904)*, 1893, tintype, unsigned, undated, Musée Bartholdi, Colmar.

and with their wings splattered against the glass.[21] For a long time, the statue would remain in darkness, without the spark of light that characterized all of Bartholdi's art. Were the Americans afraid, after all, to light their present? Were they afraid of its Promethean gift? The ancient mysteries recounted that light led to salvation, but they always required a sacrifice. If they did keep the statue in the dark, Americans might have had the illusion that no sacrifice was required. And they were probably right. The light, however,

was an integral part of Laboulaye and Bartholdi's vision for the statue, one meant to represent the rising American Republic in the morning, which would turn into the dying light of the French monarchy at night. It was like a spell—one of those terrible acts of sorcery that Laboulaye loved to describe in his stories—that only darkness could break.

DOT-DOT-DOT-DASH

W<small>E HAVE RETURNED</small>, full circle, to our opening scene. Indus-
trialists, bankers, and lawyers were ready to celebrate the Statue
of Liberty; so too were women, immigrants, the poor, and Orphic
mystics. Neither group really understood the entirety of the statue's
intended meaning, but the elites were correct in their assumption
that it was, in part, a Christian icon promising revelation in Amer-
ica, while the marginalized were right that it promised justice and
some sort of revenge.

Laboulaye knew that it meant both. But he was the only one of
the statue's creators missing from the festivities. Taking his place
was Lesseps, old and burdened with debt. Going up to the platform
one after the other, Lesseps, Evarts, Storrs, and Depew brought
with them fragments of American and world history that have been
reconstructed in this book. No less than Miss Liberty's copper sheets
and wrought-iron bones, the events and ideas they represented had
helped forge her identity. Reverend Storrs, preoccupied with the
arrogance of constructing such a titanic statue, showed himself
perfectly aware of its Promethean message. Lesseps was tactful
enough not to mention his projects in Suez or Panama, but his
presence alone was enough to reveal the statue's intrinsic links to
the French plan of recolonizing America and, indeed, the world.
Evarts, for his part, spoke on behalf of the mining, railroad, and
military interests that had shaped the meteoric rise of the American
economy, helped France in the war against Germany, and invested
in Egypt's militarization. Testifying to the statue's Egyptian origins

was not only Lesseps, but also Stone. Each in his own way had contributed to the industrialization and militarization of Egypt, without which Bartholdi would never have conceived of the project for a colossal lighthouse for the Suez Canal, the forgotten ancestor of the Statue of Liberty.

Few among those present at the inauguration would have known that the Statue of Liberty was born a fellah. Bartholdi had not mentioned it in the history of the statue he had published in the *North American Review* the previous year, and *Liberty* herself bore very few traces of her Egyptian past: her hips were covered and straight, her dress was classical, and her head was uncovered. Still, she remained a giant like those erected by the Rhodians, the Greeks, and the Egyptians, and a metallic colossus like those dreamed of by the biblical prophets of old. The star on her head alluded, distantly, to banished divinities from Babylon. Her face was masculine, her frown far from benign. She had lost all of the eroticism that orientalists habitually projected on the East, but—through her allusion to ancient mysteries of death and resurrection—she still bore traces of Western visions of oriental excess. It is worth repeating that, at the time, this connection was often tainted by racism and social discrimination, and that ideas about the statue were no exception. Her new audience did not suspect any of this, nor, for that matter, did most members of the American public imagine that the statue they were about to welcome as a gift was in fact a sort of Trojan horse, an icon of French nationalism portrayed through biblical narratives and orientalist fables.

But so it was. And it is ironic that at least one of the apocalyptic dreams that inspired the construction of the Statue of Liberty would be shattered mere years after its inauguration. In 1889, Secrétan and the Société des métaux went bankrupt, bringing down with them the bankers of the Société générale and of a bank closely associated with it, the Comptoir d'escompte. In 1892, the banker Donon; Eiffel, the builder of the statue's skeleton; and Lesseps were

all dragged into the Panama Canal fiasco and ended up standing trial for fraud.

PERHAPS BECAUSE SHE WAS French, perhaps because she retained a certain Trojan quality, perhaps because she was placed on a border, the statue was neglected by Americans since the first day of her arrival. This may be hard to imagine today, but she was long spurned in the New World. A Venus or Demeter of the cannons, a forgotten Christ framed by New York's Trinity (Staten Island, Long Island, and Manhattan), she was left there alone—only the few soldiers who lived in Fort Wood shared the island with her—and with no light. The failure to light the statue's torch in the aftermath of the inauguration had not worried Bartholdi too much. He was convinced that, sooner or later, the statue would be painted in gold, and the shine from her skin would more than compensate for the darkness of her flame.[1] He was being overly optimistic: the statue began to turn not gold but green—more and more so—and her light continued to be off for ten more years. Then, between 1896 and 1898, something happened. The torch was covered in glazed glass, which was supposed to reflect beams of red and yellow, like a real fire, into the sky, while red, white and blue lamps were placed inside the diadem.[2]

This, too, answered one of Bartholdi's original wishes. Perhaps inspired by the colorful ruins found in Egypt and Greece, maybe fascinated by Notre-Dame and medieval churches, Bartholdi had long harbored the idea of covering the windows of the statue's crown with glazed glass. Bartholdi would have rejoiced, but the colossus still did not shine in the dark night the way Laboulaye had expected it would in his magnetic fable; her feeble light would never have saved Laboulaye's mystical alter ego Daniel when he found himself lost at sea. The only thing to do was to stop trying to make a lighthouse out of the Statue of Liberty. This finally happened in 1902, when Theodore Roosevelt transferred her management

from the Lighthouse Board to the War Department. Belatedly, but surely, this was recognition that she indeed was a belligerent icon. Yet while Americans battled in Cuba, the Philippines, Argentina, Haiti, Nicaragua, and the East to conquer parts of the world over which Laboulaye had hoped to reestablish French influence, the statue idled on her little island, warmed only by a languishing light.

This state of affairs continued for another twenty years, as the statue's internal framework began to buckle, the wind wore away at her copper shell, and her red hue—symbolizing Dionysius's wine, Prometheus's fire, and the love of Venus—progressively turned to turquoise, a color that for the German philosopher Creuzer represented purity and the Virgin Mary, and for Pico della Mirandola, Venus's knowledge of the divine.

Dark and creaking, the statue was indeed haunted by ghosts. But according to the ancient mysteries, after the pain of initiation awaits the joy of revelation. This was the core message inscribed in the statue's symbols. And the Statue of Liberty too, after being neglected for so long, would fittingly be born again. What would save her from oblivion, moreover, were the same elements that had condemned her to general neglect: her alien origins and warlike essence. When the armistice ending World War I was signed on November 11, 1918, Woodrow Wilson lit her torch for the first time since she was born. Bartholdi could hardly have hoped for more. Without fire or gold, the statue was dead. But now, raising a menacing flame, she finally became what she had been supposed to be all along: an avenger against the Germans, a Prometheus gifting the fire of progress to America, a Morgenstern promising a new and better life, as well as the means of securing it. The statue was a warrior and a sentinel. It was only fitting that she shared her island with the soldiers of Fort Wood, guarding and illuminating their star fortress. Made of copper like the guns and cannons used to defend France against Prussia, the Statue of Liberty was as much a military mausoleum for those fallen during the Revolutionary War as it was an icon for present conflicts. Memorializing what has been lost,

she symbolizes what must still be won; offering regeneration, she justifies sacrifice.

But she also has had her own domestic war to fight, against German spies in America. After disfiguring and tearing down Bartholdi's statues in Colmar (the *Rapp*, the *Bruat*, and the *Schongauer*), the Germans directed their attention to the statue. Or rather, toward the factory of explosives that the Americans, in their traditional effort to help the British and French during World War I, were producing on nearby Black Tom Peninsula in Jersey City. On July 30, 1916, a terrible explosion at the factory killed seven people and managed to dislodge the arm of the statue, which has been closed ever since. All considered, it was a minor wound, but a significant one because it revealed how strongly the destiny of *Liberty* (as well as Bartholdi's other works) remained connected to the transatlantic arms trade, and to war.

That said, not even in his wildest dreams, or while posing for a picture on one of the cannons surrounding the statue, could Bartholdi have hoped for such a difficult, yet prodigious career for his statue (see Figure 27.2). And how can one blame him? *Liberty's* face—the same one that had alarmed American authorities on the day of the inauguration and had been welcomed by the country's feminists and expatriates—was becoming an official emblem of the United States in its military campaigns abroad. Beyond the romantic story of an icon traveling from the Near East to New York, there is the deeper theoretical question of explaining how a symbol that was meant to portray the dominated East became the self-representation of a victorious West; and how a statue meant to immortalize America's Declaration of Independence became an icon of social justice. Answering this question means dealing with the fact that the language of domination is more flexible and plastic than often suspected. Sure enough, the statue did not lose her colonial (or even imperialist) meaning in the process; the French long continued to see in her the promise of future control of their former colonies (no longer in the East, but in the West), and yet

this did not hinder (and may even have encouraged) Americans to see the story of their own independence and the promise of their future expansion reflected in her stern countenance.

Does this mean that the statue is open to all meanings, as has been suggested? Or does it rather point to the fact that iconic transmission and appropriation are replete with accidents that linguistic theories tend to transcend or ignore? So it happened, for example, that Miss Liberty, the freed slave symbolizing French control over the East, became Wilson's icon of peaceful control of Europe—the Freedom Program—founded on the liberty of the seas and the idea of national self-determination. Domination was deeply engrained in her iron bones. What changed was the way in which liberty—the prize for enduring domination—was interpreted. For Franklin Roosevelt, the concept of "freedom" would be enriched with other important features, consisting not only in the positive freedoms of speech and religion, but also in freedom from want and fear. Achieving and projecting this kind of freedom would require the power to fight tyranny, oppression, and destitution everywhere. It was in this guise that the statue, for a second time, returned to Europe during and after World War II; to vanquish the Axis powers, reconstruct European economies, and invest in European industries and institutions. And it was during the dark days of this greatest of all wars that the Statue of Liberty shed years of projections to reappear in her true form, armed and out for vengeance. It was then, crowned by the very star that Jews now were forced to wear on their sleeves, that the Statue of Liberty came to resolutely be identified with the oppressed, and with America's mission to save them. It was then, on D-Day, June 6, 1944, that the statue used her light, which had been turned off for the duration of World War II, to briefly speak: "dot-dot-dot-dash," the Morse code for Victory—Victory in Europe—only to then go dark again. Not for long, though, because, as a prize, the statue was adorned with a new "robe of light" for Victory Day, an empowered system of illumination that made her light shine "2500 times full moonlight."[3]

Moved by the statue's new light and voice, Keith Frazier Somerville, a journalist for the *Bolivar Commercial*, saw in the goddess "a symbol to the submerged people of the world that the light of Liberty was still burning in America."[4] The architects of the statue had, of course, framed this and other meanings while sharing deep social, racial, and gender prejudices. As Said rightly observed, nineteenth-century orientalism often took racist and anti-Semitic forms, which can still be discerned in surviving statues like Miss Liberty. And one should not be surprised, because monuments are, in Proust's language, our lasting and often invisible mirrors. Mirrors, however, not only of those who made them, but also of those who inherit them. As the curious history of the statue's construction and reception reveals, Europeans and Americans alike eventually saw their nobler selves mirrored in their past prejudices.

TOWARD THE END of the Cold War, in the second half of the 1980s, the statue underwent a second major restyling. By this time oxidation had turned it completely green, the color of the almighty dollar, which, from the perspective of its history, was a problem because it deprived *Liberty* of the diabolical air that characterized all of Bartholdi's other works. President Ronald Reagan had the statue restored, and replaced its beautiful torch, all covered with glass, with a golden fire, a small tribute to Bartholdi's grand dream of gilding his statue. The crown's lamp also became more powerful, thus intensifying the statue's apocalyptic message. This was intended to signal that a new era was about to begin, an era that would bring economic freedom after the defeat of communism. The statue had a new identity: green and gold, she was the icon of capitalism, free enterprise, and of the elevation of the freedom of employers over the rights of employees. Laboulaye might have approved from a theoretical point of view, since he had been convinced that the Declaration of Independence had grounded the whole nation on a mystical connection between individual rights and the general

good, a connection that did not need laws to care for the weak and the poor. But Laboulaye's America was equally based on the Böhmian flame of love and sin, on the gnostic fusion of light and dark, creation and destruction. And that flame no longer flickered from the statue. All green, the color of purity, but also, in the United States, of cash, the statue was now a colossal monument to libertarian regeneration.

All this purity, of course, was misleading; it was the effect of oxidation and restoration. Inside, the statue still kept her Luciferian personality intact. And she was still an exile, of European origins. Which is why, unlike Uncle Sam and Columbia, which were fully anchored within the borders of U.S. ideological territory, she continued to be a friend of oppressed minorities in the world at large, as Mrs. Somerville had well understood. A few months before the fall of the Berlin Wall in 1989, while the green "mother statue" was enjoying Reagan's identification of it as a symbol par excellence of the established order, a completely white replica of it was raised by Chinese students in Tiananmen Square as a revolutionary symbol of their protest against an intolerant and totalitarian regime. Other, more malevolent replicas have circulated around the world to criticize American capitalism and its own global ambitions, often in the very places, such as the Middle East, where the statue's architects had hoped for a French colonial renaissance. Both baron and benefactor, the face of Rooseveltian and postwar America has become so familiar to Europeans that they easily locate in its symbolic arsenal the very tools of its own demonization; indeed, they have taken that most noble of its symbols, the sacred fire of its creative and industrial spirit, and turned it into an icon of revolutionary destruction. From the wall posters that appeared in Italy during the American occupation, to those seen just a few years ago in Baghdad, to the graffiti on the former U.S. embassy in Tehran, the skeleton-statue with a flame in its hand is one of the recurring iconographic motifs of the anti-American press.

The statue's devilish personality is still present, and continues to emerge in situations of internal conflict, when opposition parties borrow her image to attack the establishment, or in situations of general change, when she is summoned as a herald of catastrophe. Feminists and African Americans have seldom doubted their conviction that the statue was a substantial ally, ever since the day of its inauguration. Lesbians have portrayed her in the act of French-kissing a female justice; gays cover her body in rainbow stripes. Now, after the election of President Donald Trump, she is more than ever represented as covering her eyes in shame and desperation, fainting, being decapitated, and, ever more frequently, having her private parts "grabbed." But the Statue of Liberty conceived of by Bartholdi and Laboulaye is neither timid nor submissive. She is armed.

Indeed, these most recent depictions are almost incomprehensibly crude in light of the statue's lofty history and epic aspirations. But they are, perhaps, the natural consequence of the statue's dichotomous personality, which spoke of vices and virtues, sacrifice and salvation. Wearing a comet on her head, a universal symbol not only of apocalypse, but also of disgrace — as well as a weapon — the statue has been perceived as a carrier of bad omens since it was first advertised in America, in 1876, when *Life* portrayed it as the gateway to Hell, with a skull for a face. After all, before imagining it, Bartholdi had visited the pyramids, the sphinxes, and the colossi of Memnon; he had unwrapped mummies; he had gone to Pompeii and gazed with morbid curiosity upon its ash-molded corpses; he had eagerly participated in the big business of death tourism. Since Bartholdi, like Nerval, believed that the immortality of a civilization depended solely on the artists capable of preserving its memory, he decanted the techniques of Egyptian and Italian artists into a vessel for America. Built like a tomb, the statue had been designed with the effect it would have on a distant posterity, perhaps even after the disappearance of the human race, firmly in mind. Bartholdi's wanderings, from Bedloe's Island to California

and back again, were prompted by the need to find the most suitable apocalyptic backdrop against which the statue would produce its intended effect in a world reduced to ruins. And New York—the city "triune" and "one"—proved to be the landscape most in line with Bartholdi's mystical ambitions.

Given Bartholdi's strong apocalyptic beliefs, it is not surprising that they would come to profoundly influence the ways in which Europeans and Americans have looked upon the statue ever since its construction. As we have seen, the statue made an appearance on stage before it was built of copper and iron. And, curiously, virtual doubles of the statue continued to coexist alongside the metal original. Just as the "theatrical" representations of *Liberty* created by Bartholdi and by his American colleagues were tragic heroines or goddesses who provoked (or averted) shipwrecks and aerial disasters, the virtual statue would continue to live on stage, on screen, and in print amid, or in the wake of, world-ending disasters. Since its first days, the statue has never really stopped reminding Americans that their society, too, will someday die, and the world with it.

In 1941, for example, an issue of the magazine *Astounding Science Fiction* appeared on newsstands with a cover image of a submerged world with the statue, like a castle perched on a small island, sticking out of the water; later, the pulp magazine *Fantastic Universe* would depict the colossus half buried by the sands of a desert planet. The step from pulp fiction to film was short indeed. Though earlier examples exist, the most famous use of the statue for these purposes is probably Franklin J. Schaffner's *Planet of the Apes* (1968), in which Charlton Heston realizes that he is still on earth, though it has been destroyed by nuclear war, when he sees the Statue of Liberty half-submerged on a beach. More recently, too, in films ranging from *The Day after Tomorrow* (2004), which culminates in an image of a colossal wave engulfing the statue, to *Cloverfield* (2008), in which a monster cuts off its head and hurls it at Manhattan, to *Iron Sky* (2012) where it is destroyed by space

Nazis, to the Tom Cruise science-fiction vehicle *Oblivion* (2013), where the audience sees its torch in a canyon following the large-scale destruction of the earth—the statue has always been at the center of the apocalyptic images that foreshadow the end not only of America but of the world.

When the Twin Towers were attacked on September 11, 2001, the Statue of Liberty bore witness to an authentic scene of apocalypse. Having seen the towers fall amid the flames from the window of his apartment, Jon Stewart, America's foremost political comedian at the time, told his audience, with tears welling up: "The view from my apartment was the World Trade Center . . . the symbol of ingenuity, strength work, and of imagination and of commerce, and now it's gone. And do you know what my view is now? The Statue of Liberty . . . the view from South Manhattan is now the Statue of Liberty . . . You can't beat that."[5]

Stewart was right. Unlike the World Trade Center, which was foremost a symbol of the economic empire Americans had established in the world, the Statue of Liberty is a syncretistic symbol of death and rebirth, sacrifice and revelation, endurance and emancipation, imperialism and rebellion, that no single nation or government, not even America, has ever managed to entirely appropriate. In this sense, as Bartholdi had hoped, it should forever be the last statue to be torn down.

Notes

PROLOGUE

1. Virgil, *The Aeneid*, trans. David Ferry (Chicago: University of Chicago Press, 2017), II: 21–339.

2. Ibid., II: 150–151.

3. Frédéric-Auguste Bartholdi, *The Statue of Liberty Enlightening the World* (New York: North American Review, 1885), 13–14.

4. Yasmin Sabina Khan, *Enlightening the World: The Creation of the Statue of Liberty* (Ithaca, NY: Cornell University Press, 2010), 47; Edward Berenson, *The Statue of Liberty: A Transatlantic Story* (New Haven, CT: Yale University Press, 2012), 8; Elizabeth Mitchell, *Liberty's Torch: The Great Adventure to Build the Statue of Liberty* (New York: Grove Press, 2014), 40.

5. Edward W. Said, *Orientalism* (New York: Vintage Books, 1994).

6. Victor Hugo, *Les Orientales* (Paris: Hetzel, 1869), 2–3, 8.

7. Victor Hugo, *Cromwell: Drame* (Brussels: Meline, 1837), xvii, xxii–xxiii.

8. Hugo, *Les Orientales*, 9–10.

9. Pierre-Simon Ballanche, *Addition aux prolégoménes: Orphée*, in *Oeuvres de Pierre Ballanche* (Paris: Barbarzat, 1830–1833), 5: 220.

10. Bartholdi, *Statue of Liberty*, 37n.

11. Khan, *Enlightening the World*; Berenson, *The Statue of Liberty*; Mitchell, *Liberty's Torch*.

12. Robert Belot and Daniel Bermond, *Bartholdi* (Paris: Perrin, 2002); Robert Belot, *Bartholdi: Portrait intime du sculpteur* (Bernardswiller: I.D. l'Édition, 2016), 78.

13. Albert Boime, *Hollow Icons: The Politics of Sculpture in Nineteenth-Century France* (Kent, OH: Kent State University Press, 1987), 113–138.

14. *Union Franco-Américaine: Discours de Martin Washburne, Laboulaye, Forney Prononcé au Banquet du 6 Novembre 1875* (Paris: Charpentier, 1875), 35.

15. Frederic Auguste Bartholdi, speech delivered at the Lycée Louis Le Grand on July 30, 1898, quoted in Jacques Betz, *Bartholdi* (Paris: Minuit, 1954), 240.

CHAPTER 1 · SEA-BOUND COMET

1. The statue of Saint Charles Borromeo, known as the *Sancarlone*, was built in 1698 after a design by Giovan Battista Crespi. It stands 23.4 meters high on a pedestal of nearly twelve meters. Its surface is made of copper (except for the hands and feet cast in bronze) and it is anchored, with hooked iron rods, to the stones and cement within. The Vendôme column, also known as the *Column of the Grande Armée*, is 53 meters high.

2. "A Franco-American Banquet," *The Times*, November 8, 1875. Ludwig Von Schwanthaler's *Bavaria* was built by Ferdinand Miller between 1844 and 1850. She is 60 feet high (with a pedestal of 28 feet) and weighs 87.36 tons.

3. Franz Kafka, *Amerika* (Munich: K. Wolff, 1927).

4. De Key, "France to America," *Scribner's Monthly* 14, no. 2 (1877): 135.

5. Cassandra Vivian, *Americans in Egypt, 1770–1915: Explorers, Consuls, Travelers, Soldiers, Missionaries, Writers and Scientists* (Jefferson, NC: McFarland, 2012), 7, 157, 172, 181–183; John P. Dunn, *Khedive Ismail's Army* (London: Psychology Press, 2005), 4, 57; Charles P. Roland, *American Iliad: The Story of the Civil War* (Lexington: Kentucky University Press, 2004); Michael B. Oren, *Power, Faith, and Fantasy: America in the Middle East, 1776 to the Present* (New York: Norton, 2007), 194–197; Dominic Green, *Three Empires on the Nile: The Victorian Jihad, 1869–1899* (New York: Free Press, 2007); Elizabeth Mitchell, *Liberty's Torch: The Great Adventure to Build the Statue of Liberty* (New York: Grove, 2015), 159–165.

6. "World-Lighting Liberty. The Statue Unveiled," *New York Tribune*, October 29, 1886.

7. "France's Gift Accepted: Liberty's Statue Unveiled on Bedlow's Island," *New York Times*, October 29, 1886.

8. "Unveiled: Bartholdi's Colossal Statue of Liberty," *Brooklyn's Eagle*, October 28, 1886; "France's Gift Accepted," *New York Times*, October 29, 1886.

9. "France's Gift Accepted," *New York Times*, October 29, 1886.

10. Thorstein Veblen, *The Theory of the Leisure Class: An Economic Study in the Evolution of Institutions* (New York: Macmillan, 1899).

11. Mary Beard, *The Roman Triumph* (Cambridge, MA: Harvard University Press, 2007), 244–245.

12. Mikhail Bakhtin, *Rabelais and His World* (Cambridge, MA: MIT Press, 1968); Victor Turner, *The Ritual Process: Structure and Anti-Structure* (Chicago: Aldine, 1969); David I. Kertzer, *Ritual, Politics, and Power* (New Haven, CT: Yale University Press, 1988); Clifford Geertz, "Centers, Kings, and Charisma: Reflections on the Symbolic of Power," in *Culture and Its Creators: Essays in Honor of Edward Shils*, ed. Joseph Ben-David and Terry Nichols Clark (Chicago: University of Chicago Press, 1977); Natalie Zemon Davis, "The Rites of Violence: Religious Riot in Sixteenth-Century France," *Past & Present* 59 (1973): 72; Edward Muir, *Ritual in Early Modern Europe* (Cambridge, UK: Cambridge University Press, 2005).

13. "World-Lighting Liberty."

14. Eric Foner, *The Story of American Freedom* (New York: Norton, 1998), 132–133; Glenn Altschuler, *Rude Republic: Americans and Their Politics in the Nineteenth Century*

(Princeton, NJ: Princeton University Press, 2000), 257–258; Rudolph J. Vecoli, "The Lady and the Huddled Masses: The Statue of Liberty as a Symbol of Immigration," in *The Statue of Liberty Revisited*, ed. Wilton S. Dillon and Neil G. Kotler (Washington, DC: Smithsonian Institution Press, 1994), 47; J. Green, *Death in the Haymarket: A Story of Chicago, the First Labor Movement, and the Bombing That Divided Gilded Age America* (New York: Pantheon, 2006).

15. "World-Lighting Liberty."

16. Emma Goldman, *Living My Life* (New York: Cosimo, 2008), 1: 11.

17. Robert Harbison, *The Built, the Unbuilt, the Unbuildable* (Cambridge, MA: MIT University Press, 1991), 55–56.

18. Thomas Jefferson to Roger C. Weightman, June 24, 1826, in *The Writings of Thomas Jefferson*, ed. Andrew A. Lipscomb and Albert Ellery Bergh (Washington, DC: N.p., 1903–1904), 16: 181–182, quoted in David Armitage, *The Declaration of Independence: A Global History* (Cambridge, MA: Harvard University Press, 2009), 1–2.

19. Armitage, *Declaration of Independence*, 94.

20. Frederick Douglass, "The Meaning of July 4th for the Negro, speech at Rochester, New York, July 5, 1852," in *Frederick Douglass: Selected Speeches and Writings*, ed. Philip Sheldon Foner and Yuval Taylor (Chicago: Chicago Review Press, 1999), 191. For the background of Douglass's contention, see William S. McFeely, *Frederick Douglass* (New York: Norton, 1991); and John Stauffer, *Giants: The Parallel Lives of Frederick Douglass and Abraham Lincoln* (New York: Hachette, 2008), 131–241.

21. Quoted in Polly Welts Kaufman, *National Parks and the Woman's Voice: A History* (Albuquerque: University of New Mexico Press, 2006), 54.

22. Saum Song Bo, "The Chinese: A Chinese View of the Statue of Liberty," *The American Missionary* 39, no. 10 (1885): 290.

23. Henry James, *The American Scene* (London: Chapman and Hall, 1907), 401.

24. Serena Zabin, *Dangerous Economies: Status and Commerce in Imperial New York* (Philadelphia: University of Pennsylvania Press, 2011).

25. Armitage, *Declaration of Independence*; David Armitage, *Foundations of Modern International Thought* (Cambridge, UK: Cambridge University Press, 2013), 196; Francesca Lidia Viano, "The Union Men: Trust and Disobedience in American State Building, 1754–1787," Ph.D. diss., University of Cambridge, 2016.

26. Frédéric-Auguste Bartholdi, *The Statue of Liberty Enlightening the World* (New York: North American Review, 1885).

27. Charles Bigot, *De Paris au Niagara: Journal de voyage d'une delegation* (Paris: Dupret, 1887), 94–95.

28. Ibid., 96.

29. "World-Lighting Liberty."

30. Joel Richard Paul, *Unlikely Allies: How a Merchant, a Playwright, and a Spy Saved the American Revolution* (New York: Riverhead Books, 2010), 204; Laura Auricchio, *The Marquis: Lafayette Reconsidered* (New York: Vintage, 2015), 24–25.

31. Jacques Brengues, "Les francs-maçons français et les États-Unis d'Amérique à la fin du XVIIIe siècle," *Annales de Bretagne et des pays de l'Ouest* 84, no. 3 (1977): 298–299; John Labiez Lanier, *Washington, the Great American Mason* (Richmond, VA: Macoy, 1922), 27.

32. Silas Deane to the Committee of Secret Correspondence, July 27, 1776; Penet and Pliarne to Silas Deane, July 30, 1776; "Wednesday, July 31, 1776," *Public Advertiser*, all in *Naval Documents of the American Revolution* (Washington, DC: U.S. Government Printing Office, 1970), 6: 509, 514–515; Thomas J. Schaeper, *France and America in the Revolutionary Era: The Life of Jacques-Donatien Leray de Chaumont, 1725–1803* (Providence, RI: Berghahn, 1995), 12.

33. "World-Lighting Liberty."

34. "France's Gift Accepted," *New York Times*, October 29, 1886; ibid.

35. "World-Lighting Liberty."

36. Hesiod, *Theogony, Works and Days*, trans. C. S. Morrissey (Vancouver: Talon Books, 2012), 35–41.

37. Aeschylus, *Prometheus Bound*, ed. A. O. Prickard (Oxford, UK: Clarendon Press, 1907), 17–19; Olga Raggio, "The Myth of Prometheus: Its Survival and Metamorphoses up to the Eighteenth Century," *Journal of the Warbourg and Courtauld Institutes*, 21, nos. 1 and 2 (1958): 44–62; Jonas Jølle, "'Prince poli & savant': Goethe's Prometheus and the Enlightenment," *Modern Language Review* 99, no. 2 (2004): 394–415; Carol Dougherty, *Prometheus* (London: Routledge, 2006), 72.

38. For a discussion of the continuity of Christian, Enlightenment, and Masonic symbolism and an overview of eighteenth-century variations on the theme of light and darkness, see Rolf Reichardt and Deborah Louise Cohen, "Light against Darkness: The Visual Representations of a Central Enlightenment Concept," *Representations* 61 (1998): 95–148.

39. Ghislain de Diesbach, *Ferdinand de Lesseps* (Paris: Perrin, 1998), 23.

40. George Barnett Smith, *The Life and Enterprises of Ferdinand de Lesseps* (Allen: London, 1895), 10.

41. Zachary Karabell, *Parting the Desert: The Creation of the Suez Canal* (London: Murray, 2004), 45.

42. Smith, *Life and Enterprises of Ferdinand de Lesseps*, 21.

43. De Diesbach, *Lesseps*, 307; John Major, *Prize Possession: The United States and the Panama Canal, 1903–1979* (Cambridge, UK: Cambridge University Press, 2002), 20.

44. Quoted by Lynn Glaser in *America on Paper: The First Hundred Years* (London: Associated Antiquaries, 1989), 112.

45. "World-Lighting Liberty."

46. Ibid.; William Hepworth Dixon, *New America* (Leipzig: Bernhard Tauchnitz, 1867), 2: 287–288.

47. "World-Lighting Liberty"; "France's Gift Accepted," *New York Times*, October 29, 1886.

48. C. L. Barrows, *William M. Evarts, Lawyer, Diplomat, Statesman* (Chapel Hill: University of North Carolina Press, 1941), 2–3.

49. *Senate Executive Documents and Reports*, no. 112, 46 Cong., 3 Sess., quoted by Barrows, *Evarts*, 364.

50. "France's Gift Accepted."

51. Ibid.

52. "World-Lighting Liberty"; ibid.

53. "World-Lighting Liberty."

54. "France's Gift Accepted."

55. Bigot, *De Paris au Niagara*, 106.

56. "They Enter a Protest. Woman Suffragists Think the Ceremonies an Empty Farce," *New York Times*, October 29, 1886.

57. Alyn Brodosky, *Grover Cleveland: A Study in Character* (London: Macmillan, 2000), 18; Daniel. H. Wicks, "Dress Rehearsal: United States Intervention on the Isthmus of Panama, 1885," *Pacific Historical Review* 49, no. 4 (1980): 581.

58. Barry Moreno, "Cleveland, (Stephen) Grover," in Moreno, *The Statue of Liberty Encyclopedia* (New York: Simon and Schuster, 2000), 58.

59. Grover Cleveland, "Woman's Mission and Woman's Clubs," *Ladies Home Journal* 22, no. 3 (1905): 3. See also Cleveland, "Would Woman Suffrage Be Unwise?" *Ladies Home Journal* 22, no. 11 (1905): 7.

60. Brodosky, *Grover Cleveland*, 155.

61. M. N. Ngai, *Impossible Subjects: Illegal Aliens and the Making of Modern America* (Princeton, NJ: Princeton University Press, 2005), 11.

62. "World-Lighting Liberty."

63. Arnold Van Gennep, *Les rites de passage: Étude systématique des rites* (Paris: Picard, 1961).

64. Ibid., 24, 28; J. G. Frazer, *The Golden Bough* (London: Macmillan, 1900), 1: 305.

65. Chauncey Mitchell Depew, *Best Things by Chauncey M. Depew: Wit, Humor, Eloquence and Wisdom*, ed. John W. Leonard (Chicago: Marquis, 1898), 3.

66. "The Bartholdi Orations," *New York Tribune*, October 29, 1886; Michael Kammen, *Spheres of Liberty: Changing Perceptions of Liberty in American Culture* (Jackson: University of Mississippi Press, 2001), 104–105.

67. Naomi L. Amoreaux, "The Mystery of Property Rights: A U.S. Perspective," *Journal of Economic History* 71, no. 2 (2011): 277; Thorstein Veblen, "Some Neglected Points in the Theory of Socialism," *Annals of the American Academy of Political and Social Science* 2, no. 3 (1891): 57–74.

68. "World-Lighting Liberty."

69. Judith Choate and James Canora, *Dining at Delmonico's: The Story of America's Oldest Restaurant* (New York: Stewart, Tabori & Chang, 2008), 11–19.

70. Charles Ranhofer, *The Epicurean: A Complete Treatise of Analytical and Practical Studies on the Culinary Art, Including Table and Wine Service* (New York: Ranhofer, 1894).

71. M. Kurlansky, *The Big Oyster: New York on the Half Shell* (New York: Ballantine Books, 2006), 220.

72. "Guests of the Merchants. The French Delegation at Dinner," *New York Tribune*, October 29, 1886.

73. "French Visitors Dined. Some Eloquent Responses to the Toasts," *New York Times*, October 29, 1886; "The Freedom of the City. Entertaining the Delegates from France. Honors from the City, a Welcome Down Town, and a Reception at the Union League Club," *New York Times*, October 28, 1886.

74. "French Visitors Dined."

75. Virginia Kays Veenswijk, *Coudert Brothers, a Legacy in Law: The History of America's First International Law Firm* (New York: Truman Talley, 1994), 5–12.

76. Ibid., 69–70, 86.

77. "French Visitors Dined."

78. Matthew 5:14.

79. Nicholas Guyatt, *Providence and the Invention of the United States, 1607–1876* (Cambridge, UK: Cambridge University Press, 2007), 35.

80. "French Visitors Dined."

CHAPTER 2 · THE WINTER PARTY

1. Frédéric-Auguste Bartholdi, *The Statue of Liberty Enlightening the World* (New York: North American Review, 1885), 12.

2. John Bigelow, *Some Recollections of the Late Edward Laboulaye* (New York: Putnam, 1888), 3–4.

3. Nelly Schmidt, *Abolitionnistes de l'esclavage et réformateurs de colonies: 1820–1851* (Paris: Karthala, 2000), 33, 39, 52.

4. Agénor de Gasparin, *Esclavage et traite* (Paris: Joubert, 1838), viii.

5. Agénor de Gasparin, *Un grand peuple qui se relève* (Paris: Lévy, 1861).

6. Agénor de Gasparin, *L'Amérique devant l'Europe: Principes et intérêts* (Paris: Lévy, 1876), 398–403.

7. Édouard Laboulaye, review of *Un grand peuple qui se relève*, by Agènor de Gasparin (Paris: Lévy, 1861) and review of *La République Américaine: Ses institutions; ses hommes*, by Xavier Eyma (Paris: Lévy, 1861), in *Journal des débats politiques et littéraires* (October 2–3, 1861). The review would be soon republished by Édouard Laboulaye in his *Études morales et politiques* (Paris: Charpentier, 1862), 253–278 (253, 256, 263–264 in particular) under the title "La guerre civile aux États-Unis."

8. Bartholdi, *Statue of Liberty*, 16.

9. "Society of Christian Morals," in *Sixth Annual Report of the American Society for Colonizing the Free People of Colour of the United States* (Washington, DC: David and Force, 1823), 46.

10. R. Cameron, *France and the Economic Development of Europe, 1800–1914: Conquests of Peace and Seeds of War* (Chicago: Rand McNally, 1961), 94; Pierre-Émile Levasseur, *La vie et les travaux de Wolowski, Viéville et Capiomont* (Paris: Viéville et Capiomont, 1877), 22; "Crédit foncier: A Study of a Well-Known French Institution Lately Much Talked about in the United States," *United States Investor* 8, no. 25 (1897): 1069; Review of *A History of Banking in All the Leading Nations* (New York:

Journal of Commerce and Commercial Bulletin, 1898), in *The Nation* 64, no. 1654 (1897): 190.

11. H. S. Sanford to J. Bigelow, November 15 and 27, 1861, Sanford Papers, 100/1, Henry Shelton Sanford Memorial Library, Sanford (Florida), quoted in Francis Balace, *L'armure liégeoise et la guerre de sécession, 1861–1865* (Liege: Éditions de la Commission communale de l'histoire de l'ancien pays de Liège, 1978), 271n.

12. Charles P. Kindleberger, "Origins of United States Direct Investment in France," *Business History Review* 48, no. 3 (1974): 385, 386; Virginia Kays Veenswijk, *Coudert Brothers, a Legacy in Law: The History of America's First International Law Firm* (New York: Truman Talley, 1994), 55.

13. Bartholdi, *Statue of Liberty*, 12–13.

14. Ibid., 13–14.

15. Ibid., 14.

CHAPTER 3 · THE *FONDEUR*

1. John A. Dickinson, "La Normandie et la construction d'une nouvelle France," *Annales de Normandie* 58, nos. 3–4 (2008): 61–62.

2. Rosemonde Salmon, "Édouard René Lefebvre de Laboulaye, 1811–1883," in *Les immortels du Sénat, 1875–1918. Les cent seize inamovibles de la Troisième République*, ed. by Jean-Marie Mayeur, Alain Corbin and Arlette Schweitz (Paris: Publications de la Sorbonne, 1995), 363.

3. "Febvre, or Lefebvre, de Laboulaye (le)," in Chaix d'Est-Ange, *Dictionnaire des familles françaises anciennes ou notables à la fin du XIX siècle* (Évreux: Hérissey, 1921), 17: 304; Geneanet: http://gw.geneanet.org/1789adrien1789?lang=it&p=jacques&n=lefebvre, http://gw.geneanet.org/1789adrien1789?lang=it&p=rene&n=lefebvre&oc=1, http://gw .geneanet.org/1789adrien1789?lang=it&p=francois+benoit&n=Lefebvre (last accessed April 18, 2018); R. Sanson, "Laboulaye, Édouard René Lefebvre de, 1811–1883," in *Les immortels du Sénat, 1875–1918. Les cent seize inamovibles de la Troisième République* (Paris: Publications de la Sorbonne, 1995), 363; "Mariages du mois de mars," *Le bulletin héraldique de France ou revue historique de la noblesse* 5 (March 1892): 159–160.

4. M. de Secondat, Baron de Montesquieu, *The Spirit of the Laws*, trans. Thomas Nugent (Cincinnati: Clarke, 1873), 1: 368.

5. Philippe Béchu, *De la paume à la presse: Étude de topographie et d'histoire parisiennes: recherches sur les immeubles des 57 rue de Seine et 62 rue Mazarine, leurs occupants et leurs familles* (Paris: Fédération des sociétés historiques et archéologiques de Paris et d'Île-de-France, 1998), 184–185.

6. Ibid., 185.

7. Jacques Flach, "La vie et les oeuvres de M. Édouard Laboulaye. Collège de France. Histoire des législations comparées. Cours de Jacques Flach. Leçon d'ouverture," *Revue politique et littéraire* 4, no. 20 (1884): 610–611.

8. Auguste René, Édouard's father, was the head of the administrative office of the "droits réunis" and one of the managers of Parisian tax duties (Sanson, "Laboulaye, 1811–1813," 363); Charles-Pierre Laboulaye, "Fonderie en caracteres," in *Dictionnaire des Arts et Manufactures: Description des procédés de l'industrie française et étrangère* (Paris: Mathias, 1845), 1: 1703–1704.

9. Ibid., 1: 1704.

10. See "Rapport au Ministère du Commerce et des travaux publics; Bureau de la librairie," which also presents the recommendations of Tissot, professor at the Collège de France, and of the printer Engelmann, who describe Charles as "a man devoted to the government and unable to misuse the press" and guarantee that he has the "skills necessary to run a printer's workshop" (F/18/1784, Archives Nationales, Paris).

11. Charles Robin, *Histoire illustrée de l'exposition universelle* (Paris: Furne, 1855), 10.

12. See, for example, Joseph-Siffred Duplessis, *Benjamin Franklin*, 1779, oil on canvas, 69.8×54.6 cm, North Carolina Museum of Art, Raleigh.

13. The Laboulaye brothers were associates at the Lion foundry, at number 33 on Saint-Hyacinthe, Saint-Michel. See Alphonse Alkan, Sr., *Un fondeur en caractères, membre de l'Institut* (Paris: Typologie-Tucker, 1936), 9.

14. P. Sbarbaro, *Laboulaye: Un fonditore di caratteri* (Rome: Perino, 1886), 32.

15. Alexis de Tocqueville, *Democracy in America*, trans. Arthur Goldhammer (New York: Library of America, 2004), 341.

16. Édouard Laboulaye, *Recherches sur la condition civile et politique des femmes depuis les Romains jusqu'à nos jours* (Paris: Durand, Jubert, 1843), 520.

17. Édouard Laboulaye, review of Ernest Legouvé, *Histoire morale des femmes* (Paris: Sandré, 1854), in *Journal des Débats*, September 8, 1855, 3.

18. Sanson, "Laboulaye, 1811–1883," 364.

CHAPTER 4 · AN AMERICAN ASTRAY

1. Nicolas Stoskopf, "Hippolyte Biesta, 1811–1870," in *Les patrons du Second Empire: Banquiers et financiers parisiens* (Paris: Picard, 2002), 89; "Fonderie en caractères," in Charles Laboulaye, *Complément du dictionnaire des artes et manufactures* (Paris: LaCroix, 1861), 262; "Rappel de médal d'or," in *Exposition de produits de l'industrie française: Rapport du Jury Central en 1844*, 3 vols. (Paris: 1864), 3: 252; "MM. Biesta, Laboulaye & C.," *Bulletin typographiques* 21–22 (1844): 2.

2. Nicolas Stoskopf, "La fondation du Comptoir national d'escompte de Paris, banque revolutionnaire (1848)," *Histoire, economie et société* 21, no. 3 (2002): 396, 403.

3. David Landes, "Vieille banque et banque nouvelle: La révolution financière du dix-neuvième siècle," *Revue d'histoire moderne et contemporaine* (1954–) 3 (July–September 1956): 204; Maurice-Édouard Berthon, *Émile et Isaac Péreire, la passion d'entreprendre* (Paris: Publication Universitaire, 2007), 19–23.

4. Darcy Grimaldo Grigsby, *Colossal: Engineering the Suez Canal, Statue of Liberty, Eiffel Tower, and Panama Canal* (New York: Prestel, 2012), 42.

5. Pierre Musso, "Introduction," in *Le Saint-Simonism, l'Europe et la Méditerranée* (Houilles: Manucius, 2008), 10–11; Christophe Prochasson, *Saint-Simon ou l'anti-Marx* (Paris: Perrin, 2005).

6. Lettres de Henri Saint-Simon à un Américain, in *Oeuvres de Saint-Simon*, 47 vols. (Paris: Dentu, 1865–), 15: 150–151, 165–166, 168.

7. Nicolas Gustave Hubbard, *Saint-Simon: Sa vie et ses travaux* (Paris: Guillaumin, 1857), 15–18; Pierre Musso, *La religion du monde industriel: Analyse de la pensée de Saint-Simon* (La Tour d'Aigues: Aube, 2006).

8. Paul Bénichou, *Les temps des prophètes: Doctrines de l'âge romantique* (Paris: Gallimard, 1977), 248–260.

9. *Doctrine Saint-Simonienne: Résumé général de l'exposition faite en 1829 et 1830* (Paris: Bureau de l'Organisateur et du Globe, 1831), 21–24, 37; Franck Yonnet, "La banque saint-simonienne, les 'travailleurs' et les 'capitalists': Les projets des sociétés mutuelles de crédit de 1853 de frères Péreire," *Revue française d'économie* 13, no. 2 (1998): 62; Helen M. Davies, *Émile and Isaac Péreire: Bankers, Socialists and Sephardic Jews in Nineteenth-Century France* (Oxford, UK: Oxford University Press, 2016), 42.

10. Michael Winship, *American Literary Publishing in the Mid-Century: The Business of Ticknor and Fields* (Cambridge, UK: Cambridge University Press, 2003), 37.

11. Stoskopf, "Fondation du Comptoir," 404, 407; Yonnet, "La banque saint-simonienne," 72.

12. Yonnet, "La banque saint-simonienne," 62–63, 65; Édouard Laboulaye, *Considérations sur la constitution* (1848), in Laboulaye, *Questiones constitutionelles* (Paris: Charpentier, 1872), 3, 4, 18, 71–72.

13. Laboulaye to John Bigelow, October 23, 1868, *Bigelow Papers*, Schaffer Library Union College, Schenectady, NY.

14. Laboulaye, *Considérations*, 33, 74.

15. See Chapter 1.

16. Laboulaye, *Considérations*, 7, 38n, 70, 74.

17. Ibid., 35–36.

18. Laboulaye, "Leçon d'ouverture," in *Trente ans d'enseignement au Collège de France* (Paris: Larose et Forcel, 1888), 16. See also Laboulaye, "Quatrième leçon," in *Trente ans d'enseignement*, 103.

19. Laboulaye, *Considérations*, 73–74.

20. Francesca Lidia Viano, "The Union Men: Trust and Disobedience in American State-Building, 1754–1787," Ph.D. diss., University of Cambridge, 2015, 200–219.

21. Michel Chevalier, "Lettre XXVIII," in *Lettres sur l'Amérique du Nord*, 2 vols. (Paris: Gosselin, 1836–1837), 1: 241–242.

22. Laboulaye, "Considérations," 18.

23. Yonnet, "La banque saint-simonienne," 72–73; Nicolas Stoskopf, "Fondation du Comptoir," 404, 407; Charles Laboulaye, *Lettre sue la creation d'une institutione de credit pour la librairie* (Paris: Laboulaye, 1848); "Sous-Comptoirs de Garantie," *Almanach Impérial* 157 (1855): 888.

24. Pierre Milza, *Napoléon III* (Paris: Perrin, 2004), 157.

25. Ibid., 398.

26. Quoted in Stoskopf, "Fondation du Comptoir," 407.

27. Nicolas Stoskopf, "Alphonse Pinard et la révolution bancarie du Second Empire," *Histoire, économie et société* 17, no. 2 (1998): 299–317.

28. Yonnet, "La banque saint-simonienne," 75–95.

29. Private correspondence with Walter D. Gray, June 7, 2008.

30. Adam Zamoyski, *Holy Madness: Romantics, Patriots and Revolutionaries, 1776–1871* (London: Phoenix, 2001), 20.

31. Chevalier, "Lettre XXXIV," in *Lettres sur l'Amérique du Nord*, 2: 406–407.

32. George Bancroft, *History of the United States*, vol. 1 of *History of the Colonization of the United States*, 3 vols. (Boston: Little, Brown, 1838–1857), 1: 287, 323; Édouard Laboulaye, *Histoire des États-Unis Depuis le premiers essais de colonization jusqu'à l'adoption de la Constitution federale, 1620–1789*, vol. 1 of *Histoire des États-Unis*, 3 vols. (Paris: Durand, Guillaumin, 1855–1866), 161.

33. Virginia Kays Veenswijk, *Coudert Brothers, a Legacy in Law: The History of America's First International Law Firm* (New York: Truman Talley, 1994), 9–11.

34. Pierre-Simon Ballanche, *Essai de palingenesie sociale: Orphée*, vol. 4 of *Oeuvres de Pierre Ballanche*, 4 vols. (Paris: Barbezat, 1830–1833), 195.

35. Édouard Laboulaye, "Philosophie du droit. Cinquième leçon," in *Trente ans d'enseignement au Collège de France* (Paris: Larose et Forcel, 1888), 139; Ballanche, *Essai de palingenesie sociale*, vol. 3 of *Oeuvres de Pierre Ballanche*, 4 vols. (Paris: Barbezat, 1830–1833), 204–205; Brian Juden, "Particularités du mythe d'Orphée chez Ballanche," *Cahiers de l'Association internationales des études françaises* 22 (1970): 137–152.

36. Laboulaye, "Philosophie du droit. Cinquième leçon," 138–139.

37. Ballanche, *Essai de palingenesie sociale*, 251, 313.

38. Laboulaye, *Histoire des États-Unis*, vol. 1 of *Histoire politique des États-Unis* (Paris: Durand, Guillaumin, 1855), 168; Ballanche, *Essai de palingenesie sociale: Orphée*, 195.

39. Laboulaye, "Quatrième leçon," 110–112.

40. Hans-Christian Lucas, "Die Eine und oberste Synthesis. Zur Entstehung von Krauses System in Jena in Abhebung von Schelling und Hegel," and Peter Landau, "Karl Christian Friedrich Krauses Rechtsphilosophie," both in *Karl Christian Friedrich Krause (1781–1832): Studien zu seiner Philosophie und zum Krausismo*, ed. Klaus-M. Kodalle (Hamburg: Meiner, 1985), 33, 92; Enrique M. Ureña, *K. C. F. Krause: Philosoph, Freimaurer, Weltbürger. Eine Biographie* (Stuttgart-Bad Cannstatt: Frommann-Holzboog, 1991), 27; Édouard Laboulaye, *Trente ans d'enseignement au Collège de France* (Paris: Larose et Forcel, 1888), 120.

41. Laboulaye, "Quatrième leçon," 110–112, 114, 118.

42. Quoted in Ureña, *Krause*, 451.

CHAPTER 5 · THE SIN OF COLOR

1. *Fichier concernant les recherches historique effectués par Jean-Charles*, Bartholdi Papers, V2, Musée Bartholdi, Colmar.

2. Jourden Travis Moger, *Priestly Resistance to the Early Reformation in Germany* (London: Routledge, 2015), 20; W. J. Sheils, *The English Reformation, 1530–1570* (London: Routledge, 2013), 49.

3. Robert Belot and Daniel Bermond, *Bartholdi* (Paris: Perrin, 2002), 11–12. On Gilles-François Bartholdi (1723–1787), see Romuald Szramkiewicz, *Les régents et censeurs de la Banque de France, nommés sous le Consulat et l'Empire* (Geneva: Droz, 1974), 391; Paul Romane-Musculus, "Généalogie Bartholdi," *Annuaire de la Societe d'Histoire d'Archeologie de Colmar* 28 (1979), 52; Christian C. Emig, "Les ascendances du célèbre sculpteur colmarien Auguste Bartholdi," *Nouveaux eCrits scientifiques*, http://paleopolis .rediris.es/NeCs/NeCs_01-2014/ (last accessed April 3, 2018).

4. Voltaire to the Comte d'Argental, February 24, 1737, in *Œuvres complètes de Voltaire, avec de notes et une notice sur la vie de Voltaire* (Paris: Firmin Didot, 1861–1872), 11: 676.

5. Voltaire to Dupont, December 6, 1754, in *Œuvres complètes*, 11: 707. See also M.-J. Bopp, "La langue et la culture française à Colmar dans la seconde moitié du XVIIIe et au début du XIXe siècle: Le groupe de Pfeffel," *Publications de la Société savante d'Alsace et des régions de l'est* 8 (1962): 158.

6. Bopp, "La langue et la culture," 161; P. Bolchert, "La bibliotheque du consistoire de l'église de la confession d'Augsbourg à Colmar," *Annuaire de la Société historique et littéraire de Colmar* (1954): 77–95; Bolchert, "La petite académie colmarienne, la 'Société de lecture' de Pfeffel (1760–1820)," *Annuaire de la Société historique et littéraire de Colmar* (1967): 79–84. On Pfeffel, see Charles Foltz, *Souvenirs du vieux Colmar* (Colmar: Barth, 1887), 252–258.

7. Foltz, *Souvenirs*, 170; Antoine Armand Véron-Réville, *Histoire de la révolution française dans le départment de Haut-Rhin, 1789–1795* (Paris: Durand, Barth, 1865), 205.

8. Foltz, *Souvenirs*, 18; Lina Beck-Bernard, *Théophile-Conrad Pfeffel de Colmar: Souvenirs biographiques* (Lausanne: Delafontaine, Rouge, 1866), 26.

9. The painting was listed in the museum's catalog already in 1866, when Bartholdi was thirty-two, but it entered the collection earlier than 1860, probably when the museum was formally established, under Karpff's supervision, in 1794, in the galleries of the municipal library. See *Catalogue du Musée de Colmar* (Colmar: Decker, 1866), 9; Claude Muller, *L'Alsace et la Révolution* (Nancy: Éditions Place Stanislas, 2009), 77; Sylvie Ramond and François-René Martin, "Aux origines du Musée à Colmar: Dèsordre révolutionnaire, ordre des collections," in *Histoire du Musée d'Unterlinden et de ses collections: De la Révolution à la Première Guerre Mondiale* (Colmar: Société Schongauer-Musée d'Unterlinden, 2003), 47–63.

10. *Charlotte Bartholdi, née Beysser*, oil on canvas, 55 × 45 cm, n.d., Musée Bartholdi, Colmar.

11. Quoted in F. W. J. Hemmings, *Culture and Society in France, 1789–1848* (Trowbridge: Leicester University Press, 1987), 244.

12. Belot and Bermond, *Bartholdi*, 16.

13. Stäel-Holstein, *Delphine* (Paris: Treuttel, 1820), 1: ix–xiv; Charlotte's personal writings, Bartholdi Papers, IV2C, Musée Bartholdi, Colmar.

14. Charlotte to Madame Soehnée, n.d., Charlotte's personal writings.

15. "February 1832," Charlotte's personal writings.

16. Ibid.

17. Janin Driancourt-Girod, *L'insolite histoire des Luthériens* (Paris: Albin Michel, 1998), 287–292; Rondo E. Cameron, *France and the Economic Development of Europe, 1800–1914: Conquests of Peace and Seeds of War* (Chicago: Rand McNally, 1961), 20–23, 82; Claude Muller, *"Vive l'empereur!" L'Alsace napoléonienne, 1800–1815* (Bernardswiller: I.D. l'Édition, 2012), 50–53, 119–121.

18. Romuald Szramkiewicz, *Les régents et censeurs de la Banque de France nommés sous le Consulat et l'Empire* (Geneva: Droz, 1974), 388–398.

19. Charlotte Beysser to Jacques-Frédéric Bartholdi, n.d., Bartholdi Papers, IV2C, Musée Bartholdi, Colmar.

20. Charlotte to Jacques-Frédéric, November 1836, Bartholdi Papers, IV2C, Musée Bartholdi, Colmar.

21. Belot and Bermond, *Bartholdi*, 21.

22. Ramond and Martin, "Aux origines du Musée à Colmar," 56; Karpff, "Compte rendu de l'an VIII, 1er fructidor (August 19, 1800)," quoted in Ramond and Martin, "Aux origines du Musée à Colmar," 58.

23. "April 6, 1851," Charlotte's Diaries, Bartholdi Papers, IV2C, Musée Bartholdi, Colmar.

24. Belot and Bermond, *Bartholdi*, 21; Jacques Betz, *Bartholdi* (Paris: Éditions de minuit, 1954), 17–18.

CHAPTER 6 · THE ROAD TO HELL

1. Michel Roblin, *Quand Paris était à la campagne: Origines rurales et urbaines des 20 arrondissements* (Paris: Picard, 1985), 88–89.

2. Victor Hugo, *Les Misérables* (Paris: Hachette, 1881–1882), 5: 76–77.

3. Archives du Lycée Louis-le-Grand, ledger 286, quoted in Robert Belot and Daniel Bermond, *Bartholdi* (Paris: Perrin, 2002), 22.

4. François Rudé, *Le départ de volontaires en 1792*, 1836; Jean-Pierre Cortot, *Le Triomphe de 1810*, 1836; Antoine Étex, *La Résistance de 1792*, 1836; and Antoine Étex, *La Paix de 1815*, 1836, all stone, sculptural groups, Arc de Triomphe de l'Étoile.

5. David Stevenson, *The Origins of Freemasonery* (Cambridge, UK: Cambridge University Press, 1988), 82–83.

6. Victor Hugo, *Les Orientales* (Paris: Hetzel, 1869), 8–9.

7. Edward Said, *Orientalism* (New York: Vintage Books, 1994), 64.

8. Ibid., 56–57.

9. Homer, "Hymn to Demeter," in *Homeric Hymner, Homeric Apocrypha, Lives of Homer*, ed. Martin L. West (Cambridge, MA: Harvard University Press, 2003), 34–35.

10. Walter Friedrich Otto, *Dionysus: Myth and Cult*, trans. Robert B. Palmer (Bloomington: Indiana University Press, 1965), 191; Brian Juden, *Tradition Orphiques et tendances mystiques dans le romantisme français (1800–1855)* (Paris: Klincksieck, 1971), 101.

11. D. G. Charlton, *The French Romantics* (Cambridge, UK: Cambridge University Press, 1984), 96.

12. Friedrich Creuzer, *Symbolik und Mythologie der alten Völker besonders der Griechen*, 6 vols. (Leipzig: Leske, 1819–1823), 1: 438–440, 750–751, 2: 220–221; 3: 89–91, 545–547; Friedrich Creuzer, *Religions de l'antiquité*, trans. Joseph-Daniel Guigniaut, 4 vols. (Paris: Treuttel et Würtz, 1825–1851), 1: 357, 472–474; 2: 176–177; 3: 60–64.

13. Juden, *Traditions orphiques*, 29.

14. Creuzer, *Symbolik*, 2: 215–217; 3: 366–381; Creuzer, *Religions*, 2: 174, 3: 258–271.

15. Albert Gallatin Mackay, *The Symbolism of Free-Masonry: Illustrating and Explaining Its Science and Philosophy, Its Legends, Myths and Symbols* (New York: Clark and Maynard, 1869), 109n.

16. Sarah Symmons, "James Barry's *Phoenix*: An Irishman's American Dream," *Studies in Romanticism* 15 (1976): 531–548.

CHAPTER 7 · THE ATELIER OF THE EXILES

1. Thomas Armstrong, *A Memoir, 1832–1911* (London: Secker, 1913), 4.

2. Elbert Hubbard, "Ary Scheffer," in Hubbard, *Little Journeys to the Homes of the Great: Eminent Painters* (New York: Putnam's Sons, 1899), 332; Walter F. Friedlaender, *David to Delacroix* (Cambridge, MA: Harvard University Press, 1952), 44.

3. Hubbard, "Ary Scheffer," 341; Marcia R. Pointon, *The Bonington Circle: English Watercolour and Anglo-French Landscape, 1790–1855* (Sussex, UK: Hendon Press, 1985), 151; Leo Ewals, *Ary Scheffer: 1795–1858: Musée de la vie romantique, 10 avril–28 juin 1996* (Paris: Musée de la vie romantique, 1996), 18; Marthe Kolb, *Ary Scheffer et son temps, 1795–1858* (Paris: Boivin, 1937), 82–83.

4. Hubbard, "Ary Scheffer," 332.

5. Stefano Recchia and Nadia Urbinati, "Introduction," in *A Cosmopolitanism of Nations: Giuseppe Mazzini's Writings on Democracy, National Building, and International Relations* (Princeton, NJ: Princeton University Press, 2009), 15.

6. Adam Zamoyski, *Holy Madness: Romantics, Patriots and Revolutionaries, 1776–1871* (London: Phoenix, 2001), 87–88. See also Hubbard, "Ary Scheffer," 339–340.

7. Ary Scheffer, *Lafayette*, oil on canvas, 233.7×157.5 cm, 1823, Collection of the U.S. House of Representatives, Washington, DC.

8. Lloyd S. Kramer, *Lafayette in Two Worlds: Public Cultures and Personal Identities in the Age of Revolutions* (Chapel Hill: University of North Carolina Press, 1999), 100.

9. Harriet Grote, *Memoir of the Life of Ary Scheffer* (London: Murray, 1860), 41–45.

10. Hubbard, "Ary Scheffer," 353.

11. Charles Blanc, "Ary Scheffer," in Charles Blanc, *Histoire de peintres de toutes les écoles*, vol. 3: *École française* (Paris: Renouard, 1863), 14.

12. Silvio Pellico, *Francesca da Rimini*, act 1, scene 5; act 3, scene 2; Arnold Anthony Schmidt, *Byron and the Rhetoric of Italian Nationalism* (London: Macmillan, 1984).

13. Charles Bartholdi, "L'éxposition des beaux-arts de 1861: Les artistes alsaciens," *Curiosités d'Alsace* 1, no. 2 (1861–1862): 124.

14. Ary Scheffer, *Dévouement patriotique de six bourgeois de Calais*, 1819, oil on canvas, 324×546 cm, Assemblée Nationale, Aile du Midi; Rembrandt, *Le Christ présenté au people, 'Ecce Homo'*, 1655, drypoint, 38.7×45.4 cm, Bibliothèque Nationale de France, Paris.

15. Ary Scheffer, *Les femmes souliotes, voyant leurs maris défaits par les troupes d'Ali, pacha de Janina, décident de se jeter du haut de rochers*, 1827, oil on canvas, 261×359 cm, Musée de Louvre, Paris.

16. Armstrong, *A Memoir*, 5.

17. Ibid., 4–5.

18. Henry Scheffer, *Ary et Henry Scheffer à l'atelier des élèves*, 1859, oil on canvas, 60.3×53 cm, private collection.

19. "May 18, 1852," Charlotte's Diaries, Bartholdi Papers, IV2C, Musée Bartholdi, Colmar.

20. Ellen C. Clayton, *English Female Artists* (London: Tinsley, 1876), 2: 291.

21. Thomas E. Crow, *Emulation: David, Drouais, and Girodet in the Art of Revolutionary France* (New Haven, CT: Yale University Press, 2006).

22. Clayton, *English Female Artists*, 2: 290.

23. Ian Frazier, "Patina: How the Statue of Liberty Colors the City," *New Yorker*, September 19, 2016, 47.

24. Ibid.

25. Walter Benjamin, *The Work of Art in the Age of Mechanical Reproduction* (London: Penguin, 2008).

26. Robert Verhoogt, *Art in Reproduction: Nineteenth-Century Prints after Lawrence Alma-Tadema, Jozef Israëls, and Ary Scheffer* (Amsterdam: Amsterdam University Press, 2007), 285.

27. Ibid., 285.

28. Théophile Thoré, *Salons de Thoré, 1844, 1845, 1846, 1847, 1848* (Paris: Renouard, 1870), 278.

29. Laboulaye, "Préface," in *Études morales et politiques* (Paris: Charpentier, 1871), vii.

30. Ary Scheffer, *Le Christ Consolateur*, 1837, oil on canvas, 64×84.5 cm, Centraal Museum, Utrecht.

31. Ewals, *Ary Scheffer*, 48.

32. Zamoyski, *Holy Madness*, 183–184.

33. Guillaume de Félice, *Émancipation immédiate et complète des esclaves: Appel aux abolitionistes* (Paris: Delay, 1846), quoted in Nelly Schmidt, *Abolitionnistes de l'esclavage et réformateurs des colonies, 1820–1851* (Paris: Karthala, 2000), 742.

34. Laboulaye, "De la personnalité divine," in *Études morales et politiques*, 17; Laboulaye, "Introduction," in *Études morales et politiques*, vii.

35. Ary Scheffer to Arie-Johannes Lamme, 1850, Archives of the Dordrecht Museum, quoted in Ewals, *Ary Scheffer*, 104.

36. Peter Vischer, *Tomb of Saint Sebald*, 1507–1519, Nuremberg. See E. H. Gombrich, *The Preference for the Primitive: Episodes in the History of Western Taste and Art* (London: Phaidon, 2006), 140.

37. On Blanchard, see Verhoogt, *Art in Reproduction*, 311.

38. Charles Lenormant, *Beaux-Arts et voyages; Précédé d'une lettre par de M. Guizot* (Paris: Lévy, 1861), 1: 297–298.

39. "May 18, 1852," Charlotte's Diaries.

40. "August 31, 1853," Charlotte's Diaries. There are even earlier mentions of personal visits between the Scheffers and Bartholdis scattered throughout Charlotte's Diaries.

41. On Scheffer's ability to portray hands and their movement, see Petrus Hofstede de Groot, *Ary Scheffer: Ein Charakterbild* (Berlin: Heinersdorff, 1870), 19.

42. Ary Scheffer, *Madame Bartholdi*, 1855, oil on canvas, 150 × 101 cm, Musée Bartholdi, Colmar.

43. "June 10, 1851," Charlotte's Diaries.

44. Ary Scheffer, *La morte d'Eurydice*, 1814, oil on canvas, 340 × 452 cm, Musée de Beaux-Arts, Châteaux Royal de Blois.

45. Régis Hueber, "Bartholdi et le romantisme allemande: A propos de quelques oeuvres de jeunesse du sculpteur," *Annuaire de la Société d'histoire et d'archéologie de Colmar* (2009–2010): 182.

46. The canticle was published in 1855 in the illustrated collection *Christenfreude in Lied und Bild* (Leipzig: Georg Wigand, 1855). See the only study to date devoted to this work of Bartholdi's: Régis Hueber, "Le jour du Seigneur: Une sculpture inédite d'Auguste Bartholdi," in *La sculpture au XIXe siècle: Mélanges pour Anne Pingeot*, ed. C. Chevillot, L. de Margerie, J. L. Rinuy, and M. Bouchard (Paris: Nicolas Chaudun, 2008), 178–181; ibid., 179–201.

CHAPTER 8 · MONSTERS OUT

1. Régis Hueber, "Les statuaires au convent: Auguste Bartholdi et la Société Schongauer," in *Histoire du Musée d'Unterlinden et de ses collections: De la Révolution à la Première Guerre Mondiale* (Colmar: Société Schongauer-Musée d'Unterlinden, 2003), 228.

2. Sylvie Ramond, Jean-Luc Eichenlaub, and François-René Martin, "Histoire de l'art, musée et dessin chez François-Christian Lersé: À propos de quelques documents inédits," in *Histoire du Musée d'Unterlinden et de ses collections: De la Révolution à la Première Guerre Mondiale* (Colmar: Société Schongauer-Musée d'Unterlinden, 2003), 29; Sylvie Ramond and François-René Martin, "Le proche et le lointain: Collections publiques et objets à Colmar de la Révolution à l'Annexion," in *Histoire du Musée d'Unterlinden et de ses collections: De la Révolution à la Première Guerre Mondiale* (Colmar: Société Schongauer-Musée d'Unterlinden, 2003), 101.

3. Émile Galichon, "Martin Schongauer: Peintre et graveur du XV^e siècle, premier article," *Gazette des Beaux Arts* 1, no. 3 (1859): 264. See also Émile Galichon, "Martin

Schongauer: Peintre et graveur du XVe siècle, suite," *Gazette des Beaux Arts* 1, no. 3 (1859): 321–335.

4. Jan Bialostocki, *L'art due XVe siècle: Des Parler à Dürer* (Paris: Broché, 1993), 103n, quoted by François-René Martin, "Le culte de Schongauer. La redécouverte du *Retable d'Issenheim* et les érudits Colmariens à la fin du XVIIIᵉ et au XIXᵉ siècles. Légende locale et connaisance de l'art du passé," in *Histoire du Musée d'Unterlinden et de ses collections: De la Révolution à la Première Guerre Mondiale* (Colmar: Société Schongauer-Musée d'Unterlinden, 2003), 213.

5. Martin, "Le culte de Schongauer," 204.

6. Albrecht Dürer, *Self-Portrait*, 1500, oil on canvas, 66.3 × 49 cm, Alte Pinakothek, Munich.

7. Catalogs of the donations are held in the Colmar library archives, which also houses the *Catalogue manuscrit de Luis Hugot* (ms 667). Also displayed in the Colmar museum were reproductions of Raphael's portrait of Castiglione and his *Virgin of the Rocks*. Various other reproductions of works by Giulio Romano, Rembrandt, and Raphael (like the *La Belle Jardinière* and *Last Supper*) were already held by the library and their presence there is documented by the *Registre d'inscription des estampes sorties pour l'encadrement ou autre cause, 1838–1850* (Colmar Municipal Library). Other works acquired by the society, besides those already mentioned—which Bartholdi no doubt would have contemplated but which historians never discuss—included the *Seven Prophetesses* and the *Five Sibyls* by Michelangelo (also documented in the *Registre*), the *Scenes from the Life of Saint Cecilia* by Domenichino, the *Madonna with Child* by Correggio, the *Holy Family* by Palma il Vecchio, and the *Moses* by Poussin. Acquisitions made after 1847 were listed in the Minutes of the Society Schongauer, Société de Martin Schongauer, Registry, Colmar Municipal Library.

8. For the comparison, see M. Schongauer, *Femme portant un écu à la licorne*, Cabinet des Estampes, B. 97-L. 96, Bibliothèque Nationale, Paris.

9. See Chapter 6; also Charles Bartholdi, "Explication des sceaux et du médaillon figurés sur la deuxième planche ci-jointe," in *Curiosités d'Alsace* 1, no. 1 (1861–1862): 112.

10. Régis Hueber, "Les statuaires au convent: Auguste Bartholdi et la Société Schongauer," 228; Charles Bartholdi, "Signes merveilleux et prophétiques qui ont aperçus dans le ciel en 1610," *Curiosités d'Alsace* 1, no. 1 (1861–1862): 73–76; Charles Bartholdi, "Unter-linden," *Curiosités d'Alsace* 1, no. 1 (1861–1862): 91–111; Charles Bartholdi, "Lettre d'un sorcier accompagnée du fac similé d'un cercle magique en 1601," *Curiosités d'Alsace* 1, no. 2 (1861–1862): 168–173.

11. For a detailed and comprehensive reconstruction of the Rapp affair, see Régis Hueber, *Le Rapp (1852–1856), prémier monument public de Bartholdi (1834–1904)* (Colmar: Musée Bartholdi, 2000).

12. Related by Henri Dabot, one of Bartholdi's friends, and quoted in Robert Belot and Daniel Bermond, *Bartholdi* (Paris: Perrin, 2002), 25.

13. Louis-Antoine Garnier-Pagès, *Histoire de la Révolution de 1848*, 11 vols. (Paris: Pagnerre, 1866–1872), 1: 360.

14. Daniel Stern, *Histoire de la révolution de 1848* (Paris: Charpentier, 1862), 1: 202.

15. Harriet Grote, *Memoir of the Life of Ary Scheffer* (London: Murray, 1860), 94, 96–97.

16. Stern, *Histoire*, 1: 266–267.

17. Ibid., 1: 266, 296n.

18. Victor Hugo, "22 June," in *Choses Vues*, 2 vols. (Paris: Imprimerie Nationale, Ollendorff, 1913): 1: 355. See also T. J. Clark, *The Absolute Bourgeois: Artists and Politics in France, 1848–1851* (London: Thames and Hudson, 1982), 25–26.

19. Gustave Flaubert, *L'éducation sentimentale: Histoire d'un jeune homme* (Paris: Charpentier, 1891), 361.

20. Maurice Agulhon, *Marianne au combat: l'Imagerie et la la symbolique républicaines de 1789 à 1880* (Paris: Flammarion, 1979); M. Agulhon, *Marianne into Battle: Republican Imagery and Symbolism in France, 1789–1880*, trans. Janet Lloyd (Cambridge, UK: Cambridge University Press, 1979), 71–72.

21. Stern, *Histoire*, 1: 204.

22. Jean-Auguste-Dominique Ingres to Pauline Gilbert, December 1848, in *Ingres d'après une correspondence inédite*, foreword by Boyer d'Angen (Paris: d'Aragon, 1965), 392; Clark, *Absolute Bourgeois*, 63–64.

23. Clark, *Absolute Bourgeois*, 46.

24. See Agulhon, *Marianne into Battle*, 78–81.

25. Denis Diderot, "Salons: Sur la sculpture," in *Oeuvres choisies* (Paris: Garnier, 1880), 2: 446.

CHAPTER 9 · LIGHTHOUSES OF THE WORLD

1. Edoardo Villata, *I chiodi di Grünewald* (Milano: Educatt, 2014), 15–17.

2. Jean Leclant, "Préface: L'égyptologie et l'Alsace," in *Textiles d'Antinoé (Égypte) en Haute-Alsace*, ed. Marguerite Rassart-Debergh (Colmar: Muséum d'Histoire Naturelle de Colmar, 1997), 5.

3. "July 27, 1851," Charlotte's Diaries, Bartholdi Papers, IV2C, Musée Bartholdi, Colmar.

4. J. Fenton, *School of Genius: A History of the Royal Academy of Arts* (London: Royal Academy of Arts, 2006), 189–195. I am grateful to the staff of the library of the Royal Academy of Arts for helping me to trace Bartholdi's path at the time of his visit.

5. Alexander Ver Huell, "Een bezoek bij Ary Scheffer," *Nederlands magazijn* 5 (1859): 33–35, quoted in Leo Ewals, *Ary Scheffer, 1795–1858: Dessins, aquarelles, esquisses à l'huile* (Paris: Institut Néerlandais, 1980), 124–125.

6. Arthur Hamilton Smith, "Lord Elgin and His Collection," *Journal of Hellenic Studies* 36 (1916): 163–372.

7. Gustav Friedrich Waagen, *Treasures of Art in Great Britain* (London: Murray, 1854), 1: 50–54.

8. Ary Scheffer to Cornélia, August 1850, quoted in Harriet Grote, *Memoir of the Life of Ary Scheffer* (London: Murray, 1860), 90.

9. Waagen, *Treasures of Art*, 1: 41–43.

10. Victor Hugo, *Cromwell: Drame* (Brussels: Meline, 1837), xvii, xxii–xxiii.

11. The Bartholdis most likely used the *Nouveau guide à Londres pour l'Exposition de 1851* (Paris: Librairie Centrale de Chemin de Fer, 1851). See also Jeffrey A. Auerbach, *The Great Exhibition of 1851: A Nation on Display* (New Haven, CT: Yale University Press, 1999); John Tallis, *History and Description of the Crystal Palace: And the Exhibition of the World's Industry in 1851* (Cambridge, UK: Cambridge University Press, 2011).

12. Tallis, *History and Description of the Crystal Palace*, 196.

13. Kate Colquhoun, *A Thing in Disguise: The Visionary Life of Joseph Paxton* (London: Harper Perennial, 2004), 170–183, 248.

14. Toby Chance and Peter Williams, *Lighthouses: The Race to Illuminate the World* (London: New Holland, 2008), 102; Jan Piggott, *Palace of the People: The Crystal Palace at Sydenham 1854–1936* (Madison: University of Wisconsin Press, 2004), 32.

15. *Album de dessins par Machereau; sur l'intérieur du plat, chant en l'honneur de la liberté et du Saint-Simonisme, de la main de Machereau, et note, de la main de Frédéric Soehnée*, MS-13910, Bibliothèque de l'Arsenal, Paris; Alfred Pereire, *Autour de Saint-Simon, documents originaux* (Paris: Champion, 1912), 5.

16. Sébastien Charléty, *Histoire du Saint-Simonisme (1825–1864)* (Paris: Hartmann, 1931), 161.

17. Jean Walch, *Michel Chevalier, économiste saint-simonien* (Paris: Vrin, 1975), 25; ibid., 169.

18. Charléty, *Histoire*, 169; Duveyrier, *La ville nouvelle ou la Paris du Saint-Simoniens* (Paris: Ladvocat, 1832), 343.

19. Duveyrier, *La ville nouvelle*, 340.

20. Ibid., 340, 343.

21. William A. Bayst, *Empire Bridge and World Approach in Lieu of War* (London: Forseith, 1935), 2–10, 12, quoted in Piggott, *Palace of the People*, 176.

22. Duveyrier, *La ville nouvelle*, 337, 339–340.

23. *Tallis's History and Description of the Crystal Palace, and the Exhibition of the World's Industry in 1851* (London: Tallis's and London Printing and Publishing, 1852), 1: 32.

24. Jean-Pierre Dantan, *Queen Victoria*, 1851, zinc statue, Crystal Palace, London.

25. Johann Halbig, *Bayerische Löwe*, 1856, Kehlheim sandstone, Lindau (Bodensee); August Karl Eduard Kiss, *Amazone zu Pferde*, 1841, bronze statue, Altes Museum, Berlin.

26. *The Crystal Palace and Its Contents Being an Illustrated Cyclopedia of the Great Exhibition of the Industry of All Nations* (London: Clark, 1851), 19.

27. "August 28, 1851," Charlotte's Diaries, Bartholdi Papers, IV2C, Musée Bartholdi, Colmar.

28. "August 11–September 30, 1851," Charlotte's Diaries, Bartholdi Papers, IV2C, Musée Bartholdi, Colmar.

CHAPTER 10 · HIDDEN DEVILS

1. "September 28, 1852," Charlotte's Diaries, Bartholdi Papers, IV2C, Musée Bartholdi, Colmar.

2. "January 3, 1853; February 21, 1853," Charlotte's Diaries.

3. "April 13, 1853," Charlotte's Diaries.

4. "April 20, 1853," Charlotte's Diaries.

5. Cara Sutherland, *The Statue of Liberty* (New York: Barnes & Noble, 2003), 19.

6. Jacques Betz, *Bartholdi* (Paris: Éditions de Minuit, 1954); Nathalie Salmon, *L'histoire vrai du modèle de la Statue: Lady Liberty I Love You* (Rouen: Comever–De Rameau, 2013), 175.

7. Jean Marnier to Charles-Joseph Chappuis, May 8, 1852, quoted in Régis Hueber, *Le Rapp (1852–1856), prémier monument public de Bartholdi (1834–1904)* (Colmar: Musée Bartholdi, 2000), 35.

8. "July 30, 1854," "July 23, 1854," "July 28, 1854," "August 16, 1854," "August 21, 1854," and "November 4, 1852," Charlotte's Diaries; Hueber, *Le Rapp*, 41.

9. Ernest Renan, "La Tentation du Christ par Ary Scheffer," in *Études d'histoire religieuse* (Paris: Lévy, 1838), 426–427.

10. Bartholdi, *Esquisses préparatoires à la statue de Rapp*, republished in Jean Bundgens, "Auguste Bartholdi, prophete et son pays," *Saisons d'Alsace* 3 (1954): 183; Hueber, *Le Rapp*, 39; "August 1, 1854," Charlotte's Diaries.

11. "June 25, 1852," "January 3, 1853," and "February 1, 1853," Charlotte's Diaries.

12. "April 3, 1853," Charlotte's Diaries.

13. Ibid.

14. Antoine Étex, *Les Souvenirs d'un artiste* (Paris: Dentu, 1877), 183. See also A. Étex, *Ary Scheffer: Étude sur sa vie et ses ouvrages* (Paris: Lévy, 1859).

15. Étex, *Les Souvenirs*, 83.

16. Carl Kerény, *Prometheus: Archetypal Image of Human Existence*, trans. R. Manheim (Princeton, NJ: Princeton University Press, 1991), 50–51.

17. Antoine Étex, *Caïn et sa race maudits de Dieu*, 1832, marble, Chapelle Saint-Louis de la Salpêtrière, Paris; Étex, *Les souvenirs*, 8, also 124 and 184.

18. Brian Juden, *Tradition orphiques et tendances mystiques dans le romantisme français (1800–1855)* (Paris: Klincksieck, 1971), 101–102.

19. Étex, *Les souvenirs*, 194.

20. Antoine Étex, *Suite aux souvenirs d'un artiste* (Nice: Malvano-Mignon, 1887), 24.

21. Robert Belot and Daniel Bermond, *Bartholdi* (Paris: Perrin, 2002), 40.

22. Carlo Augusto Viano, *Le imposture degli antichi e i miracoli dei moderni* (Torino: Einaudi, 2005), 92–110.

23. René Martin, *La vie d'un grand journaliste: Auguste Nefftzer, fondateur de la Revue germanique et du temps (Colmar 1820, Bale 1876)* (Besançon: Camponovo, 1948), 1: 13–15, 2: 40–49.

24. Charles Fourier, "Douzième notice: Caractères de fanal et d'écart," in *Oeuvres complètes de Charles Fourier* (Paris: Librairie Sociétaire, 1848), 6: 421.

25. Pamela M. Pilbeam, *French Socialists before Marx: Workers, Women and the Social Question in France* (Montreal: McGill–Queen's University Press, 2000), 119.

26. Marc Martin, *La Presse régionale: Des affiches aux grands quotidiens* (Paris: Fayard, 2002), 92–94.

27. Maurice Reclus, *Émile de Girardin: Le créateur de la Presse moderne* (Paris: Hachette, 1934), 182; Martin, *La vie d'un grand journaliste*, 1: 61–65, 69, 88–89, 96–102.

28. Martin, *La vie d'un grand journaliste*, 1: 133–134, 137.

29. Auguste began sculpting the *Rapp* on March 6, 1854, according to Charlotte, who relates Nefftzer's first visit "on the topic of Auguste" on October 13, 1854. The first letter surviving, written by Charlotte to Nefftzer, dates to August 5, 1854 (Nefftzer papers, 113ap / 5, sheets 7–13, Archives nationales, Paris). In this letter, Charlotte refers to Nefftzer's habit of visiting Bartholdi in his studio.

30. Jean-Marie Schmitt, "'Le lion en liberté': Souvenirs inédits de la jeunesse d'Auguste Bartholdi," *Annuaire de la Société d'histoire et d'archéologie* 34 (1986): 96.

31. April 2, 1858, Charlotte's diary.

32. Jules Janin, *La Normandie: Histoire, paysages, monuments* (Paris: Bourdin, 1844), 528.

33. Théophile Gautier, "Avatar," in *Oeuvres de Théophile Gautier: Romans et contes* (Paris: Lemerre, 1898), 10: 37.

34. Louis Ménard, *De la morale avant les philosophes* (Paris: Didot, 1860), 80–81; Philippe Berthelot, *Louis Ménard et son oeuvre: Étude précédée du portrait et d'un autographe de Louis Ménard et suivie de pages choisies* (Paris: Juven, 1902), 44–45, 53–54.

35. Auguste Nefftzer, "La Bible et le partis chez les anciens Israélites," *Revue Germanique* 9 (1860): 97, 100.

36. Ibid., 100–101.

37. Auguste Nefftzer, "De la littérature apocalyptique chez les Juifs et les premiers Chrétiens. I. Le livre de Daniel," *Revue Germanique* 3 (1858): 119–141; Neffzter, "De la littérature apocalyptique chez les Juifs et les premiers Chrétiens. II. La Sybille juive," *Revue Germanique* 4 (1858): 162–182; Nefftzer, "De la littérature apocalyptique chez les Juifs et les premiers Chrétiens. III. L'Apocalypse de Saint Jean," *Revue Germanique* 7 (1859): 391–418.

38. Gérard de Nerval, *Voyage en Orient*, foreword by A. Miquel (Paris: Gallimard, 1998), 649; Alphonse Esquiros, "De deux mouvements littéraires," *La France littéraire* 37 (1840): 194.

39. "November 1–3, 1854," Charlotte's Diaries.

40. Charles Laboulaye, *Essai sur l'art industriel comprenant l'étude des produits les plus célèbres de l'industrie* (Paris: Bureau du dictionnaire des arts et manufactures, 1856), 52.

41. Antoine Étex, *Essai d'une revue synthétique sur l'exposition universelle de 1855 suive d'un coup d'oeil sur l'état des Beaux-Arts aux États-Unis* (Paris: Chez l'auteur, 1856), 60.

42. Paul Ernst Rattelmüller, *Die Bavaria: Geschichte eines Symbols* (Munich: Hugendubel, 1977), 17.

43. Louis de Ronchaud, *Phidias, sa vie et ses ouvrages* (Paris: Gide, 1861), 77, 104–107.

44. Albert Gabriel, "La construction, l'attitude et l'emplacement du colosse de Rhodes," *Bulletin de Correspondance Hellénique* 56, no. 1 (1932): 331–359.

CHAPTER 11 · QUEEN OF THE SOUTH

1. James F. Macmillan, *Napoleon III* (London: Routledge, 2014), 46; Pierre Milza, *Napoléon III* (Paris: Perrin, 2004), 211–212.

2. Macmillan, *Napoleon III*, 47.

3. David Baguley, *Napoleon III and His Regime: An Extravaganza* (Baton Rouge: Louisiana State University Press, 2000), 39.

4. Louis-Napoléon Bonaparte, *Des idées napoléoniennes* (Paris: Plon, 1860), 50–51. In light of recent electoral history worldwide, it is hardly surprising that the theme of populism again has come to the forefront of public debates. See John B. Judis, *The Populist Explosion: How the Great Recession Transformed American and European Politics* (New York: Columbia Global Reports, 2016).

5. Milza, *Napoléon III*, 229, 248–249.

6. "Demande de Grace," bb/30/475, II carton, 1852–1856, H-M, Archives Nationales, Paris. The document is signed by M. C. Boucher, state prosecutor for the Seine tribunal. The clemency request was made by a "female auditor" of Laboulaye's course (possibly Julie Bouchéty).

7. "Dossier Laboulaye (1810–1883)," C XII Laboulaye 1B, Archives du Collège de France, Paris.

8. Charles Duveyrier, *La ville nouvelle ou la Paris du Saint-Simoniens* (Paris: Ladvocat, 1832), 325; Harold Philip Clunn, *The Face of Paris* (London: Spring Books, 1958), 74–75; Nicholas Papayanis, *Planning Paris before Haussmann* (Baltimore: Johns Hopkins University Press, 2004), 154.

9. Duveyrier, *La ville nouvelle*, 326–327.

10. Stephane Kirckland, *Paris Reborn: Napoléon III, Baron Haussmann, and the Quest to Build a Modern City* (London: Macmillan, 2013), 118.

11. Milza, *Napoléon III*, 426; Michael Carmona, *Haussmann* (Paris: Fayard, 2000), 281–320.

12. Émile Zola, *Au bonheur des dames* (Paris: Livre de Poche, 1971), 284.

13. Bisson Frères, *Le Palais de l'Industrie*, 3P 4/16, Bartholdi Papers, Musée Bartholdi, Colmar.

14. Quoted in Guy Fargette, *Émile et Isaac Péreire: L'esprit d'enterprise au XIX^e siècle* (Paris: L'Harmattan, 2001), 225.

15. Ibid., 227.

16. *Visite a l'Exposition Universelle de Paris, en 1855* (Paris: Hachette, 1855), 65.

17. *La Presse*, September 10, 1855; *Le moniteur universel*, December 8, 1855.

18. "Monument du général Rapp à Colmar: Registre de souscription," ms 931, Bibliothèque municipale, Colmar.

19. Frédéric Bartholdi to Colonel Jean Marnier, June 12, 1855, Archives du Louvre, Paris, quoted in Robert Belot and Daniel Bermond, *Bartholdi* (Paris: Perrin, 2002), 49.

20. Sven Beckert, *Empire of Cotton: A Global History* (Knopf: New York, 2015), 131–132. Dominic Green, *Three Empires on the Nile: The Victorian Jihad, 1869–1899* (New York: Free Press, 2007), 19.

21. Ibid., 166, 169.

22. Rondo Cameron, *France and the Economic Development of Europe, 1800–1914: Conquests of Peace and Seeds of War* (Chicago: Rand McNally, 1961), 126.

23. Maxime Du Camp, *Souvenirs et passages d'Orient: Smyrne, Ephése, Magnésie, Constantinople, Scio* (Paris: Betrand, 1848); Du Camp, *Égypte, Nubie, Palestine et Syrie: Dessins photographiques recueillis pendant les années 1849, 1850 et 1851* (Paris: Gide et Baudry, 1852).

24. Gérard de Nerval, *Voyage en Orient*, foreword by A. Miquel (Paris: Gallimard, 1998), 194.

25. Adrianne J. Tooke, *Flaubert and the Pictorial Arts: From Image to Text* (Oxford, UK: Oxford University Press, 2000), 149.

26. Verhoogt, *Art in Reproduction: Nineteenth-Century Prints after Lawrence Alma-Tadema, Joseph Israël and Ary Scheffer* (Amsterdam: Amsterdam University Press, 2007), 9, 311.

27. Gustave Flaubert, *L'éducation sentimentale: Histoire d'un jeune homme* (Paris: Charpentier, 1880), 26–27.

28. It was only in 1858 that the Goupil company began to use photography in a consistent way for the reproduction of the works of their clients, but the first experiments dated from 1851, for example, Gustave Le Gray's photograph of Scheffer, *Le Coupeur de Nappe*, 1851, salt print, Dordrechts Museum, Dordrecht. See Verhoogt, *Art in Reproduction*, 287.

29. Christian Kempf, "Bartholdi et le calotype," in *D'un album du Voyage: Auguste Bartholdi en Egypte (1855–1856)* (Colmar: Musée Bartholdi, 1990), 16–18.

30. "July 2, 1854," Charlotte's Diaries, Bartholdi Papers, IV2C, Musée Bartholdi, Colmar.

31. Ibid.

32. "July 3, 1854," "July 4, 1854," "July 6, 1854," "July 15, 1854," "July 18, 1854," "July 19, 1854," Charlotte's Diaries.

33. Léon Belly to his mother, April 1, 1856, Bibliothèque municipale de Saint-Omer, ms 1159, cited in R. Hueber, "A Thousand Miles up the Nile," in *D'un album du Voyage: Auguste Bartholdi en Egypt (1855–1856)* (Colmar: Musée Bartholdi, 1990), 42.

34. Cited in Gerald M. Ackerman, *Jean-Léon Gérôme, 1824–1904* (Paris: ACR Edition, 1997), 17.

35. Ibid., 40.

36. Bossuet, *Discours sur l'histoire universelle*, in *Oeuvres complètes de Bossuet* (Besançon: Outhenin-Calandre, 1836), 4: 350.

37. "July 17, 1854," Charlotte's Diaries.

38. Hélène Lafont-Couturier, *Gérôme* (Paris: Herscher, 1998), 21; Kempf, "Bartholdi et le calotype," 16.

39. "Demande d'une mission en Égypte, Nubie et Abissinie [Palestine] par Gérôme et Bartholdi; Arrêté accordant la mission; Demande de recommandation aux affaires étrangères; Envoi de la lettre de recommandation par les affaires étrangères," F17/2935/2, folios 1–7, Archives nationales, Paris.

40. Ghislain de Diesbach, *Ferdinand de Lesseps* (Paris: Perrin, 1998), 131–133; J. Major, *Prize Possession: The United States and the Panama Canal, 1903–1979* (Cambridge, UK: Cambridge University Press, 2002), 20; Green, *Three Empires on the Nile*, 7.

41. "Lettres de recommandation," October 30, 1855, and Fortoul to Lacour, October 30, 1855, VI4J, Bartholdi Papers, Musée Bartholdi, Colmar.

42. Charlotte to Sakakini brothers, March 22, 1856, VI4J, Bartholdi Papers, Musée Bartholdi, Colmar. See also David Landes, *Bankers and Pashas: International Finance and Economic Imperialism in Egypt* (Cambridge: Harvard University Press, 1958).

43. Zachary Karabell, *Parting the Desert: The Creation of the Suez Canal* (London: John Murray, 2003), 45.

44. Arthur John Booth, *Saint-Simon and Saintsimonism: A Chapter in the History of Socialism in France* (London: Longmans, Greem, Reader and Dyer, 1871), 203.

45. Edmond About, *Le Fellah: Souvenirs d'Égypte* (Paris: Hachette, 1869), 33.

46. *Procès en la cour d'assises de la Seine, les 27 et 28 août, 1832* (Paris: Librairie Saint-Simonienne, 1832), 91; "Extrait d'un des enseignements de notre père suprême Enfantin sur les relations de l'homme et de la femme," in *Oeuvres de Saint-Simon & d'Enfantin*, 47 vols. (Paris: Dentu, 1865–), 8: 158–159.

47. Émile Barrault, *Adieu à Paris*, quoted in Sébastien Charléty, *Histoire du saint-simonisme (1825–1864)* (Paris: Hartmann, 1931), 208.

48. Antoine Picon, *Les saint-simoniens: Raison, imaginaire, utopie* (Paris: Belin, 2002), 155–156; De Diesbach, *Ferdinand de Lesseps*, 55.

49. De Diesbach, *Ferdinand de Lesseps*, 57–58.

50. Ibid., 116–118; Green, *Three Empires on the Nile*, 7.

51. "November 15, 1854," in Ferdinand de Lesseps, *Lettres journal et documents pour servir a l'histoire du Canal du Suez (1854–55–56)* (Paris: Didier, 1875), 17.

52. For a reconstruction of the journey, see: *D'un album du voyage*, 27–44; *Dahabieh, Almees et Palmiers: Dessins du premier voyage en Orient 1855–1856 d'Auguste Bartholdi* (Colmar: Musée Bartholdi, 1998), 15–18; *Au Yemen en 1856: Photographies et dessins d'Auguste Bartholdi, 18 juin–30 septembre 1994* (Colmar: Musée Bartholdi, 1994).

53. Gustave Flaubert, *Voyage en Orient* (Paris: Gallimard, 2006), 222; Auguste Bartholdi, *Le village de Sheik Ibada*, graphite pencil, *pierre noir*, and white *rehauts* on blue-gray paper, I ADC 23/29, Musée Bartholdi, Colmar.

54. Bartholdi made five drawings and took three photographs of Qena and two photographs of Dendera. The Dendara photographs are archived in the following locations in Musée Bartholdi, Colmar: negative, 1 P1/45; photograph on cardboard backing, 1 P4/22; negative, 1 P1/46; annotated photograph on cardboard backing, 1 P3/23. See also Friedrich Creuzer, *Symbolik und Mythologie* 2: 118, 124; Creuzer, *Religions de l'antiquité* 2: 97, 101.

55. Quoted in Hueber, "A Thousand Miles up the Nile," 31.

56. Bartholdi, *Autoportrait de Bartholdi et Gérôme*, photographic print on cardboard backing, not dated or signed, 1 P3/2, Musée Bartholdi, Colmar.

57. Frédéric-Auguste Bartholdi, *Statue of Liberty Enlightening the World* (New York: North American Review, 1885), 36.

58. A. Bartholdi, *Égypte—Grand Temple de Karnak*, 1 P3/34; negative 1 P1/58, Musée Bartholdi, Colmar. See also Flaubert, *Voyage en Orient*, 185.

59. Flaubert, *Voyage en Orient*, 185–187. One of the two opposite obelisks is at the place de la Concorde.

60. Bartholdi to Émile Jacob, January 26, 185[6?], VI4J, Bartholdi Papers, Musée Bartholdi, Colmar.

61. Bartholdi to unknown correspondent [Émile Jacob?], n.d.; and Bartholdi to unknown correspondent [Émile Jacob?], n.d., VI4J, Bartholdi Papers, Musée Bartholdi, Colmar.

62. Flaubert, *Voyage en Orient*, 186.

63. Percy Shelley, "Ozymandias," 1818, available at https://www.poetryfoundation.org/poems /46565/ozymandias (accessed March 7, 2018).

64. Bartholdi, *Les "Colosses de Memnon,"* 1855, photograph on hardback support, Musée Bartholdi, Colmar 1855 (Christian Kempf).

65. Creuzer, *Symbolik* 2: 118, 124; Creuzer, *Religions de l'antiquité* 2: 97, 101.

66. Hueber, "A Thousand Miles up the Nile," 32.

67. "Demande d'une mission en Égypte," folio 3.

68. Bartholdi to some friends, April 10, 1856, VI4J, Bartholdi Papers, Musée Bartholdi, Colmar.

69. Quoted in Hueber, "A Thousand Miles up the Nile," 32.

70. Draft of a letter from Bartholdi to Vayssières, sent from Cairo and undated (Bartholdi Papers, Archives Municipales de Colmar). For a detailed discussion of the meeting between Vayssières and Bartholdi, see R. Hueber, "La Reine de Saba craint les chambres obscures: Essai d'un itineraire bartholdien en Arabie du Sud," in *Au Yemen en 1856*, 26–27.

71. R. E. Witt, *Isis in the Ancient World* (Baltimore: Johns Hopkins University Press, 1997), 20, 61.

72. Bartholdi to Vayssières, n.d., VI4J, Bartholdi Papers, Musée Bartholdi, Colmar.

73. Charlotte to Auguste, April 19, 1856, VI4J, Bartholdi Papers, Musée Bartholdi, Colmar.

74. Charlotte to Soliman Pacha, April 22, 1856, VI4J, Bartholdi Papers, Musée Bartholdi, Colmar.

75. Bartholdi to Monsieur de la Rozerie, n.d., Bartholdi Papers, Archives Municipales de Colmar, quoted in Hueber, *Au Yemen en 1856*, 27.

76. Hueber, *Au Yemen en 1856*, 28.

77. Caesar E. Farah, *The Sultan's Yemen: 19th-Century Challenges to Ottoman Rule* (London: I. B. Tauris, 2002), 25.

78. Bartholdi to Charlotte, April 15, 1868, VI3E, Bartholdi Papers, Musée Bartholdi, Colmar.

79. Périer to Bartholdi, February 18, 1857, VI4J, Bartholdi Papers, Musée Bartholdi, Colmar.

80. Belot and Bermond, *Bartholdi*, 84.

81. Charles Goutzwiller, *A travers le passé: Souvenirs d'Alsace: Portraits, paysages* (Belfort: Imprimerie Nouvelle, 1898), 235.

82. "Fêtes de l'Alsace: À l'occasion de l'inauguration de la statue du Général Rapp," *Illustration: Journal Universel*, September 6, 1856, 156; Édouard Gouin, "Fête de Colmar. Concours et fêtes agricoles—Inauguration de la statue du Général Rapp," *Illustration: Journal Universel*, September 13, 1856, 167.

83. Ibid.

CHAPTER 12 · FABLES OF MADNESS

1. J. McKaye, introduction to É. Laboulaye, *Upon Whom Rests the Guilt of War? Separation: War without End* (New York: Loyal Publication Society, 1864), 4.

2. Édouard Laboulaye, "De l'esclavage aux États-Unis et de sa législation," in *Oeuvres sociales de W. E. Channing* (Paris: Au bureau du dictionnaire des arts et manufactures, 1854), xxii–xxiii, xxxii.

3. *La Presse*, December 20, 1852, 1–2.

4. Nelly Schmidt, *Abolitionnistes de l'esclavage et réformateurs des colonies, 1820–1851: Analyse et documents* (Paris: Karthala, 2000), 107.

5. Ibid., 199.

6. Édouard Laboulaye, introduction to *Oeuvres sociales de Channing* (Paris: Au bureau du dictionnaire des arts et manufactures, 1854), xxxi.

7. William Ellery Channing, *De l'esclavage: Précédé d'une préface et d'une étude sur l'esclavage aux États-Unis*, ed. Édouard Laboulaye (Paris: Lacroix-Comon, 1855), 115.

8. Laboulaye, foreword to ibid., xl.

9. Thomas Jefferson Randolph's speech as quoted in Harriet Beecher Stowe, *A Key to Uncle Tom's Cabin* (Leipzig: Tauchnitz, 1853), 2: 79; Laboulaye, introduction to Channing, *Oeuvres sociales de Channing*, xxv.

10. Channing, *De l'esclavage*, 168.

11. Ibid.; Nicholas Guyatt, *Bind Us Apart: How Enlightened Americans Invented Racial Segregation* (New York: Basic Books, 2016), 4–5, 328.

12. Robert S. Levine, introduction to Harriet Beecher Stowe, *Dred: A Tale of the Great Dismal Swamp* (Chapel Hill: University of North Carolina Press, 2009), xvi.

13. Laboulaye, introduction to *Oeuvres sociales de Channing*, xxxiii.

14. John Matteson, *Eden's Outcasts: The Story of Louisa May Alcott and Her Father* (New York: Norton, 2007), 190; Nicholas Guyatt, *Bind Us Apart*.

15. Laboulaye, foreword to Channing, *De l'esclavage*, xxxix.

16. Laboulaye, introduction to *Oeuvres sociales de Channing*, xl.

17. Channing, *De l'esclavage*, 317.

18. Édouard Laboulaye, "L'Éducation en Amérique" [1853], in Laboulaye, *Études morales et politiques* (Paris: Charpentier, 1871), 173.

19. Walter D. Gray, *Interpreting American Democracy in France: The Career of Édouard Laboulaye* (Newark: University of Delaware Press, 1994), 69.

20. Quoted in René Martin, *La vie d'un grand journaliste: Auguste Nefftzer, fondateur de la Revue germanique et du temps (Colmar 1820, Bale 1876)* (Besançon: Camponovo, 1948), 2: 165–166.

21. Ibid., 2: 21.

22. Charlotte to Madame Soehnée, n.d., Bartholdi Papers, IV2C, Musée Bartholdi, Colmar.

23. "August 6, 1854," Charlotte's Diaries, Bartholdi Papers, IV2C, Musée Bartholdi, Colmar.

24. Robert Belot and Daniel Bermond, *Bartholdi* (Paris: Perrin, 2002), 110.

25. Ibid., 110–111. On Nefftzer see also Jacques Betz, *Bartholdi* (Paris: Éditions de minuit, 1954), 53.

26. Édouard Laboulaye, *Journal des Débats*, January 26, 1859, quoted in Charles Bartholdi, "Au Lecteur," in *Curiosités d'Alsace* 1 (1861–1862): 3, 11.

27. Charles Bartholdi, "Signes merveilleux et prophétiques qui ont aperçus dans le ciel en 1610," *Curiosités d'Alsace* 1, no. 1 (1861–1862): 73–76; Charles Bartholdi, "Unterlinden," *Curiosités d'Alsace* 1, no. 2 (1861–1862): 91–111; Charles Bartholdi, "Lettre d'un sorcier accompagnée du fac similé d'un cercle magique en 1601," *Curiosités d'Alsace* 1, no. 1 (1861–1862): 168–173.

28. Charles Bartholdi, "Explication des sceaux et du médaillon figurés sur la deuxième planche ci-jointe," in *Curiosités d'Alsace* 1 (1861–1862): 112.

29. See Chapter 8; Charles Bartholdi, "Explication," 112.

30. See, for example, "Invitation à une réunion maçonnique à Paris," Bartholdi Papers, VIII1E, Musée Bartholdi, Colmar.

31. Elizabeth Mitchell, *Liberty's Torch: The Great Adventure to Build the Statue of Liberty* (New York: Grove, 2014), 3.

32. Robert Belot, *Bartholdi: Portrait intime du sculpteur* (Bernardswiller: I.D. l'Édition, 2016), 17.

33. Charles Bartholdi to Madame Haussmann, July 17, 1862, Bartholdi Papers, Musée Bartholdi, Colmar.

34. Belot and Bermond, *Bartholdi*, 110–111.

35. Gabriel Flampin, "Projet d'une fontaine monumentale, a élever dans l'Hémicycle des quinconces à Bordeaux," *Illustration*, April 24, 1858, 268; Betz, *Bartholdi*, 51.

36. Jules Janin, "Fontaine monumentale à Bordeaux," *L'Artiste*, January 30, 1859, 65.

37. Flampin, "Projet d'une fontaine monumentale," 267.

38. Belot and Bermond, *Bartholdi*, 104.

39. Bartholdi, *Lutte de l'homme avec sa conscience*, group in plaster, Exposition Générale des Beaux-Arts, Brussels, 1857. See *Auguste Bartholdi: Desseins . . . Dessins: Esquisses preparatoires d'un statuaire, 15 septembre–31 décembre 1995* (Colmar: Musée Bartholdi, 1995), 17–23.

40. *Auguste Bartholdi*, 18.

41. Charles Goutzwiller, *À travers le passé: Souvenirs d'Alsace, portraits et paysages* (Belfort: Imprimerie Nouvelle, 1898), 269.

42. Dante, *Paradiso*, 1: 61–66.

43. See Chapter 8.

44. Michael Paul Driskel, "'Et la lumière fut': The Meanings of David d'Angers's Monument to Gutenberg," *Art Bulletin* 73, no. 3 (1991): 359–380; David d'Angers, *Gutenberg*, 1840, bronze on a granite base, Place Gutenberg, Strasbourg.

45. *Jacob Böhme's sämmtliche Werke*, ed. K. W. Schiebler (Leipzig: Barth, 1842); Cyril O'Regan, *Gnostic Apocalypse: Jacob Böhme's Haunted Narrative* (New York: SUNY Press, 2002), 32–35, 43–47.

46. M. Schongauer, *Crucifixion aux quatre anges*, 1457–1480, line engraving done with a burin on copper, china ink on paper, Musée d'Unterlinden, Colmar.

47. Charles Foltz, *Souvenirs du vieux Colmar* (Colmar: Barth, 1887), 245; *Pictorium Gloria. Martin Schongauer vu par Auguste Bartholdi. Exposition-Dossier présentée par le Musée Bartholdi, Colmar–1991 29 juin-31 octobre* (Colmar: Musée Bartholdi, 1991), 15. See also Chapter 7.

48. *Annual Report of the Light-House Board of the United States to the Secretary of the Treasury for the Fiscal Year Ended June 30, 1887* (Washington, DC: U.S. Government Printing Office, 1887), 126, quoted in Mitchell, *Liberty's Torch*, 260. See also Betz, *Bartholdi*, 201.

49. Betz, *Bartholdi*, 60.

50. Ibid., 49.

51. Bartholdi to Charlotte, January 18, 1862, September 26, 1862, and December 11 and 14, 1862, Bartholdi Papers, VI3B, Musée Bartholdi, Colmar.

52. Charlotte to Bartholdi, March 13, 1863, Bartholdi Papers, VI3C, Musée Bartholdi, Colmar.

53. Bartholdi to Charlotte, February 28, 1865, Bartholdi Papers, VI3D, Musée Bartholdi, Colmar.

54. Bartholdi to Charlotte, March 3 and 16, 1865, Bartholdi Papers, VI3D, Musée Bartholdi, Colmar.

CHAPTER 13 · CUCKOO APOCALYPSE

1. Édouard Laboulaye, *Souvenirs d'un voyageur: Nouvelles* (Paris: Charpentier, 1857); Édouard Laboulaye, preface to *Abdallah ou le trèfle à quatre feuilles: Conte arabe* (Paris: Charpentier, 1884), ii.

2. Henry James, *The American Scene* (London: Chapman and Hall, 1907), 413.

3. Quoted in Nicholas Guyatt, *Bind Us Apart: How Enlightened Americans Invented Racial Segregation* (New York: Basic Books, 2016), 328–329.

4. *Address of the Loyal National League to Messrs. Agénor de Gasparin, Édouard Laboulaye, Augustin Cochin, Henri Martin, and Other Friends of America in France, Loyal Publication Society* (New York: Bryant, 1864), 20.

5. *Reply of Messrs. Agénor de Gasparin, Édouard Laboulaye, Henri Martin, Augustin Cochin to the Loyal National League of New York* (New York: Bryant, 1863), 4–5, 11.

6. Ibid., 3–4.

7. John Warne Monroe, *Laboratories of Faith: Mesmerism, Spiritism, and Occultism in Modern France* (Ithaca, NY: Cornell University Press, 2008), 83–87.

8. Zéphyre-Joseph Piérart, quoted in ibid., 84.

9. Édouard Laboulaye, *Contes bleus* (Paris: Charpentier, 1869), 4.

10. René Lefebvre (Édouard Laboulaye), *Paris in America*, trans. Mary L. Booth (New York: Scribner, 1863), 10–14.

11. John Bunyan, *The Pilgrim's Progress from This World from That Which Is to Come, Delivered under the Similitude of a Dream* (London: Ponder & Peacock, 1678).

12. Lefebvre, *Paris in America*, 28.

13. Walter D. Gray, *Interpreting American Democracy in France: The Career of Édouard Laboulaye, 1811–1883* (Newark: University of Delaware Press, 1994), 139, n. 36, and 154, n. 26; Madame Édouard de Laboulaye, *Vie de Jeanne d'Arc* (Paris: Pelagaud, 1877).

14. See Chapter 12.

15. Cyril O'Regan, *Gnostic Apocalypse: Jacob Böhme's Haunted Narrative* (New York: SUNY, 2002), 33–35, 43–47. See also Jacob Böhme, *De Vita Triplici*, in *Jacob Böhme's sämmtliche Werke*, ed. K. W. Schiebler, 6 vols. (Leipzig: Barth, 1831–1847), 1: 33.

16. Cyril O'Regan, *Gnostic Apocalypse*, 43–47.

17. Lefebvre, *Paris in America*, 49–52.

18. Ibid., 80.

19. Ibid., 92.

20. Ibid., 94.

21. Ibid., 119.

22. Ibid., 127.

23. See Chapter 10.

24. Daniel 2: 26–46.

25. Nefftzer, "De la littérature apocalyptique chez les Juifs et les premiers Chrétiens. III. L'Apocalypse de Saint Jean," *Revue Germanique* 7 (1859): 393.

26. Lefebvre, *Paris in America*, 128–129.

27. Matthew 26: 75.

28. John Bunyan, *Pilgrim's Progress*, in *The Entire Works of John Bunyan*, ed. Henry Stebbing (Toronto: Virtue, 1859), 2: 100.

29. Thomas E. Gilson and William Gilson, *Carved in Stone: The Artistry of Early New England Gravestones* (Middletown: CT: Wesleyan University Press, 2012), 22–23.

30. Lefebvre, *Paris in America*, 162.

31. Ibid., 164.

32. Ibid., 369.

33. Daniel 7: 13–14.

34. Lefebvre, *Paris in America*, 208.

35. Ibid.

36. Ibid., 252.

37. Ibid., 318.

38. Ibid., 319.

39. George Bancroft, *History of the United States*, vol. 1 of *History of the Colonization of the United States*, 3 vols. (Boston: Little, Brown, 1838–1857), 1: 287, 323; Édouard Laboulaye, *Histoire des États-Unis depuis le premiers essais de colonization jusqu'à l'adoption de la constitution fédérale, 1620–1789*, vol. 1 of *Histoire des États-Unis*, 3 vols. (Paris: Durand, Guillaumin, 1855–1866), 161.

40. Lefebvre, *Paris in America*, 369–370.

41. Nefftzer, "L'Apocalypse de Saint Jean," 393.

42. Lefebvre, *Paris in America*, 337.

43. Bartholdi, *Le Martyr moderne*, 1863, plaster model, Musée Bartholdi, Colmar.

44. Bartholdi to Charlotte, n.d., Bartholdi Papers, VI3D, Musée Bartholdi, Colmar.

45. Théophile Gautier, *Arria Marcella*, in Gautier, *Récits fantastiques* (Paris: Flammarion, 1981), 256–259; G. de Nerval, *Isis*, in Nerval, *Les filles du feu, les chimères* (Paris: Garnier, Flammarion, 1965), 187–198.

46. Bartholdi to Charlotte, April 19, 1865, "April 5," *Journal du voyage*, Bartholdi Papers, VI3D, Musée Bartholdi, Colmar.

47. Bartholdi to Charlotte, April 19, 1865, "April 4," *Journal du voyage*, Bartholdi Papers, VI3D, Musée Bartholdi, Colmar.

48. "April 8," *Journal du voyage*, Bartholdi Papers, VI3D, Musée Bartholdi, Colmar.

49. Nerval, *Voyage en Orient* (Paris: Gallimard, 1998), 646–647, 709.

50. Draft of letter from Charlotte to Bartholdi, undated, but it is in regard to the day when Bartholdi left Rome, April 19, 1865, Bartholdi Papers, VI3D, Musée Bartholdi, Colmar.

51. "April 10," and "April 12," *Journal du voyage*, Bartholdi Papers, VI3D, Musée Bartholdi, Colmar.

52. Michelangelo, *Statue of Moses*, 1545, marble statue, San Pietro in Vincoli, Rome.

53. Sigmund Freud, "Der Moses des Michelangelo," in *Gesammelte Werke*, 18 vols. (Frankfurt am Mein: Fischer, 1968–1978), 10: 172–201.

54. Exodus, 32: 15–19, 34: 29; Jules Michelet, "Le tombeau de Jules II par Michel-Ange," *Magasin pittoresque* 33 (1865): 377–378.

55. Auguste to Charlotte, April 19, 1865, Bartholdi Papers, VI3D, Musée Bartholdi, Colmar.

56. A. Bartholdi, *L'Appenin*, private collection, n.d., Paris, reproduced in P. Provoyeur, "Bartholdi and the Colossal Tradition," in *Liberty: The French-American Statue in Art and History* (New York: Harper, 1986), 69.

57. Luke Morgan, *The Monster in the Garden: The Grotesque and the Gigantic in Renaissance Landscape Design* (Philadelphia: University of Pennsylvania Press, 2015), 123.

58. Victor Hugo, *Les orientales* (Paris: Hetzel, 1869), xxii–xxiii.

CHAPTER 14 · THE VEILED VALKYRIE

1. Philip Nord, *The Republican Moment: Struggles for Democracy in Nineteenth-Century France* (Cambridge: Harvard University Press, 1995), 113.

2. Bartholdi to Charlotte, March 3, 1865, Bartholdi Papers, VI3D, Musée Bartholdi, Colmar.

3. Frédéric-Auguste Bartholdi, *The Statue of Liberty Enlightening the World* (New York: North American Review, 1885), 13–14.

4. *Rapport sur l'Exposition Universelle de 1867, à Paris: Précis des opérations et listes des collaborateurs avec un appendice sur l'avenir des expositions, la statistique des opérations, les documents officiels et le plan de l'exposition* (Paris: Imprimerie Impériale, 1869), 298–303.

5. Genesis 4: 22.

6. Édouard Manet, *L'Exposition universelle de 1867*, 1867, oil on canvas, 108×196.5 cm, Nasjonalgalleriet, Oslo.

7. Michael Carmona, *Haussmann* (Paris: Fayard, 2000), 461–466; Béatrice de Andia, "Visages de l'Avenir," in *Les Expositions Universelles à Paris de 1855 à 1937* (Paris: Action Artistique de la Ville de Paris, 2005), 15–16; Luisa Limido, "L'Exposition Universelle de 1867: Le Champ de Mars dans le sillage d'Haussmann," also in *Les Expositions Universelles*, 70.

8. *Rapport sur l'Exposition Universelle de 1867*, 163.

9. Ibid., 113.

10. Charles Edmond, *L'Égypte à l'Exposition universelle de 1867* (Paris: Dentu, 1867), 193–194.

11. Bartholdi to Charlotte, March 9, 1865, Bartholdi papers, VI3D, Musée Bartholdi, Colmar.

12. "Monument de Champollion le Jeune," *Le journal illustré* 185 (1867): 1.

13. Jules Simon, *Le libre-échange* (Paris: Lacroix, 1870), 45–46; Edward Roger John Owen, *Cotton and the Egyptian Economy* (Oxford, UK: Clarendon, 1969), 90–104; Malcolm Yapp, *The Making of the Modern Near East, 1792–1923* (London: Routledge, 2014), 155; Sven Beckert, *Empire of Cotton: A Global History* (New York: Knopf, 2015), 256.

14. *Ausland* (1831): 1016, quoted in Sven Beckert, *Empire of Cotton*, 167.

15. Quoted in George Edgar-Bonnet, *Ferdinand de Lesseps: Le diplomate le créateur de Suez* (Paris: Plon, 1951), 399. See also Zachary Karabell, *Parting the Desert: The Creation of the Suez Canal* (London: Murray, 2004), 199.

16. Karabell, *Parting the Desert*, 202.

17. Paul Merruau, "L'Isthme de Suez au Champ de Mars," *L'Exposition Universelle de 1867 illustrée* 1, no. 8 (1867): 114.

18. Auguste Bartholdi, *Femme puissant de l'eau*, n. d., in *pietra nera*, with white and red chalk (*sanguigna*) shading on light gray-blue paper with cardboard backing, Musée Bartholdi, Colmar, IADC 45/71; *Porteuse d'eau*, n. d., graphite pencil with light white shading on light gray-blue paper with cardboard backing, Musée Bartholdi, Colmar, IADC 5/7; Amilcar Hasenfratz, *Café sur le bords du Nil*, 1860, Musée Bartholdi, Colmar.

19. Frédéric-Auguste Bartholdi, *La lyre chez les Berbères, souvenir du Nil*, 1857, plaster group, Musée Bartholdi, Colmar. The original in bronze is lost.

20. Charles Landelle, *Femme fellah*, 1866, oil on canvas, 131×84 cm, Musée du Vieux-Château, Laval, copy of the original painting, destroyed at Saint-Cloud during the war of 1870.

21. Léon Renard, *Les phares* (Paris: Hachette, 1867), 13.

22. Ibid., 15; Pliny the Elder, *Natural History*, 10 vols. (Cambridge: Harvard University Press, 1938–1963), 10: 64–67; *The Histories of Herodotus*, trans. Henry Cary (New York: Appleton, 1899), 70.

23. Susan Handler, "Architecture on the Roman Coins of Alexandria," *American Journal of Archeology* 75, no. 1 (1971): 58–60.

24. Renard, *Les phares*, 32; Albert Gabriel, "La construction, l'attitude et l'emplacement du colosse de Rhodes," *Bulletin de correspondance hellénique* 56, no. 1 (1932): 331–359.

25. Renard, *Les phares*, 21–22.

26. Said, *Orientalism* (London: Vintage Books, 1994), 91

27. Aimé Millet and Eugène Viollet-le-Duc, *Vercingétorix*, 1865, copper statue, archaeo-logical site of Alésia, Alise-Sainte-Reine.

28. See Chapter 1.

29. Burkhard Meier, *Das Hermannsdenkmal und Ernst von Bandel: Zum zweihundertsten Geburtstag des Erbauers* (Detmold: Verlag Topp + Möller, 2000), 91, 101.

30. Martin M. Winkler, *Arminius the Liberator: Myth and Ideology* (Oxford, UK: Oxford University Press, 2016), 65–69.

31. Edmond About, *Le fellah: Souvenirs d'Égypte* (Paris: Hachette, 1869), 50.

32. Auguste to Charlotte, March 23, 1869, Bartholdi Papers, VI3E, Musée Bartholdi, Colmar.

33. Auguste to Charlotte, March 31 and April 5, 1869, Bartholdi Papers, Musée Bartholdi, Colmar. The second letter contains an account of the days April 1 to 5, 1869.

34. Auguste to Charlotte, April 15, 1869, Bartholdi Papers, VI3E, Musée Bartholdi, Colmar; the letter gives an account of the day of April 13.

35. Auguste to Charlotte, March 31, 1869, describing events of April 4 and 5, Bartholdi Papers, VI3E, Musée Bartholdi, Colmar.

36. Auguste to his mother, March 31, 1969; Auguste to his mother, April 15, 1869, reporting about April 6, Bartholdi Papers, VI3E, Musée Bartholdi, Colmar.

37. About, *Le fellah*, 50, 63.

38. Auguste to Charlotte, April 15, 1869, Bartholdi Papers, VI3E, Musée Bartholdi, Colmar.

39. Ibid.

40. Ibid.

41. Ibid.

42. Auguste to Charlotte, April 15, 1869, Bartholdi Papers, VI3E, Musée Bartholdi, Colmar.

43. About, *Le fellah*, 62.

44. Auguste to Charlotte, letter dated April 15 but describing the events of April 13 and 14.

45. About, *Le fellah*, 78–79.

46. Auguste to Charlotte, April 15, 1869, Bartholdi Papers, VI3E, Musée Bartholdi, Colmar

47. Ibid.

48. Account of the days April 19–22 in a travel diary sent from Bartholdi to his mother, with the letter dated April 18, Bartholdi Papers, VI3E, Musée Bartholdi, Colmar.

49. Auguste to Charlotte, April 26, 1869, Bartholdi Papers, VI3E, Musée Bartholdi, Colmar

50. Draft copy of a letter from Charlotte to Uncle Bartholdi. The letter is not dated, but comes from the period just after the death of Jean-Charles ("Copie des lettres que j'ai écrites à soir depuis la perte cruelle du meilleur des maris, arrive le 16 août 1836, A.D . . .").

51. The Colmar library holds various books that bear witness to the mystical interests of the Bartholdi family, such as Reynaud's *Philosophie religieuse: Terre et ciel* (Paris: Furne, 1854) and Camille Flammarion's *Les merveilles célestes* (Paris: Hachette, 1865).

52. Auguste to Charlotte, April 30, 1869, Bartholdi Papers, VI3E, Musée Bartholdi, Colmar.

53. Ibid.; Andrea del Verrocchio, *Monumento equestre a Bartolomeo Colleoni*, 1480–1488, bronze, Campo San Zanipolo, Venice.

54. See Chapter 5.

55. "La Statua Colossale di San Carlo Borromeo," in *Guida storico-statistica dell'Italia e delle isole di Sicilia, Malta, Sardegna e Corsica* (Milano: Artaria, 1857), 115; "Statua colossale di San Carlo Borromeo," *L'album giornale letterario e di belle arti* 2, no. 2 (1836): 20.

CHAPTER 15 · HEMISPHERIC CONVERSION

1. Édouard Laboulaye, *Le Prince Caniche* (Paris: Charpentier, 1868), 93.

2. Pierre Milza, *Napoléon III* (Paris: Perrin, 2004), 532–539.

3. Ibid., 399; Guy Fargette, *Émile et Isaac Péreire: L'esprit d'enterprise au XIXᵉ siècle* (Paris: L'Harmattan, 2001), 243, 278–283.

4. Milza, *Napoléon III*, 503, 557.

5. Ibid., 565; Walter D. Gray, *Interpreting American Democracy in France: The Career of Édouard Laboulaye, 1811–1883* (Newark: University of Delaware Press, 1994), 106.

6. Napoléon to Eugénie, October 15, 1869, quoted in Milza, *Napoléon III*, 562, 571.

7. Édouard Laboulaye, *Questiones constitutionelles* (Paris: Charpentier, 1872), 292–293.

8. Napoléon III, *Histoire de Jules César*, 2 vols. (Paris: Imprimerie impérial, 1865–1866).

9. Ibid., 2: 451; *Vercingétorix et Alésia*, ed. Alain Duval and Christiane Lyon-Caen (Paris: Réunion des musées nationaux, 1994), 240–245.

10. Napoléon III, *Histoire de Jules César*, 2: 459.

11. See Chapters 12 and 13.

12. Gian Lorenzo Bernini, *The Vision of Constantine*, 1670, marble statue, Scala Regia, Vatican, Rome; Étienne Maurice Falconet, *Le cavalier de bronze*, 1766, bronze statue on pedestal, Senate Square, Saint Petersburg.

13. Auguste to Charlotte, Paris, November 14, 16 and 22, 1869, VI3E, Bartholdi Papers, Musée Bartholdi, Colmar. See also Robert Belot and Daniel Bermond, *Bartholdi* (Paris: Perrin, 2002), 136; *Vercingétorix et Alésia*, 344.

14. *Vercingétorix et Alésia*, 344, 365.

15. See Chapter 6.

16. Auguste Bartholdi, *L'Égypte apportant lumière à l'Asie*, 1869, photograph of a lost drawing, albuminate paper on cardboard, Inv. 2P13/1, Musée Bartholdi, Colmar.

17. Helene P. Foley, *The Homeric "Hymn to Demeter:" Translation, Commentary, and Interpretative Essays* (Princeton, NJ: Princeton University Press, 2013), 4–5, 14–15.

18. See Chapter 6.

19. Auguste to Charlotte, November 6–7, 1869, VI3E, Bartholdi Papers, Musée Bartholdi, Colmar.

20. Bartholdi to Laboulaye, cited by Jean-Marie Schmitt, who does not give its date, but places it in the spring of 1871. See Jean-Marie Schmitt, *Bartholdi: A Certain Idea of Liberty* (Strasbourg: Nuée Bleue, 1985), 43–44.

21. Nieuwerkerke, "Registre d'audiences," Archives du Louvre, 30/356, quoted in Belot and Bermond, *Bartholdi*, 145.

22. Auguste to Charlotte, March 23, 1869, VI3F, Bartholdi Papers, Musée Bertholdi, Colmar.

23. Auguste to Charlotte, May 31, 1870, VI3F, Bartholdi Papers, Musée Bertholdi, Colmar.

24. Robert Belot, *Bartholdi: Portrait intime du sculpteur* (Bernardswiller: I.D. l'Édition, 2016), 78.

25. A notable exception is found in ibid., 68.

26. I am grateful to my son Erik August for directing my attention to this detail. See Chapter 11.

27. Édouard Laboulaye, *Abdallah ou le trèfle à quatre feuilles: Conte arabe* (Paris: Hachette, 1859), 90.

28. Ibid., 101–102.

29. Nicolas de Bonneville, *De l'esprit des religions: Ouvrage promis et nécessaire à la Confédération universelle des amis de la vérité* (Paris: Cercle Social, 1792), 2: 42–43.

30. Exodus 13: 21.

31. Nefftzer, "La Bible et le partis chez les anciens Israélites," *Revue germanique* 9 (1860): 100.

32. Domenico Gatteschi, "Des lois sur la propriété foncière dans l'empire ottoman et particuliérement en Égypte," *Revue historique de droit français et étranger* 13 (1867): 459.

33. Zachary Karabell, *Parting the Desert: The Creation of the Suez Canal* (London: Murray, 2004), 169–172.

CHAPTER 16 · REVENGE

1. Auguste to Charlotte, May 31, 1870, Bartholdi Papers, VI3F, folio 6b, Musée Bartholdi, Colmar; undated draft of Charlotte's letter to Auguste, to be found between Auguste's letter to Charlotte of May 31, 1870, and another one of June 2, 1870, Bartholdi Papers, VI3F, folio 6b, Musée Bartholdi, Colmar.

2. Auguste to Charlotte, June 2, 1870, Bartholdi Papers, VI3F, Musée Bartholdi, Colmar.

3. Auguste to Charlotte, August 13, 1870, and Auguste to Charlotte, October 2, 1870, Bartholdi Papers, VI3F, Musée Bartholdi, Colmar. The events that follow are described by Bartholdi in his *Notes sur les événements Colmar 1870. Notes. Periode de la guerre à Colmar 1870*, 1999.8.10, Musée Bartholdi, Colmar, reproduced in Paul-Ernest Koenig, "Bartholdi et le combat du point de Horbourg," *La vie en Alsace* 3 (1934): 49–56.

4. Auguste to Commander Tainturier, September 20, 1870, Bartholdi Papers, 1999.8.11, Musée Bartholdi, Colmar.

5. Ibid.

6. Victor Hugo, *Les châtiments* (Brussels: Hetzel, 1853).

7. Victor Hugo, *Depuis l'exil* (Paris: Nelson, n.d.), 80–81, quoted in Pierre Milza, *L'année terrible: La guerre franco-prussienne septembre 1870–mars 1871* (Paris: Perrin, 2009), 1: 184–185.

8. Milza, *L'année terrible*, 1: 167–170.

9. Quoted in Claude Malon, *Jules le Cesne: Député du Havre—1818–1878* (Luneray: Bertout, 1995), 115.

10. Auguste to Charlotte, November 25, 1870, Bartholdi Papers, VI3F, Musée Bartholdi, Colmar;.

11. Raimondo Luraghi, "Garibaldi e gli Stati Uniti," *Rassegna degli Archivi di Stato* 42 (1982): 285–289.

12. Auguste to Charlotte, November 25, 1870, and March 4, 1871, Bartholdi Papers, VI3G, Musée Bartholdi, Colmar.

13. Philippe Joseph Bordone, *Garibaldi et l'armée des Vosges* (Paris: Lacroix, 1871).

14. Bartholdi, "November 13," *Journal de guerre*, Bartholdi Papers, Musée Bartholdi, Colmar.

15. See, for example, Bartholdi, "October 19," "October 25," "October 29," and "November 2," *Journal de guerre*.

16. Bartholdi, "November 9," "November 10," and "November 23," *Journal de guerre*.

17. Milza, *L'année terrible*, 1: 170, 188–195.

18. Ron Chernow, *The House of Morgan: An American Banking Dynasty and the Rise of Modern Finance* (New York: Grove Press, 2010), 184.

19. Helmuth Carol Engelbrecht, *Merchants of Death: A Study of the International Armament Industry* (Auburn, AL: Ludwig von Mises Institute, 1934), 48–50.

20. *Pall Mall Budget*, November 25, 1870.

21. "American Exports of Arms to France," *Pall Mall Budget*, December 23, 1870; quoted in Malon, *Jules le Cesne*, 117.

22. Auguste to Charlotte, August 2, 1870, October 4 and 5, 1870, October 10, 1870, November 17, 1870, Bartholdi Papers, VI3F, Musée Bartholdi, Colmar; Bartholdi, "November 6," *Journal de guerre*, Musée Bartholdi, Colmar.

23. Frédéric-Auguste Bartholdi, *The Statue of Liberty Enlightening the World* (New York: North American Review, 1885), 15.

24. Engelbrecht, *Merchants of Death*, 51.

25. Bartholdi, "November 18," *Journal de guerre*.

26. Bartholdi, "February 13," *Journal de guerre*; Auguste to Charlotte, March 4, 1871, Bartholdi Papers, VI3G, Musée Bartholdi, Colmar.

27. Auguste to Charlotte, March 4, 1871.

28. Quoted in Robert Belot and Daniel Bermond, *Bartholdi* (Paris: Perrin, 2002), 166, 174.

29. Philip G. Nord, *The Republican Moment: Struggles for Democracy in Nineteenth Century France* (Cambridge: Harvard University Press, 1995), 71; Neil Ferguson, *The House of Rothschild: The World's Banker, 1849–1998* (London: Penguin, 1998), 2: 198; René Mar-

tin, *La vie d'un grand journaliste: Auguste Nefftzer, fondateur de la Revue germanique et du temps (Colmar 1820, Bale 1876)* (Besançon: Camponovo, 1948), 1: 100–101.

30. This and the following account of the Commune is based on Bertrand Tillier, *La Commune de Paris, Révolution sans images? Politique et représentations dans la France républicaine (1871–1914)* (Champ Vallon: Époques, 2004), 41.

31. Édouard Laboulaye, *Questiones constitutionelles* (Paris: Charpentier, 1872), 309–329. See also Walter D. Gray, *Interpreting American Democracy in France: The Career of Édouard Laboulaye, 1811–1883* (Newark: University of Delaware Press, 1994), 116.

32. Quoted in Ferguson, *House of Rothschild*, 2: 211.

33. Quoted in ibid., 2: 213.

34. On the syndicate built to appropriate the German loan, see Hubert Bonin, *Histoire de la Société générale* (Genève: Droz, 2006), 277.

35. May 28–30, 1871, *Bartholdi's Diary*, Mss Col 223, New York Public Library; Bartholdi to Charlotte, May 29 and 31, 1871, Bartholdi Papers, VI3G, Musée Bartholdi, Colmar.

36. Émile Zola, "Le Débâcle," in *Les oeuvres complètes* (Paris: Bernouard, 1929), 24: 566.

37. Bartholdi to Charlotte, Paris, June 4, 1871, Bartholdi Papers, VI3G, Musée Bartholdi, Colmar; Bartholdi, *Statue of Liberty*, 16–17; Bartholdi to Charlotte, March 4, 1871.

38. Bartholdi, *Statue of Liberty*, 16–17.

39. Bartholdi to Laboulaye, n.d., cited in Jean-Marie Schmitt, *Bartholdi: A Certain Idea of Liberty* (Strasbourg: Nuée Bleue, 1985), 43–44.

CHAPTER 17 · THE AMERICAN SCENE

1. Bartholdi to Charlotte, Versailles, May 29, 1871, Bartholdi Papers, New York Public Library.

2. Bartholdi to Charlotte, June 17, 1871, Bartholdi Papers, New York Public Library; Auguste to Charlotte, December 20, 1870, Bartholdi Papers, New York Public Library; interview with Bartholdi, in *World*, July 10, 1886, box 1, 1–863, Bartholdi Files, Bibliothèque central du conservatoire des arts et métiers (CNAM).

3. Victor Hugo, "Stella," in *Châtiments* (Geneva: Imprimerie Universelle, 1853), 279–280.

4. Bartholdi to Charlotte, June 24, 1871, Bartholdi Papers, New York Public Library.

5. Henry James, *The American Scene* (New York: Harper, 1907), 74.

6. Olympe Audouard, *A travers l'Amérique—North America* (Paris: Dentu, 1870), 116–117. See also Bénédict Monicat, "Écritures du voyage et féminisme: Olympe Audouard ou le féminin en question," *French Review* 69, no. 1 (1995): 24–36.

7. Frances Trollope, *Domestic Manners of the Americans* (London: Wittaker, Treacher, 1832), 1: 79; Charles Dickens, *American Notes for General Circulation* (New York: Harper, 1842), 91.

8. Quoted in Jeremy Tambling, *Lost in the American City: Dickens, James, and Kafka* (London: Springer, 2001), 94.

9. James, *American Scene*, 71–72.

10. Philippe Roger, *L'ennemi américain: Généalogie de l'antiaméricanisme français* (Paris: Seuil, 2002), 65.

11. Edward Moran, *New York Harbour*, n.d., oil on canvas, 27×46 cm, private collection; Edward Moran, *Summer Morning, New York Bay*, n.d., oil on canvas, 24×42.5 cm, private collection; John Frederick Kensett, *Schrewsbury River, New Jersey*, 1859, oil on canvas, The Robert L. Stuart Collection; Thomas Cole, *The Oxbow*, 1836, 130.8×193 cm, The Metropolitan Museum of Art, New York; Bert D. Yaeger, *The Hudson River School: American Landscape Artists* (New York: Todtri, 1999).

12. Bartholdi to Charlotte, June 24, 1871, Bartholdi Papers, New York Public Library.

13. Ibid.

14. Ibid.

15. John W. Forney, *A Centennial Commissioner in Europe, 1874–76* (Philadelphia: Lippincott, 1876), 137.

16. Bartholdi to Charlotte, June 17, 1871.

17. Bartholdi's Diary, June 21, 1871, Bartholdi Papers, New York Public Library.

18. Bartholdi to Charlotte, June 24, 1871.

19. Bartholdi's Diary, June 22, 1871, Bartholdi Papers, New York Public Library.

20. Bartholdi to Charlotte, June 24, 1871.

21. Ibid.

22. "The Obituary Record: Vincenzo Botta," *New York Times*, October 6, 1894.

23. Bartholdi's Diary, June 24, 1871.

24. Bartholdi's Diary, June 27, 1871.

25. Auguste to Charlotte, July 2, 1871

26. Bartholdi's Diary, June 26, 1871, June 28, 1871.

27. Bartholdi's Diary, June 27, 1871.

28. Bartholdi's Diary, June 28, 1871.

29. Bartholdi's Diary, June 29, 1871.

30. Auguste to Charlotte, July 2, 1871.

CHAPTER 18 · STELLA

1. Bartholdi to Charlotte, July 2, 1871, Bartholdi Papers, New York Public Library.

2. Bartholdi's Diary, July 1, 1871, Bartholdi Papers, New York Public Library; Bartholdi to Charlotte, July 2, 1871.

3. Auguste to Charlotte, July 2, 1871, Bartholdi Papers, New York Public Library.

4. Auguste to Charlotte, August 1, 1871, Bartholdi Papers, New York Public Library.

5. Bartholdi's Diary, July 1 and 2, 1871, Bartholdi Papers, New York Public Library.

6. Michael O'Brien, *Henry Adams and the Southern Question* (Athens: University of Georgia Press, 2007), 47.

7. Bartholdi to Charlotte, July 4, 1871, Bartholdi Papers, New York Public Library.

8. Ibid.

9. Bartholdi to Charlotte, July 9; Bartholdi's Diary, July 8, 1871, Bartholdi Papers, New York Public Library.

10. Quoted in Alexander Tsesis, *Constitutional Ethos: Liberal Equality for the Common Good* (Oxford: Oxford University Press, 2017), 65.

11. Bartholdi to Charlotte, July 2, 1871, Bartholdi Papers, New York Public Library.

12. Ibid.

13. Auguste to Charlotte, July 4, 1871; Bartholdi's Diary, July 5, 1871 (see also the entries for July 6, 7, and 8, 1871), Bartholdi Papers, New York Public Library.

14. Auguste to Charlotte, July 4, 1871, Bartholdi Papers, New York Public Library.

15. Auguste to Charlotte, July 4, 1871, Bartholdi Papers, New York Public Library.

16. Auguste to Charlotte, Philadelphia, July 12, 1871, Bartholdi Papers, New York Public Library.

17. Bartholdi's Diary, July 9, 1871, Bartholdi Papers, New York Public Library.

18. J. Matthew Gallman, "Entrepreneurial Experiences in the Civil War: Evidence from Philadelphia," in *American Development in Historical Perspective*, ed. Thomas Joseph Weiss and Donald Schaefer (Stanford, CA: Stanford University Press, 1994), 205–222, 299–303; Mark R. Wilson, *The Business of Civil War: Military Mobilization and the State, 1861–1865* (Baltimore: Johns Hopkins University Press, 2006), 119–123; Charles Perrow, *Organizing America: Wealth, Power, and the Origins of Corporate Capitalism* (Princeton, NJ: Princeton University Press, 2002), 75–95; William Howard Roberts, "USS New Ironsides: The Seagoing Ironclad in the Union Navy," Ph.D. diss., Old Dominion University, 1992; William Howard Roberts, *USS New Ironsides in the Civil War* (Annapolis: Naval Institute Press, 1999), 18–28.

19. Auguste to Charlotte, July 12, 1871, Bartholdi Papers, New York Public Library.

20. Henry James, *The American Scene* (London: Chapman and Hall, 1907), 293–294.

21. Édouard Laboulaye, *Histoire Politique des États-Unis* (Paris: Charpentier, 1866), 3: 256; James Madison, *Notes of Debates in the Federal Convention of 1787* (New York: Norton, 1987), 659.

22. John W. Forney, *A Centennial Commissioner in Europe, 1874–76* (Philadelphia: Lippincott, 1876), 137.

23. Auguste to Charlotte, July 12, 1871, Bartholdi Papers, New York Public Library.

24. Ibid.; Bartholdi's Diary, July 12, 1871, Bartholdi Papers, New York Public Library.

25. Bartholdi to Charlotte, New York, July 21, 1871; Bartholdi's Diary, July 18, 1871, Bartholdi Papers, New York Public Library.

26. Forney, *Centennial Commissioner in Europe*, 137.

27. Ibid., 138.

28. Bartholdi, *La Malédiction de l'Alsace*, 1872, silver group, Musée Bartholdi, Colmar.

29. Bartholdi's Diary, July 22, 1871, Bartholdi Papers, New York Public Library.

30. Bartholdi to Charlotte, July 21, 1871, Bartholdi Papers, New York Public Library.

31. Bartholdi's Diary, July 23, 1871; see also the entries dated "July 20, 1871," "July 21, 1871," and "July 22, 1871," Bartholdi Papers, New York Public Library.

32. R. Butler, "Death List of a Day," *New York Times*, November 13, 1902; Matthew Hale Smith, *Bulls and Bears of New York: With the Crisis of 1873, and the Cause* (Manchester, UK: Ayer, 1972), 504.

33. Bartholdi to Charlotte, August 29, 1871, Bartholdi Papers, New York Public Library.

34. Bartholdi's Diary, July 29, 1871, Bartholdi Papers, New York Public Library.

35. Bartholdi to Charlotte, July 21, 1871, Bartholdi Papers, New York Public Library.

36. Auguste to Charlotte, August 1, 1871; Bartholdi's Diary, July 31, 1871, Bartholdi Papers, New York Public Library.

37. Billings, *National Monument to the Forefathers*, 1889, marble statue on granite and marble pedestal, Plymouth, Massachusetts.

38. Bartholdi's Diary, August 1, 1871, Bartholdi Papers, New York Public Library.

39. Auguste to Charlotte, August 1, 1871, Bartholdi Papers, New York Public Library.

40. Ibid.

41. Ibid.

42. Ibid., Bartholdi's Diary, August 2, 1871, Bartholdi Papers, New York Public Library; Robert Belot and Daniel Bermond, *Bartholdi* (Paris: Perrin, 2002), 259.

43. Auguste to Charlotte, August 1, 1871, Bartholdi Papers, New York Public Library.

44. John LaFarge, *The Manner is Ordinary* (New York: Harcourt, Brace, 1954), 10–12; Bartholdi's Diary, August 4–5, 1871, Bartholdi Papers, New York Public Library; Royal Cortissoz, *John La Farge: A Memoir and a Study (1911)* (Boston: Houghton, Mifflin, 1911), 8–17, 36, 117.

45. Bartholdi's Diary, August 6, 1871, Bartholdi Papers, New York Public Library.

46. Bartholdi's Diary, August 8, 1871, Bartholdi Papers, New York Public Library.

CHAPTER 19 · ADORABLE WOMAN

1. Tocqueville to his mother, cited in G. W. Pierson, *Tocqueville in America* (Baltimore: Johns Hopkins University Press, 1996), 310.

2. Bartholdi's Diary, August 11–12; Bartholdi to Charlotte, August 16, 1871, Bartholdi Papers, New York Public Library.

3. G. Strand, *Inventing Niagara: Beauty, Power and Lies* (New York: Simon and Schuster, 2008), 79. Bartholdi to Charlotte, August 16, 1871; Bartholdi's Diary, August 12, 1871.

4. Bartholdi to Charlotte, August 16, 1871, Bartholdi Papers, New York Public Library.

5. Ibid.; Bartholdi's Diary, August 15, 1871, Bartholdi Papers, New York Public Library.

6. Bartholdi to Charlotte, August 16, 1871, referring to August 14, Bartholdi Papers, New York Public Library.

7. Auguste to Charlotte, August 22, 1871, Bartholdi Papers, New York Public Library.

8. Ibid.

9. Ibid.

10. Ibid.; Bartholdi's Diary, August 21, 1871, Bartholdi Papers, New York Public Library.

11. Auguste to Charlotte, August 22, 1871, Bartholdi Papers, New York Public Library.

12. Ibid.

13. Bartholdi's Diary, August 23, 1871; Auguste to Charlotte, August 29, 1871, Bartholdi Papers, New York Public Library.

14. Bartholdi's Diary, August 27, 1871, Bartholdi Papers, New York Public Library.

15. Bartholdi's Diary, August 30, 1871, Bartholdi Papers, New York Public Library.

16. Bartholdi to Charlotte, September 8, 1871, Bartholdi Papers, New York Public Library.

17. Auguste to Charlotte, August 29, 1871.

18. Bartholdi to Charlotte, September 8, 1871.

19. Ibid.

20. Auguste to Charlotte, September 11, 1871, Bartholdi Papers, New York Public Library.

21. Bartholdi's Diary, September 27, 1871, Bartholdi Papers, New York Public Library.

22. Bartholdi's Diary, September 29, 1871, Bartholdi Papers, New York Public Library.

CHAPTER 20 · *AUTOPSIA*

1. Bartholdi to Longfellow, January 12, 1875, in *Longfellow Papers*, Houghton Library, Cambridge, MA.

2. Auguste Bartholdi, *Le Lion de Belfort*, 1875–1879, pink sandstone from the Vosges, Colline de la Citadelle, Belfort; Forney, *Centennial Commissioner*, 139, 227.

3. Victor Hugo, "Applaudissement," in *Les châtiments* (Saint-Helier: Imprimerie Universelle, 1853), 283.

4. Auguste Bartholdi, *Monument Voulminot*, 1872, pink sandstone from the Vosges and bronze, Municipal Cemetery, Colmar. Bartholdi made a variety of models, one of which is reproduced in this book.

5. Bartholdi, *La Malédiction de l'Alsace*, 1872, silver group, Musée Bartholdi, Colmar.

6. "Salon de 1872," in *Gazette des Beaux Arts*, 1872, cited in Robert Belot and Daniel Bermond, *Bartholdi* (Paris: Perrin, 2002), 259.

7. Belot and Bermond, *Bartholdi*, 273–274.

8. Auguste to Charlotte, January 12, 1873, Bartholdi Papers, VI4A, Musée Bartholdi, Colmar.

9. Auguste to Longfellow, January 12, 1875.

10. Auguste to Charlotte, April 21, 1872, October 29, 1872, Bartholdi Papers, VI3G, VI4A, Musée Bartholdi, Colmar. See also Belot and Bermond, *Bartholdi*, 275.

11. Ibid.

12. Auguste to Charlotte, November 30, 1872, Bartholdi Papers, VI3G, Musée Bartholdi, Colmar.

13. *Union Franco-Américaine: Discours de Martin Washburne, Laboulaye, Forney prononé au banquet du 6 novembre 1875* (Paris: Charpentier, 1875), 31.

14. Jean-Marie Mayeur and Madeleine Rebérioux, *The Third Republic from Its Origins to the Great War: 1871–1914* (Cambridge, UK: Cambridge University Press, 1984), 23.

15. John W. Forney, *A Centennial Commissioner in Europe, 1874–76* (Philadelphia: Lippincott, 1876), 138.

16. Ibid., 221.

17. Ibid., 193, 229.

18. Édouard Laboulaye, *Le Prince-Caniche* (Paris: Charpentier, 1868), 285–287.

19. Michael Stephen Smith, *The Emergence of Modern Business Enterprise in France, 1800–1930* (Cambridge: Harvard University Press, 2006), 90; Christian Schnakerbourg,

"L'immigration indienne en Guadalupe (1848–1923): Coolies, planteurs et administration coloniale," thesis, Université de Provence, 2005.

20. Forney, *Centennial Commissioner*, 193.

21. Ibid., 331.

22. Ibid., 223.

23. Ibid., 221, 227.

24. See Chapter 1.

25. Forney, *Centennial Commissioner*, 221.

26. Cornelis de Wit, *Histoire de Washington et de la Fondation de la République des États-Unis* (Paris: Didier, 1876); for a list of members of the Franco-American Union, see *Souscription pour l'érection d'un monument commémoratif du centième anniversaire de l'indépendance des États-Unis*, 1875, http://gallica.bnf.fr/ark:/12148/bpt6k4089439 .r=statue%20de%20la%20liberte%20souscription?rk=107296;4 (last accessed April 12, 2018).

27. Forney, *Centennial Commissioner*, 126.

28. Ibid., 144, 198, 314–315; Charles J. Kindleberger, "Origins of United States' Direct Investment in France," *Business History Review* 63, no. 3 (1974): 382–413.

29. Forney, *Centennial Commissioner*, 198–199.

30. *Projet d'organization du comité de l'Union franco-américaine*, 13768–0008–149, Bartholdi Files, Musée des Arts et Métiers, Paris.

31. Rondo Cameron, *France and the Economic Development of Europe, 1800-1914* (Chicago: Rand McNally, 1961), 232–233; Nicolas Stoskopf, "Armand Donon," in *Les patrons du Second Empire: Banquiers et financiers parisiens* (Paris: Picard, 2002), 142–148; Dominique Barjot, *Morny et l'invention de Deauville* (Paris: Armand Colin, 2010), 34–38, 42.

32. "Notices sur les principales industries du départment de la Gironde," *Bulletin de la Société de Géographie Commerciale* 1 (1874–1875): 58–60; Nicolas Stoskopf, "From the Private Bank to the Joint-Stock Bank: The Case of France (Second Half of the 19th Century)," Sixth Annual Congress of the European Business History Association, August 2002, Helsinki, 2003, 7, https://hal.archives-ouverts.fr/hal-00934946 (last accessed December 24, 2016).

33. *Projet d'organization du comité de l'Union franco-américaine*, 13768–0008–149, Bartholdi Files, Musée des Arts et Métiers, Paris.

34. Forney, *Centennial Commissioner*, 331–332.

35. Albert Gallatin Mackay, *The Symbolism of Free-Masonery: Illustrating and Explaining its Science and Philosophy, Its Legends, Myths, and Symbols* (New York: Clark & Maynard, 1869), 147, 156.

36. Ibid., 322.

37. Pierre Simone Ballanche, *Essai sur les institutions sociales*, vol. 2 of *Oeuvres de Ballanche*, 4 vols. (Paris: Barbazat, 1830–), 273.

38. Erwin Panofsky, *Studies in Iconology: Humanistic Themes in the Art of the Renaissance* (New York: Harper, 1962), 70–128; Martin Trachtenberg, *The Statue of Liberty* (London: Penguin, 1986), 65.

39. Forney, *Centennial Commissioner*, 258–259.

40. Botticelli, *La nascita di Venere*, 1482–1485, tempera on canvas, 172.5 × 278.9 cm, Museo degli Uffizi, Firenze.

41. *Souscription pour l'érection d'un monument*, 2.

42. Hubert Bonin, *Histoire de la Société générale* (Geneva: Droz, 2006), 277.

CHAPTER 21 · THE DEMOCRATIC WATCH

1. *Petit journal*, September 28, 1875.

2. Emmanuel Viollet-le-Duc, "Plomberie," in Viollet-le-Duc, *Dictionnaire raisonné de l'architecture française ou XIᵉ au XVIᵉ siècle*, 10 vols. (Paris: Morel, 1864), 7: 219–220.

3. Ibid., 209.

4. Ibid.

5. Undated document, Bartholdi files, 863, box 1, Conservatoire national des arts et métiers, Paris.

6. Ibid.

7. Benjamin Constant, "De l'esprit de conquête et de l'usurpation," in *Cours de politique constitutionelle ou collection des ouvrages publiés sur le gouvernement représentatif par Benjamin Constant*, ed. Édouard Laboulaye, 2 vols. (Paris: Guillaumin, 1861), 2: 254.

8. Franklin to David Hartley, "The Americans," September 6, 1783, in *Correspondance de Benjamin Franklin*, ed. Édouard Laboulaye (Paris: Hachette, 1870) 3: 152; Édouard Laboulaye, "Philippe II," in Laboulaye, *Études morales et politiques* (Paris: Charpentier, 1862), 135.

9. Constant, "De l'esprit de conquête et de l'usurpation," 2: 254.

10. John W. Forney, *A Centennial Commissioner in Europe, 1874–76* (Philadelphia: Lippincott, 1876), 126–127.

11. "Déposition de M. Dietz-Monin: Séance du vendredi, 20 janvier, 1882," *Commission d'enquête sur la situation des ouvriers et des industries d'art* (Paris: Quantin, 1884), 77.

12. "Cuivre repoussé appliqué á la statuarie," *Gazette des architects et du batiment* 3, no. 1 (1865): 90.

13. Forney, *Centennial Commissioner*, 369.

14. Édouard Laboulaye, "Destiny," in *Laboulaye's Fairy Book* (New York: Harper, 1870), 110–112; Laboulaye, "The Gold Bread," in *Laboulaye's Fairy Book*, 129.

15. Albert Bataille, *Causes criminelles et mondaines de 1890* (Paris: Dentu, 1891), 184.

16. Christopher J. Schmitz, "The Changing Structure of the World Copper Market, 1870–1939," *Journal of European Economic History* 26, no. 2 (1997): 296; C. Harry Benedict, *Red Metal: The Calumet and Hecla Story* (Ann Arbor: University of Michigan Press, 1952), 105.

17. Christopher Schmitz, "The Rise of Big Business in the World Copper Industry, 1870–1930," *Economic History Review* 39, no. 3 (1986): 392–410, republished in *Big Business in Mining and Petroleum*, ed. Christopher Schmitz (Aldershot, UK: Elgar, 1995), 114.

18. *Enquête: Traité du commerce avec l'Angleterre. Industrie métallurgique* (Paris: Imprimerie impériale, 1860), 218.

19. "Year of 1878: General Results of Its Commercials and Financial History," *Supplement to the Economist*, March 8, 1879.

20. *Enquête*, 218, 221, 223.

21. *Letters and Recollections of Alexander Agassiz* (Boston: Houghton Mifflin, 1913), 54.

22. "Clarke Mine," in *The Mines Handbook: An Enlargement of the Copper Hand Book; A Manual of the Mining Industry in North America* (Tuckahoe, NY: The Mines Handbook, 1922), 858.

23. *Le Temps*, October 10, 1875.

24. The following account of Secrétan's life is based on Eric Ratzel, "Un aventurier des temps industriels: Pierre Eugène Secrétan (1836–1899)," *Cahiers d'histoire de l'aluminium* 22 (1998): 37–48.

25. LH 5271, Archives Nationales, Paris, quoted in ibid., 40.

26. Bernard Secrétan, *Secrétan: Histoire d'une famille Lausannoise de 1400 à nos jours* (Lausanne: Editions du Val de Faye, 2003), 181.

27. Charles Laboulaye, *Organisation du travail: De la démocratie industrielle* (Paris: Mathias, 1848), 40.

28. *The Illustrated History of the Centennial Exhibition* (Philadelphia: National Publishing, 1876), 235, 464.

29. *Courier de France*, October 29, 1875.

CHAPTER 22 · OPEN TOMB

1. *La Presse*, November 8, 1875; *Figaro*, November 7, 1875; *Xix^e siècle*, November 8, 1875.

2. Bartholdi, *La liberté éclariant le monde* or *Modèle du comité*, 1875, bronze statue, Musée Bartholdi, Colmar.

3. Cesare Ripa, *Iconologia*, 3 vols. (Siena: Matteo Florimi, 1613), 206.

4. Ibid.

5. On the connection between the statue and the symbol of faith, see Carol E. Harrison, "Dr. Lefebvre's American Dream," *New York Times*, April 1, 2014.

6. Édouard Laboulaye, "King Bizarre and Prince Charming," in *Laboulaye's Fairy Book: Fairy Tales of All Nations* (New York: Harper, 1866), 193.

7. John W. Forney, *A Centennial Commissioner in Europe, 1874–76* (Philadelphia: Lippincott, 1876), 368–369.

8. Jean-André Faucher, *Les Franc-Maçons et le pouvoir: De la Révolution à nos jours* (Paris: Perrin, 1986), 118; *Histoire de la Franc-Maçonnerie en France* (Paris: Nouvelles éditions latines, 1967), 352. See also Mildred J. Headings, *French Freemasonry under the Third Republic* (Baltimore: Johns Hopkins University Studies in Historical and Political Sciences, 1948).

9. Exodus 4:10, 5.

10. Exodus 32: 4.

11. José Marti, "Dedication of the Statue of Liberty," in José Marti, *Inside the Monster: Writings on the United States and American Imperialism*, ed. Philip S. Foner (New York: NYU Press, 1977), 146.

12. "Carnet de Journée," *La France*, November 7, 1875; "Nouvelle du jour," *Le siècle*, November 7, 1875; "A Franco-American Banquet," *The Times*, November 8, 1875.

13. "A Franco-American Banquet."

14. See Chapter 12.

CHAPTER 23 · CHILDREN'S TORCH

1. "A Franco-American Banquet," *The Times*, November 8, 1875.

2. John W. Forney, *A Centennial Commissioner in Europe, 1874–76* (Philadelphia: Lippincott, 1876), 370.

3. Édouard Laboulaye to Ulysses Grant, October 26, 1875, quoted in *The Papers of Ulysses Grant*, ed. John Y. Simon, 28 vols. (Carbondale, IL: SIU Press, 2005), 28: 157.

4. *Union Franco-Américaine: Discours de Martin Washburne, Laboulaye, Forney prononcé au banquet du 6 Novembre 1875* (Paris: Charpentier, 1875), 43.

5. *Paris Journal*, November 8, 1875.

6. Jamie Goode and Sam Harrop, *Authentic Wine toward Natural and Sustainable Winemaking* (Berkeley: University of California Press, 2011), 39.

7. "Bibliographie," *Bulletin de la Société d'acclimatation* 23, no. 3 (1876): 237.

8. Laboulaye to Ulysses Grant, October 26, 1875.

9. *Union Franco-Américaine*, 17–18.

10. Ibid., 17.

11. *National*, November 8, 1875; *Union Franco-Américaine*, 22–23.

12. I borrowed the expression "story-seeker" from Henry James, *American Scene* (London: Chapman and Hall, 1907), 35.

13. *Union Franco-Américaine*, 23.

14. Ibid., 27.

15. Ibid., 35.

16. Ibid.

17. Ibid., 39–40.

18. *Le Figaro*, November 7, 1875.

19. *Union Franco-Américaine*, 39–40.

20. Ibid., 38–39.

21. Ibid., 32.

22. The shipment is mentioned in Jonathan Leitner, "Upper Michigan's Copper Country and the Political Ecology of Copper, 1840s–1930s," Ph.D. diss., University of Wisconsin-Madison, 1998, 114.

23. Jean-Marie Welter, "Understanding the Copper of the Statue of Liberty," *Journal of the Minerals, Metals & Materials Society* 58 (2006): 30–33; Jean-Louis Bordes, "Ernest

Deligny (1842): Une vie d'ingénieur au XIXe siècle (1820–1898)," *Centraliens* 604 (2010): 62.

24. Marthe Barbance, *Histoire de la Compagnie générale transatlantique: Une siècle d'exploitation maritime* (Paris: Paris arts et métiers graphiques, 1955), 41.

25. *Courier de Paris,* November 8, 1875; *Union Franco-Américaine,* 38.

26. Édouard Laboulaye, "King Bizarre and Prince Charming," in *Laboulaye's Fairy Book: Fairy Tales of All Nations* (New York: Harper, 1870), 193.

27. *Xixe siècle,* November 8, 1875.

CHAPTER 24 · THE PHANTOM OF THE OPERA

1. *Le Temps,* October 10, 1875; *La Presse,* November 8, 1875.

2. *Le Loire,* October 17, 1875; *Le Temps,* October 10, 1875.

3. *Le Temps,* October 10, 1875; *Stational,* April 30, 1876.

4. G. Frantz, "Exposition de l'Union Centrale: Le métal," *Gazette des architectes et du bâtiment* 9 (1880): 248; *Le petit journal,* September 28, 1875.

5. See Chapter 11.

6. Emmanuel Viollet-le-Duc, "Plomberie," in Viollet-le-Duc, *Dictionnaire raisonné de l'architecture française ou XIe au XVIe siècle,* 10 vols. (Paris: Morel, 1864), 7: 211.

7. "Le monument franco-américaine," *L'exposition illustrée,* June 16, 1875, 8.

8. "Échos de Paris," *Le Figaro,* November 19, 1875.

9. "Revue économique," *l'Économiste française,* October 10, 1874.

10. "Causerie," in *Le moniteur de la mode,* August 1, 1875; Robert Belot, *Bartholdi: Portrait intime du sculpteur* (Bernardswiller: I.D. l'Édition, 2016), 294.

11. "Bateaux at roues et hélices," in *Complément du dictionnaire des arts et manufactures,* ed. Charles-Pierre de Laboulaye (Paris: Lacroix, 1861), 65.

12. Albert Charles, "L'industrie de la construction navale à Bordeaux sous le Second Empire," *Annales du midi: Revue archéologique, historique et philologique de la France méridionale* 66, no. 25 (1954): 52.

13. *Stational,* April 30, 1876. The same article reports an unquantified donation from Auvergne, where Lafayette was born.

14. Eric Saugera, *Bordeaux port négrier (XVIIe–XIXe siècles)* (Paris: Karthala, 2002), 193.

15. *Illustration,* May 13, 1876.

16. Marthe Barbance, *Histoire de la Compagnie Générale Transatlantique: Une siècle d'exploitation maritime* (Paris: Paris Arts et Métiers Graphiques, 1955), 41, 88, 95

17. Quoted in ibid., 39.

18. *Le Commerce,* December 23, 1875.

19. *Journal de Commerce* (Alexandria), December 25, 1875.

20. T. Faucon, *Le Nouvel Opéra: Monument—Artistes* (Paris: Lévy, 1875); Frédérique Patureau, *Le Palais Garnier dans la société parisienne* (Liège: Mardaga, 1991), 91–92, 320, 347.

21. *La Liberté,* April 27, 1876.

22. *L'Evenment*, April 27, 1876; *Le Figaro*, April 26, 1876.

23. The details of the evening provided in the next paragraphs are provided from "La Soirée," *Le Figaro*, April 25, 1876, and *La Gazette*, April 26, 1876.

CHAPTER 25 · *MISCENDO UTILE DULCI*

1. "Cuivre repoussé appliqué á la statuarie," in *Gazette des architects et du batiment* 3, no. 1 (1865): 90; "Chaudronnerie," in *Dictionnaire des arts et manufacture*, ed. by Charles Laboulaye, 3 vols. (Paris: Librairie du Dictionnaire des arts et manufacture, 1873), 1: 562.

2. Charles Talansier, in "La Statue de la Liberté éclairant le monde," *Le génie civil* 3, no. 19 (1883): 10–35.

3. Ibid., 13–15.

4. *Le bien public*, April 17, 1876.

5. Auguste to Charlotte, October 30, 1876, VI4D, Musée Bartholdi, Colmar.

6. Robert Belot, *Bartholdi: Portrait intime du sculpteur* (Bernardswiller: I.D. l'Édition, 2016), 321.

7. Ibid., 59.

8. L. Simonin, "Le centenaire américaine et l'exposition de Philadelphie," in *Revue des deux mondes* 17 (1876): 801.

9. Gustave de Molinari, *Lettres sur les États-Unis et le Canada* (Paris: Hachette, 1876), 51; ibid., 404.

10. Tocqueville, *De la démocratie en Amérique*, 3 vols. (Paris: Gosselin, 1840) 3: 93–94.

11. Frédéric Auguste Bartholdi, *Exposition internationale de Philadelphie. Section française. Rapport sur les arts décoratifs, Imprimerie nationale* (Paris: Imprimerie nationale, 1877), 5.

12. See Chapter 5.

13. Bartholdi, *Exposition*, 11.

14. Giuseppe Arcinboldo, *Vertumnus*, 1590, oil on panel, 56×68 cm, Skokloster Castle, Skokloster.

15. Bartholdi, *Exposition*, 7–8; *Boston Chronicle*, December 17, 1876.

16. Bartholdi, *Exposition*, 6.

17. The following account of Salmon's history is based on Nathalie Salmon, *L'histoire vraie du modèle de la Statue: Lady Liberty I Love You* (Mesnil-Esnard: Comever–De Rameau, 2013), 30, 159–160.

18. Auguste Bartholdi to Alphonse Salmon, December 23, 1874, quoted in ibid., 225.

19. Ibid., 98.

20. Bartholdi to Kern, October 14, 1888, quoted in Jacques Betz, *Bartholdi* (Paris: Éditions de Minuit, 1954), 218.

21. Elizabeth Mitchell, *Liberty's Torch: The Great Adventure to Build the Statue of Liberty* (New York: Grove Press, 2014), 140.

22. André Michel, *Revue alsacienne*, July 1884, quoted in Betz, *Bartholdi*, 171.

23. Bartholdi to Salmon, April 30, 1877, in Salmon, *L'histoire*, 227.

24. Salmon, *L'histoire*, 176.

25. Bartholdi to Charlotte, July 1 and 7, 1876, VI4D, Musée Bartholdi, Colmar.

26. *Harper's Weekly*, July 14, 1876; Julia Kristeva, *Soleil Noir: Dépression e mélancolie* (Paris: Gallimard, 1987), 17, 153.

27. "The Next Morning," *Life*, February 26, 1877.

28. "The Gates of Hell," *Harper's Weekly*, April 2, 1881; Dante, *La Divina Commedia, Inferno*, canto 3, verse 9.

29. *Courier des États-Unis* (1896), quoted in Betz, *Bartholdi*, 206.

30. John La Farge, *The Manner Is Ordinary* (New York: Harcourt, Brace, 1954), 14–15.

31. Edward Moran, *Commerce of Nations Rendering Homage to Liberty*, 1876, oil on canvas, 241.3 × 179.1 cm, private collection.

32. Belot and Bermond, *Bartholdi*, 317; Carol A. Grissom, *Zinc Sculpture in America: 1850–1950* (Blue Ridge Summit, PA: Associated University Presses, 2009), 200.

33. Bartholdi to Charlotte, September 24, 1876, VI4D, Musée Bartholdi, Colmar; *New York Times*, September 29, 1876.

34. Bartholdi, *Exposition*, 17.

35. *Philadelphia Press*, October 5, 1876. The "volunteers" were J. W. Forney, A. P. Brown, W. W. Weighley, C. S. Keyser, M. Borda, T. B. Birch, A. L. Buzby, T. B. Pugh, W. D. Gemill, E. J. Hinken, J. P. Scott, T. Cochran, H. Tyndale, and M. R. Mucklé.

36. "Philadelphia Conspiracy," *New York Times*, October 8, 1876.

37. *Le Loir*, November 19, 1876.

38. *New York Times*, February 26, 1877; *New York Tribune*, January 9, 1877; *World*, December 23, 1876; draft of the letter held in the Bartholdi Files, Conservatoire nationale des arts et des métiers, 1095. The final group included Coudert (lawyer for the statue of Lafayette and member of the Cercle), Charlier, Salmon, Stucklé (architect of the *Lafayette* and member of the Cercle), Am. Vatable (Cercle), Ch. Villa, G. Batchelor, E. Auert, A. d'Ouville, V. Fortwengler, A. Guiraud, W. B. McClellan, L. Meunier, Ch. Renauld, and J. Tartter.

CHAPTER 26 · ADVICE TO ALL NATIONS

1. Bartholdi to Salmon, March 2, 1877, in Nathalie Salmon, *L'histoire vraie du modèle de la Statue: Lady Liberty I Love You* (Mesnil-Esnard: Comever–De Rameau, 2013), 230.

2. *L'Exposition Universelle de 1878* 3, no. 79 (1877): 185.

3. "Union Franco-Americaine," Bartholdi Files, Conservatoire nationale des arts et des métiers, 1118.

4. Ibid., 1110.

5. Bartholdi to Salmon, March 2, 1877.

6. *Le journal illustré*, May 28 and June 30, 1876.

7. Unidentified newspaper clipping, Bartholdi Files, Conservatoire nationale des arts et des métiers, 652.

8. Jean-Marie Mayeur and Madeleine Rebérioux, *The Third Republic from Its Origins to the Great War: 1871–1914* (Cambridge, UK: Cambridge University Press, 1984), 27–31.

9. Jean Garrigues, *La République des hommes d'affaires* (Paris: Aubier, 1997), 78–79.

10. H. de Mareil to Ulysses Grant, February 27, 1877, and John Welsh to Ulysses Grant, January 19, 1877, both in *The Papers of Ulysses Grant*, ed. John Y. Simon, 28 vols. (Carbondale, IL: SIU Press, 2005), 28: 499.

11. *Congressional Record: Containing the Proceedings and Debates of the Forty-Fourth Congress, Second Session* (Washington, DC: Government Printing Office), 1877, 1404.

12. Thomas L. Leonard, *Historical Dictionary of Panama* (Lenham, MD: Rowman & Littlefield, 2015), 217; John Major, *Prize Possession: The United States and the Panama Canal, 1903–1979* (Cambridge, UK: Cambridge University Press, 1993), 19–20.

13. Hubert Bonin, *Histoire de la Société générale* (Geneva: Droz, 2006), 282.

14. Mira Wilkins, *The History of Foreign Investment in the United States to 1914* (Cambridge: Harvard University Press, 1989), 684, endnote 198; *Le courrier des États-Unis*, August 15, 1877.

15. William Evarts, "Report of the Commissioner-General," in *Reports of the United States Commissioners to the Paris Universal Exposition, 1878*, 5 vols. (Washington, DC: Government Printing Office, 1880), 1: 7.

16. McCormick to Evarts, May 14, 1878, in *Reports of the United States Commissioners to the Paris Universal Exposition, 1878*, 1: 186.

17. *New York Times*, February 28, 1877. Subscriptions from John Mackay and MacMahon ($5,000) were part of that same funding round.

18. *L'exposition universelle de 1878 illustrée* 5, no. 123 (1878): 549.

19. Robert Belot and Daniel Bermond, *Bartholdi* (Paris: Perrin, 2002), 329.

20. Ibid., 330.

21. *L'exposition universelle de 1878 illustrée* 8, no. 149 (1878): 757.

22. "Sections étrangères," *Exposition universelle illustrée* 7, no. 142 (1878): 701.

23. On this topic, see Sven Beckert, "American Danger: United States Empire, Eurafrica, and the Territorialization of Industrial Capitalism, 1870–1950," *American Historical Review* 122, no. 4 (2017): 1137–1170.

24. Quoted in Daniel Bermond, *Gustave Eiffel* (Paris: Perrin, 2002), 141.

25. Jean-Louis Escudier, *Edmond Bartissol: Du Canal de Suez à la bouteille d'apéritif* (Paris: CNRS, 2000), 47–50.

26. Michel Hau and Nicolas Stoskopf, *Les dynasties alsaciennes du XVIII^e siècle à nos jours* (Paris: Perrin, 2005), 270; Bermond, *Gustave Eiffel*, 207.

27. Bermond, *Gustave Eiffel*, 233.

28. Ibid., 241.

29. Charles Talansier, in "La Statue de la Liberté éclairant le monde," *Le Génie Civil* 3, no. 19 (1883): 15.

30. Ibid.

31. Édouard Feret, *Statistique générale, topographique, scientifique, administrative, industrielle, commerciale, agricole, historique, archéologique et biographique du département de la Gironde: Partie topographique, scientifique, agricole, industrielle, commerciale, et administrative* (Bordeaux: Féret, 1878), 636; Bonin, *Histoire de la Société Generale*, 59; Pierre Guillaume, *La Compagnie des mines de la Loire, 1845–1854* (Paris: P.U.F., 1966).

32. Fr. Duguing, "M. Schneider," in *Les Contemporaines célèbres illustrés, 106 portraits, 106 études* (Paris: Librairie internationale, 1869), 268.

33. *Enqête: Traité de commerce avec l'Angleterre. Industrie métallurgique* (Paris: Imprimerie impériale, 1860), 305–306.

34. Jean-Marie Welter, "Understanding the Copper of the Statue of Liberty," *Journal of the Minerals, Metals & Materials Society* 58 (2006): 32.

35. H. Hamon and George Bachot, *L'agonie d'une société: Histoire d'aujourd'hui* (Paris: Savine, 1889), 27n; ibid., 30.

36. Målfrid Snørteland, "Dei Kalte Oss Visnesslusk. Ein studie av rekruttering, sosial organisasjon og sosialt liv i gruvesamfunnet Visnes, 1865–1940," master's thesis, University of Bergen, 1984, 15.

37. Miguel A. López-Morell, *The House of Rothschild in Spain, 1812–1941* (London: Routledge, 2013), 176.

38. On Cernuschi's involvement, see also Catherine Hodeir, "The French Campaign," in *Liberty: The French-American Statue in Art and History* (New York: Perennial, 1984), 124.

39. Édouard Laboulaye, "King Bizarre and Prince Charming," *Laboulaye's Fairy Book: Fairy Tales of All Nations* (New York: Harper, 1866), 193.

40. "Grande Cavalcade organisée avec le concours de la garnison, au profit de pauvres," May 11, 1879, Bartholdi Files, Conservatoire nationale des arts et des métiers.

41. Stoskopf, "Armand Donon," in *Les patrons du Second Empire: Banquiers et financiers parisiens* (Paris: Picard, 2002), 145.

42. "American Pork in France," *New York Times*, February 22, 1881.

43. "American Pork in Europe," *New York Times*, February 23, 1881.

CHAPTER 27 · THE IDEA

1. *New York Times*, January 14, 1883.

2. Paul Baker, *Richard Morris Hunt* (Cambridge, MA: MIT Press, 1986), 284.

3. J. Hargrove, "The American Fund-Raising Campaign," in *Liberty: The French-American Statue in Art and History* (New York: Perennial, 1986), 160.

4. Auguste reproduced the note in the confessional interview *The Statue of Liberty Enlightening the World* (New York: North American Review, 1885).

5. Victor Hugo, "Stella," in *Châtiments* (Geneva: Imprimerie universelle, 1853), 279–280.

6. Victor Hugo, *Les orientales* (Paris: Hetzel, 1869), 5–10.

7. *New York Herald*, January 27, 1884.

8. John P. Dunn, *Khedive Ismail's Army* (London: Routledge, 2005), 65–66, 68, 134–150.

9. *New York Herald,* January 28, 1884.

10. Elizabeth Mitchell, *Liberty's Torch: The Great Adventure to Build the Statue of Liberty* (New York: Grove, 2014), 167.

11. Hargrove, "American Fund-Raising Campaign," 159, 160–161.

12. *New York World,* March 16, 1885.

13. For the contents of the copper box and the events of the day, see *New York Times,* August 6, 1884.

14. Ibid.

15. See Chapter 8.

16. Joseph Hubert Willems, H. Lamant, and Jean-Yves Conant, *Armorial français; or, Répertoire alphabétique de tous les blasons et notices de familles nobles, patriciennes et bourgeoises de France* (Dison: Lelotte, 1973), 51.

17. See Chapter 23.

18. Betz, *Bartholdi,* 179; Mitchell, *Liberty's Torch,* 152.

19. Mitchell, *Liberty's Torch,* 204.

20. "Absorption and Improvement," *New York Times,* September 20, 1885.

21. "Le flambeau électrique de la statue de 'La Liberté' à New-York," *Illustration,* October 29, 1887.

EPILOGUE · DOT-DOT-DOT-DASH

1. Jacques Betz, *Bartholdi* (Paris: Éditions de minuit, 1954), 201.

2. These developments are documented at the website Lighthouse Friends, at http://lighthousefriends.com/light.asp?ID=581 (accessed January 23, 2018).

3. Keith Frazier Somerville, *Dear Boys: World War II Letters from a Woman Back Home* (Jackson: University Press of Mississippi, 1991), 42; "Miss Liberty's New Robes of Light to Glow on V-Day," *New York Times,* December 28, 1944.

4. Somerville, *Dear Boys,* 42.

5. *The Daily Show with Jon Stewart,* September 20, 2001, available at http://www.cc.com /video-clips/1q93jy/the-daily-show-with-jon-stewart-september-11–2001 (last accessed April 20, 2018).

Acknowledgments

It is disquieting to note that it took me almost as long to write *Sentinel* as it took Bartholdi to build the Statue of Liberty. And like Miss Liberty, my book would not have come to be without the generous help of a very large number of people. The similarities end there. I first stumbled upon a series of old articles on the unveiling in New York of a statue meant for Egypt in the basement of Olin Library at Cornell University in the spring of 2003, and began then to discuss the topic with R. Laurence Moore. He shared my enthusiasm, and I would like to thank him for encouraging me to pursue my interest on a larger scale. Closer to home, Carlo Augusto Viano and Giorgia Marogna have believed in the project since the very beginning, and I will remain forever grateful for their wise counsel. Many friends and colleagues read parts of my book during its long gestation, and I would particularly like to thank David Armitage, John Brewer, Giovanni Carletti, Antonella Emmi, Nick Guyatt, Istvan and Anna Hont, Andrea Iacona, Joel Isaac, Steven Kaplan, Christian Kempf, Graham Kerslick, James and Mary Kloppenberg, Isaac Kramnick, Sergio Luzzatto, Peter Mandler, Eric Nelson, John Ngo, Tricia O'Brien, Erik, Fernanda, and Hugo Reinert, Emma Rothschild, Quinn Slobodian, Reese Scott, Daniel Smith (Laboulaye's alter ego), Michael Sonenscher, Maurizio Vaudagna, and Jennifer Wilkins (who first initiated me to the American mysteries).

Working with my editor at Harvard University Press, Ian Malcolm, proved to be a once-in-a-lifetime experience. His trust, appreciation, and deep knowledge of the writing process ultimately helped

me transform a long and sometimes meandering history of the Statue of Liberty into *Sentinel*. My friend Robert Fredona did more than anyone to help me navigate the treacherous terrain of translation. Two anonymous readers at Harvard University Press provided truly expert commentary. Julie Carlson helped me polish the text, and I would like to thank her for her contagious enthusiasm.

This book has been written in Italy, France, Norway, the United Kingdom, and the United States. In each country, I have relied on the help of libraries, archives, and museums. I would therefore like to thank the Fondazione Einaudi and the Fondazione Luigi Firpo in Turin, Italy; the Bibliothèque nationale de France and the Musée des Arts et Métiers in Paris; Visnes Kobberverk at Karmøy, Norway; the Cambridge University Library in Cambridge, England; the British Library in London; Olin Library at Cornell University in Ithaca, New York; the New York Public Library and the Statue of Liberty National Monument in New York; and the Widener Memorial Library at Harvard University in Cambridge, Massachusetts. I am also grateful to the Musée Unterlinden and the Musée Bartholdi in Colmar, France. The latter, a veritable temple to Bartholdi and the Statue of Liberty, has hosted me on numerous occasions through the years, and I would like to thank Régis Hueber, Isabelle Bräutigam, and Chirstian Kempf (of Studio K) for going so far beyond the call of duty to help and encourage me. I am also grateful to Simone Kempf for introducing me to the beautiful Alsatian language.

My research for this project has, at different times, been funded by the University of Turin, the University of Pavia, the Consiglio Nazionale delle Ricerche, the Fondazione Luigi Firpo, the Accademia dei Lincei, the British Academy, and the Royal Society. I remain grateful for their financial and moral support. During the last phases of writing I was blessed to be part of the Global Initiative at Harvard University, and would like to thank Sven Beckert and the participants in his seminars for lively debates.

Finally, I owe a special debt to my husband Sophus A. Reinert, who may have read a few versions of the manuscript, and to our son Erik August, who allows us to see the world by the light of his lively flame. The late Michael O'Brien taught me to savor the pleasure of writing histories, journeying with historical characters and probing their emotions. Michael is no longer here to read this book, but my hope is that he would have recognized in it traces of our many early afternoon conversations at Jesus College, Cambridge, under his black and white portrait of John Steinbeck. He is deeply missed.

Illustration Credits

Plate 6. Photo: © RMN-Grand Palais / Jean-Gilles Berizzi / Art Resource, NY.

Plate 7. Photo: Image © Collection Centraal Museum, Utrecht.

Plate 8. Photo: © The Royal Collection, HM The Queen / Victoria and Albert Museum, London.

Plate 9. Photo: © Musée du Louvre, Dist. RMN-Grand Palais / Philippe Fuzeau / Art Resource, NY.

Plate 10. Photo: Christian Kempf, Studio K, Colmar.

Plate 11. Photo: © Musée d'Unterlinden, Dist. RMN-Grand Palais / Art Resource, NY.

Plate 12. Photo: © RMN-Grand Palais / Hervé Levandowski / Art Resource, NY.

Plate 13. Photo: Christian Kempf, Studio K, Colmar.

Plate 14. Photo: © RMN-Grand Palais / Hervé Lewandowski / Art Resource, NY.

Plate 15. Photo: Christian Kempf, Studio K, Colmar.

Plate 16. Photo: Christian Kempf, Studio K, Colmar.

Plate 17. Photo: Christian Kempf, Studio K, Colmar.

Plate 18. Photo: Maurizio Leigheb, De Agostini Picture Library, licensed to Alinari Archives.

Plate 19. Photos: Christian Kempf, Studio K, Colmar.

Plate 20. Photo: Christian Kempf, Studio K, Colmar.

Plate 21. Photo: Christian Kempf, Studio K, Colmar.

Plate 22. Photo: Christian Kempf, Studio K, Colmar.

Plates 23A, B. Photos: Hervé Lewandowski / RMN-Réunion des Musées Nationaux / distr. Alinari Archives.

Plate 24. Photo: Widener Library, Harvard University, Cambridge, Massachusetts.

Index

Italicized page numbers indicate illustrations.